THE LETTERS OF
PETER PAUL RUBENS

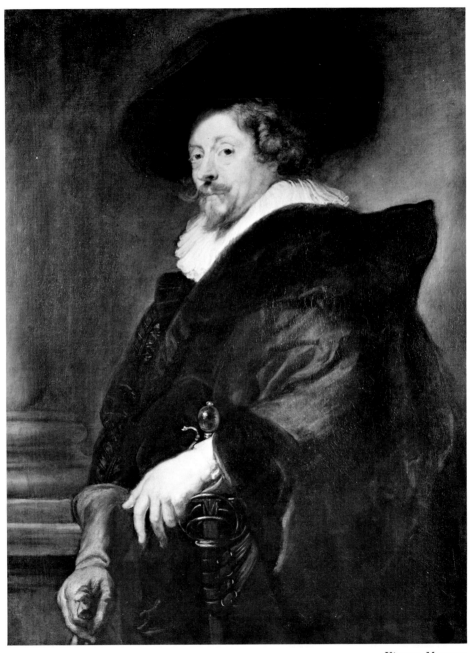

Peter Paul Rubens. 1638–1640.

THE LETTERS OF
PETER PAUL RUBENS

Translated and Edited by
RUTH SAUNDERS MAGURN

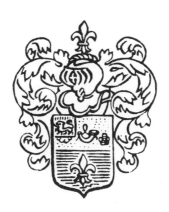

HARVARD UNIVERSITY PRESS
Cambridge, Massachusetts

© Copyright 1955 by the President and Fellows of
Harvard College
Second Printing, 1971

Distributed in Great Britain by
Oxford University Press, London

Library of Congress Catalogue Card Number 55-5223
SBN 674-52825-5
Printed in the United States of America

To Jakob Rosenberg
to whom this book owes so much

PREFACE

The correspondence of Peter Paul Rubens was first made available in published form in 1840, exactly two hundred years after the Flemish painter's death. This volume was Émile Gachet's *Lettres inédites de Pierre-Paul Rubens*, which provided a French translation of sixty-seven letters along with original texts for the most part in Italian, Rubens' favorite language. As additional items came to light, the corpus of correspondence grew, and in 1877 Charles Ruelens undertook the monumental task of bringing together in one publication all the known documents relating to Rubens, adding to the artist's own letters those written to him and those concerning him as well. This *Codex Diplomaticus Rubenianus*, brought to completion by Max Rooses, appeared in six volumes (1887–1909) and remains the standard work on the Rubens correspondence, presenting the text of each document in its original language along with the French translation, and with a full commentary. In 1926–27 Paul Colin brought out a new French translation, treating only Rubens' own letters and departing from a chronological order in favor of an arrangement by subject. Gregorio Cruzada Villaamil published in 1875 his *Rubens diplomatico español*, which included thirty-one letters, mainly those in the Archivo General of Simancas, and in part translated into Spanish. The first German edition was published in 1881 by Adolf Rosenberg, without, however, providing a translation; the letters were printed as originally written. It was not until 1918 that the correspondence was translated into German by Otto Zoff.

An English translation of all the known letters has not yet appeared. Three letters in English were to be found as early as 1784 in *A Year's Journey through the Pais-Bas, or Austrian Netherlands*, by Philip Thicknesse, and eight were included in William Hookham Carpenter's *Pictorial Notices* of 1844, but the first English publication to deal more fully with the subject of the Rubens correspondence was W. Noel Sainsbury's *Original Unpublished Papers Illustrative of the Life of Sir Peter Paul Rubens*, which came out in 1859. This volume included thirty-eight of the artist's

letters, preserved for the most part in the Public Record Office in London. It remained the only English publication until 1950, when the Phaidon edition of Jakob Burckhardt's *Recollections of Rubens* numbered among its selected letters twenty-four not previously translated.

The present volume offers the reader the complete collection of Rubens letters insofar as they are known to us. Of the two hundred and fifty items, one hundred and eighty-eight have not appeared in English before and ten are published for the first time anywhere. The ten are Letters 56, 57, 83, 90, 91, 116, 139, 169, 173, and 247; transcripts of their original Italian, French, or Spanish texts may be found in the Appendix. Ten other letters which have appeared during the last forty years in various publications are here first incorporated in Rubens' correspondence.

Existing English translations have been completely revised, not only in the interest of accuracy, but in order to lend a certain harmony and consistency of language to the whole. Wherever possible I have studied the original manuscripts, notably those in London, Paris, Brussels, and Antwerp; in other cases I have relied upon the texts in the *Codex Diplomaticus*. My dual aim in the translation of the letters has been the ambitious one of preserving the literal sense, while suggesting as much as possible of the writer's spirit and style of expression. To this end it seemed advisable to leave unchanged the numerous Latin phrases and quotations that Rubens used so freely, and to supply translation in footnote form. The removal of these classical embellishments from the text would rob the letters of much of their humanistic flavor. Many of the quotations are here for the first time traced to their sources in Latin literature, vividly confirming Rubens' thorough knowledge of the classics. His engaging habit of adding parenthetical remarks, corrections, or postscripts in the margins of his pages could only be hinted at by bracketing these phrases and inserting them in the text where they seemed to belong. I have not attempted to retain his spelling of proper names, for this would lead to confusion. But in trying to rectify Rubens' inconsistencies, I have perhaps fallen into others, for which I ask indulgence. It seemed that in dealing with persons of so many nationalities, certain discrepancies in orthography were unavoidable.

The letters follow a strictly chronological arrangement, as perhaps the most natural method of tracing the many parallel currents and interrelationships in the career of this painter-diplomat. Within the chronological framework I have divided the material into parts according to the chapters in Rubens' life and the subjects that occupied his interest. A

general introduction attempts to define the significance of his correspondence both as a personal record and as a historical document. In addition, the foreword to each part provides a more detailed analysis of the complex political situation in Europe at every phase of Rubens' career. In this way the individual letters, with their often cryptic implications, may be better understood. I hope that these historical commentaries will guide the reader through the labyrinth (to use Rubens' own word) of international politics and clarify Rubens' position in diplomatic spheres.

To all those who, in one way or another, have aided me in the preparation of this volume, I wish to express my sincere thanks. Especial gratitude is due to Mr. John P. Coolidge, Director of the Fogg Art Museum, for his constant interest and encouragement. Mr. Paul J. Sachs, Associate Director Emeritus, has followed the progress of my work with friendly and stimulating counsel. I am indebted to Mr. William A. Jackson of the Houghton Library for generous advice, and to Dr. Erwin Panofsky of Princeton University and Dr. Herbert Bloch of Harvard University, for helpful assistance in tracing the Latin quotations. Dr. Ludwig Burchard of London has been extremely kind in providing valuable information, and I am grateful to Mr. Michael Jaffé of King's College, Cambridge, for the important material he has put into my hands.

I am glad of this opportunity to thank my colleagues at the Fogg Museum — Miss E. Louise Lucas for bibliographical assistance, and my other good friends for various suggestions and general helpfulness. To the institutions and individuals who have granted permission to publish manuscripts or to reproduce works of art I acknowledge my appreciation. The book in its present form owes a deep debt of gratitude to Mrs. Chase Duffy of the Harvard University Press.

Finally, I should like to thank the Belgian American Educational Foundation for the financial aid which enabled me to study the Rubens letters in European collections, and thus to add a number of hitherto unpublished items to the painter's correspondence.

R. S. M.

Fogg Art Museum
Harvard University
April 1955

CONTENTS

xi

V

1 6 2 8 (January–August)

V I

1 6 2 8 - 1 6 2 9

V I I

1 6 3 0 - 1 6 4 0

ILLUSTRATIONS

xiii

"I could provide an historian with much material...very different from that which is generally believed."

RUBENS TO PEIRESC, *December 18, 1634*

INTRODUCTION

The creative power and boundless vitality of Peter Paul Rubens are qualities clearly revealed in his art. We recognize in Rubens the great Baroque figure who was able to fuse classic and Christian ideals and to express them in a new and coherent idiom — the painter whose capacity for selection and synthesis was broad enough to embrace the most diverse elements of northern and southern art without any sacrifice of his integrity. Linked with this creative intensity was Rubens' ability to give full expression to the leading cultural and spiritual tendencies of his whole period. It often happens that a strong individual is the most articulate representative of general trends, and Rubens thus may be said to epitomize the Baroque. His career, moreover, may exemplify the relation of a great individual to the state in the seventeenth century.

Rubens' letters furnish an added proof of the artist's close touch with the complex currents of his time. His correspondence reveals him as scholar, as antiquarian, and above all as diplomat, and Rubens emerges as a man of the world in the broadest sense. The letters span the years from 1603, when he was twenty-five, to 1640, a few weeks before his death. The half century they cover was one of conflicting dynastic and religious interests leading to widespread military activity throughout Europe, and Rubens played no small part in international affairs. It is true that these letters, taken by themselves, present an incomplete, not to say unbalanced picture of the great Fleming. Fate has handed down much of his diplomatic correspondence, for such documents were preserved in the national archives, but has left us without a single letter to any member of his family. Disappointment faces the reader who seeks to find in Rubens' writings the secrets of his artistic genius. We do not hear as much as we might wish about Rubens' art or his aesthetic theories. The letters deal, for the most part, with public matters. Yet references to his painting are frequent enough to show that even during the years of most active political service, and in spite of the formidable range of other interests, his art always remained, in Rubens' own words, his "dolcissima professione."

I

A brief survey of the letters that have survived will prove that they represent but a small fraction of what must have been a vast correspondence — that Rubens was indeed as productive with the pen as with the brush. The family papers are not the only lost items; we learn, from specific reference by Rubens himself, that he carried on a regular exchange of letters with many persons whose names do not appear today in the roster of his correspondents. Among these are Balthasar Moretus, Girolamo Aleandro, Jan Brueghel, and the Abbé de St. Ambroise. Furthermore, in the preserved correspondence, we find clues to the extent of our losses by certain comparisons between the number of letters received by Rubens and those written by him. For the year 1622, for example, after the first meeting with Peiresc in Paris, we know of nearly fifty letters to the artist from the French scholar. Surely Rubens contributed his share in this heavy correspondence, but we possess no letter earlier than August 1623. From 1626 to 1628 Rubens wrote to Pierre Dupuy each week with a regularity that allows a fairly accurate estimate of the total number of letters he must have written during that time — a total far in excess of the number that has survived. The earliest of Rubens' diplomatic letters, dated September 30, 1623, finds the artist already deep in negotiations for renewal of the Twelve Years' Truce with the United Provinces. This is clearly not the first of the reports he made to his superiors. For the years marking the peak of his diplomatic activity, the most fully documented period of Rubens' life, we possess in some cases several letters written on one day to the same person. For March 30, 1628, there are five letters addressed to the Marquis Spinola, and for July 22, 1629, an equal number to the Count Duke of Olivares. But even for this rich period there are wide gaps in the correspondence. A letter written after the death of Spinola in 1630 informs us that Rubens possessed one hundred letters from the great Italian general. Of those he must have written in reply, the surviving number is but a small proportion. Unfortunate also, from the point of view of diplomacy, is the disappearance of Rubens' correspondence with the Secretary of State of the Spanish Netherlands, Pedro de San Juan. We learn from the Infanta Isabella, Governor of those provinces, that Rubens was given a private code in order to write freely to the Secretary, and these letters would today have great documentary interest. Careful calculation once led the Rubens scholar Charles Ruelens to name a figure close to eight thousand for the number of letters written by the artist during his lifetime, and of this staggering total, a scant two hundred and fifty have come down to us.

Rubens' correspondents as we know them from existing letters form a

distinguished company of princes and church dignitaries, statesmen and scholars of many countries. In the pages of his letters we may trace the rise of the young court painter of Mantua who becomes "Secretary of His Catholic Majesty in his Privy Council"; we may follow the successful diplomat who ultimately renounces a public career for the more enduring pleasures and rewards of private life and painting.

The earliest letters, preserved in the Archivio Gonzaga, Mantua, cover the years 1603–1608, when Rubens was in the service of the Duke Vincenzo I. Most of them are addressed to the Duke's Secretary of State, Annibale Chieppio, and they provide a fascinating record of the artist's formative years. Although Rubens' position in Vincenzo's entourage was a modest one, the opportunities it offered were of inestimable value for his future development. The wealth of artistic treasure in the Ducal Palace of Mantua, the renowned Medici collections in Florence, the antiquities of Rome — all afforded a rich cultural experience to this eager student from northern Europe. In Spain, while in Vincenzo's service, Rubens had the rare privilege of seeing the famous Titians and other Italian paintings in the Hapsburg collections. All in all, he had the finest opportunities to study Italian art that any young painter could wish; and from the Italian masters he extracted all those elements that served him best in creating a new type of monumental painting.

These early years were fruitful also for his future diplomatic career. In Italy, Rubens learned to know the important and influential personalities in the various states, the high-ranking Church officials, the patricians and rich bankers of Venice and Genoa. He learned the etiquette of court life in Mantua and also in Valladolid. His first visit to Spain came in a critical year, 1603, when political repercussions following the death of Elizabeth of England gave Rubens his first lessons in international diplomacy. Close contact with Philip III's all-powerful Prime Minister, the Duke of Lerma, taught him how to deal, in later years, with the haughty Prime Minister of Philip IV, the Count Duke of Olivares. It was during these years in the employment of the Duke of Mantua that Rubens gained complete fluency in the Italian language, which was to serve during the rest of his life as his favorite vehicle of expression. Italian, it is true, was the preferred language of international communication in the seventeenth century. It was the language of diplomacy and was beginning to supplant Latin in the correspondence of scholars. Rubens used Italian for his letters except when writing to his closest friends, or to a correspondent unfamiliar with that language. Then he used either Flemish or French. He does not seem to have used Spanish at all, even in

3

letters to the court of Madrid. And even when writing in Flemish to a compatriot, he signed his name in the Italian form: Pietro Pauolo Rubens.

The letters written during the first decade after Rubens' return to Antwerp show a widening circle of correspondents and are very informative in tracing his rapid rise to prominence. We find the artist in 1609 longing for Italy and the companionship of his good friends there. He cannot decide whether to "return forever to Rome" or remain in his own country, where the prospects are promising. Antwerp at that time boasted an active group of scholars and humanists calling themselves "Romanists," and they welcomed Rubens as a member of their society. His elder brother Philip, who had directed Peter Paul's classical studies in Rome, was also a member; he had recently been named Secretary of the City of Antwerp, and gave promise of a brilliant public career. It was Antwerp, in 1609, that witnessed the final negotiations for the Twelve Years' Truce between Spain and the United Provinces of the Northern Netherlands. Thus, upon his return to his own city, Peter Paul Rubens came into contact with the important personalities not only of the Spanish Netherlands but of Holland as well, and the shining ideal of peace between these warring provinces was first held up before his eyes. The signing of the truce brought to Antwerp high hopes for a revival of her prosperity, and the opportunities for an artist were never greater. Paintings and altars destroyed during the previous century by the iconoclasts were being replaced; new churches were being erected. The religious orders were returning to the city and growing rich and powerful. Rubens, fresh from Italy and eager to give expression to his new ideals, found unusual scope for his artistic genius. He became court painter to the sovereigns of the Spanish Netherlands, the Archduke Albert of Austria and his wife, the Infanta Isabella Clara Eugenia, daughter of Philip II of Spain. Rubens' diplomatic activity in their service may well have begun as early as 1609, for the letters patent naming him court painter read: "because of Peter Paul Rubens' knowledge and great experience, as well in painting as in several other arts."

It is chiefly as a painter, however, that Rubens is revealed in the letters of these years during which he came to dominate the Flemish Baroque School. His reputation was established, and his workshop grew along with the increase in number of commissions. Rubens gathered a group of engravers about him and founded his own school of engraving, for he recognized the value of this method of dispersing his compositions, and he wished to control production. In 1619 he set about obtaining copyrights in France, the Spanish Netherlands, and Holland, to insure

4

against illegal imitation. He was very systematic and businesslike in his workshop procedure, and everything points to that combination of cool-headed planning with creativeness, of reason with imagination, so eminently characteristic of Rubens. We learn most about the workshop from the letters he wrote to Sir Dudley Carleton, British Ambassador to The Hague, regarding an exchange of Rubens' paintings for Carleton's collection of ancient sculptures. This correspondence of 1618, preserved in the Public Record Office in London, is of unparalleled importance for its description of the part played by the pupils in Rubens' studio. It shows the great artist as very careful in discriminating between his own work and that of assistants. Carleton on his part, as a keen connoisseur, had perhaps requested the precise distinctions that Rubens gave him, for his final selection favored the works of the master's own hand. The busts and statues that Rubens received in this exchange greatly augmented his collection of antiquities, and became the ornaments of the museum he built to house his artistic treasures.

A survey of Rubens' correspondence would be incomplete without some consideration of an extraordinary series of letters preserved in the Biblioteca Ambrosiana, Milan. These are the letters of the Antwerp painter Jan Brueghel, but they were in fact written largely by Rubens, who over a period of twelve years, from 1610 on, acted as secretary to his friend, whose fluency in Italian fell far short of his own. This correspondence furnishes a most interesting commentary upon the relationship of the two artists. Not only is the handwriting in thirty of the letters that of Rubens, often even to the signature: Giovanni Brueghel; the mode of expression is also Rubens' own, and frequently the very thoughts expressed. It is surely Rubens himself speaking in the letter of December 9, 1616, when he writes, concerning the war in Montferrat: "To tell the truth, I sympathize deeply with that poor state of Milan, and with the miseries of the neighboring peoples, who suffer the penalty of others' madness" — and when he concludes, characteristically, with a quotation from Horace.* This Brueghel correspondence is doubly precious when it fills gaps in Rubens' own correspondence, as in the years 1610, 1613, 1615–1617, from which not a single letter has come down to us. Toward 1622 the Brueghel letters begin to dwindle, and the Rubens handwriting is replaced by Jan Brueghel's. In a letter of February 11, 1622, Brueghel admits what is probably the main reason for the termination of this unique partnership: "My secretary Rubens is in France, otherwise I should have written. The Queen Mother of the

* Giovanni Crivelli, *Giovanni Brueghel o sue lettere* (Milan, 1868), p. 240.

King has built a palace, and desires to ornament it with pictures by Rubens." *

This assignment — the decoration of the two great galleries in Marie de' Medici's new Palace of the Luxembourg — was the noblest Rubens had yet received, and the most coveted commission in all Europe. His first visit to Paris for this purpose brought the artist into contact with many eminent personalities, among them Nicolas-Claude Fabri de Peiresc, with whom he formed a friendship that produced a fruitful correspondence lasting many years. The French scholar was very helpful in smoothing Rubens' path in his preliminary dealings with Marie de' Medici, and acted as intermediary between Rubens and the Queen Mother's adviser, the Abbé de St. Ambroise. It required both tact and ingenuity to weave the inglorious episodes of Marie's life into a pictorial cycle. In the regular exchange of letters between Rubens and Peiresc following the artist's return to Antwerp there was frequent discussion of choice and order of subjects, as well as practical details such as measurements and compositional arrangement of the paintings for the Medici Gallery.

The closest bond of friendship between Rubens and Peiresc, however, was their enthusiasm for classical archaeology. Our knowledge of the artist, particularly with regard to his antiquarian interests, owes much to Peiresc and his methodical ways. The Peiresc archives in Paris, Aix, and Carpentras, notwithstanding the deplorable destruction by the niece who used the letters for kindling and curl-papers, hold a large proportion of the extant Rubens correspondence. The letters of the two men show a high mutual regard. Rubens admired without reservation the French scholar's encyclopedic knowledge, while Peiresc wrote in 1622 to Guidi di Bagno, Papal Nuncio at Brussels, that if he had esteemed Rubens' talent before, he could now say, after meeting the artist, that he found his conversation "the most agreeable and erudite" he had ever enjoyed; that "in matters of antiquity principally, Rubens' knowledge was the most universal and remarkable" he had ever seen.

When Peiresc left Paris in 1623, his brother Palamède de Fabri, Sieur de Valavez, became Rubens' Paris correspondent. Valavez sent to Peiresc in Provence copies of all his letters from Rubens, and to this habit we owe their preservation, for the originals have not survived. When Valavez, in turn, left the French capital in 1626, the correspondence was taken over by Pierre Dupuy, Keeper of the King's Library. Rubens' letters to Dupuy, numbering more than seventy and preserved

* Crivelli, p. 283.

for the most part in the Bibliothèque Nationale in Paris, form by far the longest continuous series in the painter's extant correspondence. They differ in content from those addressed to Peiresc in that political news becomes the chief topic of interest. Every week, from 1626 to 1628, the two friends exchanged letters with an almost unbroken regularity, discussing events not only in their own countries of France and the Netherlands, but in Germany, Italy, England, and the New World. Although Dupuy's letters have disappeared, the letters Rubens wrote every Thursday furnish a vivid record of this phase of the Thirty Years' War. The regular exchange of letters among scholars and statesmen was one of the substitutes for newspapers at that time. The first printed "gazettes" were also beginning to appear with a certain regularity, such as the *Holland Gazette* from about 1619, and the *Nieuwe Tydinghe* published by Abraham Verhoeven of Antwerp. A letter from one of Rubens' correspondents, Jan Woverius, written about 1623 to Balthasar Moretus, says, "I am again sending you the news of the past months, not only of a single town, but of the entire universe. . . What is more useful than to have everyone know what men are doing everywhere? . . . What pleasure to see unrolled before our eyes, so to speak, the spectacle of the entire world? In the future you will receive regularly from our Rubens the weekly news, which you will please return to me." *

By means of such regular communications with his friends, as well as by the exchange of current books and printed periodicals, Rubens broadened his horizons and methodically established his international connections. There is no doubt that he had an aptitude for politics. From 1621, when the Twelve Years' Truce expired, the artist found himself drawn more and more into diplomatic spheres. That same year saw the deaths of Philip III in Madrid and the Archduke Albert in Brussels. Albert's death without issue brought to an end the sovereignty in the Southern Netherlands which the King of Spain, in sending Albert and Isabella to Brussels, had intended to be hereditary. The provinces reverted to the Crown of Spain, and Isabella's role was reduced to governor, under the direct domination of the new King Philip IV. Just before his death Albert, in a dispatch to Madrid, had defined the political situation in terms that left no room for ambiguity. Strongly urging a renewal of the truce, he had stated that a resumption of the struggle against the United Provinces of the Northern Netherlands would be possible only if the King of Spain would furnish regularly 300,000 crowns per month. The accession of Philip IV brought no notable change in Spanish policy:

* CDR, III, 111.

7

Madrid wanted an immediate resumption of hostilities, insisting that the Hollanders must be reduced to submission and heresy stamped out. The King promised the military subsidies necessary for resuming the war, although the crumbling royal treasury had scant hope of meeting these promises. The United Provinces, on their part, having gained profit and prestige during the truce, were all the more insistent upon recognition as "Free States." Between these two stubborn powers the unfortunate provinces of the Spanish Netherlands were in danger of again becoming the battleground. The Infanta Isabella, carrying on her husband's policy, bent all her efforts toward a renewal of the truce, and in this she was supported by her court painter Rubens. Peace was the goal that drew Rubens into active politics, and he plunged into this task with his characteristic intensity and conviction. He became the Infanta's diplomatic agent, and we know from his letters to her that he enjoyed her fullest confidence. On September 30, 1623, she granted him a monthly pension of ten crowns, "taking into consideration the merits of Peter Paul Rubens and the services which he has rendered to His Majesty" — services which can only have been political. This pension, charged to the citadel of Antwerp, was regarded as a particular honor, since the funds came from Spain for the maintenance of the royal army. Rubens' new role did not long remain secret. On August 30, 1624, the French Ambassador in Brussels, Seigneur de Baugy, wrote to his government: "The proposal of a truce is by no means displeasing to the Infanta, from whatever quarter it may come, and she listens nearly every day to the suggestions made to her in this matter by Rubens, famous painter of Antwerp, who is known in Paris by his works in the palace of the Queen Mother."

Rubens' efforts in the cause of peace in the Netherlands gradually drew him into the struggle for European supremacy on the part of the Great Powers. In 1622, the year of the artist's first visit to Paris, the young Richelieu was raised to the dignity of Cardinal. Even then he was laying his secret plans against Spain, and his ascendancy in French politics coincided with the beginning of Rubens' political activity. The vigilant Cardinal from the first suspected the painter-diplomat from Flanders as an agent in the service of the Hapsburgs, while Rubens, on his part, soon came to recognize in Richelieu the embodiment of French hostility to Spain. In Paris in 1625 the artist met the Duke of Buckingham, and this encounter resulted in prolonged negotiations to bring England and Spain together, in order to resist the threatening aggression of France. Rubens devoted the years 1626–1630 largely to efforts to bring about a general Anglo-Spanish peace, with the secondary aim of thus isolating

the United Provinces and making them more inclined to peace with Spain. In paving the way for an accord between Spain and England he was ultimately successful, but this brought peace no nearer to the Spanish Netherlands.

The letters written between 1621 and 1630 show Rubens' sober and penetrating view of this tangled political situation. His official correspondents during these years were the Infanta Isabella and her faithful councilor, the Marquis Spinola; the Duke of Buckingham and his agent, Balthasar Gerbier; and finally, the Count Duke of Olivares, Prime Minister of Spain. The letters are preserved, for the most part, in the Public Record Office in London and the Archivo General in Simancas. Rubens' months in London are documented with greater detail than any phase of his life, partly through his own full and precise reports, and also because, as Privy Councilor of the King of Spain, he is now openly treated, not as a painter, but as a diplomat. There is frequent mention of him in the confidential correspondence of other diplomatic agents. His every action is observed and recorded; he is a public figure. We find Rubens using the Italian language even in his regular communiqués to the Prime Minister of Spain (on one occasion, at least, Olivares complained of the "Italian verbiage"). Spanish translations of his letters were sometimes sent to the Emperor Ferdinand in Vienna (where a few of them are still preserved), proof of the importance that Madrid attached to these reports from London.

When Rubens left England in March 1630 with the Anglo-Spanish peace assured, he had before him the choice of politics or painting. There is no doubt that he could have reached great heights in a diplomatic career. For five years he had devoted his best energies to this form of public service. Without holding the title of Ambassador he had accomplished prodigious things, and had gained esteem for his tactful handling of the most difficult situations. But he had never made diplomacy his whole existence. From Madrid he had written to his friends Peiresc and Dupuy: "I keep to painting here, as I do everywhere." To his Antwerp colleague Gevaerts he devoted a letter to the subject of the ancient manuscripts in the Library of San Lorenzo in the Escorial. And it is the connoisseur who speaks in the letter he wrote to Peiresc from London: "When it comes to fine pictures by first-class masters, I must admit that I have never seen such a large number in one place as in the royal palace and in the gallery of the late Duke of Buckingham." Rubens' sincere wish, upon reaching Antwerp, was to retire from politics. The duplicity, so alien to his spontaneous nature, and the webs of intrigue that

he encountered on every side made court life more and more abhorrent to him, and he longed to return to his painting. But he had proved himself too valuable to Philip IV, as well as to the Infanta Isabella, for them to let him go readily. Efforts were made to retain him in their service, and he was several times drawn back into diplomacy. On behalf of Marie de' Medici, whose banishment from the French court brought to an end Rubens' work on the second of the Luxembourg galleries, the artist found employment of a different sort. He was sent to meet the royal fugitive at the French border, when she sought asylum in the Spanish Netherlands. In the remarkable letter to Olivares written on August 1, 1631, Rubens pleads for Spanish aid for Marie and her son, the Duke of Orléans, in their struggle against Richelieu. For this cause he departed from his customary peaceful policy to advocate armed intervention. To Rubens this seemed the opportunity of a lifetime to overthrow Richelieu and weaken France, for he had the foresight to realize that in the coming generation France, more than any other nation, would disturb the peace of Europe. His letter did not convince the court of Spain. Whether Olivares and the other ministers were fearful of proving the Cardinal's power, whether they were too proud to heed the counsel of a person of lower rank, such as Rubens, or whether the royal treasury was simply unable to furnish the funds, the decision was unanimous against intervention in the affairs of France. During 1631 and 1632, when the Infanta Isabella made renewed efforts to negotiate a truce between the Northern and Southern Netherlands, Rubens again played a part in the discussions, although with a growing awareness of their futility. With the Infanta's death the following year, hopes for peace faded, and this marked the virtual end of Peter Paul Rubens' political activity.

Communication between Rubens and Peiresc had, of necessity, been suspended during the negotiations on behalf of the Queen Mother of France. The suspicion the artist had incurred in that country made the French scholar unwilling to risk continuing their correspondence. But with Rubens' withdrawal from French politics, his old friend banished all scruples and sent him a letter, dwelling upon many of the subjects so dear to them both. We are most fortunate in possessing Rubens' reply, in which he mentions the "astonishment mingled with incredible joy" with which he received this communication. His own long letter, dated December 18, 1634, gives a full account of the intervening years. After describing his part in the affairs of France, the artist goes on to tell of his retirement from politics and his second marriage. From his last years, that period so extraordinarily rich in pictorial production, fewer letters

have survived. But those we possess are more intimate than at any other time in Rubens' life, reflecting the relaxation that followed his withdrawal from court. With the burden of politics behind him, the artist has leisure to write about his painting and his antiquarian studies as well. He permits us brief glimpses of his family, his country estate, and his studio — with occasional reference to his failing health — until we come finally to the warmly human letter of May 9, 1640, in which the master, shortly before his death, sends congratulations to a favorite pupil on his marriage.

Turning from a chronological account of the letters to a characterization of their writer, we may learn a great deal from his own words. The letters, like Rubens' paintings, glow with vitality, but reveal, in addition, a greater directness of expression than the conventions of the time permitted him to show as court painter. The formal phrases and flourishes of the epistolary style of the Baroque thinly veil the frankness of the man's nature. Personal revelations, to be sure, are few; Rubens seldom drops the reserve of the cultivated gentleman. But on certain rare occasions we are allowed a glimpse of his inner life. The report from Rome of the untimely death, in unhappy circumstances, of his dear friend Adam Elsheimer evoked a deep lament in the letter he wrote to Johann Faber in 1611: "I have never felt my heart more profoundly pierced by grief than at this news, and I shall never regard with a friendly eye those who have brought him to so miserable an end." The most precious remnant of Rubens' private correspondence is his response to Pierre Dupuy's letter of condolence on the death of his wife in 1626. In simple, unaffected language the artist speaks of his love for Isabella Brant and his profound sorrow at her death. His letter is significant in that it shows Rubens turning away from the Stoicism then so popular in intellectual circles. Too vital and spontaneous by nature to conform to the philosophical attitude recommended by his friend, he writes: "Such a loss seems to me worthy of deep feeling. . . For I have no pretensions about ever attaining a stoic equanimity. . . I do not believe that one can be equally indifferent to all things in this world." Three years later, upon the death of his friend Gevaerts' wife, it was Rubens' turn to write a letter of sympathy. To Gevaerts, one of the most active of Antwerp humanists, and at that time engaged in a study of Marcus Aurelius, Rubens attributes the stoicism that he himself had not been able to practice. "If any consolation is to be hoped for in philosophy," he writes, "then you will find an abundant source within yourself. I commend you to your Antoninus." Gevaerts was the scholar to whom the artist entrusted the education of

his eldest son Albert, and in writing to his friend from abroad, he mentions the boy with affection and pride.

The letters as a whole portray a man of amiable disposition and generous nature, with an extraordinary ability to get along with others, of whatever rank or station. Confirmation of this is found in many a contemporary reference to the artist's pleasing personality. Before Rubens was thirty, the classical scholar Scioppius wrote of him with prophetic praise as: "My friend Peter Paul Rubens, in whom I know not what to commend the more — whether his skill in painting, in which, to the eyes of connoisseurs, he seems to have attained perfection, if anyone has attained it in these times; or his knowledge of all that pertains to letters; or that refinement of judgment which he combines with a particular charm of speech and conversation." * Sandrart stated that Rubens "was highly esteemed by persons of the most exalted as well as the most humble rank," and Peiresc wrote: "He was born to please and delight, in all that he does or says." A man of boundless adaptability, Rubens entered into each new undertaking with intensity and conviction. He was, moreover, a good businessman, taking every advantage of his social and diplomatic contacts in order to gain important commissions for painting. On the other hand, his international reputation as an artist was often useful in veiling his secret diplomatic activity. Rubens was in every sense a cosmopolitan, as he himself stated in a letter of 1625 to Valavez: "Other things being equal, I regard all the world as my country, and I believe I should be very welcome everywhere."

The erudition so highly esteemed by Peiresc and others is abundantly evident in Rubens' letters. The sound classical education received in his earliest years, greatly enriched during his sojourn in Italy, was of lasting influence and value. Throughout his life he was able to express himself easily in Latin, although none of the extant letters are written entirely in that language, and in writing to Gevaerts from Madrid in 1628 (partly in Latin and partly in Flemish), Rubens insists that he does not deserve to receive his friend's Latin letters and apologizes for his own grammatical errors. His knowledge of ancient authors was both thorough and extensive, as the numerous quotations from them bear witness. Virgil and Juvenal, Cicero, Seneca, and Tacitus were among his favorite writers. In his relations with renowned savants Rubens was in no way inferior, and his opinion was often sought in archaeological matters. It was in response to inquiries by the Papal Nuncio, Guidi di Bagno, that the artist devoted two letters, in 1626, to a rather detailed history of the temple of

* *Bulletin-Rubens,* IV, 113–117.

Diana at Ephesus, although he had to write it from memory, since he was away from home, without his books and notes. Rubens' admiration for classical culture was a deep-rooted passion, but it was only in part antiquarian; for him everything he learned contributed to the development of his artistic genius. His views on how a painter ought to make use of ancient statues for perfecting his art are set forth in his Latin treatise *De Imitatione Statuarum*. He warns the painter against a slavish and insensitive imitation of the marble, emphasizing the necessity of being not only acquainted with the sculptures, but imbued with a thorough comprehension of them — "and the use of them must be judicious." Rubens was well aware of the limited artistic appreciation of some of his humanist friends, and in writing to them he seldom mentioned his painting, just as he was discreetly silent about his diplomatic activity. The letter of August 1630 to Peiresc, devoted mainly to an essay on tripods (with a page of quotations on the subject by the sixteen-year-old Albert Rubens) might have issued from the pen of a specialist whose interest was centered upon the civilization of the ancient world.

But Rubens, as we know, was no less interested in the world about him, and his wide circle of correspondents kept him informed on new books dealing with a great variety of subjects. An active exchange of books and periodicals was carried on among them, as far as political conditions would allow. Rubens' critical judgment on current literature was keen, and we find him appraising an author's style as often as the thesis. In addition to politics and history, his reading embraced astronomy and the natural sciences, colonial expansion, philosophy, and religion. A devout Catholic in a time of intense sectarianism, and numbering many Jesuit scholars among his friends, Rubens followed closely the theological controversies of his day. Along with works by various Catholic writers, he mentions reading the *Mémoires* of the Huguenot theologian, Duplessis-Mornay, and trying to obtain books on the doctrines of the Arminians of Holland. His long intimacy with the great publisher Balthasar Moretus also helped to keep Rubens abreast of current literature, and he, in turn, designed many title pages for the Plantin-Moretus Press over a period of nearly thirty years. Moretus was the official printer of the Catholic Church for all of Europe, and his association with Rubens was of particular significance for the cultural life of Baroque Flanders. "How fortunate is our city of Antwerp," wrote the humanist Jan Woverius in 1620, "to have as her two leading citizens Rubens and Moretus! Foreigners will gaze at the houses of both, and tourists will admire them." *

* CDR, II, 254.

13

Rubens himself published a book which exerted a certain influence upon the Flemish architecture of the seventeenth century. This was his *Palazzi di Genova*, which came out in 1622, a remarkable book in many ways. The usual architectural publications of the period were either model-books for architects and builders, or theoretical treatises on the various orders. Here was Rubens, more as amateur than architect, presenting a series of practical and functional designs for private houses. His intention, as set forth in his preface, was to aid in introducing "that style of architecture which has true symmetry, conforming to the rules of the ancient Greeks and Romans," to replace "that style called barbaric, or Gothic, which is growing old and disappearing little by little." By presenting Genoa as an example of a modern city, and its palaces as admirable models for residences north of the Alps, Rubens hoped, as he said, to "do a meritorious work for the public good." The fine house he built for himself in Antwerp did much to popularize the new style, and his book enjoyed considerable success, appearing in five editions between 1622 and 1775.

The largest group of Rubens' letters, by far, deals with his political activity, and for this reason it is the diplomat, or we may say, the statesman, who stands most clearly revealed in the self-portrait the artist provides for us with his pen. His fundamental preparation for a diplomatic career may be attributed to the foresight of his mother in placing him, at fourteen, as a page in the household of Marguerite de Ligne-Arenberg, Countess de Lalaing. Brief as this experience was, it gave the boy his first training in the rules of courtly life and doubtless helped to develop that ease of bearing that distinguished him in later years. The rigid etiquette of the Baroque courts imposed many limitations upon one who was of middle-class origin, but Rubens met the arrogance of high-born aristocrats with the same natural dignity with which he accepted the favor of sovereigns. He possessed all the qualities of a good diplomat: quick grasp of a situation, skill in judging personalities, tact, persistence, and a remarkably retentive memory. That same memory which enabled him, after twenty years, to describe in detail the famous fresco of the "Aldobrandini Marriage," which he had seen as a young man in Rome, also served him in his diplomatic reports, when he had to repeat long interviews, word for word. Loyalty to his patrons was one of Rubens' outstanding qualities, yet this never caused him to abandon his own ideals or convictions. True son of the Baroque that he was, he did not question the "divine right" of the king he served. His devotion to the ideal of Absolutism was as firmly grounded as his Christian faith, and he employed all his talents

in the service of this ideal. But while Rubens the court painter responded in the most flattering terms to the Baroque demand for glorification of the sovereign, Rubens the statesman was a sober realist who saw through the pomp of court life to the grim issues of international politics. Though a loyal subject of the Hapsburgs, and appreciating the personal qualities of Philip IV, he did not hesitate, in his letters, to express sharp criticism of the evasive, procrastinating policy of the Spanish court. "A person who deals with the Spaniards," he declared, "finds that, as soon as he turns his back, they postpone the execution of their promises." Few of his contemporaries understood or shared the broad outlook which Rubens expressed when he wrote: "Today the interests of the entire world are closely linked together, but the states are governed by men without experience and incapable of following the counsel of others." He tersely summed up the situation in England in December 1625 with the words: "When I consider the caprice and the arrogance of Buckingham, I pity that young king who, through false counsel, is needlessly throwing himself and his kingdom into such an extremity. For anyone can start a war, when he wishes, but he cannot so easily end it." Rubens predicted Buckingham's downfall ("as for Buckingham, he is heading for the precipice") but could not foresee that the war begun by Buckingham would be brought to an end largely by his own efforts.

The peace of 1630 between England and Spain was not won without untiring perseverence on Rubens' part, for he had to contend with the equivocal attitude of both parties, as well as the powerful intrigues of France. In London he succeeded in establishing a certain sympathetic contact with Charles I, but he felt the instability of the King's position, as his first communiqué to the Spanish Prime Minister stated: "Whereas in other courts negotiations begin with the ministers and finish with the royal word and signature, here they begin with the King and end with the ministers." Rubens' own straightforwardness in working for peace did not always find favor with the court of Madrid, and on at least one occasion Olivares seems to have reprimanded him for showing too much initiative. This letter is lost, but we have Rubens' reply, which answers the Prime Minister's charge with spirit and self-confidence. "I do not think I have acted contrary to orders," he writes; "I do not feel that I have employed my time badly since I have been here, or that I have overstepped in any way the terms of my commission." During the prolonged negotiations the artist often felt that Madrid was using him as a decoy in order to gain time, but he had the final satisfaction of seeing his task accomplished, and of receiving the approbation of the Royal

15

Council "for the tact with which he had acted in this matter." Philip IV, who had at first objected to the selection of a mere painter for such a high diplomatic mission, came to recognize Rubens' competence in foreign affairs. He won the esteem of the English court as well, and before his departure Charles I conferred upon him the rank of knight. The only criticism had come from his adversaries, the French, Dutch, and Venetian ambassadors; Richelieu's consistent efforts to thwart him can only be termed a tribute to his ability. The Anglo-Spanish peace served as a temporary check to Richelieu's schemes, though it could not retard the steady decline of Spanish power.

For the Infanta Isabella Clara Eugenia, Rubens had nothing but praise. Her interest in the welfare of the Spanish Netherlands and her desire for peace were as genuine as his own. Of Isabella he wrote in 1628: "Long experience has taught her how to govern these people and remain undeceived by the false theories which all newcomers bring from Spain." He had the greatest admiration also for the Marquis Spinola. Among these three there existed a sympathy and unity of purpose not always in accord with the dictates of Madrid. Rubens' familiarity with the great courts and cultural centers of Europe made him well aware of the comparatively provincial narrowness of the court at Brussels. More than once, in his weekly newsletter to Dupuy in Paris, we find reference to the "sterility" of a court where "each minister grows old and even dies in office." But his Flemish patriotism and his devotion to the Infanta induced Rubens to lend all his support to her repeated though vain attempts in the cause of peace. "However much I rejoice at the birth of our Prince of Spain," he wrote to Gevaerts in November 1629, "I confess that I should be happier over our peace than over anything else in this world."

Ten years later this peace was as far away as ever. The obstinate struggle between the Northern and Southern Netherlands dragged on, without decisive engagements — a war of exhaustion shifting back and forth across the border. Rubens' abhorrence of war was far deeper than that of the patriot who sees his own country devastated; as an artist he knew the fearful and far-reaching consequences of war's destructiveness. Nowhere is this more eloquently expressed than in one of his last great paintings, the "Horrors of War" in the Pitti Gallery, Florence. The theme is embellished with all the trappings of Baroque allegory, but we are fortunate, in this case, to have the painter's own detailed explanation in a letter dated March 12, 1638. Although Rubens considers that the subject of the picture is very clear, hardly requiring his interpretation, we of today may be glad to learn from him that, among the other more read-

ily identifiable figures, "that grief-stricken woman clothed in black, with torn veil, robbed of all her jewels and other ornaments, is the unfortunate Europe who, for so many years now, has suffered plunder, outrage, and misery." Here, in simpler terms than those employed by the painter, is a sober statement showing how close was the link between Rubens' human conviction and his artistic creation. More than that, it is the confession of a man who realizes that, in spite of personal success and high honors in the field of diplomacy, he has devoted himself to a losing cause.

For Rubens the diplomat, retirement to private life was the true reward, although the hardest to attain. We learn, from his letter to Peiresc, how he finally turned his back upon court life at the height of his success, renouncing a court marriage, and how he begged the Infanta, as the sole reward for his many services, to exempt him from further missions. "This favor I obtained," he writes, "with more difficulty than any other she ever granted me. . . Now, for three years, I have found peace of mind, having given up every sort of employment outside of my beloved profession." The abundance of his pictorial output in the 1630's bears ample witness to the enthusiasm with which Rubens turned again to painting. And his new life, with its new experiences, is most intimately reflected in his work. Instead of the pernicious atmosphere of the court, the society of faithless princes and scheming politicians, the artist now enjoyed the naturalness and freedom of family life with his young wife and children. His numerous portraits of Helena Fourment charm us by their warmth and informality, and none the less when she is represented in saintly or mythological guise. As potent as the influence of Rubens' domestic happiness was the spell exerted by the homeland he loved. Returning to his own country after long absence, and free at last to appreciate its beauty to the full, he responded to the impact of nature with a rare freshness and directness. And in landscape painting he found unusual scope. The art of landscape, unhampered by the conventions prescribed for the courtly and religious painting of the Baroque, and more independent of current cultural trends, allowed the painter freer rein, and in Rubens' hands reached unprecedented power of expression. The superb series of landscapes inspired by the surroundings of his country estate, Castle Steen, are intimately realistic and at the same time richly imaginative. All the artist's own vitality is reflected in the dynamic sweep of these compositions, in the radiance of light, the warmth of color; a deep pantheistic mood breathes in the spacious distances and arching vault of the sky. The painter whose brush has exalted many a Baroque sovereign turns in his last years to the glorification of nature. Here he

triumphantly breaks through the bounds of the Baroque to become the inspiration of many generations of landscapists. The letters give us only occasional moments of insight into this culminating phase of Rubens' artistic career. Yet his vivid personality illuminates their pages to the end. While revealing less than we might wish about the man as painter, the letters contribute greatly to our understanding of this many-sided genius.

PART I

1 6 0 3 – 1 6 0 8

Rubens in Italy

Mission to Spain

1603–1608

The earliest of Rubens' preserved letters finds the twenty-five-year-old artist in Italy. For nearly three years he has been in the service of Vincenzo I Gonzaga, Duke of Mantua, as court painter, and is now on the point of embarking for Spain, bearing costly gifts from Vincenzo to the King and the court favorites. For Philip III there was a coach with six bay horses, also eleven arquebuses and a rock-crystal vase filled with perfumes. For the Duke of Lerma, all-powerful Prime Minister, there were vases of silver and gold and sixteen copies after Raphael, Titian, and other masters, painted by one of Vincenzo's artists, Pietro Facchetti. Don Pedro Franqueza, Secretary of State, was to receive two crystal vases as well as precious brocades, and the Countess of Lemos a rock-crystal cross and two chandeliers. By this lavish gesture the Duke hoped to gain Spain's favor and protection for Mantua. He clearly attached great importance to the mission, and his choice of Rubens to conduct it may be regarded as a compliment to the young Fleming. For some reason that is not clear Rubens, instead of taking the direct route to Genoa for embarkation to Spain, was sent, with his heavy baggage, across the Apennines to Florence, and thence to Pisa and Livorno. It is this seemingly unnecessary detour, with its attendant difficulties, to which he refers in his first letter.

Annibale Chieppio, the recipient of most of these early letters, was Secretary of State of the Duke of Mantua. He was a man of ability and fine personal qualities, Rubens' friend as well as counselor. The correspondence reflects the pleasant relationship that existed between the two. Vincenzo's representative in Spain, Annibale Iberti, was less well disposed toward the young envoy, and received him coolly upon his arrival. Jealously guarding his prerogatives as Ambassador, Iberti made no effort to seek a royal audience for Rubens, and allowed him to witness only from a distance the presentation of the gifts to the King. In spite of this treatment the artist succeeded in making a very favorable impression upon the Prime Minister. Lerma gave him a number of commissions,

more important and interesting to him than the monotonous portraits of court ladies he was turning out for the Duke of Mantua's "Gallery of Beauties." Chief among the Lerma commissions was the life-sized equestrian portrait of the Duke himself, and this painting has fortunately survived as a striking example of Rubens' pictorial power and originality at this early period in his career. He returned to Mantua in the spring of 1604 with a fund of diplomatic experience as well, gained through close contact with Spain's Prime Minister during the crucial months following the death of Queen Elizabeth of England. The letters show that Rubens already possessed the tact and intelligence that were later to make him the trusted confidential agent of the Infanta Isabella, Governor of the Spanish Netherlands. While maintaining respect for his patrons, he was not afraid to offer criticism, or to express his own views when he found it necessary.

After nearly two years in Mantua, Rubens received Vincenzo's permission, late in 1605, to go to Rome for a second visit, "in order to pursue his studies." His brother Philip had recently been appointed Librarian and Secretary to Ascanio Cardinal Colonna, and the two lived for a time together. Peter Paul's position in Vincenzo's service did not prevent his seeking other patrons. This was partly through necessity to supplement his income, since his salary from Mantua was often in arrears. His talent was, in fact, soon recognized, and generous patrons were not wanting. Among them were Scipione Cardinal Borghese, nephew of Pope Paul V, and Jacobo Cardinal Serra, Grand Treasurer of the States of the Church. It may have been through their influence that Rubens was offered what he calls "the finest and most splendid opportunity in all Rome" — the decoration of the high altar in the new church of Santa Maria in Vallicella. Or the contract may have come from the Cesi family, which had contributed liberally to the construction of the Chiesa Nuova. Bartolomeo Cardinal Cesi was an intimate friend of Justus Lipsius, while his Librarian, Jan de Hemelaer, was a friend of the two Rubens brothers. In any case, Peter Paul Rubens received this commission in preference to such reputable Italian painters as the Cavaliere d'Arpino, Caravaggio, Guido Reni, and Baroccio, and he was justly proud of his success. The carrying out of this commission, however, was attended by delays and disappointments. During the summer of 1607 the artist was summoned to accompany the Duke of Mantua on a visit to Genoa, and not until the following February was the altarpiece ready for unveiling. Only then was it discovered that an unfavorable reflection of the light rendered the picture almost invisible. Rubens set to work at once upon a second paint-

ing, using slate that would absorb rather than reflect the colors. This is the altarpiece still in place in the choir of Santa Maria in Vallicella. The artist's efforts to interest the Duke of Mantua in the purchase of the first version for his gallery were unsuccessful.

Rubens' letters from Italy are silent on his studies of antiquity and the lessons he learned from the great Italian masters. He makes no mention of the numerous other paintings he produced during his stay in that country. His term of service to Vincenzo Gonzaga was brought to a sudden end by his departure for Antwerp in October 1608, upon receiving news of his mother's serious illness. Forced to leave without his patron's permission, Rubens mounted his horse resolving to return once more to Mantua. His mother had died nine days before. And Rubens was never again to see Italy.

To Annibale Chieppio *Florence, March 18, 1603*

Most Illustrious Sir and Esteemed Patron:

First of all, in obedience to His Most Serene Highness, who ordered me expressly to report to him the progress of my journey from place to place, and secondly because a serious occurrence makes it necessary, I have resolved to bother you. I turn to you rather than anyone else, for I have confidence in your kindness and courtesy; I know that in the vast sea of your many important affairs, you will not refuse to care for this poor little boat of mine, badly guided until now by the incompetent advice of I know not whom. I speak always with respect, and with the intention neither of blaming anyone nor of excusing myself, but in order to explain to His Most Serene Highness how he may suffer through the mistakes of others.

Well, I finally arrived in Florence on March 15 [1] (not without the greatest expense, as I will tell you later, in transporting the baggage across the Alps — especially the little coach). I gave Signor Cosmo Gianfiliacci's letters to Signor Capponi at once, and the other letters to Signor Pierio Bonsi. They are the leading merchants of this city. When they heard of the undertaking, they were amazed; they almost crossed themselves in their astonishment at such a mistake, saying that we should have gone to Genoa to embark, instead of risking the roundabout route to Livorno without first being assured of a passage. And everyone asserts that I might perhaps wait there three or four months in vain, with the danger, even after such a delay, of being forced to go to Genoa in the end.

On the following day (to our good fortune) there arrived some Genoese merchants straight from Genoa. They told me that in that city there were galleys ready to sail, among them a ship loading for Alicante, which would remain in port for eight or ten days longer. And so, on the advice of the above-mentioned Florentines and the Genoese, I have decided to leave as soon as possible for Livorno. There I shall embark immediately for Genoa, where (God willing) I may arrive in time, as I hope to do by

virtue of the guardian angel of our Prince. I shall not fail to urge all possible haste, and indeed I should have departed already, if I were not delayed by the coach. It has not yet arrived, thanks to the oxen which are drawing the cart, for want of mules. And our derrick, especially constructed in Mantua and brought this far, now has to be left behind, to the derision of the muleteers, who say that it would exceed the maximum weight possible, even without any other load. The coach alone, without the other seven pieces of luggage, cost forty ducatoons to transport from Bologna to Florence. And this price included all the concessions and assistance offered by Signor Andrea de Rossi and other merchants, who were most friendly and helpful to us, because of Signor Cosmo's letters. These same letters had secured for us the aid of Signor Martellino [2] in Ferrara. And there the Count Balthasar Langosco rendered the Duke a service by interceding for us with the Cardinal [3] for protection against the officiousness of the tax-collectors who insisted upon opening our trunks. His Eminence condescended not only to guard us against their violence, but graciously surpassed our expectations by exempting us from all tolls and duties. And then in Bologna also (influenced, perhaps, by this good example) the collectors were content with an honest tip. I hope it will be the same in Florence, even though the Grand Duke is away in Livorno. It is no small thing to be exempt from the duty; for if this had to be paid (as I fear it will in Spain), the taxes would have cost more than the whole journey (judging by the Ferrarese tax, which was 150 crowns). [*In margin*: This is what the tax collectors in Ferrara demanded, even with Signor Martinello on our side, before the exemption granted by the Cardinal.] Already the expenses far exceed the narrow limits prescribed by the paltry ideas of the palace steward and others. I will do what I can; the risk is my Lord the Duke's, and not mine. If he mistrusts me, he has given me a great deal of money; but if he trusts me, then he has given me very little. If the funds should fail (may I never have that experience), what a blow that would be to his reputation! But in giving me too much, there would surely be no risk, for I should always submit my accounts to censure, however severe. Does he think the surplus would not be returned, if he paid me in advance? What, then, is there to lose, unless interest and time?

But now I am making you lose time, with this long and tiresome letter of mine. I did not realize such an error, but carried away by my feeling, I am perhaps too free and impetuous in dealing with one of your rank. May your goodness pardon me, therefore, and your discretion make up for my defects. I pray, I beseech you to report to His Most Serene High-

25

ness what pleases you and seems necessary to my requirements. And if these complaints and troubles of mine do not perhaps deserve so much urgency and emphasis, I entrust myself completely to your wise judgment. Speak and act according to your inclination, and dispose of your servant, who bows to your patronage, humbly kissing your hands.

<div align="right">Your most affectionate servant,</div>

Florence, March 18, 1603 Peter Paul Rubens

I should like especially, if possible, to obtain with your help a letter to some agent in Genoa, or to some gentleman who is a friend of my Lord the Duke, for any emergency that might arise.

<div align="center">– 2 –</div>

To Annibale Chieppio *Pisa, March 26, 1603*

My Most Illustrious and Esteemed Sir:

I hope that the advice of Signor Cosmo will help us to succeed better than everyone in Florence thinks — even though perhaps by mere chance — and that this advice will be sufficient without seeking any other. The carriage delayed me somewhat, and I was detained in Florence for six days longer because of floods and other unforeseen hindrances, thus taking ten days for such a short journey. Finally, having arrived safely in Pisa with the baggage, horses, and men, I went alone that evening to Livorno, and found there two or three ships from Hamburg, come at the request of the Grand Duke with a load of grain and corn and now ready to set sail for Spain in search of return cargo. I took the occasion to talk with one of the captains. We came to an agreement, and I was hoping to embark at once, when the Grand Duke intervened by ordering the cargo of corn to go to Naples. Thus deprived of the first ship, I am depending upon the other. And although I do not doubt that I shall succeed, the matter is not yet settled because the captain has not finished dealing with the merchants. Tomorrow I shall know for certain.

I have not yet presented myself to the Grand Duke [1] nor to Don Virginio; [2] first because I have neither letters nor orders from His Most Serene Highness and because up to the present I have had neither the occasion nor the necessity to bother them. Furthermore, I did not wish to seem to angle for their generosity in order to obtain franchise for the horses or a permit for passage, which the Grand Duke is in the habit of

<div align="center">26</div>

granting to many, as I have both heard and seen. He is kept very well informed by others, as certain gentlemen who are my friends in this court have told me; as proof of it, this very evening he sent me a request, through a Flemish gentleman in his service, to take one of his own palfreys along with the other horses, and to give it to someone in Cartagena. I agreed to accept it with the greatest possible promptness, offering my services and those of a groom to care for the animal, etc. The gentleman gave as an excuse the expense of sending it any other way.

This is the story of our journey up to the present. Pardon me for fatiguing thus with trifles your ears which are occupied with more important affairs, and for recounting so minutely things of no consequence. In closing, I respectfully kiss your hands.

<div style="text-align:right">Your most humble servant,
Peter Paul Rubens</div>

Pisa, March 26, 1603

– 3 –

To Annibale Chieppo *Pisa, March 29, 1603*

My Most Illustrious and Esteemed Sir:

This very day I have transacted and settled my embarkation for Spain, with that ship-master from Hamburg who, as I wrote you in my last letter, is now in Livorno. I hope, therefore, with the grace of God, to set sail on the third day of the holidays. The Grand Duke summoned me today after dinner; and he spoke in the most friendly terms of His Most Serene Highness and Madame, our Duchess. And when he inquired somewhat curiously about my journey and other personal affairs of mine, this prince astonished me by showing how minutely he was informed in every detail as to the quantity and quality of the gifts destined for this person or that. He told me, moreover, not without gratifying my pride, who I was, my country, my profession, and the rank which I held. I stood there like a dunce, suspecting some informer, or in truth the excellent system of reporters (not to say spies) in the very palace of our Prince.[1] It could not be otherwise, for I have not specified my baggage, either at the customs or elsewhere. Perhaps it is my simplicity which causes me such astonishment at things that are ordinary at Court. Pardon me, and read, as a pastime, the report of a novice without experience, considering only his good intention to serve his patrons, and particularly yourself.

<div style="text-align:right">Your most humble servant,
Peter Paul Rubens</div>

Pisa, March 29, 1603

To Annibale Chieppio *Livorno, April 2, 1603*

My most Illustrious and Esteemed Sir:

It seems to me now that for my part I have almost brought the journey to a good conclusion; may the Lord God do the rest. The horses, the men and the baggage are on board ship; we now need only a favorable wind, which we expect from hour to hour. We have taken provisions for one month and paid the charges. In short, everything is perfectly arranged, through the kind assistance of Signor Dario Thamagno, leading merchant of Livorno, but actually a Florentine, a man who is very friendly with Signor Cosmo and genuinely devoted to my Lord the Duke. I should be pleased if His Highness, in passing through here, would be willing to give him a kindly glance or a friendly word; this would convince him (for he aspires to honors and nourishes himself on the atmosphere of the Court) of my good report of his services to us.

As for the money which His Highness has given me, to the great displeasure of the critics of the voyage, it will not be sufficient for expenses from Alicante to Madrid (even without counting taxes, customs, or whatever emergency might arise). Signor Cosmo had told me that the trip was only a short one of three or four days, but I learn that the distance is actually more than 280 miles. And to spare the poor horses, we can travel but a little way each day. Of His Highness' funds, there remains little more than 100 ducats; but it does not matter if this is insufficient, because I will use the funds my Lord the Duke has given me for my own account. No one can accuse me of negligence or extravagance; my clearly balanced accounts will prove the contrary.

I should not be making this explanation, which is so tiresome to me and even more to your ears, were I not urged by the remembrance of many words I have heard from the lips of His Highness himself. And all the crowd of busybodies and pseudo-experts who have interfered in this undertaking agreed, as in admiration of my Lord the Duke's liberality, that the sum was much greater than I needed for so short a journey! They declared, moreover, that it would provide generously for every expense or misfortune that might arise, even for the burden of taxes, for which it would not accord with His Highness' reputation to seek exemption! That is all very well, and I believe that I have observed the proprieties in this and in all other details. Now I swear to you, by my faith as a loyal servant of His Most Serene Highness and of yourself in particular, that we have

not suffered adversity of any consequence (thank God). On the contrary, we have had the greatest luck in finding passage so promptly and conveniently and, by the spontaneous liberality of the authorities everywhere, in receiving exemption from the customs, except for small tips to the revenue officers. The pay for my men is honest; it was fixed at so much per day, according to an agreement made in Mantua. The expenses for the horses are large but necessary, including wine-baths and other costly things. The freight charges have been estimated to our advantage, as one will see from the contracts, written for the most part in the handwriting of Martellini in Ferrara, Rossi in Bologna, Capponi and Bonsi in Florence (these men also took care of changing my money), and Riccardi in Pisa. The chartering of the ship, which was most important, as well as the purchase of supplies, were arranged by Signor Dario Thamagno with particular efficiency. We have had the luck to find here three empty ships, ready to take on cargo in Alicante. In short, where my Lord the Duke's honor was concerned, we have proceeded in a businesslike manner, but in spite of all that, expenses have reached the sum that I have mentioned. The Grand Duke has entrusted to me his palfrey, to present to Don Juan de Vich, Captain of His Catholic Majesty in Alicante, and also a table of very beautiful marble. Otherwise I have nothing to add for now; the rest from Spain.

I beg you to favor me by informing His Highness freely of everything, or by having him read this letter, in order that he may banish from his mind every other vain persuasion concerning the expenses of my voyage, which are really such as I will maintain in the face of everyone. And with this pray keep me in your favor, and commend me also to the favor of His Most Serene Highness; I aspire to this not through merit but through pure and sincere affection for him.

<div style="text-align: right">Your most humble servant,</div>

Livorno, April 2, 1603 Peter Paul Rubens

It would be better for me if you were to make a verbal report; the letter in certain places may exceed the limits of modesty and reverence for His Highness. But I defer to your discretion, for you are my only patron, after Their Highnesses, at this Court.

To Jan van der Neesen *Alicante, April 22, 1603*

Most honored Sir:

I have arrived (thank God) safe and sound, with the baggage, the horses and men; and I immediately carried out the little I had to do for the service of the Grand Duke. The letters for Don Juan, the horse, completely equipped and lacking nothing of any sort, I have consigned to Signor Louis Pasquall, lieutenant of Don Juan, for he himself is absent in Valencia. The other letter to Signor Lorenzo de Puigmolti, Notary of the Holy Office, I have delivered into his own hands. This man has placed himself completely at my service and at the service of the ship-captains, all of whom are well satisfied with him and ask me to inform you of the favors they have received. Will you, therefore, report all this to the Grand Duke, with boundless gratitude for all his favors; thank him especially for my part with all possible earnestness. For this I shall be obliged to you, and hope I may find occasion to serve you in return.

<div align="right">

Your most affectionate servant,
</div>

Alicante, April 22, 1603 Peter Paul Rubens

To the Duke of Mantua *Valladolid, May 17, 1603*

Most Serene Lord:

I have unburdened upon the shoulders of Signor Hannibal Iberti [1] my charge of men, horses, and vases; the vases are intact, the horses sleek and handsome, just as I took them from the stables of Your Most Serene Highness, the men in good health, with the exception of one groom. Everything else, particularly the coach, is coming slowly in a mule-drawn cart, with no risk of damage, and is now nearly here.

I hope that for this first mission which Your Serene Highness has condescended to entrust to me, a kind fate will grant me your satisfaction, if not complete, at least in part. And if some action of mine should displease you, whether excessive expenditure or anything else, I beseech and implore you to postpone reproach until the time and place when I may be permitted to explain its unavoidable necessity. In the meantime I console myself in the thought of your boundless judgment, commensurate

with the greatness of your heroic spirit, before the serene splendor of which I bow with reverence and humbly kiss your most noble hand.

<div align="right">Your Most Serene Highness' humble servant,</div>

Valladolid, May 17, 1603 <div align="right">Peter Paul Rubens</div>

<div align="center">– 7 –</div>

To Annibale Chieppio <div align="right">*Valladolid, May 17, 1603*</div>

My Most Illustrious and Esteemed Sir:

My continual complaints will by this time have made you accustomed to read them as patiently as I write them. But the reasons are serious which force me to bother you so often. I shall describe them all one by one, but first I'll finish the report of the journey from which these complaints spring in consequence.

After twenty days of tiresome travel, through daily rains and violent winds, we arrived on the 13th of May in Valladolid, where Signor Hannibal did not fail to receive us courteously, although he said he had not received any orders from my Lord the Duke concerning me, nor any word about the horses. I answered in surprise that I was convinced of the good intention of His Most Serene Highness, but that to recall a thing forgotten would be superfluous after so many other cases, for I was not the first envoy the Duke had sent to him; and that for lack of advice the present necessities must serve as orders. He perhaps has his reasons. But he presented himself to me as a most charming and gracious gentleman, and he bade me write everything to you.[1] The expenses for the men and horses are certainly heavy, and owing to the absence of the King will perhaps continue still longer. In addition to the transportation charges for the horses, beasts of burden, and cart from Alicante here, they include the payment to Signor Andrea Ullio of the remainder of the customs tax of Ecla, so that all together they will amount to about 300 crowns, not counting the traveling expenses which I paid myself, and which for twenty days exceeded 200 ducats. [*In margin*: For these expenses I made use of the 150 ducats which I anticipate receiving from my Lord the Duke; the other 50 come from my salary for the past months — all remitted by Signor Eugenio Cagnanio.] Thus I find myself in a most uncomfortable situation, without a cent, but facing heavy expenses for clothes and other things. However, I shall maintain my position modestly

<div align="center">31</div>

and place myself entirely under the guidance and instruction of Signor Hannibal, who is very kind and helpful to me in every way. Thanks to him I have been provided with money by a merchant among his friends, until it pleases His Most Serene Highness to repay the sum of three hundred ducats to my account. This includes the two hundred which I spent on the journey, as well as another one hundred which I beg to have added to my account for the salary I shall earn in his service. Signor Hannibal will bear witness that I cannot manage on less; unavoidable necessity in this case demands such expenditures as I will make all the more willingly when I can thereby contribute to the honor of my Lord the Duke. For his service alone I regret that I am poor and have not the resources to correspond to my good will. If this repayment of my loan is made promptly, I shall be grateful; I do not ask it as a gift or a reward, as others will perhaps pretend I do. If you, therefore, will use your good influence to obtain my request, you will have the greater part in the favor which I receive, and which I await eagerly, commending myself affectionately to your good graces.

<div align="right">Your most humble servant,</div>

Valladolid, May 17, 1603 <div align="right">Peter Paul Rubens</div>

<div align="center">– 8 –</div>

To Annibale Chieppio <div align="right">*Valladolid, May 24, 1603*</div>

Most Illustrious Sir:

Malicious fate is jealous of my too great satisfaction; as usual, it does not fail to sprinkle in some bitterness, sometimes conceiving a way to cause damage which human precaution cannot foresee, still less suspect. Thus the pictures which were packed with all possible care by my own hand, in the presence of my Lord the Duke; then inspected at Alicante, at the demand of the customs officials, and found unharmed, were discovered today, in the house of Signor Hannibal Iberti, to be so damaged and spoiled that I almost despair of being able to restore them. For the injury is not an accidental surface mold or stain, which can be removed; but the canvas itself is entirely rotted and destroyed (even though it was protected by a tin casing and a double oil-cloth and packed in a wooden chest). The deterioration is probably due to the continuous rains which lasted for twenty-five days — an incredible thing in Spain. The colors have faded and, through long exposure to extreme dampness, have swollen and flaked

off, so that in many places the only remedy is to scrape them off with a knife and lay them on anew.

Such is the true extent of the damage (would it were not!).[1] I am in no way exaggerating, in order to praise the restoration later. To this task I shall not fail to apply all my skill, since it has pleased His Most Serene Highness to make me guardian and bearer of the works of others, without including a brushstroke of my own. I say this not because I feel any resentment, but in reference to the suggestion of Signor Hannibal, who wants me to do several pictures in great haste, with the help of Spanish painters. I agreed to this, but I am not inclined to approve of it, considering the short time we have, as well as the extent of the damage to the ruined pictures; not to mention the incredible incompetence and carelessness of the painters here, whose style (and this is very important) is totally different from mine. God keep me from resembling them in any way! In short, *pergimus pugnantia secum, cornibus adversis componere.**

Moreover, the matter will never remain secret, through the gossiping of these same assistants. They will either scorn my additions and retouches, or else will take over the work and claim it as all their own, especially when they know it is in the service of the Duke of Lerma, which may easily mean that the paintings are destined for a public gallery. As for me, this matters little, and I willingly forego this fame. But I am convinced that, by its freshness alone, the work must necessarily be discovered as done here (a thankless trick), whether by the hands of such men, or by mine, or by a mixture of theirs and mine (which I will never tolerate, for I have always guarded against being confused with anyone, however great a man). And I shall be disgraced unduly by an inferior production unworthy of my reputation, which is not unknown here.

If, however, the commission of my Lord the Duke had been such, I could have brought more honor to him and to myself, and much greater satisfaction to the Duke of Lerma. For he is not without knowledge of fine things, through the particular pleasure and practice he has in seeing every day so many splendid works of Titian, of Raphael and others, which have astonished me, both by their quality and quantity, in the King's palace, in the Escorial, and elsewhere. But as for the moderns, there is nothing of any worth.[2]

I state frankly that I have no purpose in this Court other than the constant service of His Most Serene Highness — a service to which I

* We proceed to combine things that are hostile, with horns directed against each other (Horace, *Sermones* 1.1.102).

33

have devoted myself since the first day I saw him. Let him command, let him dispose of me on this and every other occasion, and let him be assured that I will not overstep in the slightest degree the limitations he sets. Signor Iberti has the same authority over me (although indirectly). I know that it is sincerely and with the best intention that he does not accept my opinion; and he shall be obeyed. I write to you not to criticize him, but to show you my reluctance to identify myself with anything, unless it be worthy of me or of my Most Serene Patron, who will, I am sure, through your kind report, interpret these views of mine rightly.

<div style="text-align: right">

Your most humble servant,

</div>

Valladolid, May 24, 1603 Peter Paul Rubens

Today our groom Paul died, provided with all the comforts of body and soul. He was wasted and exhausted by a long, continuous fever.

<div style="text-align: center">

− 9 −

</div>

To the Duke of Mantua *Valladolid, July 17, 1603*

Most Serene Highness:

Although the diligence of Iberti renders my letters superfluous, I cannot help adding a few words to his very adequate report, not so much to supply any further information as to express my joy at our success. I can bear true testimony to this as one who had a part in the two ceremonies of presentation, either as witness or as participant. That of the little coach I saw, but I myself made the presentation of the pictures and vases.[1] In the first ceremony I observed with pleasure the indications of approval which the King showed by gestures, nods, and smiles. In the second I could even hear the Duke's words by which, after long admiration judiciously applied to the finest things, he expressed great satisfaction, not in the least assumed, as far as I could detect, but inspired by the quality and the quantity of the presents.

I hope, therefore, that, if the donor's reward is the approval of his gifts, Your Most Serene Highness will have achieved his purpose. Everything contributed to the success of the event; time, place, and other circumstances all chanced to favor us. To this I add the excellent judgment of Iberti, who is experienced in the clever use of terms appropriate to this Court. I leave to his ability and his accuracy the rest of the story, all

<div style="text-align: center">

34

</div>

the more so, since my poor qualities seem to me ill suited to do other than serve Your Highness devotedly in my own humble way.

<div align="right">Your Serene Highness' most humble servant,</div>

Valladolid, July 17, 1603 <div align="right">Peter Paul Rubens</div>

<div align="center">– 10 –</div>

To Annibale Chieppio <div align="right">*Valladolid, July 17, 1603*</div>

My Most Illustrious and Esteemed Sir:

I have not written because Signor Iberti has done so; he alone makes up for all my negligence, but this negligence is based upon his sufficiency. Besides, my nature keeps me from encroaching (except by necessity) upon that which is more fitting for others; this is not laziness but modesty. Today, however, I can no longer restrain myself from telling you of my happiness at having successfully accomplished my mission. The details I leave to the sincere report of Signor Iberti, from whom you will hear, with more enjoyment, all the success, minutely told. It would, therefore, be superfluous to tell you the same thing twice, had he not himself cited me as a witness who attended the ceremony. I was, in fact, simply an observer at the presentation of the coach, but a participant in that of the pictures. The first ceremony as well as the other one pleased me as being well directed by the judicious Signor Hannibal. It is true that he could still have reserved the entire management for himself, and yet have given me a place near His Majesty, to make him a mute reverence. There was ample opportunity, for we were in a public place, open to everyone.

I do not wish to interpret this wrongly (for it does not matter), but I am surprised at such a sudden change. For Iberti himself had mentioned to me several times the letter of my Lord the Duke in which he expressly commanded my presentation to the King (an especial favor of His Most Serene Highness). I say this not to complain, like a petty person, ambitious for a little flattery, nor am I vexed at being deprived of this favor. I simply describe the event as it occurred, convinced that Signor Iberti would have changed his decision at that moment, had not this reminder, although fresh, slipped his mind at the ceremony. He gave me no reason or excuse for the alteration in the order which, half an hour before, had been settled between us. He did not lack opportunity to speak to me about it, but he did not say a single word.

<div align="center">35</div>

I went to the Duke's and took part in the presentation. He showed great satisfaction at the fine quality and the number of the paintings, which (thanks to good retouching) had acquired a certain authority and appearance of antiquity, from the very damage they had suffered. Thus they were, for the most part, accepted as originals, with no suspicion to the contrary, or effort on our part to have them taken as such.[1] The King and Queen also saw and admired them, and many nobles and a few painters.

Now that I have discharged this mission, I shall occupy myself with doing the portraits ordered by His Highness, and I shall not interrupt the work unless I am summoned by some whim of the King or the Duke of Lerma. The latter has already made some sort of proposition [2] to Signor Iberti, and I shall obey, for the high discretion of this man will not, I am sure, commit me to anything unworthy of our patrons. In their name I submit to all his decisions. After that, hoping that my Lord the Duke will persist in his intention, I shall set out for France.[3] Will you do me the favor of advising Signor Iberti or me, by a special message sent either here or there, or to both places, as to how I may be of service.

<div style="text-align:right">

Your most devoted servant,
</div>

Valladolid, July 17, 1603 Peter Paul Rubens

— 11 —

To Annibale Chieppio *Valladolid, September 15, 1603*

Most Illustrious Sir:

I have received from the hands of Signor Bonati a letter from you which assures me that His Highness is somewhat satisfied with my services. I attribute this partly to the favor of your patronage, and partly to the fairness of Signor Iberti, since I myself am not aware of any merit, still less of any error committed, either in the expenses of the journey or on any other occasion up to the present. I do not fear the slightest suspicion of carelessness or fraud; I can meet the first accusation with a certain experience of my services, and the second with pure innocence. I say all this not unmindful of the proverb "He who makes excuses, accuses himself," but my remarks are not inappropriate to the circumstances which you already know.[1] As for my return, I can do nothing unless the judgment of Signor Iberti permits, for his prudence, up to now, has had the

disposal of me and my work, to satisfy the taste and demand of the Duke of Lerma, and the honor of His Highness, with the hope of proving to Spain, by a great equestrian portrait,[2] that the Duke is not less well served than His Majesty. I will do as much in France, if Our Most Serene Highnesses confirm that project which was ordered at my departure, but which has since been passed over in silence in all the letters.

If you will favor me with some new orders, I will carry them out at once, for I am deprived of every personal wish and interest; everything is transubstantiated into that of my patrons. In anticipation of receiving this favor, I commend myself to your good graces, and humbly kiss your hands.

<div style="text-align: right;">
Your most affectionate servant,
</div>

Valladolid, September 15, 1603 Peter Paul Rubens

<div style="text-align: center;">– 12 –</div>

To Annibale Chieppio *Valladolid [November ?] 1603*

It seemed to me, from your last letter, that His Most Serene Highness was still holding to the orders which he had given, before my departure, to have me go to France. May I be permitted, in this regard, to express my opinion as to my capacity for a mission of this sort, if (as I believe) my Lord the Duke has no other purpose in this journey than to have those portraits made. I am now somewhat puzzled that in several letters to Signor Iberti he urges my return so strongly, as you yourself do in your letter of October 1. Now this mission is not an urgent one and, besides, contracts of this sort always result in a thousand inevitable consequences. I have the examples of Spain and Rome in my own case: in both places the prescribed weeks dragged into as many months. Signor Iberti knows the inexorable necessity which has forced both him and me *ad jus usurpandum* * in default of orders. Believe me, the French yield neither to the Romans nor the Spaniards in "curiosity," mainly because they have a king and queen who are not strangers to this art. This is proved by the great works which are now interrupted, *inopia operariorum.*† I have detailed reports on all this, as well as on the efforts they have made to obtain artists of merit in Flanders, in Florence, and even, on the basis of ill-founded information, in Savoy and Spain.

* To assume authority.
† For want of workmen.

I should not confide such things to you (I say it with your pardon), had I not chosen my Lord the Duke as patron, for as long as he will grant me the favor of calling Mantua my adopted country. The pretext of the portraits, even though a humble one, would satisfy me as an introduction to greater things. Otherwise, I cannot imagine that it is my Lord the Duke's intention simply to give Their Majesties a taste of my talent, considering the expense of the expedition. I should like, therefore, to suggest that, in my opinion, it would be much safer, and a saving both of time and money, to have this work done through arrangements with M. de la Brosse or Signor Carlo Rossi,[1] by one of the painters active at that Court, who may already have a collection of such portraits in his studio. Then I should not have to waste more time, travel, expenses, salaries (even the munificence of His Highness will not repay all this) upon works unworthy of me, and which anyone can do to the Duke's taste. Nevertheless I submit myself, like a good servant, completely to the decision and to the slightest command of my patron, but I beg him earnestly to employ me, at home or abroad, in works more appropriate to my talent, and in continuing the works already begun. I shall feel certain of obtaining this favor, since you are always willing to be my friendly intercessor before my Lord the Duke. And in this confidence I kiss your hand with all humble reverence.[2]

<div style="text-align: right">

Your most humble servant,

</div>

Valladolid, 1603 <div style="text-align: right">Peter Paul Rubens</div>

<div style="text-align: center">

– 13 –

</div>

To Annibale Chieppio <div style="text-align: right">*Rome, July 29, 1606*</div>

Most Illustrious Sir and Esteemed Patron:

I should not know to whom to apply with confidence of obtaining this favor, if not to you, from whom I have already received another similar to this, or rather, the same favor. I refer to the salary which you paid me promptly for four months. Now the time has passed, and the salary is already in arrears for four more months, from the first of April to the first of August. I beg you to intercede for me before His Most Serene Highness, so that it may please him to continue the same favor toward me. Then I can carry on my studies without having to turn elsewhere for resources — which would not be lacking for me in Rome. I shall remain most obliged to you, as always, and humbly kiss your hand, begging

<div style="text-align: center">

38

</div>

you to show me a proof of your graciousness by giving me some order which would please you.

<div align="right">Your most affectionate servant,</div>

Rome, July 29, 1606 <div align="right">Peter Paul Rubens</div>

<div align="center">– 14 –</div>

To Annibale Chieppio <div align="right">*Rome, December 2, 1606*</div>

My Most Illustrious Sir and Esteemed Patron:

I am very much embarrassed by the sudden decision of His Most Serene Highness concerning my return to Mantua, within a time so short that it will be impossible for me to leave Rome so quickly. This is because of some important works which (to confess the true secret to you) I was forced to accept out of pure necessity, after having devoted all the summer to the study of art. For I could not furnish and suitably maintain a house with two servants for the period of one year in Rome on the mere 140 crowns which I have received from Mantua during my entire absence. Therefore, when the finest and most splendid opportunity in all Rome presented itself, my ambition urged me to avail myself of the chance. It is the high altar of the new church of the Priests of the Oratory, called Sta. Maria in Vallicella — without doubt the most celebrated and frequented church in Rome today, situated right in the center of the city, and to be adorned by the combined efforts of all the most able painters in Italy.[1] Although the work mentioned is not yet begun, personages of such rank are interested in it that I could not honorably give up a contract obtained so gloriously, against the pretentions of all the leading painters of Rome. Besides, I should do the greatest injustice to all my patrons, and they would be very much displeased. In fact, when I showed some hesitation, because of my obligations to Mantua, they offered, in such a case, to intercede for me with my Lord the Duke; they protested that His Most Serene Highness ought to be very much pleased to have one of his servants do him such honor in Rome. Among others, I know that Cardinal Borghese [2] would not fail to speak on my behalf, but for the present it seems to me unnecessary to apply to anyone but you. You alone will be sufficient; no one is more capable of making my Lord the Duke understand how great my interest is, in the honor as well as the profit.

I have no doubt at all that your effective intercession, along with the benevolence of His Highness, will result in the granting of my wish.

<div align="center">39</div>

Nevertheless, if the immediate service of my Lord the Duke is so pressing that it will endure no delay, I will give it precedence over everything else in the world, and hasten back at once. But I beg His Highness to give me, in exchange, his princely word that next spring I may return here for three months, in order to satisfy these gentlemen in Rome. Either one or the other of these concessions would be the greatest favor which I could hope for from His Highness and yourself: whether for the present I postpone my return for three months, or whether, in the spring, I am permitted to come back to Rome for the same length of time.[3]

This is the extent of my request. I entrust and commend it with customary affection to your favor, upon which I depend. Pardon me if I dare hope for too much; your own kindness and benignity are the chief causes of such importunity. I can do no more than to pray that His Divine Majesty will be as gracious to you as you are toward me; and in this spirit I humbly kiss your hands.

<div style="text-align:right">

Your most devoted servant,
</div>

Rome, December 2, 1606 Peter Paul Rubens

<div style="text-align:center">

– 15 –
</div>

To Annibale Chieppio *Rome, April 28, 1607*

My Most Illustrious Sir and Esteemed Patron:

I have received the letter of credit for fifty crowns, payable at usance, which does not matter; a delay of these few days causes me no inconvenience. But you show too much delicacy in the way you grant favors to your servants, along with your reflections on such trivial matters. I shall always accept your letters with this condition; I should even willingly grant my Lord the Duke double the term to pay that which is due me. I, too, understand what the difficulties are (be it said for the comfort of the Treasurer). It remains for me to tell you that I am as much obliged to you as if I received this money as a gift from yourself. And thanking you again with all my heart, I humbly kiss your hands.

<div style="text-align:right">

Your most devoted servant,
</div>

Rome, April 28, 1607 Peter Paul Rubens

<div style="text-align:center">

40
</div>

To Annibale Chieppio *Rome, June 9, 1607*

My Most Illustrious and Esteemed Sir:

My Most Serene Patron summons me home by urgent letters from Filippo Persio, so that he may make use of me during a journey to Flanders.[1] Therefore I shall obey at once, and show His Highness that I have no interest in this world preferable to his service. And so I am leaving my work without unveiling it and without receiving any recompense for it; such things cannot be settled so impetuously. The reason for such a delay, however, lies not with me, but in the absence of Monsignor Serra, Commissary-General of the States of the Church. Since this controversy with the Venetians, he has not yet returned.[2] Now it was to him that my contract was first entrusted, and because of the affection which he has for me, I do not care to have this transferred to others. Also, the sacred image of the Madonna della Vallicella,[3] which is to be placed at the top of my picture, cannot be transported before the middle of September; the two go together, and one cannot be unveiled without the other. Besides, it will be necessary for me to retouch my picture in its place before the unveiling; this is usually done in order to avoid mistakes. I wish to mention this because I hope that His Highness will consider my good will to serve him, but will recognize how inconvenient for me this departure will be. Perhaps, in return, it will not be difficult for him, after the trip to Flanders, to allow me to come to Rome for a single month to settle my affairs. For I am leaving them in the greatest confusion by this departure, and not without displeasing certain prominent persons who profess to favor me.

I wanted to give you an account of my affairs because you can influence the mind of His Highness before my arrival, and predispose him in my favor. I shall leave here (God willing) within three days, and will make all haste to arrive a few days before the 25th. It will be the greatest consolation to me to be able to serve you in person, and to kiss your hands. In the meantime, I commend myself with all affection to your good graces.

Your most humble and affectionate servant,

Rome, June 9, 1607 Peter Paul Rubens

[A fragment of a Rubens letter, written in Italian and dated November 1607, was in the possession of the late Dr. Ludwig Burchard, London. It is written on the reverse of a pen sketch representing three apostles. A facsimile of this damaged fragment appears in the catalogue by J. Goudstikker, *Rubens-tentoonstelling*, August-September, 1933, no. 83b.]

To Annibale Chieppio *Rome, February 2, 1608*

Most Illustrious Sir:

Since you have always shown an interest in my affairs, due to your affection for me, it does not seem to me inappropriate to inform you of a strange thing that has happened to me. I do this all the more willingly since I believe that this personal misfortune may turn out to the advantage of His Most Serene Highness. You must know, then, that my painting for the high altar of the Chiesa Nuova turned out very well, to the extreme satisfaction of the Fathers and also (which rarely happens) of all the others who first saw it. But the light falls so unfavorably on this altar that one can hardly discern the figures, or enjoy the beauty of coloring, and the delicacy of the heads and draperies, which I executed with great care, from nature, and completely successfully, according to the judgment of all. Therefore, seeing that all the merit in the work is thrown away, and since I cannot obtain the honor due my efforts unless the results can be seen, I do not think I will unveil it. Instead I will take it down and seek some better place for it, even though the price has been set at 800 crowns (at 10 jules to the crown), that is, ducatoons. This can be confirmed by Signor Magno, who knows exactly how the arrangement was made. But the Fathers do not wish the picture to be removed unless I agree to make a copy of it by my own hand, for the same altar, to be painted on stone or some material which will absorb the colors so that they will not be reflected by this unfavorable light.[1] I do not, however, consider it fitting to my reputation that there should· be in Rome two identical pictures by my hand.

I recall that my Lord the Duke and Madame the Duchess formerly told me they would like to have one of my paintings for their picture gallery. And I confess that since Their Highnesses wish to do me this honor, it would be very agreeable if they would take the above-mentioned picture, which without doubt is by far the best and most successful work I have ever done. It will not be easy for me, another time, to resolve to

put so much effort into a work; and even if I should, perhaps it would not be so successful. The picture would surely hold its place in that gallery which is filled by the competition and rivalry of so many reputable men. As for the price (although fixed and agreed upon at 800 crowns), I should not base it upon the estimate of Rome, but leave it to the discretion of His Highness. The payment also I leave to his convenience, except for one or two hundred crowns which I shall need now during the painting of the copy. This I shall finish as soon as possible — in a couple of months at the most, since I need not make any new studies for it. Therefore I shall not fail to be in Mantua certainly before Easter.

If you will condescend to favor me once more by presenting this proposition to the Duke, even though my obligations to you cannot be increased, this will be a renewal of all obligations in one. I beg you to advise me as soon as possible as to His Highness' decision, because I am keeping the painting covered and all negotiations suspended in the meantime. In case His Highness accepts the offer, I shall take down the picture at once and exhibit it to the public, in the same church, under a better light, for the satisfaction of Rome and my own as well. I shall not need to put so much perfection and finish into the copy, for it can never be properly enjoyed.

In order that you may be well informed on everything, I will tell you that the composition is very beautiful because of the number, size, and variety of the figures of old men, young men, and ladies richly dressed. And although all these figures are saints, they have no special attributes or insignia which could not be applied to any other saints of similar rank. And finally, the size of the picture is not so excessive that it would require much space; it is narrow and tall. All in all, I am certain that Their Highnesses, when they see it, will be completely satisfied, like the crowds who have seen it in Rome.[2]

May you graciously pardon the boredom which I cause by this trifling affair; I know how inconsistent it is with the gravity of your occupations, and I admit that this is really an abuse of your courtesy. Nevertheless, since it is a very pressing matter to me, I beg you to take it to heart, and be assured that you could not favor anyone who appreciates your favors more than I do. And in closing I humbly kiss your hands.

Your most devoted servant,
Peter Paul Rubens

Rome, February 2, 1608

43

To Annibale Chieppio *Rome, February 23, 1608*

Most Illustrious Sir:

Although my negotiation has not turned out well, I remain no less obliged to you than if it had succeeded according to my proposal, for I am certain that you have done much more on my behalf than I ever ought to expect from a person of your rank. Besides, to tell the truth, it is no longer so urgent. The picture has been publicly exhibited in a better location in the same church, and for several days has been viewed with great approval by all Rome. In this way I am sure to find a good placement for it in Rome itself; and this would not matter, because the Fathers have given me the liberty of making certain variations in the copy according to my fancy.[1] I believe also that, due to the urgent expenditures for this marriage,[2] I should have caused no little embarrassment *in re pecuniaria* to your treasury in Mantua, if it had had to satisfy me (as will happen when it pays my salary, long in arrears). Therefore, in thinking it over well, it almost seems that I ought to consider it fortunate that such a proposal was not carried out.

It only remains for me to beg you to speak to the Most Serene Madame, requesting payment for the picture which Her Highness had done here in Rome, at her express order, for her chapel, by Signor Cristoforo Pomarancio.[3] I have written all the particulars about this picture to Signor Filippo Persio, who, to my astonishment, has departed without giving me any reply. Thus I am obliged to bother you once more, and inform you briefly of the fact that it was by my urging that the Most Serene Madame was served promptly and well, although Pomarancio was very busy. As for the terms of the price, Her Highness referred it to me several times, but I was unwilling to accept such a responsibility. However, I discussed it with Pomarancio, who, after indulging in compliments to Her Highness, finally asked 500 gold crowns. This sum seemed exorbitant to the Most Serene Madame, who perhaps did not know the practice of these leading masters of Rome, but believed she could deal with them according to our fashion in Mantua. Nevertheless, she turned the matter over to me once more; and after having shown the picture to many connoisseurs, among them Signor Magno, I have decided with him that Her Highness cannot pay less than 400 gold crowns.

Therefore I beg you to do me this one more favor of requesting that the Most Serene Madame pay this sum as soon as possible. Otherwise I

shall be ashamed, and shall never risk accepting any commission similar to this one, which was imposed upon me by Her Highness through countless letters and numerous solicitations. And now that the service has been most excellently performed, I am alarmed at such indifference in the matter of payment.

I appeal, then, to you, according to my custom in every difficulty. I know by experience with what warmth you take me under your protection in all things. And humbly kissing your hands, I pray God to grant you every happiness.

<div style="text-align: right">Your most devoted servant,</div>

Rome, February 23, 1608 Peter Paul Rubens

<div style="text-align: center">– 19 –</div>

To Annibale Chieppio *Rome, October 28, 1608*

My Most Illustrious Sir:

It seems to me that it is my duty, even though His Highness has not yet returned to Mantua,[1] to explain to you the necessity which forces me to commit a sort of impertinence: namely, to extend an absence already so long by another journey to lands more remote, but which I hope will be a short one.[2] The reason is that the day before yesterday I received very bad news concerning my mother's health. She is so ill from a serious attack of asthma that, considering her advanced age of seventy-two years, one can hope for no other outcome than the end common to all humanity.[3] It will be hard for me to go to attend this scene, and likewise hard to leave without the permission of My Most Serene Patron. Therefore I have consulted Signor Magno, and have decided that I should do well to try to meet His Highness somewhere on the way, and to choose this or that route according to the news which I may have of him. It is no small comfort to know that when His Highness was in Antwerp, my family made a request for my return, and fully informed Signor Filippo Persio and Signor Annibale Iberti as to the necessity of my presence. Thanks to the intervention of these gentlemen, they will have reason to hope for the sympathy of His Highness in such a case. But the illness was at that time not yet at the critical stage which it has now reached. Therefore they did not make the ultimate effort to have me return, as they are doing at present. I pray you to favor me by reporting this distress of mine to the Most Serene Madame, and presenting my excuses if, in order to gain

<div style="text-align: center">45</div>

time and to meet His Serene Highness the Duke, I do not touch Mantua but go with all haste by the direct route.

Concerning my return I will say no more, except that every wish of my Most Serene Patron will always be carried out, and observed as an inviolable law in all places and at all times. My work in Rome on the three great pictures for the Chiesa Nuova is finished, and, if I am not mistaken, is the least unsuccessful work by my hand. However, I am leaving without unveiling it (the marble ornaments for it are not yet finished), for haste spurs me on. But this does not affect the essence of the picture, for it was painted in public, in its proper place, and on stone. And so on my return from Flanders I can go directly to Mantua. This, in countless ways, will be very agreeable to me, especially to be able to serve you in person. I kiss your hands in begging you to keep me in your favor, and in that of my Most Serene Patrons.

<div align="right">Your most devoted servant,</div>

Rome, October 28, 1608 Peter Paul Rubens
Mounting horseback

PART II

1609–1621

The Twelve Years' Truce

The Antwerp Studio

The Carleton Correspondence

1 6 0 9 – 1 6 2 1

Rubens' return to Antwerp came at a favorable time, just as the Twelve Years' Truce was concluded between Spain and the United Provinces. For Spain this was the first confession of military decline, but for the Spanish Netherlands, which had served as battleground in the long struggle, it promised a welcome relief, and an opportunity for economic revival. The city of Antwerp, which had suffered most grievously, was filled with a new hope and enthusiasm. Although Rubens' first letters turn back to Italy with fond recollection, and he still thinks of "returning forever to Rome," the ties that bind him to Antwerp prove the stronger. His brother Philip's entrance into public affairs, and appointment as Secretary of Antwerp in January 1609, brought the artist into contact with the leaders of the city. The Burgomaster Nicolas Rockox, a man of great wealth and learning, who devoted himself to restoring the former glory of Antwerp, became his friend and patron, providing many important commissions. Less than a year after his return, Rubens married Isabella Brant, daughter of the eminent Antwerp lawyer and humanist, Jan Brant. His social position was thus immediately assured, and the demand for portraits, altarpieces for the new churches, paintings of every sort promised employment for his ready brush.

Not only in his own city was Rubens' talent recognized. He was honored by the Spanish regents of the Netherlands, the Archdukes Albert and Isabella, and on September 23, 1609, was named their court painter. This appointment provided an annual pension of five hundred florins, as well as all the "rights, honors, liberties, exemptions, and franchises" enjoyed by members of the ducal household. An extraordinary privilege relieved Rubens of the obligation to live at the court in Brussels. He was permitted to remain in Antwerp, and to "teach his art to whomever he wished, without being subject to the regulations of the guild."

Under circumstances as propitious as these, Rubens' studio expanded rapidly. By 1611 we find him writing to a friend that he has had to refuse over one hundred applicants, and in 1618 he states that he is "so burdened

with commissions, both public and private," that he cannot accept any more for some years to come. Increasing prosperity enabled him to build a fine house, modeled after the palaces he had admired in Genoa and elsewhere in Italy. This princely establishment, which became the pride of Antwerp, combined residence, workshop, and also museum for a growing collection of paintings, sculptures, and antiquities.

It was in 1616 that Rubens came into contact with the English connoisseur and statesman Sir Dudley Carleton, then newly appointed Ambassador to The Hague. Carleton had instructed his agent for the purchase of works of art to offer Rubens a "chaine" of diamonds of Lady Carleton's in exchange for a "hunting-peece" by the Antwerp master. This first transaction led to the more notable exchange of paintings for sculptures. Carleton, during five years' residence in Italy as Ambassador to the Republic of Venice, had formed a collection of ancient marbles which attracted the interest of Rubens, and the English diplomat, since his taste had turned to painting, was disposed to offer these antiquities in return for more of Rubens' work. The correspondence between the two during the spring of 1618 describes every step of the negotiations. Rubens' detailed list of the paintings he offered in the exchange, clearly defining the part played by pupils, shows the value the artist, as well as the collector, gave to "authentic" work and presents a vivid suggestion of studio procedure. The bargain was settled to the satisfaction of both parties. Rubens' share was not inconsiderable, if we may rely upon the inventory of the sculptures sent to Carleton in 1617 from Venice to The Hague. The list comprised twenty-one large statues, eight statues of children, four torsos, fifty-seven heads of various sizes, seventeen pedestals, five urns, four bas-reliefs, as well as miscellaneous fragments and small items. The Carleton collection also included eighteen busts of Roman emperors. Rubens thus acquired a collection of antiquities that placed him in the front rank among amateurs. He did not, however, keep these sculptures very long. Most of them were included in the sale of the artist's collection to the Duke of Buckingham in 1627.

The friendship of Sir Dudley Carleton proved very useful to Rubens when, in 1619, he sought to protect the engravings of his workshop from forged imitation in Holland. Through the influence of the British Ambassador the States General of the United Provinces, on February 24, 1620, forbade all engravers and etchers in those provinces, for a period of seven years, from copying any of Rubens' works, under penalty of confiscation of the engraved plate and a fine of one hundred florins. Similar copyright privileges, obtained at about the same time in France and the

Southern Netherlands, enabled the artist to develop his great Antwerp school of engraving with less risk of unauthorized imitation. The engravings, etchings, and woodcuts that began to issue from Rubens' workshop in such numbers contributed, in no small measure, to his financial gain, as well as to the spread of his fame throughout Europe.

It was Rubens' good fortune to return to his Antwerp home at the very moment of the signing of the Truce, and to remain there during twelve years of respite from hostilities. His opportunities were almost unlimited. And to Antwerp fell the distinction of receiving the greatest creative genius of the day, whose talents were to give the city a new glory and a unique position in European painting.

To Johann Faber *Antwerp, April 10, 1609*

Most Illustrious and Excellent Sir:

Your kindness deserves a better correspondence from our side, and I should not know how to excuse such tardiness if the truth did not speak for itself. We have been so involved in the marriage of my brother [1] that we have been unable to attend to anything but serving the ladies — he as bridegroom and I as best man. If you do not believe that such an affair is so intricate, have your friend, Signor Martellano, tell you his experience, and I am sure that you will then accept our excuses as legitimate. In short, my brother has been favored by Venus, the Cupids, Juno, and all the gods: there has fallen to his lot a mistress who is beautiful, learned, gracious, wealthy, and well-born, and alone able to refute the entire Sixth Satire of Juvenal. It was a fortunate hour when he laid aside the scholar's gown and dedicated himself to the service of Cupid. I myself will not dare to follow him, for he has made such a good choice that it seems inimitable.[2] And I should not like to have my sweetheart called ugly if she were inferior to his. It is therefore Martellano's turn to boast of serving the most beautiful lady in the world. But tell him that he ought to do it promptly, without thinking of the two years that have glided by; and that if, by chance, he feels himself touched to the quick, and spurred by the approval of Don Giovanni and Don Alfonso, as well as by that of the old man, he ought to let himself be drawn to this good and ardent resolution. To be sure, in delaying I see no danger other than the death of the old man, which would greatly upset Martellano's hopes. For it was through him that Martellano was first invited to that house, and from him comes the good impression produced upon all the family.

I find by experience that such affairs should not be carried on coolly, but with great fervor. My brother has also proved this, for since my arrival he has changed his tactics, after pining for two years in vain. But to come to my own affairs, I have not yet made up my mind whether to remain in my own country or to return forever to Rome, where I am invited on the most favorable terms. Here also they do not fail to make every effort to keep me, by every sort of compliment. The Archduke and the Most Serene Infanta have had letters written urging me to remain in their service. Their offers are very generous, but I have little desire to become a courtier again. Antwerp and its citizens would satisfy me, if I could say farewell to Rome. The peace, or rather, the truce for many

years [3] will without doubt be ratified, and during this period it is believed that our country will flourish again. It is thought that by next week it will be proclaimed through all these provinces.

Signor Scioppius [4] has sometimes favored us with his letters, but lately we have heard little from him, and I believe he is occupied with affairs of importance. Scaliger [5] (or Bordone) has departed for the other world, and now awaits consecration among the ranks of the gods, according to the custom of Holland. When Scioppius learned, through a letter from my brother, that Scaliger had fallen ill, he replied with a verse from Menander: *Vivus mortuusque vapulabit malus,** and with many threats to pursue their controversy *etiam si ad genitorem imas Erebi descenderit umbras.*† I beg that on the arrival of Signor Scioppius in Rome you will commend me to him, and to his convert, Signor Adam,[6] to Signor Enrico [7] and to the other friends whose good conversation makes me often long for Rome. Patience: *non cuivis homini contingit ea.*‡ I kiss your hands with all my heart, and so does my brother, who tells me that he wishes to serve you likewise, when his Juno gives him permission. *Vale.*

<div style="text-align: right">

Your most affectionate servant,
</div>

Antwerp, April 10, 1609 <div style="text-align: right">Peter Paul Rubens</div>

—21 —

To Johann Faber <div style="text-align: right">*Antwerp, January 14, 1611*</div>

My Illustrious and Honored Sir:

I have received from you two letters of very different tenor and content. The first was thoroughly amusing and gay; but the second, of December 18, was the bearer of the most cruel news — that of the death of our beloved Signor Adam,[1] — which was very bitter to me. Surely, after such a loss, our entire profession ought to clothe itself in mourning. It will not easily succeed in replacing him; in my opinion he had no equal in small figures, in landscapes, and in many other subjects. He has died in the flower of his studies, and *adhuc sua messis in herba erat.*§ One

* Living or dead, the rogue shall get a beating.

† Even if he descends to his sire, in the deepest shades of Erebus (Virgil, *Aeneid* 6.404).

‡ This does not fall to every man (Horace, *Epistles* 1.17.36).

§ His wheat was still in the blade (Ovid, *Heroides* 17.263).

could have expected of him *res nunquam visae nunquam videndae; in summa ostenderunt terris hunc tantum fata.*†

For myself, I have never felt my heart more profoundly pierced by grief than at this news, and I shall never regard with a friendly eye those who have brought him to so miserable an end. I pray that God will forgive Signor Adam his sin of sloth, by which he has deprived the world of the most beautiful things, caused himself much misery, and finally, I believe, reduced himself to despair; whereas with his own hands he could have built up a great fortune and made himself respected by all the world.

But let us cease these laments. I am sorry that in these parts we have not a single one of his works. I should like to have that picture on copper (of which you write) of the "Flight of Our Lady into Egypt" come into the hands of one of my compatriots who might bring it to this country, but I fear that the high price of 300 crowns may prevent it. Nevertheless, if his widow cannot sell it promptly in Italy, I should not dissuade her from sending it to Flanders, where there are many art-lovers, although I shouldn't want to assure her of obtaining this sum. I shall certainly be willing to employ all my efforts in her service, as a tribute to the dear memory of Signor Adam. And with this I kiss your hands with all affection, and also on behalf of my brother. He is greatly surprised at the delay of his letter to Signor Scioppius, who could be classed among the antiquities of Rome, were he not known as a modern author. I'd write also something on the doings of Don Alfonso and Martellano, but that this subject seems little suited to the tragedy of Signor Adam, which merits an entire letter *a qua exulent risus jocusque.*‡ Again I commend myself to your good graces, praying heaven to grant you every happiness.

<div style="text-align:right">

Your most affectionate servant,

</div>

Antwerp, January 14, 1611 Peter Paul Rubens

Surely the widow would do well to send that picture on copper (the Flight into Egypt) directly to Antwerp, where there are countless numbers of people interested in works of small size. I shall take particular care of it and serve as curator with all my ability. And if the painting should not be sold immediately, we shall in the meantime find a way to advance her a good sum of money on it, without prejudice to the sale.

† Things that one has never seen and never will see; in short, destiny had only shown him to the world (cf. *Aeneid* 6.869).
‡ From which jokes and pleasantries are omitted.

To Jacob de Bie *Antwerp, May 11, 1611*

Monsieur de Bie: I am very glad to see that you place such confidence in me that you ask me to render you a service, but I regret from the bottom of my heart that I have no opportunity to show you by deeds rather than words my regard for you. For it is impossible for me to accept the young man whom you recommend. From all sides applications reach me. Some young men remain here for several years with other masters, awaiting a vacancy in my studio. Among others, my friend and (as you know) patron, M. Rockox, has only with great difficulty obtained a place for a youth whom he himself brought up, and whom, in the meantime, he was having trained by others. I can tell you truly, without any exaggeration, that I have have to refuse over one hundred, even some of my own relatives or my wife's, and not without causing great displeasure among many of my best friends.

Therefore I beg you to accept my excuses in this case. But in all other things you will not lack proof of my esteem, insofar as it is within my power. Herewith I commend myself heartily to your good graces, and pray that God grant you good fortune and health.

<div style="text-align: right">Your servant,</div>

Antwerp, May 11, 1611 Peter Paul Rubens

P. S. I believe that you will not be offended if I take an opportunity that has presented itself to sell at a reasonable profit my picture of Juno and Argus.[1] I hope that, in time, something else will issue from my brush that may better satisfy you. I only wanted to tell you of this before concluding the sale, for I like to be correct in my affairs, and to give full satisfaction to every one, especially to my friends. I know well that with princes one cannot always carry out one's good intentions. But to you I remain just as much obliged as ever.

To Jacobo Cardinal Serra *Antwerp, March 2, 1612*

Most Illustrious Lord:

Having learned by your very gracious letter of February 4 that Your Most Illustrious Lordship was going to send me that small sum due on the

Chiesa Nuova,[1] it seemed to me well to spare you this trouble, through the kindness of a friend of mine named Jacomo de Haze,[2] bearer of this note, and to whom I have given the commission of buying me a few trinkets in Rome. Therefore I beg Your Most Illustrious Lordship to have the above-mentioned money paid to him, at your convenience, without his knowing anything about the Chiesa Nuova, or having to deal with those Fathers. Pardon me this trouble, and keep me in the good graces of Your Most Illustrious Lordship, whose hands I humbly kiss.

Your Illustrious Lordship's most devoted servant,
Antwerp, March 2, 1612 Peter Paul Rubens

– 24 –

To the Archduke Albert *Antwerp, March 19, 1614*

Thanks to his extremely good memory, the Archduke must remember well having seen, two years ago, a colored sketch [1] done by my hand, to serve as a study for the triptych of the high altar of the Cathedral of Ghent. It was done at the order of the Most Reverend Bishop Maes of that city (may he rest in glory). He had planned to have this work carried out with all possible magnificence, so that without doubt it would have been the largest and most beautiful ever made in this country, if death had not prevented him.[2] Thereupon, although the Chapter had approved the whole project, everything was suspended. And I, after putting considerable effort into drawing up the plan of the entire work, as much for the marble ornamentation as for the picture, received no recompense at all. I cherished the hope that Monsignor the present Bishop,[3] in succeeding to this dignity, would also take up this enterprise, but I was greatly mistaken. For through false counsel, and without even once looking at my designs, he has allowed himself to be persuaded to erect a most preposterous high altar, without a picture of any sort, but only a statue of St. Bavo in a marble niche with some columns [*in margin*: however, up to the present he has not made any arrangement or contract with the sculptors, nor any purchase of marbles], and a repository behind the altar for the Most Holy Sacrament. According to my design this repository, in spite of the picture, was to have been on the altar to hold the relics.

The important thing is this: Monsignor the Bishop has resolved to spend the same sum of money as his predecessor would have done. Therefore I am extremely sorry to have such a fine enterprise come to naught,

56

not because of my own personal interest, which matters little, but because of the loss of a public ornament to that city. This will be the case unless His Most Serene Highness is moved by the strong affection which he has always shown for the art of painting, and for me in particular, and desires to increase the beauty of that cathedral, whose revenues will pay the expenses; unless, I say, His Highness condescends to inform the Bishop of Ghent that he has seen this design of mine and approves it, and that His Most Reverend Lordship would do well to retain it, or at least to look it over before making another decision. I shall certainly be more obliged than I can say, to the benevolence of His Most Serene Highness, if he deigns to favor me with a note conceived in such a vein and addressed to Monsignor the Bishop of Ghent.[4] I assure His Highness that I am not influenced by the profit I might receive from this work [*in margin*: for I am at present charged with more great works than I have ever had; I am thinking of taking some of them to Brussels to show to His Highness, when they are finished, for they are painted on canvas], but I can say, with a Christian conscience, this Ghent design is the most beautiful thing I have ever done in my life. Therefore, my keen desire to carry it to completion leads me to use terms which are perhaps too insistent for His Highness, whom I pray the Lord God will keep in good health.

His Most Serene Highness' most devoted servant,
Antwerp, March 19, 1614 Peter Paul Rubens

– 25 –

To M. Felix *Antwerp, January 18, 1618*

Monsieur Felix:

You must make the best of these drawings, poor and bad as they are, for it is impossible for me, because of other duties, to do any more to them now. So you will have to make use of them. They could be made wider or narrower, according to the proportions of your work. Wherewith I commend myself heartily to your father, wishing him from God Almighty complete happiness and contentment.

Your friend and servant,
Antwerp, January 18, 1618 Peter Paul Rubens

To François Swert *[Antwerp, February–March 1618]*

My dear M. Swert:

As for the Isis of the honorable Mr. Camden,[1] to tell you the truth, I do not clearly understand it. Nor, from such a crude drawing (if the artist will forgive me) have I been able to derive a plausible interpretation. For in place of the heifer, unless this be credited on the faith of Mr. Camden, I should suspect something else, since the form, proportion, gesture, and pose differ remarkably from the natural properties of this animal. Apis, who, in almost all ancient marbles, as far as I have observed, is found either at the side of Isis or Egyptus himself, is represented with the stature of an almost full-grown bull. On his side is seen his particular symbol of a moon more than half full, and he has the horns and the other characteristics of a bull. But what girl has ever fondled a cow instead of a little dog, and held it on her lap? The fillets and garlands which are usually the almost inseparable attributes of Isis, are here not to be seen at all; and no one, unless I am mistaken, has ever seen her, painted or carved, without the sistrum, for this is her distinctive sign.

But in order to say something — although in a matter so obscure I should not venture to affirm anything — I will say that if this animal is a heifer, I suspect that it has to do with some vow made for a good harvest, according to the dictum: "Sacrifice a heifer, that the fruits of the earth may increase." This interpretation is confirmed by the bowl of fruits and by the drinking vessel which the figure holds in its other hand, and which is entirely different in size and shape from the urns of the river-gods. [*In margin*: These urns were large and had a flatter body.] For at the sacrificial feasts they used to drink like Saufeia.[2] And the crowns appropriate to the sacred rites were either of flowers or leaves, or made of gold or some other material, as one can prove by many examples. This that I offer you is nothing for the subject at hand, but it is a great deal for me, my dear sir, for my duties call me elsewhere. Therefore we must leave the question of the Isis, entire and intact, to wiser men. Farewell, and love me always.

<div align="right">

Ever yours,
Peter Paul Rubens

</div>

To Sir Dudley Carleton *Antwerp, March 17, 1618*

Most Excellent Sir:

Having learned from various persons of the rare collection of antiquities
which Your Excellency has gathered together, I wished to come to see it
in the company of Mr. George Gage,[1] your countryman. But upon the
departure of that gentleman for Spain, and because of the pressure of
my affairs, this idea has had to be abandoned. However, since Your Ex-
cellency led Mr. Gage to understand that you would agree to make some
exchange of these marbles for pictures by my hand, I, as a lover of an-
tiquities, would be readily disposed to accept any reasonable offer, should
Your Excellency still have this intention. But in order to come to some
agreement, I can think of no method more expedient than through the
bearer of this letter, by asking Your Excellency to show him your objects
and permit him to take notes so that he may give me an account. I like-
wise will send you a list of those works which I have at home. [*In mar-
gin*: Or else I should expressly make some pictures which would be more
to Your Excellency's taste.] In short, we could begin to formulate some
sort of negotiation that would be favorable to both parties. This gentle-
man is called Frans Pieterssen de Grebbel,[2] a native and resident of
Haarlem. He is an honorable person, of good repute, whose sincerity we
can surely trust. With this I commend myself with all my heart to Your
Excellency's good graces, and pray heaven to grant you every happiness
and contentment.

 Your Excellency's most humble servant,
Antwerp, March 17, 1618 Peter Paul Rubens

To Sir Dudley Carleton *Antwerp, April 28, 1618*

Most Excellent Sir:

By the advice of my agent, I have learned that Your Excellency is very
much inclined to make some bargain with me concerning your antiqui-
ties; and it has made me hope well of this business, to see that you go
about it seriously, having told him the exact price that they cost you.
In regard to this, I wish to place complete trust in your knightly word. I

am willing also to believe that you made such purchases with all judgment and prudence, although high personages, in buying or selling, are sometimes likely to have a certain disadvantage, because many people are willing to compute the price of goods by the rank of the purchaser — a practice to which I am very averse. Your Excellency may be assured that I shall put prices on my pictures, just as if I were negotiating to sell them for cash; and in this I beg you to rely upon the word of an honest man. I find that at present I have in the house the flower of my stock, particularly some pictures which I have kept for my own enjoyment; some I have even repurchased for more than I had sold them to others. But the whole shall be at the service of Your Excellency, because I like brief negotiations, where each party gives and receives his share at once. To tell the truth, I am so burdened with commissions, both public and private, that for some years to come I cannot commit myself. Nevertheless, in case we agree as I hope, I will not fail to finish as soon as possible all those pictures that are not yet entirely completed, even though named in the list here attached. [*In margin*: The greater part are finished.] Those that are finished I would send immediately to Your Excellency. In short, if Your Excellency will resolve to place as much trust in me as I do in you, the matter is settled. I am content to offer Your Excellency of the pictures by my hand, enumerated below, to the value of 6,000 florins, at current cash prices, for all those antiquities in Your Excellency's house, of which I have not yet seen the list, nor do I even know the number, but in everything I trust your word. Those pictures which are finished I will consign immediately to Your Excellency, and for the others that remain in my hands to finish, I will furnish good security to Your Excellency, and finish them as soon as possible. Meanwhile I submit to whatever Your Excellency shall conclude with Mr. Frans Pieterssen, my agent, and await your decision, while I commend myself with a true heart to the good graces of Your Excellency, and kiss your hands with reverence.

From Your Excellency's most affectionate servant,
Peter Paul Rubens

Antwerp, April 28, 1618

List of the pictures which are in my house:

500 florins	A Prometheus bound on Mount Caucasus, with an eagle which pecks his liver. Original, by my hand, and the eagle done by Snyders.[1]	9 x 8 ft.
600 fl.	Daniel among many lions, taken from life. Original, entirely by my hand.[2]	8 x 12 ft.

600 fl.	Leopards, taken from life, with Satyrs and Nymphs. Original, by my hand, except a most beautiful landscape, done by the hand of a master skillful in that department.[3]	9 x 11 ft.
500 fl.	A Leda, with the swan and a cupid. Original, by my hand.	7 x 10 ft.
500 fl.	Crucifixion, life-sized, considered perhaps the best thing I have ever done.	12 x 6 ft.
1200 fl.	A Last Judgment, begun by one of my pupils, after one which I did in a much larger size for the Most Serene Prince of Neuburg,[4] who paid me 3500 florins cash for it; but this one, not being finished, would be entirely retouched by my own hand, and by this means would pass as original.	13 x 9 ft.
500 fl.	St. Peter taking from the fish the coin to pay the tribute, with other fishermen around; taken from life. Original, by my hand.	7 x 8 ft.
600 fl.	A hunt of men on horseback and lions, begun by one of my pupils, after one that I made for His Most Serene Highness of Bavaria,[5] but all retouched by my hand.	8 x 11 ft.
50 fl. each	The Twelve Apostles, with a Christ, done by my pupils, from originals by my own hand, which the Duke of Lerma has; these need to be retouched by my own hand throughout.[6]	4 x 3 ft.
600 fl.	A picture of an Achilles clothed as a woman,[7] done by the best of my pupils, and the whole retouched by my hand; a most delightful picture, and full of many very beautiful young girls.	9 x 10 ft.
300 fl.	A St. Sebastian,[8] nude, by my hand.	7 x 4 ft.
300 fl.	A Susanna, done by one of my pupils, but the whole retouched by my hand.	7 x 5 ft.

– 29 –

To Sir Dudley Carleton *Antwerp, May 12, 1618*

Most Excellent Sir:

Your very welcome letter of the 8th instant reached me yesterday evening, by which I learned that Your Excellency has had in part a change of thought, in wishing to have pictures for only half the value of the marbles, and for the other half tapestries or cash. However, I shall not find the former except by means of the latter. This change seems to result from a scarcity of pictures on my list, since Your Excellency has taken only the originals, with which I am perfectly satisfied. Yet Your Excellency must not think that the others are mere copies, for they are so

well retouched by my hand that they are hardly to be distinguished from originals. Nevertheless, they are rated at a much lower price. I do not wish to influence Your Excellency by fine words, because if you persist in your first idea I could still furnish pure originals up to this amount. But to speak frankly, I imagine that you haven't the desire for such a quantity of pictures. The reason I would deal more willingly in pictures is clear: although they do not exceed their just price in the list, yet they cost me, so to speak, nothing. For everyone is more liberal with the fruits that grow in his own garden than with those he must buy in the market. Besides, I have spent this year some thousands of florins on my estate,[1] and I should not like, for a whim, to exceed the limits of good economy. In fact, I am not a prince, *sed qui manducat laborem manuum suarum.** I should like to infer that if Your Excellency should wish to have pictures for the full value of the sum, whether originals or well-retouched copies (which show more for their price), I would treat you liberally, and would always refer the price to the arbitration of any discerning person. If, however, you are determined to have some tapestries, I am content to give you tapestries to your satisfaction, to the amount of 2000 florins, and 4000 florins in pictures; that is, 3000 florins for the originals already chosen by Your Excellency — the Prometheus, the Daniel, the Leopards, the Leda, the St. Peter and the St. Sebastian — while for the remaining 1000 florins you may choose from the other pictures on our list. Or else, I will pledge myself to give you, for that sum, such originals by my hand as you will consider satisfactory. If you will believe me, you will take that Hunt which is on the list, which I will make as good as the one Your Excellency already has by my hand. They would match each other perfectly, that one showing tigers and European hunters, and this one lions and Moorish and Turkish riders, very exotic. I rate this piece at 600 florins, and there remain, then, 400 florins. As a supplement the Susanna would be appropriate, similarly finished by my hand to your satisfaction; and finally, for the last 100 florins I should add some other trifle by my hand, to complete the 4000 florins.

I hope that Your Excellency will be satisfied with this arrangement, which seems so reasonable, considering that I accepted your first offer willingly, and that this change comes from Your Excellency and not from me. I certainly could not increase my offer, for many reasons. Therefore, will Your Excellency be good enough to inform me, as soon as possible, as to your decision. And in case you are willing to accept my offer, you could, at your convenience, before your departure for England,

* But one who lives by the work of his hands (Psalm 128.2).

consign the marbles to Mr. Frans Pieterssen. I will do the same with the pictures which are ready, and send the rest in a few days.

As for the tapestries, I can be of great help to this merchant friend of yours, for I have had great experience with the tapestry-makers of Brussels, through the many commissions which come to me from Italy and elsewhere for similar works. I myself have made some very handsome cartoons [2] at the request of certain Genoese gentlemen, and which are now being worked; and, to tell the truth, if one wishes to have exquisite things, they must be made to order. In this I will gladly take care that Your Excellency is well served, although I defer to your opinion. In closing, I kiss Your Excellency's hands with all my heart, and remain, *in omnem eventum nostri negotii,** always your most devoted servant. Mr. Frans Pieterssen has not yet sent me the list of your marbles, and I should also like, in case we come to an agreement, that list with the names which you write me that you have found.

Antwerp, May 12, 1618 Peter Paul Rubens

I beg Your Excellency that if the matter is settled, you will proceed to obtain free passage for these marbles; and if you still have the wooden cases in which they were sent from Italy, these will now be useless to you, but of great convenience to me for this journey.

— 30 —

To Sir Dudley Carleton *Antwerp, May 20, 1618*

Most Excellent Sir:

I have just today received notice from my friend Pieterssen that Your Excellency has finally agreed with him conforming to my last offer. *Quod utrique nostrum felix faustumque sit.†* I have already, during the negotiations, given the finishing touch to the greater part of the pictures chosen by you, and brought them to what perfection I am able, so that I hope Your Excellency will be completely satisfied. I have entirely finished the Prometheus, the Leda, the Leopards, the St. Sebastian, the St. Peter [*in margin*: only the St. Peter still lacks a little bit], and the Daniel, and I am ready to deliver them to the person who has Your Excellency's express order to receive them. It is true, they are not yet

* Whatever the outcome of our negotiations.
† May it be fortunate and favorable to both of us.

thoroughly dry, and still need to remain on the stretchers for some days before they can be rolled up without risk. [*In margin*: In this fine weather, they will be put out in the sun.] Next Monday, with divine aid, I shall not fail to get at the Hunt and the Susanna, as well as that little thing for 100 florins; this I shall do more for honor than for profit, since I know how important it is to preserve the favor of a person of Your Excellency's rank.

As for the tapestries, I can say little, since I gave the list today to Mr. Lionel,[1] with the intention of negotiating with him, but he was unwilling to speak with me about them because Your Excellency had given him absolute orders not to confer with others. I am very well satisfied to be spared the trouble, for I have little inclination to act as agent. Therefore, I beg Your Excellency to give me instructions as to whom I am to pay the 2000 florins in cash, which I shall not fail to do upon receipt of your order. I cannot, however, help informing Your Excellency that at present there is little that is good in the tapestry factory of Antwerp. In my opinion the least bad is a series with the history of Camillus,[2] 4½ ells in height, in eight pieces, making 222 ells, at a price of 11 florins per ell. [*In margin*: 225 ells cost 2,442 florins, if I am not mistaken.] A similar tapestry, that is, with the same story, has been made after the same cartoons, and of equal quality, for Mr. Cabbauw at The Hague, where Your Excellency can see it and decide how it suits you. To me, as I have said, it does not matter; I shall be very glad if Mr. Lionel renders Your Excellency good service. Commending myself heartily to your good graces, I kiss your hands with humble reverence, remaining always Your Excellency's most devoted servant.

Antwerp, May 20, 1618 Peter Paul Rubens

The picture promised to Your Excellency shall, with divine help, be completely finished in eight days, without fail.

– 31 –

To Sir Dudley Carleton *Antwerp, May 26, 1618*

Most Excellent Sir:

I have given the exact measurements of all the pictures to Your Excellency's man who came to take them, as he told me, at Your Excellency's order, for the purpose of having frames made, although you had not

mentioned this in your letter. For some time now I have not given a single stroke of the brush, except in the service of Your Excellency. Therefore all the pictures, even the Hunt and the Susanna, together with that piece left to my discretion, which closes our account, as well as those works agreed upon at first, will be finished, by divine aid, on the very day of the 28th of this month, according to my promise. I hope that Your Excellency will be satisfied with these works of mine, as much for the variety of subject as for the affection and desire which prompt me to serve Your Excellency in the best way possible. I have no doubt at all that the Hunt and the Susanna can appear among the originals. The third picture is painted on a panel about three-and-one-half-feet long by two-and-one-half-feet high. The subject is truly original — neither sacred nor profane, so to speak, although drawn from the Holy Scripture. It represents Sarah in the act of reproaching Hagar who, pregnant, is leaving the house with an air of womanly dignity, at the intervention of the patriarch Abraham.[1] I did not give the measurements of this one to your man since it already has a little frame on it. It is done on a panel because small things are more successful on wood than on canvas; and being so small in size, it will be easy to transport. According to my custom, I have employed a man competent in his field to finish the landscapes,[2] solely to augment Your Excellency's enjoyment. But as for the rest, you may be sure that I have not permitted a living soul to lay a hand to them. My desire is not merely to abide most punctually by my promise, but even to surpass this obligation, for I wish to live and die Your Excellency's most devoted servant. I cannot, however, affirm as precisely as I might wish, the exact day on which all these pictures will be dry. To tell the truth, it would seem to me better to have them all go together, considering that the first ones are freshly retouched. Still, with the aid of the sun, if it shines bright and without wind (which raises dust and is injurious to freshly painted pictures), they will be ready to be rolled after five or six days of fine weather. As for me, I should like to be able to deliver them immediately, for I am ready to do everything agreeable to you; but I should be very sorry if, through being too fresh, they were to suffer some damage on the way. This would cause Your Excellency some displeasure, in which I should participate to a great degree.

In regard to the tapestries I can say little, because, to tell the truth, there are no very fine pieces at present; and as I have already written, they are rarely to be found unless made to order. Since that history of Camillus did not satisfy Your Excellency, it seemed to me that the one of Scipio and Hannibal, to which your agent did not appear disinclined,

might perhaps please Your Excellency more. To tell the truth, the choice is arbitrary among these things, which are all without doubt of great excellence. I will send Your Excellency all the measurements of my cartoons of the history of Decius Mus,[3] the Roman Consul who sacrificed himself for the victory of the Roman people; but I must write to Brussels for the exact figures, since I have consigned everything to the master of the factory. Meanwhile I commend myself to the good graces of Your Excellency, and with humble affection I kiss your hands.

<div align="right">From Your Excellency's most devoted servant,</div>

Antwerp, May 26, 1618 <div align="right">Peter Paul Rubens</div>

The 2000 florins will be paid punctually at the pleasure of Your Excellency. I confess I feel a great desire to see these marbles, the more so since Your Excellency assures me of their being things of value.

<div align="center">– 32 –</div>

To Sir Dudley Carleton <div align="right">*Antwerp, May 26, 1618*</div>

Most Excellent Sir:

I am surprised that Mr. Frans Pieterssen has not, up to now, presented himself at The Hague. According to what he wrote to me, he was to return there by the 19th, that is, last Saturday; but from Your Excellency's letter I learn that on the 23rd he had not yet appeared. I am, therefore, writing him a letter in which I urge him to go there as soon as possible, and if, by chance, something should prevent him, to send some suitable person to present Your Excellency a note written by my hand. But in case neither he nor another person in his name appears very soon, I beg Your Excellency to let me know at once, that I may not fail to dispatch one of my men on purpose, at your first notice.

Today we have had such a fine sun that, with a few exceptions, all of your pictures are so dry that I could pack them tomorrow. The same may be expected of the others within three days, depending upon the good weather. Having nothing else to say for today, I kiss Your Excellency's hands with all reverence.

<div align="right">From Your Excellency's most devoted servant,</div>

Antwerp, May 26, 1618 <div align="right">Peter Paul Rubens</div>

To Sir Dudley Carleton *Antwerp, May 26, 1618*

Most Excellent Sir:

Your Excellency will, at your pleasure, kindly deliver your antiquities
to Mr. Frans Pieterssen, bearer of this note, or to the one who shall
present this note on behalf of the said Pieterssen. They will be as safely
consigned as into my own hands. In conclusion, I kiss Your Excellency's
hands with humble affection.

<div style="text-align:right">Your Excellency's most devoted servant,</div>

Antwerp, May 26, 1618 Peter Paul Rubens

To Sir Dudley Carleton *Antwerp, June 1, 1618*

Most Excellent Sir:

Conforming to Your Excellency's order, I have paid the 2000 florins to
Mr. Lionel, for which he has given me a receipt in his own hand, and will
report to Your Excellency. Moreover, I have delivered to Mr. Frans Pie-
terssen all the pictures [*in margin*: the Daniel, the Leopards, the Hunt,
the St. Peter, the Susanna, the St. Sebastian, the Prometheus, the Leda,
Sarah and Hagar], in good condition and packed with care. I believe
Your Excellency will be completely satisfied with them; Mr. Pieterssen
was astonished to see them all finished *con amore* and placed in orderly
fashion in a row. In short, in exchange for marbles to furnish one room,
Your Excellency receives pictures to adorn an entire palace, in addition
to the tapestries.

As for the measurements, which proved somewhat less than you had
expected, I did my best, taking the dimensions according to the measure
current in this country. But you may be sure that this slight difference
has no effect upon the price. For one evaluates pictures differently from
tapestries. The latter are purchased by measure, while the former are
valued according to their excellence, their subject, and number of figures.
Nevertheless, the trouble it gave me is so gratifying and honorable, that
I regard it as the highest favor. Therefore I shall most willingly send
Your Excellency my portrait on condition that you reciprocate by doing
me the honor to allow me to have in my house a memento of your person,

for I consider it reasonable that I should hold Your Excellency in much greater esteem than Your Excellency holds me.[1]

I have just received the marbles today, but have not been able to see them because of the hasty departure of Mr. Pieterssen. However, I hope they will come up to my expectations. Mr. Lionel has taken upon himself the charge of procuring free passage for your things; I had given him Your Excellency's letter for Brussels several days before. For my marbles I did not find that route favorable, so I made other arrangements. Nevertheless I remain infinitely obliged to Your Excellency for all that has been done on my behalf, and with this I conclude, kissing Your Excellency's hands with all my heart, and desiring to be ever

<div style="text-align:right">

Your most devoted servant,
</div>

Antwerp, June 1, 1618 Peter Paul Rubens

<div style="text-align:center">

– 35 –
</div>

To Pieter van Veen *Antwerp, January 4, 1619*

Most Illustrious and Honored Sir:

It will perhaps seem strange to you to receive a letter from me after so long a silence, but I beg you to consider that I am not a man who indulges in vain compliments; and I believe the same is true of every man of worth. Up to the present I have exchanged with you only the greetings and return-greetings which one offers to passing friends. But now I need your advice. I should like information about how I ought to proceed to obtain a privilege from the States General of the United Provinces, authorizing me to publish certain copper engravings which were done in my house, in order to prevent their being copied in those provinces. Many people advise me to do this, but I, being an uninformed novice in these things, should like to know whether, in your opinion, this privilege is necessary, and also whether it would be respected in such a free country. I should like to know the steps necessary to obtain it, and whether the request would involve much difficulty. Please do me the favor of giving me your advice, for I have resolved to govern my action absolutely according to your prudent counsel.

In closing, I kiss your hands with all my heart, and pray God to grant you a very happy New Year.

<div style="text-align:right">

Your most affectionate servant,
</div>

Antwerp, January 4, 1619 Peter Paul Rubens

To Pieter van Veen *Antwerp, January 23, 1619*

Most Illustrious and Honored Sir:

I am very much obliged to you for your courteous offer to help me in soliciting the privilege. To tell the truth, you run the risk of being taken at your word; for I am one of those who abuse courtesy by accepting everything. The prints, to be sure, are not yet entirely ready, but in order to gain time, one could at least commence negotiations, by specifying the subjects in writing. And it would seem fitting for me to pledge to present, when the time comes, the prints which correspond to the list previously announced. I will not fail to keep a record of all you will have paid, given, or promised to Secretary Arsens [1] or others on this account. As for the subjects, they could not cause any difficulty, for they touch in no way upon affairs of state; they are quite simple, without ambiguity or mystic meaning, as you will see in the attached list.

To be frank, I should like to include some pieces that will not be finished for some time, in order to avoid the bother of applying anew. For this reason I consider it more expedient to negotiate in writing, without exhibiting the examples beforehand (but only if this procedure is practical, for I do not wish to be impertinent), since the subjects are all common ones, raising no scruples, however slight. I will formally pledge to send the proofs in due time, complete and without fail. In fact, the greater part is finished, and can soon be published. I should have preferred to have an engraver who was more expert in imitating his model, but it seemed a lesser evil to have the work done in my presence by a well-intentioned young man, [2] than by great artists according to their fancy. On this point I shall await your answer, at your convenience. And if in this way we cannot obtain our request, let us wait until we are ready to do what has to be done. Meanwhile I commend myself, with all my heart, to your good graces, and pray heaven to grant you, *publice et privatim,* perfect health and happiness. I also kiss the hands of M. de Gheyn, [3] with all affection.

<div align="right">

Your most affectionate servant,
</div>

Antwerp, January 23, 1619 Peter Paul Rubens

A battle between the Greeks and the Amazons
Lot with his family leaving Sodom
St. Francis receiving the stigmata
A Nativity of Christ

A Madonna and Child, with young St. John, and St. Joseph
A Madonna and Child and St. Joseph returning from Egypt
Some portraits of eminent men of various sorts
An Adoration of the Magi
A Nativity of Christ
A Descent of Christ from the Cross
Where Christ is raised on the Cross
Martyrdom of St. Lawrence
Fall of Lucifer
A piece with the deeds of Ignatius Loyola
Another of Xavier
A Susanna
A St. Peter extracting the coin from the fish
A story of Leander

<center>– 37 –</center>

To Peter de Vischere *Antwerp, April 27, 1619*

Monsieur:

I have received from M. Annoni the exact measurements of the picture which I am to do for the Archduke Leopold. The canvas also is all ready for beginning the work, which will be very soon, if God gives me life and health. I shall employ all the slight talent I have in the world to make something pleasing to a prince of such rank, as you can assure this gentleman who is His Highness' representative in Brussels. I hope that the work will be finished in every detail within two months; and if it is possible to do it sooner, there will be no delay on my part. But one must consider that paintings need to dry two or three times before they can be brought to completion. In the meantime I kiss your hands very humbly, and remain always, Monseiur,

<div align="right">Your very affectionate servant,</div>

Antwerp, April 27, 1619 Peter Paul Rubens

To Sir Dudley Carleton *Antwerp, May 28, 1619*

Most Excellent Sir:

I have not by any means deceived myself in believing Your Excellency to be the only one who can, by his dexterity, carry to a conclusion negotiations otherwise impossible. Certainly the Hunt with so many wild animals, which you offered those gentlemen, was a fortunate choice; so was the Fishing of the Apostles, who have really succeeded in becoming for us "fishers of men," as Your Excellency cleverly observed. This does not seem strange to me, for everything is more efficacious in the proper atmosphere. In fact, without these means nothing would have been attained. The reason alleged by the States General, that I am neither their subject nor resident in their states is not of such consequence, for other princes or republics have never made this claim; to them it seemed just to provide that their subjects do no wrong or injury to any other person, by infringing upon the work of others. Besides, all potentates, however divided among themselves in greater matters, are usually of one accord in favoring and protecting the virtues, sciences, and arts; at least they ought to be. The details of my application I have sent to that friend, who will give Your Excellency a most minute report. In the meantime I beg Your Excellency to lend a hand to the enterprise, until its successful conclusion. In closing I kiss your hands with a thousand thanks for the esteem and the great affection which you show toward me; I should certainly like to be of some value in serving Your Excellency, to your greater pleasure and my own.

Your Excellency's most humble servant,

Antwerp, May 28, 1619 Peter Paul Rubens

It often happens in great assemblies that after having shown themselves individually favorable to a thing, many of these Lords, nevertheless, when united, act quite contrary to their private promises. Therefore I beg Your Excellency to consider seriously, with customary prudence, whether our request does not run the risk of meeting the same refusal again. If you should foresee such a thing, even vaguely, I beg you to break off negotiations at once, wthout making any further advances; not that I have changed my mind, or that I should consider it a little thing to obtain this favor, but because, for other important reasons, it does not suit me to be importunate in soliciting it. Once more I kiss Your Excellency's hands.

To Duke Wolfgang Wilhelm of Neuburg *Antwerp, October 11, 1619*

I have seen the design for the altar of St. Michael, and think it is beautiful and very good, except that the height, which is double in proportion to the width, appears exorbitant. Therefore that outer half-pilaster on each side seems to me superfluous. Considering the lack of space, they needlessly occupy an additional foot and a half which could be added to the picture. And with this slight increase its proportions would be greatly improved. It is true that these pilasters would not give a bad effect, and would indeed enrich the work, if the space were not so narrow. Therefore will Your Most Serene Highness let me know your wishes in this respect. As for the subject of St. Michael, it is a very beautiful but very difficult one, and I doubt that I can find among my pupils anyone capable of doing the work, even after my design; in any case it will be necessary for me to retouch it well with my own hand.

I shall not fail to provide Your Highness with an inventory of the collection of the late Duke of Aerschot. Since the Father [1] is absent at this time, I do not have it now, but immediately upon his return, I will see that you have it as soon as possible. There now remains nothing else for me to do but to kiss Your Most Serene Highness' hands with the most humble reverence, while begging to be kept in your good grace.

<div style="text-align: right">

Your Most Serene Highness' most
devoted and humble servant,

</div>

Antwerp, October 11, 1619 Peter Paul Rubens

The two pictures for the side altars are both already well advanced; they lack only the final touches, which I hope, with divine favor, to give them soon, and with the greatest care possible.

To Duke Wolfgang Wilhelm of Neuburg *Antwerp, December 7, 1619*

Most Serene Lord:

I have already written to Your Most Serene Highness my opinion on the ornamentation of the altar of St. Michael, and have sent back the design itself, indicating on it the changes which seemed to me necessary for the

embellishment of the work. But since then I have heard no further from Your Highness, to whose convenience I submit; perhaps you are occupied with affairs of greater importance. In the meantime I have not ceased working on the two paintings of the Nativity of Christ and the Holy Spirit. By the grace of God I have finished them, and Your Most Serene Highness may have them at your pleasure. I hope that you will be satisfied not only with my great willingness to serve you, but also with the results obtained in these works. Your Highness needs only to give orders, whenever it is convenient to have them shipped, and to name the person who is to receive them from my hands. I beg the favor of employing myself in something for your service and taste, and I will not fail to serve you punctually as long as I live.

I wrote Your Highness a bit about the collection of the late Duke of Aerschot, which is for sale in this city.[1] To tell the truth, the time did not seem to me favorable for negotiating over such trinkets, but I have nevertheless obeyed Your Highness, since you ordered me, in your last letter, to send the list and inventory of the objects composing this collection. These lists are here attached. The price would be some 40,000 florins in Flemish money, at 20 sous per florin. But at this rate the purchaser would gain little, for the collection cost about this amount. Having no more to write for now, I commend myself most humbly to the good graces of Your Most Serene Highness, and kiss your Most Serene hand, with all my heart.

<div align="right">Your Most Serene Highness' most devoted servant,</div>

Antwerp, December 7, 1619 <div align="right">Peter Paul Rubens</div>

<div align="center">– 41 –</div>

To Pieter van Veen <div align="right">*Antwerp, March 11, 1620*</div>

Most Illustrious and Honored Sir:

I have received from His Excellency, Ambassador Carleton, the prohibition decree of the States General, which is very agreeable to me, for I hope that in this form it will have the same effect as a privilege. I am certainly under great obligation to you in this affair, not only for your diligence, but also for the clever and apt reply which gave the decisive blow to all the difficulties placed in your way. I should like to be able, in return, to serve you, and I should consider myself happy if you would

give me the opportunity to show my gratitude by deeds rather than by words. But I shall find a time and place for that.

As for that rascal you mention,[1] I shall abide by your advice, for fear of committing some blunder for the future. I would not like to throw away my things on one who does not deserve them; on the other hand, to offer little to a personage of this rank *esset contumeliae proximum.** But on this point I shall await more definite advice from you. Toward the Ambassador I shall conduct myself as you tell me, for I shall have other occasions to serve him. The engravings you may leave where they are, since we have attained our end. And with divine grace there will soon be other and better ones.

Hereupon I kiss your hands a thousand times, and thank you again with all my heart for the zeal and the affection you have shown on my behalf.

<div style="text-align: right">Your most affectionate servant,</div>

Antwerp, March 11, 1620 <div style="text-align: right">Peter Paul Rubens</div>

– 42 –

To Hans Oberholtzer <div style="text-align: right">*Antwerp, April 3, 1620*</div>

Monsieur:

I consigned the paintings to the same merchant [*in margin*: he is called Jeremias Cocq] to whom I delivered the picture of the Judgment, for he showed me an order from a gentleman correspondent from Frankfort, which was an authorization on the part of His Highness. He tells me they are assuredly well addressed, for he had a report from Cologne two weeks ago that they had arrived there in good condition and had been sent on directly. That is all I can say for certain. If you like, I will send you a list of all the names of the merchants to whom they are addressed, from place to place, but I think this little will suffice to assure His Highness that they are clearly addressed. Hoping that we shall soon have news of their safe arrival, in the meantime I kiss your hands, and remain

<div style="text-align: center">Monsieur,</div>

<div style="text-align: right">Your very affectionate servant,</div>

Antwerp, April 3, 1620 <div style="text-align: right">Peter Paul Rubens</div>

* Would be the height of contempt.

To Duke Wolfgang Wilhelm of Neuburg *Antwerp, July 24, 1620*

Most Serene Lord:

Finding myself in Brussels these past days, I learned, to my great satis-
faction, from the Commissioner Oberholtzer, that the two pictures sent
lately to Your Highness have arrived in good condition. But on the other
hand, I regret to hear that they are too short in proportion to the orna-
mental frame already set in place. This error, however, is not the result
of any negligence or fault of mine; nor can it be a misunderstanding of
the measurements, as the design sent me by Your Highness proves, and
which I still possess. It calls for 16 Neuburg feet in height and 9 feet
in width, also noted in Neuburg feet. These measurements all agree ex-
actly with the frames on which the canvases were stretched, and which
still exist. But I comfort myself with the hope that the difference is not
so great that it cannot easily be remedied by adding, either at the upper
or lower part of the ornamentation, a little piece to fill the space without
destroying the symmetry. And if Your Highness will inform me how
great the discrepancy is, I offer to make a design from my imagination,
which might be most suitable to remedy the defect.

Having nothing else to say for now, I humbly kiss Your Most Serene
Highness' hands, and offer myself as your most devoted servant.

Antwerp, July 24, 1620

All those who saw the pictures in my house agree that their propor-
tions are too slim, and that if the height were less, the labor expended
would appear to better advantage. But the requirements of the space are
the excuse for this.

Your Most Serene Highness' most humble servant,
Peter Paul Rubens

Antwerp, Early January, 1621

To Duke Wolfgang Wilhelm of Neuburg

Most Serene Lord:

I have delayed too long in thanking Your Most Serene Highness for the
generous remuneration which you condescended to give me for the two

pictures I did lately at your order. I have given a receipt for 3000 florins to M. Ringout, agent of Your Most Serene Highness in Brussels. He has always treated me with great courtesy, and this time informed me that he had orders from Your Most Serene Highness to give some souvenir to my wife. I am indeed embarrassed by such kindness and liberality on the part of Your Highness toward me, your very humble servant; this mode of conduct corresponds to your magnanimity rather than to my slight merit. And so I can render Your Most Serene Highness no other thanks than to dedicate myself completely and perpetually to your service. And in paying my deepest respects to Your Most Serene Highness, I pray the Lord God to grant you a very happy New Year.

Antwerp, at the beginning of January, 1621

> Your Most Serene Highness' most humble and devoted servant,
> Peter Paul Rubens

<div align="center">– 45 –</div>

To William Trumbull [*Antwerp, January 26, 1621*]

Sir:

The painting made for my Lord Ambassador Carleton is all ready and well packed in a wooden case adequate for the journey to England. And so I will deliver it, without any difficulty, into the hands of Mr. Corham, any time it pleases him to take it, or to send his porter for it. But to retract what I have said to our judges — namely, to say that the picture is not worth so much — that is not my way of acting. For if I had done the entire work with my own hand, it would be well worth twice as much. It has been gone over by my hand not lightly, but touched and retouched everywhere equally. I will conform to what I have said, that notwithstanding the fact that the picture is of this value, the obligations which I have to my Lord Ambassador will make me content with whatever recompense may seem good and just to His Excellency, without any argument. I do not know how to say more, nor how to submit myself more completely to the pleasure of this gentleman whom I esteem much more than anyone would believe. The picture by Bassano, which I received in exchange, is so ruined that I will sell it to anyone, such as it is, for 15 crowns.

> Transcribed from the original by
> W. Trumbull

To William Trumbull *Antwerp, September 13, 1621*

Sir:

I am quite willing that the picture done for my Lord Ambassador Carleton be returned to me and that I paint another Hunt less terrible than that of the lions, with a rebate on the price, as is reasonable, for the amount already paid; and all to be done by my own hand, without a single admixture of anyone else's work.[1] This I will maintain on my word as a gentleman. I am very sorry that there should have been any dissatisfaction in this affair on the part of my Lord Carleton, but he never let me understand clearly, although I asked him to state whether this picture was to be a true and entire original or merely retouched by my hand. I should like to have an opportunity to restore his good humor toward me, even though it should cost me some trouble to render him service. I shall be very glad to have this picture located in a place as eminent as the gallery of His Royal Highness the Prince of Wales, and will do everything in my power to make it superior in design to that of the Holofernes [2] which I painted in my youth. I have almost finished a large picture, entirely by my hand, and in my opinion one of my best, representing a Lion Hunt, with the figures life-sized. It is ordered by my Lord Ambassador Digby [3] to be presented, I understand, to the Marquis of Hamilton. But as you rightly observe, such things have more grace and vehemence in a large picture than a small one. I should be glad if this painting for the gallery of His Royal Highness the Prince of Wales were of larger proportions, because the large size of a picture gives one much more courage to express one's ideas clearly and realistically. In any case I am ready in every respect to employ myself in your service, and recommending myself humbly to your favor, offer myself at all times.

As for His Majesty and His Royal Highness the Prince of Wales, I shall always be very much pleased to receive the honor of their commands; and regarding the hall in the New Palace,[4] I confess that I am, by natural instinct, better fitted to execute very large works than small curiosities. Everyone according to his gifts; my talent is such that no undertaking, however vast in size or diversified in subject, has ever surpassed my courage.

 Sir,

 Your very humble servant,
Antwerp, September 13, 1621. St. No. Peter Paul Rubens

PART III

1622–1626

Rubens in Paris

The Medici Gallery

The Peiresc Correspondence

Entry into Politics

1 6 2 2 – 1 6 2 6

Early in January 1622 Rubens paid his first visit to Paris. Marie de' Medici, the Queen Mother, had summoned him to discuss plans for the decoration of her newly finished Luxembourg Palace. Her reasons for choosing Rubens for this important task, in preference to French or Italian painters, are not stated. A true Medici, she took an active interest in the arts, and the growing fame of the Flemish master had doubtless been brought to her attention, perhaps by the Infanta Isabella, with whom the Queen Mother maintained the most friendly relations. After six weeks of discussion, the contract was signed and Rubens returned to Antwerp to begin the work. He had agreed to decorate two great galleries in the Luxembourg Palace for the sum of 20,000 crowns. The first gallery was to be devoted to the history of Marie de' Medici herself; the second was to glorify her husband, Henri IV. The Queen's adviser, the Abbé de St. Ambroise, was probably right when he declared publicly that Rubens was the only man in Europe capable of carrying through such an assignment — that the Italian painters would not accomplish in ten years what he promised to do in four. By the end of May 1623 nine of the pictures were ready to be taken to Paris. When the artist delivered them to the Queen Mother, she expressed her complete satisfaction. Cardinal Richelieu also, according to one report, "could not weary of admiring them." Two years later the first cycle was finished, and in February 1625 Rubens found himself once more in Paris for the installation of the Medici Gallery.

This was the most important commission and the greatest pictorial cycle of Rubens' career. And for us today this series of twenty-one paintings, now in the Louvre, remains a most significant and representative creation of Baroque courtly art. A mediocre subject has been raised to celestial spheres; the tedious episodes of Marie's life have been glorified, befitting a sovereign by divine right. Embarrassing details in her quarrelsome career have been tactfully avoided, and she is presented as endowed with all the virtues. We know from the letters that the artist had an active

part in the choice of the scenes and their interpretation. Classical allegory infused with a Baroque vitality resulted in a new type of monumental painting.

There is no record of a ceremonial unveiling of the gallery. Shortly after its completion Richelieu gave a great feast, on May 27, 1625, to celebrate the marriage of the Princess Henrietta Maria and Charles I of England — a marriage which the Cardinal, in his own words, "had brought to a happy ending with so much pain and prudence." He chose for this gathering the Queen Mother's Luxembourg Palace. And although his *Mémoires* describe the event in some detail as "worthy of the magnificence of France," there is no mention of Rubens' splendid new cycle of paintings glorifying the Queen. The great Cardinal's attitude toward the painter had, in fact, become more and more unfavorable as he recognized in Rubens a political adversary. We know that he made an effort to have the contract for the second of the Luxembourg galleries, that of Henri IV, taken out of Rubens' hands. Diplomatic activity on the artist's part caused repeated interruption of this work, and the Cardinal's banishment of Marie de' Medici in 1631 put a definite end to the project.

On Rubens' first visit to Paris he made the personal acquaintance of a French scholar with whom he was already in correspondence. This was Nicolas-Claude Fabri de Peiresc, one of the most remarkable personalities of his time. Peiresc was three years younger than Rubens; he was born in Beaugensier, in Provence, in 1580, of a distinguished family. His father was Councilor of the Court of Aids at Aix, and in later years, when an uncle resigned the post of Councilor of the Parliament of Provence, Peiresc succeeded to this office and held it until the end of his life. At the age of nineteen Peiresc had gone to Padua to study law, and three years in Italy allowed him to pursue with increasing interest the study of antiquity, its art, institutions, and history. Then followed several years of travel in France, England, and the Netherlands, during which he established contact with scientists, artists, scholars in every branch of learning. He went to Paris to live in 1616, but in 1623, just after Rubens' second trip to Paris, Peiresc returned to Provence, and the two friends never met again. From his home in Aix, Peiresc carried on a fabulous correspondence with scholars in every land, and on almost every subject. He was an indefatigable collector, maintaining agents in Greece, Egypt, and the Orient who sent him not only antiquities of every description, but exotic animals and plants, manuscripts and books in all languages. His house became a museum, with an observatory on its roof; his botanical garden was famous. He employed sculptors, engravers, and

bookbinders, as well as copyists to transcribe his manuscripts and letters.

The earliest contact between Rubens and Peiresc was in 1619, when the latter was instrumental in obtaining a French copyright for the Flemish master's engravings. Rubens was known to Peiresc at that time as a collector of antiquities, and it was not long before an active correspondence was under way. The first letters they exchanged dealt with engraved gems and cameos — a subject of absorbing interest to both men. Rubens' share in this early correspondence has not survived, but the numerous letters from Peiresc to the artist indicate the friendship that had sprung up between them. Only the first of Peiresc's letters, dated October 27, 1621, was written in French. All the subsequent ones, perhaps at Rubens' request, were written in Italian.

The meeting in Paris in 1622 brought the keenest pleasure to both men and cemented the friendship that was to last until Peiresc's death in 1637. Their conversations covered the same wide range of subjects as their letters, and Peiresc told all his correspondents of his delight in being able to converse with a man so richly endowed. Long hours were spent in discussing the paintings ordered for the Medici Gallery, with Peiresc acting as intermediary between the artist and the Abbé de St. Ambroise, who was in charge of the work. After Rubens' return to Antwerp, Peiresc continued to help him in countless ways, sending him necessary measurements, portraits of persons who were to appear in the compositions, details on the costume of the characters and the appearance of certain places. He informed Rubens of the jealousy on the part of French and Italian artists, and the Queen's firmness in silencing them; as long as he remained in Paris he served as Rubens' agent at the court of France.

Following Peiresc's departure for Provence, the letters became less frequent. The two friends communicated for a time through Peiresc's brother, the Sieur de Valavez, who remained in Paris and became Rubens' regular correspondent. Classical archaeology continued to claim their interest, particularly the subject of engraved gems. They carried on preparations, begun long before, for a joint publication of the more famous gems and cameos of antiquity, but this ambitious project was never completed, perhaps because politics came to demand more and more of Rubens' time. Nor was the artist's long-cherished and often mentioned hope of visiting Peiresc and his museum in Provence ever realized. During his busiest years of diplomatic service Rubens had little opportunity for private correspondence, but the letter he wrote to Peiresc from Madrid, and another from London, indicate that whenever possible he

tried to maintain the contact with his old friend. The only serious interruption in their relations occurred during the early thirties, when Rubens' active part in the struggle between Marie de' Medici and Richelieu placed him under suspicion in France. After the artist's withdrawal from politics, the correspondence was resumed with enthusiasm on both sides. Once again long letters were devoted to the art and customs of antiquity; drawings, plaster casts, engravings, and books passed between Antwerp and Aix. The bond of intellectual curiosity was a strong one that united these two men of such widely differing temperament. Peiresc, whose frail health and retiring nature caused him to live in comparative seclusion in a world of his own making, was in most respects the complete antithesis of the uninhibited Rubens, who was so closely in touch with the world about him. Yet their friendship, with only a brief period of personal contact, endured for fifteen years, and produced a correspondence of extraordinary warmth and mutual confidence.

The same year that brought Rubens the contract for the decoration of the Luxembourg Palace saw the artist enter into active politics. The Twelve Years' Truce expired on April 9, 1621, and the question of war or peace between Spain and the United Provinces loomed large. While the Archduke Albert was decidedly in favor of a renewal of the truce, in order to allow the Spanish Netherlands further opportunity to recover from the misfortunes of war, Madrid wanted an immediate resumption of hostilities. The Hollanders were still regarded as rebels who must be reduced to submission. Their growing maritime power, moreover, was a source of increasing anxiety to Spanish interests in the East and West Indies. Philip IV was willing to consent to a new truce only if the United Provinces agreed to reopen the Scheldt to navigation, to give up trade relations with the East Indies, and to withdraw their troops from the West Indies — conditions totally unacceptable to the Hollanders. The death of Archduke Albert, three months later, left the Infanta Isabella faced with this overwhelming problem, while at the same time she was deprived of her rights of sovereignty. Since she was childless, the Netherlands reverted to the Crown of Spain, and her position was reduced to that of governor.

In the meantime a Dutch lady, Bertholde van Swieten, widow of Florent T'Serclaes, who was highly esteemed by the House of Orange and known to the Infanta Isabella, had been trying on her own part, and purely in the interests of peace, to reopen negotiations. Before the expiration of the truce she had approached Maurice, Prince of Orange, pointing out to him the advantages he might derive from persuading the

United Provinces to acknowledge allegiance to their former sovereigns. Although at first indignant, the Prince finally told her in confidence that he was willing to lend his aid to restore the United Provinces to the sovereignty of Spain, in return for a suitable reward. He thereupon authorized Mme. T'Serclaes to go to Brussels to inform the Archduke and the Infanta of his intention, asking them to send a qualified person to The Hague in order to discuss the matter. For this delicate mission Albert and Isabella chose Pierre Pecquius, Chancellor of Brabant. When, however, Pecquius laid before the States General the proposals for their allegiance to Spain, these proposals were flatly rejected. A terse statement was issued on March 25, 1621, declaring the United Provinces to be free and independent, determined to defend their freedom at any price. The next move of Prince Maurice was to express astonishment that Chancellor Pecquius should have undertaken a mission which must necessarily fail. It is possible that in suggesting the sending of an envoy to The Hague the Prince's object had been to provoke the very answer which the States General gave, and thus to break off negotiations and render war inevitable. The Prince of Orange anticipated greater advantages from a resumption of the war than any the King of Spain might promise. Shrewd as he was, however, he continued, through the mediation of Mme. T'Serclaes, who made many trips between Brussels and The Hague, to assert his readiness to negotiate for the prolongation of the truce, holding out hopes that the new conditions would be more favorable to the Spanish Netherlands than the terms of 1609. Those dealing with the Hollanders learned that they must reckon with two mutually suspicious groups — the House of Orange and the States General. And the obstinate refusal of the States General to talk peace led Albert, and after his death, Isabella, to place their hopes in negotiations with the Prince of Orange.

Rubens' participation in these negotiations is first brought to our attention by a letter he wrote to Chancellor Pecquius on September 30, 1623, reporting his meeting with an agent called "the Catholic." This man has been identified as Jan Brant, a cousin of Rubens' wife, Isabella. He belonged to the branch of the family that had settled in Holland and enjoyed high esteem there. It appears that the Prince of Orange, quite apart from his dealings with Mme. T'Serclaes, had employed Jan Brant to reopen negotiations with the Infanta Isabella, and through him Rubens may have been drawn into the affair. When, and in what manner the artist was first induced to participate, we do not know; he was already deeply involved in the truce negotiations when he wrote to Pecquius.

As the confidential agent of the Infanta, Rubens became more and more closely identified with affairs of state; even the responsibility of installing the paintings in the Medici Gallery did not prevent his carrying on his diplomatic activity. With the death of Maurice of Nassau, however, on April 23, 1625, all negotiations for a renewal of the truce came to a standstill. The two armies had in the meantime taken the field, and the frontier between the Northern and the Southern Netherlands was once more the theater of hostilities. When, after eleven months of siege, the key fortress of Breda fell to the Marquis Spinola on June 5, 1625, the military, as well as the diplomatic advantage lay for a time on the side of Spain and the Spanish Netherlands.

The captors of Breda were too exhausted by the long siege to turn this strategic success into a vigorous offensive. The partisans of peace, who tried at this favorable juncture to reopen negotiations between Rubens and Jan Brant, likewise accomplished nothing, and a period of stalemate followed. The new Prince of Orange, Frederick Henry, profited by the situation to conclude an agreement with Richelieu whereby he was to receive financial aid for his war with Spain in return for providing Dutch naval aid against the Huguenots. The Duke of Buckingham pushed England into the conflict by launching a naval attack upon Cadiz in October of the same year. This abortive attempt was followed by England's formal alliance with the United Provinces and Denmark, signed on December 14, 1625, which marked the virtual beginning of her war with Spain. Rubens followed its course with close interest. It was he who, four years later, succeeded in paving the way to peace by his negotiations in Madrid and London.

To Pieter van Veen Antwerp, April 30, 1622

Most Illustrious and Honored Sir:

I have received the passports with great pleasure, and regret only that they have given you so much trouble. To tell the truth, I suspected that there might be some scruples as to my qualifications; and that is why I turned to you, because the affair was not, in my opinion, of the sort one could entrust to an ordinary agent, who procures passports for anybody. I am indeed particularly obliged to you for this favor. I am pleased that you wish to have more of my prints; unfortunately we have made almost nothing for a couple of years, due to the caprices of my engraver, who has let himself sink to a dead calm, so that I can no longer deal with him or come to an understanding with him.[1] He contends that it is his engraving alone and his illustrious name that give these prints any value. To all this I can truthfully say that the designs are more finished than the prints, and done with more care. I can show these designs to anyone, for I still have them. You will do me a favor by sending me a little list with the names of those prints you already have, so that I can see what is lacking; and as soon as I know this, I shall send you the rest. In the meantime, I kiss your hands with all my heart and commend myself to your good graces, praying heaven to grant you every happiness and contentment.

 Your most affectionate servant,
Antwerp, April 30, 1622 Peter Paul Rubens

To Pieter van Veen Antwerp, June 19, 1622

Most Illustrious and Honored Sir:

I have been delayed so long in answering you because of traveling and other hindrances. I now learn from your very kind letter of the 12th of May which of my prints you lack. I am sorry I have so few; for some years we have done almost nothing, on account of the mental disorder of my engraver. However, what few there are I shall gladly send you.

These are: a St. Francis receiving the stigmata, engraved somewhat coarsely, since it is a first attempt; the Return from Egypt of the Madonna

with the Child Jesus; a little Madonna kissing the Child — a plate that seems good to me; and also a Susanna, which I count among the best; a large print of the Fall of Lucifer, which did not turn out badly; and the Flight of Lot with his wife and daughters from Sodom, a plate made when the engraver first came to work with me. I have also a Battle of the Amazons in six sheets, which requires only a few more days' work, but I cannot get it out of the hands of this fellow, although he was paid for the engraving three years ago. I should like to be able to send this to you with the others, but there is little likelihood that I can do it so soon.

I have also published a book on architecture, of the most beautiful palaces of Genoa — about 70 folios, together with the plans,[1] but I do not know whether this would please you. I should like very much to know your opinion on it. I beg you to give orders to some boatman or messenger of your acquaintance, to whom I could entrust these things. Otherwise the transportation will cost too much.

I am glad that you have found that method of drawing on copper, on a white ground, as Adam Elsheimer [2] used to do. [*In margin*: As I imagine, but perhaps you have a still better method than that.] Before he etched the plate with acid, he covered it with a white paste. Then when he engraved with the needle through to the copper, which is somewhat reddish by nature, it seemed like drawing with a red chalk on white paper. I do not remember the ingredients of this paste, although he very kindly told me.

I hear that M. Otto van Veen, your brother, has published a little anonymous work on the Universal Theory, or something of the sort. I should like very much to see this, and if it should be possible for you to lend it to me (for doubtless you have a copy), this would be very agreeable to me. I should accept it on my word of honor to keep this favor a complete secret, without speaking of it to a living soul, in case secrecy is necessary.[3]

In closing, I kiss your hands with all my heart, and pray heaven to grant you every happiness and contentment.

<div style="text-align: right">

Your affectionate servant,
Peter Paul Rubens

</div>

Antwerp, June 19, 1622

To Federigo Cardinal Borromeo *Antwerp, July 8, 1622*

Most Illustrious and Most Reverend Lord:

M. Brueghel has delivered to me, on behalf of Your Most Illustrious Lordship, a gold medallion with the figure of San Carlo Borromeo, which I esteem as a very special favor, not only for the value of the gift, but also because it comes to me as a spontaneous offering of Your Most Illustrious Lordship, without any previous service on my part. It has pleased Your Lordship to anticipate me, and by this gift to bind me to your perpetual service. Therefore I beg you to count me in the future among your most affectionate servitors — although of slight talent, yet for eagerness and good will, one of the best. With this sentiment I kiss Your Lordship's hands, and with a thousand thanks for the favor received, I commend myself to your good graces.

<div style="text-align: right">

Your Illustrious and Reverend Lordship's
most humble servant,
Peter Paul Rubens

</div>

Antwerp, July 8, 1622

Fragment, to Frederik de Marselaer *Antwerp, February 27, 1623*

. . . for me, Monsieur, a thing which is not entirely in my power, because of my journey to Paris, and that nevertheless I ought to finish the "Cambyses," to face the doors, before my departure, though it will not easily be possible. However, I beg you to inform these gentlemen that I must finish the canvases for the Queen Mother before I do any other work.

But while they are drying and being sent by wagon (I myself following by post), I ought to be able to employ the interval for the advancement of our work. I hope, with God's help, to depart by Easter, or shortly after, and to be away only a month, or a little more, so that on my return I shall find enough time to deliver the whole work for St. John's Day. But I . . .

[Reverse of sheet] . . . rather say *Pacem et bellum, nempe quod a legatis quaevis negocia pacis bellive tempore tractanda vel ipsa pax aut*

*bellum conficiantur.** But I shall consider the matter more carefully and maturely.

In the meantime I commend myself heartily to your good graces, and thanking you very much for the care you are taking on my behalf, I remain, in turn, ever ready to serve you with all my power.

<div style="text-align: right">

Your humble servant,

</div>

Antwerp, February 27, 1623 Peter Paul Rubens

– 51 –

Fragment, to Sauveur Ferrary [*Antwerp, Spring 1623* ?]

I pray you to communicate to M. Jean Sauvages the following: I beg you to arrange to secure for me, for the third week after this one, the two Capaio ladies of the Rue du Verbois, and also the little niece Louysa. For I intend to make three studies of Sirens in life size, and these three persons will be of infinitely great help to me, partly because of the wonderful expression of their faces, but even more by their superb black hair, which I find it difficult to obtain elsewhere, and also by their stature.

– 52 –

To Peiresc *Antwerp, August 3, 1623*

Monsieur:

I have never in my life seen anything that gives me more pleasure than the gems you have sent me. They seem to me inestimable, and beyond all my expectations; but to accept them as a gift, and deprive you of such valuable things is not my intention. Believe me, were it not that I am afraid you will perhaps have departed before the arrival of this letter, I should send them back today by the same courier. But fearing they might reach a wrong address in your absence, at a time when this dread of contagion has put many friends to flight,[1] I have decided to keep them with me as a most precious trust, until the first journey which the Lord shall permit me to make to Paris. Then, I hope, I shall find an opportunity to return them to you in person, or by some safe method. In the

* Peace and War, that is, that peace and war themselves are the result of the negotiations of the ambassadors in time of peace or of war.

meantime, toward the end of next September I shall send you some good impressions of them, so that you may make use of these for the time being. And for your generosity — or rather prodigality — I send you a thousand thanks. I marvel at your affection for me which leads you, amateur of curios as you are, to deprive yourself of things so rare.

I am glad you have received the design of the perpetual motion; [2] it is accurately done, and with the sincere intention of communicating the true secret to you. Moreover if, in Provence, you should try the experiment and it is not successful, I pledge to clear up all your doubts. Perhaps (although I dare not yet affirm it with certainty) I shall prevail upon my sponsor [3] to have a complete instrument made here, with a case, as if to be kept near me in my private study. If I can obtain this, I shall gladly make you a present of it. Some means will be found to have it reach you safely in Provence, through the aid of certain merchants, provided that you have connections in Marseilles. As for the little mirror, [4] I shall talk it over with this same sponsor of mine, to see whether we can make one that will magnify more strongly, yet will be smaller in size, so that it can more easily be sent a long distance. My obligation toward you is so great that I should like to be able to think of some little thing within my power, which might give you pleasure. Time does not permit me to thank you again in detail for all the good services you have rendered me in my relations with M. de Loménie, [5] M. l'Abbé [6] and your other friends; nor to thank you for your revenge upon Chaduc, [7] and for the wounds, or rather dagger-thrusts, you gave that rude and stupid spirit. He deserved them as punishment for his incivility.

But to come back to our gems, I am extremely pleased with the *diva vulva* with the butterfly wings. But I cannot distinguish what is between the altar and the opening of the vulva, which is inverted. Perhaps I shall be able to discern it better when I have made an impression of it, which I could not do today, because of my many duties — not even in Spanish wax. The reason for comparing the vulva to the snail I cannot imagine, unless perhaps because of the capacity of the shell, which is a receptacle both deep and capable of conforming to its tenant — or perhaps also because the snail is a viscous and moist creature. *Et cornua possent comparari cristae qum videntur utrinque exerere cunni cum pruriunt.** I tell you this freely between ourselves; the explanation is perhaps a little far-fetched, but the subject is very indecent. We shall investigate it more thoroughly at leisure. I did not at first find the in-

* And the horns can compare to the crest that appears on both sides of the vulva when prurient.

scription which I wanted to see and prize so highly: *Divus magnus majorum pater*. But it is on the reverse of the carnelian, and I soon discovered it, to my great joy. I am sorry that in the *Victoria Nicomediana* I do not understand the letters or signs G.G.G.SV., which are on the under edge of the gem.[8] But I regret still more that I cannot discuss this with you any longer. It is very late and some friends are expecting to have supper with me. I understand that you have consigned to M. Frarin [9] the little box containing your medals and the case of marbles which I should be glad to offer as a gift to some friend. But we shall see what can be done, please God, on our return, and in the meantime I commend myself humbly to your good graces, and with all my heart I kiss your hands and those of M. de Valavez,[10] praying heaven to grant you a most happy journey.

Antwerp, August 3, 1623

P.S. A day will seem like a year to me, until I learn that you are out of Paris and have reached safety as far as contagion is concerned; the best antidote for that is flight.

I shall not fail to render M. l'Abbé all the service due his rank.

The Messalina [11] pleases me. But I believe it has suffered in the enlargement.

Your most affectionate servant,
Peter Paul Rubens

– 53 –

To Peiresc *Antwerp, August 10, 1623*

Monsieur:

So many duties have unexpectedly come up today that I cannot answer your most welcome letter as I ought to do, *sed summa sequar fastigia rerum.** The rest I shall have to leave to the next post. As for the gems, I continue to give you endless thanks, but I still intend to return them to you one day. In the meantime I shall provide you with impressions of them. I do not recall having seen anything more to my liking in all my life.

The decree of the Inquisition promulgated against the Basilidians in

* But I shall take up the most important points (*Aeneid* 1.342).

92

Seville [1] will be difficult to procure just now; as far as I know, only one copy has come to this city. But I shall do my utmost to obtain it.

The sect of the Rosicrucians [2] is already old in Amsterdam, and I remember having read, three years ago, a little book published by their society, in which is described the life, and the glorious and mysterious death of their first founder, as well as all their statutes and rules. To me it seems nothing but a kind of alchemy, pretending to possess the Philosopher's stone, but in reality a mere hoax.

The collection of M. Goly still makes my mouth water when I think of it; may it be a great asset to M. Fontenay,[3] who had the courage to buy it. I shall be pleased to have the design of the mirror sometime, if Signor Aleandro [4] has the copy of it in Rome. As for the drawing of the sistrum, I think it could be found more easily, but M. Coberger [5] is away on business in Wynokberga in Flanders, and will not return very soon.

The story of Paul Parent [6] seems to me ridiculous and without equal. *Hoc enim est insanire potius quam delirare.*† Let him go in peace with his stuff, and Chaduc too; they could be hitched to a cart like a pair of oxen. I only regret that you have had so much trouble with this rascal, for my sake.

I should have been glad to answer your request today on the subject of those ancient unpublished Latin epigrams, but M. Gevaerts [7] is absent. He has gone to Brussels to take leave of Cardinal de la Cueva,[8] his patron, who has gone to Rome, summoned by the Spanish faction in order that it may have one more vote. One may thus assume that this conclave will be of long duration, for His Eminence is not leaving at once; and yet he believes that he will arrive in time, for a majority has not yet been formed by ballot.

The Marquis Spinola [9] leaves today or tomorrow for Maastricht, where the arsenal is being established, notwithstanding the fact that he is still negotiating secretly for a truce. I have nothing else to say now, for lack of time, and so, in closing, I kiss your hands and those of M. de Valavez, your brother, praying God to grant you a most pleasant journey.

<div style="text-align: right">Your most affectionate servant,</div>

Antwerp, August 10, 1623 Peter Paul Rubens

† This is indeed madness rather than folly.

Fragment, to Peiresc *Antwerp, August 25, 1623*

I have made every effort with M. Gevaerts regarding those ancient poems of M. Rigault's which you suspected might have remained in Gevaerts' hands. But he tells me definitely that he never had the good fortune to see them, though he recalls having heard of them. In fact, he had many times urged M. Rigault to show them to him, but without ever succeeding. Rigault always made excuses, and put him off for so long that Gevaerts finally left without having seen them. He commends himself to your good graces, and asks me to write this to you. This inquiry was made in the most modest and courteous terms, without causing him the slightest shade of displeasure.

Antwerp, August 25, 1623

To Chancellor Pecquius *Antwerp, September 30, 1623*

Most Illustrious and Esteemed Sir:

I found our Catholic [1] deeply affected by his father's serious illness which, in the doctors' opinion, is critical. And he himself is tormented daily by an almost continuous fever, so that one reason or the other, or the two together, will perhaps detain him longer than would otherwise be necessary. It is true that he proposes, in such a case, to have his uncle come to Lillo, in order to give him *ex propinquo* a report on his negotiations. But I shall try, if possible, to put off this plan, at least for a few days.

When I communicated the reply to him, his fever almost redoubled, although I did this after a lengthy preliminary discourse, and he admired the great industry, prudence, and spirit which that note reflects. In fact it would be impossible to handle the same subject by more varied means or with greater skill than has been done. Finally the Catholic took out his instructions and showed me a statement there which did not please me: it said that he was not to accept from us or bring back any answer that was ambiguous or like the other one already sent; it must be a simple acceptance of the truce or nothing. At that I laughed and replied that these were threats to frighten children, but that he himself was

surely not so naïve as to believe them; that this secret treaty was without prejudice to either party, and would not prevent either one from doing its utmost in the meantime. He then answered again as I have already told you, saying that we are making use of the Prince's [2] dispatches to his disadvantage, sending them to France, in order to arouse the mistrust of the King and the suspicion of the States against him. I said that if the Prince would condescend to furnish Her Most Serene Highness [3] with a little more information on this subject, she would probably manifest her displeasure so clearly that he would be convinced of her innocence; that these were nothing but tricks and frauds to break the treaty. He was obstinate, however, insisting that it was true, and that the Prince could exhibit (as he had already done to some persons) the very copies sent to him from the Court of France. Finally the Catholic allowed himself to be persuaded to copy our reply with his own hand, in order to deliver it to the Prince at the first opportunity. He would have done so immediately, had I not advised him to wait until this attack had passed and he was completely free from fever. And so I took the note away with me, promising to return to see him, because I wished the copy to be made in my presence, at his convenience and mine. To that he agreed, and thus we are gaining a little time. I commend myself heartily to your good graces, and kiss your hands.

<div align="right">Your affectionate servant,</div>

Antwerp, September 30, 1623 <div align="right">(paraph)</div>

I have written with more security, because of the great confidence I place in the reliability of the bearer of this letter. He has promised me to deliver it into your own hands. I will use the same means when, in due time, I send back to you the original of the reply.

The Catholic told me, furthermore, that the Secretary of the Prince, through whose hands these negotiations pass, is called Junius — a very corrupt person, who will take bribes with both hands. [*In margin*: it was due to this secretary that the last reply was not sent in better form; for he had crossed out something or other that was in our favor. He has great influence with the Prince.] The Catholic said, however, that his uncle would not be inclined to try to win over the man by such means, for his own integrity would regard such procedure as contemptible. But I thought it right that you should know this.

I believe also that it will be very dangerous in the future for the Catholic to appear in Brussels, because of the suspicion this will arouse in Cardinal de la Cueva.[4] Therefore, if the negotiations are not broken

off this time, it would be better for him, on his return, to remain in Antwerp, and for me to send his reply or deliver it in person. But this suggestion ought not to come from me, for perhaps he might become suspicious of me, and think that I wish to exclude him and take over all the negotiating myself. And so, if it seems necessary to you, it would be well if I could show him a note or order from you on this point.

In this city they are talking of nothing but the return of the Prince of Wales to England.[5] But the report is not generally believed, for it came from Zeeland.

<p style="text-align:center">– 56 –</p>

To Chancellor Pecquius *Antwerp, January 22, 1624*

Most Illustrious Sir:

You will have seen the reply brought by the Catholic, who did not wish to take the ordinary way, hitherto used, of addressing himself to you and to the Marquis, but went straight to the Most Serene Infanta and delivered it into her own hands, with many complaints and accusations that negotiations are being carried on by other means, and that persons have been sent expressly to the Prince by certain ministers of this Court, et cetera. In short, this fellow does not trust anyone, and is suspicious of his own shadow. He is particularly doubtful about you, Sir, and about me, although I call the Lord God to witness that I have treated him like a brother, and I know you gentlemen will vouch for my sincerity. But let this be between us. I wanted to advise you about this so that you would not be ignorant of anything. In the meantime, knowing that the negotiation will not suffer because of this, I am inclined to think that he should be somewhat humiliated. And since we need to gain time, let him really wait to obtain his reply. Thus, without prejudice to the negotiation, he might be taught to esteem and revere his friends and patrons, and might become in the future more cautious and less presumptuous in despising the Prince's ministers. And in closing I kiss your hands with all my heart, and commend to you the secret that I tell you with as much confidence as though I were dealing with my own father.

<div style="text-align:right">Your most humble servant,</div>

Antwerp, January 22, 1624 Peter Paul Rubens

To J. J. Chifflet (?) *Antwerp, April 23, 1624*

Monsieur:

I did not answer your first letter, intending to send you the drawing whenever it was required. Moreover, I did not think it necessary to assure you in the meantime of my good will to serve you in this matter, having offered my humble service verbally, not only in this particular, but to the extent of my power on every occasion when I might do something to please you. Here is the drawing — very crude, but in conformity to its original, whose artifice bespeaks its century. Also, I am afraid that it will be too large, but it is very easy to reduce it *per craticulam* * without altering the proportions. I'd have done this for you very willingly, had you not written me that you wished to have engraved only the child in swaddling clothes. This I am sending you separately, rendered fairly exactly, as it seemed to me. If there is anything else in my power which is acceptable to you, it will always be ready at your command, and I myself will never fail to be

<div align="center">Monsieur,</div>

<div align="right">Your very humble servant,
Peter Paul Rubens</div>

Antwerp, April 23, 1624

To Valavez *Antwerp, December 12, 1624*

Monsieur:

I did not want to write to you before I had sent the perpetual motion [1] to Paris. I have now provided it with a special case, in which it is to operate according to the instructions which I have already sent to M. de Peiresc, but which I will send once more to refresh his memory about how it ought to function. I believe that it will be well to send the apparatus to Aix in the same way, presuming that it reaches Paris in good condition. In any case will you please remove the cover and lift off the cloth enough to see the glass tube; if that is intact you may be well assured about the rest. There is danger only for the tube; the flask is very solid and strong. There is also a little glass half-filled with green water, and with the same water I have filled the tube as much as is necessary

* By squared paper.

for its operation. I have also put beside the flask a little box with some impressions of gems. It seemed to me advisable to consign this case into the hands of Antoine Muys,[2] chief carrier to Paris; he has undertaken to have it delivered safely to you in Paris. Even though I believe he will not go there in person, he is a man very reliable in his promises. I have given him an unsealed letter addressed to you, leaving the transportation payment to your discretion, and promising him that, in addition to the usual charges according to the weight, you will reward him for his care in handling this chest. Three days ago he told me that the wagon would leave the following day, and probably, because of the bad roads, it will be a long time on the way.

I have not yet received the letters of Cardinal d'Ossat,[3] with the other books which it has pleased you to send me, according to the list enclosed in your last letter. I saw that it includes a collection of all the works of Théophile,[4] from the time of his arrest up to the present. This will be very acceptable to me, but I am especially desirous of seeing his *Satiricon,* which was the cause of his downfall, of his being condemned to be executed so cruelly. I now have the book of Father Scribanius entitled *Politico Christianus,* for which I designed the frontispiece.[5] I have also been sent the *Ordonnances des Armoiries* from Brussels. But it was not possible to fit these books into the above-mentioned chest. Besides, the *Ordonnances des Armoiries* had then not yet arrived. It will therefore be necessary to make a small separate packet and consign it to the same Antoine Muys. Meanwhile I shall look for some other things which might please you.

News there is none. The siege of Breda [6] continues with the same obstinacy, in spite of the extraordinarily heavy rains which make it very disagreeable in the camp. For all the roads are ruined, and the convoys advance with the greatest possible difficulty. In any case the Prince of Orange is finding no means to combat them or to stop them, and has given up this attempt as impossible. The Marquis, in order to relieve the hardship of finding forage, and also to spare the horses, has distributed the greater part of his cavalry in the towns nearest the camp, such as Herenthals, Lierre, Malines, Turnault, and Bois-le-Duc, where it is well provided for. It meets the convoys coming from the camp, giving them escort as far as is necessary. The Prince of Orange has some scheme in his head, but one does not yet know whether it will serve to save Breda or simply divert the Marquis. He has had forty ships built at Rotterdam, capable of holding both men and horses, with pontoons attached, in order to put their loads ashore with ease anywhere.

The murderer of the Duke of Croy has not yet been found.[7] As for his wife, they say that he has left her a good settlement, but I could not at present say how much.

As for myself, I expect, with divine grace, to be ready within six weeks to go, with all my work, to Paris. I confidently hope to find you there, which will be the greatest comfort in the world to me. I also hope to arrive in time to see your celebration of the royal marriage,[8] which probably will take place at the next carnival. In the meantime I commend myself humbly to your good graces, and kissing your hands with all my heart, I remain, Monsieur, your very humble servant,

Antwerp, December 12, 1624 Peter Paul Rubens

− 59 −

To Valavez *Antwerp, December 26, 1624*

Monsieur:

I owe you a reply to two letters, for the first came to me a little too late to answer by last week's courier, even though it urged me to haste by the news which you gave me (from the lips of the Abbé de St. Ambroise) of the departure of the King and the entire Court from Paris in February, without explaining whether it would be at the beginning, the middle, or toward the end of the month. Now I have received by this post a letter from M. de St. Ambroise himself, dated the 19th of this month, in which he asks me, on behalf of the Queen Mother, the exact time when I could deliver my pictures in Paris. He does not add anything else, makes no mention of the departure of the Court, nor does he in any way urge me to haste. On the contrary he sends me the measurements of a picture which the Cardinal de Richelieu would like to have by my hand; I am only sorry it is not to be larger, for I guard against falling short in his service.[1] I have answered the Abbé that if there is such great haste, as he has informed me through you, I can finish the whole by the end of next January (God granting me life and health). But if there is no such great urgency, it would be better to give me a little time to allow the colors to dry completely, so the pictures can be rolled and packed without danger of spoiling anything. Moreover, it is necessary to allow fifteen days at the least for the journey of the cart which will bring the pictures from Brussels to Paris, since the roads are all torn up and ruined. In spite of all that, I pledge myself, by divine grace, to be in Paris, with all the

pictures, at the end of February at the latest. But if it is necessary for me to come earlier, I shall not fail in my duty. On this point I urgently request him to advise me with certainty, as soon as possible, so that I may know how to proceed. For I should not like to fail to be in Paris, by whatever means, before the departure of the Court. I pray you also to urge M. de St. Ambroise to inform me with certainty as to the time set for my coming, without any mistake; and also for your own part to take care to let me know promptly any new plan or change concerning the King's departure. This will greatly increase my obligation to you (if any increase is still possible).

The day before yesterday I received the packet of books mentioned in your list. All of them were there, but I did not think they would make such a heavy package. The letters of Cardinal d'Ossat are in better form than I have ever seen them. And those of Duplessis-Mornay [2] are also very acceptable to me, for I do not remember having heard of them in our quarter, although their author is well known by his other works and by his dispute with du Perron. I do not know how to repay you other than by repeated thanks, for here I find nothing worthy of your interest or that of your brother, the Councilor. I have not yet consigned to the carrier the book by Father Scribanius, with the *Ordonnances des Armoiryes,* hoping to find some other trifle. But in my opinion there is nothing but a Latin book, just published, by M. Chifflet — *De Sacra Lindone Vesuntina aut Sepultura Christi* [3] which seems to me very nice. I shall get it tomorrow, and send all three to you by the first coach that leaves. I have also had made, for your brother's contemplation, an accurate drawing of the mummy in my possession,[4] but I dare not put it with the books, for I should have to fold it too small. It seems to me that it would be safer, even though it is only one sheet of paper, to roll it in with my paintings, the better to protect it against dampness. However, I shall think it over, for it is all ready, and I should not like to keep your curiosity so long in suspense. In the meantime, Monsieur, I beg you to be assured of my devotion; and lest I be in danger of not finding you in Paris, by delaying too long, I shall not fail to hasten expressly for this one purpose. You will oblige me by informing me punctually, and while I commend myself to your good graces, be assured that I shall be, during all my life, Monsieur,

<div style="text-align: right">

Your very humble servant,

Peter Paul Rubens

</div>

Antwerp, December 26, 1624

To Valavez *Antwerp, January 10, 1625*

Monsieur:

I am very glad that you have received the perpetual motion [1] in fairly
good condition, as I suppose, since the glass tube was not broken. I be-
lieve that Monsieur your brother still has the directions which I sent
him a long time ago, as to how to set it in operation. But in case of doubt,
I shall refresh his memory at the first opportunity — as I ought to have
done already. But I beg you to believe that, due to the brief time allowed
for finishing the Queen Mother's pictures, and to other duties besides,
I am the busiest and most harassed man in the world. I thank you for the
minute instructions which you give me concerning my obligations.
These instructions conform in every point to those which M. de St.
Ambroise writes, namely: that I must be in Paris, with all my pictures,
on the second, third, or at the latest, the fourth of February. This period
is so short that I must resolve, from this hour, to take my hands off my
pictures; for otherwise there will be no time for the colors to dry or for
the journey from Antwerp to Paris. However, this will not cause any
great inconvenience, for I should have had to retouch the entire work,
anyway, in its destined place (I mean in the Gallery itself). If a little,
more or less, is lacking, it can be done all at once; and whether I do the
necessary work in Antwerp or in Paris, the result will be the same. For
even though I believe there will be some miscalculation as to the time
of Madame's [2] departure (there are always delays in the affairs of the
great) I do not want to rely upon this, but prefer to be punctual with
my paintings, as far as possible. What bothers me more than anything
else is the fact that the picture for the Cardinal cannot, in my opinion, be
quite finished, and even if it were ready, I could not possibly bring it so
freshly painted. Even though I desire to serve His Eminence, especially
knowing how important his favor is, I do not believe that it matters a
great deal whether I complete this picture in Paris or in Antwerp. In
the end I hope that he, as well as the Queen Mother, will be satisfied
with my diligence, and that I shall find some subject to his taste. As to
the desire Madame shows to see my pictures before her departure, I
feel highly honored, and will be glad to offer her this satisfaction. The
Prince of Wales, her husband, is the greatest amateur of paintings
among the princes of the world. He already has something by my hand,
and, through the English agent resident in Brussels, has asked me for my

portrait with such insistence that I found it impossible to refuse him. Though to me it did not seem fitting to send my portrait to a prince of such rank, he overcame my modesty. And if the projected alliance had taken place, I should have been obliged to make a voyage to England.[3] Since, however, this friendship has dissolved, in general, so also has private intercourse grown cool; for the fortunes of the great draw everything else along with them. But as for me, I assure you that in public affairs I am the most dispassionate man in the world, except where my property and person are concerned. I mean (*ceteris paribus*) that I regard the whole world as my country, and I believe that I should be very welcome everywhere.

Here the Valtelline [4] is considered completely lost, and there is talk of a very close understanding between the Pope and the King of France. That is all as to that. But as for Breda, the Marquis Spinola is more and more determined to take the place; and believe me, unless he is recalled by an express command of his master, to prevent some new disaster elsewhere (which I do not believe) there is no power which can save the town, so well is it besieged. Even from the beginning, he never calculated to take it by force, but only by blockade. They are making great preparations for the defense of the provinces of Artois, Luxembourg, Hainault, and Flanders. God grant that I may go and return safely before there is any outbreak. I have nothing more to say this time than that I kiss your hands humbly, and commend myself with all my heart to your good graces, assuring you that I shall remain devoted to you all the length of my life.

I have delivered to Antoine Muys a little packet of three books — or rather two books, for the *Ordonnances des Armoiries* is only a single folio. The two others are the *Prince Cristiano-politicus* of Father Scribanius and *De Linteis Salvatoris* by M. Chifflet. You may be sure that you will pay very dearly for them, for this Master Antoine has never asked less than two francs for transportation. I leave it to you to deduct what seems to you beyond reason, which, in my opinion, is more than half. The mummy is not there; I shall bring it with the pictures.

Antwerp, the 10th of the year 1625

To the Infanta Isabella [*Paris, March 15, 1625*]

Most Serene Madame:

Since writing to Montfort by the last post, I have received another very peculiar report regarding the coming to this Court of the Duke of Neuburg,[1] with the King's authorization to negotiate and conclude the truce with the Hollanders. Although I recognize the worth, the capability and the industry of this Duke, it seems to me very strange — all the more so since we know with certainty that this decision of His Majesty's is based on very weak grounds, and that the whole thing is due to the persuasion of the Secretary de Bie.[2] This man believes that through a certain Fuquier at this Court he has made an important negotiation with the King's favorite, named Toiras.[3] Since there were some indications of this before my departure from Brussels, I informed myself carefully about the qualities of these personages. Then, seeing that the affair was not a secret, and considering the prudence of the Seigneur de Meulevelt,[4] I told him everything, in order to learn his intention and his judgment in this matter. Your Highness will learn his opinion from his own letter, here attached, but which is not as explicit as mine, since he has not been informed about what has been transacted by other agents, and particularly with the Catholic.[5] Although I am certain that Your Highness knows all that is going on, and perhaps has reasons, unknown to me, for approving this action of de Bie, I hope Your Highness will not take offense if I express my opinion according to my capacity, and with accustomed freedom. I do this the more boldly since the Seigneur de Meulevelt considers the matter of great importance. That is why he judged it necessary to send this express messenger to Your Highness, in order that we may know how to conduct ourselves on the Duke's arrival at this Court, which may be soon.

It appears, then, that this negotiation ought to be judged both by its origin and by its author, who is called Fuquier, as I have said. I do not know what he wants at this Court — he is a man of the worst reputation, accustomed to taking money by means of groundless claims, to the detriment of others. [*In margin*: This man is well known to the Seigneur de Meulevelt, who finds him just as I have described him.] It was he who, last year, brought de Bie to Paris and put the idea into his head that, to obtain the truce, it would be necessary to win over, or even to bribe, the King's favorite, M. de Toiras, with whom this Fuquier claimed

great intimacy. This is the course de Bie has proposed to the Duke of Neuburg [*in margin*: first in person, and then by letters written to the Duke while he was in Spain]. And he, in his goodness and credulity (a quality which is peculiar to well-intentioned persons) has put complete faith in de Bie and has informed the King and his ministers about it. Unless I am mistaken, even the sum of this bribe has been determined; but this would be of little importance, for the greater part of it would be for the contractors, should the plan ever be carried out. In our opinion, considering the present state of this Court, we firmly believe no decision could be taken which would be more alien to the end we desire, or more shameful to His Majesty. For, in the first place, the Duke, coming from Spain, will arouse suspicion; he may even be considered interested in the truce for the sake of his own estates, which are suffering greatly from the war in Flanders, and thus he will be little trusted. It will appear as though Spain were trying, through the Duke and (which is worse) through the French, to come to terms with her rebels. This seems directly counter to the honor of His Majesty, since he would be the first to make advances, which, in our opinion, would be vain and fruitless. For with the French it is a state maxim to keep the war in Flanders ever alive, and to cause the King of Spain constant expense and trouble. This they have shown by so much support [to the Hollanders] both in money and men, from the beginning of the reign of Henri IV to the present day. Your Highness may recall that the Prince of Orange has always protested, through the Catholic, that if the negotiations should come to the knowledge of the kings of France and England, they would be broken off at once; and that he complained (although unjustly, I believe) that we had sent his dispatches to France solely to break up the confederation of the States and the friendly relations with that Crown. The proposition of the Duke of Neuburg, then, will only serve to disclose our secrets and to warn our French enemies in time to oppose our plans with greater certainty and violence, to frustrate them with all their power; it will completely disgust the Prince of Orange and result in breaking all the other negotiations which are already so advanced, as Your Highness knows. I do not see how the French can in any way remove the obstacle which alone prevents the success of our enterprise, since they are supporting the opposing party with as much persistence as if its failure concerned their own interests. And to me it seems ridiculous to believe that by their persuasion we are expected to abandon the siege of Breda, or that the Prince will give it up at their demand. It is foolish to believe either that the French desire this, or that they can find suitable

means for the cessation of hostilities any more easily than we can do ourselves, if we wish. Finally, we need neither their favor, as Your Highness knows, nor the mediation of the Duke; nor is it necessary to buy from the French what we can have for nothing.

As for Toiras, may Your Highness believe me when I say that it is madness to expect from him a thing that is not within his power. [*In margin*: If, however, Toiras lends an ear to the proposal, Your Highness will see that it will be treason and a double bargain on his part, enabling him to reveal everything to the King and prove his own fidelity and integrity, just as M. van Kessel did with Father Ophovius.] [6] For Toiras does not interfere in affairs of state, but is regarded as a wise and modest gentleman who has no other charge than the command of Fort St. Louis near La Rochelle. He came to Court at the instigation of Soubise,[7] in order to negotiate for a port which he wishes to build at that fortress, and it is thought that within a few days he will depart again. One must realize that the entire government of this kingdom lies at present in the hands of the Queen Mother and Cardinal Richelieu, who oppose Toiras wherever they can, and who would be hostile to anything whatsoever contracted by him or for him. And as for the King's special inclination toward him, he stands in His Majesty's graces far below the new favorite, named Barradas.[8] This man enjoys such preference that the entire Court is astonished, and even the Cardinal has become so jealous that he is trying by every possible artifice to put him under obligation to himself. [*In margin*: With all that, the King has told Barradas that he is not to interfere in the conduct of affairs, nor ever to think of taking part in matters of state.]

Considering all the above-mentioned reasons, I beg permission of Your Highness to state my opinion plainly, since Your Highness has already on other occasions done me the honor of consulting me on this same subject. I consider the Duke of Neuburg very capable of negotiating this treaty, but not here at this Court, where the truce is abhorred more than anything on earth. Moreover, I hear from all sides, to my regret, that there is slight hope of success. And I suspect, knowing the manner of this prince, that the affair will soon be made public everywhere, and I leave it to Your Highness to consider what the consequences of that would be. Therefore it seems necessary to the Seigneur de Meulevelt and to me for Your Highness by every means to detain de Bie [*in margin*: I believe that he has already received permission from Your Highness to come at Easter], who says he is willing to go by the post as far as Orléans to meet the Duke in order to assist him in this negotiation. Also it would

be a good thing if Your Highness should warn the Duke (before any overtures can be made here) to undertake nothing without first consulting Your Highness, and that he ought, therefore, to go directly to Brussels, without stopping at this Court at all. And after Your Highness has had time to think about it, and to learn the Duke's intention and his instructions, you can together make the decision that seems most appropriate.

In the meantime I beg Your Highness to advise me as soon as possible how I am to conduct myself toward the Duke in this affair. The Seigneur de Meulevelt also wishes to be informed of Your Highness' intention (since it is quite possible that the Duke will seek his assistance at this Court), and wonders whether he ought to encourage or restrain him from putting a finger in the pie. I myself, although a small accessory, could, through the favorable inclination the Duke has always shown toward me, serve to divert him, if I were instructed by Your Most Serene Highness' will, to which I submit most humbly. I beg forgiveness if I am too bold, and pray that Your Highness will believe I am guided only by my zeal for the service of the King and Your Highness, and the welfare of my country.

With this I close, and with all reverence kiss the feet of Your Most Serene Highness.

<div style="text-align:right">Peter Paul Rubens</div>

Since the Marquis de Mirabel, Catholic Ambassador at this Court, and a very prudent and discreet person, has got wind of the Duke's commission to treat this matter, and takes it very ill, I believe he will try to prevent it. Therefore it will be necessary for Your Highness to furnish instructions as soon as possible, so that no false step may be taken here, counter to the intention of Your Highness, who perhaps knows things which we cannot fathom, or which we are not permitted to know — I speak for myself alone, for whom the slightest word of Your Highness is sufficient for me to obey.

If it is a question of a general settlement of all the differences existing between the crowns of Spain and France, it would be better, in our opinion, for the first overtures to be made by the Papal Legate [9] (who they say will surely come soon to this Court) as a neutral person. And if then there were a desire to include the question of the truce, in order to remove the obstacle of this war in Flanders, which causes great inconvenience and hinders friendly relations between the two crowns, it would be more advisable for such a proposal to come from a third party who,

like the Legate, is neither prejudiced nor suspected, rather than from a prince who has the greatest interest in Spain and comes directly from that Court. [*In margin*: All of this is said with due submission and apologies.] For this affair cannot be negotiated in passing. Or at least, if the Duke is to handle it, a more opportune and more seemly time would be after the arrival of the Legate, and after His Eminence has made proposals for settling affairs in Italy and the Valtelline. In this way one treaty could easily be connected with the other, because of the assistance which the King of France gives the Hollanders, and similar reasons.

Again I beg Your Highness' forgiveness for the presumption I show in speaking too freely of matters of such moment.

If I were informed of Your Highness' will, I could write to Don Diego [10] and to the Count of Olivares on this subject; I should have written also to the Marquis Spinola, but I dared not risk the letter. If Your Highness considers it wise, you may communicate this information to His Excellency. But I beg Your Highness to maintain secrecy, and to have this letter thrown into the fire. For I am the Duke of Neuburg's most devoted and dutiful servant, and have no reason to hold the slightest malice toward M. de Bie (as the Lord God knows). On the contrary, I am his friend, and do not wish in any way to arouse his animosity. But the public welfare and the service of Your Highness move me more strongly than any other passion. I commend myself, therefore, to the prudence and the discretion of Your Most Serene Highness.

– 62 –

To Peiresc *Paris, May 13, 1625*

Monsieur:

The day before yesterday [*in margin*: the 11th of May] Madame, sister of the King, was married by proxy, with all due solemnity, to the Duke of Chevreuse, in the name of the King of England. Cardinal de la Rochefoucauld officiated. You will learn more details from the various written and printed reports, to which I must refer you.[1] For, to tell the truth, I lost all pleasure in this ceremony because of the accident which befell M. de Valavez, your brother. He was with me on the same balcony which was reserved for the English of the Ambassador's suite, and on which great numbers were gathered. [*In margin*: It was through the great diligence of M. de Valavez that we obtained this very advantageous position,

just opposite the platform where the ceremony took place.] Suddenly, under the enormous weight of this crowd, the wooden beams collapsed and, to my consternation and horror, I saw your brother, who was just beside me, fall with the others. I myself was standing on the edge of the adjoining scaffolding, which remained safe, *ut solemus aliquando duabus sellis sedere.** I had hardly time to draw my foot from the collapsing scaffolding and set it on the floor that stood firm. And from here there was no possibility for anyone to descend without falling. Therefore I was unable, at this moment, to see your brother or to have any news of his fate, whether he was injured or not. I was obliged to remain there in this anxiety until the end of the ceremony. And then, slipping away as quickly as possible, I found him at his home with a wound in his forehead. I was terribly distressed at this, all the more since, out of the group of over thirty who fell, I have not heard of anyone else who was injured or badly bruised. His skull was not affected, but only the flesh, and were it not for the bruise around the wound, I believe it would heal within a few days. But since the contusion is close to the wound, the infection can without danger be drained off through the same opening. Thank God, he is without fever, having taken immediate and appropriate remedies, such as bloodletting and injections, to prevent any disorder. I hope, therefore, that in a few days he will recover his former health.

What bothered him most is the fact that this accident has befallen him just at the time of the arrival of the Papal Legate,[2] and he fears that he will be unable to comply with your desire and his own in presenting homage to His Eminence and the gentlemen of his suite. We do not yet know the precise day of the Legate's arrival in Paris, but it is certain that on last Saturday, the 10th of May, he arrived at Orléans, and that today, the 13th, he will stop at Etampes. This journey of the Legate seems to have been attended, so far, by many inauspicious omens, particularly the sudden illness which seized his uncle, Signor Magalotti, immediately upon his arrival at this Court as a precursor of the Legate. He has been given up by the doctors, who are unable, either by severe bleeding or any other remedy, to reduce his malignant fever. Unless your brother is soon on his feet again, and able to perform the introductions, it will be hard for me to find an opportunity to present my respects to those distinguished persons whom you describe in your letter in your own colorful terms. First of all there is Signor Aleandro, from whom you have in a short time learned many important things [*in margin*: as you say, in your mod-

* Just as one sometimes sits between two chairs (see the proverb in Erasmus, *Adagiorum Chiliades Tres* [Froben, Basel, 1520], p. 207).

esty], but none of which, I am sure, were unknown to you. Now if I should have a chance for some conversation with him, I could be instructed all the more, and corrected in all sorts of errors! It would also have been a particular favor to me to be permitted to kiss the hands of the Cavaliere del Pozzo [3] and of Signor Doni,[4] both persons of high reputation and famed for their knowledge of antiquity and their love of beautiful things.

I am somewhat concerned about my own personal affairs, which certainly suffer because of the public events. In this pressure of public affairs I cannot make any requests without incurring the blame of fatiguing the Queen with private matters. Withal, I shall exert what little talent I have to obtain my payment before the departure of the bride, which will be about Pentecost. The Queen Mother and the reigning Queen will accompany her as far as Boulogne, and the King as far as Amiens. I am certain that the Queen Mother is very well satisfied with my work, as she has many times told me so with her own lips, and has also repeated it to everyone. The King also did me the honor of coming to see our Gallery; this was the first time he had ever set foot in this palace, which they had begun to build sixteen or eighteen years ago. [*In margin*: I was at the time in bed, through the fault of a shoemaker who, in fitting a new boot, almost crippled my foot. I remained in bed for ten days, and even now, although I can mount a horse, I still feel the effects of it keenly.] His Majesty showed complete satisfaction with our pictures, from the reports of all who were present, particularly M. de St. Ambroise. He served as interpreter of the subjects, changing or concealing the true meaning with great skill. I believe I've written you that a picture representing "The Departure of the Queen from Paris" has been removed, and in its place I have painted an entirely new one, representing "The Felicity of Her Regency." This shows the flowering of the Kingdom of France, with the revival of the sciences and the arts through the liberality and the splendor of Her Majesty, who sits upon a shining throne and holds a scale in her hands, keeping the world in equilibrium by her prudence and equity. This subject, which does not specifically touch upon the *raison d'état* of this reign, or apply to any individual, has evoked much pleasure, and I believe that if the other subjects had been entrusted entirely to us, they would have passed, as far as the Court is concerned, without any scandal or murmur. [*In margin*: The Cardinal perceived this too late, and was very much annoyed to see that the new subjects were taken amiss.] For the future I believe there will not fail to be difficulties over the subjects of the other gallery, which ought to be easy and free from scruples. The

theme is so vast and so magnificent that it would suffice for ten galleries. But Monsignor the Cardinal de Richelieu, although I have given him a concise program in writing, is so occupied with the government of the state that he has not had time to look at it even once. I have therefore resolved that, as soon as I succeed in obtaining my settlement, I will depart immediately, and leave it to him and to M. de St. Ambroise to send me their decisions at their leisure, even though confused and topsy-turvy, according to their method, and perhaps a year from now, in Antwerp.[5]

In short, I am tired of this Court, and unless they give me prompt satisfaction, comparable to the punctuality I have shown in the service of the Queen Mother, it may be (this is said in confidence, *entre nous*) that I will not readily return. However, to tell the truth, up to now I cannot complain about Her Majesty's attitude, for the delays have been legitimate and excusable. But meanwhile time passes, and I find myself far from home, to my great disadvantage.

We have no news from Belgium; the siege of Breda continues as usual, without incident, as we learn from letters of May 6. But I believe it cannot go on this way, for the two camps (both so strong) are too close to one another. In conclusion I commend myself to your good graces, and with all my heart I kiss your hands.

<div align="right">Your humble servant,</div>

Paris, in your brother's apartment, May 13, 1625 Peter Paul Rubens

P.S. I feel this accident of your brother's as if it had happened to me; for on every occasion he has not failed to render me every possible service, in small things or great — all that one could expect of one's own brother.

<div align="center">– 63 –</div>

To Valavez *Antwerp, June 12, 1625*

Monsieur:

I beg you to pardon the brevity of this letter, which I cannot write as carefully as I should like, in the midst of visits and congratulations from my relatives and friends. I'll say only that I arrived last night, Wednesday, at Brussels, after the greatest difficulty. In the environs of Paris we could not find horses, so that we were forced to continue for four stages with

the poor beasts half dead, and three times we had to let them go alone, with the postilions on foot driving them like muleteers. However, we overcame these difficulties and obstacles. But arriving in Brussels, I found that the Most Serene Infanta had gone to visit the camp of Breda, before demolition of the fortifications. I then hoped to meet her in Antwerp, in order to accompany her, but when I reached here today, Thursday, at noon I found, to my annoyance, that she had left this very day at six o'clock in the morning. But it is thought that Her Highness will return in three or four days, since she went only at the request of the army, in order to inspire the troops, and to reward them for their hardships by distributing double pay and other gifts, to each one according to his merit.

I pray you to kiss the hands of Signor Aleandro for me, with deep affection, and also those of the gracious Cavaliere del Pozzo, Signor Doni, and all those friends who seem to you to take an interest in my health. And in closing I kiss your own hands with all my heart and commend myself to your favor.

On the evening of my arrival, Antwerp, June 12, 1625

<div align="right">Your most devoted servant,
Peter Paul Rubens</div>

<div align="center">– 64 –</div>

To Valavez *Antwerp, July 3, 1625*

Monsieur:

Since you recommend it, and since Signor Aleandro promises me not to let those other gentlemen see these prints, I deliver them into your hands without retouching, as you will see. I believe that, aside from the two larger cameos, you will find the one with the triumphal quadriga very fine and worthy of consideration. It is quite out of the ordinary, and full of beautiful details, of which I shall be glad to learn the interpretation from Signor Aleandro, as well as the name of the emperor. He resembles Theodosius more than anyone else, but otherwise the details would apply to Aurelian or Probus. And also remarkable, it seems to me, are those two figures with fasces and globes in their hands, on both sides of the triumphal figure.[1]

By the first cart leaving Antwerp or Brussels for Paris you will receive copies of the *Electorum Rubenii*, the *Homiliis Asterii et Parentali-*

bus Rubenii, and the *Epistolarum Isidori Pelusiotae* which, all together, make too large a packet to be sent by the post.[2] I am surprised that Justo [3] is so late; surely his delay seems to me excessive. It is now twenty days since my departure, and M. Frarin wrote me on June 19 that the funds were ready and that I should be paid on the following day. I am extremely provoked at the lack of punctuality on the part of M. d'Argouges, as I wrote you by the last post. I doubt that he has yet settled the account, for M. Frarin has not written me anything by this post, which seems to me a bad sign. I hope, however, that there will be no slip, other than some delay. For it seems to me incredible that, on the request of M. de St. Ambroise, he would not have given prompt satisfaction to M. Frarin; or, in default of funds, the assurance that the letters of exchange will not be revoked. All the more so since (let this be *entre nous*) I made M. d'Argouges [4] a fine present of a large picture by my own hand, which he seemed to like very much. I hope to have better news with the next post.

On public affairs I have little to report. The Most Serene Infanta is still at Breda, but her return to this city is expected in a day or two. The Hollanders are fortifying Zevenbergen and, in order that our men may not hinder them, have put all the nearby meadows under water.

The Queen of England arrived safe and sound at Dover on June 22, if I am not mistaken. The King had left there a few days before, due to lack of provisions, which, as the English say, are difficult to transport to that place in sufficient quantity to support for a long time a great Court like that of His Majesty. But you will be informed of all this by now, particularly how the King then came to meet the Queen, the reception ceremonies, etc.

With this I close, kissing your hands with all my heart, and commending myself to your favor and that of Signor Aleandro.

<div align="right">

Your most affectionate servant,
Peter Paul Rubens
</div>

Antwerp, July 3, 1625

I have spoken with M. Rockox about our enterprise, and found him very well disposed to participate, but on condition that it is certain to be carried out. He is an honest man and a connoisseur of antiquities, who could also contribute from his store of observations and thus have a part in the honor. If I know him well, he would also wish to contribute his share of the expenses, at least to a certain point. And this would only be reasonable. He is rich and without children, a good administrator, and

Rubens' House, Antwerp. Portico with view toward the garden.

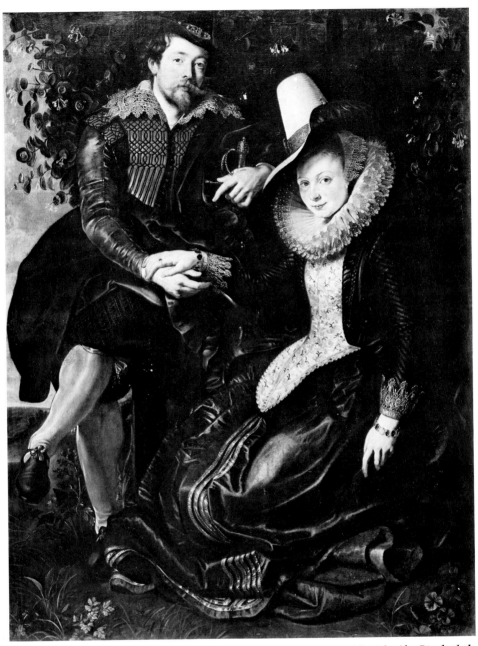

Rubens with his first wife, Isabella Brant, in a honeysuckle bower. 1609–1610.

all in all a gentleman of the most blameless reputation, as M. de Peiresc, your brother, knows, for he has had personal dealings with him. You would do me a favor in communicating all this to him and also to Signor Aleandro, for in order to carry out our enterprise to a good conclusion, we really have need of assistance.

I am surprised that Justo has not written to me this time, nor told me the day of his departure. The letter of M. Dupuy to M. Gevaerts has been well received. Pray kiss his hands on my behalf.

– 65 –

To Jan Brant *Antwerp, July 20, 1625*

Most Illustrious Sir:

From my previous letter you will have learned the disposition of 3 and of 26. I confirm it in this one. I also assure you once more that if you can bring with you again the document you brought last year, which has lost its force or become annulled through the death of the principal [1] figure mentioned in that negotiation, you will be welcome, and no difficulty will be raised on our side. This 3 and 26 have confirmed to me with their own lips, since I wrote you on the 8th of this month. And in order to make it clearer, I am sending you a copy of this note here enclosed.[2]

But it would be like addressing a dead man, and quite pointless, for us to give you some empty reply. [*In margin*: As you write me in your letter of the 10th of this month, and which I have communicated to 26. You may be assured that from our side no such reply has ever been given, and you ought not to make any such claim.] It is up to you, on your side, to supply what is wanting. Our position, by God's grace, is safe and secure, and it seems to me that the moderation shown on our side is by no means slight. For after so great a change, and with so considerable an advantage, we are keeping the same terms, without revising them in a single point. I have taken care to exclude other agents, and have received word that at the present there is no cause for alarm. Father Ophovius, in particular, has been mentioned to me as having neither commission nor introduction of any sort, so no one knows why he should have asked for a passport. [*In margin*: I beg you not to be disturbed about the Capuchin Fathers mentioned in your letter to your father, nor about others whom you might suspect; because up to now the post is vacant, and you have a great advantage over all others who might begin new

113

negotiations or resume those that have been interrupted.] I have also been told that 14 has no orders to negotiate in this affair. Since I learned this from 26 himself, I had little inclination to communicate with 14. But I invited him to my house along with 12. I discovered that he possessed no special information, but that his discourse was vague, without any knowledge of our negotiation; that the things he proposed were contrary to our views, and that he did not know what had been done last year in 28. I resolved, therefore, to confine myself to telling him that negotiations had been completely broken off with the death of 11, and that it would be necessary to begin all over again. I said that he would be advised by me in due time. He was satisfied with this and promised to do the same on his part, and to continue our correspondence. I have not seen him again since then; he left for Brussels several days ago. I believe he will probably be somewhat angry with me, but the way he pointed out is too long and does not correspond with our plans. I have learned that our suspicions are false concerning a lack of secrecy in our communications with 12. He has conducted himself with great prudence and loyalty, and we were wrong in distrusting him. It now remains for you to make every effort to bring the desired answer as soon as possible, indorsed by the advice and the orders of those who can maintain and carry it out; then it will be accepted at once by our side and put into effect. We can now settle the question in every detail, which, as you know, was impossible before. It would be a great advantage if you could come before the Court leaves Brussels for Flanders. This will be within eight days, and 13 will go with the others. He has done little or nothing in our present negotiations, although I have, out of respect, communicated to him the intention of 3 and 26. I do not know whether he has written to you — it is enough that we are friends. As for him, he usually has a thousand other things of importance in his head. And since I have nothing more to say I will close, kissing your hands and begging you to do the same, on my behalf, to 16. Now is the time, as a good patriot, to offer every service to the general welfare, for which we have worked so hard that I hope, with God's help, our efforts will not be in vain.

<div align="right">

Your affectionate servant and cousin,

</div>

Antwerp, July 20, 1625 Peter Paul Rubens

Nothing has been communicated to 7 or 5, nor has any advice been given them. And it does not seem advisable, for various reasons, for 24 to be included in any way in this affair, so that at present we alone are

involved. Therefore we must act quickly, to prevent some busybody from interfering before you bring the authorization. For this alone will be able to exclude every other agent; but in the meantime the position is vacant and open to all who can with good reason employ new methods.

– 66 –

To Jan Brant *Brussels, August 25, 1625*

Most Illustrious Sir and Esteemed Cousin:

I have once more spoken urgently with 3 and 26 in favor of your proposition. According to what 26 writes me, it was not received favorably by 3 who, through magnanimity or for other reasons unknown to us, does not wish to approve that method of negotiation, but is willing to do everything within reason through the ordinary means you have used up to now. Therefore you will act prudently not to persist in this idea, for instead of being prudent, this would be more detrimental to your credit, and the authority of your negotiations, than anything [*in margin*: and contrary to the reputation of your family]. But I assure you that if you can bring the proposal which you brought the last time, it will be well received, as I have already stated. I pray God that this may be as promptly as the difficulties of negotiation will permit, for I know well that to deal with a group of persons is very different from dealing with one alone.[1] In the meantime it will be well for you to furnish some information as to the progress of the matter, in order to keep our side in good humor and to exclude anyone else who might interfere.

 With this I close, kissing your hands and those of your parents with all my heart, and commending myself to your favor and theirs.

 Your affectionate servant,
Brussels, August 25, 1625 Peter Paul Rubens

– 67 –

To Valavez *Brussels, September 19, 1625*

Monsieur:

On my return from Dunkirk [1] I found two letters from you, dated August 29 and September 14. They pleased me very much — all the more since

the second was accompanied by a note from the gracious and erudite Signor Aleandro. I wrote you several days ago from Dunkirk via Calais; I hope you have received the letter. This time I must ask you to excuse my brevity; I am writing with one foot in the stirrup, having received orders from the Most Serene Infanta to go in all haste to meet a certain prince [2] at the German border, on a matter of urgent importance to Her Highness. But I hope, with God's help, to be able to return soon, and then to have a little more leisure to keep up our correspondence as ought to be done.

As for the painting of the cameo,[3] I find (if you will pardon me) that you speak much more of it than I should like, to a man of good intention but limited capacity. I do not see that a slight delay would be such a calamity; moreover, in Antwerp there is no lack of most reliable communication with Marseilles, to have it sent there at my risk. After all, these are only matters of pleasure, but if my life depended on it, I could not do otherwise, with all these hindrances of so much traveling. On my return from Germany I shall have to go back to Dunkirk, and then somewhere else. However, although I shall perhaps remain in Brussels all this winter, I shall probably be able, even without being in Antwerp, to do a little piece of work of this sort. But to do it now and send it to Paris before your departure will be impossible for me, since the time is so short. In spite of every possible entreaty on my part, I have never succeeded in obtaining from your brother the assurance that he would accept this little souvenir by my hand when it should be finished; and I am very much obliged to you that you have given me this assurance. But the necessity of these journeys in the service of my Princess does not permit any exception. Once this is over, it will no longer be necessary to urge me to do my duty, for I shall esteem it the greatest favor and honor to be able to serve you gentlemen in any way within my power.

I have not had any letters from M. l'Abbé [4] since my departure from Paris. I thank you with all my heart for the news you give me, and especially of English affairs, which in conclusion do not correspond at all to the glorious beginnings. The fleet, though still so formidable, seems to have missed the opportune moment for producing a great effect. While I was in Dunkirk, there were twenty splendid ships gathered, and I saw eighteen of them leave for the port of Mardyk. The other two were to go out the day of my departure. And there was constantly in view, opposite that port, a fleet of thirty-two Dutch ships, so that a battle with them could easily have resulted. However, I believe that we are going to remain strictly on the defensive, and will not be the first to break it. But should

the English armada make a single move against the King of Spain, you may believe me that the world will see a bad game.

With this I close, against my will, but I cannot defer my departure any longer. I kiss your hands with all my heart, and beg you to do the same, on my behalf, to the Cavaliere del Pozzo. I am certainly under such obligation to him that I ought not to let him leave without a letter from me. But the time is too short now for me to correct in a moment my past negligence. This will be done, please God, on his safe return to Rome. To your brother the Councilor I commend myself humbly, and to him as well as to you I sincerely remain

Brussels, September 19, 1625

Your very devoted servant,
Peter Paul Rubens

– 68 –

To Valavez *Brussels, October 18, 1625*

Monsieur:

Hardly back from the German border, I am obliged to go at once to Dunkirk to present to the Most Serene Infanta a report of my negotiations, which I succeeded in carrying out to the satisfaction of Her Highness. Upon my return to Brussels I found your most welcome letter of September 26, filled with your accustomed courtesy and politeness. For you are not content to favor me with your own friendship, but you take care that others do the same, as the enclosed letter from the gracious Cavaliere del Pozzo proves. This pleased me exceedingly, because I desired some correspondence with this gentleman, but saw no means of commencing it. Now you have provided the bridge, and I shall not fail to answer him at the first opportunity. However, since they say here that the Legate is returning directly to Rome, it would be safer, in such a case, to wait until his arrival there.

From M. l'Abbé de St. Ambroise I have had no news, up to now, other than from your letters. Probably this is because he has nothing in particular to write to me, but I think that, in due time, he will.

I thank you very much for your detailed report on the naval defeat which Admiral Montmorency inflicted upon M. de Soubise.[1] The Hollanders attribute it entirely to their Admiral Haultain. The victory is all the more certain in that M. de Toiras has also taken the Ile de Ré, possession of which is so important in the opinion of those who know this

region. I now doubt very much whether, after this advantage, the King will consent to enter into agreement with the people of La Rochelle, who have hitherto shown themselves so stubborn.

As for the affairs of Italy, one hears nothing certain here; we know only that the Duke of Feria [2] is making no progress, and believe he would have done better to be satisfied with the defensive, instead of wishing to attack.

Count Tilly still finds himself opposed by the King of Denmark. When he distributed his soldiers, to the number of four or five hundred men, in order to guard different parts of the country, they were massacred by the inhabitants, aided by the troops of Denmark, who had been let in. But all those places have been won back, and cruelly treated. The Prince of Wallenstein has arrived in that region with a great army. He was sent by the Emperor and conducts himself like a tyrant, burning villages and towns like any barbarian; thus one can say that the war is really beginning in that country.[3]

The Most Serene Infanta and the Marquis are still in Dunkirk, devoting themselves to nothing but the building and arming of ships. At the time of my departure I saw in the port of Mardyk a fleet of twenty-one well-armed ships, of which nine were ready to set sail with the first favorable wind. In my opinion this would be very dangerous, since they would have to pass thirty-two Dutch ships which were standing in sight ready to receive them with cannon fire. We are waiting from hour to hour for news of the issue, but possibly you will hear it before we do, by way of Calais.

I have nothing else to tell you now, worthy of your curiosity. I have received a letter from M. Gerbier,[4] from Paris. I should have answered it, if I did not think he had already left; but his letter is now old. He tells me that he was sent to the [French] Court to refute the calumny of Father Bérulle, who had returned from England much dissatisfied with the treatment of the Catholics in that kingdom. But I do not believe that M. Gerbier alone will be able to win this case against Father Bérulle.[5] And since there remains nothing more than to commend myself to your good graces, I kiss your hands with all my heart.

<div style="text-align: right">

Your most affectionate servant,
Peter Paul Rubens

</div>

Brussels, October 18, 1625

To Balthasar Gerbier [1625]

Summary from the Sale Catalogue of Thomas Thorpe, London, 1833

The present letter alludes to the sickness then prevalent which had driven him from his house added to which, the Infanta having sent him in a journey of business, had caused a delay in painting his highness's portrait on horseback. Sr. Balt. Gerbier was intrusted by Rubens with some private communication respecting the picture, which he desired might be only between them selves, "car je ne voudrois que ces Princes jaloux prinsent exception qui toujours sont désireus de tenir tout entre leurs mains."

To Valavez Brussels, November 28, 1625

We have no news of importance here, except that our ships from Dunkirk have ruined the herring-fishing for this year. They have sent to the bottom a number of fishing-boats, but with the express order of the Most Serene Infanta to save all the men and treat them well; this has been done. Should I tell you the news which, in order to reach us, had first to pass through France: namely, that the English fleet has seized land at Cadiz and put ashore 12,000 men? Some people write that they have taken the fortress by storm, but this is denied by others. In short, all Spain is in arms and hastening to that point — all the more since the Moors of Algiers have threatened to join the English and the Dutch, or to make an attack from some other side. This was bravado on Buckingham's part, and seems to me an extreme, unheard of measure, an act of desperation. To ally themselves with Turks and Moors, for the overthrow of Christians — they who profess a "reformed" religion, as they call it! What the result will be, we shall learn in greater detail from a special messenger, although there is no doubt about the certainty of this news.[1] In the meantime I hope the Court will return to Brussels, for in its absence one cannot hear the more guarded reports.

I am not surprised that the King of France wishes to profit by the favorable occasion and the great advantage he has now gained over his rebels, especially since the war in Italy, it seems to me, will offer little fruit for either side.

I am thinking of returning very soon to Antwerp. The plague, thank

God, is diminishing day by day, and I am tired of remaining so long away from home. In closing, I kiss your hands with all my heart and commend myself to your good graces. I beg you to present my condolences to your brother, the Councilor, on the death of your father,[2] and remind him that I always at his service.

<div align="right">Your most obedient servant,</div>

Brussels, November 28, 1625 Peter Paul Rubens

I have read with the greatest pleasure the little book of the *Miroir du temps passé*; it seems to me clever and stimulating. I thank you also for the *Réponse,* which I shall read with attention, although I doubt whether its arguments will please me as much. I hope that you will have received the three copies of the *Admonition,*[3] and if there is anything else I can do for you, please do me the favor of informing me.

<div align="center">– 71 –</div>

To Valavez [*Brussels, December 12, 1625*]

We have as yet no certain news here of the arrival of the Duke of Buckingham in Holland.[1] But we do know with certainty, from an express messenger from Spain on November 18, that the English landed below Cadiz on the first of the month, with 6000 troops to attack the place, but were repulsed. On the fifth, an old captain of seventy years, Don Fernando Gyron, made a sortie from the fortress with only 500 musketeers, but picked men, and supported by a handful of skirmishing infantry and a detachment of light cavalry. In a few moments the English were forced to reëmbark in great disorder, leaving 500 to 600 dead on the shore. Since then we have heard no further details concerning the direction they took. This is the information the King gave to the Most Serene Infanta. But Don Diego Messia (who has been appointed General Field Marshal of the King of Spain in this war, which is thought due to last a long time) has written that all measures were taken to insure the safe arrival of the silver galleons. For without any doubt the English were seeking to encounter them, in order to seize a portion.

That mad head of Halberstadt [2] is for once at rest, for he has died of a malignant fever. The caprice of M. de Vaudemont [3] is worthy of admiration, but it can cause some confusion, if the son has no male heirs by his wife.

The lifting of the siege of Verrue is indeed a disgrace to the Duke

of Feria and Don Gonzalo.[4] I believe that this winter little will be done, in general, unless perhaps by the English fleet.

To Valavez *Laeken, December 26, 1625*

Monsieur:

If this *Auctarium* of Goltzius [1] (whether by him or by another author) really exists, a copy will be found, without any doubt, either in the Royal Library or in that of M. de Thou, in Paris. Therefore I beg you to look it up, and take note of the year in which it was published, the name of the printer, and the city where it was printed. For it seems strange to me that here, where the works and the *Thesaurus* [2] of Goltzius are common enough — M. Rockox as well as countless others have them — not a single antiquary or a single book-dealer has any knowledge of this *Auctarium*. I do not remember that the Councilor, your brother, has ever spoken of it to me. Nor does it seem likely that Goltzius, who published only one-tenth of his projected works before his premature death, would have done an *Auctarium*. But I remember well having talked with M. de Peiresc about a manuscript of Goltzius in the possession of Jacob de Bie,[3] who hoped to publish it some day. For that reason your brother wanted de Bie to come to Paris, thinking that he might obtain some help there. It is true that at that time de Bie published his book on gold medals, as well as another on certain medals of Goltzius, with some notes of little importance, which are now augmented by a few remarks, and will soon appear in a new edition. But these books your brother has already seen, several years ago, as well as the commentary by Louis Nonnius on the "Greece and Islands of the Archipelago" of Goltzius; and none of these works has the title of *Auctarium* as far as I know. It is true that I am still here, outside of Brussels, and far from my own library, but I hope, with God's help, to return home soon. This Jacob de Bie, by his bad management, has squandered all his fortune and mortgaged it in different hands, so that one can hope for no good result, for it is a matter involving thousands of francs. I beg you once more, sir, to inform yourself well on this point, for I desire to serve your brother as well as yourself in every way possible, and to the extent of my power.

There must be some new attitude at the Court with regard to me,

for the Abbé de St. Ambroise has never written to me since my departure, nor has he even answered the cordial letter I sent him last month. I can augur nothing else from his silence than some change of mind, which affects me little; and to tell you the truth, in confidence, the whole thing will not cost me a second letter. But if you can discreetly obtain information from some person who is able to furnish it, you will do me a great favor. For the rest, when I consider the trips I have made to Paris, and the time I have spent there, without any special recompense, I find that the work for the Queen Mother has been very unprofitable for me, unless I take into account the generosity of the Duke of Buckingham on this occasion.

The Duke has, in fact, been in Holland, and has concluded with those States an offensive and defensive alliance for 15 years. But he was unable to obtain the occupation of Brielle and some of the other fortresses once ceded to Queen Elizabeth. I believe you must have seen the 40 articles of this treaty, which is to be found here only in manuscript form, written in Flemish. Otherwise I should have been glad to send you a copy, in return for the little books which you are good enough to send me continually, and which give me the greatest pleasure, even though M. de Meulevelt, Ambassador of the Most Serene Infanta, sometimes obtains the same ones for me.

The fleet reached Cadiz safe and sound, a few days after the departure of the English, and without having sighted a single enemy vessel. This seems almost a miracle, as the Count of Olivares himself writes me. For had it arrived a little earlier, it would have found the English in that port. And since it is thought they had come to waylay our fleet, it seems strange that the two could have passed so close to one another without having met.

I thank you very much for the report on those duelists. This mania of the French really ought to be suppressed, for it seems to me to be the curse of that kingdom, and will exterminate the very flower of French nobility.[4] Here we fight a foreign foe, and the bravest is he who conducts himself most valiantly in the service of his King. Otherwise we live in peace, and if anyone oversteps the bounds of moderation, he is banished from the Court and shunned by everyone. For our Most Serene Infanta and also the Marquis wish to render all private quarrels dishonorable and detestable. Those who think to gain fame in this way are excluded from all military offices and honors, and this seems to me the true remedy, since all these exaggerated passions are caused by mere ambition and a false love of glory.

Little will be done here this winter, except that everyone will stand on his guard. If I am not mistaken, the attack and the pretended defense of Breda have exhausted both parties. The ships from Dunkirk are doing well, and besides having spoiled the fishing for this year, they have made some very good captures.

I should like to know whether this is true: they say here that the Queen of England is not treated by the King in a manner conforming to her rank and merit, and that she has hardly been able to obtain even a low mass for her devotions; and that the Catholics are treated worse than ever in that kingdom, so that the Spaniards consider themselves very fortunate not to have put trust in the English. I suspect that emotions are playing a part in this. The Secretaries of Spain and Flanders, resident in England, have been recalled, and I have no doubt that war will follow. And indeed, when I consider the caprice and the arrogance of Buckingham, I pity that young King who, through false counsel, is needlessly throwing himself and his kingdom into such an extremity. For anyone can start a war, when he wishes, but he cannot so easily end it.

I have nothing else to say for now, and in closing I kiss your hands with all my heart, and pray heaven to grant you and your brother a very happy New Year.

Laeken, outside Brussels Your affectionate servant,
December 26, 1625 Peter Paul Rubens

– 73 –

To Valavez *Laeken, January 9, 1626*

Monsieur:

Pardon me if I do not always write to you with the same punctuality which you use toward me; and please believe me that it is not through lack of affection or willingness to serve you, but because certain insurmountable hindrances prevent me from fulfilling my duty. But if anything urgent presents itself, to be done in your service, I shall give up everything to carry it out according to the best of my ability.

I am sending you the 40 articles of the alliance between the English and the Hollanders; [1] the text is in Flemish, because my many duties make it impossible for me to translate it into French or Italian for you, and here in the country I cannot find anyone able to do it. I must therefore ask you to excuse this impertinence, and to believe that it is due to

123

the absolute impossibility even of having a copy made; for I am sending you the document just as I myself received it, however badly written. But I'll tell you how to have it translated with very little trouble: and that is to send it to our Ambassador of Flanders, who has also asked me for it. I am writing to him by this post, saying that I have already sent it to you, and that, having no opportunity to copy it, I have asked you to communicate it to him. In this way you can obtain the translation, which he can easily have done by one of his secretaries. [*In margin*: The Ambassador will in this way believe that I had already sent you the document by the previous post.] In these articles there is no mention that the Hollanders will be obliged to receive an English garrison in Brielle, Rammekens, and other fortresses formerly pledged to Queen Elizabeth, but returned, miraculously, by James. The Duke of Buckingham made the most urgent demands of the States on this point, but up to the present they have not consented. The strongest opposition, however, comes from your Ambassador from France. For this reason M. Aerssens [2] was to go to your Court as Envoy Extraordinary. He had formerly been Ambassador there during the lifetime of Henry the Great, but had then become very unpopular in France because of the death of Barnevelt,[3] in which he was the chief instigator. Fearing for his skin, he has declined this mission, but they say (though I cannot believe it) that the King has sent him, as a security, the chain of the Order of the Holy Ghost. As for Buckingham, I am of your opinion that he is heading for the precipice; I have written this freely to M. Gerbier, and I have heard it affirmed by an Englishman, a very good friend of mine, recently come from England. He told me that the same day on which Buckingham returned from Holland — a voyage in which two fine ships were lost, one belonging to the King and called the "Assurance" [*in margin*: it seems a bad omen that a ship of this name should be lost], and the second belonging to Burlamachi [4] — fifty other ships of the English fleet arrived safely; and all the nobles rejoiced at this misfortune which they attributed to the temerity of Buckingham.

During these last days I have heard from the Marquis Spinola, who is extremely reserved in his remarks, that the expedition against Cadiz seemed to him utterly foolhardy. The English apparently thought they could take all Spain with 12,000 infantry and a few horsemen. They landed on an island on which not a tree was growing; they did not even bring with them fascines to fill up the ditch which they had to cross to attack a place defended by 4,000 men. These defenders had the thickly populated city of Seville at their backs, and all Spain in arms to offer aid.

Therefore the only prudence the English showed in this enterprise was in retiring as speedily as possible, even though with great losses, and in disgrace.

The Englishman I just mentioned told me that the Queen is now very beautiful and in good health, and that the King loves her very much. But she is not well treated in the practice of her Catholic faith; she has been given only one small chapel, holding four or five persons, so that almost all her suite have to hear the mass without seeing it. But enough of England.

As for the Abbé de St. Ambroise, I consider him a good and sincere man, and to tell the truth, I have nothing at all against him; but his silence is becoming endless, and for the future I shall likewise give myself up to silence. Having nothing else to say, I commend myself, with all my heart, to your good graces, and praying heaven to grant you every contentment, I kiss your hands.

<div style="text-align:right">

Your affectionate servant,
Peter Paul Rubens
</div>

The Legate [5] has arrived safely in Rome, although they say that he might leave again for Spain.

Laeken, outside Brussels, January 9, 1626

The postage on those little books is of small consequence, but since you place some value on them, I shall write about this to the Ambassador, whose letters always come to me post-free.

<div style="text-align:center">

– 74 –
</div>

To Valavez *Brussels, January 30, 1626*

Monsieur:

This letter serves only to accompany the little book which you requested and which I finally obtained by the means I have already told you. There is only one copy, and to tell the truth, as far as I can judge in running through it hastily, it seems to me highly infamous. I should consider the author deserving of punishment, and I believe he would be punished, if he were known. For the Most Serene Infanta, as well as her principal ministers, are very hostile to such libelous publications; that is why they have very little vogue in this Court.

I find myself at this time occupied with certain affairs which do not permit me to be too long. And even though I had much more leisure, I do not recall the slightest bit of news worthy of being written by me or read by you. Thereupon I close, kissing your hands with all my heart, and praying heaven to grant you every fortune and contentment.

Brussels, January 30, 1626

Your affectionate servant,
Peter Paul Rubens

<center>— 75 —</center>

To Gian Francesco di Bagno [*Laeken*], *February 1, 1626*

Most Illustrious and Reverend Lord:

Various hindrances have prevented me from thinking of Your Lordship's question until a little while this morning, and since I find myself deprived of books and my notes, I cannot answer you as precisely as I should like. But I shall tell you what I think as far as my memory serves me. If I am not mistaken, this temple of Diana at Ephesus was not built by any particular king or republic, *sed ab universis Asiae populis*,* and especially by the Ionians and Greeks who lived in Asia Minor. They were prevented from finishing this building for the space of four hundred years, or, as some say, two hundred and twenty. But I remember having read that the first, most ancient building was almost all of bronze, and perished through being swallowed by an earthquake. Then it was rebuilt of marble in a marshy place full of traces of carbon. This one burned, if I am not mistaken, on the night of the birth of Alexander the Great, for the poets say that Diana (alias Lucina) was unable to guard her temple from the fire because she had gone to assist Olympias at the delivery of this great king; that after being restored in the time of Philip of Aminta, father of Alexander, it was set ablaze by that wicked Herostratus.[1] [*In margin*: I cannot affirm for certain whether this was the fire of Herostratus.] The temple was reërected under the rule of Lysimachus, not, however, at his expense, but that of the same ones who built it in the beginning, namely, the peoples of all Asia. And if I remember rightly, it was ruined seven times, by fire, earthquake, and the incursions of the barbarians, and always restored by the same peoples up to the time of the Romans. And they, during the reign of Augustus or Tiberius, rebuilt it anew.

* But by all the peoples of Asia.

<center>126</center>

It is true that many kings and tyrants contributed their aid to the cost of such a building, just as they also sent their gifts, one rivaling another. But I know that no one in particular had the title of having re-dedicated or restored it by himself. This is as much as I can tell you now, under protest that my memory is weak. It may be that I have forgotten something, or have erred in some point. And in closing I kiss Your Lordship's hands with all my heart, and commend myself humbly to your good graces.

<div align="right">
Your Illustrious and Reverend Lordship's
most humble servant,
Peter Paul Rubens
</div>

[Page damaged] February 1, 162[6]

– 76 –

To Valavez *Brussels, February 12, 1626*

Monsieur:

I am astonished by what you write me — that the Cardinal wishes to have two pictures by my hand. This is not at all in accordance with the report which the Ambassador of Flanders sends me. He says that the paintings of the second gallery of the Queen are to be given to an Italian painter, notwithstanding the contract with me. It is true that he says he has only heard this, but does not know it for certain. He has been told, however, that it is a certainty, and he supposes it was done with my consent. But I believe that if this were the case, you would know it, and would have informed me.[1]

I have not yet been able to get the little book of the Arminians,[2] and this will be difficult, because relations with their country are very strained, or even almost nonexistent.

I have resolved to return to Antwerp in a few days, and I think I shall leave next week.

And so I close, kissing your hands with all my heart, and commending myself to your good graces.

<div align="right">
Your affectionate servant,
Peter Paul Rubens
</div>

Brussels, February 12, 1626

To Valavez [Brussels, February 15(?), 1626]

The Hollanders, with their usual severity, and notwithstanding all the
courtesy imaginable shown by the Most Serene Infanta and the Marquis
to their prisoners (as I myself have seen at Dunkirk), have thrown into
the sea, tied in pairs, back to back, about seventy of our men who were
serving on private ships under the royal standard. They have done this
at different times, but there were thirty on one ship alone. I hope, and I
believe it is true, that orders have been dispatched to these private ves-
sels, though not yet to the royal ships, to take reprisals up to the same
number of men. Thus it may be seen with what patience and reserve our
side is proceeding. They say here also that the King has appointed the
Marquis Admiral of these seas. I have not yet noticed that he has taken
the title, although he is in complete charge. One of the King's ships was
destroyed in the port of Mardyk by the betrayal of two Hollanders whose
lives had been spared by the Most Serene Infanta and who had been
taken into the King's service. But these ingrates, in return for such kind-
ness, set fire to the powder during the night, and escaped by dory. The
ship blew up with about fifty men, but among them the captain and
seven or eight sailors were saved, although badly injured. For they were
hurled into the air and fell into the sea clear of the ship. And another
thing happened — not so tragic, but rather ridiculous — which I cannot
help telling you. A Hollander came to Dunkirk as a deserter, to give him-
self up, saying that he was disgusted at certain bad treatment by the
States. He wanted, therefore, to take vengeance upon them, and said
that he knew of some important booty in a certain part of Zeeland. He
was trusted and given a small armed ship, manned by an adequate num-
ber of sailors and soldiers. He set sail toward Zeeland but on the way met
a larger vessel with the arms and the standard of the Prince of Orange,
which immediately bore down upon him. This fellow had all hands go
below, as if he were willing to fight. And then, in answer to those on the
big ship, who said they were from Rotterdam, he told them to come
gladly aboard his ship, that they would have a good prize. This they did.
But when they started to lay hands on the crew to take them prisoner,
they were recognized as comrades. For the large ship was bearing the
arms of Holland and the Prince only by a stratagem of war. It was also
from Dunkirk, but since it had been captured a short time before, from
the Hollanders, it still had their arms carved on the poop. The unfortu-

nate traitor was ridiculed and taken, with his accomplice the pilot, back to Dunkirk. Nothing remains for him but the disgrace of his betrayal, and he will be treated as he deserves.

Another extraordinary thing happened several months ago, which perhaps you have not heard. The Governor of Isendyck, an important place between Flanders and Zeeland, in the hands of the Hollanders, had always been considered a courageous and prudent man. Well, he came in person to Gravelines, disguised as a merchant, in order to spy on the place; but he was recognized and held prisoner until the present. Now he has been set free, although the Council of War stated that it would have been justified in having him pay the ordinary ransom according to his rank. This seemed to everyone to be an act of unheard-of boldness for the Governor of so important a place.[1]

There will be more ships, they say, and an attempt will be made to induce the King to increase armaments, in order to maintain a powerful fleet at Dunkirk. For one can see that even these few ships are having the greatest success and are taking much booty. During these last days they brought in, among others, a captured Turkish vessel.

– 78 –

To Gian Francesco di Bagno *Laeken, February 16, 1626*

Most Illustrious and Reverend Lord:

I wrote to Your Lordship during these past days in great haste, and therefore I am afraid I made a mistake in affirming that the temple of Ephesus was restored during the rule of Augustus Caesar or Tiberius. I should not like to maintain this as strictly as it was written, but rather say that all the Roman emperors consecutively took care that it was kept up and restored more or less according to the need, until the time of Julian, who was the last of the emperors who sought to perpetuate the ancient superstitions. After him, as Christianity gained strength, these vanities little by little declined, and finally, as one reads in the ecclesiastical *Annals*, totally vanished. And by main force, through excessive zeal, those proud edifices were ruined which could have been preserved and applied to our religion. This was done later, when the first fervor of the fanatics had moderated a little. [*In margin*: One reads in the same *Annals* that this was practiced, and we have an example in the Pantheon

and other temples in Rome.] It seemed advisable to me to tell Your Lordship about this doubt of mine, and with a true heart I kiss your hands.

<div align="right">Your Illustrious and Reverend Lordship's

most devoted and humble servant,</div>

Laeken, February 16, 1626 Peter Paul Rubens

<div align="center">– 79 –</div>

To Valavez *Brussels, February 20, 1626*

Monsieur:

I have received your most welcome letter of the 13th of this month, along with that of the Abbé de St. Ambroise, who shows himself courteous, as is his custom, and as well disposed toward me as ever. The purpose of his letter is to inform me that Monsignor the Cardinal wishes to have two pictures by my hand for his collection, just as you had written me in your last letter. As for the Gallery,[1] the Abbé tells me that the Queen Mother offers the excuse that she has had until now neither time nor opportunity to think about the subjects. All that will be done in due time, since the Gallery is still but little advanced. I am thus forced to believe there is no truth in what the Ambassador of Flanders wrote me on this matter, which I told you in my previous letter.

I have received the *Apologeticus* [2] of Rigault, refuting the *Admonition*, but until now have not been able to read it, because of certain duties. However, the little I saw in turning over the pages pleased me, especially the style, which is clear and vigorous. I have found it impossible to procure that little book of the Arminians, because of the limited relations we have with their country. But in Antwerp I will make another attempt to find it. In its place I am sending you another book in the Flemish language, which is so highly esteemed by the Jesuit Fathers that it could have come from their offices. The letters for Cologne have been forwarded in good order.

Here no one was pleased to hear of the peace between the King and the Huguenots.[3] There is fear of a general rupture between France and Spain — which would be a conflagration not easily extinguished. Surely it would be better if these young men who govern the world today were willing to maintain friendly relations with one another instead of throwing all Christendom into unrest by their caprices. But one must believe

<div align="center">130</div>

that this is heaven's decree, and must accept the divine will. In closing, I kiss your hands with all my heart, and commend myself to your favor.

<div align="right">Your affectionate servant,</div>

Brussels, February 20, 1626 <div align="right">Peter Paul Rubens</div>

<div align="center">– 80 –</div>

To Valavez <div align="right">*Antwerp, February 26, 1626*</div>

Monsieur:

The letters with which you continually favor me, and the particular news on all that takes place at the Court, are most welcome to me. You will already have learned, by my previous letter, that I am completely satisfied with the attitude of the Abbé de St. Ambroise. From his letter which you sent me, and which I answered by last week's post, I realize that he still feels the same kindness and inclination for me. I have no doubt that the rumor concerning the Gallery was false; for the Cardinal is employing me in his own service, which he would not do if there were so great a change in a matter which His Eminence had negotiated and concluded with me personally. But this is not the first time that a report without foundation has been given to the Ambassador.

I am sorry that I have no news to tell you. On Carnival Sunday many Lords of this Court staged a race in the ring à la Saracen to celebrate the birth of the little daughter of the King of Spain. The livery and costumes of the cavaliers were very handsome, but they ran disgracefully, and with very little skill. The Marquis de Campo-Lataro and Don Pedro de Braccamente were the chief contestants, but they did not win the prize of the tournament.[1]

The Most Serene Infanta would be extremely happy if the pregnancy of your Queen should continue, for she loves her as her own daughter. And truly this would be a desirable thing for all the kingdom, and for the Queen and the King in particular. I returned the day before yesterday, by divine grace, to my home in Antwerp, from where I shall be able to provide you with news more easily than from Brussels.

I regret to learn from the letters of M. de la Planche that there appears to be no inclination to pay the remainder of the sum due me for those tapestry cartoons I did in the service of His Majesty.[2] M. de Fourcy and M. Katelin are clearly not men of their word. I should like to know whether you think I could obtain something through the Abbé de St.

<div align="center">131</div>

Ambroise and the favor of the Queen Mother or the Cardinal. I shall do nothing without first receiving your advice on whether this seems practical to you.

I am glad to hear that Signor Aleandro's illness has turned into a tertian fever. For the Nuncio had frightened me by telling me that he was suffering from a constant fever and that his life was in danger. The Nuncio also told me that the Cavaliere del Pozzo would accompany the Cardinal-Legate on his journey to Spain. In closing, I kiss your hands with all my heart and commend myself to your good graces.

<div align="right">

Your most humble servant,
</div>

Antwerp, February 26, 1626 Peter Paul Rubens

<div align="center">

– 81 –
</div>

To Valavez *Antwerp, April 2, 1626*

Monsieur:

You will receive with this post, I hope, with divine aid, the commentaries of Louis Nonnius on the medals *Universae Graeciae, Asiae Minoris et Insularum* in one volume, and in another packet the book on the medals of Julius, Augustus, and Tiberius, with their lives and a commentary by the same Nonnius.[1] I believe that of this material there is nothing else your brother the Councilor needs. It would be well to take care of these books, because they cannot be found separately, but must be bought along with the complete *Thesaurus* of Goltzius, which costs 50 francs. This I have done, in order to serve you according to your wishes. But do not worry about it, for the rest will not be thrown away.

Thank you for the news you send me, which, along with the Decree,[2] I have communicated to the Jesuit Fathers. They had not yet seen it, and were somewhat mortified. But I can assure you that these Fathers, rather than lose once more the beautiful kingdom of France, recovered at great pains, will subscribe to everything and do all that is required of them.

Here things are as quiet as if both parties had agreed in deciding to have no more war. There is no talk of beginning a campaign this summer, as in other years. Even though the cavalry cannot go out until the grass has grown and the hay is ready, preparations are usually made early; but so far we have seen no indication.

The edict against dueling is remarkable by its decision to show no mercy, and to me it seems the only remedy for such an incorrigible

mania.[3] I shall be pleased to have a copy of this edict, as you promise me. I should also like to have a copy of Father Mariana, on the defects in the institution of the Society of Jesus.[4] This book you gave me in Paris, but on my return Father Andreas Schott saw it, and begged me with many entreaties to let him have it for a few days. Now he tells me that the Provincial has taken it away from him, with a stern reprimand. That is why I should like very much to have another copy. But I should prefer to have it in Spanish rather than in French, for if I remember rightly, you said that it would soon be printed in that language.

I hope, although I cannot definitely affirm it, that with the next post I can send you the picture of the cameo of Ste. Chapelle.[5] In order to avoid the most serious difficulties it has been necessary to give up the attempt to observe so precisely all the variations in the stone which you probably remember, as, for example, the white, which becomes more pallid or gray in places. I have been obliged to represent only the white and the upper and under layers of the sardonyx. I hope that the Councilor, your brother, great connoisseur that he is, will find some satisfaction in it. And having nothing else to say, I close in kissing your hands with all my heart. I beg you to present my greetings to your brother. I am sorry to hear that he is not yet entirely cured, as I had thought when you wrote me that he would go to greet the Legate on his way through Provence. I hope that the Lord God will grant both to you and to him perfect health and a long life; that is what I desire with all my heart.

<div style="text-align:right">

Your most affectionate servant,
</div>

Antwerp, April 2, 1626 Peter Paul Rubens

– 82 –

To Pierre Dupuy *Antwerp, April 24, 1626*

Monsieur:

M. de Valavez has assured me that you will be willing to correspond with me during his absence. This would be the greatest comfort to me, provided that it does not cause you any inconvenience. For you probably have many such obligations, and if I am not mistaken, you spend a great part of your time in maintaining correspondence with all the most distinguished personalities of Europe. Thus I am afraid of being accused of ambition in presuming to be included in the number of your friends and servants. But this must be attributed to M. de Valavez, who, having over-

whelmed me with all sorts of favors, has wished to oblige me still more by choosing you for me as his successor. He did it without my knowledge, for I myself should not have been so bold as to hope for such a thing. But if you decide to take this trouble, you will oblige me by taking complete liberty, always choosing the hour and the day which will suit you best, without binding yourself in the least. And I shall ask for the same privilege for myself, because my duties do not permit me to fulfill all my desires, or to treat my friends with the punctuality which I should like, befitting their rank and my obligation to them. I pray you, therefore, to bear with patience my negligence in writing, as well as the slight pleasure which I am capable of furnishing you. Finally, you will have to put up with an unfair exchange; your letters compared to mine will be like gold in return for lead. But, as I have said, this disadvantage must be ascribed to the agent of this transaction. I confess, however, that I am infinitely obliged to him. In closing I kiss your hands with all my heart, begging you to extend a similar greeting to M. the Councilor de Thou and to your brother, to whom, as well as to you, I shall always remain the most humble servant,

Antwerp, April 24, 1626 Peter Paul Rubens

– 83 –

To the Marquis Spinola *Antwerp, June 29, 1626*

Your Excellency:

I am afraid of boring Your Excellency with my letters, even though my importunity must be attributed to the occasions that present themselves, and not to myself. Now I have to inform Your Excellency of the little I hear from that friend from Zeeland with whom Your Excellency ordered me to maintain correspondence. It is true that, due to the difficulties of passage, the letters almost always take some days longer than they ought to. Letters that arrived recently tell about the fleet of the [Dutch] West India Company. They write that it is lingering about the Cape of Lope Gonzalez, at the second degree latitude below the Equator, having captured some little boats of small value which serve as booty — insignificant, but only to keep that fleet in good humor, and not to bring any profit to the West India Company; that when the directors learned this, they promptly ordered fifteen ships with very few soldiers but with thirty sailors each, which departed on the 20th of May in the direction of the

said Cape of Lope Gonzalez, in the hope of finding there the above-mentioned fleet. The Admiral's orders to these fifteen ships were to make an extreme effort to join that fleet, to distribute a good part of their seamen according to the greatest need, and to proceed together toward the coast of Brazil, with the purpose of recapturing the Bahia de Todos os Santos by surprise attack. This is certain [*in margin*: these are the words of my correspondent], as he writes, and serves as an infallible warning to His Majesty. The reason for this haste, notwithstanding the fact that the West India Company had intended to send a fleet of thirty ships on that expedition, is that certain Portuguese who had been with the pirates, when questioned rigorously, declared that the said coast of Brazil is poorly provided with defenders, and particularly the Bahia de Todos os Santos, with the city of San Salvador. They say it is guarded with such negligence that the ruin inflicted by our artillery when it recaptured the place has not yet been repaired. [*In margin*: I speak in the person of the Zeelander.] I warned two months ago that the said Company was arming thirty ships for this purpose, but the report of these Portuguese has already precipitated the affair, because of the great hope the directors [of the Company] have of being able to make use of their fleet which is at the Cape of Lope Gonzalez, and of gaining control of Bahia by assault. A warning of this obvious danger deserves to be sent to His Majesty by express messenger; and perhaps there would be time to warn the Governor of Bahia by some special caravel, so that he might be on guard.

This, word for word, is what that friend wrote me. I refer it to the judgment of Your Excellency, and humbly kiss your hands.

<div style="text-align: right">

Your Excellency's most humble servant,
Peter Paul Rubens
</div>

Antwerp, June 29, 1626

<div style="text-align: center">– 84 –</div>

To Pierre Dupuy *Antwerp, July 15, 1626*

Monsieur:

You do well to remind me of the necessity of Fate, which does not comply with our passions, and which, as an expression of the Supreme Power, is not obliged to render us an account of its actions. It has absolute dominion over all things, and we have only to serve and obey. There is nothing to do, in my opinion, but to make this servitude more honorable and less painful by submitting willingly; but at present such a duty seems

neither easy, nor even possible. You are very prudent in commending me to Time, and I hope this will do for me what Reason ought to do. For I have no pretentions about ever attaining a stoic equanimity; I do not believe that human feelings so closely in accord with their object are unbecoming to man's nature, or that one can be equally indifferent to all things in this world. *Sed aliqua esse quae potius sunt extra vitia quam cum virtutibus,* * and they arouse in our souls a kind of sentiment *citra reprehensionem.*† Truly I have lost an excellent companion, whom one could love — indeed had to love, with good reason — as having none of the faults of her sex. She had no capricious moods, and no feminine weakness, but was all goodness and honesty. And because of her virtues she was loved during her lifetime, and mourned by all at her death. Such a loss seems to me worthy of deep feeling, and since the true remedy for all ills is Forgetfulness, daughter of Time, I must without doubt look to her for help. But I find it very hard to separate grief for this loss from the memory of a person whom I must love and cherish as long as I live. I should think a journey would be advisable, to take me away from the many things which necessarily renew my sorrow, *ut illa sola domo moeret vacua stratisque relictis incubat.*‡ The novelties which present themselves to the eye in a change of country occupy the imagination and leave no room for a relapse into grief. For the rest, it is true *quod mecum peregrinabor et me ipsum circumferam,*§ but believe me, it would be a great consolation to see you and your brother again, and to be able to serve you in some way that will please you, according to my ability. For your sympathy, your friendliness in consoling me, and for the correspondence which you have promised me during the absence of M. de Valavez, I am deeply obliged to you, and I shall remain your most humble servant as long as I live.

<div align="right">
Your most humble servant,
</div>

Antwerp, July 15, 1626 Peter Paul Rubens

* There are certain things which are rather outside the vices fhan with the virtues (Tacitus, *Historiae* 1.49).

† Beyond censure.

‡ Just as she [Dido] mourns alone in the empty house, and broods over the abandoned couch (*Aeneid* 4.82).

§ That I shall travel with myself, and shall carry myself about with me.

To Pierre Dupuy *[Brussels, July 24, 1626]*

I have nothing of importance to report because of the present state of in-activity in this country. It is true that the Hollanders are planning a cam-paign. They are drawing only twenty to thirty men from each company, which seems to indicate that they are not forming an army, but simply mobilizing at the request of their allies in Germany. We have definite news from that country through M. de la Mottine, Governor of Maas-tricht, who has just come from there. He says that Wallenstein has a powerful army which could, altogether, reach the number of 50,000 combattants; but that Tilly's does not exceed 15,000 men, including 5,000 horsemen.[1] The peasant uprising in Upper Austria is spreading furiously.[2] They have taken possession of Linz — that is to say, the town but not the castle, which so far is holding out. Wallenstein has moved suddenly, without saying where he was marching in such haste, but one can guess it is in that direction. The peasants have sent their demands to the Emperor in thirteen articles, utterly exorbitant, and to the great dis-advantage of the Emperor and the Duke of Bavaria. Thus their claims are unacceptable, and the affair, it seems, will have to be settled by the sword. In the meantime, as the above-mentioned Governor of Maastricht tells us, the expedient of killing all the peasants in the surrounding prov-inces has been carried out, in order to prevent an increase in the number of rebels. The country has therefore been reduced to such desolation that one finds on the roads nothing but heaps of human corpses and innumer-able swine. [*In margin*: This part of Hesse abounds in swine.] These animals running about through the already ripe grain, have multiplied to such an extent (you know how prolific they are) that they are serving to feed Tilly's army.

The city of Cassel is besieged by the Imperial troops. The capital of Hesse, it is well fortified and provided with an arsenal containing more than one hundred pieces of artillery in bronze, and all sorts of munitions. But since it has become the refuge of a countless number of useless per-sons, it will probably very soon lack provisions. Some agreement may then be reached, since the opposing parties are not deadly enemies.

Here they are considering two very impressive undertakings. One is to cut a new navigable canal from the Meuse, in the vicinity of Maastricht, as far as a river called the Demer, near Malines; this would be a distance of fifteen leagues. I have seen the plans, which look very promising, but

it will be a long and costly operation. The other project is to divert the Rhine from its usual course, leaving dry large areas of enemy territory, and removing every obstacle of the other rivers branching off from the Rhine, thus allowing entry into the Veluwe, and control of all the province as far as Utrecht. But I have not yet seen the plan of this project, and do not believe every detail has been decided upon. If we come to the point of putting these plans into operation, we shall have to expect war in this region, unless I am mistaken. For the Hollanders will surely try to hinder the work with an armed hand, and we shall carry it out only by force.

Three days ago I received a brief letter dated June 30, old style reckoning, from M. Gerbier.[3] It was a letter full of victory and triumph with regard to his master Buckingham. Among other things he told me that all the machinations of the Duke's enemies have never struck so near his heart as to divert his taste for pictures and other objects of art.

– 86 –

To Pierre Dupuy [*Antwerp, July 30, 1626*]

We have no news, except that the Hollanders have begun a campaign and are stationed between Emmerich and the Rhine with a moderate force. They have left all their fortresses well defended, and particularly those in Cadzant near l'Ecluse, where they have stationed a garrison of 2,000 men. In the same proportion they have provided for the defense of Bergen, Heusden, and other places, according to the size and needs of each, so that the Marquis Spinola, knowing exactly how many troops they have in all, can easily judge how strong they are in the field. It might well be that they are planning to besiege some place like Groll or Oldenzaal. That is why our troops are marching in that direction, under the command of Count Henry de Bergh,[1] with the Count d'Isembourg leading the advance guard. The Marquis, up to the present, shows no indication of wanting to go in person.

– 87 –

To Valavez [*Antwerp, September 11, 1626*]

On August 28 the Hollanders began to show themselves with countless ships, so that one could see their fleet from the towers of this city. Some

days before, reports came in from all sides that they must be going to attempt an attack on Antwerp (others said on Hulst) and that they wanted to seize control of the dykes. More ships were said to be coming by way of Dunkirk. It is true that campaigns against Antwerp and against Hulst would coincide in many points, and an attack on one would mean an attack on the other. Our troops were already marching toward the province of Flanders, in particular four regiments from the camp of Calloo, under Don Juan Carlos de Guzman y d'Idiaquez. The brave old Captain Baglioni marched in person with his battalion. Last night a fire signal was shown from the tower of Notre Dame; the citadel shot off a volley of cannon, and all the forts responded. And the Marquis is having a bridge of boats immediately thrown across our river before the city, to serve as passage for soldiers going from Brabant to Flanders, or in the opposite direction, when necessary.

On the 29th the enemy ships advanced so that one would think they must be coming directly toward this city; but having arrived a little above Lillo, they took the curve of the river and proceeded toward the inlet of Saftingen. And entering this arm of the river, they sailed directly toward Hulst, but then stopped, all together, above Kieldrecht, a league this side of Hulst. In the lead were four warships and a galley, recently built, which had been captured from us at Ostend during a mutiny of the convicts, and thanks to the negligence of its captain. Kieldrecht has a very advantageous situation on a sort of promontory, with a small artificial canal behind it which transforms it into an island, or at least a peninsula, since the canal is sometimes dried up in spots. When this occurs the place is not very strong, since it possesses only one small fort with two companies of Walloons as garrison.

The Hollanders did not attack the fort, but tried to enter and seize this little canal, in order to erect ramparts on both sides and set up their artillery there. They calculated that in this way Kieldrecht would have to fall into their hands within two or three days, owing to lack of provisions and also to the weakness of the defense. It was their plan, since Kieldrecht is in the middle of the province of Flanders, to turn it into a royal fortress and thus to gain control of all the country between Hulst and Antwerp as far as the river. They would then have been able at leisure to take possession of the dykes and cut off these two cities. But shortly before there had arrived six pieces of field artillery which Baglioni set up on a dune opposite the mouth of the canal; he stationed the infantry in good order behind the dyke and filled all the plain with peasants well armed. The Hollanders had worked for two hours, from ten until twelve,

in the greatest heat of the day, but now the tide, which had allowed them to approach without wind, turned against them, and they were forced to retire with some losses inflicted by our artillery. We did not lose a single man. The enemy had to abandon two grounded ships, one laden with munition, and the other with twenty-eight horses. They tried to come to the aid of these vessels by means of launches (small boats with oars and flat bottoms) manned by musketeers, but were repulsed by the soldiers of Kieldrecht, who seized both ships and set fire to one of them.

All that day the Dutch vessels remained together, and everyone thought they would return toward nightfall with the high tide, and that this had been only a stratagem to divert our forces. But it proved to have been a genuine attempt, for the following day they retired toward Tholen, where they put ashore many horses wounded by our artillery and suffocated by the intense heat which had prevailed during those days.

And now the Marquis, who had never left Brussels, has given orders to turn Kieldrecht into a fortress capable of defense against all attacks on four sides. Work on it has already begun.[1]

Just in the nick of time (for we were reduced to absolute penury), a courier from Spain arrived bringing 1,600,000 crowns, with a promise of a larger sum. He also brought the news that forty warships would soon leave Biscaya for Dunkirk, to oppose the English fleet. The latter has delayed too long to accomplish anything, for a great number of ships has also left Seville, well armed with sufficient forces to support the naval operations on land.

Last Saturday there came an express messenger to the Most Serene Infanta from Don Francisco de Medina, Governor of Wesel. He reported that on August 26 the King of Denmark had cut to pieces four companies of Tilly, who was on the march to surprise another town after having taken Göttingen. But upon receiving a reinforcement of 7,000 infantry from Wallenstein, Tilly decided to attack the King, who was retiring in good order. He pursued him for two days and two nights, and finally stopped him behind a marsh. But since the enemy was protected on one side by a mountain, Tilly could not attack him in this position, and so began a skirmish from another side. And the King, whether through bravura or inexperience, left his advantageous position and accepted battle on the plain. After a long conflict he was completely put to rout; he lost his baggage and his artillery, almost all his infantry perished, and his cavalry also suffered heavily. A great number of banners and pennants fell into our hands, and countless standards. As to the King himself, we have no news of what has become of him. [*In margin*: We

learned yesterday, through letters from Cologne, that the King retreated with a good part of his cavalry.] But his Lieutenant General Fuchs fell on the battlefield. And Lohausen, Linstein, Pinckinck, Cernile, Bernt, Gentsen, with a great number of officers and 3,000 soldiers, after withdrawing to a castle named Lutter, were forced to surrender as prisoners to Count Tilly. They say that the number of our dead is not very great, although the Captain of Cavalry, Assuerus, and a Captain Ferarti died in combat. The Most Serene Infanta had a Te Deum sung, and fires of joy were lighted first in Brussels and then in the other cities subject to the King of Spain.

Letters from Cologne, which arrived last night, confirm the news of Tilly's victory, and say that he took more than one hundred standards, twenty-three pieces of artillery, and all the King's silver-plate, but that the King himself was saved, with a part of his cavalry.[2]

– 88 –

To Pierre Dupuy *Antwerp, September 17, 1626*

Monsieur:

It seems that I must finally believe that M. de Valavez has left Paris, since he told me the exact day. I feel the keenest regret, for I am in truth deprived of the best correspondence in the world, considering the unbelievable care and punctuality with which this gentleman favors his friends and servants. I should not like to have you assume such a burden, but since you are pleased to honor me with your correspondence, it will be enough for you to send me copies of various public news-sheets of the better sort, but at my expense. For it is not reasonable or fitting for you to offer any more than the courtesy and the care of sending them to me. I am sorry that we do not have the same convenience here, but we are not accustomed to news-sheets. Everyone informs himself as best he can, although there is no dearth of rumor-mongers and charlatans who print reports unworthy of being read by honest men. I will do my utmost here to gather information and not mere trifles, *sed summa sequar fastigia rerum.** But this time we have no news of any sort to report. By the last courier I wrote somewhat fully to M. de Valavez concerning the Hollanders' attack upon Kieldrecht, and the defeat inflicted by Tilly upon the King of Denmark, my account of which has been confirmed

* But I will take up the most important points (*Aeneid* 1.342).

141

on all sides. I should be sorry if that last letter of mine did not reach the hands of M. de Valavez, but he wrote me that he was to leave Paris on Tuesday, and I am afraid that our letters did not arrive until Wednesday.[1] It would disturb me all the more that, being off on a trip, I was unable to write to him by the previous post. Having nothing else to say I will close, kissing your hands with all my heart, and begging you to do the same on my behalf to the Councilor de Thou and to your brother, and to keep me in your good graces and theirs.

<div style="text-align:right">

Your most devoted servant,

</div>

Antwerp, September 17, 1626 Peter Paul Rubens

On September 13 the Dominican Father Michel Ophovius was consecrated Bishop of Bois-le-Duc. He is the one who was in prison at Heusden and The Hague, and in peril of his life for having tried to bribe van Kessel, Governor of Heusden. He has done well to exchange bonds for the miter.[2]

<div style="text-align:center">

– 89 –

</div>

To Pierre Dupuy *Antwerp, October 1, 1626*

Monsieur:

I am sorry not to have any interesting reports which could give you some pleasure. But this Court is sterile, and offers no news like that of France, which, by its great size, is subject to momentous changes. Here we go on in the ordinary way, and each minister serves as well as he can, without overstepping his rank; and in this manner each one grows old and even dies in office, without expecting any extraordinary favor, or fearing disgrace. For our Princess shows neither hate nor excessive love, but is benevolent to all. The Marquis Spinola alone is powerful, and possesses more authority than all the others together. In my opinion he is a prudent, able, and diligent man, and untiring in his work.

The Hollanders, after the failure of the attack on Kieldrecht, encamped once more, with the greater part of their forces, between Retz and Emmerich. Our object in the war this year will be the cutting off of the Rhine, which is already begun, as a servant of the Marquis told me today.[1] It is thought that this work will be of great consequence, if its execution corresponds to the plan. The project which was described to me in Brussels was to change the bed of this river near Düsseldorf, and

to divert it by means of dykes into an arm of the Meuse. [*In margin*: I do not know whether it has since been modified, for this often happens in such enterprises which are subject to so many accidents peculiar to the site.] In this way the Yssel and the other rivers which flow from the Rhine and serve as defense to the Veluwe will be dry, allowing a free passage into Holland, without any natural obstacles. But it is feared that the Meuse and the Rhine together, when swollen by rains, as they often are in winter or in other seasons, will inundate all the neighboring plains, to the disadvantage of both parties; *sed pereant amici, dum inimici intercidant.**

The people of Liége [*in margin*: Leodienses] oppose this enterprise by words and protests, but rather, it is thought, to maintain their neutrality than for the sake of their own interests [*in margin*: since it can bring them only profit and advantage]. Meanwhile Count Henry de Bergh, with a good army, protects the workers, ready to resist by armed force anyone who comes to disturb them. However, the Hollanders and the Prince of Orange in person are advancing in that direction. I believe that the Marquis Spinola has been moved to undertake this work for several reasons. The first is to rid the country of the enemy and to open a passage, as I have said. [*In margin*: Not in the hope of taking Holland by force, but in order to impose levies throughout that country without any hindrance.] Furthermore, he fears to embark upon the siege of some strong place at the wrong time, without being certain of success, and yet, on the other hand, does not want to leave his soldiers inactive, thus appearing to spend the King's money uselessly. He has therefore undertaken this project to avoid doing nothing. For the Hollanders it is important in every way to prevent this above-mentioned diverting of the river, not only for their own convenience and the defense of their country, but for the sake of their commerce with Germany and even of their reputation. It is said that during this time the Marquis will remain in Brussels, but will make a very hasty trip to Dunkirk to arouse a little enthusiasm in the naval militia, for it has become very cool, through various disorders and the bad management of the Spanish ministers [*in margin*: also by the lack of money].

Since I have nothing else to say, I thank you again for your news of the Court, as well as of the condemnation of *La Somme* of Father Garasse.[2] [*In margin*: This condemnation was not a hasty one; in fact, it was slow in coming.] They say here that he has left the Society, and I should like to know whether this is true. I am sorry that I have nothing

* But let friends perish, as long as enemies are destroyed with them (Cicero).

this time with which to repay your courtesy. I beg you to let me know if you hear of any new publication which I might be able to send you; I shall not fail to do so. In closing, I kiss your hands with deep affection and commend myself humbly to your good graces.

Your servant,

Antwerp, September 31 [*sic*], 1626 Peter Paul Rubens

Since we have no commercial relations with Holland here, we knew nothing of the disgrace of the French Ambassador. His wife, while passing through here, paid me the honor of a visit. I beg to be informed of this affair.

I feel troubled at the departure of our dear M. de Valavez — all the more since he left without receiving my letter. But M. Tavernier [3] writes me that he forwarded it immediately. I hope God will grant him a good voyage.

– 90 –

To Pierre Dupuy *Antwerp, October 8, 1626*

Monsieur:

Although I do not feel too much disposed to write, I cannot refrain from informing you of the news which reached this city today, and which is universally believed. The report is that Count Henry de Bergh received word that the Hollanders were marching with a troop of one thousand cavalry of picked men to hinder this work of diverting the Rhine toward the Meuse through an artificial canal. (I wrote you in my previous letter that this, in my opinion, would be our object in the war for this year and perhaps for some years to come.) Thereupon the above-mentioned Count stationed three thousand musketeers in ambush in the vicinity of Calcar. The move was so well-timed that the greater part of the enemy was captured or killed. The day I cannot tell so precisely, but it is thought to have been the second or third of this month. And today some persons who arrived from Brussels affirm having seen four captured standards, sent by Count Henry to the Most Serene Infanta as a sign of her victory. It does not appear that the present Prince of Orange possesses the genius for warfare to so propitious a degree as his brother, whose glory he will hardly reach unless these unfortunate first fruits of his government are obscured by subsequent prosperity.[1] I hope that by the next post I can

144

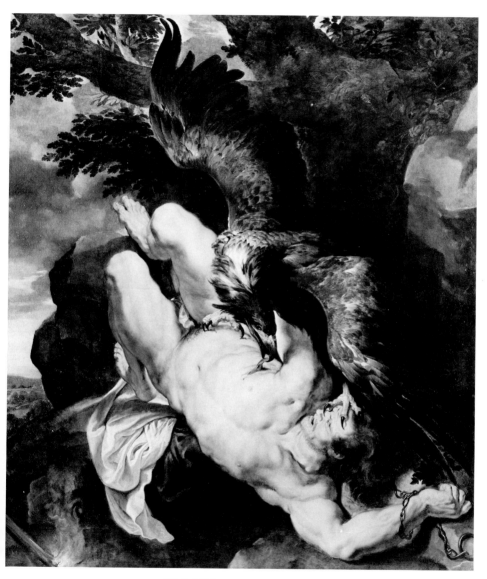

Prometheus. 1611–1612. One of the Rubens paintings exchanged for Sir Dudley Carleton's ancient sculptures and described in Letter 28.

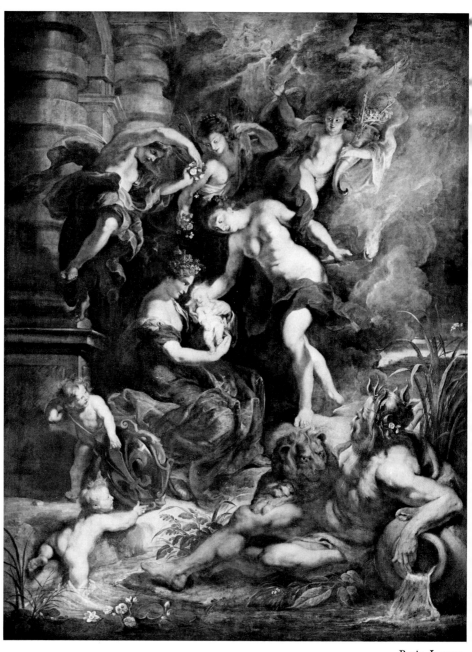

The Birth of Marie de' Medici. 1622–1625. Painted for the Medici Gallery in the Luxem-
bourg Palace and described in Letter 93.

give you some further details on this success. And since I have nothing else to say now, I kiss your hands with all my heart.

<div align="right">
Your affectionate servant,

Peter Paul Rubens
</div>

Antwerp, October 8, 1626

<div align="center">

– 91 –

</div>

To Jacques Dupuy *Antwerp, October 15, 1626*

Monsieur:

I have learned, with great sympathy, of your brother's illness, and I am extremely sorry that, finding myself likewise in bed with a violent tertian fever, I cannot substitute, to carry on our correspondence, my own brother whom the Lord God took away from me many years ago.[1] And so I rely upon your discretion and courtesy to accept these few lines as a most unequal response to your very complete and copious letter of October 4, which has given me particular comfort for the variety of reports it contained, with the brief and effective remarks which accompanied them. I feel languid both in body and spirit, because even though the fever is going down, you know that the intermittent days have been occupied by doctors with purges, bloodletting, and similar remedies often more grave than the illness itself. And so you will excuse me if this letter shows little vigor, in conformity to its writer.

The most important thing we have to report now from here is the skirmish and the foray of Count Henry de Bergh into the encampment of Dutch cavalry. This was stationed, along with their infantry (although somewhat separated) near the Rhine in order to prevent the cutting off and diverting of that river from its ordinary course into the Meuse. For greater conciseness I am sending you a printed diagram and also a published report of this action which you may trust, though it is written with a certain degree of passion. For in comparing it with the letters written from all sides (of which this account must be supposed to be an extract), I reject that last report from Wesel, dated October 6, which I consider false and an addition of the author. Moreover, in the diagram there is no regard for the proportions of the site, nor any cosmographical [*in margin*: geographical] symmetry. You will merely be able to note the cities and rivers there named, and refer to some other more accurate map, being content to recognize in this picture the place where this cut-off is being made, and the position of the two armies. [*In margin*: In

<div align="center">

145

</div>

the number of captured and dead there is no exaggeration in this report, because there were actually taken about one thousand horses but not so many men, who numbered not quite four hundred, with about the same number killed.] I have not been able, because of my indisposition, to translate this report from Flemish into French, but I hope that M. Grotius [2] will not fail to do this service for you, and I beg you to kiss his hands in my name. It appears that the Hollanders want to divert our forces; again last night they tried to cut certain causeways near there, but in vain. It seems that the Marquis Spinola has his eye everywhere, and that is why, notwithstanding the fact that his presence was very necessary at Dunkirk, he did not wish to go away from the center, or leave the Most Serene Infanta to undertake and carry out all the expedient decisions according to the circumstances that arise unexpectedly from one hour to the next.

Having nothing else for now which deserves to occupy your leisure and mine, it only remains for me to thank you for your careful reports, among which the first, concerning the happy arrival of M. de Valavez in Lyon, was most welcome to me, auguring the same felicity for the rest of his journey. But the death of the Constable [3] gives the lie to his astrologer, who had assured him of an entire century of life, and a victorious death equal to that of Epaminondas,[4] on a bed of honor. Surely Mons. de Crécqui [5] made a *coup d'état* by marrying his daughter, in order, with a few ceremonies, to play safe and hold such united riches as would almost suffice for an absolute prince, and arouse the jealousy of a sovereign.

I beg you to oblige me by telling me clearly your opinion about this conspiracy,[6] whether the case was as atrocious as many people think, on the basis of the royal charge given to the judges of Chalais, and his sentence for the crime of making an attempt upon the person and the life of His Majesty. This, however, does not seem likely to others, because it would be too reckless on the Grand Prior's part, presupposing such knowledge, to allow himself to be drawn into the plot, or, on a mere false promise of impunity, to let his brother the Duke of Vendôme and himself be led into the snares of inextricable perdition. Besides, it is seen that the brothers have now been released, as well as the widow of the Marshal d'Ornano and certain others. I confess that I cannot fathom this affair. It seems that in the meantime the Cardinal is availing himself of the occasion to protect his person with guards. But this will greatly increase the hatred toward him, since it has not been seen, up to now, in any favorite in the world, except Seiano.[7] Our Marquis, although he is general of all the armed forces, has no personal guard except in camp.

Nor does the Count of Olivares live with such suspicion that he needs to ask for such a thing unless for grandeur and ornament. Even the Duke of Buckingham, in all the recent troubles and in spite of the universal grudge of an entire kingdom, has not availed himself of this ultimate remedy which alone distinguishes sovereign majesty from private power, however great.

I had a chance to see Mons. Ferrier[8] in Paris, and if I am not mistaken, once in your house. And I have read some of his anonymous things written in favor of the present government and of the pure "reason of state" of the kingdom of France, without any other consideration or respect for Catholicism. They pleased me very much, both for elegance of style and energy of argument. I have seen little by Theophilus,[9] except something in honor of the late Prince of Orange and some lamentations written during his imprisonment. But that famous *Satirico* of his, which was the cause of so many ills, has not yet come to my hands. I remember well that in Paris some people considered him an Atheist and a corrupter of the noble youth. And the members of the Rosicrucian sect [*in margin*: and also many others] esteemed him very highly.[10] It is too bad that in death [*in margin*: which lifts the mask of dissimulation] it has not been granted him, through that imposter, to undeceive either one group or the other. But not being able to say more, I come to a close, kissing your hands with all my heart, and begging that you do the same, on my behalf, to your brother, whose convalescence and health I desire as much as my own. And commending myself humbly to the favor of both of you, I remain

<div style="text-align:right">

Your most humble and affectionate servant,
</div>

Antwerp, October 15, 1626 Peter Paul Rubens

<div style="text-align:center">

– 92 –
</div>

To Jacques Dupuy *Antwerp, October 22, 1626*

Monsieur:

Although the fever has left me, I still feel the effects of my recent illness. Just as the sea, after a great tempest, does not subside at once, but retains a certain agitation before becoming calm, so do I find myself in an intermediary state — out of danger, but not entirely free from illness. I hope that your brother also will soon recover his health. Were it not that I regard M. the Councilor de Thou[1] as my master and patron, how I

should envy him for enjoying before I do that good fortune which I have promised myself for so long! I pray the Lord will grant him a good journey and an even happier return, with all the enjoyments and all the satisfaction which that beautiful country can promise a spirit like his. I am glad that M. de Valavez has arrived safe and sound in his homeland, and I hope that we shall soon receive some news of the health of M. de Peiresc, his brother. A few days ago I received a letter from Signor Aleandro, dated the 19th of September, from Rome. He tells me that his life has been in danger through a long illness, and that he still suffers repeated relapses.

Here we have no news except that the Marquis Spinola left on the 18th for Dunkirk with the majority of the first officers of the Court. His intention is to reorganize, as well as he can, our naval forces in that region. Last year, by his presence and that of the Most Serene Infanta, incredible progress was made in a very short time, but then the bad management of the Spaniards, and especially the lack of money, greatly reduced the enthusiasm. Some of those ships have gone out cruising and have caused some damage to the herring-fishing, but I do not know whether they will meet opposition on their return. It is criminal cruelty on the part of the Hollanders to refuse to give quarter in these waters; for I can testify that, in spite of the thoroughly good treatment which the Most Serene Infanta has shown their prisoners, they, on the contrary, have mercilessly thrown into the sea all of ours who have fallen into their hands. The result is that Her Highness, after having vainly persevered for a long time in her merciful treatment, has finally been forced to take reprisals and pay them in their own coin. In the meantime those ships from Dunkirk sometimes make good captures; but the forty ships which were to come from Biscaya are no longer expected. It seems that they have been sent to meet the fleet from Peru, which, according to the reports of merchants, is laden with 20 millions in gold, not counting the treasure which is coming in secret, as is usually the case. The English have gone out to seize their part of it, but we believe that they have delayed too long and that Spain has provided for the event of an encounter; at least she has not lacked time to do so.[2]

Here there is talk of a defeat inflicted by the Imperial troops upon Bethlen Gabor [3] and the Turks, but since this is not yet certain, I shall wait until the next post to write to you about it.

I thank you for the minute details which you give me on the news of the Court — noteworthy news, especially with regard to the grandeur of the Cardinal. One could rightly tell of him the same thing as that

148

which happened to King Philip III during my time in Spain. The King, in granting audience to an Italian gentleman, referred him to the Duke of Lerma (with whom an audience was extremely difficult). "But if I had been able to have an audience with the Duke," replied the gentleman, "I should not have come to Your Majesty." All this confirms my belief that it is difficult to conduct affairs in a country where a single man has the power and where the King is only a figure-head; or one can say *quod agat magistrum admissionum ad cardinalem.* * This is a state of affairs which cannot long endure. May it please the Lord to change it for the better. And I pray Him to grant to you and to your brother long life, health and every satisfaction.

P.S. I am sending you *Scopas Ferrarianas.*[4] I have not read it, nor do I wish *bonas horas tam male collocare* † as to read this nonsense, toward which I feel a natural animosity. But if I can serve you in any other way, I am entirely at your command.

The verses on the Medici Gallery [5] are very beautiful, but I realize that I owe little thanks to the poet, since he passes over me in silence. I must confess that I have not had the time to read them with care, *sed sparsim tantum.*‡ I thank you for this gift.

<div style="text-align:right">

Your affectionate servant,

</div>

Antwerp, October 22, 1626 Peter Paul Rubens

<div style="text-align:center">

– 93 –

</div>

To Jacques Dupuy *Antwerp, October 29, 1626*

Monsieur:

I have read with more attention the poem on the Medici Gallery. It is not for me to judge the quality of the verses; I leave that to persons of that profession. But they appear to be of a generous and fluent vein, and both words and phrases seem to express readily the idea of the author. If I am not mistaken, he must be a son or relative of a *maistre de requestes* [*in margin*: named M. Mareschot] [1] whom I have seen in Paris. I only regret that while the subjects of the pictures are in general well explained, in certain places he has not grasped the true meaning. He says, for example, of the fourth painting: *Mariam commendat Lucina Rheae*

* Where he serves as Chief Marshal to the Cardinal.
† To employ good hours so badly.
‡ But only cursorily.

(instead of Florence) *quae tanquam nutrix ulnis excipit suam alumnam.*[*] This error results from the similarity between the figure of a city, which is crowned with turrets, and the usual representation of Rhea or Cybele. For the same reason a similar error occurs in the ninth painting, where the author mistakes the city of Lyon, where the marriage took place, for a Cybele, because of the turreted crown and the lions drawing the chariot. But to come back to the fourth picture, the figures that he calls Cupids and Zephyrs are the happy Hours attending the birth of the Queen; they can be recognized by their butterfly wings and because they are feminine. As for the youth who carries the cornucopia filled with scepters and crowns, he is the good Genius of the Queen, and at the top is found the ascendent sign of the horoscope, Sagittarius. These things seemed to me to be most appropriate and significant. But let these remarks be *entre nous,* just to pass the time, for, after all, I am not the slightest bit interested. I could find other passages here and there, if I wished to examine the whole. But the poem is indeed brief, and one cannot say everything in a few words. But it does not serve brevity to say one thing instead of another.

Just at this moment I received your most welcome letter of the 22nd, along with that of your brother. I rejoice with all my heart that he has recovered his health, in which I pray the Lord will preserve him for a long time. I am not writing to him separately, in order to spare him the obligation of sending me a superfluous reply.

We have very little news, except that work progresses valiantly and in good order on the canal of which you have heard. Count Henry de Bergh, with his army, protects the laborers [*in margin*: within sight of the Dutch camp]. The surest indications that a skirmish of some importance has taken place are the number of prisoners [*in margin*: among them some persons of rank], the captured standards, and the great number of horses which are being sold everywhere; a group of the best ones has arrived in Brussels. It is true that in Holland the whole thing has been published in reverse, with the report that Count Henry has been beaten. But these are the tricks of a popular government, to keep the people in good humor. Our Court, however, you may believe me, is very moderate, thanks to the prudence of the Most Serene Infanta and the Marquis Spinola, who abhor such vanity. A commander will guard against giving a false report when it is possible to learn the truth; this would endanger his credit in the future.

The news has been confirmed from all sides that Tilly with his army

[*] Lucina commends Marie to Rhea, who holds her charge in her arms like a nurse.

has penetrated as far as the environs of Bremen, and that he intends to pass the winter in laying siege to that city. The Grand Turk has broken with the Emperor and has been joined by Bethlen Gabor. But it seems, according to letters from Vienna, that the Hungarians have abandoned Gabor and declared themselves neutral, not wishing to fight any more, and this would place him in great danger. Out of this difficulty, however, there has resulted some treaty about which we know nothing certain.[2] This Emperor, who never arms himself, must have the protection of heaven, since in the midst of the greatest misfortunes, when he seems reduced to despair, there appears some *deus ex machina* which sets him again at the top of the wheel. I confess that many times I have judged him to be a ruined prince who, by his own untimely zeal, was throwing himself into destruction. I am surprised that the Turk has broken with the Christians at a time when his kingdom is torn by internal dissensions, when he encounters such obstinacy on the part of the Janissaries and continual affronts from Persia, and when he is badly treated by all, and obeyed by no one. That monarchy seems to me to be marching to ruin with great strides, and needs only an accident to give it the finishing stroke.[3]

I thank you for your news of France, and I am glad to learn that the decoration of the Queen's palace is progressing. The Abbé de St. Ambroise must be very busy, since he does not write to me any more, even though he has occasion to do so. Since I have nothing else to say, I kiss your hands and your brother's with all my heart, and commend myself to your good graces.

<div style="text-align:right">Your affectionate servant,</div>

Antwerp, October 29, 1626 Peter Paul Rubens

Every possible effort has been made to obtain the *Quaestio Politica*,[4] but so far no one here has seen it, or even knows of it.

<div style="text-align:center">– 94 –</div>

To Pierre Dupuy *Antwerp, November 5, 1626*

Monsieur:

You have done me a great favor in giving me a report on this trial,[1] which I wanted very much to see. But this does not seem to me to be the real plot, but only an incident connected with the imprisonment of the

<div style="text-align:center">151</div>

Marshal d'Ornano. It is evident that the object of the conspiracy was the Purple and not the King, although the King declared to the delegation of judges that an outrage had been committed against the kingdom and his own person. It is possible that the first plot, which must be called the principal one, was different from the second, which was perhaps only an expedient to liberate the prisoners. I am surprised that the Prince of Piedmont [2] has come to the Court at this juncture, and I cannot imagine what purpose or what part the Duchess of Chevreuse could have had in this affair, without her husband's knowledge. I doubt that Monsieur has an easy mind, and I believe that it is fortunate for France that Madame is already pregnant. But for the personal security of the husband it would have been better if there were not so much haste. The Queen [3] must be annoyed at her own slowness, or that of the King; for this reason she might some day return to her own country. There are diverse opinions here of the embassy of Bassompierre.[4] They write from London that matters have taken a very bad turn, and that he has already sent one of his secretaries to France to inform His Majesty and to ask permission to return as soon as possible.

The Count de Gondomar [5] has died in Biscaya, on his voyage to Spain. He was a good friend of the English, and was highly regarded and well liked, although a Spaniard, by King James. He had made the arrangements for the marriage of the Prince of Wales and the Infanta of Spain, and had given the Prince the opportunity to make that journey. One of his chief aims was to make peace between the Spanish and the English, and I believe if he had arrived safely at the Court, he would have urged it strongly. But the Count of Olivares, who dominates absolutely here just as your Cardinal does with you, is most hostile to the English, and particularly to the Duke of Buckingham. With this death, therefore, it is believed that negotiations for peace will also be buried.

The English fleet is thought to have gone out to waylay the fleet from Peru and the cargo ships from Goa, reported to have arrived by now at Terceira. We hear that forty galleons have left Lisbon to escort this fleet, which is also accompanied by a convoy extraordinary, so that probably some naval conflict will result. The English have more than forty ships in all [*in margin*: it will be forty-five ships in all], of which ten, commanded by Denbigh, form the vanguard. These set out three weeks ago, although they are still holding to the west coast of that island. Twenty others, along with fifteen Dutch ships, form the whole armada, in addition to those just mentioned, and they have as Admiral the Baron Willoughby. That their intention is not to make a landing somewhere

one can guess from the small number of men they are carrying — all seamen, but enough to combat the enemy vessels. Moreover, they have not brought with them the necessary equipment for land warfare. [*In margin*: In order to put men ashore, many soldiers are needed.]

The Marquis Spinola, under the pretext of going to restore naval affairs at Dunkirk, is said to have attempted a raid upon a fortress called Le Pas, near l'Ecluse. The leader of the enterprise, and its originator, was a certain so-called Count de Hornes, who acquired this empty title through some transaction with the States of Holland. He is also a chemist and an engineer, but this time he was no more successful in leading this expedition than in his search for the Philosopher's Stone. For the attempt was discovered, and when, in the company of M. de la Fontaine, Governor of Bruges, he reached the fortress, they were received by the garrison with arquebuse and cannon-fire, which killed some of their men and wounded the above-mentioned Count in the face. It is very strange that it has not yet been possible up to now to learn the exact truth about this event, though it took place on October 29. Rumors are so diverse that one can affirm nothing certain, except that the enterprise failed. Having nothing more to tell you, I close, humbly kissing your hands and those of your brother, and commending myself to your good graces.

Your most affectionate servant,
Antwerp, November 5, 1626 Peter Paul Rubens

This *Quaestio Politica*, of which you wrote me, has now appeared, and also another little book entitled *Instructio Secreta ad Comitem Palatinum*.[6] I should have been glad to send them to you, if you had not countermanded this commission. To tell the truth, these trifles are not worth the postage, and I am often surprised that M. de Valavez pays so dearly for them. When you would like to favor me by sending me some book such as the one you tell me is now in publication, you have only to consign it, through M. de la Mothe, to the Ambassador of Flanders, and he will have it delivered safely to me. In the same way, if anything turns up here, worthy of your interest, I shall find some friend passing through who will take it and forward it to you.

Monsieur:

You oblige me so much by the punctuality with which you write to me that I am afraid it causes you great inconvenience in your other affairs. I am very glad that MM. de Peiresc and de Valavez are in good health. I pray God to preserve them a long time, for they are two gentlemen who would deserve to be immortal, if human frailty permitted it. You are right, I did make a mistake in the name of the poet of the Gallery. He is named Morisot, and since I mentioned him at length in my previous letter, I shall not say any more now.

I have received letters from England which make no mention of the negotiations of Marshal de Bassompierre, but refer to some other matter which depends upon good relations between France and England; therefore I assume that he was successful. Here they say that the English navy has returned to Plymouth because of the death of its commander; but that is not a sufficient reason, for in such a case a second and a third successor is always provided, and not just a single leader. The cargo ships from Goa have arrived safely in Coruña in Portugal, richly laden, they say, but the bill of lading has not yet arrived.

Here there are no other preparations for war than the continuation of this canal; it is not as wide now as it will have to be, but it goes along quickly, with the earth thrown up on the side of the enemy and serving as an entrenchment. And when it is carried in this manner as far as the Meuse, it will be given an outlet to test the force of the water and to see what course it will take, as well as the effect of the junction of the waters. The bed of the Meuse will perhaps not be sufficient to take this increase, and we may have to enlarge it and strengthen it with new dykes. It seems that the Hollanders do not want to oppose this; at least it is confirmed that they have retired and distributed their troops in their respective garrisons.

The Marquis Spinola still remains in Dunkirk, and is very busy re-mobilizing the navy and putting our maritime forces into the best possible shape. It is certain that his presence is a valuable asset, and that this activity arouses suspicion in the English. In Spain orders have been given to those in charge of guarding the seas to attack the English fleet wherever it may be encountered. No news yet of the fleet from Peru, except that it is laden with 20 millions in gold, of which only eight are

for the King. One need not be surprised at this rich cargo, for it is a double one; the last consignment was ordered back, for fear of the English, and so did not arrive for the period just past. Upon this one depends the fortune of Spain, since all payments have been postponed until its arrival, and meanwhile we have pawned even our shirts. From Lisbon and Seville all the naval forces which could be brought together have been sent out to meet it. At the worst, the English can only inflict a loss upon their enemy (which is bad enough) but gain nothing for themselves; for all the captains of those galleons have received orders, under pain of death, not to allow their ships to fall into enemy hands while they are still alive. In case there is no hope of saving the vessel, they are to set fire to the powder, and in order to do this with a clear conscience, they wear around their necks the Pope's dispensation, permitting them to kill themselves legitimately.

Our attack upon l'Ecluse was not of great importance, as we have learned from someone who was there. The assault was made upon a fort named Le Pas, whose gate, after being blown up, was found to be barricaded with earth. The poor Count de Hornes, although completely armed, received a musket-shot in the cheek. We left seventeen men dead, among them a captain of infantry. Several were wounded, but could be saved.

Those portraits of Master Michel,[1] engraved on copper in Holland, as you tell me, have not appeared in these parts; and this annoys me very much, for I am very curious to see them.

Here enclosed is a letter from Cologne which ought to be addressed to the house of M. de Peiresc. I have received many others in the same manner, but now that M. de Valavez is not there to act as intermediary, I must send it to you to be forwarded to Aix. Having nothing more to say, I humbly kiss your hands and your brother's, and commend myself with all my heart to your good graces.

Antwerp, November 12, 1626

P.S. I have sent some prints to M. Tavernier,[2] at his request and at the urging of M. de Valavez, but he has never acknowledged receiving them. Therefore I ask you to make inquiries through a servant, about whether they have reached his hands, as I am sure they have. I shall be greatly obliged to you, and I beg your forgiveness for the trouble.

To Pierre Dupuy *Antwerp, November 19, 1626*

Monsieur:

I am embarrassed to answer you, for I have nothing to say worthy of your attention. This Court is quieter than ever, without any change, and the Marquis still remains at Dunkirk, where he is hastening naval preparations. His purpose, I believe, is to arouse suspicion in the English, whose fleet has for the most part retired, it has been affirmed here, after having suffered severe damage by the bad storms. I am surprised that the English have the boldness to use such piratical methods and other outrages against France, without thinking of the reprisals to which they expose themselves, as they have justly experienced, according to *quid pro quo* [*in margin*: in Bordeaux]. They are probably trusting to their maritime power and the natural situation of their island. I believe, however, that they would find themselves very much embarrassed if they had to wage war upon Spain and France together. This foggy season does not seem at all favorable for the negotiations of the Marshal de Bassompierre, for although everything looks hopeful, it is certain that the King of England will remain unwilling to readmit any of the French already expelled, either bishop or monk.

The attack upon l'Ecluse has been followed by an event of quite a different sort. The inhabitants of l'Ecluse, Cadzant, and the neighboring villages, as well as those of Bruges and the surrounding territory, have made an agreement for the exemption of war, just as it was during the time of the truce, and have decided to cease hostilities among themselves and to carry on free commerce. [*In margin*: I cannot be certain about the free commerce, but the first point is true, and I believe this one is also.] This accord is unexpected and seems strange to everyone.

Here we know nothing of the difficulty of which you write concerning the new canal; on the contrary, it is affirmed that the work is progressing with incredible activity. As to its success, I await its completion, but so far it is considered certain to succeed; they hope soon to test it by giving free passage to the waters, as soon as the banks are made smooth. In Holland it is reported and published that all this will have no effect, that it is even impossible to carry out (after their vain attempts to prevent it).

It is true that in Germany the peasants are raising the devil again, after having almost reached an accord with the Emperor; and that Mans-

feld has once more penetrated into Silesia.[1] It is feared that Gabor Bethlen, with Turkey, will attack the Emperor from the rear. But the season is already too far advanced to expect anything important this year.

It appears, as some correspondents write, that the charges against the Duke of Vendôme are not as serious as at first believed. Surely if this was not a plot directed against the King's person, as the public rumor and press have stated, the Cardinal Richelieu will have aroused great hatred against himself; and in my opinion he ought not to rely upon Monsieur in the future, or upon the other princes whom he has so mistreated, not only by imprisonment, but by covering them with eternal disgrace. The trial of Chalais [*in margin*: about which you had the kindness to write me] interested me very much. I find it extremely curious, though all the details do not correspond to the outward appearance of the affair. It has been impossible for me to learn all these details through others.[2]

There is still no news of the fleet from Peru, and the delay arouses great anxiety here. For if it does not arrive, we can hope for nothing good, but on the contrary, all sorts of disorders resulting from lack of payments.[3] Having nothing more to tell you, I humbly kiss your hands and those of your brother, and commend myself with all my heart, to your good graces.

Antwerp, November 19, 1626

P.S. I am extremely pleased at the severe example of the King's justice against the duelists. The cargo vessels from Goa are in the port of Coruña, on the coast of Galicia.

You need not give yourself the trouble of writing to me for three weeks, because I have to make an unexpected little journey which will last about a month.[4] In the meantime I commend myself, as usual, to your good graces, and pray heaven to grant every good fortune and happiness to you and your brother.

<div style="text-align:right">

Your affectionate servant,
Peter Paul Rubens

</div>

PART IV

1627

The Gerbier Negotiations

The Dupuy Correspondence

1627

Rubens' first meeting with George Villiers, Duke of Buckingham, occurred in Paris in 1625, on the occasion of the marriage by proxy of Henrietta Maria and Charles I. The royal favorite had been charged by his sovereign to conduct the young queen back to England. It was a brief contact, therefore, between Rubens and Buckingham, but it led to further relations of a personal as well as a diplomatic nature. The artist drew the Duke's likeness at that time, in preparation for a monumental equestrian portrait which Buckingham had commissioned. Of even greater consequence, from a practical standpoint, were the talks that resulted in the Duke's purchase of Rubens' private collection for the sum of 100,000 florins. The outbreak of hostilities between England and Spain postponed final arrangements until 1627. The works of art ultimately shipped to England included the ancient marbles Rubens had purchased from Sir Dudley Carleton, a large number of engraved stones and medals, paintings by Italian and northern masters, as well as a group by Rubens himself.

The arrogant and ambitious Buckingham, when Rubens met him, was at the height of his power, and was fast leading his country toward disaster. No sooner had he returned with the queen to London, than trouble arose regarding the exercise of her Catholic faith and the retention of her French attendants. Preparations for war with Spain were also pushed forward vigorously. The ill-advised raid on the coast of the Peninsula ended in an ignominious retreat from Cadiz. An army of 12,000 men sent into the Palatinate under Mansfeld to aid the Protestant cause in Germany was no more successful. For Rubens the Duke of Buckingham soon came to represent a champion of the Protestants and an ally of the Hollanders. He well knew the terms of the treaty which Buckingham concluded in December 1625 with the United Provinces and Denmark against Spain and the Hapsburg Emperor. These acts of aggression provoked Philip IV to recall his representative from London and threaten reprisals. Shortly after, by the treaty of Monzon of March 1626, Philip

adjusted some of his differences with France. A state of war with Spain and France at the same time proved too much for the bravado of even a Buckingham. In January 1627 Buckingham sent a Dominican, Father William of the Order of the Holy Ghost, to Madrid to express regrets to the Count Duke of Olivares for the rupture between the two crowns. At the same time he sought to open negotiations through another intermediary who was known to favor the cause of peace. This intermediary was Peter Paul Rubens.

The initial stages of Rubens' participation in the diplomatic maneuvers of the Great Powers are wrapped in the same obscurity that shrouds his earliest negotiations for a truce in the Netherlands. We know that in Paris in 1625 he made the acquaintance of the painter Balthasar Gerbier, Master of the Horse to the Duke of Buckingham, and secret agent as well. Conversations between the two artists seem to have dealt not only with painting but with politics. And when Rubens returned to Antwerp and Gerbier to London, a correspondence was carried on which continued (according to Gerbier) even after war was declared. When, therefore, the Duke of Buckingham wished to make overtures for peace with Spain, he utilized the contact already established between his own agent and Rubens. And to cloak the more serious proceedings an excuse lay ready at hand: the negotiations still pending for the purchase of Rubens' artistic treasures.

Balthasar Gerbier was an enigmatic personality, a man of many accomplishments but none too scrupulous in gaining his own ends. Born in Middleburg in 1592 of French-Spanish stock, he grew up in France and in Holland, where he studied painting. At the age of twenty-four he went to London, and two years later entered the Duke of Buckingham's service, where he remained until the Duke's assassination in 1628. The Gerbier-Rubens negotiations for peace occupied a good part of the year 1627. Thanks to Gerbier's habit of keeping memoirs, preserving letters, and making copies of those he wrote to others, these complicated dealings have come down to us in fairly complete form. The memoirs of this extraordinary painter-politician are disconnected, often confused or distorted, and written for the most part in his own peculiar French. According to Gerbier's account it was Rubens, and not Buckingham, who made the first effort at opening negotiations. In any case, Rubens went to Calais early in December 1626 expecting to meet Gerbier, in order to discuss not only the works of art to be shipped to the Duke of Buckingham but other topics as well. After waiting in vain for three weeks, Rubens went to Paris, and there, early in January 1627, he and Gerbier

met. His report on their talks was sent to the court of Madrid. Late in February, Gerbier arrived in Brussels with letters to Rubens from the Duke of Buckingham stating that if the Infanta Isabella were authorized by the King of Spain to negotiate a general armistice between Spain, England, and England's allies, the United Provinces and Denmark, Buckingham would undertake to induce these allies to accept the suspension of arms for a period of two to seven years, during which time efforts would be made to establish a lasting peace.

Thereupon began the involved negotiations in which Rubens represented the Infanta Isabella, who in turn kept the King of Spain informed on each step of the proceedings. In writing to her nephew Philip IV on April 17, asking for authorization to preside at the negotiations, Isabella warned the king that failure to effect a reconciliation with Charles I would lead Charles to turn to the side of France, and chances for a settlement would be irremediably lost. The King of Spain, on his part, unknown to the Infanta and Rubens, had just ratified a treaty with France (on March 20) aiming at nothing less than the invasion of England and the restoration of Catholicism in that country. The Infanta's request therefore placed Philip IV in a somewhat awkward position. He found a solution to this difficulty by the simple expedient of antedating the letter of authorization she had asked for. Hesitating to reject the overtures made by the Duke of Buckingham, the King of Spain, on June 1, 1627, granted Isabella the necessary powers for negotiating a peace, a truce, or an armistice; but he dated this authorization February 24, 1626, that is, fifteen months earlier, in order to avoid the appearance of breaking his treaty with France. At the same time Philip expressed his royal displeasure that the Infanta had entrusted affairs of such importance to "a painter," adding that this gravely compromised the dignity of the monarchy. The Governor of the Spanish Netherlands, however, had placed all possible confidence in her painter, and had just granted his request that he meet Gerbier in Holland for further discussions. "Gerbier," she replied to her nephew on July 22, "is a painter just as Rubens is. The Duke of Buckingham sent him here with a letter by his own hand for Rubens, and with instructions to present these propositions. We could not, therefore, refuse to hear them. It matters little who makes the first steps; if they are followed up, direction will naturally be entrusted to persons of the highest rank." The function of intermediary remained provisionally in Rubens' hands.

The passport to Holland which Rubens obtained through the British Ambassador, Sir Dudley Carleton, "under pretext of a treaty betwixt

him and Gerbier about pictures and other rarityes" allowed him to travel anywhere within the United Provinces. On July 10 he arrived in Breda, from where he wrote to Gerbier in The Hague, suggesting a meeting in the Dutch village of Zevenbergen, not far from the frontier. The English agent, on the advice of the Ambassador, refused, lest a meeting in a small town so close to Spanish territory arouse suspicion and make it appear that England was seeking favors of Spain. Instead he proposed one of the large cities — Delft, Rotterdam, or Amsterdam, "if the Infanta and the Marquis Spinola are so eager and zealous about this good business." Rubens had formal instructions not to go beyond Zevenbergen. When a second invitation to Gerbier brought the same refusal, he felt obliged to return to Brussels for further orders. This time he received permission to penetrate farther into Holland, and met Gerbier in Delft on July 21. The two spent a week together, visiting different towns under pretext of looking at pictures. Rubens, to be sure, took this opportunity to meet some of the leading painters of Holland — Abraham Bloemaert, Terbrugghen, Poelenburg, and Honthorst, who gave a banquet in his honor. The youthful Joachim Sandrart, then a pupil in Honthorst's Utrecht studio, had the good fortune to accompany the great Flemish painter for ten days following Gerbier's departure. In his *Teutsche Academie,* which appeared in 1675, Sandrart's biography of Rubens includes an enthusiastic record of this journey.

In the world of politics Rubens' appearance in Holland caused a sensation. The alleged reason for his meeting with Gerbier failed to satisfy the French and Venetian ambassadors, who kept a watchful eye on his movements. The artist purposely stayed away from The Hague, and Sir Dudley Carleton, in order to remove suspicion, avoided meeting Rubens elsewhere. He sent his nephew Dudley Carleton expressly to the Prince of Orange, to remove any mistrust on the part of the Prince and to keep him fully informed regarding Rubens' visit. "For in this ombragious tyme and place," the Ambassador wrote, "there cannot bee too much circumspection used to prevent inconveniences." The week Rubens spent in Gerbier's company was far from fruitful regarding the peace negotiations. His orders were to promise nothing and to put nothing in writing. All he could do was to assure the English envoy of the peaceful intentions of the Infanta Isabella and the Marquis Spinola, and to say that further orders would soon be brought from Madrid by Don Diego Messia, Marquis de Léganès, at present detained in Paris by illness. This statement did not satisfy Gerbier, who complained that "Rubens had brought nothing in black and white, and that all he said was only in words." Sir Dud-

ley Carleton declared impatiently that Messia's "long abode in Paris under pretence of sicknes must needs cover somwhat else." These suspicions were amply justified upon the final arrival of the Marquis de Léganès in Brussels on September 9, 1627. For then the news of the Franco-Spanish alliance became known, blasting the hopes of those who desired a truce between Spain and England. The eagerly awaited Don Diego Messia, it was learned at the Brussels court, had been detained in Paris on the King's business, discussing with Richelieu the plans for the joint expedition against England. The command of the allied invasion forces was to be given to the Marquis Spinola. The Infanta was expected to lend her advice and aid to this extravagant project, while at the same time encouraging the peace talks to continue. For Rubens this meant the keenest disappointment and discouragement — the failure of his mission. For Gerbier, who had learned of the plot, it meant that "the game was finished." In confidential letters to the English envoy, Rubens frankly expressed his dismay at the turn of events, stating his opinion that France and Spain would agree "like fire and water," and holding the Count Duke of Olivares responsible for this aggressive alliance. There was nothing for Gerbier to do, after four unproductive months in Holland, but return to England; he was recalled to London on October 4. His report to the Secretary of State indicated that he and Sir Dudley Carleton did not blame Rubens for the failure, but trusted his sincerity. "I will say," Gerbier wrote, "that according to all their protestations, all bordering upon the appearance of truth, the Infanta, the Marquis, and this Don Diego, the pretended Messiah even, have all had a very sincere will, but which, passing through pestilential places, has left health or life behind."

The widening range of Rubens' interest in politics, as the international situation became more tense and complex, is clearly reflected in his letters written at this time. But concerning his own active part in foreign affairs he makes no mention outside the circle of his associates in diplomacy. This was the period of the weekly news letters to Pierre Dupuy, who, following the departure of Peiresc and Valavez, had become Rubens' regular Paris correspondent. Throughout the course of his negotiations with Balthasar Gerbier, the artist preserves complete silence on this subject in writing to Dupuy, and gives no hint of his disappointment at the abrupt termination of the talks upon the announcement of the Franco-Spanish pact.

Pierre Dupuy, at the time Rubens' correspondence with him began, was Royal Librarian to Louis XIII. He was also one of the King's Coun-

cilors, enjoying royal favor and an important position at the French court. Dupuy took part in all the religious and political debates of his time, and along with his younger brother, Jacques Dupuy, carried on an extensive correspondence with many of the notable scholars and statesmen of Europe. His weekly exchange of letters with Rubens continued almost without interruption until the latter's departure for Madrid in 1628. The range of subjects covered by the painter and the librarian was a wide one, with literature, art, and scholarship still figuring prominently, but with politics occupying first place. Rubens kept his correspondent fully informed regarding military operations in the Netherlands, where activity on both sides was confined to border engagements, since neither army felt strong enough to assume a large-scale offensive. He devoted many pages to the Marquis Spinola's ambitious engineering enterprise of cutting a canal between the Rhine and the Meuse, with the twofold aim of providing troops with an unobstructed entry into Holland, and cutting off commerce between Holland and Germany. The fall of the frontier town of Groll to the Dutch forces, after a brief siege, was the major event of the campaign of 1627, and a severe blow to Rubens' side.

The Spanish Netherlands were, in fact, suffering sorely under the continued hardships of a war that began to seem purposeless to them. The burden of supporting the ill-disciplined troops was felt by almost every village in Brabant and Flanders. Financial aid promised by the King of Spain was hopelessly in arrears, and the Infanta Isabella, in her regular reports to Madrid, was repeatedly forced to beg for the necessary funds, warning Philip that if he could not meet the needs of the army, mutiny and disaster would result. Rubens, in his letters to Pierre Dupuy, made no secret of this critical situation. The city of Antwerp he described as "languishing like a consumptive body, declining little by little." The root of the financial trouble lay in the rapidly worsening state of the Spanish national treasury. Several times during the previous half-century the kings of Spain, unable to meet payments on loans, had issued decrees repudiating their public debts, ordering a compulsory reduction of the rate of interest, or debasing the coinage. The harshest of such confiscatory measures was taken in 1627, to the great loss of the bankers who had backed the Spanish monarchy with loans.

Spain's crumbling economic structure provided Rubens and Dupuy with material for long discussion and penetrating analysis. As for affairs in France, there was the subject of Cardinal Richelieu and his ever-tightening control. The sensational Chalais conspiracy, and the equally

celebrated "duel of the six champions" which resulted in the execution of the Count de Bouteville and the Count des Chapelles, excited Rubens' keenest interest, as did the untimely death of the Duchess of Orléans, with its bearing upon the question of the royal succession. Anglo-French relations were also discussed in some detail. There was agreement between Rubens and Dupuy regarding the rashness of Buckingham in sending a fleet to aid the Huguenots of La Rochelle, and rejoicing when this expedition ended in another retreat for the English in November 1627. By that time the Rubens-Gerbier negotiations had broken off. Concerning the Franco-Spanish treaty which had brought about the collapse, Rubens had this to say to Pierre Dupuy: "We have had Don Diego Messia here, bringing the news of a close alliance between Spain and France against the common enemy. This greatly surprised some people, considering past events, but one must attribute it to an excess of ardor for the Catholic faith, and hatred for the opposing party. . . It seems strange that Spain, which provides so little for the needs of this country that it can hardly maintain its defense, has an abundance of means to wage an offensive war elsewhere. But let us leave all this to the future, and in the meantime put our minds at rest."

To Pierre Dupuy *Brussels, January 22, 1627*

Monsieur:

This letter is simply to advise you of my safe arrival in Brussels, although
not without difficulty, due to the bad condition of the roads and the slow
pace of the carriage, which finally completed the journey in eight and
a half days. The trouble with my foot accompanied me as far as Péronne.
From there on the pain diminished, little by little, and upon my arrival
in Brussels it had completely disappeared. Now, by divine grace, I am
entirely free from it. May it please the Lord to guard me in the future
from familiarity with this domestic enemy and its wiles, and to confine
it, as far as I am concerned, at the French border! [1]

I shall not give you any news now, because I have not yet had time
to inform myself. I am occupied in discrediting a bit of slander that
has been spread about me. Various reports have it that I went to England,
and this idea has been planted so firmly in the minds of the Most Serene
Infanta and the Marquis, that I am having great difficulty in refuting it
even by my presence. The offense, to be sure, is not a case of *lèse-majesté*,
but still it would have been serious if, in time of war, I had gone to an
enemy kingdom without the permission of my sovereign. However, the
clouds are beginning to dissolve, and the light of truth is shining through.

On the whole, I found this Court as quiet and undisturbed as if we
were living in the most secure state of peace. There are great hopes for
the canal, but I shall wait for the arrival of Don Giovanni de' Medici,
the director of this undertaking, before telling you any details. He is
expected hourly at the Court, and is a very good friend of mine. Having
nothing else to say, I shall close, humbly kissing your hands and those
of your brother, and commending myself, with a true heart, to your good
graces.

Your most affectionate servant,
Brussels, January 22, 1627 Peter Paul Rubens

To Pierre Dupuy *Antwerp, January 28, 1627*

Monsieur:

I informed you by the last post of my happy arrival in Brussels; and now,

by divine grace, I am again in Antwerp, resting from the hardships of my journey. We have little or no news. I have informed myself, however, about the canal, and found that work is somewhat interrupted now, due to the rigors of winter. The cold is so intense that the earth has become impenetrable to the tools. Nevertheless, the work is well advanced, and as far as I can learn, there is every hope of success. But the plans of the Most Serene Infanta and the Marquis do not stop there; they wish to cut another canal from the Meuse as far as Herenthals [*in margin*: at the very place where the first canal flows into the Meuse, and it will be a sort of continuation of the same canal], and to divert it into a little river which flows into Antwerp. This is an admirable project, and of great consequence. It is my opinion, as I have often written you, that this canal will, for many years, be both the stake and the theater of the war in Flanders. And since it is necessary to build it with an armed hand, it will offer both employment and exercise to the royal army. The entrenchments, redoubts, and fortresses necessary for its defense against the enemy will serve to lodge and garrison the troops, with less burden on the towns and villages. [*In margin*: *Erunt tanquam castra aestiva et hiberna.*] * This is an intermediary stage between inactivity and offensive warfare which demands the greatest expenditure and labor, and shows slight results against a people so powerful and so well defended by both art and nature. That is all I have to tell you now, and in closing I kiss your hands and those of your brother with all my heart, and commend myself sincerely to your good graces.

Antwerp, January 28, 1627

P.S. I shall not fail to send you, at the first opportunity, that book on the House of Linden,[1] and it will give me great pleasure to be at your service in any other respect.

– 99 –

To Pierre Dupuy *Brussels, February 18, 1627*

Monsieur:

I could not write to you last week since I was traveling; and then in Brussels I could not receive letters from Paris until my return to Antwerp, too late to answer you. I thank you for the news which you gave me in

* They will serve as camps both summer and winter.

your most welcome letter of the 4th of this month, although it was bad news for us. It is true that this report had already reached here with great speed, and the loss is considered very great, both for the King of Spain and for private individuals. [*In margin*: It is estimated altogether at four millions.] We have not been able to learn anything certain, however, since the letters were lost along with the cargo. It is a strange thing that these vessels, after remaining for two months in safety, were sent out to their destruction in this stormy season! In my opinion the disgrace of such foolish counsel is harder to bear than the loss itself.[1]

The resolution taken by the Lord Notables of France to maintain so great a fleet always in readiness seems to me to be quite in accord with the security and the dignity of that kingdom.[2] We have found, through experience, how difficult it is to rebuild the naval forces. All the diligence of the Marquis has hardly been able to arm and maintain a small fleet of a few ships at Dunkirk, but the results have been very satisfactory.

It seems that the agreement between France and England is not as near as was thought on my departure from Paris. I cannot believe, however, that things will come to a break, because it would be too much for England to have a war with Spain and France at the same time.

I have received detailed information from Don Giovanni de' Medici himself, the superintendent-general of the works of our canal, and he regards success to be infallible. I think one can safely believe him, for he is a man of sound judgment and the greatest experience in such matters. He has shown me the most exact diagram and the plan of the entire project. This is not to cut off the Rhine or the Meuse, or to turn one river into the other, as had been thought, but to build a new canal, closed by locks at its extremities, from Rynberg through Guelders as far as Venlo. It is to be navigable and will receive its supply of water from a small river called the Neers, near Guelders. The plan is very ingenious, for the canal rises toward the middle, and exceeds the level of the Rhine by 25 feet. And since the Rhine is about 32 feet higher than the Meuse, our canal is approximately 60 feet above the level of the Meuse, so that it is almost suspended in the air by its locks, and fed at its highest point by the aforesaid rivulet. In this way boats will be raised and lowered by the two locks at the ends, and may pass to and fro between the Rhine and the Meuse. This work is far advanced, and is at the same time being fortified by entrenchments and redoubts erected frantically by the soldiers. From Rynberg to Guelders it is completed, and the other part is going along well. The entire length amounts to about eight leagues, and forms an angular line with several curves to avoid hills that prevent a

straight course, which would have been much shorter. Several engineers and members of a commission have been named to survey the site with a view to continuing this canal from Venlo as far as Herenthals [*in margin*: Don Giovanni de' Medici himself left the day before yesterday for this purpose]; from there, as a natural advantage, runs a little navigable river, although narrow, and capable of taking only small boats to Antwerp. They wish to see whether art cannot aid nature, and remove the obstacles which are believed to exist between Venlo and Herenthals — all of which we shall know with certainty upon the return of this commission. Having nothing else to say now, I commend myself with customary affection to your good graces and those of your brother, and pray heaven to grant to both of you every happiness and satisfaction.

P.S. I thank you for the book which you say you have consigned to M. de la Mothe for me; and just as soon as I reach Antwerp, I shall not fail to send you the one on the House of Linden.

The calumny about my trip to England has finally been dissipated like clouds before the sun, and I find myself once more, through divine grace and my own innocence, in customary favor with my patrons. They have exonerated me from a suspicion to which reports from all sides gave a certain foundation.

I beg you to take care of forwarding the enclosed to Councilor de Peiresc.

Brussels, February 18, 1627

– 100 –

To Balthasar Gerbier [*February 24(?), 1627*]

Her Highness has seen the proposition of my Lord the Duke of Buckingham, and says, as for the difficulties between the Emperor and the King of Denmark, that she began some time ago to try to bring them to an understanding, and will do all in her power to complete it. But since success is uncertain (for there might also be difficulties with regard to the States of the United Provinces) it would be well for the Duke of Buckingham to declare whether the King of Great Britain would wish in this case to deal only with regard to these crowns. As soon as Her Highness is informed, she could report to His Catholic Majesty, and upon receiving an answer, could inform the Duke. Therefore it may be ad-

visable for M. Gerbier to return to England and bring back to us a report on the decision.

<div align="right">Rubens</div>

<div align="center">– 101 –</div>

To Pierre Dupuy *Antwerp, March 4, 1627*

Monsieur:

We have no news here, except that there is talk of beginning a campaign. But nothing certain is known, although the ordnance companies (as they are called) have received word to hold themselves in readiness, and this is the usual indication of some expedition. There is a great deal of whispering in this place, especially among the Genoese bankers, because it is believed that the King of Spain wishes once more to make a decree [1] suspending payment of the notes [*in margin*: "polici," as they say in Spanish] they hold on the capital credited to him. His Majesty wants to reduce the interest to four per cent because the mortgage is very good and because others have offered to take it at this figure.

I now have the book on the House of Linden,[2] but since the volume is rather large, I am afraid it will cost too much to send it by messenger. On the other hand, it seems a small thing to send by cart. And when a packet is not large enough to pay by the pound, the drivers are not very coöperative. However, the Fair of St. Germain is approaching, and then there will be no dearth of friends who will be willing to take it. Some way will be found to get it to you, and I will send along with it two prints of the Fossa Eugeniana [*in margin*: as the canal is called], for which I have written to Brussels, since there are not yet any good proofs here.[3] Having nothing else to tell you, I kiss your hands with all my heart, and commend myself to your good graces.

<table>
<tr><td></td><td align="right">Your most affectionate servant,</td></tr>
<tr><td>Antwerp, March 4, 1627</td><td align="right">Peter Paul Rubens</td></tr>
</table>

I have received the book of the Royal Marriages, and send you a thousand thanks for it.

To Pierre Dupuy *Antwerp, April 9, 1627*

Monsieur:

Twice the post has failed to bring me any news from you. I hope there is no reason for this other than your own obligations. The times are not very favorable to our correspondence, forcing the mind to turn to more urgent and important things. Here there is nothing new; on the contrary we are living in extraordinary tranquility, even though it is thought that war will begin at the first opportunity. But so far no one knows from which side to attack the enemy in order to have the advantage. The special courier from Spain who arrived the day before yesterday brought confirmation of the suppression of the decree,[1] along with the notes of payment for the Genoese and Portuguese, and also the Fuggers. This provision was necessary, since without it we were reduced to such an extremity that the Ministers and officers of the King were beginning to raise a subscription, each according to his means, in order to lend His Majesty a certain sum to pay the troops, and thus avoid any disorder resulting from such penury. All the bankers of this city were beside themselves with joy when they heard of the annulment of the decree that would have meant their ruin. Having nothing else to say, I kiss your hands and those of your brother with all my heart.

<div style="text-align:right">Your most affectionate servant,</div>

Antwerp, April 9, 1627 Peter Paul Rubens

To Pierre Dupuy *Antwerp, April 19, 1627*

Monsieur:

This time I have really nothing of interest to tell you. Things are very quiet everywhere. They say, though, that the States have attempted an attack on Breda,[1] with the aid of certain inside intelligence, but so far there are no apparent signs of it, except that the garrisons have been reinforced and the sentinels doubled. To me it seems difficult to take by surprise a city guarded by 5000 soldiers. I have learned from a friend who came the day before yesterday from Holland that the Ambassadors of Poland and Sweden are there now (as you had already written me) to

settle their commercial differences by the intervention of the States. He tells me also that M. Aerssens[2] has gone to France, to act as intermediary in the agreement between France and England, and also to renew the alliance of the States with the Crown of France, though intending to modify one of the articles which appeared prejudicial to Holland's liberty. But you will know all this better than I do.

I hope that you have by now received the book on the Linden family. If not, I should be afraid it was lost by the messenger, who would be obliged to make good the loss. I am sorry that I could not send these packets in care of our Ambassador. Now that I am in Antwerp I cannot know when his mother-in-law or brother-in-law have something to send him. Moreover the messenger would not take packets of such size gratis, even though addressed to the Ambassador. Having nothing else to tell you this time, I commend myself to your good graces and sincerely kiss your hands.

<div style="text-align:right">Your most affectionate servant,</div>

Antwerp, April 19, 1627 Peter Paul Rubens

<div style="text-align:center">– 104 –</div>

To the Duke of Buckingham *[April 21, 1627]*

My Lord:

By the letter which it pleased you to write me on the 9th of last March, I have received complete assurance of the good will of Your Excellency toward me, which I shall try to merit on the occasions agreeable to you, when it may please you to employ me in your service. I beg you most humbly to excuse my having delayed so many days in replying on the matter which Your Excellency knows. I have been expecting every day some news from Spain, but as this is so delayed, I did not wish to postpone any longer acknowledging receipt of the said letter, and kissing your hands for the favor which you have been pleased to show me. As soon as the answer comes from His Catholic Majesty, I shall inform Your Excellency. For I wish as much as I ought to see the completion of this *beau chef d'oeuvre*. In the meantime I commend myself with all submission and most humble reverence to the favor of Your Excellency, resolved to live and die

<div style="text-align:right">My Lord, etc.</div>

<div style="text-align:right">Rubens</div>

To Balthasar Gerbier [*April 21, 1627*]

Sir:

I have postponed answering your letter of the 9th of last March (according to your reckoning) hoping that Her Highness might receive some advice on what she had written concerning the first proposition. But since that is delayed, I do not want to defer longer acknowledging the receipt of your letter with the papers enclosed. They have been dispatched by courier to His Catholic Majesty, informing him of the contents, and praying him to answer directly. I am sure he will do this, and I shall then inform you in the manner you have written to me. Praying God that this affair may have the end that is desired, for the good of Christianity, and having nothing else to tell you at this time, I kiss your hands with all my heart, remaining ever, Sir,

<div align="right">Rubens</div>

To Pierre Dupuy *Antwerp, April 22, 1627*

Monsieur:

I owe you a reply to your two letters of the 2nd and the 16th of this month. Last week certain duties made me put off writing until the evening, and then unexpected obstacles prevented me from fulfilling my obligation to you.

I am greatly indebted to you for so many gifts of fine books which you are continually sending me. I have received the *Bibliothèque des Auteurs Typographes de France*,[1] but I have not yet been able to read it, due to various interruptions. And I have just received the *Déclaration du Roi. . .*[2] For the first as well as the second I kiss your hands with all my heart. The packet from M. Peiresc reached me in care of the Ambassador, and I am very glad to see that our friend has completely recovered and that his passion for Antiquity — especially for cameos and medals — has revived. He wrote me a most voluminous letter, full of new and interesting observations on this material, which gave me the greatest pleasure. I shall not fail to answer him at the first opportunity. At the moment I cannot do this in a suitable manner, for I want to repay

him in the same coin. The letters which were enclosed have all been forwarded to the proper addresses. I hope you have by now received the book on the Linden family. I delivered it into the hands of Antoine Souris,[3] and I shall find out from him this very day why it has not reached its destination. [*In margin*: Antoine Souris says that it cannot be lost, and that he expects within a few days the return of the driver who took it.]

Writing in care of the Ambassador is the best method for the security and the facility of our correspondence, as long as the excellent M. de la Mothe [4] is willing to act as intermediary for our exchanges. I have little confidence in the trustworthiness of the servants of great houses.

And now we come to the subjects of your letters. First of all, your discussion of the dire need and general penury of the princes, not only in Europe, but almost everywhere, is worthy of consideration. [*In margin*: The Grand Turk, in particular, has not a penny in reserve, and the King of China is no better off.] It is a thought which has often passed through my mind. For it seems incredible that all the Christian kings should at the same time be reduced to such an extremity. They are not only deep in debt, with all their resources pledged, but can hardly find any new expedients, in order to keep breathing somehow, and to extend their credit, which is already so strained that it seems it cannot last long. I beg you to believe that I do not write this rashly. The artifices of this Court are not for us, but for the people. It is now certain that a new loan has been contracted with the bankers of Genoa and Lucca. [*In margin*: But even this loan, of two and one-half millions, is too little for our needs.] I could write you the details of the transaction, and how much we shall have to pay in this city, if I were of that trade; but I have no doubt that you will have been informed, since your letter of the 16th, for a matter that has to pass through so many hands cannot remain secret. With this loan the decree will be annulled, or at least postponed for several years. Surely if I were one of those brokers, it would be enough to be threatened; I shouldn't wait for the blow! In Spain they have taken extreme measures to avoid the total ruin menacing that kingdom: the *quartos de billon* whereby the coinage is debased by three-quarters of its value, with the promise that in four years it may be redeemed by the holder at its full value. I can hardly believe this [*in margin*: but it is considered certain], and to tell the truth, I have not yet seen the published text.

But to return to the penury of the princes, I cannot explain it otherwise than that the riches of the world are distributed in the hands of

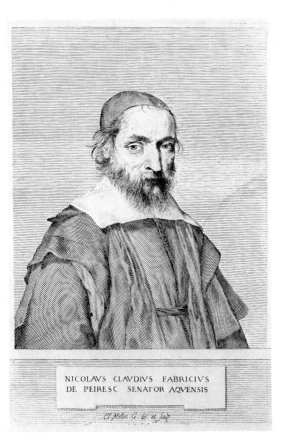

NICOLAVS CLAVDIVS FABRICIVS
DE PEIRESC SENATOR AQVENSIS

Cl. Mellan G. del et sculp.

Nicolas-Claude Fabri de Peiresc. Engraving by Claude Mellan.

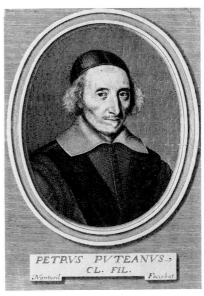

PETRVS PVTEANVS·
CL. FIL.

Nantueil Faciebat.

Pierre Dupuy. Engraving by Robert Nanteuil.

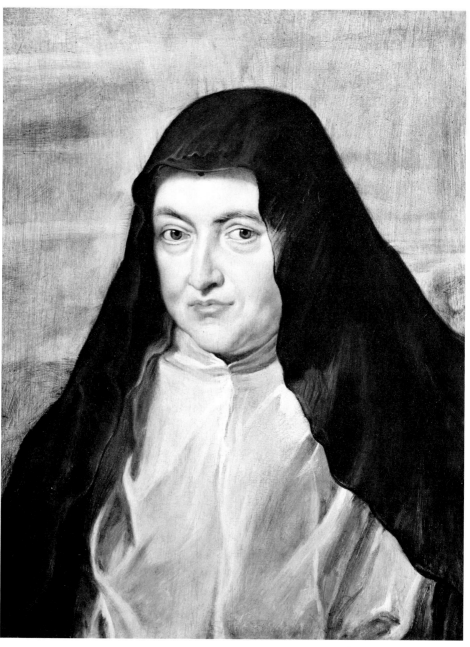

The Infanta Isabella Clara Eugenia. 1625. The Governor of the Spanish Netherlands wears the habit of the Poor Clares which she adopted after the death of the Archduke Albert. This portrait is probably the one Rubens painted on July 10, 1625, when Isabella stopped in Antwerp on her return from Breda, which had just surrendered to the Marquis Spinola.

private individuals, and that this is the cause of the public poverty. For a river, however great, will dry up if divided and drained into many streams. Besides, the economic system of almost all the princes is so badly organized, and confusion is so deep-rooted, that it will be difficult to restore order. A merchant or, if you will, the father of a family *cuivis rationes semel sunt perturbatae, raro emergit, sed aeris alieni ponderi succumbens pessumdatur,** for the rate of interest increases in proportion to the diminution of his credit. It is true that the recent decrees of the King of Spain, limiting usury, have kept this kingdom more or less alive, because the interest on loans used to go up to 30 and 40 per cent, and even higher in time of necessity. [*In margin*: This interest, even reduced to 5 per cent, amounts to an incredible sum.]

As for what you write me about the canal, namely, that the enterprise has been completely despaired of and abandoned, I beg you to believe that we have heard nothing of the sort here. It is true that work has been suspended for some time, because of the ice and the cold, which have been terrible this winter — and also because of lack of funds. But about three weeks ago a finance commissioner raised a good sum of ready money in our city for this purpose, and I cannot believe that the people of Liége will now oppose this undertaking in the least. [*In margin*: The good print of the canal has not yet appeared in published form. I shall not fail to write you about it, according to my promise.] I find one difficulty in the fact that the lower locks, which will stand under water at the time of the inundations of the Rhine, will be hard to maintain against the force of the current, or to keep free from the refuse that will collect there. But Don Giovanni de' Medici told me that he has already devised a remedy for this inconvenience. I do not know, of course, whether any new obstacle will present itself; one must await the outcome. I can only assure you that up to now the work is progressing with great enthusiasm.

There has never been any rumor of the marriage of the Marquis Spinola and the Duchess of Aerschot; but I think the one meant is the Duchess of Croy, who is mentioned in the French pamphlets. [*In margin*: This lady is noted for her great beauty of soul and body, *et omnibus una omnes surripuit veneres.*†] Indeed this lady is very much loved and respected by His Excellency, and I believe that if the grandees of Spain could marry according to their taste, and without permission of the King, he would already have followed this course. But up to now there is no

* Whose affairs are once upset, rarely rights them, but succumbs to the weight of his debts and ends in ruin.

† And has snatched all the charms from everyone at once (Catullus 86.6).

certainty about it, *et aegre capitur annosa vulpes.*† [*In margin*: The Marquis Spinola is now fifty-seven years old, as he himself has told me.] The rumor perhaps originates from a misunderstanding caused by the recent marriage of the young Duchess of Croy (heiress of that house and daughter of the first marriage of the Duke of Croy who was murdered) to the Marquis de Renthi.[5]

The flattering reception which M. de Thou [6] experienced in Rome was appropriate to his own merit as well as the hereditary fame of his father; it was due also to the courtesy of His Holiness. I shall be glad to learn of his safe return, and if, in the meantime, you will do me the honor to keep me in his memory and his favor, I shall be much obliged.

I find it all the easier to believe that the States of Holland will intervene to settle the breach between Sweden and Denmark, now that it is thought certain that they will do the same between France and England. For my own part, I should like the whole world to be in peace, that we might live in a golden age instead of an age of iron. Having nothing more to say, I shall close with this wish, kissing your hands with all my heart.

P.S. The Apostolic Nuncio, Mons. Bagno,[7] is one of the best patrons and friends I have in the world. His appearance as well as his pleasing manners and his solid virtues lead me to consider him a papal possibility, and worthy of every good fortune.

The passions of Father Petau [8] are nothing new in that Order, *quae plerumque spirant merum, pus atque venenum, in omnes quorum virtutibus aut invident aemulantur.*‡

I shall gladly send you the prints of the cameos, although they are unworthy to be published, being only an abortive production. I shall add them to the prints of the canal.

Antwerp, April 22, 1627

– 107 –

To Pierre Dupuy *Antwerp, May 6, 1627*

Monsieur:

I am extremely sorry that that rascal of a driver has not delivered to you, as he was supposed to do, the packet with the book on the House of

† And an old fox is hard to catch (Erasmus, *Adagiorum Chiliades Tres*, p. 290).

‡ Which so often exhale their inebriation, their insults, and their venom against all those whose merit causes envy or emulation.

Linden. However, the book was not of such value that its loss cannot be replaced by another similar volume. No doubt it was due to misfortune rather than to knavery, for experience teaches us that small parcels are more easily lost in transit than large ones. I shall speak to Antoine Souris again today to find out whether his servant has returned. I am more fortunate in receiving all your gifts than in sending them. I have recently received the treatise *De Pictura*,[1] but have not yet been able to read it. I kept it only two days, since it was not bound. [*In margin*: I send you due thanks for it.] I shall send you a little book on astronomy entitled *Loxias seu de Obliquitate Solis, Diatriba*, by Godefroid Wendelinus.[2] Of its kind it is highly praised. If I knew of something else which might please you, I'd send you the lot together, with another copy of the House of Linden, to lessen the expense and increase the security.

As for public affairs we know nothing except that torpor and weariness are evident on every side. But as far as I can gather from certain indications, if Spanish pride could be made to listen to reason, a way might be found to restore Europe (which seems all in chains together) to a better temperament. Secret negotiations with the Hollanders are still maintained here, but you may be sure that Spain has not given orders to deal with them in any way, in spite of the fact that our Princess and the Marquis Spinola are very much in favor of it, both for the public welfare (which is dependent upon peace) and for their own peace of mind. We are exhausted not so much by the trials of war as by the perpetual difficulty of obtaining necessary supplies from Spain, by the dire need in which we constantly find ourselves, and by the insults we must often endure through the spitefulness or ignorance of those ministers, and finally by the impossibility of acting otherwise.

The expedient of the *quartos* [3] is essential for Spain; for, as you say, unless some suitable remedy were found, great ruin could result. Here we still have no certainty regarding the method I mentioned the other day, but the effect in one way or another is certain, for the evil cannot be postponed very long. I am sorry that I have no more important subject to write to you; this must be attributed to the sterility of the times, and not to my negligence. And so, in closing, I kiss your hands and those of your brother with all my heart.

<div align="right">
Your affectionate servant,

Peter Paul Rubens
</div>

Antwerp, May 6, 1627

P.S. I beg you to have the enclosed letter safely forwarded to M. de Peiresc.

To Pierre Dupuy *Antwerp, May 13, 1627*

Monsieur:

We have no news here other than the arrival of the Ambassador of Savoy,[1] who came, three days ago, from your Court. He has been received and treated as befits the rank of the Duke, his master. But so far the real object of his mission is not known, although it is supposed that he is here to seek the mediation of the Most Serene Infanta in settling the differences between the King of Spain and the Duke. A few days ago a horseman arrived by post from Spain, bringing the Royal Edict on the *Quartos*, with two declarations, all of them already printed, but so far I have not been able to see them. But according to all I hear, the edict is in practically the same form as I had written you by the last post.[2] I have told Antoine Souris that the packet containing the book, which I had consigned to him, has not yet arrived, and he has written to his agent in the Paris office. There is also a possibility that the packet has remained at the customhouse. Perhaps it would be a good idea for you to send your servant there to inquire about it; the address might have been lost or obliterated on the way.

The engraving of the new canal was just on the point of being published when Her Highness wished to change the name from Fossa Eugeniana to Fossa Mariana or Notre Dame. That is why I have not yet received the copy promised me, but I shall have it as soon as possible.

It is considered certain that within a few days the Most Serene Infanta will leave for Notre Dame de Montaigu to attend the consecration of that church. From there she will take a trip to Maastricht to see the work on the new canal. This must be regarded as a sure sign that the enterprise is going well and is near completion. It is not likely that Her Highness or the Marquis — still less the two together, with all the Court — would rashly expose themselves to the risk of being ridiculed by all the world. Already some engineers, accompanied by a strong cavalry escort, have been commissioned to study on the site the possibility of carrying out the canal formerly planned between Venlo and Antwerp, which would extend for at least twenty leagues. But to me this seems an enterprise almost beyond the powers of our century. We shall know nothing certain as to the decisions of Her Highness until these delegates have returned and their report has been carefully examined.

Since I have nothing else to say now, I commend myself with all

my heart to the good graces of you and your brother, and affectionately kiss your hands.

<div align="right">Your most devoted servant,</div>

Antwerp, May 13, 1627 <div align="right">Peter Paul Rubens</div>

<div align="center">– 109 –</div>

To Balthasar Gerbier <div align="right">*Antwerp, May 19, 1627*</div>

Dear Sir:

Your silence surprises me, and leaves me in doubt whether our packets were correctly addressed or not. In a correspondence of such importance, it is necessary always to acknowledge receipt of letters, so that in case of a mishap duplicates may be furnished. You will see from the enclosed letter of the Ambassador of Savoy [1] that we have been together in Brussels, and I, for my part, admit that I received all the satisfaction in the world, after the Ambassador paid his respects to the Infanta and to the Marquis Spinola. He did not wish to touch upon the secret except through me, and since we found him as well informed as ourselves, it was thought advisable to confer with him openly, without reserve or hesitation. I have informed him very explicitly, at the express order of Spinola, about the present state of the affair, and have fully assured him of our good and serious intentions. I can now tell you that we have received word from 70 which gives us courage, and leads us to hope for success. But that is not enough to put it into execution. We believe that, by divine grace, the rest will soon follow. I have returned to Antwerp, after clearing up the matter, and bringing Scaglia and Spinola together so they may talk it over in person. They have always done me the honor, in case of any doubt, ambiguity, or scruple, to make use of my advice, in order to see the point from two sides. But now I believe there is no longer any difficulty between them. They seem to understand each other very well, and are satisfied with each other, showing no mistrust. Indeed we find Scaglia extraordinarily capable in affairs of such importance, and I am glad that he has decided to go to Holland. For the whole debate, as I have told Scaglia, and you also, many times, will hinge upon the claim of the States to possess in name what they have in reality. Scaglia told me that he thought you would go to meet him there. I should consider myself very fortunate to be able to meet you too, but I believe that my masters will not risk sending me, of their own accord. However, I am of

<div align="center">181</div>

the opinion that my presence would greatly serve to promote the matter, because we could, among ourselves, clarify the difficulties already debated. For inasmuch as I have been employed in this treaty constantly since the rupture, I still have in my hands all the papers presented by both sides. We could consult together with Scaglia and Carleton.[2] That is why I beg you to find a means of having this request presented to Buckingham, and to write me a letter to this effect, saying that he is sending you to that place, charged with many things which can neither safely nor easily be trusted to paper. And that he dares not send you again to Brussels, lest this may cause too much rumor, as it did the other time, but that His Excellency desires that I be sent, with the permission of my superiors, to the place where I can meet you under the favorable circumstance of the presence of Carleton and Scaglia. This would be a *grand coup*; for, as I have told you, every difficulty which could prevent, or at least render incomplete this fine *chef d'oeuvre* lies in the business of the States. I have friends there of high standing, and my old correspondents, who will not fail in their duty. I beg you to make the arrangements, but with the strictest provision that you keep this request of mine secret, so that no one may ever know that this was done at my instruction. Scaglia will be in this city the day after tomorrow, and we have sent his letter applying for a passport to the States. I am sure he will be of my opinion concerning my going there, although I have not yet told him, reserving the secret of this letter for you alone, to communicate to Buckingham. But I shall have to obtain a passport by the same means, at least through Carleton or Scaglia, immediately. I beg you to answer me at once, also concerning the details of which I have already written so often, regarding the rest of the pictures belonging to Buckingham.[3] Without your order I dare not send them; the passage is so embroiled and dangerous that I would not risk it without your express order. [*In margin*: I pray you to put in a word also on the painting by Moucheron.] And since there is nothing more to write, I kiss your hands most humbly and commend myself to your favor, remaining ever

<div align="right">Your most humble servant</div>

Antwerp, May 19, 1627

I beg of you to burn this letter as soon as you have made use of it, for it could ruin me with my masters, even though it contains no harm. But at least it would spoil my credit with them, and render me useless for the future.

To Pierre Dupuy Antwerp, May 20, 1627

Monsieur:

Among the items of news which you have given me with customary courtesy and punctuality, I found especially noteworthy the duel of the six champions in the Place Royale.[1] Indeed it seems as if they purposely chose this famous place, without any regard for the majesty of that name, in order to emphasize their contempt of the royal edict. Here it was thought that Bouteville had fled to the environs of Liége, without having aroused any suspicion. The Marquis Spinola has often told me that he did not recall ever having met a gentleman whose bearing, noble manners, and conduct were more to his liking; and that he had also found him intelligent, judicious, very eloquent, and well-informed on world affairs. I told His Excellency that under the skin of a lamb lurked a fierce wolf, and that he would have discovered this, without doubt, if Bouteville had made a longer stay in this Court. It seems strange that they could have escaped so quickly, and that not one of them was caught, at that hour of the day, in a place so crowded with people. Here we have no such spectacles, nor is there any regard for this kind of bravado. Whoever pretends to be courageous must prove it in battle and in the service of the King.

Orders are beginning to be issued for baggage-trains and munitions, the usual prelude to a campaign. But I stick to my opinion that we shall not undertake anything more than the canals, for I see that there are preparations in this city to begin another canal from Herenthals to Antwerp. It seems that they wish, by so many canals, to corner the enemy within his entrenchments, not being able to conquer or subjugate him by arms.

The Ambassador of Savoy is still in Brussels. They say that in a few days he will come to this city, and that he has asked for a safe-conduct to go to Holland. Without going into the reasons for this journey, it is true that he told the Most Serene Infanta that the differences between his master the Duke and the King of Spain were on the point of being settled, and that he begged Her Highness to be favorable to him. But this does not seem a sufficient reason, nor does it fit in with his going to Holland; aside from that, reports from Italy say that the Duke of Savoy, with 12,000 men, is marching against the Genoese.

The Pope does well to go in person to give the last benediction to the Duke of Urbino. In this way, little by little, St. Peter might become

prince of all Italy, according to Borgia's plan, if the kingdom of Naples and the state of Milan were not ruled by too strong a hand. I am amazed at the impudence of Cardinal Spada, who, if I remember rightly, is merely the son of a doctor — rich, but without any nobility.[2] I am sorry that I have nothing else with which to entertain you, and so I close, humbly kissing your hands and those of your brother.

Your most affectionate servant,

Antwerp, May 20, 1627 Peter Paul Rubens

P.S. As soon as I receive an answer from Antoine Souris, who has written to the agent in Paris, I shall send you everything I have promised in one packet.

<center>- I I I -</center>

To Pierre Dupuy *Antwerp, May 28, 1627*

Monsieur:

This time you will be badly served, for the hour is very late, and besides, the news from this quarter is so scarce that there are very few subjects to be mentioned in my report. We learned here with general regret of the imprisonment of Bouteville; for in the short time he spent at this Court he gained the reputation of a prudent, intelligent, and brave gentleman, who cared more for attaining glory than for offending others through hatred or vengeance. It is true that his behavior was very bad, and his words very different from his actions. I cannot believe that the Royal Edict will be able to resist such powerful and energetic intercessors. In any event, the force of this edict will depend upon the clemency or the severity which His Majesty shows in so distinguished and famous a case.

Here it is believed that the agreement between France and England has made a good start through the mediation of a Scottish gentleman who has left your Court for England. The ban on commerce, however, will produce the contrary result, for in my opinion it is very rigorous and will be hard to apply without causing the greatest prejudice to traffic and vexation to the traders. Perhaps its enforcement will be tempered with more moderation and regard.

Public affairs are going along very quietly here, and we find ourselves rather without peace than at war; or, to put it better, we have the incon-

<center>184</center>

venience of war without the advantage of peace. This city, at least, languishes like a consumptive body, declining little by little. Every day sees a decrease in the number of inhabitants, for these unhappy people have no means of supporting themselves either by industrial skill or by trade. One must hope for some remedy for these ills caused by our own imprudence, provided it is not according to the tyrannical maxim, *Pereant amici dum inimici intercidant.** But even this plan would not succeed, for our own misery far exceeds the little damage we can inflict upon our enemies.[1]

Since I have nothing more to say, I close with a thousand greetings to you and your brother, remaining ever

<div align="right">Your most affectionate servant,</div>

Antwerp, May 28, 1627 Peter Paul Rubens

I have not yet received an answer from Antoine Souris, or rather from his agent in Paris, nor have I up to now obtained the engraving of the Fossa Mariana.

<div align="center">– 112</div>

To Pierre Dupuy *Antwerp, June 4, 1627*

Monsieur:

I have read with pleasure the King's declaration on the restitution of the Duke of Halluin and Sieur Liancourt.[1] I suppose that His Majesty, in order to maintain the authority of his edict, did not mind accusing himself of hastiness, and admitting that he wrongly condemned these innocent gentlemen. He preferred to annul the crime rather than to grant mercy, which might have consequences. This subterfuge is not unlike that which Pope Clement VIII employed (although in quite different circumstances) in the separation of King Henry IV and Queen Marguerite, when, after so many years together, he declared their marriage annulled. Thus he did not place himself or the affair in danger, by granting a dubious dispensation which could some day be retracted. All this could be read in the numerous pamphlets which were published during the negotiations [*in margin*: and in some since then], some of them even by Catholics who criticized the pontifical authority and declared the dispensation impossible.

I have hope now for Bouteville, since the mother of the king who is to be born is interceding for him on the very eve of her confinement. It

* Let friends perish, as long as enemies are destroyed with them (Cicero).

<div align="center">185</div>

seems to me that so extraordinary an intercession deserves exceptional consideration, without establishing a precedent. I don't think it will go as far as complete acquittal, but there may be a mitigation of the penalty, the confiscation of property and the imprisonment. [*In margin*: "*In luctu atque miseriis mortem aerumnarum requiem, non cruciatum esse,*" Sallust.] * Meanwhile, he who gains time, gains life.

The Most Serene Infanta has gone [*in margin*: the last of May] with the Marquis and a small suite to Notre Dame de Montaigu, and it is thought (although not known for certain) that she will make a detour to look over the new canal. I have not yet been able to get the engraving of it. I think that for various reasons this will not be printed until after the return of Her Highness. These canals, as I have often said, serve to exercise our troops and will be of great use to us for the development of commerce. They will also free a wide area from the incursions of the enemy, and from the exaction of the enormous contributions which every year furnish a good sum to his treasury.

I suppose that our packet containing the House of Linden is lost, since Antoine Souris sends me no reply, and you have not found the book at the customs. As soon as possible I shall provide you with another copy. I'll send it along with the engraving of the canal, the impressions of the cameos and the book entitled *Loxias*. I beg you to tell me whether we have anything else here that would please you, so that I may make one big package of them. For we see that small packets are more easily lost than large ones.

The Ambassador of Savoy went to Holland on the first of June, after having received his passport to the States by a courier of the Marquis' who was sent especially for that purpose to the Ambassador of Venice. I had the honor of conferring with him several times and agree with your judgment that he is a man of the keenest intellect. In my opinion he is equal to his task; he serves a master who will exercise him continually, and who needs a servitor endowed with these gifts. Our Marquis has the same impression, having dealt with him several times, and I think the two make a good pair. Scaglia speaks well and often; our Marquis speaks little and is very reserved, hearing everything and thinking none the less.[2]

I have read the memorandum which you sent me concerning the pictures for you, but owing to lack of time, I have not yet been able to think about it.[3] I beg you to give me until the next post, and I shall not

* "In grief and misery death is not torture, but respite from trials," Sallust (*Catalina,* 51.20; *Jugurtha* 13.22).

fail to serve you to the best of my ability. The subject, however, is very limited, for there were very few favorites who outlived their masters. Having nothing more to say, I kiss your hands and those of your brother with all my heart, and commend myself to your favor.

<div style="text-align:right">Your most affectionate servant,</div>

Antwerp, June 4, 1627 Peter Paul Rubens

<div style="text-align:center">– 113 –</div>

To Pierre Dupuy *Antwerp, June 10, 1627*

Monsieur:

The death of the Duchess of Orléans[1] seems to me extremely unfortunate in the present circumstances, not only for the birth of a child *sequioris sexus,** and the immature age of this princess, but also for the tranquility of the state and the security of the royal succession. It is certainly a bitter blow, and considering all that could reasonably have been hoped for, one can only say of her: *Quam longe a destinatione sua jacet.*† It appeared that this marriage was going to suppress many intrigues and prevent numerous disorders. The Cardinal, if I am not mistaken, must feel it very keenly, and although Monsieur will not lack opportunities to remarry, no suitable choice so far comes to my mind.

Bouteville and Chapelles will have a great part in this mourning; they have lost the only one whose intercession could have saved them, unless regard for the deceased, and compassion for Monsieur in his affliction will move the King to gratify him. But above all, I believe the Cardinal will hesitate to provoke the prince, along with the most devoted nobility, by punishing these two. On the contrary, he will seek, perhaps, not only to avoid hatred and opprobrium, but to show appeasement by using the royal clemency placed at his disposal. For it is likely, now that the bridle of Monsieur's marriage is removed, that causes for dissension and animosity between them will break out anew.

The English are increasing every day their insolence and barbarity. They cut to pieces the captain of a ship coming from Spain, and threw all his crew into the sea for having defended themselves valiantly. It is also reported that they have prohibited their allies and friends from having commerce with France, regarding even Dutch ships bound for

* Of the weaker sex.
† How far from her goal she lies (Petronius, *Satyricon*, 115).

<div style="text-align:center">187</div>

that country as a lawful prize. We do not yet know this for a certainty, but it is enough to make our merchants very apprehensive.

I have given some little thought to the subjects of pictures such as you suggested in your previous letter, but I am not yet satisfied. As I have already written you, there are very few examples of such favorites. As for Alexander's, it is certain that Hephaestion died before him, but that Craterus survived him. These two, Plutarch says, were the principal favorites of Alexander, that he loved Hephaestion more, but gave more honor to Craterus. But for a most fortunate favorite who long outlived his prince and ended his life at the height of honor and prosperity, I find no example like that of Cassiodorus. For many years he was in the service of King Theodoric, and always in favor. He survived the king by some thirty-five years, esteemed and respected by all, and extending his life almost over an entire century. He finally retired to a monastery he had founded, and there he died in the utmost tranquility of spirit.

Now, as for examples of conjugal love, I find many memorable cases, but not with those circumstances which you suggest. I should prefer a true story to some poetic fable like that of Orpheus. I beg you to give me a little more time, in order to be able to think more about it. And since the hour is now late, I shall close, humbly kissing your hands and those of your brother.

<div style="text-align: right">

Your most affectionate servant,
</div>

Antwerp, June 10, 1627 Peter Paul Rubens

The Most Serene Infanta will not go beyond Montaigu. Having made her novena there, she will return to Brussels. However, the general opinion is that so far the Fossa Mariana is making very favorable progress.

<div style="text-align: center">

– 114 –
</div>

To Pierre Dupuy *Antwerp, June 25, 1627*

Monsieur:

I have received your two letters of the 10th and the 12th of this month, as well as various printed booklets, and the report on the true causes of Madame's death. The midwife defended herself very well against the slander of the doctors, but all this wrangling is useless, since the error (whoever is to blame) is irreparable. However, it is some consolation for the friends to see that it was a natural and inevitable death, and not the result of chance or negligence on the part of the attendants. This little

daughter will be a great princess, if the Lord God spares her life, and will be able, with her rich dowry, to attract some powerful prince of the realm.[1] It will not be surprising if Monsieur were to revert to his old affection for Mlle. de Condé, who, according to the precosity of her sex, *suis velocius annis crescet in tantam spem.** Thus the Queen Mother and the Cardinal will perhaps be punished.

The defense of Messieurs de Bouteville and Chapelles offers arguments which are more pathetic than decisive; this is usual in a desperate case where discussion is no longer possible. The salvation of the accused depends solely upon the mercy of the King. He will perhaps be guided by some *raison d'état*, superior to civil law, in order not to arouse anew so many tempers already stirred by past intrigues, even to oblige his brother and so many other princes, as well as almost all the nobility of his kingdom.

I have not yet read the booklet on the Valtelline.[2] I thought this question had subsided, and that perhaps that war begun with the sword would be continued with the pen. I cannot believe that the Duke of Buckingham will engage personally in the affair. It seems to me that he would be badly advised, whatever the undertaking, to pledge himself to such an extent that he will have no means of avoiding further false moves, should his plans be unsuccessful.

We have as yet no certain information here whether the English fleet has sailed. None of the numerous letters from Calais confirm this rumor. There is nothing to fear for Dunkirk; the coast of Flanders is considered dangerous for foreign ships, because of its difficult approach, and besides, our Marquis has everywhere provided *in omnem eventum*.

For a long time we have been expecting this "Revisidor."[3] I think that he is coming more at the request of the Most Serene Infanta and the Marquis than for any other reason, in order that the King may know at first hand that it is necessary to furnish more supplies if he wishes to carry on the war as it should be done. In any case, things cannot go on in the present state of scarcity and want. And you may be sure that were this evil not universal, prevalent on all sides, it would cause great disorder here. I have seen letters fresh from The Hague which say that in order to avoid expense, they will not undertake a campaign this year, and I do not think that on our side much will be done. They write from Maastricht that the Most Serene Infanta, with the Marquis, will return to Brussels on the 27th of this month, after having viewed the new canal from one end to the other. We do not yet know, however, whether she was satisfied with

* Thrives on such hope more quickly with her years.

the work. But I can augur nothing but success from this visit of Her Highness. The latest news from Spain, that reinforcements have entered Mantua, and that Tilly's troops have retreated, is regarded here as true.

I am ashamed of my sterility of invention, at not being able to find subjects more fitting for the theme of the pictures you asked for. So far I can think of nothing more appropriate than that of Cassiodorus. But it is up to you to inform me more exactly whether this suggestion appeals to you. Then one could choose the most noteworthy points in this story, and the painter who will do the work will distribute his designs according to the space to be filled. It seems to me that Cassiodorus alone would furnish enough material for three paintings or even more.

As for conjugal love, among the many examples of couples expiring together, for love, I find few which suit our subject. If you look into the matter you will find in Valerius, Pliny, Fulgosius, and other authors more frequent examples of intense devotion on the part of wives for their husbands than the reverse. And even when some cases do occur, all are tragedies reflecting the violence of those times. *Sed aut qui super ipsum uxoris cadaver ferro incubat aut rogo insilit, aut in serpente se ipsum jugulat,** or even a T. Gracchus, have not the slightest similarity to the subject you propose, where it is necessary to represent, calmly and without any exterior signs, a widower sad and faithful *in conjugii memoria* which can hardly be rendered in a picture. It would be different in a scene of more striking action, as in the case of the Moor, Rahum Renxamut [*in margin*: see Lipsius, in *Exemplis Politicis*, p. 199], who showed the greatest bravery in rescuing his wife from the hands of the Portuguese; or of the Neapolitan who had been thrown into the sea, but who refused to leave the pirate craft carrying off his wife until he was taken aboard, preferring miserable servitude with her to liberty without her. But none of this quite suits the subject you propose, and so we shall have to think more deeply about it.

As soon as Her Highness returns, we shall have the picture of the Mariana Canal, and then I shall make one big packet of all the things I have promised you. And since you are willing to favor me with the latest *Mercure,*[4] you could consign it to our Ambassador, to be sent on to me when convenient, by some traveler. Having nothing more to tell you, I close, humbly kissing your hands and those of your brother.

<div align="right">Your most affectionate servant,</div>

Antwerp, June 25, 1627 <div align="right">Peter Paul Rubens</div>

* But one who falls upon his sword over the body of his wife, or leaps upon her funeral pyre, or cuts his throat.

Will you do me the favor of forwarding the enclosed to M. de Peiresc? And forgive my silence in the last post; it was caused by lack of subject-matter and various duties.

– 115 –

To Pierre Dupuy *Antwerp, July 1, 1627*

Monsieur:

Surely the King has shown himself to be a stern judge in the execution of poor Bouteville and Chapelles. And he has closed the door to all hope of pardon for similar offenses in the future. But I fear that the Cardinal will have increased the mistrust and brought upon himself the hatred not only of the relatives of the victims, but of almost all the nobility of the kingdom. I should like very much to know the details and circumstances of this execution, and so if there is a printed report (as there usually is), I beg you to send me a copy. I shall be endlessly obliged for your diligence.

At last I have the print of the Fossa Mariana, most accurately done, as you will see. I am sending you two copies, so that you may pass one on to M. de Peiresc, if you think it would please him. The first cart-load (which leaves next Saturday, if I am not mistaken) will bring you another copy of the House of Linden, the prints of the cameos and the booklet by Wendelinus.[1] I am sorry I have nothing else suitable to your taste.

The special messenger from Spain has brought great news. The Prince-Cardinal, brother of the King, is coming to this country.[2] He will succeed the Most Serene Infanta in the government, and the young man, with the help of his aunt, will be instructed little by little, to enable him to govern, and thus the disorders of an interregnum will be avoided. Her Highness returned to Brussels the day before yesterday, after having seen and examined the canal from one end to the other. But I have not yet received letters from my friends, since their return to the Court, and so cannot give you any details.

I should not have believed that the dissensions between France and England could have gone so far. It seems that the English, according to their actions, could with good reason restore the old device on their standard of St. George: *Amys de Dieu et ennemys de tout le monde.** If France regards their armaments with apprehension, I can assure you that Spain is no less suspicious. The Governor of Calais has seized and opened

* Friends of God and enemies of all the world.

all letters going to England. And since I have nothing more to say this time, I kiss your hands with all affection, and those of your brother, and humbly commend myself to your favor.

P.S. The enclosed letter to M. de Peiresc comes from Cologne. I shall not fail to answer his most welcome letter of June 7, which you forwarded to me recently, but I need time to do it properly.

Antwerp, July 1, 1627

<center>– 116 –</center>

To Pierre Dupuy *Brussels, July 7, 1627*

Monsieur:

I shall be brief because I am traveling and find myself with few subjects I can write about that would be worthy of your notice. The Most Serene Infanta has returned, by divine grace, safe and sound from her visit to the new canal. No one doubts its success, but some are of the opinion that the work is going slowly because it is not being pushed with greater zeal, or with a greater number of laborers. But Her Highness herself, who remained entirely satisfied with it, told me that she did not find any difficulty, and that the operation would continue in the way it had been started; that in a short time it would be brought to a good conclusion. She told me moreover that she had ordered some forts to be built on the opposite bank, and some regiments of infantry (in addition to the cavalry) to be stationed there in front of the standards, for the defense and security of the laborers. But Her Highness also named a sum for the expenses incurred up to now — a sum so small that I dare not mention it, and I fear that she has been deceived by her ministers.[1]

I do not know whether, by this little trip of mine,[2] I shall miss the first cartload bound for Paris. But I shall return home, with divine aid, in a day or two at the most, and I shall not fail to dispatch the things I promised you at the first opportunity.

Here we do not know whether the English fleet has stirred up to now; and by delaying so long it may be that it will not produce any great effect. Ambassador Carleton arrived at The Hague on the 19th of last month, and conferred the Order of the Garter upon the Prince of Orange.[3] This, at least, was the pretext; perchance it served to cover some secret negotiation that I cannot guess. The affairs of the Hollanders are prospering in both the Indies, and particularly with regard to Brazil,

<center>192</center>

where they report the capture of more than twenty ships laden with sugar and other things, thanks to the valor of that famous pirate [4] you mentioned. [*In margin*: These ships were from Antwerp, but were chartered and laden by the Portuguese.] Letters from Holland do not refer to such a great rumor, or mention a sum as excessive as that reported by our Ambassador in Paris.

I have read with pleasure and compassion the letters of the Count des Chapelles, which seem to me to be the song of a dying swan. When I showed them to my Lord the Marquis, His Excellency wanted to read them all that very instant. Finally he told me that it was not possible that they were written under the anxiety and torment of a man condemned to death but determined to be as brave as possible, nor did it appear to him that the style was that of a warlike gentleman, but rather of one who was very well versed in letters. [5]

Here we do not believe that the English fleet has yet moved to anyone's disadvantage, and on our own account we have no great apprehension. Nevertheless, we are on our mark, just as your King is also, preparing with great prudence and valor for the worst that could occur. Having nothing else for now, I commend myself humbly to the good graces of you and your brother, and kiss the hands of both of you.

<div align="right">Your most affectionate servant,</div>

Brussels, July 7, 1627 <div align="right">Peter Paul Rubens</div>

I have written this letter in advance because I shall not be able to do it properly on schedule, on account of my traveling.

P.S. We are surprised by the coming of Don Diego Messia, having supposed that he would probably not give up, even for a few months, the eminent post that he holds in Spain, or postpone his marriage with the daughter of our Marquis without some urgent necessity which we cannot fathom, even though it is known that he brings negotiations of the greatest consequence. [6]

[*Marginal postscript*:] A few days before the arrival of Her Highness at the canal the Hollanders seized and ruined five or six redoubts and took prisoner some hundred of those laborers, spoiling a good part of their instruments. There were also a few dead on both sides, although our side made little resistance, since that place is poorly provided with troops.

To Balthasar Gerbier *Breda, July 10, 1627*

Dear Sir:

I have communicated your letter to the proper quarter, and have been ordered, for reasons which you will find just and equitable, not to go beyond Zevenbergen this time. I beg you to go there at once, and as soon as you arrive, notify me by special delivery, addressing it to Breda, at the "Swan," where I am staying, awaiting news from you. I shall not fail to come to you at the same moment, to kiss your hands. In the meantime, begging you to keep me in your good graces, I kiss your hands with all my heart, remaining ever, Sir,

Breda, July 10, 1627 Rubens

To Pierre Dupuy *Antwerp, July 19, 1627*

Monsieur:

You will regard me as a negligent person, since you received no news from me last week. But I beg you to forgive me, for I have been traveling, and found myself far from any line of communication with France or with places through which the regular couriers pass.[1] And what is worse, I fear that next week will find me in the same predicament. Therefore I write this in advance, in great haste, before having to go away again for several days. However, I am leaving orders at home for the packet which has been promised you so often to be consigned to the same Antoine Souris, and I do not think he will stumble twice upon the same stone. I was forced to leave so unexpectedly that I was unable to have this little thing done before I went. I beg you to show your customary indulgence in understanding this long delay in writing to you — a delay which is not at all in keeping with my obligation.

Here we have no news. The Prince of Orange still remains at Arnhem and neighboring places like Nymwegen and Schenckeschans. Some say that he is advancing toward Groll, but since the greater part of his troops has not yet gone ashore, it is thought that he intends to change sail suddenly and attack some place that least expects it. That is why our Marquis does not move far from the center and watches all sides. He

has thrown a bridge of boats across the river before Antwerp so that the troops of Flanders and Brabant can easily come and go to assist one another when necessary. Count Henry de Bergh is stationed on the side which faces the enemy. He commands a strong force, with 8000 mercenaries, called "stoepschijters," to guard the city, and will use the veteran legionnaires in his expedition.

We have as yet no certain news of the setting out of the English fleet. No one can imagine where this storm is going to break, and we believe that France is more apprehensive than the rest of us. Still, if the fleet is divided into several parts, it seems to me that the whole thing will probably dissolve into smoke, as before. Having nothing else to say, I close, kissing your hands and those of your brother most sincerely, and humbly commending myself to your good graces.

<div style="text-align: right">

Your most affectionate servant,
</div>

Antwerp, July 19, 1627 Peter Paul Rubens

<div style="text-align: center">

– 119 –
</div>

To Pierre Dupuy *Antwerp, August 12, 1627*

Monsieur:

Upon returning from out of town I saw that my orders to send you that packet of books had not been carried out. This was not through the negligence of my servants, but because in this entire city not a single copy of the House of Linden is to be found, even if one were willing to pay twenty crowns for it. My brother-in-law has made every possible effort to obtain one at any price. Thus the misfortune of this loss cannot be remedied, and makes me all the more annoyed with the driver whose fault it was. The reason given for the rarity of the book is that the members of this family are keeping for themselves (no one knows why) every copy allotted to the bookdealers.[1]

You will receive with this post the prints of the canal and the cameos, as well as several booklets which I do not know whether you have seen. I send them more for the sake of sending something, than because I consider them worthy of your curiosity. [*In margin*: The little work of Louis Nonnius [2] is considered a good book, in the opinion of our physicists.] The packet addressed to the Abbé de St. Ambroise I pray you to have delivered to him by one of your servants. It contains nothing but the

<div style="text-align: center">

195
</div>

prints of the cameos. I have received the *Mercure,* for which I thank you, as well as the packet from M. Peiresc, which I shall answer at more leisure.

Here we are suspended between hope and fear, because of the siege of Groll. This is of great importance, for it is a strong place and, so to speak, the key to the passage to Germany. The Prince of Orange has entrenched himself in three places; he intends to establish batteries at three points and to take the place by a general assault. He calculates that the defenders (numbering 1500) are few, and when spread out will be too small a number, and too weak for the defense of every point. The Prince faces one difficulty, and that is the distance of six leagues which lies between his camp and Zutphen, the nearest place from which he can obtain provisions [*in margin*: the country roads having been ruined by the rains]. He has the possibility of bringing them to within a league of Groll by boats with shallow draft, along a little river or stream; but this would fail him if reinforcements should come to us. A gentleman who came from Holland the day before yesterday told me that the Prince had given the States assurance that he would be master of the place in less than fifteen days, for the moat was already bridged and he was ready to begin the assault. On the other side it is certain that Count Henry de Bergh faces the Prince with a considerable force, for the Marquis has sent him the flower of the royal army. In addition he has reinforcements from Anhalt and Cratz, experienced officers sent by Tilly, with express orders to have them go into battle if possible. But if the Prince is well entrenched, and has taken care that his supply lines cannot be cut, it will be difficult to make him fight against his will. We shall soon hear some news, for matters cannot long remain in the present state.

In the meantime France is occupied with the English fleet. I confess that I never believed the English would have the boldness to make war on Spain and France at the same time. This is an indication of extreme temerity, or extraordinary confidence in their naval power. Here it is thought they have not yet seized any of the forts of the Ile de Ré, but have landed with great tumult on both sides of the island. What surprises me the most is that the Duke of Buckingham has preferred to abandon the person of his King, rather than to entrust so difficult and dangerous an enterprise to some other leader of greater experience.[3] It must be very annoying to the King to be ill at this time. They say, however, that His Majesty is almost entirely cured, and the same is true of Don Diego Messia, whom we expect at this Court within a few days. It might be that the insolence of the English, and the common offense, will serve to bring

the crowns of Spain and France to a better understanding. And having nothing more to say, I kiss your hands with all my heart, and commend myself to your good graces.

<div style="text-align:right">Your most affectionate servant,
Peter Paul Rubens</div>

Antwerp, August 12, 1627

<div style="text-align:center">– 120 –</div>

To Pierre Dupuy *Antwerp, August 19, 1627*

Monsieur:

The post has come twice since my return, without bringing letters from you. But I hope that you, your brother, and M. de Thou are all in good health. I shall not discuss the affairs of France since we know nothing definite here. Some say that the English have been beaten and driven from the Ile de Ré, and others affirm the contrary. We wonder at such diversity in the letters from France. As for the King's illness, all agree that it is very serious and that his life is apparently in danger. Our Don Diego, they say, has likewise had a return of his fever; in any case he has not yet appeared in these parts.

Here there is talk of nothing but the siege of Groll, and every day many false rumors are spread.[1] The town is lost, it is taken, it is relieved and then lost again, daily, there are skirmishes and combats, and the insidious lie *quemlibet occidit populariter* * according to each man's inclination. It had been considered certain that the Prince of Chimay, the young Grobbendonck and several others had died in combat, but letters have arrived telling us that all of them are safe and sound. [*In margin*: Without an engagement having taken place, up to now. This news came with letters from The Hague.] It is certain that up to now (as we know) no assault has been made, for after the Prince [of Orange] had thrown his bridges across the moat, they were shattered by the artillery of the defenders, which was placed under the outer ramparts at water level in a new fortification never used before, and called in Spanish "bragas falsas." Count Henry has entrenched himself near the Prince's camp. Therefore, since the Count ventures so far forward, and the Prince makes no move, one must believe that these two armies, of equal strength and courage, will not leave the spot without making the utmost effort to carry out their intentions. This is as much as I can say to you this time, and in

* Gains popularity (Juvenal 3.37).

<div style="text-align:center">197</div>

closing I sincerely kiss your hands and those of your brother, and pray heaven to grant you every happiness and contentment.

<div align="right">Your most affectionate servant,</div>

Antwerp, August 19, 1627 <div align="right">Peter Paul Rubens</div>

P.S. I need not ask you to forward the enclosed to M. de Peiresc.

<div align="center">– 121 –</div>

To Balthasar Gerbier <div align="right">*Antwerp, August 27, 1627*</div>

Sir:

You have apparently good reason to complain of us, since we have kept you so long away from my Lord your master and from Mademoiselle your companion, while awaiting the arrival of Don Diego Messia. But you must excuse us, since we are proceeding in good faith and according to our judgment, not being able to foresee the unexpected incidents which have occurred. In any case we have news that he was to have left Paris on the 22nd, but up to this hour there is no certainty that he has really left. It is reasonable to expect some advance-messenger to appear several days before his own arrival. I have communicated your letter to my Lord the Marquis, accompanied by one of my own mentioning your resolution to return to England. I will not fail to inform you what he orders me to tell you in this matter, and having nothing else to say at this time, I humbly kiss your hands, remaining ever,

<div align="right">Your most humble servant,</div>

Antwerp, August 27, 1627 <div align="right">Peter Paul Rubens</div>

New orders are necessary for addressing our letters, since the passage through Calais is cut off, as M. Steltius has informed me. I have authority to write to and receive letters from Holland, but I prefer to do this under the name of M. Arnold Lunden,[1] living in Antwerp.

<div align="center">– 122 –</div>

To Pierre Dupuy <div align="right">*Antwerp, September 2, 1627*</div>

Monsieur:

Groll surrendered on the 20th of last month to the same conditions as Breda. The artillery lacked ammunition, so that the defenders were

forced to make use of all the iron, lead and tin utensils in the city. It was a great misfortune that by the last, or nearly the last shot, a piece of a pewter spoon killed the natural son of Prince Maurice, called William of Nassau. He was a man of great promise, already appointed Admiral of Holland, and married only three months ago to the daughter of M. van der Noot. An English captain was struck by the same shot. The Prince remains quietly in his position, and Count Henry has retreated, they say, toward Westphalia [*in margin*: for want of provisions]. A captain of cavalry named Robert van Eyckeren [*in margin*: under the name of Colonel Craetz], who had recently raised a company in this city, has gone in disgust, so they say, to offer his services, along with his men, to the Prince of Orange. A thing hitherto unheard of in this war of Flanders!

Not far from this city an attack has also been attempted upon the region of Goes, but with little success. There are diverse reports about it. Some say that our men found the frontier well defended by troops, so that in advancing they would march to certain destruction. Others maintain that our troops, having landed, came to a trench, and then after wading through a wide stretch of country, meeting no one, suspected some sort of ambush and stopped. Then suddenly a great number of arquebusiers appeared; our men, with banners unfurled, retired hastily, and thanks to the trench, reached their ships without a shot having been fired. Only on the way back they were greeted by cannon-fire from enemy warships, but this caused more fright than damage, since the wind and the tide prevented the ships from approaching. Only one man was killed and two were wounded. It is thought certain that the defenders were few, and were only peasants equipped as soldiers. And the blame falls upon the captains who conducted themselves badly, and who, instead of inspiring the soldiers, increased their fright. It is very probable that they will be disqualified, at the least. This is all the news we have for the moment.

I am glad that you have received the two packets in good condition. I shall not fail to send you, at the first opportunity, the portrait of the Count de Bucquoy [1] and a book on the medals of the Duke of Aerschot.[2] Having nothing else to say for now, I close, humbly kissing your hands and those of your brother.

<div style="text-align: right">

Your most affectionate servant,

Peter Paul Rubens

</div>

Antwerp, September 2, 1627

I have indeed painted the portrait of the Marquis Spinola from life,

but up to now it has not yet been engraved on copper, due to other occupations that have prevented it.[3] Here it is believed that the Duke of Buckingham has returned to England, having left the fortresses of the Ile de Ré closely surrounded and besieged.

To Pierre Dupuy *Antwerp, September 9, 1627*

Monsieur:

When I wrote to you in my letter before last, nothing definite was known about the capture of Groll. But the following day the news came with letters from Cologne and Wesel. I believe I informed you in my previous letter about everything that has occurred in this war, and since then there is nothing new.

It is thought certain that the troops which the King of Denmark had recently mobilized not far from Hamburg have been put to rout. [*In margin*: This defeat has not been confirmed by letters from Hamburg dated the first of this month, which arrived this evening; they simply say that Tilly has a strong force within sight of the city.] Tilly is not only courageous, he is lucky, *nam ille incidit in feminas, nos in viros.**

Here it is said that the English have captured some Dutch ships, but this does not seem to me likely, unless they wish to replace on their standard the old motto: *Amys de Dieu ennemys de tout le monde.* [*In margin*: As Jean Froissart has written.] Your fortress of St. Martin[1] is holding out better than Groll did, which, however, was courageously defended. But when munitions fail, necessity knows no law.

I wish the King of Spain were as well as the King of France. His Majesty is ill with chicken pox [*in margin*: variole] and purple fever. But since no special report has come for several days, one may have good hopes for his health, for even the first announcement mentioned some improvement.

I received with pleasure the design (although badly done) of the cameo of Mantua.[2] I have seen it several times, and have even held it in my hands, when I was in the service of Duke Vincenzo, father of the present Duke. I believe that among cameos with two heads it is the most beautiful piece in Europe. If you could obtain from M. Guiscard a cast

* For he sets upon mere women, we upon men (probably a paraphrase of a line in Quintus Curtius, *De rebus gestis Alexandri Magni* 8.1.37).

of sulphur, plaster, or wax, I should be extremely grateful. [*In margin*: I have seen plaster casts of it at Mantua.] I thank you for the book *De Tempore humani partus*.[3] In return I shall send you the one by Giuliano Cossi.[4] Since I have nothing else to say this time I humbly kiss your hands and those of your brother.

<div align="right">

Your affectionate servant,
</div>

Antwerp, September 9, 1627 Peter Paul Rubens

P.S. I have two copies of the Giuliano Cossi, but they are too big to send in care of the Ambassador. It will be necessary, therefore, to consign them separately to the courier.

<div align="center">

– 124 –
</div>

To Balthasar Gerbier [*Antwerp*,] *September 18, 1627*

Monsieur Gerbier:

Your letter of the 6th of this month has arrived and has been taken in good part. However, with regard to the answer you desire to your document of March 9, it is thought that since you on your part remain firm in the resolution contained in the said document, which is to include everything in one transaction, as you have reiterated to me — no answer could at present be found to advance the affair. *For the arrival of Don Diego Messia has enlightened us on the agreement of the Kings of Spain and France, for the defense of their kingdoms.*[1] Nevertheless, the Most Serene Infanta has not altered her opinion, and wishes to continue the same efforts to carry out her good intentions. For Her Highness desires nothing in this world other than the repose of the King, her nephew, and a good peace for the public welfare. My Lord the Marquis on his part will also offer all the assistance he can for the success of so good a work, if England, on her part, does the same. And so our correspondence will be maintained with vigor, and we shall give each other the necessary information as opportunities offer. Hereupon, awaiting news from you, I commend myself to your good graces, remaining ever, Monsieur

<div align="right">

Your most humble and affectionate servant,
</div>

September 18, 1627 P. Rubens

To Balthasar Gerbier [*Antwerp,*] *September 18, 1627*

Dear Sir:

The answer which I send you herewith is all that can be given at this juncture. It was written on the advice of the Most Serene Infanta and my Lord the Marquis, and was seen and approved by Don Diego Messia. A copy was given to the latter, with a copy of your communication of the 6th of this month, to be sent all together to Spain. Since receiving your letters of the 6th I have been constantly in Brussels, and received the last one of September 10 on my return. I have negotiated frankly with Don Diego, by order of my masters, and I can assure you that they are very much troubled at the decision taken in Spain, in spite of all their efforts to the contrary; they do not conceal their opinion at all, but make their perseverence in this matter apparent, not only to Don Diego, but to Spain itself. *We believe that this alliance will be like thunder without lightning, making a noise in the air without effect, for it is a compound of divers tempers brought together into a single body against their nature and constitution, more by passion than by reason.* All men of spirit, who are interested in the public good, are of our opinion, and above all the Infanta and the Marquis. *Don Diego himself has recommended me to keep up our correspondence with vigor, saying that affairs of state are subject to much inconvenience* and change easily. He has been undeceived in several things since his arrival here. As for me, I feel extremely sorry at this poor success, so entirely contrary to our good intentions. But my conscience rests in the knowledge that I did not fail to use all sincerity and industry in order to achieve the goal, had not God ordained otherwise. Neither can I complain of my masters, who have honored me with a strict communication of their intimate intentions in affairs of such importance. I cannot believe that those on your side have any occasion to ridicule us or our insufficiency, or to distrust me, *since my masters are unwilling to abandon the affair, but still persist in the same intention, without any pretence or deception. In fact, this artifice could not serve any purpose,* since they do not pretend by this means to throw cold water on, or to hold in suspense, any warlike effort or exploit on your side. I pray God to employ us more successfully in the future, in this and on other occasions, and to keep you under his protection and me in your good favor, for I am and always will be, Sir,

Your most humble and affectionate servant,

September 18, 1627 Rubens

To Balthasar Gerbier [*Antwerp, September 18, 1627*]

Dear Sir:

I beg you to believe that I am doing all I can, and that I find my masters very much agitated in this affair. They feel annoyed and affronted by Olivares, whose passion has prevailed over all reason and consideration, as I have observed from the words of Don Diego himself (although he tries to conceal it). The majority of the Council of Spain were of our opinion, but its head has forced all to accept his. They are scourges of God, who carry out His work by such means. So many remonstrances have been made to Don Diego that he is beginning to waver and feel embarrassed. The perfidy of the French has been impressed upon him, and the help which the King of France is giving to the States and would give, if he could, to Denmark. He has been told that the French mock at our simplicity, and seek by means of this phantom of aid from Spain to force England into an agreement which will, in fact, follow.

These proposals and arguments, by order of the Infanta and the Marquis, I, Rubens, have often demonstrated at length to Don Diego, frankly and freely, and not without effect. But the thing is done, and the orders from Spain he cannot change. I shall not deceive you under pretext of friendship, but openly speak the truth, and tell you that the Infanta and the Marquis are determined to continue our negotiations, believing that the agreement between France and Spain will have no effect and will not last. All intelligent men here, both clergy and laity, laugh at it. However, as long as no test is made, no change can be expected, and this will take some time. It is hoped that Olivares will finally open his eyes and make amends, but then it will be too late. In the meantime, if you are willing to maintain matters with us in their present state, and to keep Buckingham in good humor, this can do no harm. We do not pretend thereby to prevent or to retard any warlike enterprise, nor are we trying to conceal any plot. We do not wish to keep you any longer, by vain hopes, away from my Lord your master and from your dear wife; this has been done, up to now, with good intentions and apparently good reason. Meanwhile let us keep one another informed as to what happens, in order to keep the princes on the alert and the negotiations open. I am sending you the enclosed letter to my Lord the Duke for your exoneration and my own. I know of nothing further I can do, and trust in my own good conscience and God's will. *In magnis voluisse sat est, Diis aliter*

*visum est.** I pray you to present my humble respects to my Lord Carleton, and assure him of my service and affection. And herewith I commend myself to you with all my heart, remaining ever, Sir,

<div align="right">Yours, etc.
Rubens</div>

I have just received your last letter of the 14th, and my answer is that I shall avail myself of your advice and that it will be well employed.

As to the collection about which I had written to you, it is useless to make any further mention, for I could not obtain the permit necessary to make the journey. Besides, the matter has lapsed somewhat, and in case it does continue, I may buy the pictures on my own account.

The pictures for my Lord the Duke are all ready.[1] The best thing would be for you to give the commission to M. le Blon, and for him, lacking any other consignment, to come over on purpose for them. I shall deliver them to him immediately, and assist him in procuring free passage from this side, but there must be a letter from you requesting this. I recommend to you my passport to the Low Countries.[2]

<div align="center">– 127 –</div>

To the Duke of Buckingham *Antwerp, September 18, 1627*

My Lord:

If I had been as fortunate as I was well-intentioned in the affairs which Your Excellency entrusted to me, they would now be in a better state. I call God to witness that I have proceeded sincerely, and that I have neither said nor written anything which did not conform to the good intention and express orders of my masters. They have done all their duty required, and all in their power to bring the matter to a conclusion, but reason had to yield to private passions. Notwithstanding the completely adverse results, they persevere in their opinion and do not change their minds at the caprice of fortune. But (being wise and experienced in world affairs, and considering how changeable these are, and how many alterations state matters must undergo) they are determined not to abandon the treaty. This they have ordered me to write to Gerbier, and to continue the same efforts for the success of this good work. I beg you

* In great things it is sufficient to have wished, but the Gods willed otherwise (Propertius 2.10.6 and *Aeneid* 2.428).

to believe, my Lord, that there is not the slightest artifice in their proce-
dure, but that they are governed by the utmost zeal and interest in the
public good. Neither do they wish to influence warlike exploits on one
side or the other, nor to postpone any such action under this pretext. If
Your Excellency is of the same opinion, I shall be very glad to hear from
you through Gerbier, for we have corresponded a long time away from
you, in the hope of success. I beg Your Excellency, in spite of the iniquity
of the times, to keep me in your favor, and to believe that no accident of
fortune or violence of public destiny can separate my affections from your
very humble service, to which I have dedicated and devoted myself once
and for always, my Lord, as

<div align="center">Your very humble and very obliged servant,</div>

Antwerp, September 18, 1627 Peter Paul Rubens

<div align="center">– 128 –</div>

To Pierre Dupuy *Antwerp, September 23, 1627*

Monsieur:

I could not write to you by the last post because I was absent. In the
meantime we have had Don Diego Messia here, bringing the news of a
close alliance between Spain and France against the common enemy.
This greatly surprised some people, considering past events, but one must
attribute it to an excess of ardor for the Catholic faith, and hatred for
the opposing party. I believe that this alliance will serve to settle the dif-
ferences between France and England, but that it will have little effect
in conquering that kingdom or in subjugating the Hollanders, for they are
the strongest on the sea. I do not think that France's intention goes that
far, but that she is, for the present, accomodating herself to the will of
her ally, and exploiting the other's passions in order to achieve her own
end. And in the meantime the King of Spain will show himself a true
friend in need and a zealous Catholic, without any other reason of state,
and even at his own expense. Certainly I do not believe the English ex-
pected this blow, but they deserve it for their presumption in declaring
war upon the two most powerful kings of Europe at the same time.

Your fortress of St. Martin is holding out valiantly; this serves to keep
the enemy in check, and gives the King [of France] time to make plans
elsewhere. Unless the English make better progress, they must anticipate,
from this beginning, a very bad end.

Here we are doing little, for the present, and it appears strange that Spain, which provides so little for the needs of this country that it can hardly maintain its defense, has an abundance of means to wage an offensive war elsewhere. But let us leave all this to the future, and in the meantime it will be well to put our minds at rest.

Only three or four leagues from this city they are building a fortress, or rather transforming a whole village into a fortress,[1] to the great hardship of the soldiers who, in changing guard, have to wade in water almost up to their waists. The same is the case at the sentry posts, so that every day many become sick and others are deserting. Since I have nothing more to write now, I humbly kiss the hands of you and your brother, and pray heaven to grant you every happiness and satisfaction.

P.S. I have received the little book *Des Troubles du Royaume de Naples*, etc., which pleased me very much. I remember that in Rome, twenty years ago, I read it in Italian, with especial pleasure. Since then I have looked for it everywhere, but have never been able to find it. Its title, if I am not mistaken, was *La Congiura degli baroni di Napoli contra il re Ferdinando I*.[2] I assure you that you could not have sent me a finer present than this, and I duly thank you for it.

You will receive with this post the two copies of Giuliano Cossi, *Degli Archibuggi*.

P.S. I have received your welcome letter of the 17th, as well as the report of the relief of St. Martin, and the letters of Buckingham and of Toiras, Governor of Ré,[3] etc., and I am infinitely obliged to you for the punctuality and the generosity you show me. I am of your opinion that upon this expedition depends the fate of Buckingham, *qui non erit par invidia praesertim absens.*[*] And to tell the truth, I do not see how one could excuse the temerity of that government. Hereupon I kiss your hands once more.

I beg you to do me the favor of delivering the enclosed letter to the Abbé de St. Ambroise at once, if he has not yet departed; in case he has already gone, perhaps you will find means of forwarding it to him on his journey.

Antwerp, September 23, 1627

* Who will be no match for jealousy, especially while absent.

To Pierre Dupuy *Antwerp, September 30, 1627*

Monsieur:

I cannot help sending you this greeting today, although I have no news worthy of your notice. Things still continue in the same state in which they have been during the last few days. There has been only the proposal of Don Diego Messia for a union of all the kingdoms and states of the King of Spain, for reciprocal assistance in time of war.[1] There would be a certain number of troops furnished by each state at its own expense, but under very reasonable conditions, as one can see in the printed list. I will not fail to send you the first copy that comes into my hands, but so far there are none in Antwerp. [*In margin*: Already many of the King's states have agreed to this demand, among the first being Aragon, Valencia, Majorca, and others.] This is a device for the purpose of maintaining continuous war in this country at the expense of others, and everyone is surprised that the Spaniards allow each nation to choose its own officers to command its troops, and to pay them, without the intervention of a single royal minister. Hitherto they have always refused to do this, when the suggestion has been made voluntarily to them. And as long as our country must serve as the battlefield and the theatre of the tragedy, we are exempted, as a compensation, from furnishing our quota of soldiers. But on the return of peace we shall have to exchange places with our allies. I certainly wish that we were already at that point. But I believe that if this proposal goes into effect, we may no longer hope for any respite which the King's weariness could grant us. For now he will have an opportunity to catch his breath and easily maintain a defensive war in this country without much inconvenience to himself. I do not believe that in the future we shall attack our opponents from this side. We shall hold them in check within their borders by canals, fortifications, and trenches, and protect these provinces from their insults, as well as we can. But in the meantime, according to what I hear, the storm will burst over Germany and Denmark, where it is easier to take the offensive, while Fortune herself will show the way, *ac si nos manu ducat et ultro trahat.** This is all I can tell you this time. In conclusion I humbly kiss your hands and those of your brother, and commend myself to your favor.

Your most affectionate servant,

Antwerp, September 30, 1627 Peter Paul Rubens

* As if she were leading us by the hand and urging us onward.

P.S. Up to now I have received no letter from you by this post. It did not arrive last evening, as it usually does, and I am leaving this morning for Brussels.

To Pierre Dupuy *Antwerp, October 14, 1627*

Monsieur:

Two posts have come without bringing me news from you, and the Ambassador does not mention any indisposition on your part. I should be very sorry if the cause of your silence were poor health. I did not write by the last post because I was in the country, and to tell the truth, the news is so scarce that it is not worth taking the pen in hand. Our troops are still in Santvliet, fortifying this place with great diligence, as if they wanted to make a city of it. What purpose this can serve I do not know, *nisi ad proferendas fines,** since we despair of ever retaking Bergen-op-Zoom, and to have a stronghold on the water, even though accessible only to frigates or brigantines, like Dunkirk. Perhaps this garrison will also be able to harass the nearby islands, and in time force some of them to pay tribute *ad redimendam vexam.*†

At Dunkirk there are said to be twenty warships ready to join the Spanish fleet, which is going to set sail from France against the English. Among these nations a glorious combat could result, unless the Duke of Buckingham makes excuses with the well-known proverb, *Ne Hercules contra duos.*‡ He seems to me, by his own audacity, to be reduced to the necessity of conquering or of dying gloriously. If he should survive defeat, he would be nothing but the sport of fortune and the laughing-stock of his enemies.

Don Diego Messia has gone to present his proposal throughout the provinces. There is no certainty of success, but there is hope of it. As I promised you in my previous letter, I am sending you a copy of this proposal. Having nothing else to say, I humbly kiss your hands and those of your brother, and commend myself to your good graces.

Your most affectionate servant,
Antwerp, October 14, 1627 Peter Paul Rubens

* Unless to extend our frontiers.
† To ward off trouble.
‡ Not even Hercules can cope with two adversaries (Erasmus, *Adagiorum Chiliades Tres,* p. 155).

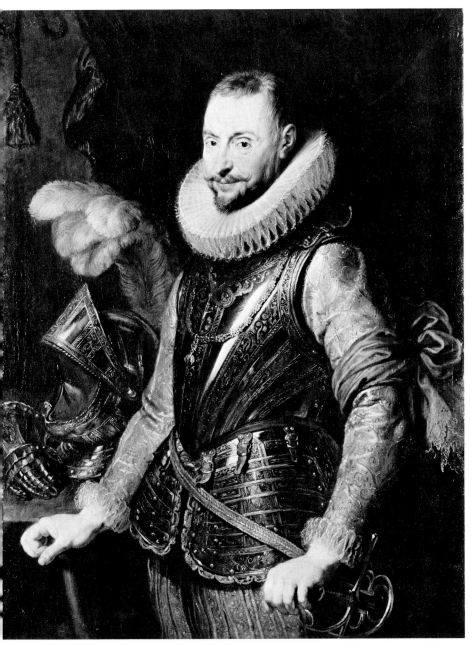

The Marquis Spinola. 1625–1628.

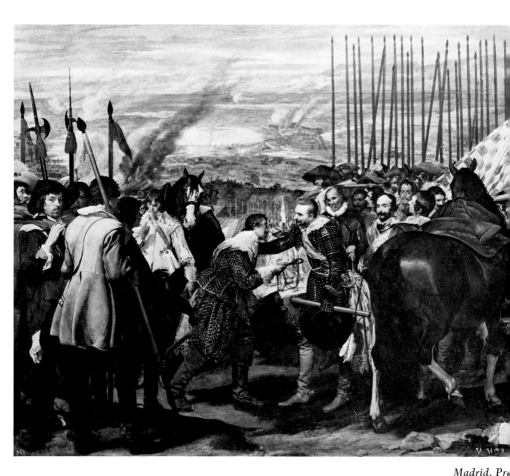

Velásquez: The Surrender of Breda. 1634–35. Painted ten years after the event, the picture sh
the Marquis Spinola receiving the key to the fortress from the Dutch commander, Justin of Nas

To Pierre Dupuy *Antwerp, October 21, 1627*

Monsieur:

The affairs of Flanders are insignificant and of little importance compared to those of Germany or France. It is true that we are exhausted and have endured so much hardship that this war seems without purpose to us. First anger usually spends itself with great violence, and so one may expect some striking action between the two or three war-fleets which, according to latest reports, must be at very little distance from one another. Surely the English will have to show courage and prove their worth, if there is still some virility left to them. And the French, in rivalry with the Spanish, will not fail to show the world that they are not inferior in valor to their allies. It seems strange that the English dare to treat the Hollanders with such insolence; they have detained in England three ships which were returning richly laden from the Indies, after having seized four others, also from the Indies. And at the mouth of the Texel they captured a beautiful ship which the King of France had bought or had constructed in Amsterdam. As a result an express messenger was sent to make a complaint to the King of England and to demand right and justice. We are surprised that the States on their part could grant permits for safe passage without being sure that we would do likewise.[1] But this would be necessary for the welfare of this poor city, for which the enemy seems to have greater sympathy than we do ourselves. They do this probably to satisfy the people, and to prove it is not their fault if trade does not have its former activity and volume.

Our men had planned to build a fortress near Santvliet, on a dyke which controls the water, and is called Blauwegarendijk, but the enemy discovered this, occupied the place, and set up defenses in one night. We have not yet succeeded in driving them out. This will cut off navigation between Santvliet and Antwerp, and render our fortification almost useless.

By the latest post we have heard of the relief sent to Fort St. Martin, to the great disadvantage of the English. They would do better to return as soon as possible to defend their own homes instead of attacking those of others. The Duke of Buckingham will this time learn through experience that the profession of arms is quite different from that of courtier.

I have received by this post your letter of the end of last month; the Ambassador apologizes that he forgot to add it to his packet. I am sorry

to hear of the decision of M. de Thou concerning his journey to the Levant. He is of a very delicate constitution, and will run the risk of meeting some misfortune, even if it be only the hardships of so long and uncomfortable a journey. But I hope the Lord will keep him safe and well, and bring him home under the protection of his guardian angel.[2] Since I have nothing else to write, I humbly kiss the hands of you and your brother, and commend myself to your good graces.

<div style="text-align: right">

Your most affectionate servant,

</div>

Antwerp, October 21, 1627　　　　　　　　　　　　　Peter Paul Rubens

I beg you to have the enclosed delivered by one of your servants to the Abbé de St. Ambroise.

<div style="text-align: center">

– 132 –

</div>

To Pierre Dupuy 　　　　　　　　　　　　　*Antwerp, October 28, 1627*

Monsieur:

The Marquis Spinola left with Don Diego on the 23rd of this month for Dunkirk, for the purpose of sending out immediately the fleet of twenty-two or more warships, well-armed with troops and everything necessary. Their destination is thought to be France. It is quite true that twenty-six Dutch ships have appeared before the port of Mardyk to prevent their departure and to lie in wait for others, so that a naval combat could well take place there, rather than at La Rochelle. But it is also true that if our ships have a favorable wind, it will be difficult to impede their passage, as we have seen on other occasions; that is, provided they simply wish to pass, without giving their commander the chance he hopes for to have Don Diego witness the bravery of his fleet and then report it in Spain. It is very possible that your men will hasten to get rid of the English without our help, not only to save their reputation, but also to escape an obligation which could never be repaid. I believe that France still remembers the price demanded by the Spanish for their help at the time of the League, *et quanti steterint Gallis isti soteres.** I believe also that the English will have rendered a great service to the King of France by their temerity in thus furnishing him a just cause for attacking La Rochelle in earnest, and a plausible reason for reducing it to submission. In my opinion this town, hard pressed and blockaded by land, will submit

* And how dearly the French paid their deliverers on that occasion.

to the discretion of His Majesty just as soon as the English fleet has departed, and I cannot imagine that the Duke of Rohan [1] will produce any considerable effect, *nam vanae sine viribus irae.*†

At Santvliet things remain in the same state as when I wrote you by the last post, the enemy having completed the fortification of his stronghold at a point very advantageous for dominating the channel. Our men seized the crescent which formed the landing-place, killing seven or eight of the defenders, but were forced to demolish and then abandon it, because of the unusually high tide.

Having nothing else to tell you, I now close, kissing your hands and those of your brother with all my heart. To a certain degree I feel glad about M. de Thou's illness, now that he is out of danger. Perhaps it will deter him from this fatiguing and hazardous journey, and I hope he will soon return safe and sound.

<div style="text-align:right">Your most affectionate servant,</div>

Antwerp, October 28, 1627 <div style="text-align:right">Peter Paul Rubens</div>

– 133 –

To Pierre Dupuy <div style="text-align:right">*Antwerp, November 11, 1627*</div>

Monsieur:

I shall be brief because the hour is very late, and also because nothing of importance has occurred. I shall only tell you that during the night from the 7th to the 8th of this month our ships, to the number of seventeen belonging to His Majesty and ten or twelve others belonging to private persons left Mardyk. The Hollanders had taken to the high seas, since as experienced seamen they foresaw the storm that was threatening. Very shortly it struck our fleet with such violence that the flagship [*in margin*: this ship carried forty guns], either by the force of the wind, or purposely to save its men and artillery, ran aground on the beach. The vessel was lost, along with another smaller one which suffered the same fate. The others have not reappeared, and it is thought that they have continued their voyage. Therefore they must now have reached your waters; that is what we assume, without any certainty. But many people believe they have gone to join the Spanish fleet in Biscaya [*in margin*: to bring more aid against the English].

At Santvliet things are going badly for the soldiers because of the

† For anger without force is in vain (cf. Tacitus, *Historiae* 4.75).

rains; they wade in mud to their knees. Having nothing else to say, I sincerely kiss your hands and those of your brother, and commend myself to your favor.

<div align="right">
Your most affectionate servant,
</div>

Antwerp, November 11, 1627 Peter Paul Rubens

<div align="center">

– 134 –

</div>

To Pierre Dupuy *Antwerp, November 25, 1627*

Monsieur:

I was glad to hear by the last post of the victory of the Most Christian King over the English. He has driven them completely from the Ile de Ré, to their great loss and eternal disgrace.[1] I am surprised that our ships from Dunkirk have not yet reached there. Some say that, finding the wind unfavorable to go to France, they went in the meantime to harass the herring-fishers who are at sea at this season, and that Admiral Dorp went in pursuit of them. In Ireland the news was spread that they had fallen into his hands, but of this there is no certainty. All in all, one must admit that it is a coup of the first order for France to have routed so powerful an enemy without any outside aid.

I have received the letters of Phyllarque against Narcissus, and have read a good part of them.[2] I find them very fine and entirely to my taste, as much for the beautiful language and the ironic manner of refuting and criticizing the adversary, as for the clarity and brevity of style and the method of holding the reader's constant interest and attention. But I should like very much to see M. de Balzac's book, to compare it with the other. That is why I beg you to send me a copy; and redoubling my thanks and obligation to you, I ask you to send me also a copy of the *Life of Henry VII,* by Roger Bacon.[3] This book, which I brought recently from Paris, upon your suggestion, pleased me so much that I did not want to enjoy alone the satisfaction it gave me, and so I lent it to an intimate friend. I have never been able to get it back, which will make me more careful about lending books in the future. I pray that in exchange you will ask me for something to your taste, which can be found here, so that I can send it to you at the same time as the de Bie, by some friend. For there will be an opportunity, if you will be a little patient.

There is no news here. The proposal of Don Diego has been accepted by some provinces but absolutely rejected by others, such as Luxem-

<div align="center">

212

</div>

bourg; still others, like Brabant and Hainault, accept it with so many restrictions and reservations that one begins to doubt the success of the affair. That is why they are going to hold a general council of the States of all the provinces. Since I have nothing else to say, I humbly kiss the hands of you and your brother.

<div align="right">
Your affectionate servant,
</div>

Antwerp, November 25, 1627 Peter Paul Rubens

<div align="center">– 135 –</div>

Fragment, to Pierre Dupuy *Antwerp, December 3, 1627*

An accurate report of the last act of the English tragedy has come out, and yet we have positive information that the Duke was received by the King with the same affection and joy as if he had returned victorious. Had he really succeeded, all London would have been covered with triumphal arches.

Here we have no other news except that the Marquis Spinola, to the surprise of everyone, is leaving in a few days to go to Spain in person.[1] Without being able, so far, to penetrate the true reason for this journey, which must be of the greatest importance, considering the rank of the emissary, I believe that private interests enter into it to a great degree, but that the principal reason concerns public matters and is of the highest significance.

Antwerp, December 3, 1627

<div align="center">– 136 –</div>

To Pierre Dupuy *Antwerp, December 9, 1627*

Monsieur:

I have just this moment arrived from Brussels, and find at home your most welcome letter of the 2nd of this month, with its usual report of the events that have occurred in your kingdom. No one but Bautru could make a compliment as meager as his position as Ambassador would permit. Indeed the Spaniards will consider his words less as thanks than as a countermand and disapproval of their tardiness.[1] It is certain that this audacity of the English has given your King occasion to augment his glory considerably. But I am surprised that your Ambassador at this

Court pays compliments like those of Bautru, saying that the English fleet had fled at the mere mention of that of Spain, and that the terror of its name had accomplished the same effect as one could hope from its presence and actual assistance. *Quis temperet a risu?* *

Seeing the reciprocal liberation of prisoners and the good offices of the mediators [*in margin*: Hollanders], I am led to believe that the differences will soon be settled. The Most Christian King can be satisfied with the victory he has achieved, to the great shame of his enemies; and they are more deserving of sympathy than hatred. As a consequence, La Rochelle will pay the penalty for the audacity of others, and will serve as the denouement of this tragedy.

Here we have no news except the already mentioned decision of the Marquis to go to Spain in the middle of winter. I pray the Lord to grant him a good journey and a still better return, for his person is necessary, I believe, to the welfare of this country. I do not think I am wrong in saying that he will carry our fate in his hands, and that upon his return we shall see something new, or a change of great importance. Don Diego Messia would like to accompany him, if it is permitted; in any case he will soon follow, and in the meantime Don Carlos Coloma [2] is coming here to take over military matters in place of the Marquis. The proposals of the Marquis de Léganès are progressing quite smoothly. Many people are inclined to agree to them in the hope of winning the King's favor, that is, to consent without having to take the consequences, assuming that someone will be sure to upset the plan without their being blamed for it.

I thank you for the books you have sent me with your customary generosity, and in closing I kiss your hands and those of your brother with all affection, and heartily commend myself to your good graces.

<div style="text-align:right">Your most affectionate servant,</div>

Antwerp, December 9, 1627 Peter Paul Rubens

I shall set to work upon the portrait of the Marquis as soon as possible.

The day before yesterday the wind was so violent that it destroyed, or rather demolished the tower of the church of Tirlemont; the vault of the church has also fallen in. But it caused more fright than danger to persons, since it happened about noon.

* Who could help laughing?

To Pierre Dupuy *Antwerp, December 16, 1627*

Monsieur:

Our Don Fadrique de Toledo [1] finally arrived, *tanquam post bellum auxilium,** but only to turn back at once, for it is unlikely that he will want to spend the winter in Morbihan. Regarding our ships from Dunkirk we augur nothing good; up to the present the greater part has not appeared, and of those that have returned, three are stranded by the force of the wind in the very port of Mardyk, which is becoming notorious for frequent shipwrecks. The Baron de Wacken, a prominent Flemish nobleman who armed five ships at his own expense, has come to grips with the Hollanders. They have captured two ships and sent two others to the bottom, so that he has only one left. Our Marquis Spinola is preparing for his voyage; in a few days all his baggage will be sent and it is thought that he will depart immediately after the Christmas holidays. I have seen letters from England which say that the King and the Duke of Buckingham are very much angered against the French and are already beginning to assemble a new fleet. All the blame for their ill success has been attributed to the contrary winds which detained the reinforcements from England. The Duke had no more than three thousand infantry and fifty cavalry left when he was forced to retreat from the Ile de Ré. In the meantime, if I am not mistaken, the King of France will take control of La Rochelle and laugh at these threats. Here they are doing very little; at Santvliet the winds have caused more havoc to both sides than the war. And having nothing further to say, I sincerely kiss your hands and those of your brother, and commend myself to your good graces.

<div style="text-align: right">

Your affectionate servant,

</div>

Antwerp, December 16, 1627 Peter Paul Rubens

To the Marquis Spinola *[Antwerp, December 17, 1627]*

Your Excellency:

Today there came to me, by an express messenger who had orders to wait for an answer, letters from M. Gerbier and the Abbé Scaglia. The

* In truth, aid after battle (Erasmus, *Adagiorum Chiliades Tres*, p. 635).

latter's note is here enclosed, but Gerbier's I have kept because it is written in the Flemish language. The content of the two is the same, and the intention of the writers is to reopen the negotiations with Spain. For the English are so embittered by their poor success against the French that they will do anything to enable them to take up that war again without hindrance on the part of the Spanish.[1] I could not fail to give Your Excellency this information, although I imagine that you can give me only an answer of little substance. But I beg Your Excellency to favor me by letting me know as soon as possible, since the express messenger is meanwhile waiting in this city for the answer. Gerbier adds an excuse for the failure of his Duke, who enjoys greater favor with the King than ever before. But it will be better for me to repeat Gerbier's very terms: "It is neither extraordinary nor new for impassioned or ignorant persons to judge great undertakings by instinct alone; but the prudent ones who know how many accidents war is subject to, always rely upon the fact that it is the usual stratagem of great leaders to retire in order to take up the same enterprise soon after with greater force and advantage. It is a fact well known to everyone that help from England was detained by unfavorable winds, and that was the sole reason for the unfortunate outcome, for the Duke had no more than three thousand infantry and fifty cavalry, which seemed to him to be very little against the seven thousand infantry and two hundred horsemen of the Marshal de Schomberg. That is why he decided to retire in very good order, skirmishing with about two hundred and fifty men at the most, more for honor than for necessity. In the meantime the others embarked without the slightest disorder, and the Duke last of all. Now they are making the necessary preparations, much greater than before, and with all diligence, so as to renew the enterprise with more courage and more force than the previous one." So spoke Gerbier in favor of his patron. And since I have nothing else to say, I commend myself most humbly to Your Excellency's favor, and kiss your hands with devout reverence.

<div align="right">Peter Paul Rubens</div>

<div align="center">– 139 –</div>

To Pierre Dupuy *Antwerp, December 25, 1627*

Monsieur:

The sterility of this season in these parts concurs with the haste which I now feel, due to lack of time. The Marquis Spinola will leave next

Monday, with the Marquis de Léganès and Don Filippo, Duke of Sesto, eldest son of Spinola. On the road they will meet with Don Carlos Coloma, who is now in the vicinity of Cambrai, where he is governor. It is doubtful that Count Henry de Bergh has departed from Court any too well satisfied, for he stayed there a very short time.[1]

The King of France appears both magnanimous and firm in his intention not to let La Rochelle slip from his hands, now that he has such a fine opportunity. It is this alone, in my opinion, which could prevent the accord with the English, who, since the ruin of the Rochellese is apparent, and caused by this enterprise of theirs, cannot, under any pretext, abandon them.

We have news from Holland that the West India fleet has arrived in Spain, or in that vicinity; but here we have no special report of a thing so important, which casts doubt on the truth of this news. I beg your pardon if I conclude too dryly; the hour being so late that it allows me nothing more than humbly to kiss your hands and your brother's.

<div align="right">
Your affectionate servant,
</div>

Antwerp, December 25, 1627 <div align="right">Peter Paul Rubens</div>

<div align="center">

– 140 –

</div>

To Pierre Dupuy <div align="right">*Antwerp, December 30, 1627*</div>

Monsieur:

The triumph of Paris clearly shows *à bonnes enseignes* the extent of the English defeat, although they wish to conceal as much as possible their losses and disgrace. I have seen letters from London written by persons of rank, for purposes of publication, filled with what seemed to me the most impudent lies, exalting the extraordinary valor of their general and praising his retreat as a heroic action. They minimize the number of their dead in that skirmish to two hundred and fifty, so that one must assume that those forty-four standards had been loaded on a cart and captured along with the baggage, or else that their standard bearers had all surrendered without striking a blow. For forty-four companies are in fact a small army [*in margin*: rather more than the 3000 men which they said there were in all]. I believe that some agreement would easily follow if La Rochelle should fall, because then the English would lose their scruples at having abandoned it. Our Marquises Spinola and Léganès will leave tomorrow, it is said, but I cannot believe they will

start their journey on the last or the first day of the year; maybe they will wait until the 3rd or the 4th of January.

For the rest, we have no news of importance. At Santvliet each side is repairing the damage suffered by its fortifications in the recent storm. Finally, the Prince of Orange has forbidden any more provisions to be brought to our camp; they still come in secretly, although in smaller quantity.

I thank you for the letters of M. Balzac,[1] which I hope to receive soon. I have read his *Censor* very carefully; it is truly well written and proves, not only by the most beautiful and learned argument, but by his own style, how well he understands the art of eloquence. But in the end I was not displeased to find certain sentences which Balzac had taken and translated from ancient authors, nor do I see anything reprehensible in this borrowing. I wish I could think of something to offer you in return; and humbly kissing your hands, I commend myself to your favor, and pray heaven to grant you and your brother a very happy New Year.

<div style="text-align: right">Your most affectionate servant,</div>

Antwerp, December 30, 1627 <div style="text-align: right">Peter Paul Rubens</div>

I shall make an effort to procure from Holland, if possible, those books of Cardan and Grotius,[2] and I thank you for the information.

PART V

1628
(January–August)

Resumption of Anglo-Spanish Negotiations

The Siege of La Rochelle

The Mantuan Succession

1628
(January–August)

If the aggressive plans of the Count Duke of Olivares against England had caused the breakdown of Rubens' peace talks in 1627, the disastrous failure of the Duke of Buckingham's expedition to La Rochelle paved the way for a renewal of negotiations in 1628. The Duke had returned to England to find the country in a state of general discontent. His folly was recognized by all except the King, and the attitude of Parliament and people alike was becoming increasingly hostile. Moreover, the same Franco-Spanish pact which had caused the miscarriage of the Anglo-Spanish negotiations now, upon sober reconsideration, began to be regarded as a good and sufficient reason for resuming these interrupted negotiations. Before the end of December 1627 Buckingham ordered Gerbier to reopen diplomatic relations with Rubens, with a view to placating at least one of England's enemies.

The Infanta Isabella had not altered her disposition toward peace. Her paramount concern was the plight of the Spanish Netherlands, and she had not waited for the new overtures from London before writing to Madrid with a suggestion of her own. She requested of the Prime Minister that the Marquis Spinola be summoned to Spain in order to explain the dangerous situation in the Netherlands, as well as to present good reasons for a treaty with England. In reply, Philip IV had granted Spinola a three-month leave of absence from December 1, to allow him to go to Madrid. It was not until January 3, 1628, that he left Brussels, accompanied by Don Diego Messia, Marquis de Léganès.

A meeting of the Council of State in Madrid soon after his arrival gave the Marquis Spinola an opportunity to present his views. He made a clear and forceful statement, urging a new truce with the Hollanders, since the experience of seventy years had demonstrated the impossibility of reaching a settlement by force of arms. Chief obstacles, he said, to any understanding had hitherto been, on the one hand, the King of Spain's demand that his sovereignty be recognized, and on the other, the insistence of the United Provinces that Spanish recognition of their

independence form the indispensable condition and basis for all further negotiation. Spinola pointed out that there was at present reason to hope that the Hollanders might be willing to modify this condition (perhaps because of their alarm at the proximity of the Imperial troops around Emden). Therefore the time was ripe for concluding a truce, and some slight concessions on the part of the King of Spain might make the rebels less insistent upon the recognition of their independence. Modification of the Spanish demands regarding the religious issue might result in greater tolerance toward the Catholics in Holland. One might hope also for the reopening of the Scheldt. As for the military situation in the Spanish Netherlands, Spinola declared that a defensive war accomplished nothing; that offensive tactics would require ample and regular provisions, otherwise there was the grave danger of a general mutiny and the loss, for Spain, of all the Netherlands. In conclusion, the Marquis repeated that a truce, which might last from thirty to forty years and during which a final peace treaty might be drawn up, would result in better conditions than could be hoped for in time of war. It would put an end to a critical situation; it would encourage commerce, stabilize the finances, and enhance respect for the King throughout the world.

These moderate and conciliatory remarks of the Marquis Spinola aroused the vigorous opposition of Prime Minister Olivares, to whom concession of any sort was intolerable. His answer to Spinola was that there could be no question of a truce with the Hollanders; it must be a final peace or nothing. His conditions he drew up in a formidable list of twenty-three articles, more uncompromising than ever. Deliberation of the Royal Council, and long discussion of these conflicting proposals led finally to the King's decision in favor of his Prime Minister. Philip IV declared on April 10 that there could be no question of a truce, but only of a peace with the Hollanders, and that none of the conditions laid down by Olivares were unreasonable. The King informed Spinola that he was expected to conduct military operations on a lārge scale during the coming year, because military success would lead to successful peace negotiations; and to this end he was to return at once to the Netherlands. These orders were not acceptable to the Marquis Spinola. He wrote to the Prime Minister declaring his unwillingness to leave Spain until the affairs of the Netherlands were more satisfactorily settled. He repeated that it would be impossible, with the inadequate aid furnished by Spain, to consider a military offensive during the year, and therefore his presence in the Low Countries was not indispensable; that it was more important for him to remain in Madrid. Spinola asserted that in

the Netherlands everyone awaited his return in the hope that he would bring a remedy for all their miseries; it was this hope alone that staved off a general mutiny of the army. For him to return now to Brussels empty-handed would not only be a serious disappointment for the Infanta Isabella; it would mean inevitable disaster.

Further sessions of the Royal Council during the month of June deliberated the question of Spinola's attitude. Sentiment was, in general, unfavorable toward the Marquis. The King's decree, dispatched to the Infanta on July 15, 1628, stated that Spinola would remain in Madrid until decisions had been reached on all the matters which had brought him there; his command in the Netherlands was to be divided, in the meantime, between Don Carlos Coloma and Count Henry de Bergh. Spinola never succeeded in persuading the court of Madrid to adopt a more pacific attitude toward the Hollanders, and he never returned to the Netherlands. In July 1629 he was sent to Milan as Governor and Commander General, and there he died a year later. From Brussels the Infanta Isabella had watched with alarm Madrid's disregard for Spinola's advice. In a letter to the Prime Minister she spoke of Spinola with the highest praise, saying that she hoped his services to the King would be recognized, that "if all those who dealt with him spoke as clearly as he did, there would not be so many disputes." To the King, her nephew, she delivered a sharper warning, amounting to an ultimatum: either he must send funds adequate for carrying on the war (to which the Hollanders were said to be devoting more than 5,000,000 crowns per year), or he must come to an agreement with the rebels as promptly as possible.

The Marquis Spinola's mission to Spain came as a surprise to Rubens. The artist was not told the reason for the journey, and could only guess that it "concerned public affairs of the highest significance." Before departing for Madrid, Spinola, who had seen Gerbier's recent letters to Rubens, had written to the artist by order of the Infanta, declaring that both she and he favored a resumption of negotiations with England and promising to inform the King of Spain of all that had happened, in order to learn his royal will. By the first express courier to leave Madrid after his arrival the Marquis communicated to Rubens the King's disposition to treat with England. Spain had by that time lost confidence in the French alliance, for Louis XIII had not kept his promise to withdraw support to the United Provinces. With the assent of Madrid Rubens took up the interrupted negotiations with renewed enthusiasm and an evident desire to play an even more active role. His reputation as a diplomat was steadily growing, and his advice was frequently sought by the

agents and envoys of other countries. Through Rubens the Ambassador of Savoy, the Abbé Scaglia, had become involved in the Anglo-Spanish discussions in 1627, and the Abbé was now in London with Gerbier, eager to take up the matter once more. The Danish Minister to the United Provinces, Josias Vosberghen, visited Rubens in Antwerp with the argument that Spain, in negotiating with England, must necessarily include England's allies, namely, Denmark and the United Provinces. And the Earl of Carlisle, en route to Lorraine and Savoy as Ambassador Extraordinary of Charles I, obtained through Rubens a passport to cross the Spanish Netherlands and stopped to see the artist late in May. In a long letter to the Duke of Buckingham describing their talks on Anglo-Spanish relations, and the snags in the road to a settlement, the Earl said of Rubens (a trifle grudgingly): "He made mee believe that nothing but good intentions and sincerity have been in his heart, which on my soul I think is trew, because in other things I finde him a reall man, and as well affectet to the King of England's service as the King of Spaine can deseyer."

All the communications Rubens received from Balthasar Gerbier, the Abbé Scaglia, and Vosberghen he forwarded to the Marquis Spinola to be brought to the attention of the King. There was in Madrid no longer any thought of an expedition against England; the talk now was of peace. But Philip IV wished negotiations to be directed from Madrid and not from Brussels. On May 1, 1628, he instructed the Infanta Isabella to have Rubens send him all the original documents of the Gerbier correspondence, on the pretext that the painter had omitted or misinterpreted certain passages. Rubens' reply was that he was ready to obey, but that the letters would be unintelligible without his personal explanation. He offered to communicate them in confidence to someone in Brussels whom the King might designate, or to take them himself to Madrid, if such were His Majesty's pleasure. The latter alternative was clearly Rubens' wish. Twenty-five years had passed since he had visited the court of Spain as the envoy of the Duke of Mantua. This time, as the representative of the Infanta Isabella, he saw himself as the instrument of negotiations which could affect the course of European events. Philip IV convoked the Council of State on July 4 and the decision was taken to summon Rubens to Madrid, with all the papers in his possession. "It will thus be possible," said the King's advisers, "to keep up these negotiations or to retard them, as may be judged necessary. If they are to be continued, the coming of Rubens will be more advantageous than harmful." Philip accepted this suggestion, but added, with characteristic ambiguity, "One

must not urge Rubens; it is for him to decide whether it is to his interest to make the journey." Rubens needed no urging. On August 13 the Infanta wrote the King that within a few days he would leave Brussels.

Until the very week before his departure Rubens continued to write with unbroken regularity to Pierre Dupuy in Paris. The state visit of the Marquis Spinola, on his way to Madrid, had aroused much interest in the French capital, and Dupuy had seen him on that occasion. From Paris, Spinola had gone to La Rochelle to inspect the siege operations which the King and the Cardinal in person were conducting against the Huguenot stronghold. Memories of Spinola's long siege of Breda, with its attendant hardships, gave Rubens an added interest in the siege of La Rochelle. "Reflecting upon the mutability of human affairs," he wrote Dupuy, "it passed through my mind that at the siege of Breda the kings of France and England made every effort to defeat this same Marquis who now goes as a friend to visit the King of France in his camp, at a time when the latter is engaged in a similar siege against his rebellious subjects, and numbers the King of England among his enemies." Pierre Dupuy's letters kept Rubens well informed on the progress of the siege, and the artist responded, week by week, with his own views and comments. The task of subjugating the Huguenots by laying siege to their chief citadel had been undertaken in earnest by Richelieu following the withdrawal of Buckingham and the English fleet in November 1627. The King's troops opened the siege on the landward side, while the royal fleet under the Duke of Guise blockaded the port. Construction was begun on two stone dykes extending from either side of the harbor mouth, with the intention of shutting off the town from all supplies and assistance by sea. Throughout the winter the blockade continued and work on the dykes was pushed forward.

By the spring of 1628 starvation began to threaten the heroic defenders, clinging to the hope of promised aid from the Duke of Buckingham. In May a fleet of thirty English vessels under Lord Denbigh reached La Rochelle. The dykes closing the port were by that time completed and well fortified; the passage between them was blocked by sunken ships. After a futile demonstration the English fleet sailed off again, accomplishing nothing. It was while the Duke of Buckingham was trying to organize yet another expedition for the relief of the desperate city that he was murdered in Portsmouth, late in August, by a Puritan fanatic. The fleet nevertheless set sail on September 17, with specific instructions to launch an attack. But Richelieu's fortifications were too strong to be assailed, and the English stood helplessly by when La Ro-

chelle finally capitulated on October 28, 1628. The news of Buckingham's assassination did not reach Rubens as he crossed France on his way to Spain. The siege was then still in progress. The artist's only detour in a hurried journey was to La Rochelle to view the fortifications, which he described as "a spectacle worthy of admiration."

Another absorbing issue in 1628, one which vitally concerned both France and Spain and had a particular interest for Rubens, was the war in Italy, centering about Mantua. Vincenzo II di Gonzaga, Duke of Mantua and Montferrat, had died in December 1627, leaving as his nearest male heir Charles di Gonzaga, Duke of Nevers, a peer of France and devoted to the French cause. Charles at once took possession of the two states. Spain, as Rubens correctly predicted, refused to recognize a French prince in Italy and supported a rival claimant, César di Gonzaga. A third contestant, the Duke of Savoy, saw in this affair an opportunity to revive his own pretensions to Montferrat. Early in 1628 Spain and Savoy concluded an alliance, occupied Montferrat, and laid siege to its key fortress of Casale. Rubens' familiarity with that region, dating from his residence in Mantua, enabled him to give Pierre Dupuy a detailed description of the place, along with a penetrating analysis of the conflicting loyalties of the population. He admitted that events in Italy threatened the good relations between Spain and France, and realized that he and his correspondent took opposite views of the situation. Both knew that as long as La Rochelle held out, France would be unable to take a very active part in support of the Duke of Nevers. This proved to be the case. With the collapse of Huguenot resistance Richelieu and the King were free to direct their attention to Italy, and thus began the great struggle which was finally to ruin Spain. The war of the Mantuan Succession, which came to an end in April 1631, was followed by a peace in which all the sacrifice was on the side of Spain, and the Duke of Nevers' possession of Mantua and Montferrat was confirmed.

During the entire course of his weekly correspondence with Pierre Dupuy, Rubens, with customary discretion, avoided all reference to his own participation in politics. In announcing the long journey that would interrupt this correspondence, he carefully refrained from mentioning his mission or his destination. All his other friends were equally uninformed, but rumors persisted that he was going to Italy. On August 24, 1628, Peiresc wrote to Aleandro in Rome that Rubens' departure hinged only upon the return of Spinola, who was at last on the way. A few days later he wrote Pierre Dupuy that Rubens would pass through Aix en route to Italy. On August 26 the French envoy in Brussels wrote to his

government that Rubens had gone to Venice to terminate negotiations with the Earl of Carlisle. Only Philippe Chifflet, in the immediate entourage of the Infanta, came closer to the truth. On September 1 he wrote to Guidi di Bagno, "Rubens has gone to Spain, where he says he is summoned to paint the King, but from what I hear on good authority, he is engaged by Her Highness for the affairs which he is negotiating with England concerning commerce."

Before undertaking his journey Rubens put his personal affairs in order. On August 19 he certified a recommendation for his pupil Deodate del Monte. And on August 28 he submitted to his father-in-law Jan Brant and his brother-in-law Hendrik Brant, joint guardians of his two sons, the statement of his property at the time of his wife's death in 1626, and the accounts of his dealings with it since that time. The statement and the accounts approved, the artist set out posthaste for Madrid.

To Pierre Dupuy *Antwerp, January 6, 1628*

Monsieur:

When this letter reaches you, our Marquises will have arrived in Paris and perhaps already departed. Probably they will hasten as much as possible in crossing your country, since the time granted to the Marquis Spinola for this journey is very brief. In fact, he has only three months to go and return. One might hope for some extension were it not that his presence is necessary for the next season of military operations in this country.

La Rochelle will, as you say, give some trouble to the besiegers this winter, but there will be no comparison to the hardships suffered by our troops at Breda. For them the greatest difficulty lay in transporting provisions across seven or eight leagues of country exposed to the enemy. It required each time an escort of not less than fifteen hundred horsemen and three or four thousand infantry, and often (as I myself have seen), five or six pieces of artillery which had to go through very sticky mud. Each convoy consisted of three, four, and sometimes five thousand cases. One can say that all that region was the graveyard of the horses which perished on the roads, and we still feel, in the high cost of horses, the great losses which we suffered in that siege. The King of France, on the other hand, is waging war in his own country, and is comfortably encamped, with all his kingdom behind him and the greatest abundance of all necessary things. He is master both on sea and land, while the beleaguered city is now surrounded on all sides and given up by all. What surprises me is the fact that work can continue on the dyke during these storms which the completed and long established fortifications can hardly withstand.[1]

I am of your opinion that the death of the Duke of Mantua will bring about some changes, for I cannot believe that the greed of the Duke of Savoy will be satisfied with this marriage of his granddaughter to the son of the Duke of Nevers, from which he personally will derive no profit. The Spaniards, on their part, will not look with favor upon France or one of her vassals in possession of a state beyond the Alps and incorporated, so to speak, with the state of Milan. It may be that possession of Mantua will not be disputed, but I strongly doubt that this will be the case for Montferrat, and certainly not for Casale, main fortress of that state and seat of a Spanish garrison.[2]

Here nothing is happening except that at Santvliet everyone is busy repairing the damage caused by the recent storms, even though winds more terrible than ever still continue to rage.

I thank you for the diligence with which you have delivered my message to the Abbé de St. Ambroise. I have received from him the most complete response possible. I am very sorry about his indisposition. I beg you to forward the enclosed to him, and asking your pardon for so much bother, I kiss your hands along with those of your brother.

<div align="right">

Your most affectionate servant,
</div>

Antwerp, January 6, 1628 Peter Paul Rubens

I have received the book on the life of Henry VII, King of England. I am deeply obliged for your generosity and I send you due thanks.

<div align="center">

- 142 -
</div>

To Pierre Dupuy *Antwerp, January 13, 1628*

Monsieur:

You can imagine that little or nothing is being done here during the winter, largely because of the absence of the Marquis. Don Carlos Coloma [1] is expected, on his way to Santvliet; the fortifications there have so far brought nothing but expense and labor, without the least profit. And these storms have caused the greatest damage everywhere. The nephew of a State Councilor, who arrived yesterday from Holland, told me that the Hollanders lost more than one hundred and fifty ships, including those sunk and those thrown up on the shore, with incredible loss to private owners. At Plymouth also four royal ships were wrecked in the harbor, and countless others along the entire coast of that kingdom. Surely Aeolus must have been incited by some angry Juno, or has loosed the bridles of the winds and given them complete freedom.

It is not without great distrust and suspicion that the Hollanders regard the Imperial troops stationed in the region of Emden, so close to Frisia. However, the States General have decided to treat them as friends and to refuse them neither provisions nor other necessities unless the Emperor himself begins open hostilities which cannot be laid to the insolence of the soldiery, without a formal declaration of war.

I believe that the Marquis Spinola will be very welcome in the camp of the Most Christian King, for he has great experience in the under-

taking which His Majesty now has in hand. Reflecting upon the mutability of human affairs, it passed through my mind that at the siege of Breda the kings of France and England made every effort to defeat this same Marquis who now goes as a friend to visit the King of France in his camp, at a time when the latter is engaged in a similar siege against his rebellious subjects, and numbers the King of England among his enemies, and when the Duke of Guise and Don Fadrique de Toledo have united their fleets against the English, common enemy of their kings. Yet I cannot believe that the King of France would ever abandon the Hollanders; in defiance of the Spaniards he will probably continue to assist them. And unless I am mistaken, just as soon as La Rochelle is taken, we shall see France and England easily come to an agreement, and their friendship and complicity will become as close as in the past, or perhaps even more so.

The Duke of Mantua ought to have died some months earlier, before selling his collection to the English. M. de Nevers must have tried to stop its shipment by every possible means, for it has not yet been sent out of Italy.

And since I have nothing else to tell you this time I commend myself sincerely to your good graces, and with all affection kiss your hands and those of your brother. I am surprised that we have not had news of M. de Peiresc for such a long time. I should be very sorry if this silence were caused by some indisposition on his part. I have just found a box full of impressions and engravings which I intend to consign in a few days to a Flemish merchant of his acquaintance who lives in Marseilles and who will return there very soon [*in margin*: he is now in this city]. If you hear any news, pray let me know.

<div align="right">Your devoted servant,</div>

Antwerp, January 13, 1628 <div align="right">Peter Paul Rubens</div>

P.S. I shall not fail to procure a copy of the little work by Grotius upon the first occasion when some friend goes to Holland.

<div align="center">– 143 –</div>

To Pierre Dupuy <div align="right">*Antwerp, January 20, 1628*</div>

Monsieur:

Considering how bad the weather is, I am not surprised that my Lords the Marquises have been seven days on the road, not counting the first

day, the 3rd of this month, since they departed toward evening. They write that they suffered great discomfort due to the bad roads and that some of the baggage carts were overturned. I believe that the fame of the Marquis Spinola will have caused a great crowd of people to gather, for I know the curiosity of the Parisians. Now that you have seen him in person, you will be better able to judge the resemblance of the portrait I am working on, which is now well advanced. [*In margin*: Painting goes slowly in winter, since the colors do not dry easily.]

I have received the two volumes of the letters of M. Balzac, and as I leafed through them a little, before having them bound, I at once discovered, almost on the first page, his *philautia,* for which he deserves to have been nicknamed Narcissus.[1] There is indeed a certain grace in the style, and the acumen of a distinguished mind, were it not intoxicated by vain ambition. [*In margin*: *Inest illi contemptor animus et commune nobilitatis malum, superbia.*] * I send you a thousand thanks for this, with the desire to serve you to a similar or a greater degree.

I have not yet sent you the de Bie because it is in the press, and will soon appear revised and augmented by the same author [*in margin*: Jan de Hemelaer]. You shall have it at the first opportunity.[2] M. Morisot, with his praises, would turn me into another Narcissus, but I attribute all the great and good things he says to his courtesy and his art and feel that he has exercised his magniloquence upon a slight subject. His verses are indeed admirable, and breathe a magnanimity rare in our century. My thought, in complaining, was never anything but annoyance that so great a poet, in doing me the honor of celebrating my works, was not well informed in all the details of the subjects — details which are difficult to ascertain entirely by conjecture, without some explanation by the artist himself. I cannot answer his letter now, but I shall be very glad to do so at the first opportunity, and will point out what he has omitted and what he has changed or distorted *in alium sensum.* But these passages are few, and I marvel that he has fathomed so much by vision alone. To be sure, I haven't the theme of those pictures in writing, and perhaps my memory will not serve me as accurately as I should like, but I will do all I can to satisfy him.[3]

Our Ambassador is very glad to come back; he has been wanting this leave of absence for a long time.[4] I believe, however, that he will accomplish little, and will not find a successor as soon as he wishes, unless, by his presence, he overcomes the feminine resistance of the Most Serene

* He has the haughty spirit and the common fault of nobility: pride (Sallust, *Jugurtha,* 68).

Infanta. Here we have no news, and therefore I close, humbly kissing your hands and those of your brother.

<div align="right">Your affectionate servant,</div>

Antwerp, January 20, 1628 Peter Paul Rubens

<div align="center">– 144 –</div>

To the Infanta Isabella *Antwerp, January 26, 1628*

Your Most Serene Highness:

My Lord the Marquis wrote to me, on his departure from Brussels, that if any affair of state should arise, I was to inform Your Highness directly. And so now I cannot refrain from telling Your Highness that the Minister of the King of Denmark in Holland,[1] to whom Your Highness granted a passport for the journey from here to England, has been for several days in this city. He came to visit me and engaged me in a long conversation, having learned, perhaps through the English or others, that Your Highness has sometimes shown me the honor of entrusting me with certain matters, although with little fruit. He is a Hollander, and is closely related to the leading members of the State Council in those provinces. To tell the truth, I find him very well informed on all the diverse methods of both present and past negotiations with the Hollanders. Furthermore he is on very intimate terms with the Prince of Orange. I am convinced that he has artfully planned his route to England to pass through here, with the sole purpose of transacting some secret negotiation with Your Highness. He does not intend to go to Brussels, nor will he stop in Ghent, which he will pass on the way to Dunkirk or Calais. He is satisfied to deal with me, while waiting until I receive from Your Highness the authority to confer with him by word of mouth and, as soon as he has gone to England, by writing. For this purpose he wanted to leave me a secret code. I have taken the liberty of listening to him, relying upon the confidence that Your Highness and my Lord the Marquis have shown me at various times. But it seems to me that before going further into the matter, he would like me to have particular orders from Your Highness to negotiate with him. This could be done by a few lines from the hand of Your Highness in a note such as the Marquis gave me to qualify and to authorize my person in the negotiations with Gerbier. This note would remain in my possession, and to show it to him once would be enough. He has his own commission and the orders of his king in the most complete form.

<div align="center">232</div>

The argument of this Minister of Denmark I can tell Your Highness in a few words (the meager fortune of his king leads me to believe that he speaks the truth and is sincere). It is as follows: the interests of the King of England, the King of Denmark, and the States of the United Provinces are inseparable, as far as religion and all other reasons of state are concerned. I consider this Minister no less informed on the affairs of Holland and the Prince of Orange than on those of his own king, and therefore one can assume that he represents the sentiment of all. Since, therefore, their interests are identical, it is time lost to negotiate with some among them individually. It is not to be thought that the United Provinces will ever voluntarily yield a single point of their title as free states, still less that they will ever recognize the King of Spain as sovereign, be it only a title without substance; yet one may hope that by means of the kings, their allies, rather than by force, the States General may be made to feel the necessity of giving some satisfaction to the King of Spain.

And if I am not mistaken, the journey of this Minister to England, to all appearances, aims at seeking help for his king, and laying the foundation for an agreement. He also took up with me certain points on the special interests of the Prince of Orange, which I shall some day communicate to Your Highness by word of mouth, and which most likely come from the Prince himself. He told me that Your Highness' reputation for sincerity was great in the opinion of all, and that one might enter into negotiation with Your Highness more willingly and with greater confidence than with any other person. . . If Your Highness will give me orders,[2] I shall try to draw further details from this Minister, perhaps some written statement, and will give an immediate report to Your Most Serene Highness, whose feet I kiss with the most humble reverence, etc.

Antwerp, January 26, 1628 Peter Paul Rubens

He wishes to hasten his departure, and therefore it will be well if Your Highness will answer me as soon as possible. He says that if it should please Your Highness to enter into some agreement, he would pass through here on his return from England, and that in the meantime we could negotiate by correspondence, without losing time.

To Pierre Dupuy *Antwerp, January 27, 1628*

Monsieur:

I received your most welcome letter of the 20th of this month along with one from our Ambassador. This was quite unexpected, since I thought he had already left Paris, according to what he had told me some days before. I am glad to hear that the Marquis has left your Court satisfied.[1] He really deserves in every way to be treated as a man of honor, as I can affirm because I have dealt with him on familiar terms. He is the most prudent and sagacious man I have ever known, very cautious in all his plans; not very communicative, but rather through fear of saying too much than through lack of eloquence or spirit. Of his valor I do not speak, since it is known to everyone, and will only say that, contrary to my first opinion [*in margin*: I had at first distrusted him, as an Italian and a Genoese], I have always found him firm and sound, and worthy of the most complete confidence. But as for my Gallery, His Excellency did not take the trouble to go to see it, for he has no taste for painting, and understands no more about it than a street-porter. He leaves this to the Queen Mother and the Marquis de Léganès, his son-in-law, who can be numbered among the greatest connoisseurs of this art in the world. I have now begun the designs for the other Gallery [2] which I believe, according to the quality of the subject, will succeed better than the first, so that I hope to rise higher rather than to decline. It rests with the Lord God to give me life and health to bring the work to a good conclusion, and to grant the Queen Mother a long time to enjoy this golden palace of hers.

We have no news here, either in matters of peace or war, or in other things of importance. The Minister of Denmark to the United Provinces came to this city and has now gone to England with a passport from us.

I thank you for that triumphal inscription,[3] but our grammarians are doubtful that the first syllable in *fugatis* is short. To me the inscription seems magnificent and very fine. You will receive de Bie's book through a merchant called Jan van Mechelen, who is going to the fair of St. Germain. [*In margin*: He serves as an agent of the Jesuit Fathers.] I will likewise send you, at the first opportunity, the *Stemmata Principum* of Miraeus.[4] And since I have nothing else to say, I kiss your hands and those of your brother, with all my heart.

Your affectionate servant,
Antwerp, January 27, 1628 Peter Paul Rubens

I am extremely glad that M. de Peiresc is feeling well. I have already given his box of impressions to that friend who will deliver it to him in person.

Pardon me for my carelessness; I thought this sheet of paper was complete, but now finding that it is torn, I have no time to copy the letter.

The Ambassador has not advised me what to do about addressing and receiving our letters. On my own initiative I am sending this to Secretary Le Clerck, in the hope that it will reach your hands. The cold here is so intense that the ink freezes in the pen.

– 146 –

To the Marquis Spinola [*Brussels, February 11, 1628*]

Your Excellency:

The Most Serene Infanta has ordered me to inform Your Excellency of a matter which took place after your departure. It concerns a passport which Her Highness, through Your Excellency, granted at my request to the Minister of the King of Denmark in the rebel Provinces. This man is a Hollander by nationality, related to the leading ministers of that government, and a most intimate friend of the Prince of Orange. When he came to Antwerp a few days ago he visited me to thank me for the passport which he had received at my recommendation. And entering into conversation on public affairs, he showed himself rather well informed on the secret negotiations that have passed between the Dutch and the English. He admitted to me that he was on very confidential terms with Carleton. And finally he told me that he did not believe in the possibility of an agreement with one of the allies in particular, but only with all together, since they are closely united and their interests are inseparable. Moreover, the last alliance concluded in The Hague between the King of Great Britain, the King of Denmark, and the States of the United Provinces, forbids any treaty which is not made by common consent.

I answered him that if those States necessarily had to participate, one could hope for little, because of their stubborn insistence upon maintaining the title of a free country, a title which was granted only during the last truce and expired with it. And since His Catholic Majesty demands recognition as sovereign, whether willingly or by force, I told

him that the obstacles seemed to me insurmountable, and forced me to doubt the success of any treaty whatever.

Thereupon he replied that if the King dealt directly with the States, he would never attain his purpose. But if he were willing to make some concessions to the kings of England and Denmark, regarding their particular interests and claims, they could probably force the States to allow the King of Spain to maintain the title to his satisfaction; that is, the title without possession. For it is unjust that, for the sake of a mere name, all Europe should live in perpetual war.

Recalling that Don Diego Messia had asserted and often repeated that the King, our Lord, desired nothing except the title, more for the honor than the substance, I told the Minister that he would have to explain the claims of those kings, since it was not certain that our King could give them satisfaction. For the difficulties between the Emperor and the King of Denmark concern Spain only because of its blood-relationship with the House of Austria, and as for the restoration of the Count Palatine in his dignity and his estates, that depends entirely upon the Emperor.

To that he replied that the power and authority of the King of Spain were well known throughout the world, that if he took a serious interest in the affair nothing would be impossible, and that depending upon the concessions granted to the claims of those kings, they would make every possible effort to bring the States of Holland to give satisfaction to His Catholic Majesty. Finally he added that if I would present this proposal to Her Highness, and she would assure him of her favor and assistance, he would put into writing some clauses of a treaty (but without a signature), and submit it to the will and approval of his superiors, before sending it to Spain. In the meantime he would go to England in order to obtain special powers for this treaty, since he required authority not only from his own king but also from the King of Great Britain. And when I told him that the authorization of the States of Holland was also necessary, he answered that he did not wish to promise the impossible, but that if our King were willing to give guarantees to the Prince of Orange and to compensate for such loss of reputation and material advantages as might result from the peace, he was sure that the Prince, on his part, aided by the aforesaid kings, would devote all his energy and all his authority to bring those States to reason.

I do not know this man, and dare not hope that he will be in a position to carry out these promises; in fact, I doubt it very much. But since he showed me his commission and his powers from his king's own

hand, written and signed in the best form, as I could see, it seemed to me that I could not refuse to submit his proposition to Her Highness, and this I have done. Her Highness has ordered me to enter into negotiations and to inform Your Excellency (as I do by this letter). At the same time I send, for my justification, the original document which I have shown Her Highness. The Minister himself gave it to me, and as Your Excellency will see, it contains certain conditions of the treaty, as well as a very detailed statement of the advantages and disadvantages which would result for each party from such a peace. The most important thing is secrecy, which this envoy claims to be the soul of the affair; that is why he wishes no one to see him in Brussels, and I do not know by what particular inclination he has insisted that he wishes to correspond or negotiate with no one but me, and has left me a cipher for this purpose. And so, in the hope that when this letter arrives, Your Excellency will have reached the Court safely, with God's help, I commend myself most humbly to your favor, and kiss your hands with all submission.

Peter Paul Rubens

This Minister desires above all to have in writing the form of the treaty by which His Majesty would agree to a peace with the Hollanders, and with his own claims and demands specified, so that negotiations can begin on a firm and secure basis.[1]

- 147 -

To Pierre Dupuy *Antwerp, February 17, 1628*

Monsieur:

I do not recall having failed to write to you. But if such was the case, it must have been during my little trip to Brussels. Your last letter of the 10th of this month I received by the ordinary post, without having been sent in care of M. Le Clerck. This is not important, for I am very sure that letters with a simple address will be safely delivered to me.

And so our Marquises have again departed, after having been highly honored, as you write me, and heaped with favors by the King. But since I no longer receive letters from the Ambassador, who used to give me very minute and detailed reports on such things, I beg you to favor me by telling me some of the circumstances. Here it is thought that the King has let Don Fadrique de Toledo go either because he no longer

fears any help the English might give, now that the harbor of La Rochelle has been closed, or because he believes himself strong enough to resist them with his own fleet and does not want to be under any obligation to the Spaniards or allow them a part in his glory; or it may be that the presence of so many ships which he must furnish with provisions and other necessities is a burden to him and perhaps a cause for suspicion.[1] For the friendships of princes *sunt meri ignes suppositi cineri doloso.** Be that as it may, we consider it certain that His Most Christian Majesty has dismissed Don Fadrique with some apparent reason, and that this has willingly been complied with, since the coasts of Spain cannot long remain deprived of their maritime forces. And perhaps in time of need he will return with more promptness than before. But when I consider the Spanish temperament, and the variety of incidents in a short time, I am very doubtful. It is certain that England is making great preparations and many threats, but for the citizens of La Rochelle this will be *post bellum auxilium.*

Here nothing is being done, but within a few days we expect a large part of the royal cavalry in the vicinity of this city, with Don Carlos Coloma in person. The reason for this maneuver is not yet known, but no doubt it must have something to do with Santvliet. The announcement of the three million has somewhat appeased our troops, who were becoming heated in the middle of winter, and were stirring up disorder. But with this reserve we shall be able to hold out all through next summer. I have, of course, not computed the cost of any new undertaking or campaign, but only the ordinary pay.

I have spoken to Count Sforza Visconti, who has just come from Prague and is on his way to Spain. He expressed admiration for the Imperial forces and particularly for the powerful army of the Duke of Friedland,[2] which is constantly growing. This Count is negotiating with the Emperor and the Duke of Friedland on the subject of the encampment of their troops in Frisia, and the probable consequences of such proximity. This is all I have to tell you; it is not worthy of a letter but will serve at least to keep up our correspondence. And kissing your hands and those of your brother, I remain

<div style="text-align:right">Your most humble and affectionate servant,</div>

Antwerp, February 17, 1628 Peter Paul Rubens

* Are live coals covered with deceptive embers (Horace, *Carmen Saeculare* 2.1.8).

To Pierre Dupuy *Antwerp, February 25, 1628*

Monsieur:

You entertain me continually with something new and interesting, such as the verses of M. Gaulmin [1] on the miserable state of La Rochelle. These verses seem to me very nice and pathetic, because the poet has shown a certain discretion in attributing to the King alone a victory whose glory is enhanced by the quality of the vanquished; on the other hand, he excuses and consoles the vanquished by the greatness of the victor, and shows them that it is better to be French than Spanish. I shall not fail to show this poem to M. Gevaerts, who often favors me with his visits.

Here there is nothing but the usual cannonading at Santvliet, where they are continually firing from both sides at the passage of ships, thus giving the illusion of war with more noise than terror. Three days ago the Prince of Orange came in person to Lillo and, to the steady thunder of artillery which caused some uneasiness to our men, visited all the new works at the forts. The following day Don Carlos Coloma went likewise to Santvliet, after amassing a good part of the royal cavalry on that side. It might be that by this diligence he thought to forestall some scheme of the Prince's. But this is more a mere image of war than anything, for in winter it is not customary to do more.

The King of France does well to return home, for such undertakings are usually tedious, and since the city is surrounded on all sides, there is nothing to do but keep a strong guard. Perhaps also the Cardinal wishes to gain for himself the glory of this enterprise, but unless I am mistaken, when the city is reduced to its last extremity, he will do as Joab did and reserve for the King the honor of completing the operation.[2] Our Marquis has been of good service to the King as engineer, because he can speak with experience in such matters.

I shall be very glad to see the sentence published against the Duke of Rohan.[3] It cannot be more terrible than the one inflicted by the Signoria of Venice upon Giorgio Cornaro, son of the Doge, for having assassinated Zeno in the Palace.[4]

The second volume of *Phyllarque* will be very acceptable to me. I wish I knew how to return so many favors. I have written to Holland for the books of Grotius and Cardan, but so far they have not been sent to me. I shall not fail to send you, at the first opportunity, the portrait of

the Marquis and the *Stemmata principum Belgii.* Since I have nothing else to tell you, I humbly kiss your hands and those of your brother, and commend myself to your good graces.

Your affectionate servant,

Antwerp, February 25, 1628 Peter Paul Rubens

The coming of the Prince of Orange was not at all without purpose; he has projected a new fortress on the site of the old one at Lillo, opposite our fortress called La Cruysschans. This fort will be a great annoyance to our ships bringing supplies and ammunition to the camp at Santvliet. Don Carlos Coloma returned from there today with little hope of remedying this inconvenience, since the fort is to be built on enemy territory.

By the next post I shall send you a letter for M. Morisot. I have delayed doing so until now solely because I had hoped to find among my papers some memorandum of the subjects represented in the Medici Gallery. So far I have not been able to lay my hands on it, but I still hope to find it.[5]

– 149 –

To Jacques Dupuy *Antwerp, March 2, 1628*

Monsieur:

I confess that I am deeply obliged to your brother for the care which he puts into his correspondence with me, but with you I have nothing to lose in the exchange. I am only sorry that I am unable, on my part, to equal your courtesy, *sed ne Hercules contra duos.* As far as news is concerned, we find ourselves in a desert here, with no other subject than Santvliet; and this does not deserve mention, for since the visit of the Prince of Orange, the enemy has observed a profound silence. The Prince has forbidden the useless cannon-fire on our ships which bring munitions and supplies to the camp. It wasted too much powder and cannon balls in proportion to the slight damage inflicted upon us; out of 300 shots there was hardly a direct hit, and when, unluckily, this did happen, it was with little effect. The fortress planned by His Excellency upon the foundations of the old Lillo is not yet under construction, as had been thought. An English friend of mine who arrived from there three days ago told me for a certainty (and it has been confirmed by others) that just as the Prince of Orange was leaving his boat, a cannon ball tore off

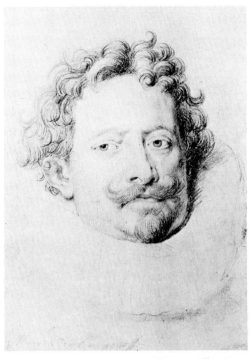

Vienna, Albertina.
Don Diego Messia, Marquis de Léganès. Drawing
by Rubens. 1625–1627.

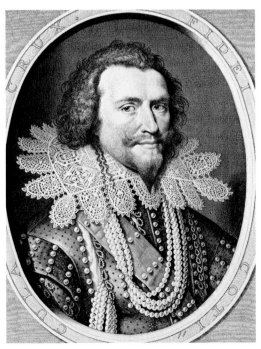

George Villiers, Duke of Buckingham. Engraving
by W. J. Delff after Michiel Mierevelt.

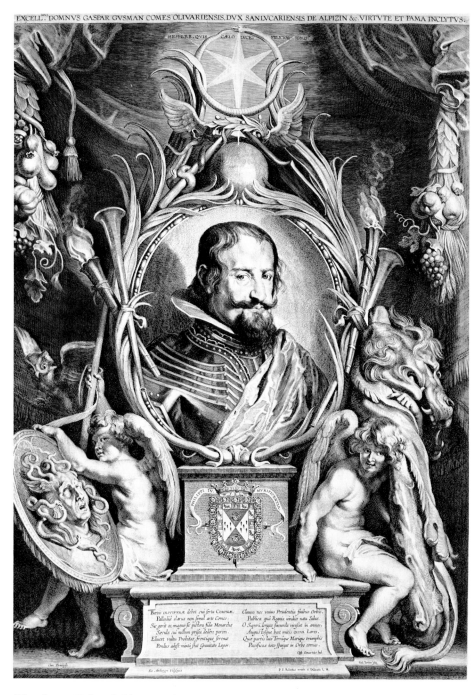

The Count Duke of Olivares. Engraving by Paulus Pontius after Rubens and Velásquez. Olivares, in a letter of August 8, 1626, thanked Rubens for this portrait, saying he hoped the praises implied in the allegorical frame would not be misplaced.

the leg of His Excellency's Master of the Hunt, at the very spot where the Prince had been a moment before. If the gunner had touched the Prince's person, he could not have hoped for any reward from the Most Serene Infanta, for, politics aside, she respects and honors His Excellency, and there is between them the best correspondence which these evil times allow.

We have received word through the courier from Spain that, on the 13th or 14th of February, he met the Marquises Spinola and de Léganès at Vittoria, five days' journey from Madrid. I am surprised that Don Fadrique de Toledo was not appeased by the word of those Lords. Perhaps he had some secret orders to retire as soon as possible. I admit that our assistance in this case was poorly timed. The same Englishman mentioned above left London twelve days ago and he says that at his departure there were forty ships well laden with things most necessary for the aid of La Rochelle, and that because of their sailing, all the ports of that kingdom were being closed. However, the news of the King's departure for some relaxation with the two queens leads one to suppose that the harbor mouth is now blocked so as to prevent any penetration into the city.

I should like very much to know whether the French prisoners released by the Queen of England and sent to Calais have arrived safe and sound. I hear from London that they were thought to have perished in the great storm that overtook them, or to have been thrown onto the coast of Flanders, but up to now there is no certainty that they have appeared there.

The proximity of Tilly's troops arouses great suspicion and mistrust in the Hollanders. Although there has been no strife between them so far, I doubt that this pretense will last for long. And since I have nothing else to tell you, I kiss your hands and those of your brother and sincerely commend myself to your good graces.

Your affectionate servant,
Antwerp, March 2, 1628 Peter Paul Rubens

I thank you for the two orders of arrest issued against the Duke of Rohan and Cornaro. They are utterly terrible.

Will you please forward the enclosed to M. Morisot, since I do not know how to reach him by any other means.

To Pierre Dupuy Antwerp, March 6, 1628

Monsieur:

I have received the second volume of *Phyllarque*,[1] along with your very punctual letter, and I am endlessly obliged to you for both of them. I am sorry I cannot answer you in the manner I should like, but I had some blood drawn from my right arm, which interferes with my handling the pen, to my great annoyance. But my indisposition, thank God, is slight, and I hope will pass quickly, so that I shall again be able to take up our correspondence; for I have no brother to make up for my deficiency. You will receive with this letter two copies of Grotius' booklet, *De Vera Religione,* and one of Cardan's *De Prudentia Civili.*

The war in Italy, they say, has already begun, by consent of the Governor of Milan and the Genoese, but the instigator is the Duke of Savoy. *Dic aliquem sodes hic Quintiliane colorem.** I confess that I am a Davus [2] in this affair. I see nothing in it but a *raison d'état,* without any plausible pretext. I cannot write any more, and that is why I sincerely kiss your hands and those of your brother, and commend myself to your favor.

Antwerp, March 6, 1628

Your affectionate servant,
Peter Paul Rubens

To Pierre Dupuy Antwerp, March 9, 1628

Monsieur:

The Secretary M. Le Clerck writes me that you have given him a book to send to me. It must be the second volume of *Phyllarque,* and I am deeply obliged to you, for this author pleases me very much. I have received three copies of that book of Grotius, *De Veritate Religionis*, and will send you two of them, as well as the booklet by Cardan, *De Prudentia Civili.* But I do not know how to have them sent, for even one of these books alone would be too big to send by the courier in care of the Ambassador. And so I beg you to let me know whether you think it advisable to put all four together into one parcel, or to pack each book alone; or do you want me to send only the Grotius, and arrange with the courier for

* Tell me, Quintilian, if you please, what color this is (Juvenal 6.279).

the lowest price possible? Or is it better to make one packet of these four, together with the Miraeus [*in margin*: *Stemmata Principum Belgii*] and wait for some friend who is going to Paris or sending some goods there? There is no news of any importance here. The friend who brought me these books told me that in Holland there is considerable annoyance over the audacity of our men from Dunkirk who came to plunder as far as Scheveningen, near The Hague, and who captured a vessel on the very beach and took it with them, as well as another of the finest and richest ships that Amsterdam had. It is really astonishing how a handful of men with so few ships can cause so much talk. [*In margin*: He said also that there is the greatest apprehension over the proximity of the Imperial troops.]

The States have dismissed Count Ernest of Nassau, as well as all the garrisons of the Imperial towns, and offered him the title of Prince Palatine.[1] But I do not know whether this stratagem will be accepted and understood by the Emperor, for, as some people think, it could easily lead to a break. His Imperial Majesty has, up to the present, been afraid to aggravate the Hollanders, since they would only ally themselves more closely with Denmark. It is certain that a stronger alliance between the Emperor and the King of Spain is being worked out, so that they would have friends and foes in common, and each would furnish assistance to the other. In such a case the Emperor would declare the United Provinces rebels of the Empire, and the King of Spain would do the same to the enemies of the Emperor. But I still cannot imagine such a plan, for it would arouse too much jealousy against the House of Austria on the part of all the other princes; unless it is that the Duke of Bavaria, with his brother the Elector, and the other princes of Germany have decided to carry out their long-contemplated alliance against the House of Austria, and that this is a necessary expedient to counteract their conspiracy. Certainly something big is brewing in Germany, as one can conjecture from the extraordinary preparations for war to be seen everywhere, forcing one to believe either that the House of Austria wishes to ward off the tempest which it fears, or else wishes to make a last effort to stabilize and extend its power.

From Rome we have received the same news as you have, concerning the creation of two cardinals, and the marriage of M. Taddeo Barberini and Donna Anna Colonna. I will show M. Gevaerts the marriage-poem of Holstenius.[2] He has also seen the verses of Gaulmin, which pleased him very much. [*In margin*: The Grand Duke was to leave Florence for Rome on February 21.]

You really need not worry about M. de Thou, for this journey is not as disagreeable as one thinks. One of my friends who has recently returned from the Levant tells me that he had gone to Jerusalem in very poor health, but that he is now much better, and he really seems very strong and robust in comparison to his previous state.[3] Perhaps the change of air and the sea voyage, along with constant exercise, can work such miracles, quite apart from piety and devotion. I hope that it will be the same with M. de Thou, and that his pilgrimage will be as beneficial to his body as to his soul. This I pray the Lord to grant him, and to you as well as your brother, every contentment. With this I close, and kiss the hands of both of you.

Your affectionate servant,
Antwerp, March 9, 1628 Peter Paul Rubens

– 152 –

To Pierre Dupuy *Antwerp, March 16, 1628*

Monsieur:

We have received news that on the 26th of February our Marquises made their entry into Madrid, and that on the following day they had an audience with His Majesty. On the 8th of the same month[1] was celebrated the marriage of the Marquis de Léganès and Donna Polyxena Spinola. On the 9th occurred the death of the Marquis de San Germano, also called the Marquis d'Inojosa, enemy of the Marquis Spinola. His office of President of the Council of the Indies was immediately conferred upon the Marquis de Léganès, who, to tell the truth, is rising posthaste to the height of all the honors which a man of his quality can attain.

There is nothing of importance here except a fire at Santvliet, which became so violent by strong gusts of the north wind, that in a short time all the quarters of the cavalry, the soldiers' barracks, and the greater part of the village were destroyed. The losses of the shopkeepers were due not only to the fire, but also to the looting of the soldiers under pretext of assistance in saving the goods. But however disastrous this fire was to private individuals, it will contribute greatly to the improvement of the place, for thanks to this empty space the streets and blocks can now be laid out in good order and proportion.

The fortresses planned by the Prince of Orange on the opposite bank

are not yet under construction; no one knows why. The States are arming themselves strongly. They are not only raising recruits, but even forming many new companies, both foot and cavalry, for the proximity of the Imperial troops has made them very apprehensive. But in my opinion the Emperor will not break easily with the Hollanders, nor is it at all fitting for him to do so now, since in the war of Denmark they were careful to avoid any hostility both on land and sea; this deserves great consideration, inasmuch as they alone, with their maritime power, could have ruined the Emperor's entire project. [*In margin*: I think that his intention is simply to frighten them somewhat, at our request.] It is thought that the King of Denmark has concluded an offensive and defensive league with the King of Sweden, and that together they will form a good fleet.

We regard La Rochelle as finished, and believe that your King is going rather to a triumph than to a war. His arrival in Paris was very fortunate for our merchants at the Fair of St. Germain, for otherwise they would have been badly off. Since I have nothing else to tell you, I kiss your hands and those of your brother, and commend myself sincerely to your good graces.

Your devoted servant,
Antwerp, March 16, 1628 Peter Paul Rubens

I have read the letters of Narcissus with great pleasure.[2] I like his style, which seems to me gracious and agreeable, with some very beautiful antitheses, but his conceit and vanity are insufferable, and his hyperbole passes all measure.

– 153 –

To Josias Vosberghen *Antwerp, March 18, 1628*

Sir:

I have received an answer from the Marquis Spinola, dated Madrid, the 3rd of this month of March. It came by the first express messenger to be sent since his arrival. Our letters of February 11 have been received and are acceptable to His Excellency, but he says there cannot be any basis for negotiations until you obtain your powers in good form, and authorization to deal with the matters mentioned in the papers you presented.[1] Futhermore, the Marquis writes me in these exact words: "It is certain

that His Royal Majesty of Spain is very well disposed to make peace with those with whom he is at war." On this you may be assured, there has been a great change in a short time, and one must take advantage of the presence of the Marquis at the Court of Spain, for otherwise no good will come of it. He is prompt in his undertakings and by his diligence will overcome all delays on the part of Spain; moreover, his presence is necessary in this country. Therefore, *quod vis facere fac cito.** And having nothing else to say, I commend myself to your good graces, remaining ever, etc.

Antwerp, March 18, 1628 Rubens

Memorandum

Sir, I cannot help informing you that I have discovered that the treaty of M. van den Wouwere [2] is making progress, and therefore he has recently been sent to Spain, with great hope of success. The affair is conducted under the title of "Principes feudatarii."

– 154 –

To the Duke of Buckingham *Antwerp, March 18, 1628*

My Lord:

I do not wish to fail in my duty toward Your Excellency and the public good, to inform you that My Lord the Marquis Spinola wrote me from Madrid on the 3rd of this month that he finds His Catholic Majesty very well disposed to make peace with those with whom he is at war. This is enough said to a willing listener. If Your Excellency continues in your good and holy intention to procure as you can, on your part, this good for the world, it will be necessary to give me the means of assuring the Marquis of this during his stay at the Court of Spain. This will be brief, for his presence is very necessary in the Netherlands. I beg you, my Lord, to give me the honor of a word in reply, and to keep me in your good graces, for I have no other desire in this world than to remain, during all my life,

 My Lord, etc.
Antwerp, March 18, 1628 Rubens

* What you wish to do, do quickly.

246

To Pierre Dupuy *Antwerp, March 23, 1628*

Monsieur:

This letter will serve solely to keep up our correspondence, for I have no news worthy of your notice. The report of the arrival of our Marquis Spinola is already old; he made his entry into Madrid on the 24th of February, and not the 26th, as I had written you. His Excellency was met a half-league from the city by the Count of Olivares and all the grandees; but when they approached Madrid, the Marquis and the Count rode alone in a coach and drove across country to the palace, to make their reverence to the King. (This custom had not been practiced for a long time.) The others entered the city by the ordinary route, to the displeasure of the Marquis's suite, who would have liked to see the first ceremonies of a public reception by His Majesty.

On the last of February was celebrated the marriage of Don Diego and Donna Polyxena Spinola. On the following day there was a fête and ball at the palace. I have received by the express messenger a letter from the Marquis dated March 3; from this it is easy to see that the festivities and triumphs are not making him negligent, nor do the honors cause any change in his mind.

Here things remain very quiet on both sides, except for the nonsense they are writing from Holland. They say that a phantom shows itself in broad daylight to many people; it is in the form of a bishop with miter and pontifical robes, walking on the waters of Haarlem Meer. You will probably also have seen the engraving representing the shapes observed in the section of a sawn tree, and which bear some resemblance to nuns and monks with two violins. The people marvel at this as a great phenomenon, and as a certain omen that that country, through some great revolution, will have to turn back to obedience to the Catholic faith. How great an impression the dread or fear of something new will make upon the minds of men! I suppose, however, that the Imperial army, there in the vicinity, gives credence to the miracle, as well as to the interpretation of it. In my opinion, one may recall what Pliny said of the tables of lemon-wood: *vitium ligni in nodos et maculas a natura feliciter torti potius quam infeliciter.**

* A defect, in the knots and stains of the wood, that turns out to be favorable, rather than unfavorable.

And since I have nothing else to tell you, I humbly kiss your hands, together with those of your brother.

<div align="right">Your affectionate servant,</div>

Antwerp, March 23, 1628 Peter Paul Rubens

This last courier brought me no letters from you.

<div align="center">– 156 –</div>

To the Marquis Spinola *Brussels, March 30, 1628*

Your Excellency:

I have received, by express, a packet of letters from England dated February 25, containing a long and confused discourse, with many repetitions, and written in different languages. It constitutes a response to the letter which Your Excellency addressed to me on December 21, a copy of which I was to give to Gerbier, and in which Your Excellency offered to make every effort, while in Spain, toward an agreement between the two crowns.

The excuse for having been unable to answer the letter before is the fact that the messenger from Antwerp who was to deliver it died in Holland, and the dispatches he was carrying have only recently, and with great difficulty, been found. [*In margin*: This is no mere pretext, for the man really died in The Hague, as I have been informed with certainty. And his dispatches, even when found, were detained a long time by the contrary winds which prevailed in Holland.] They regret this misfortune very much, and really seem to continue in their good intentions. I am sorry I cannot send Your Excellency the original papers which are partly in cipher and which, as I have said, are written in different languages, including Flemish. For this reason I am sending Your Excellency the substance of them separately.

I had written to Gerbier not to confide the matter to the Abbé Scaglia, for certain reasons. But he replies that this is impossible, because of the great confidence the Abbé enjoys with his masters, and that furthermore he is working with such fervor and courage that to suspect and exclude him would do him an injustice and jeopardize the negotiations. For there is great diversity of opinion; and a large number of persons and ministers, both native and foreigners, who possess great authority, are trying by all kinds of tricks to hinder these negotiations and bring about an agreement

<div align="center">248</div>

with France. [*In margin*: There are also foreign ambassadors who are making great efforts in favor of France.] Now the above-mentioned Abbé serves as a powerful instrument of opposition to these persons, either because he considers a peace between England and Spain as more advantageous to the interests of his master, or because of the hatred and disgust he has conceived for the French in his private dealings with them. And for greater certainty the Duke of Buckingham sends me a passport by means of which he can freely, under the name of the Abbé, send his couriers on English ships, barks, or shallops to Dunkirk (on the pretext that they are going to Savoy or elsewhere). He asks that Her Highness issue a similar pass for the same purpose, on condition that other passengers without passports do not travel with the couriers. He writes me that this is necessary, since the route through Holland is very long and uncertain, due to contrary winds and other inconveniences. Recently it happened that for eight weeks, because of bad weather, they could not receive news from that country.

The Abbé also writes to me at great length, assuring me of his good offices, and begging me to convince Her Highness and Your Excellency of the good disposition on the part of his prince to serve His Catholic Majesty and the Most Serene Infanta. He promises, on his own part, to do everything possible to promote the matter and not to abandon it until the goal is reached. And so, if I may express my opinion, I think one cannot and should not exclude or offend the aforesaid Abbé, lest one risk the failure of the whole plan; and Gerbier tells me the same thing clearly. This will serve to inform Your Excellency. For the rest, I refer to the documents which accompany this letter, and kiss Your Excellency's hands with humble reverence.

<div align="right">

Your Excellency's most humble and devoted servant,
</div>

Brussels, March 30, 1628 Peter Paul Rubens

<div align="center">

— 157 —
</div>

To the Marquis Spinola [*Brussels, March 30, 1628*]

Your Excellency:

I had hardly finished the dispatch which accompanies this one, when I received another large packet from Gerbier, containing three letters written by his hand. One of them, which is in French, I send to Your

Excellency. Of the other two, written in Flemish and filling four whole sheets of paper, I shall tell Your Excellency the substance.

In none of these letters does Gerbier mention the Abbé Scaglia, considering perhaps that he has already written enough about him. But in one of the two Flemish letters he repeats to me, in a much clearer form, everything contained in the Abbé's letter, but without naming him. The other letter, which is extremely long, is full of complaints and repetitions of things past. He claims that on the part of his King and the Duke so much has been done that no one could desire more; that he had been sent in person to Brussels at my request, with letters of authority by the very hand of the Duke, his master, and that since then he has sent documents to me, particularly the one of March 9, which had been drawn up with the consent of his King and the advice of the Royal Council. But he says that we have always been so reserved that he has had nothing but answers of little substance, stating merely that Her Highness would communicate with Spain, without Your Excellency's deigning to write with his own hand a little note which he, Gerbier, could show to his King and to the Duke, in return for the three or four which he has written to me. Furthermore, he states that after having waited for four months at The Hague in the company of Carleton, who had gone there for this purpose, although under another pretext, I came to visit him more as a friend than for any other reason, without showing any kind of commission from my masters; and that after I had detained him a long time, I gave him only one feeble answer: that *les deux rois s'etaient accordés ensemble.*[1] He says that this was as prejudicial to the reputations of Her Highness and Your Excellency as if Spain had mocked his masters, and exploited them solely to achieve opposite results; that his King and the Duke have always maintained their good opinion of the sincerity and zeal of Her Highness and Your Excellency, and believe that your good intentions were thwarted in France by ill-disposed persons [*in margin*: the Marquis de Mirabel], perhaps jealous that the mediation of the Most Serene Infanta was preferred to their own. But the Council has interpreted it otherwise, and now suspects that our efforts were a pretext instigated by Spain to catch the English unawares, perhaps even with the intention of gaining control of the kingdom of England, as if this were a trifle that required no further consideration. [*In margin*: He writes this ironically, and not without foundation, referring to what Don Diego told me in Brussels.] This suspicion has been to a great extent dissipated by the copy I sent to Gerbier of Your Excellency's letter of December 21, the one written to me before your departure for Spain, in which Your Excellency offers

to make every effort with our King toward an agreement between the two crowns. To be sure, he was offended because I had not sent the original letter, but only a copy.

Concerning the contents of this letter, Gerbier says that it seemed to him strange that Your Excellency should speak in these words: "There are two things which I believe necessary: first, that those gentlemen explain more or less the conditions under which they think they could agree with us . . ." just as though Your Excellency had forgotten or pretended not to know the proposals made on their part and presented, among others, in the most ample form, in the document of March 9. Here he says their King had declared himself satisfied to leave the affairs of Germany until a better opportunity, on the promise of the King of Spain to interpose his authority with the Emperor for settling these affairs in due time. [*In margin*: The style of this document was very obscure, but it contained what is said here.] Furthermore, the King of Great Britain was at that time directing all his efforts toward bringing the Hollanders to reason, and said that if the dispute over their title could not be decided quickly, one could make a truce with them, calling them simply allies of His Majesty of Great Britain. It was for this purpose that he sent Carleton to The Hague, where he still remains. To all this no response had ever been given. It is incomprehensible, therefore, that Your Excellency, making no mention of things past, should demand new proposals of them, without having rejected the old ones. These were simple and reasonable, conforming to the Peace of 1604, and could serve as a model, so explicit are they in all points. Moreover, there is no necessity for what Your Excellency says in the same letter: "When one has the intention of making an agreement with another, it is well to offer him an acceptable proposal," for the proposals and the aforesaid peace are such that the King of Spain could not ask for more, particularly at the present time. This is brought to the consideration and discretion of Your Excellency.

And that is the content of one of Gerbier's letters, written in Flemish and dated February 18, old style. What he says in the other one Your Excellency will see in the following letter,

To the Marquis Spinola *Brussels, March 30, 1628*

Your Excellency:

Gerbier says in the second letter of the same date that his King and the Duke, his master, in spite of the small satisfaction they have received from us, persist in their first resolution to negotiate an agreement with the King of Spain under conditions just and favorable to both parties, and not only for the relief of their own subjects, but for the general good of all Christendom. Since their common interests at this time are gravely compromised, it is to be hoped that an agreement would bring about a change [*in margin*: and on his part he offers to do everything within his power], and that the whole would benefit as well as the parts. The King and the Duke would also desire that the differences between the allies of both parties be settled at the same time; but considering the diversity of interests of each one, the great number of participants and the distances which separate them, they judge a settlement impossible to carry out unless the occasion is very favorable and a great deal of time is given to it. However, since the present state of affairs demands a more prompt remedy, he who wishes to embrace the whole will succeed in nothing; but if one part were concluded the rest would follow. And since the proposals to which they refer have already been made, there remains nothing to do but for Your Excellency to procure absolute power and authority for the person of the Most Serene Infanta and for those whom Her Highness may appoint to negotiate and conclude a general treaty with all the allies or with a part of them, or only between the two crowns of Spain and England, in one way or another, in the best manner possible. On their part, they will not fail to grant the most ample and sufficient powers in order to bring the affair to an absolute conclusion. But for many reasons it would be advisable for the negotiations to be secret, and carried on without rumor by persons who are able and qualified for such a task [*in margin*: without their having to turn to Spain every moment for advice and new orders, which are subject to many variations and accidents; and so that in this way it will be possible for Her Highness to negotiate as an equal with the King of Great Britain, who, on his part, is an absolute sovereign and depends upon no one]. Otherwise it could cause trouble and embarrassment. If it should please His Catholic Majesty to treat with the Hollanders simply under the name of allies of the King of Great Britain, without mention of liberty or any other title odious

to His Majesty, the Duke of Buckingham considers it certain that the States would be satisfied and would take part in a treaty in this form.

That is all I have to tell Your Excellency of the contents of Gerbier's letter. But he also tells me in confidence that he would advise Your Excellency, if permission could be obtained from Spain, to have the negotiations handled by able persons with sufficient power, that these persons should not separate before they have reached in one way or another conclusions which conform to the disposition of his masters. Your Excellency will be able to make use of this advice according to your own prudence; but it would be dangerous, in my judgment, to communicate it to many persons. And since nothing else presents itself, etc.

Brussels, March 30, 1628 Peter Paul Rubens

– 159 –

To the Marquis Spinola [*Brussels, March 30, 1628*]

Your Excellency:

Her Highness has seen all these papers, and approved them. She has given the order to make a packet of them for Your Excellency and to send them by the next express messenger. He will depart shortly, Her Highness tells me, although this packet alone is worth being sent by special delivery. She has also ordered me to write to Gerbier that he may assure his King and the Duke of Buckingham of the good intention of Her Highness to do her utmost, by letters to the King, her nephew, to promote the negotiations; and that she will charge Your Excellency to proceed with all diligence and the greatest possible effort at that Court. I hope, therefore, that through your presence there we shall soon have a reply, and a decision which conforms to what Your Excellency writes me, namely, that the King, our Lord, is well disposed to make peace with those with whom he is at war. At least I shall know soon, if it pleases Your Excellency, whether this spring I shall be able to make a journey to Italy, or not.[1] And with this I close.

They write me from Paris that the Dutch Ambassadors have been well received, and that their intervention in favor of peace with England was agreeable to the King.[2]

Peter Paul Rubens

[*In margin:*] Her Highness has granted to the courier a passport for Dunkirk and England in the form required.

To the Marquis Spinola Antwerp, March 30, 1628

Your Excellency:

In conformity to one of the two notes which Your Excellency sent me on
March 3, I have written to the agent of the King of Denmark. I said that
one could not place much confidence in his propositions since, by his
own admission, he possessed no power or commission authorizing him
to enter into any sort of negotiation. I told him that if he wished to pro-
ceed, he would have to provide himself with the necessary powers, as he
had promised to do while in Brussels; and that for the rest, Your Excel-
lency would give him assurance that the King was well disposed to make
peace with those with whom he was at war.

On the day after I received the dispatch from Your Excellency, I also
informed Gerbier (with the knowledge of Her Highness), repeating ver-
batim what Your Excellency had written to me about His Majesty's dis-
position to peace. I think he will be glad to hear it at this time, etc.

Antwerp, March 30, 1628 Peter Paul Rubens

To Pierre Dupuy Antwerp, March 30, 1628

Monsieur:

Just at this moment, upon my return from Brussels, I have received your
very welcome letter of the 24th of this month; but I shall answer only
briefly, because it is very late, and also because of the same reason you
mention, that there is nothing worthy of being written or read by the
gentlemen of our circle.

Here it is considered certain that our Marquis will return the end of
April or the beginning of May, but I know * that His Excellency will
wait for the dispatches which Her Highness has sent him by express mes-
senger, and that he will conduct himself according to their contents. He
himself cannot, up to now, know the precise time of his departure, for it
depends upon others and upon the success of his negotiations in that
Court. It is certain that he confers often with the King, who grants him a
long audience every day.

* *Correction by Peiresc:* some believe.

I have seen letters from England, dated March 18, which say that the Duke of Buckingham has gone to Plymouth in order to send the fleet of perhaps fifty vessels to the aid of the inhabitants of La Rochelle.[1] But I believe it will arrive too late, for the harbor mouth is now blocked up. The Cardinal is conducting himself courageously at La Rochelle, but the construction of this dyke leads me to suspect † that the place is not yet as ready to surrender as one thought. In fact, such a city is not a cat to be caught without gloves, even with inside intelligence, for a beleaguered city usually keeps a good watch, and quickly places all its inhabitants under arms. Here they say that the Cardinal sometimes wears a corselet under his tunic and that an armorer carries before him a helmet, pike, and sword. These things would not be strange in certain other countries, and under similar circumstances the same has been done elsewhere. It is considered certain here that there will be war in Italy over Montferrat. Prince Maurice [2] and his brother have been seen with Don Gonzalo, governor of Milan, dressed in Spanish uniforms, and it is thought that the troops of the Duke of Savoy were already marching in that direction, at the time the courier left.

Since I have nothing else to say, I commend myself to your good favor and humbly kiss your hands and those of your brother.

<div style="text-align:right">Your affectionate servant,</div>

Antwerp, March 30, 1628 Peter Paul Rubens

It is true that M. de Ville, Ambassador of Lorraine, passed through here, as you said, on his way to England.

The Most Serene Infanta has always been careful to give quarter on the sea; the Hollanders have always refused it, and have continued to throw our men taken prisoner into the water. That is why the Infanta has resolved to do the same, and with good measure, throwing overboard two of theirs for one of ours; that is what has been done in the last few days.

<div style="text-align:center">– 162 –</div>

To Pierre Dupuy *Antwerp, April 13, 1628*

Monsieur:

I hope that you will have received by the last post two copies of the

† *In margin, in Peiresc's hand:* Many people suspect it, who do not wish to be persuaded.

Grotius and one of the Cardan. There still remains the *Stemmata Principum Belgii*, which will be difficult to send in one packet; but we shall see that it reaches you somehow. I have read the *Phyllarque*,[1] which gave me the greatest pleasure. I can say that in my opinion he is one of the few best authors in the world. Nevertheless, he cannot persuade me that Balzac is as worthless and as inept as he says (in spite of the faults which are justly criticized). For it seems to me that there is sometimes considerable wit in his pleasantries and irony in his invectives. His ideas show acumen and his moral discourses a certain gravity, but all this is spoiled by the bad seasoning of his *philautia*.

I have read with pleasure the detailed and accurate report of the assault on the citadel of Montpellier. This was a great blunder for the Duke of Rohan,[2] *qui videtur mihi supremum furorem furere, et sibi ipsi et partibus suis quodammodo superstes, inferias ducere potius quam exercitum.* *

It is certain that in England they are preparing a fleet for the aid of La Rochelle, but it will be *post bellum auxilium*.

Here we are inactive. At Santvliet, however, they are working upon laying out the streets and squares of a new city, thanks to the fire which left a wide area vacant. The Hollanders continue to fortify the old Lillo, and our men, having discovered that the enemy had some plan to occupy and fortify Stabroek, forestalled them and seized the place with the regiment of the Count of Salazar and a great many cavalry. Stabroek is a large and beautiful village, nearer to us than Santvliet, and if the Hollanders had fortified it, they would have rendered useless, even dangerous, the enterprise at Santvliet, which would have been cut off like a limb separated from its body.

The Marquis is negotiating successfully in Spain and is gaining great authority with the King and his ministers. But according to my own experience at that Court, I am afraid that this favor will last only as long as he remains there, but will change as easily to envy and jealousy as soon as he has turned his back. [*In margin*: He has been suffering from gout, which has interfered with his affairs.]

Count Sforza arrived from Spain three days ago, and he reports that the Marquis hopes to return here very soon. I know, however, that he is still awaiting the arrival of some dispatches from here. We have been told that the Earl of Carlisle [3] will arrive here soon, en route to Lorraine and Savoy, having obtained a passport for this purpose three months ago. But

* One might call it the last act of desperation of a man who is losing his faculties as well as his party, and who is leading an inferno rather than an army.

I do not believe he will see the Most Serene Infanta. Nevertheless, he will come to Brussels, if his passport permits, and if the political situation has not changed in the meantime, which I doubt. And since I have nothing else to tell you, I kiss your hands and those of your brother with all affection.

P.S. I am sending you here enclosed the print of that miraculous tree found at Haarlem.[4] If you think it worthy of M. de Peiresc's interest, you may send it to him, but in my opinion it is not the thing for him.

You will also find herewith the plan of the site and fortifications of Santvliet, from which you can gain a better idea of the means employed by both sides in fortifying themselves against one another. And once more I kiss your hands.

Antwerp, April 13, 1628

– 163 –

To Pierre Dupuy *Antwerp, April 20, 1628*

Monsieur:

I have received the packet from M. de Peiresc, but I cannot answer it promptly enough to satisfy my own obligation or his curiosity and other demands. Indeed his letters deserve to be multiplied one hundredfold and communicated to the public, so filled are they with the most important questions and observations. I hope that by the next post I shall be able to make up for my present deficiencies.

I thank you for the curious information you give me concerning the affairs of Italy. I find it all the more interesting because I was in the service of the House of Gonzaga for about six years,[1] and never received anything but good treatment from the princes of that family. But if I express my opinion on the outcome of this war, I will say that I do not have great hopes for the Duke of Mantua. His position at the center of the invasion renders assistance very difficult. The new citadel of Casale, which I have seen many times, is separated from the city, or at least the connection is poor. It is so vast that its size exceeds our fortress in Antwerp by at least a third, and to defend it against a royal army would require a minimum of six thousand men. And according to what I have seen of the poor management of those Lords, I do not believe that in the

midst of so many changes and innovations they have thought of supplying the fortress with provisions and ammunition for a long period. The town of Casale is well fortified for ordinary circumstances, but not sufficiently to withstand the arts of siege as practiced nowadays in these parts. As for the old castle, it is good but very small, and once the large citadel is taken, the whole state must be considered lost. Were it not that the hatred of the Italians for Spanish domination outweighed every other consideration, I should strongly doubt the fidelity of the people of Montferrat toward the House of Gonzaga. In the time of Duke William they conspired [*in margin*: with the aid of the Duke of Savoy] to assassinate the father and at the same time the son, Vincenzo, on the point of his accession. The plot was discovered, and Vespasiano Gonzaga di Sabbioneta, to whom was entrusted the care *ne quid Respublica detrimenti caperet,** meted out to the conspirators a just but severe penalty, rather than indulgence. Many of the principal heads fell at the hands of the executioner. Since then the Duke Vincenzo and his sons, lavish spendthrifts who squandered the funds of their subjects, have always burdened that state with the heaviest taxation. The Italians, as I say, have little affection for Spain, but they have always been well disposed toward Savoy — unless, however, since that Duke's alliance with the Spaniards in the recent war, this sympathy has now lessened. Believe me when I say that, with the exception of Casale, the entire state lies open, for the towns are not fortified for modern warfare.

There will be the greatest changes in the alliance between Spain and France against the English and the people of La Rochelle, for these powers will have occasion to fight between themselves elsewhere. What seems strange to me (although I know it to be true) is the fact that the English will consent to and even take part in this league with Savoy. But I cannot find anyone here who can give me any apparent reason for the pretexts upon which the Emperor bases his claim.

I beg you to let me know what you have heard about all this, whether true or probable; you will oblige me very much. And since I have nothing else to say, I sincerely kiss your hands and pray the Lord to grant you and your brother a very happy Easter.

<div align="right">Your most affectionate servant</div>

Antwerp, April 20, 1628 Peter Paul Rubens

* That no harm befall the state.

To Pierre Dupuy *Antwerp, April 27, 1628*

Monsieur:

You are always favoring me with your reports and presents, such as the poem of the Dioscuri,[1] which M. de Peiresc had already sent me. The foreword of the *Phyllarque* is keen and witty, with all the flavor peculiar to this author. He is indeed a terrible adversary for the poor Balzac, whose vanity and self-conceit deserve no sympathy, and who obscures even his good points by his boasting. [*In margin*: As he does in the preface of this latest edition, where his boastfulness and his contempt for all the ancient authors seem insufferable.] I am sending you by this post the rest of the little book of Cardan. It had been forgotten, due to the negligence of the servant who made up the packet, and it comprises the greater part of the book. I think I will send it in care of M. Le Clerck, in two parts, for it will not exceed the size of a large packet of letters.

So Montagu has been freed.[2] His imprisonment must have caused him some mortification, considering his restless nature, as I have observed in the short time I have known him. What seems strange to me is the return of Mme. de Chevreuse[3] to the Court; if I am not mistaken, she will be able to serve as intermediary for a peace between France and England. In my opinion this will succeed even more easily because of affairs in Italy, with which, if I am to believe certain indications, the English have some connections, at least with Savoy.

Already the news which you gave me has spread here, namely that the Marquis will not find it easy to return to Flanders. I am certain that this will be quite contrary to his expectations, since His Excellency departed with the indubitable hope of returning to these parts as soon as possible. This was also the intention of the Most Serene Infanta, who was extremely displeased at his departure. In my opinion, his absence will be longer than he thought. For he will not be able to change the lazy and indolent character of that nation, which has even developed the art of augmenting this natural fault. But as I have said, I hope that he will finally return to continue his assistance to the Most Serene Infanta. For they will never have him serve in Italy, since he is an Italian. Time will clear up our doubts in this respect.

Don Lorenzo Ramírez de Prado[4] is known here by his rank, but not as an eminent man of letters. He cannot compete with the least of your

luminaries in France. But France, so to speak, contains within itself the flower of the world.

I beg you to forward the enclosed to M. de Peiresc with all possible security and promptness. And having nothing else to tell you, I sincerely kiss your hands and those of your brother.

Antwerp, April 27, 1628

– 165 –

To Pierre Dupuy *Antwerp, May 4, 1628*

Monsieur:

I thank you for the detailed report you have given me of the war in Montferrat. Here we were informed only about a treacherous though vain attempt against Casale, but with no details. One can well understand the words of our Nuncio that this is not at all pleasing to His Holiness. It is no more pleasing to the Italian gentlemen who are here in the service of the Catholic King; and this surprises me because they come from regions which for a long time have been subject to Spanish rule. I do not see what interest they can have in the freedom of the rest of Italy, unless they think that the more Spanish power increases, the more their own hope of liberty diminishes. I believe it would be a good thing for them if this war could be terminated with all possible speed (no matter by what means) in order to keep the Spaniards from gaining greater advantages. For the latter, tired of war in Flanders, are perhaps seeking to exercise their armies with more effectiveness elsewhere.

I have the feeling that the Duke of Savoy will be the brand that sets all Italy afire, if he finds the opportunity, and if one takes him seriously. The reasons which the Emperor alleges, as you write me, are the same as we have heard here; but as for the claims of the Dowager of Lorraine, they have no justification, and still less valid are those of her younger sister, the Empress. In fact, if women can inherit the state of Montferrat, the daughter of Duke Francesco would without doubt be the heiress in a direct line.[1] By her marriage her rights have passed to her husband, and as for the other formalities neglected in the previous investitures, they do not seem to me serious enough to deprive a legitimate heir of his succession. I do not believe an example can be found where so slight an offense has been punished in this way, when there was no other crime

or illegality committed *per dolum malum*. In fact, I see here no grounds for exclusion, unless *sit pro ratione voluntas*,* because the Spanish are unwilling to admit any French prince as ruler of a state situated so close to, or in the midst of the Alps. That is why it seems to me that the Duke of Nevers ought to put his son immediately in possession of these states, under condition that he renounce his possessions in France and transform himself into a prince of Italy. And in order to show greater confidence and allay all suspicion and jealousy, he ought, on his way to Montferrat, to pay his respects to the Governor of Milan. To put it in a word, the son ought to conduct himself like a good Spaniard, or at least pretend to be, and the father ought not to appear in Italy in the future. I know on good authority that it is feared he will act in this manner in order thus to forestall the Spanish and predispose them in his favor.

Here we have no news except that Don Carlos Coloma has left with an armed force to attempt a secret enterprise in Flanders. I do not believe it will succeed, because he has delayed too long.

In closing, I sincerely kiss your hands and those of your brother, remaining, as ever,

Your most humble and affectionate servant,

Antwerp, May 4, 1628 Peter Paul Rubens

- 166 -

To Pierre Dupuy *Antwerp, May 11, 1628*

Monsieur:

It is evident that religion exerts a stronger influence upon the human mind than any other motive. Who would have thought that the Hollanders who, a few years ago, fought for the King against La Rochelle, now *rebus perditis* wish to aid the Duke of Rohan in opposing His Majesty? For that is what we learn from copies of the letters of that Duke to the Governor of Orange, whom I know very well. I am certain that this man is acting in opposition to his Prince, and that there are great differences between them, as I have learned from most reliable sources. I would say that the Hollanders are following no other guide in their alliances than their hatred of Spain, and according to the turn of affairs in that country they are changing friends. The war in Italy, however, has greatly weak-

* Let it be will, instead of reason (Juvenal 6.223: *Hoc volo, sic iubeo, sit pro ratione voluntas*).

ened the good relations between Spain and France, and thus the result may be that the Hollanders will come to support the same cause as the Spaniards. But of this I have no certainty. It seems very likely that, as a result of these events in Italy, all those who are making an invasion in France are giving the King a great deal of trouble in his own kingdom, by diverting his forces; and when he wishes to help the Duke of Mantua, his aid will not be very effective, through this division of his forces into so many parts. It seems to me that La Rochelle is the *caput rerum* and His Majesty ought not to abandon his effort, now that the town is reduced to such an extremity; and although the Duke of Rohan has remained irreconcilable, I do not see that he can hope for any other outcome of his desperate rebellion than the ultimate destruction of himself and his adherents. *Tene igitur relinquam an rem?* * the King can say to the Duke of Mantua. But if La Rochelle cannot hold out any longer than the 15th of June, then His Majesty would still have time to join the game in Italy. I do not believe that this will be decided by the sword, because, unless I am mistaken, the Italians are too shrewd to expose their country to invasion by foreigners and to offer it as a theater for the tragedy which the disputes between Spain and France have presented there in the past. It seems strange to me that under these circumstances the Grand Duke of Tuscany continues his journey to Germany, against the will of the Venetian Senate, which has advised him (so they say) to return home. We believe that His Highness is going in order to court one of the daughters of the Emperor, and that he will choose the most beautiful (or the least ugly). I think that Venice will do everything in her power, financially, to keep the Duke of Mantua as neighbor, rather than Spain. But it is doubtful that affairs will come to an open war, which would allow French mercenaries, with the help of Venice, to achieve some success. However, I do not understand too well the passages from France to Italy, and can only say that in my opinion they will be difficult and dangerous.

As far as our affairs are concerned, I have little news. All I can tell you is that Count Henry de Bergh is marching with an army calculated to provide Linghen with supplies and munitions, which can only be done (since the loss of Groll) by making a wide detour through Westphalia, and with large forces.

Here the rumor runs that Don Carlos Coloma went to have an interview with the Earl of Carlisle in Dunkirk, but I assure you that this is false. (Don Carlos was planning an attack upon Cadzant, which did not work out.) And I have information from England that the Earl will go

* Shall I abandon you, or the matter at hand? (Horace, *Sermones*, 1.9.41.)

by way of Holland (I do not think he will touch Brussels) and then direct to Lorraine and Savoy.

We are not so disturbed about our Marquis Spinola as some people say. He did, so to speak, invite rebuke in wishing to make plain to the King and his ministers the excessive expenditures and difficulties of this war, and in telling them that if they wished to have greater success in the future, they would also have to increase their credits. And for this purpose the Marquis, before his departure, had already put in order all the papers and necessary accounts, so as to present this argument in good form (not to take them with him, but to have them ready if necessary). He asked for these papers by the last special courier, but the Most Serene Infanta had already anticipated this on the occasion of Don Giovanni de Velasco's journey; he must have arrived a few days after the departure of the courier. The Marquis is in the habit of doing things with exactness; he will not wish to abandon his proposals (which are very important and very diversified *in omnes eventus*) without having some resolution taken. He knows the Spanish character and is familiar with their indolence. It is true also that jealous and hostile persons are not wanting in that Court.

I have received a large packet from M. de Peiresc, dated April 18 by the Marseilles post, in which he asks me to reply in the same way. It is filled, as usual, with interesting things, verses and other curiosities. And since I have nothing else to tell you, I humbly kiss your hands and those of your brother.

<div align="right">Your most humble servant,</div>

Antwerp, May 11, 1628 Peter Paul Rubens

The portrait of the Marquis is all ready and at your service. I am only waiting for a good opportunity to send it to you by someone who is going to Paris.

<div align="center">– 167 –</div>

To Peiresc *Antwerp, May 19, 1628*

Monsieur:

After I had written you, I gave more thought to the subject of the ancient painting [1] in the gardens of Vitellius, recalling it to my memory as well as possible, and I believe I described it wrongly to you. For the bride is draped in a long white garment, somewhat yellowish, covering her from

head to foot; her attitude is pensive and melancholy. The maid-of-honor is half nude, with a violet drapery, and the nuptial bed is covered with some decoration. If I remember rightly, there is also nearby, but standing somewhat apart, an old woman who seems to be a servant, holding the *scaphio* and a little basket, perhaps for the use of the bride. And the more I think of it, I recall that the majority of the antiquarians in Rome considered the young man, half nude and crowned with flowers, as the bridegroom *qui impatiens morae tanquam ex insidiis sponsam respicit, et quid colloquantur mulieres auscultat.** As for the three women offering sacrifices, two of them have radiating crowns on their heads, if I remember rightly, and the third a miter. I do not recall anything certain about them, unless it be that they are the deities who preside over marriage and generation. Perhaps one of them is Queen Juno, although I have never seen her with such a crown, and the other one Lucina, *nam radii procul dubio lucem significant et ipsa Luna etiam suum lumen a radiis solaribus mutuatur.*† The group on the other side of the bed, opposite the sacrifice, I discussed in my previous letter. This is all I can tell you, vaguely, *memoriter et ex tempore.* But if you would be good enough to send me a drawing which, the better to judge it, ought to be colored and done by a good hand, I could answer you with a little more clarity and foundation. In closing I kiss your hands with all my heart, commending myself to your good graces.

<div align="right">

Your most affectionate servant,
Peter Paul Rubens
</div>

Antwerp, May 19, 1628

– 168 –

To Pierre Dupuy *Antwerp, May 19, 1628*

Monsieur:

Everyone agrees with what you write me about La Rochelle: that the place is lost, and the harbor mouth so firmly blocked that there is no hope of any help from the English. Only the Hollanders in their published reports persist in affirming the contrary, so powerful is the bond of religion (perhaps it is also the bond of rebellion and a common hatred

* Who, full of impatience, casts longing looks at the bride, and lends an ear to the discourse of the matrons.

† For the rays evidently indicate light, and Luna herself also borrows her brightness from the solar rays.

for all kings and princes). In reality their former obligations to France and their possible need of this country in the future ought to make them rejoice in every success of His Most Christian Majesty. In accordance with what you write me, we are hoping that the Marquis Spinola will return promptly to Flanders toward the end of June; we cannot believe that the father will be treated ill when the son, without any personal merit, has obtained the chief command of the cavalry of the State of Milan.

The Genoa conspiracy [1] was terrible. It is thought to have been instigated by the Duke of Savoy, who never tires of interfering in such causes, without, however, espousing any of them. The discontent of those people is certainly justified, as many Genoese gentlemen of the most moderate opinions have confessed to me, and it will never come to an end except by the transformation or the ruin of that republic. The nobility has, in fact, assumed a tyrannical domination, contrary to the oaths and pacts which were solemnly sworn in the late agreements between the nobles and the people, and concluded after long and cruel struggles. The conditions were that each year a certain number of the most qualified citizens should be admitted to the nobility; by this means the people would participate in the administration and all the public offices. But they have been cheated out of this benefit by a wicked plot on the part of the nobles, who never gave the necessary number of votes or ballots to these candidates. The result is that for many years not a single one of them has been elected, while the people remain completely excluded from all honors and participation in the government, deprived of the fruits of such a dearly won peace. It is to be noted that the new nobles, who had been chosen from the people by virtue of the agreement with the old nobility, are the most obstinate in excluding from this dignity men of their former caste. They hope that in time their nobility will mature, enabling them to pass as nobles of long standing (who consider themselves of higher rank and do not like to associate with the others); thus they do not want their number to increase, lest their new authority be weakened by the participation of many of their equals. I have discussed this subject at some length because I have been several times in Genoa, and remain on very intimate terms with several eminent personages in that republic.

Here there is nothing worthy of your notice. Coloma's undertaking seems to have failed; some think it has not been attempted. At any rate, everything is cloaked in such silence that one cannot even discover precisely what the enterprise was, or what obstacles have interfered with it.

Having nothing else to tell you, I humbly kiss your hands and those of your brother.

<div align="right">Your most devoted servant,</div>

Antwerp, May 19, 1628 Peter Paul Rubens

<div align="center">– 169 –</div>

Fragment, to Pierre Dupuy (?) [*May – August 1628*]

As for the return of the Marquis there is no news here, which causes the greatest displeasure to Her Highness and all those persons who are well disposed.

Here it is considered certain that the English have made an attempt upon Calais, with the connivance of certain members of that garrison, and particularly with an individual named du Parcq, who is said to have been seized. Of the rest we have no details. Some say that Boulogne has run the same risk, but that seems to me too much, *nisi qui duos sectatus lepores neutrum capit.**

<div align="center">– 170 –</div>

To Pierre Dupuy *Antwerp, June 1, 1628*

Monsieur:

The outcome of the assistance sent by the English has surprised no one; it had been considered impossible, after the news that the harbor mouth had been closed, and the dykes had withstood the violence of the recent storms. Besides, their delay gave the King and Cardinal Richelieu time to provide at their leisure for every emergency that could arise. [*In margin*: We believe that this aid was sent solely on the part of the Duke of Buckingham and that this is the epilogue of the tragedy. Once this obstacle is removed, it will be easy to settle the differences, which are not really very serious, between the crowns of France and England.] His Majesty is in fact under great obligation to the English, for by their inopportune invasion of the Ile de Ré, they have given him just cause to attack La Rochelle and take it in spite of them. This will be a most beau-

* Unless like the one who, when pursuing two hares, catches neither (the source is a Greek proverb; see Erasmus, *Adagiorum Chiliades Tres*, p. 591).

tiful jewel in the triumphal crown of His Majesty; and having freed himself from internal warfare, he will be able to employ his forces elsewhere, and give his time, as I believe, to the destiny of Italy.

From that country we hear that the siege of Casale is making poor progress with very few soldiers, so that the place is no more than half encircled. It seems to us that the climate of Italy is not favorable to Don Gonzalo, and that he runs the risk of losing there the glory he won in Germany in the company of Tilly, which was of no small importance. To be sure, they write that the Duke of Savoy, having taken Trino, is going to join forces with Don Gonzalo.[1] But it could happen that the Duke of Mantua, in attacking Cremona, would draw him to the aid of this important place which, however, in my opinion, is not a cat to be caught without gloves. The capitulation of Trino is very strange; the Duke had the garrison leave without firearms, but only swords, and then imposed upon the citizens a fine of 7000 pistoles. He abandoned the Jews to the plunder of his soldiers, but this will cause greater loss to the Christians than the Jews, since the houses of the latter are always filled with all kinds of things left in pawn by the Christians. [*In margin*: The pawns are left for the money which they lend at interest to poor Christians; this trade is permitted them.]

The Earl of Carlisle is now stopping here, en route to Lorraine and Savoy and perhaps farther. But he has no special commission for the Most Serene Infanta, *per transitum*; of this I am very well informed. However, unless I am mistaken, he will pay his respects to Her Highness in passing through Brussels.

We firmly believe that the Marquis Spinola has now left the Court of Spain, although we have not yet received any report of his departure. But His Excellency wrote on May 7 that it would not be necessary to send him any more letters, at least not to Madrid.

It seems that the Hollanders are making preparations for some undertaking. We have not yet been able to learn what it is, but according to various reports, it is thought they are establishing their arsenal near the fort of St. André, not far from the city of Bois-le-Duc. These States are waging the bitterest war against the King of Spain, at the expense of private individuals and especially the West India Company. This Company, unless I am mistaken, has just sent out a very strong fleet toward the Bay of Todos os Santos, in order to recapture the city of San Salvador which they lost, contrary to their custom, in a disgraceful manner. And since I have nothing else to say I shall close, humbly kissing your hands and those of your brother.

P.S. I did not write to you last week because I was off on a little trip, too far from the main highways to be able to keep up our correspondence.[2]

Antwerp, June 1, 1628

To Pierre Dupuy *Antwerp, June 15, 1628*

Monsieur:

The same reason as before makes me appear negligent toward you, and once more I had to let the last post go by. I found myself in Wavre, on the confines of Namur, in order to accompany the Earl of Carlisle, at Her Highness' orders. He was simply passing through here on his way to Lorraine and Savoy, and although he was very well received and highly honored at this Court, and twice had an audience with the Most Serene Infanta, nevertheless he brought no letters from his King (believe me), and no particular report to Her Highness. It is true that the hard feelings between Spain and England are very much alleviated, and the exchange of couriers, which had been broken off as between enemies, has again become free. I consider this man as little disposed in our favor, and to tell the truth, he is practically the head of the opposing party. Yet I found that he also felt the greatest dislike for Cardinal Richelieu, so that one could call him *falsum in amore odia non fingere.** He plans to return by the same route in about six months. His business with those princes cannot be fathomed; possibly the principal motive was the desire to remove him under some honorable pretext. The only thing certain is the fact that he has with him a diamond of great value to present, in the name of the King, his master, to the Prince of Piedmont. This ring is to serve as a gracious compliment, binding the two in eternal friendship, quite apart from their relationship by marriage.[1] In England things are going well, with agreement between the King and Parliament. After His Majesty had obtained the desired subsidy, orders were sent through Montagu to Mylord Denbigh bidding him to return victorious or die at La Rochelle;[2] all the Council had been very much displeased that he had retired without striking a blow. Nevertheless, I do not believe that

* However false in his affections, he does not conceal his hate (Tacitus, *Annals* 6.44).

he will produce any great result. *Durum est contendere cum victore.**

In Italy the Duke of Savoy is carrying on his affairs alone, and is now in possession of all to which he laid claim, that is, the region of Montferrat which is separated from his territory by the Po. Don Gonzalo has not enough troops, and it is thought that he was seriously beaten by the garrison of Casale, which made a courageous sortie on May 10. [*In margin*: About eighteen captains were killed and a large number of other officers, besides a thousand soldiers.] One must believe either that the climate of Italy is not favorable to him, or that his thriving success in Flanders was accidental, brought about by good fortune rather than by his own valor.

The English gentleman who is taking the art collection of Mantua to England has arrived here.[3] He tells me that everything is now well on the way and that he expects any day the arrival of the greater part of it in this city. This sale displeases me so much that I feel like exclaiming, in the person of the Genius of that state: *Migremus hinc!* †

I thank you for the gift of the little book on the English expedition. I shall have it bound with another one on the same subject, so as to be able to compare them with one another. I should like to be able to send you something similar, but I can find nothing at all. I shall wait until an opportunity presents itself, or until you let me know what would please you, since I have neither the power nor the qualities necessary for things of greater importance. But you may be sure that I shall never lack good will. In closing, I kiss your hands and those of your brother, with all my heart.

<div style="text-align:right">Your most devoted servant,</div>

Antwerp, June 15, 1628 Peter Paul Rubens

There was in the company of the Earl of Carlisle a Secretary of the King named Boswell.[4] He appears to be a very cultivated man, comprehensive in his discourse and endowed with great modesty and sincerity. Perhaps you know him by reputation.

I beg you to forward the enclosed letter to M. Vosberghen. It has been entrusted to me with great urgency by one of his relatives who is also one of mine.[5]

* It is hard to contend with a victor (Horace, *Sermones* 1.9.42).
† Let us depart hence!

To Pierre Dupuy *Antwerp, June 22, 1628*

Monsieur:

Nothing has happened here worthy of your notice. The return of our Marquis is very much delayed, although the term which he had set has now come to an end. But he let us know recently, in his letter of May 8, that he would be on the way as soon as possible. We believe that this delay is caused by nothing more than his prudence and caution. His Excellency is unwilling to trust to promises and has no faith in the future, *sed habet oculatas manus,** for he knows that if he leaves his business in Spain unfinished, it will never be completed once he has turned his back.

It is reported that we planned an assault upon Bergen-op-Zoom, with the collusion of some members of the garrison who had offered to betray the fortress (called the Head of Bergen) and to set fire to the munitions, But one of the accomplices revealed everything, and his companions have been taken to The Hague, where they will probably receive the punishment they deserve. But this news comes from Holland, where they also say that our men from Santvliet and Stabroek were drawn up in good numbers under the outer ramparts of Bergen on the 13th of this month; from our side it has not been possible to learn anything certain concerning this affair. I suspect, however, that those soldiers have not been imprisoned without cause, or sufficient proof to convict them.

I have received by the post from Marseilles some copious letters from M. de Peiresc. In the midst of so many duties it surprises me that he can carry on his antiquarian research. Indeed this man shows an aptitude for all the professions as great as each man has for his own, and I cannot imagine how a single mind *tot functionibus diversis possit sufficere.*†

I have seen here a little book that pleases me very much, entitled *Imperatoris Justiniani defensio adversus Alemannum.* The author is Thomas Rivius; his style is good and in my opinion really Ciceronian, without any affectation. His argument is praiseworthy, although in subject matter dealing with princes, one can believe anything one wishes. One thing, however, cannot be admitted, namely, that one finds in Procopius an unbridled and immoral passion, rather than an expression of

* But has hands that can see (cf. Plautus, *Asinaria* 1.3.50: *semper oculatae nostrae sunt manus: credunt quod vident*).
† Can suffice for so many different functions.

the truth.[1] I regret that I have nothing else to tell you, and so I close, humbly kissing your hands and those of your brother, and commending myself to your favor.

<div align="right">
Your affectionate servant,

Peter Paul Rubens
</div>

Antwerp, June 22, 1628

<div align="center">– 173 –</div>

To Pierre Dupuy *Antwerp, June 29, 1628*

Monsieur:

This time I find myself so badly provided with news that there remains hardly anything for me to do but to send you a bare compliment, with due thanks for the most interesting and accurate reports which you continue to give me of the state of your kingdom. I find by experience that the outcome always corresponds to your conjecture and judgment, which is based partly upon the definite information you have on current affairs, and partly upon the prudence that makes you foresee the future. As for La Rochelle, I consider it lost without remedy, though the English may make every effort; I am of the opinion that as often as they attempt to send assistance, *toties in eundem scopulum impingent,** to their disgrace and detriment. I am surprised that the Marquis de Mirabel is not ashamed to offer his customary proposals, when in the past they have had so little effect that one could rightly say what is used as a proverb in Italy, whenever someone accepts lightly what is offered him as a compliment: "You are spoiling the courtesy." England is in the meantime hard pressed, which is regarded as an infallible indication that a fleet is about to go out — so much the more since the King and the Duke of Buckingham were in person at Portsmouth to hasten its departure.

Here we wearily await the arrival of the Marquis, who was mistaken in his hopes, as others were, for the duration of his stay in Spain is exceeding all his and our expectations and patience. The anger of the English toward the Spaniards has cooled off greatly, perhaps because they find themselves more deeply involved in the French war than they had thought, and because of the profit they will derive from the commerce. I have found the Earl of Carlisle, according to his custom, more French

* Just as often they will dash against the same rocks.

than Spanish, but irritated beyond measure *contra illos aut illum potius qui nunc penes vos rerum potitur.**

Here they are contracting to build a new canal from this city to Lier and Herenthals, by which a wide area of the country would be insured against the incursions of the enemy, and the levy of a large part of the contributions which yield them a fairly good revenue.[1]

It is incredible with what profit the two Companies of the East and the West [Indies] keep enlarging their fleets every year, and make themselves, little by little, masters of the other hemisphere. I have heard on good authority, but in secret and in great confidence, the positive report that they have discovered *ultra Tropicum versus Austrum* a great country, not to say a new world.[2] This will be a memorable thing for our time. But so far we have no details of the manner in which it was discovered, or the nature of the country. And having nothing else to say, I humbly kiss your hands and those of your brother, and commend myself with a true heart to your good graces.

<div align="right">Your affectionate servant,</div>

Antwerp, June 29, 1628 <div align="right">Peter Paul Rubens</div>

I shall reply to M. de Peiresc by way of Marseilles (which seems to me the shortest, and without bothering you) through our merchants here.

<div align="center">– 174 –</div>

To Pierre Dupuy <div align="right">*Antwerp, July 6, 1628*</div>

Monsieur:

We are surprised at such a delay on the part of the Marquis Spinola, and by the fact that since May 8 he has not sent a single special courier. It is thought certain that His Excellency has some important business on hand which he does not wish to leave unfinished, and that he is unwilling to rely upon promises which are rarely carried out. For a person who deals with the Spaniards finds that, as soon as he turns his back, they postpone the execution of their promises in his absence. We have had this experience in many similar cases. The Marquis had planned to return by way of Italy, as his secretary told me before His Excellency left here. And he had written to Genoa to all his relatives and friends that

* Against those — or rather him — who is now in control of things in your country (allusion to Cardinal Richelieu).

25. XI

Molto Illustre Signor mio osservandissimo

La Debilità de questa staggione per di qua
concorre colla forza ch'io mi sento adosso
per la breuità del tempo. Il Signor Mar=
chese Spinola insieme con quello di Leganes
et don Filippo Duca di Sesto Primogenito
del Spinola partira Lunedy prossimo et
si riscontraranno per strada col Signor don Carlos
Colonna che sarà hormai vicino al suo gouerno
de Cambray. Si dubita che Il Conte Henrico
de Berghes non sia troppo contento partito
di Corte oue si è firmato pochissimo. Il
Re di Francia mostra d'esser Generoso e fermo
nel suo proposito de non voler lasciarsi scap=
par dalle mani la Rochella hauendo l'ouasion
con bella la qual sola al parer mio potreb=
be impedire l'Accordo con Inglesi li quali
essendo la ruina apparente di Rochellesi, causata da questa loro impre=
sa non possono sotto alcun colore abbandon=
narli. Habbiamo noua d'Ollanda che la
flotta occidentale sia arriuata in Spagna
o iui vicino ma non habbiamo qui alcun
auiso straordinario de una cosa tan importante
che gi fa dubitar della verità di questa noua.
La supplico mi perdone se finisco troppo
seccamente essendo tra corsa l'hora che non
mi permette altro che baciar à V. S. et al Signor
suo fratello humilmente le mani
Di V. S. molto Illustre
seruitore Affettuosissimo
Pietro Paolo Rubens

d'Anuersa el 25 di decembre 1627

Letter 139, to Pierre Dupuy, December 25, 1627.

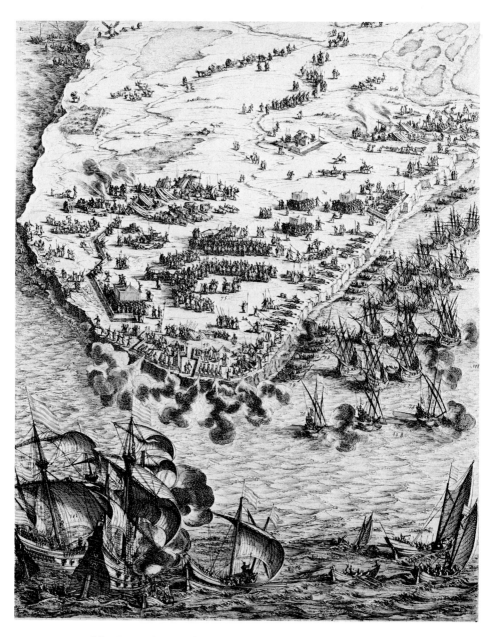

The Siege of La Rochelle. Detail of etching by Jacques Callot.

upon his return from Spain he hoped to have the supreme pleasure of seeing them once more before his death.

The treaty between Savoy and Nevers had given rise to some suspicion here, but it is thought that this has now vanished, and that, as you say, it was only a stratagem of that trickster [1] to divert the help of France, or at least to suspend it. We shall see what d'Esplang [2] reports. I cannot believe that the Earl of Carlisle will do much to advance the affair in our favor; and as for me, I believe that the best thing he can offer is his absence.

At Santvliet *tumultuatum est a sociis navalibus* * for lack of pay; but the day before yesterday their demands were satisfied. Everyone (even the Hollanders, in their *Gazette*) [3] regards La Rochelle as lost, and the assistance of the English of no avail. But some are of the opinion that it can still hold out for some time. The unheard-of cruelty which the Prince has inadvisedly used against the unfortunate rebels embitters their souls all the more, and reduces them to greater desperation. [4] And even if this policy were justified, it does not seem fitting that its execution should be in the hands of this man whose forefathers were nurtured and sustained by that region. I have always regarded him as a pernicious influence for France from the time when I first saw him in Brussels showing the greatest intemperance in his inclinations and passions, to the scandal of our Court.

I have read the apologia on Justinian by Rivius, and it seems to me good but incomplete. For he does not say a single word in favor of Theodora Augusta, who, in her tireless defense of her husband, was accused with him of countless enormous crimes. I am sorry that I have not yet found an opportunity to send you your Marquis, [5] along with the *Stemmata Principum Belgii*. I shall try to do so through the agency of M. Frarin, since the other method through M. Gault [6] is not possible. And since I have nothing more to tell you, I humbly kiss your hands and those of your brother, remaining

Your affectionate servant,
Antwerp, July 6, 1628 Peter Paul Rubens

* The naval crews have been in revolt.

To Pierre Dupuy *Antwerp, July 14, 1628*

Monsieur:

The La Rochelle affair is certainly dragging out longer than we expected; but I am not really surprised when I recall how many times our Marquis was mistaken in his calculations concerning the capture of Breda, which finally fell into his hands when he least expected it. At that time, to be sure, such a long delay increased the expenses for the convoy of provisions to such a degree that we still feel it. Your King has none of these inconveniences, since he is comfortably encamped in his own kingdom, with an abundance of provisions, and having only one maritime passage to guard against aid from the English [*in margin*: but a task demanding great diligence and expense]. The Marquis Spinola, on the contrary, was surrounded by five or six leagues of enemy territory, and could himself be attacked from all sides. I say this not to minimize in any way the glory of the assault on La Rochelle, but only to confirm what I have always said: now that the King has fortified the dykes by such stupendous works, closed the harbor mouth by such masses of earth, and stands there himself with all the forces of his kingdom, or the greater part of them, His Majesty cannot fail to see the town fall into his hands within a few months. Even though the English make every possible effort, I believe they will exhaust themselves in vain, only increase their losses and add to the glory of the victor. This is my prediction, which I hold for gospel.

In the meantime the poor Duke of Mantua is probably running a great risk, since, as you say, he has three powerful enemies to fight. And I am afraid that the aid of private individuals will not be sufficient to save his state, already half lost, while the King is occupied at La Rochelle. In a few months the season for long marches by large armies will have passed; the roads and the fields will be ruined by the autumn rains. Besides, even if His Majesty should take La Rochelle soon, his army will probably need some rest, in order to recover from the fatigue and hardships suffered in the siege. In all probability the treasury will also be exhausted by such a long and costly undertaking.

As far as Casale is concerned, I believe that as soon as the rest of Montferrat has been captured, its enemies will lay siege to the town at their ease, according to the custom of the times, without attempting to take it by force. Some think their greatest difficulty will be to close the river; but to me this seems very easy, since the Duke of Nevers does not

possess a single vessel or galley armed to defend it or to send necessary help by water. [*In margin*: He would also have to pass the Spanish garrison of Valentia and the other places occupied by them on the Po.] The result is that Don Gonzalo, by putting a few frigates or armed barks on the river, will gain complete mastery over it. And since the enemy is in control of the surrounding country, I do not see how the garrison of Casale can be furnished with provisions by land. Therefore, the more numerous this garrison is (and they say it is large), the sooner its supplies will fail.

We have no news here except that the concentration of troops in Bergen is larger than usual, and therefore our men are also marching toward Stabroek and its vicinity. There now appear to be at least 9000 infantry and a good number of cavalry not far from Antwerp.

The delay of the Marquis' arrival begins to appear suspicious to me. We do not know what to think, since he neither comes nor writes — not even to the Most Serene Infanta, as Her Highness told me herself, a few days ago. Construction has not yet begun on the canal near this city, and since it has already been postponed so long, I don't believe it will be started this year. As for the other canal, I have no knowledge that it is as unsuccessful as you say. It remains unfinished only for lack of funds, which have been diverted elsewhere. Therefore it is because of the wars in Italy and Germany that we remain dry here. The book by M. de Brèves [1] would be very acceptable to me if only I knew how to repay the generosity which you continually show toward me.

And since I have nothing more to say, I humbly kiss your hands and those of your brother, and remain

<div style="text-align: right;">Your most devoted servant,</div>

Antwerp, July 14, 1628 Peter Paul Rubens

I am surprised to have you write that my packet arrived entirely open, and that my seal was missing. This was carelessness on my part, perhaps due to my haste on that day, when I had some friends to supper. In the future I shall be more careful, and I thank you for telling me.

To Jacques Dupuy *Antwerp, July 20, 1628*

Monsieur:

Notwithstanding the fact that your brother, in his letters, always pays me in good measure, with a liberality and courtesy far superior to mine, I find that I lose nothing in the exchange when you replace him from time to time. You are like a fresh person with new vigor, lending a certain impetus to the correspondence which sometimes slackens a bit on my part. This is due not at all to coolness of affection but to lack of subject matter, or *tedio toties eadem reiterandi.** I am tired of repeating that our Marquis is delaying too long in finishing up his affairs (that is, the political affairs) promptly, in accordance with his own desire and that of everyone. It is certain that he has the good and laudable intention of opening the eyes of the King of Spain and his ministers, who appear to have sunk into a profound lethargy; and so bring to an end the miseries of Europe. He hopes to persuade them finally to cease hurling themselves upon the ill-omened reefs of Batavia, to their own detriment and misfortune. The difficulties are much more insoluble in words than in reality. But they appear deaf to advice. Now nearly two months have passed, and His Excellency has neither written nor come himself, as he had thought he would. For he had asked the Most Serene Infanta not to write to him again at Madrid, because the courier would not arrive before his own departure. I believe the Spaniards think they can treat this sagacious man as they are in the habit of treating all those who go to that Court for any business: all are dismissed with empty promises, and kept in suspense by vain hopes which are finally frustrated without having settled anything. But our Marquis is very discerning. And so, believe me, he will not return, either to conclude peace or continue the war, without being well prepared and provided with all things necessary to achieve one or the other goal.

The Most Serene Infanta has not been very well these last days. She was suffering from gallstones which caused a continuous light fever. After a bloodletting, however, and other effective remedies, she is now, thank God, a little better. Her health is of great importance to Belgium. She is a princess endowed with all the virtues of her sex; and long experience has taught her how to govern these people and remain uninfluenced by the false theories which all newcomers bring from

* Tedium of repeating the same thing so often.

276

Spain. I think that if Her Highness, with the help of the Marquis, could govern in her own way, *et sponte sua componere curas*,† everything would turn out very happily, and one would soon see the greatest change, not only among us but everywhere. For today the interests of the entire world are closely linked together, but the states are governed by men without experience and incapable of following the counsel of others; *ipsi non expediunt sua consilia et oderunt aliena.*‡ Nevertheless we have as yet no certainty as to what report the Marquis will bring, but from his silence we expect nothing good. Let this be said confidentially and remain *entre nous.*

As for La Rochelle, I can only repeat the old refrain, that the city will fall, in the end, into the King's hands. In the meantime, it is sustained only by the vain hope of the ultimate effort which the English may make in its behalf.

As for affairs in Italy, I expressed my sentiments in my last letter, and they have been confirmed.

I am sorry that M. Frarin has no occasion at present to send any articles to Paris. But we are expecting in a few days the arrival of M. Gault, who will have to send some cases of pictures in that direction. I will not let this opportunity pass. And since I have nothing more to say, I kiss your hands and those of your brother with all affection, and remain

<div style="text-align: right">

Your most humble servant
</div>

Antwerp, July 20, 1628 Peter Paul Rubens

To Pierre Dupuy *Antwerp, July 27, 1628*

Monsieur:

I should have found no subject for my letter other than to thank you for the news you send me, if you yourself had not brought up the sensation caused by the excommunication issued by Monsignor the Nuncio of Brussels. The affair is not as great as rumor would have it, and I will tell you the whole story as well as its origin; but the papers or documents haven't been made public. The subject of the controversy was a very complicated affair concerning the inheritance of a certain M.

† And regulate affairs according to her wishes (*Aeneid* 4.340).
‡ They neither carry out their own counsel nor listen to that of others.

Billy. He came from Liége and was a great favorite of the Elector of Cologne [*in margin*: Ernest of Bavaria]; in fact he had the entire management of that state, from which he had amassed a fortune. Great lawsuits and conflicts arose between his sons and their guardians, and the opposing party. The latter was headed by M. Occhoya, Commissary of the Cavalry, who had married a daughter of Billy, and by M. Antonio Perez, this daughter's uncle and guardian. During the last few days the aforesaid Occhoya died, and according to Italian custom there was published, in regard to the intrigues and complications of the Billy inheritance, an "excommunication," that is, an ordinance by which any person who may know something to the advantage or disadvantage of that house is forced to reveal it, under penalty of excommunication. This ordinance was annulled by the Attorney General [*in margin*: the equivalent of the Attorney of the King, in France], on the order of the Council of Brabant. Now Monsignor the Nuncio, instigated by the Archbishop of Malines, who was annoyed by the Council of Brabant for some personal reason, or perhaps through malice or ignorance, did not hesitate to issue a second ordinance, directed this time against the Council of Brabant itself, and the Chancellor, head of this Council. But the Chancellor, they say, tore it up with his own hands and sent off the messengers at the expense of the official of the Archbishopric who had offended him. [*In margin*: The expenses would have to be paid from this member's own funds.] Finally, by order of Her Highness and the intervention of the Cardinal de la Cueva, things were settled, and the Chancellor was content to regard the Nuncio as a new man with little experience in this country. But he pointed out that the Council of Brabant has privileges and ancient charters granted by the Popes (and he produced these documents), proving that in this country such excommunications cannot be published without the authorization and consent of this Council. I was not in Brussels, but it was commonly said that the people had been urged to refuse to sell the necessary provisions to the household of the Nuncio; thus if the matter had not been settled promptly, he would have run the risk of lacking food in the very center of Brussels.[1]

That is all I can tell you. Otherwise I find myself without any news worthy of you. In closing I humbly kiss your hands and those of your brother, and pray heaven to grant you both every happiness and contentment.

Your most affectionate servant,

Antwerp, July 27, 1628 Peter Paul Rubens

To Pierre Dupuy Antwerp, August 10, 1628

Monsieur:

Last week I was unable to fulfill my obligation toward you, since I was in the country, some distance from the main road. Upon my return I found at home your two most welcome letters, which gave me the most complete report of events in your country. Everyone is surprised that La Rochelle is holding out so long. It is probably the courage of desperation, combined with a very faint hope of help from England, which, in my opinion, will not have the least effect, after so long a delay.

Here we remain inactive, in a state midway between peace and war, but feeling all the hardships and violence resulting from war, without reaping any of the benefits of peace. Our city is going step by step to ruin, and lives only upon its savings; there remains not the slightest bit of trade to support it. The Spanish imagine they are weakening the enemy by restricting commercial license, but they are wrong; for all the loss falls upon the King's own subjects. *Nec enim pereunt inimici, sed amici tantum intercidunt.** Cardinal de la Cueva alone is adamant and maintains his erroneous opinion, *ne videatur errasse.*†

I have seen letters from the Marquis, dated July 9, by which I learn that he will not return as quickly as we had thought. There still remains some important business for him to settle. He does not wish to leave it unfinished, as others have done in allowing themselves to be fed by vain promises which are never fulfilled; this I wrote in my last letter to you.

From Italy we have no news other than what you write. Worse still, it appears that Don Gonzalo had encamped under the walls of Casale with so few men and so little money, that the garrison came out to harvest the grain and brought it into the city right under his nose, without his being able to do them the slightest harm. In addition to that, the continuous rainfall has caused the waters to overflow their banks and wash away a good part of his fortifications. The day before yesterday the news was spread that the Emperor and the Duke of Mantua had made peace. If this is true, we can say, *Sic nos servavit Apollo.*‡ [*In margin*: I learned today that the Duke of Savoy is gathering forces to hinder the help of the French, and that he is determined to fight them if necessary, rather than let them pass.]

* It is not the foes who perish, but the friends who fall.
† Lest it be seen that he made a mistake.
‡ Thus has Apollo delivered us (Horace, *Sermones* 1.9.78).

They write from Spain that a remedy has finally been found for the debased currency. The King will lose one-quarter and the possessor one-quarter,[1] and the provinces and towns will bear the loss of the other two-quarters, so that the public pays three-quarters, by these different means. To be sure, I never thought it possible to cure this great evil except by some drastic remedy. But the kingdom is going to feel very keenly the consequences of such a measure, at this time when the population is reduced to the last extremity of poverty and misery.

We have learned here of the conversion of the Duke de la Tré-mouille.[2] This is greatly to the edification of the Catholic church and the confusion of the Huguenots, since this prince has always been, so to speak, the head of their party. If the Duchess should do the same, she would set a great example for the wife of Dom Manuel of Portugal. This lady has recently retired to the environs of Geneva because her eldest son, a fortnight ago, entered the austere Order of the Barefoot Carmelites in Brussels.

I am glad to learn that M. de Thou is well. I hope that some day he will publish an account of his journey. God grant him a happy return! I am afraid that our correspondence will be interrupted for some months, since I have to make a long journey. But inasmuch as nothing in this world is certain until the moment it happens, I shall inform you just before my departure. And in order that you may not write to me needlessly, I shall let you know if any delay or hindrance occurs. In the meantime I commend myself with all my heart to the good graces of you and your brother, praying heaven to grant to both of you every happiness and contentment.

Your most devoted servant,

Peter Paul Rubens

Antwerp, August 10, 1628

PART VI

1628–1629

Rubens in Madrid

Rubens in London

Rubens obeyed his instructions to travel in haste; before the fifteenth of September he was in Madrid. His arrival excited the curiosity of the foreign diplomats at the Spanish court, and several wrote to their governments about him. The Papal Nuncio, Giovanni Battista Pamphili, wrote to the Cardinal Secretary of State in Rome: "It is considered certain that Rubens, the Flemish painter, is the bearer of some negotiation, for we hear that he often confers in secret with the Count Duke, and in a manner very different from that which his profession permits. They say that he left England a short time ago; and since he is said to be a great friend of Buckingham, it is believed that he comes with some peace treaty between the two crowns. Others think his main object is the truce of Flanders, and that he has received this commission as one who enjoys the confidence of all that country." The Venetian Ambassador, Alvise Mocenigo, wrote to the Doge: "Rubens the painter has had several secret interviews with the Count of Olivares. I could not affirm to Your Serenity whether this was to negotiate the truce with the Hollanders, or the peace with England, or both at once. I learn that he was in England, where he negotiated long and mysteriously with the Duke of Buckingham; then he went to Flanders and thence to this court."

It was soon clear, in spite of the secrecy surrounding Rubens' mission, that the great artist had come to Madrid for reasons other than to paint the King's portrait. Although the conjectures that he had come from Buckingham were false, it could not be concealed that Anglo-Spanish relations were under discussion. Two agents of the Duke of Buckingham, along with the Abbé Scaglia, had arrived at the court of Brussels from London immediately after Rubens' departure. The Buckingham agents were Balthasar Gerbier and Endymion Porter. Porter (who, like Gerbier and Rubens, was also a painter) sought a passport to Spain in order to bring assurances of England's disposition toward peace. Scaglia and Gerbier, after conferring with the Infanta on the same subject, proceeded to Savoy. Spain and Savoy were now very close because of their joint action in Montferrat, in order to resist French influence on the question of the Mantuan succession. It was very much

in Savoy's interest, therefore, to promote an Anglo-Spanish alliance, and the Abbé Scaglia worked with great zeal toward this end.

On September 28, 1628, Olivares, by order of Philip IV, assembled the Council of State. Rubens was summoned to present his papers and to give an account of his negotiations. His assertions of England's willingness to consider a treaty were fully confirmed by the recently arrived Endymion Porter, who stated that the Duke of Buckingham was ready, if necessary, to come in person to a Spanish port in order to conclude peace. Moreover, Charles I's Secretary, Sir Francis Cottington, had written to Olivares that he himself expected to be sent soon to Spain as English Ambassador.

Such was the situation in Madrid when word was received that Buckingham had been murdered a month before. This news caused some dismay to Olivares, who, although personally hostile to the Duke, had lately recognized in him an instrument for peace. Spain now needed assurances that Buckingham's death had not altered Charles I's pacific intentions. She was becoming alarmed at rumors of an Anglo-French alliance. These reports were not without foundation, for the fall of La Rochelle gave Charles I no further reason to continue hostilities against France, and an agreement between the two countries was likely. Rumors of French armies en route to Italy also made Philip anxious to conclude peace with England before France did. Assurances came from Sir Francis Cottington, confirmed by the Lord Treasurer Richard Weston, that the King of England still desired a firm and honorable peace with His Catholic Majesty. Cottington did not deny, however, that the Venetians were urging a reconciliation between England and France. Once more he promised to set out soon for Spain, and Philip awaited his arrival with impatience. But by December, when Endymion Porter left Madrid, Cottington had not appeared. England was clearly playing a waiting game, listening to the proposals of France at the same time as the pacific assurances of Spain.

What had Rubens been doing during these months since his arrival? Concerning his diplomatic negotiations in Madrid not a single word from his own pen has come down to us. His official correspondence with the Infanta Isabella, describing interviews with the King, with Olivares, and with his good friend the Marquis Spinola, has completely disappeared. It is certain, however, that Rubens' prestige steadily increased, and his advice carried more and more weight. Philip IV lost all prejudice against him and even the Prime Minister, who had promoted the alliance with France against England, changed his views. Rubens seems

to have escaped censure, either because his correspondence with Gerbier had not been examined carefully, or because the most compromising of the letters, written in Flemish, had passed unnoticed. Don Diego Messia had become one of his admirers and patrons.

As for his nonpolitical activity we are more fortunate. We have Rubens' own statement, in letters to Dupuy and Peiresc, that he kept to painting in Madrid, as he did everywhere, and had painted an equestrian portrait of the King, as well as the heads of all the royal family. A more detailed description of his artistic production appears in Francisco Pacheco's *El arte de la pintura*, published in Seville in 1649. Pacheco, father-in-law of Velásquez, writes of Rubens: "During the eight months he spent in Madrid he painted a great deal, without neglecting on that account the important mission with which he was charged, and in spite of several attacks of gout." The Spaniard then goes on to list some of Rubens' works, telling us that "he painted five portraits of His Majesty, one of them being an equestrian portrait which is a masterly work," and "he copied all the pictures by Titian in the King's possession" (an obvious exaggeration). "It seems incredible," Pacheco writes, "that in so short a time, and in the midst of so many duties, he could have painted so many pictures . . . He spent little time with our painters, and the only friendship he formed was with my son-in-law, with whom he had corresponded before." (Velásquez, not quite thirty, had been court painter for five years.) "Rubens praised his works very highly because of his modesty. They visited the Escorial together."

Early in January 1629 the Abbé Scaglia again appeared upon the scene, coming this time as the Ambassador of Savoy to the court of Spain. His orders from the Duke his master were to urge the prompt conclusion of peace between Spain and England. This was no less the aim of the Prime Minister Olivares, but more months elapsed before further word was received from London, and then indirectly. In April dispatches came from the Infanta Isabella, including a letter from the Lord Treasurer Weston which stated that the English Cabinet recognized the good intentions of the King of Spain and was ready to open negotiations; that if Philip would send an Ambassador to London, Charles would send one to Madrid. Thereupon the Prime Minister resolved to send Rubens at once to England on a mission similar to that of Endymion Porter in Spain — not as ambassador, but as envoy empowered to negotiate a truce preparatory to the exchange of ambassadors and the conclusion of peace. In order to give this mission a more significant and official character, the King of Spain named Rubens Secre-

tary of his Privy Council of the Netherlands. And as a personal token he presented to the artist, on the day of his departure, a ring set with diamonds.

Rubens' hopes of visiting Italy before returning home, and of seeing Peiresc in Provence thus had to be abandoned. But the honor conferred upon him could not be declined, and the painter was too deep in politics to be able to withdraw easily. He left Madrid on April 29, 1629, and by traveling day and night, crossed France even more swiftly than before. He reached Paris on May 10 and departed the following evening. But this time secrecy did not prevent him from seeing his friends. He visited Marie de' Medici's Luxembourg Palace, by then completely furnished, and told Pierre Dupuy that he had not seen anything of equal magnificence at the court of Spain. On the morning of May 13 Rubens reached Brussels, and although it was Sunday, he was received at once by the Infanta Isabella, and he presented to her the dispatches he had brought from Madrid.

The news that greeted Rubens' arrival in Brussels was that on April 24, five days before his departure from the Spanish capital, England had concluded a treaty with France. Although not entirely unexpected, this report lent an added urgency to the artist's mission to London, and was bound to make his task more difficult. Both he and the Infanta realized there was no time to lose. He remained in Brussels only long enough to receive instructions, and after a brief stop of a few days at his home in Antwerp, hastened to Dunkirk with his brother-in-law, Hendrik Brant, who was to accompany him to England. On June 3 they boarded the British man-of-war *Adventure,* bound for Dover.

The appointment of Rubens as envoy had apparently met with royal favor in London. Sir Francis Cottington, in a letter which accompanied Rubens' passport, had written: "The King is well satisfied, not only because of Rubens' mission, but also because he wishes to know a person of such merit." On the day after Rubens' arrival Charles I summoned him to Greenwich and gave him a gracious welcome, telling him that the recent French agreement was only an armistice and might be broken if an understanding with Spain could be reached. But Rubens soon learned that there was a strong pro-French faction at the court, and that the King often met with opposition on the part of his ministers. The Flemish envoy knew that he could rely upon the support of Cottington, who had just become Chancellor of the Exchequer, and upon his former patron Sir Dudley Carleton, now Secretary of State. He believed that the Earl of Carlisle was also well disposed to peace with Spain. His

host was Balthasar Gerbier, whose reputation had suffered since the death of Buckingham. As for the sentiments of Richard Weston, Lord Treasurer and most prominent of the King's advisers, Rubens was not at first certain. Among the foreign diplomats in London his closest friend was Lorenzo Barozzi, representative of the Duke of Savoy.

The political situation that Rubens encountered in London was an intricate one, and his own position was far from easy. He was not authorized to conclude peace between England and Spain, but simply to negotiate a truce — the final treaty being reserved for further negotiations after the establishment of embassies in the two capitals. But Charles I was unwilling to consider a mere truce. He regarded it, and not without reason, as a possible artifice on the part of Spain, in order to gain time. He wished to treat with Rubens as plenipotentiary, without waiting for the exchange of ambassadors, and insisted upon a final peace treaty. Rubens, on his part, faced with the task of removing the difficulties obstructing the peace, found these difficulties formidable, if not insurmountable. For one thing, there was the question of the United Provinces. The King of England declared he could not make any treaty with Spain that did not include his allies the Hollanders. Rubens, on the other hand, had been specifically instructed not to touch upon the Dutch problem; this was being treated separately by the Infanta in Brussels, and only if she were unsuccessful was he to take it up. Among the determined opponents to any agreement between England and Spain was Albert Joachimi, Ambassador of the United Provinces in London. Joachimi tried in every way to undermine Rubens' efforts, because an Anglo-Spanish peace would mean the end of England's aid to the Hollanders.

The crucial point in relations between England and Spain was the problem of the Palatinate. Charles I had made it a point of honor to demand the restitution of the estates of his brother-in-law Frederick, Count Palatine, who had been stripped of all his territories in the struggles that initiated the Thirty Years' War in Germany. The Palatinate, since 1623, had been occupied by Imperial and Spanish troops. Although Spain held only the smaller part of this territory, it was very important to her as a passage between the Netherlands and Milan. Charles' claim was that the towns in this region had been given in trust to Spain by his father, James I, with Spain's promise to return them. He now demanded the return of these Spanish-held garrisons, and asked Philip IV to use his influence with the Austrian Emperor to obtain the reëstablishment of Frederick in his hereditary estates. Rubens' reply was that he

had no authority to treat this question, but that restitution depended upon the consent of the Emperor and the Duke of Bavaria, and that Spain could not be expected to antagonize them for the sake of peace with England. The King's determination, however, made Rubens agree to refer the matter to Madrid; in return he received Charles' promise not to let the agreement with France turn in the meantime into an offensive league against Spain. In so doing, the Flemish envoy was perhaps overstepping the limits of his instructions and risking the criticism of Olivares. But his first thought was for peace, and he did not forget that peace with England was even more important for the Spanish Netherlands than it was for Spain.

Rubens anticipated serious opposition on the part of the French Ambassador, the Marquis de Châteauneuf, who was momentarily expected in London for the ratification of the peace with France. His suspicions regarding the French diplomat were fully justified. Châteauneuf arrived at the English court on July 5 armed with counterproposals concerning the Palatinate, and began at once to bend his efforts toward keeping England and Spain apart. Cardinal Richelieu himself had a watchful eye on London, and directed the activities of numerous agents whose task was to counteract Rubens' negotiations. Opposition also came from the Republic of Venice, which, because of its position, wedged between Hapsburg Austria and Spanish-held Milan, generally adopted a pro-French, anti-Hapsburg policy. The Venetian Ambassador, Alvise Contarini, was extremely hostile to Rubens, describing him in a report to the Doge as "an ambitious and greedy man, who wants only to be talked about, and is seeking some favor."

The instructions Rubens had received from the Count Duke of Olivares charged him, on his part, to oppose the intrigues of Richelieu in every way possible. As one method of doing this, he was to provide financial aid to the Huguenot leader Soubise, who was then in London seeking support for his party. For just as the French Cardinal actively aided the Hollanders in their struggle against His Catholic Majesty, so Philip sought to weaken France by fomenting rebellion among the French Protestants. Rubens, in leaving Madrid, had been given some bills of exchange promising aid to Soubise. The Infanta Isabella was asked to advance the funds in Brussels, but Rubens was instructed not to part with the money in England without being assured that Charles I meant seriously to treat with Spain and would participate in aiding Soubise. But the Infanta, in her simplicity, could not understand that her nephew should be supporting the Huguenots; she had not, there-

fore, advanced the funds, believing they could be better employed in the war against the Hollanders. It caused Rubens some embarrassment, upon reaching London, when Soubise demanded the funds promised by Spain. He wrote to Olivares explaining his difficult position and asking for renewal of the credit. Before the matter could be settled, news was received that Louis XIII had made peace with the Huguenots on June 28, 1629, and had pardoned their leaders, Soubise and Rohan.

The reports that Rubens sent to Prime Minister Olivares between June 30 and September 21 give a minutely detailed account of his interviews with Charles I and his friendly relations with the King, but enumerate and describe the difficulties he had to overcome in carrying out his instructions. Equally frustrating to the Flemish envoy was the procrastinating, evasive policy of the court of Spain. The naming of ambassadors in London and Madrid may be credited almost entirely to Rubens' persistence and tact. Sir Francis Cottington was appointed Ambassador to Spain, and Don Carlos Coloma Ambassador to England. Letters of praise were sent to Olivares on Rubens' behalf by the Lord Treasurer and by Cottington. The Prime Minister thanked Rubens "in the name of His Majesty for the zeal, the solicitude, and the attention with which he reported all that happened in this affair." With the appointment of ambassadors Rubens considered his mission at an end, and hoped to be able to return home. But there were many more delays and postponements before the ambassadors arrived at their respective posts, and Rubens was kept in London six months longer. During this period his letters are fewer and our knowledge of his activities far less complete than before. We learn that in October he visited Cambridge. The university received him with honor and conferred upon him the degree of Master of Arts, the highest distinction that could be accorded to an artist. Not until January 11, 1630, did Don Carlos Coloma make his public entry into London, and it was several weeks later that Rubens went to take leave of the King. On that occasion, March 3, at a ceremony in Whitehall, Charles I conferred upon him the rank of knight. He added the gift of the jeweled sword which he had used for the accolade, as well as a diamond-studded hat-band and a ring from his finger.

Charles I, no less than Philip IV, was a keen connoisseur of painting and an enthusiastic admirer of Rubens' art. It will be remembered that as Prince of Wales he had owned works by the Flemish master, and had asked for the self-portrait now in Windsor Castle. During Rubens' months in London the King commissioned him to decorate the ceiling of the Banqueting House at Whitehall in honor of James I. This project, with

the exception of a few preliminary sketches, was carried out in Antwerp after the artist's return. While in England he painted the beautiful "Landscape with St. George" (now in Buckingham Palace) in which the saint bears the features of Charles I and the princess those of Henrietta Maria. As a parting gift and token of gratitude, Rubens presented the King with the allegorical composition now in the National Gallery entitled "Peace and War."

The peace between England and Spain, for which Rubens had laid the groundwork, was finally signed on November 15 and proclaimed on December 15, 1630. With the conclusion of peace the King of England had the patent of Rubens' knighthood drawn up and sent to the artist in Antwerp. It read: "We grant him this title of nobility because of his attachment to our person and the services he has rendered to us and to our subjects, his rare devotion to his own sovereign and the skill with which he has worked to restore a good understanding between the crowns of England and Spain."

To Pierre Dupuy *Madrid, December 2, 1628*

Monsieur:

You must think me lost, and I confess that, without knowing the cause of such secrecy, you have reason to complain of me. But I have such faith in your discretion, that I believe you will not take it ill to hear that I passed through France without allowing myself to see you or anyone else. It displeased me so much that I could not express it in words when I learned that I was bound by a precise order of the Most Serene Infanta, my patroness — an order so strict that I was even forbidden to pay my respects to the Spanish Ambassador in Paris, or M. Le Clerck, Secretary of the Ambassador of Flanders. I cannot imagine the reason for such scrupulousness, but I think Her Highness must have considered that, since I have done much work in the service of the Queen Mother, I might easily have been detained several days in that Court. This would not have been convenient, for the King of Spain, my Lord, had commanded me to come posthaste. I did not, however, miss making a slight detour in my journey, in order to see La Rochelle, which seemed to me to be a spectacle worthy of admiration. The dyke is indeed a regal piece of work, and my satisfaction was all the greater since M. de Marsillacq, the superintendent of operations, let me see and enjoy it in detail, under his guidance. Now the happy conclusion of this glorious enterprise does not permit further silence; it obliges me to congratulate you, as well as every good Frenchman — not to say every Christian — on the favorable outcome of an action so heroic that it surpasses everything else in our century.[1]

But in order that you may know what my life is like in this Court, I will say that I am painting here, as I do wherever I find myself. I have already done an equestrian portrait of the King, to his great pleasure and satisfaction.[2] I have also done portraits of all this royal family, for the particular interest of the Most Serene Infanta, my patroness. But notwithstanding the fact that His Majesty takes an extreme pleasure in painting, I think I will remain here only a little while. I hope, since the Most Serene Infanta has given me permission to make a tour of Italy on my return, that I can take advantage of the voyage of the Queen of Hungary,[3] who intends to embark at Barcelona, toward the end of March, for Genoa. In the meantime I shall inform you of what occurs.

And so, in closing, I humbly kiss the hands of you and your brother, and commend myself, with a true heart, to your good graces.

<div style="text-align: right">

Your most affectionate servant,
Peter Paul Rubens

</div>

I hope that you have received the portrait of the Marquis. I left exact orders to have it sent, on my departure from Antwerp.

Madrid, December 2, 1628

<div style="text-align: center">

– 180 –

</div>

To Peiresc *Madrid, December 2, 1628*

Monsieur:

It seems to me a thousand years since I have heard any news of you. All our correspondence was interrupted by my journey to Spain, which the Most Serene Infanta wished to be made with such silence and secrecy that she did not permit me to see a single friend, not even the Spanish Ambassador or the Secretary of Flanders resident in Paris. It was indeed very hard for me to be forced to pass through a city so dear to me, without being able to kiss the hands of Messieurs Dupuy, of M. de St. Ambroise, and my other friends and patrons. My displeasure was so great that I find it difficult to express in terms proportionate to my grief and disappointment. I cannot fathom the secrets of princes; but it is true that the King of Spain ordered me to come posthaste, and perhaps Her Most Serene Highness, my patroness, thought that because of my long service to the Queen Mother, I might easily be detained several days in that Court.

Here I keep to painting, as I do everywhere, and already I have done the equestrian portrait of His Majesty, to his great pleasure and satisfaction. He really takes an extreme delight in painting, and in my opinion this prince is endowed with excellent qualities. I know him already by personal contact, for since I have rooms in the palace, he comes to see me almost every day. I have also done the heads of all the royal family, accurately and with great convenience, in their presence, for the service of the Most Serene Infanta, my patroness. She has given me permission, on my return, to make a tour of Italy, and therefore I hope, God willing, to take advantage of the voyage of the Queen of Hungary from Barcelona to

Genoa, which is expected to take place certainly at the end of next March. It is possible that my route might diverge a little from the royal itinerary, in the direction of Provence. This will be for no other purpose than to pay my respects to my dear Peiresc and to enjoy a few days of his much desired presence in his own home, which must be a museum of all the curiosities of the world. I did make one small detour on my way here and saw the siege of La Rochelle, which seems to me a spectacle worthy of all admiration. I rejoice with you and all France, as well as with all Christendom, at the success of this glorious enterprise. And since I have nothing else to say for now, I shall close, sincerely kissing your hands and those of M. de Valavez, and praying that you keep me in your good graces.

<div align="right">Your most devoted servant,</div>

Madrid, December 2, 1628 <div align="right">Peter Paul Rubens</div>

I hope that you have already received my portrait.[1] Many days before my departure from Antwerp I consigned it to the brother-in-law of M. Picquery, as he ordered me to do.

Up to now I have not met a single antiquarian in this country, nor have I seen medals or cameos of any sort. Perhaps I have missed them because of my duties. And so I shall make inquiries with greater diligence, and inform you in due time. But I believe this diligence will be in vain.

<div align="center">– 181 –</div>

To Jan Caspar Gevaerts <div align="right">*Madrid, December 29, 1628*</div>

Dear Sir:

My response in the Flemish language will be sufficient to show that I do not deserve the honor which you confer upon me with your letters in Latin. My practice and studies in the humanities have fallen so far behind that I should first have to beg permission to commit solecisms. Therefore, please do not put me, at my age, in competition with schoolboys. I have made some effort to learn whether in the private libraries something more is to be found about your Marcus[1] than is already known. So far I have not discovered anything. However, there are some who affirm that in the famous Library of San Lorenzo they have seen two manuscripts bearing the name of Marcus Aurelius. But from the description of the weight and appearance of the volumes (for I was talking with a man who knew not a word of Greek) I augur nothing new or

<div align="center">293</div>

important. I believe they contain only the familiar and already long-known works of Marcus. Whether there is any light to be gained from collating the texts, or it is simply a mass of rubbish, I am not the one to do the research. For my time, my mode of life, and my studies draw me in another direction, and besides, my ruling genius keeps me away from this intimate sanctuary of the Muses.

I think you will have made the acquaintance of Don Francisco Bravo (nephew of the governor of our citadel),[2] who left here a few months ago for our country. He has made a great reputation as man of letters, and, unless I am mistaken, he aspires to leadership among critics, or else already occupies that position. I gave him the memorandum which you had given me on my departure, thinking that he would be able to find something and do what you wish. But since then I have seen neither him nor your memorandum again. I beg you to write out the same list again, and send it to me. It is true that this gentleman has exercised great diligence in the manuscript Library of San Lorenzo, and not without expense. He said he had found some wonderful things, especially among the writings of the ancient fathers; these writings throw much light upon Tertullian, who is threatened by many surprising references. [*In margin*: This letter is nothing but erasures and ought to be corrected, but you will forgive a friend who is working hard and who is struggling against illness.] As for Papinian and your commentary on him, this man seemed inclined to make some kind of criticism, but more from habit, unless I am mistaken, and from vanity, than from reason or judgment. But see the man himself and judge his character. You will derive either benefit or enjoyment from it, and perhaps (depending upon your prudence) both.

I have also made the acquaintance of Don Lucas Torrio, who is a very likable and modest person and has promised to make every effort for me. But I should like to examine that volume of *Inscriptiones Africae* myself, not so much for the sake of Marcus or to render you a service (that can be done by others with more accuracy), but to indulge my personal taste. Since I am writing from my bed, between attacks of gout, I had to communicate with Don Torrio through the medium of friends; he wrote me a brief reply, which you will see.

These last few days I have been very sick with gout and fever, and to tell the truth, I could hardly draw a breath between groans and sighs. But now, thank God, I am better.

As for public affairs, I can tell you nothing certain or good; I see no ray of light as yet. The Marquis does not move, nor does he show any apparent inclination to return to the Netherlands, in spite of the Infanta's

urgent requests to the King, saying that all is lost in his absence. But the Marquis, with firm conscience, fosters some kind of plan in secret (please interpret this in the good sense), and remains fixed in his purpose. He has already received orders from the King for the fourth time, and I do not know by what means he has eluded or rejected them. I cannot tell what the outcome will be, but I clearly see in what spirit the plans are made, and toward what end. The rest is in the lap of the gods. To say more is neither permissible nor possible.

The loss of the fleet has caused great discussion here, but as long as no report comes from our side, we are unwilling to believe it. However, according to the general opinion it is only too true that the loss is enormous. It is imputed to folly and negligence rather than misfortune, since no precautions were taken, in spite of many timely warnings against the threatened disaster. You would be surprised to see that almost all the people here are very glad about it, feeling that this public calamity can be set down as a disgrace to their rulers. So great is the power of hate that they overlook or fail to feel their own ills, for the mere pleasure of vengeance.[3]

The King alone arouses my sympathy. He is endowed by nature with all the gifts of body and spirit, for in my daily intercourse with him I have learned to know him thoroughly. And he would surely be capable of governing under any conditions, were it not that he mistrusts himself and defers too much to others. But now he has to pay for his own credulity and others' folly, and feel the hatred that is not meant for him. Thus have the gods willed it.

But I must break off, and bring an end to this letter and my fatigue, but not to my feeling for you. Farewell, excellent and incomparable man, and make daily prayers to Fortune for the return of your Rubens, whom you rightly love as a true friend. Once more, farewell.

<div style="text-align: right">

Your humble and devoted servant,

Peter Paul Rubens
</div>

Madrid, December 29, 1628

This letter is full of erasures and more carelessly written than it ought to be, to you. But you must excuse me because of my illness. I beg you to take my little Albert,[4] my other self, not into your sanctuary but into your study. I love this boy, and it is to you, the best of my friends and high priest of the Muses that I commend him, so that you, along with my father-in-law and brother Brant, may care for him, whether I live or die.

As for affairs in England, nothing is certain, since the fatal stroke [5] which ruined everything. However, the two parties seem to seek to unite once more, and everything gives more cause for hope than apprehension. But these things still hang in the balance, as does the entire future; and according to the train of events in this world, I dare speak with certainty only of that which is past. Farewell, farewell.

I wish you, in good Flemish, a happy New Year, as well as your wife, and your family.

– 182 –

To the Earl of Carlisle *Madrid, January 30, 1629*

My Lord:

I have received your very agreeable letter of the 27th of November from Novara through the Abbé Scaglia, your great friend and servant. He was very welcome here, and was well received at this Court, as I had always assured him in my letters. I hope we shall soon see the effects of his worth and prudence, and that the interests of the kings, our masters, will be rendered inseparable, and their reputation and glory so united that there will remain no scruple among their servants in serving either the one or the other. In all events, I shall always remain what I profess to be, with all my heart.

<div align="right">

Your Excellency's most humble,
affectionate and obliged servant,
Peter Paul Rubens

</div>

I am sorry not to have had the pleasure of being able to render you my little assistance on your journey to Brussels. I am very sure, however, that others more able and accomplished than I am, worthily acquitted themselves in serving and honoring you as befits your merit and quality, and according to the best intention of the Infanta, my patroness.

Madrid, January 30, 1629

To the Earl of Carlisle [*Madrid, January–April 1629*]

My Lord:

I have diligently sought information of all those in the Perfumer's trade as to whether there is at present anything in Madrid which could be of service to you. But all of them assure me that there is nothing of importance, and that in order to satisfy your discriminating taste, it will be necessary to await the arrival of the ship from Goa, which, according to definite reports, has put in safely at Angola. It cannot be very long in arriving, and then one can purchase really good perfumes, and carry out everything according to your orders and instructions. I will take care to inform Your Excellency in time to receive whatever orders you may wish to send. In the meantime I humbly kiss your hands and commend myself to your good graces.

To Pierre Dupuy *Madrid, April 22, 1629*

Monsieur:

Six days ago, by the last courier, I received your most welcome letter of February 5. It came in care of the Ambassador of Flanders, and I am surprised that it arrived at all, after such a delay. I am glad to learn that you and your brother are in good health, and also that M. de Peiresc is feeling well and still remembers me. Indeed, for my devotion to him I deserve to live in his memory, and the more so because he has almost forced me to overcome my modesty and give him my portrait as a pledge of friendship. I hope he has received it, for I sent it by a safe route shortly before my departure from Flanders.[1] I do not know whether the evils of the present time will permit me to fulfill my promise to visit him as I wish with all my heart to do. It will be necessary for me to conform to circumstances which perhaps will lead me in another direction. It may be that I go first to Paris, to atone for the rude manner in which, against my will, I treated you the last time.[2]

I thank you for that heroic inscription *devictis Rupellanis.** I showed

* To the vanquished Rochellese.

it to the Count of Olivares, and it seemed to him very beautiful, as in fact it is. The same author will be able to exercise his talent on a subject of greater renown on the day when the glory of the victories over foreign foes shall surpass that of internal victories, and when His Most Christian Majesty can appropriately apply to himself the words of Caius Julius Caesar on his Pontine triumphs: *Veni, vidi, vici.*

We have seen here the articles of that treaty which is so infamous for the Crown of Spain (one must confess the truth), that it is doubtful whether those ministers behaved more shamefully in conducting the war or in treating the peace, and which is greater, the loss or the infamy.[3] As for the Duke of Savoy, I can only say that he always conducts himself valiantly against the Spaniards but allows himself to be beaten easily by France. I do not know whether one ought to attribute this phenomenon to some peculiar quality of his genius, or to our fatal indolence. In this way we also lost the fleet from New Spain, to the great astonishment of the captors themselves; they were surprised and ashamed to have taken it more by luck than valor, and for so important an engagement, without the loss of a single man. It is reported that the commander and all the officers have been taken to Seville, where they will face a severe trial. Their punishment will not make good the loss, *sed statuet exemplum in posterum.*† The fleet from Peru [*in margin*: which arrived recently in Seville, under the command of General Rasbare] is very rich because, in addition to the usual gold and silver, it is laden with an extraordinary gift from that kingdom. Those proverbs are true which say that disorder engenders order, *et sero sapiunt Phriges.*‡ For here they are putting affairs into good order, now that they are goaded into action, and seem to want to rouse themselves from their lethargy. The carrack and the galleon from Goa, which it was feared had fallen into the hands of the Hollanders, finally reached here safely, and this serves as some comfort in this dreadful calamity.

Since I have nothing else to report to you, I commend myself humbly to your good graces, as well as to your brother, and sincerely kiss the hands of both of you.

<div align="right">

Your most devoted servant,
Peter Paul Rubens

</div>

I beg you to commend me to the Abbé de St. Ambroise, and assure

† But will serve as an example in the future.
‡ And the Phrygians (or Trojans) are wise too late (*Adagiorum*, p. 31).

him of my devotion; and please do the same to the charming M. de la Motte.

Madrid, April 22, 1629

To the Count Duke of Olivares [*London, June 30, 1629*]

Your Excellency:

On the 25th of June the King summoned me to Greenwich and talked a long time alone with me. He said that since he saw I had instructions which were sufficient and to his satisfaction, he wished to treat with me freely, in order to save time; and that therefore, in case I had some reserved and more private commission, I ought not to delay in informing him; but that even if I had no such commission, he was no less willing to declare openly how far it lay in his power to go, in order to make peace with Spain. His Majesty called God to witness that he desires this with all his heart, but said that it would be necessary for our King to offer something on his side, to facilitate the matter; the good intentions which the King of Spain expressed on behalf of the Emperor and the Duke of Bavaria were too general and contained nothing positive; it would be necessary to come down to particulars. His Majesty swore to me that he was bound and obliged, not only by blood relationship and by nature, but also by the closest bonds of confederation, so that neither his faith, conscience, nor honor would permit him to enter into any accord with His Catholic Majesty without the restitution of the Palatinate. But he added that since he realized it was not in the King of Spain's power to hand over to him the entire Palatinate, he was content to make peace with Spain from crown to crown, in the form of the Peace of 1604, on condition that the King of Spain give up the places in the Palatinate where he had garrisons. He said this was his final decision; that he could not do more, and that I might make this report whenever it was convenient.

I excused myself with the remark that I had no orders to deal with this matter, that this was to be turned over to the Ambassadors, and that since the principal points would require time and leisure for discussion, with the lawful participation of all those interested, I had brought a truce signed by His Catholic Majesty, in order to save time and take advantage

of the present occasion. But the King answered me that he could not accept this, because all his alliances prohibited a truce just as much as the peace itself; and inasmuch as he had already announced everywhere his peace negotiations with the King of Spain, he would have to make the same efforts with all of them for a truce, and this would cause a much greater delay. He desires, therefore, that the peace be negotiated in Madrid, and that His Catholic Majesty arrange to have the Emperor and the Duke of Bavaria send their ambassadors also, in order to have the entire affair discussed in the presence of all interested parties. This could be done with all the convenience and time required, provided His Catholic Majesty offered assurance that he would relinquish the above-mentioned places. With this assurance the peace could be acknowledged without waiting for the end of all the negotiations.

Seeing the King so determined and resolute, I said that I would be glad to inform our King of all His Majesty had told me, provided that, in the meantime, he took no further steps toward a peace between France and England, but left this matter suspended in its present state. This he was not willing to agree to, saying that it was impossible, since within a few days the French ambassador was to arrive and his own was to depart. But after much debate he gave me his royal word of honor that during negotiations with Spain he would not conclude any offensive or defensive league, neither would he renew any former league with France against Spain.

This is all that can be done for the present. Your Excellency may be sure that I have brought forward and stated all the arguments one could imagine, but it would be tedious to enumerate them in this letter. As far as I can comprehend, however, little more will be done. For when I related the above to Weston and Cottington, saying that I considered the discussion as broken off, they told me the King had been too hasty, and they feared that if the matter came before the Council it would be rejected; for it was clear that to accept a part of the Palatinate was virtually to renounce all the rest.[1]

On the same day I went back to the King, and without showing any satisfaction, but using as a pretext my weakness of memory, I begged him to explain once more and to confirm the things he had told me in the morning. This His Majesty did very distinctly, and when the two aforesaid Lords came to his audience, he repeated and confirmed anew what he had said to me.

I make this report in such detail not because I believe I have accomplished anything that could give satisfaction and pleasure to Your Ex-

cellency, but because I am very apprehensive as to the instability of the English temperament. Rarely, in fact, do these people persist in a resolution, but change from hour to hour, and always from bad to worse. Therefore, instead of hoping for any notable improvement, I fear that, with the coming of the [French] Ambassador,[2] and the great effort which the Venetian Ambassador [3] will make, along with the entire French faction, the King will be so overruled that he cannot maintain even that which he has himself offered. For whereas in other courts negotiations begin with the ministers and finish with the royal word and signature, here they begin with the King and end with the ministers.

The King told me that he well remembered the letters the Abbé Scaglia had written him. This Abbé, with his great zeal, had misled him as well as the King of Spain, and Your Excellency also, in persuading all of you that peace could be based upon promises of a general nature. However, His Majesty judges it necessary for the Abbé to take part in the negotiations at Madrid, both for the sake of his master's reputation and because of his own merit. And when I said that the restitution of the above-mentioned places could not be made without the consent of the Emperor and the Duke of Bavaria, and that I was certain His Catholic Majesty would not wish to antagonize either one of these princes in order to have peace with England, the King replied that he believed this would surely happen, if it were done too suddenly, but that success would depend upon the time and the manner in which it was carried out. He said that in both respects he would conform to reason, and would easily come to an understanding with His Catholic Majesty, just as soon as he was sure that results would follow in due time.

With this decision I would have returned to Brussels to make a report to the Most Serene Infanta, if Cottington had given me permission. But he protested that if I left at this juncture, the negotiation would be lost forever, and he promised me that in a short time we should be able to make a report of a common accord. Since he is slow, and I know that he will proceed in the usual way, it seems to me advisable to gain time, and to inform Your Excellency as soon as possible without Cottington's knowledge. For I know that the report of which he speaks will not be made until after the French Ambassador has come and had an audience.

I have also written to the Most Serene Infanta begging her to grant me permission to return home. The duration and present state of the siege of Bois-le-Duc,[4] which holds both sides in suspense, in addition to the sorry state of affairs here, do not allow me to hope for any success. But I think that, in order not to displease the King of England, and to

satisfy Weston and Cottington, it will be necessary for me to await the reply of Your Excellency, whose orders I shall punctually follow, as

<div align="center">
Your Excellency's most humble and obedient servant,

Peter Paul Rubens
</div>

<div align="center">– 186 –</div>

To the Count Duke of Olivares *London, June 30, 1629*

Your Excellency:

I have learned from Cottington that the proposition which the King of England made to me has come to the notice of some of his ministers, and that he has been blamed for it and considered imprudent. For they are certain that in this way the King would receive those places in the Palatinate only after a very long delay, or perhaps not at all, because the King of Spain, in collusion with the Emperor and the Duke of Bavaria, would not fail to propose new arguments and new conditions by which the affair would be drawn out interminably. And if in the end he should receive this part of the Palatinate, he would be completely excluded, with good reason, from all the rest of it, since our King would then have fulfilled his commitments and the other princes would have no obligations. The ministers say that in order to hope for something profitable, (more through their own discretion than through the requirements of the agreement), it will be necessary at least to set a time limit, proportionate to the importance of the negotiation and consequently to the restitution of the places upon which the King has insisted. But I justified myself in saying that any delay would come not from our King but from others who might intervene in this conference, and that it would be unjust to expect him to answer for others who are not dependent upon his will.

Discussions are still being held here, and the King himself told me in a friendly way that it would be advisable to propose some marriage between the children of the Count Palatine and the brother of the Duke of Bavaria. No one has any idea of the ages and qualities of these young people, but if there is any conformity between them, all would approve the alliance.

The two memoranda enclosed are as follows: the one is from Soubise concerning a private effort at negotiation, as Your Excellency will see in the note. The other is from the Count of Laval, brother-in-law of the

Duke of Bouillon. Your Excellency will see what it contains and will be able to judge it with customary prudence. It is certain that he is a leading figure in that party and has a great following. I could not refuse to send these documents to Your Excellency, because of the urgency with which they were presented to me, and it would be well if there were at least some complimentary response.

The King has insisted that he never had any other intention, nor would he have been able, for the reasons mentioned, to do more than he offers now. He says that his inclination is even stronger now than when he was in Spain with the hope of becoming the brother-in-law of His Catholic Majesty.

London, June 30, 1629 Peter Paul Rubens

<center>– 187 –</center>

To the Count Duke of Olivares *London, June 30, 1629*

Your Excellency:

It has seemed to me necessary to inform Your Excellency what has happened up to the present, seeing that the report which I had thought to make with the assent and the common accord of the King and his ministers will be long delayed, and realizing that this delay is intentional on their part. For they await the coming of the French Ambassador and will first listen to his proposals, in order to accept those which appear the most advantageous. Yesterday morning the royal coaches left to meet the Ambassador of France; and the previous evening Mr. Edmondes, Ambassador of the English King to France,[1] set out upon his journey. There has been a little dispute about the fact that the King of France is so far away, that this ambassador cannot reach Languedoc in the same short time it will take the French Ambassador to reach London. They cannot, therefore, take oath on the same day. This difficulty has been settled in the following way: notwithstanding the presence here of the French Ambassador, the oath will be deferred until the Ambassador of England reports to his King his arrival at the Court of His Most Christian Majesty, and the day fixed for this ceremony. In the meantime it has been agreed that the French Ambassador, called Châteauneuf [*in margin*: he was formerly called M. de Préaux], shall have free access and shall be admitted as Ambassador by His Majesty and ministers, to treat the points contained in his instruc-

<center>303</center>

tions. He is expected here within four days. Already, as is publicly known, he has sent ahead his secretary with letters to the King and the ministers, urging them not to precipitate any treaty with Spain, whose King, he says, is reduced to the last extremity, and thus will make every effort to prevent an Anglo-French peace from turning into a close offensive and defensive league, prejudicial to his own interests. [*In margin*: Useless to write this at length, since it is known to all.] The Ambassador writes that he is bringing with him the absolute authority of His Most Christian Majesty to conclude such a league, and particularly to discuss the means of uniting the forces of France and England for the purpose of recovering the Palatinate. Cottington told me confidentially that he had also seen a letter from Cardinal Richelieu to the Lord Treasurer, which contained, word for word, the same things.

There are in this Court several factions. The first, which is headed by the Earl of Carlisle, wants peace with Spain and war with France; the second is much larger and wants peace with all. To tell the truth, I believe that the Lord Treasurer is of this opinion, and the Earl of Holland also. The third is the worst; it wants war with Spain and an offensive league with France against her. This party places great hope in the coming of the French Ambassador and is making great efforts through the Ambassador of Venice, who is a very bad influence in this Court for the disturbance of all Europe. The Marquis de Mirabel had already written to me about the mission of this French Ambassador; and the Most Serene Infanta sent me an express dispatch in order that, if I could do nothing else, I might manage to prevent the above-mentioned league between France and England against Spain. I discussed this matter at great length with the King of England, under another pretext, as Your Excellency will see in the enclosed paper. Here I shall only say that His Majesty persists in the resolution he has taken to send an ambassador to Spain, and we think he wants to appoint him now. I have discussed this subject with Cottington, for I should like the appointment to fall to him. But he told me plainly and, I think, truthfully that in his absence the affair would run the risk of failure, through the weakness of the men who support it; for Weston is cold and ponderous in his negotiations, and completely dependent upon Cottington. To these reasons he added some personal ones. It is certain, in fact, that Cottington has now reached such an eminent position here, and has become so popular, that he is on the way to making his fortune, and he does not seem to be a man so imprudent as to let it slip from his grasp. Therefore this post of Ambassador might well fall to Carlisle, who shows great zeal, or to Sir Walter Aston.[2] Cottington

would prefer the former, for his merit and efficiency, but fears that the exorbitant expenses which he has incurred in similar missions would count against him.

In the meantime Soubise persists with his urgent requests.[3] I wrote Your Excellency in detail on this particular point in my last letter of June 15, but I repeat that if the money had been ready, the King of England would not have hesitated a moment to do as much on his own part as he had offered. Your Excellency may be sure that if I had had this money in my hands, I should not have parted with a single crown without first thinking of the security of our King. But if I may be permitted to express my opinion, I cannot believe that the King of England, after being unable to save the [Huguenot] party by arms, will attempt to do so by an agreement, on the very occasion of the arrival of the French Ambassador. They write from France that the Queen Mother, at the King's order, has freed the dowager Mme. de Rohan from prison and sent her to her son the Duke in order to propose certain peace terms on the part of His Majesty. Soubise himself confirmed this to me. [*In margin*: But he does not believe this would be successful because one cannot place faith in the promise or the word of the King of France, who has deceived people so often.] With all this, I judge success to be very uncertain. If the necessary money had reached here before, I believe the move would never have been made, because already Soubise is promising not to enter into any agreement with the King of France without the consent of the King of Spain. And if no agreement is made, this will give an incredible authority to the Spanish party in this Court and add to its reputation with the King and all the kingdom.

Cottington told me in secret that he has learned some information directly from the gentleman whom the King of England sent to Holland.[4] This man brought back the last reply of the States and the Prince of Orange, which is that whether Bois-le-Duc falls to them or not, they are willing to enter into negotiations with the King of Spain. I believe this to be the truth, but during the siege it will be very difficult to carry out, unless I am mistaken.

The other day there arrived here a gentleman from Turin, a favorite of the Prince of Piedmont. He brought letters from his masters urging this King to allow the peace negotiations between Spain and England to be turned over to His Highness. He says that His Catholic Majesty has given the Marquis Spinola full authority to negotiate in Italy. When I was asked about this I answered that I knew absolutely nothing.

Your Excellency ought not to attach any importance to the negotia-

tions of the Marquis de Ville, for they are entirely without foundation. He has made so many concessions relative to the Palatinate that I am not surprised he has received a favorable response. To tell the truth, I believe that with his facility he has nearly ruined the business, and made our position much worse. If I had had the authorization in my pocket, as he thought I had, to offer similar concessions, I should have been able to break the peace between France and England within twenty-four hours, in spite of the French Ambassador and all the opposing faction. For the King of England told me with his own lips that we were to blame for this peace with France, because we would not decide to give him the chance to make an agreement with us while safeguarding his faith, conscience, and honor. He said that he detested the French and had never trusted them; that in all past dealings they had deceived him and always violated their promises.

In order not to fatigue Your Excellency more, I close, commending myself most humbly to your favor, and kissing your feet.

Your Excellency's most humble
and obedient servant,
Peter Paul Rubens

London, June 30, 1629
To the Count Duke

– 188 –

To the Count Duke of Olivares *London, July 2, 1629*

Your Excellency,

On the 30th of last month I made a report and sent it to the Most Serene Infanta, to be forwarded immediately to Spain by an express messenger. In it I gave Your Excellency a detailed account of all my negotiations in this Court. I mentioned the present state of the most important point of the treaty, which, in these few intervening days has not grown worse. On the contrary, it appears that through the good services of our friends, His Majesty will confirm the decision of which I informed Your Excellency. As soon as I obtain some certainty of this, I think it would not be a bad idea (and Cottington is of the same opinion) for me to go to Brussels to give the Infanta a detailed report. I should much prefer to do this by word of mouth, to Your Excellency, but the distance between the places is so great and the time which would be consumed is so precious that I could not travel to Spain without doing harm to the negotiations. From

Brussels, however, I could always return to England within a few days, if Your Excellency should judge it advisable. As for all I wrote in my last letter, I confirm it once more, and hope to be able to verify it within a short time by an even more explicit and certain report, upon which Your Excellency could base a resolution. I assure you that, from all I can learn from Weston and Cottington, there is no other result to be expected, for now, and those who offer hopes of an agreement based upon general terms and good intentions, etc. are deceiving both themselves and their friends.

I have been strongly urging a decision concerning both the nomination of the Ambassador the King of England is to send to Spain and the time of his departure. On both points His Majesty informed me of his resolution yesterday, through his Secretary of State Carleton. Although Cottington has done everything in his power to excuse himself, the King of England does not wish to choose anyone else but him, and has set his departure for the first of next August. This postponement is considered sufficient to allow some response to the report of the mutual agreement which we are to issue, and which will be of the same substance, but perhaps more positive, than mine of June 30. Cottington, in place of the Lord Treasurer, who is ill, has also assured me in the King's name, that during the negotiations with Spain no offensive league with France against Spain will be either concluded or renewed.

That is all I can write to Your Excellency on this matter except that Secretary Carleton also told me that His Majesty did not approve the proposal of the Duke of Savoy to hold the conference in Turin, but prefers that it take place in Madrid. If it should be necessary to negotiate through a third party, he would prefer the Infanta to any other mediator, and Brussels to Turin, because of its proximity.

Herewith I shall close, kissing Your Excellency's feet with all submission, and commending myself humbly to your good graces.

<div align="right">

Your Excellency's most humble servant,
Peter Paul Rubens

</div>

This will go with the special courier the envoy of Savoy is sending to Turin by way of Paris, in reference to the points just mentioned.

London, July 2, 1629

To the Count Duke of Olivares *London, July 6, 1629*

Your Excellency:

On the 30th of last month and the 1st of this month I wrote Your Excellency at great length about everything I thought I ought to report. Today I shall only say that the King holds to the propositions I have mentioned, and has ordered me to inform Your Excellency of something which I have deferred until now, for many reasons which, for the sake of brevity, I shall not explain. Sir 81 [Cottington] has promised me to write to Your Excellency, but I see that he is so burdened with important affairs that I do not think he will be able to send a letter by this courier. And the Lord Treasurer is suffering from gallstones, so that one must excuse him for the moment. Neither one of them is lacking in good intentions. The chief purpose of this letter is to say that the King of England has bidden me to inform Your Excellency that he has named his Ambassador to Spain. It is Sir Cottington, as I told Your Excellency on July 1. The King has fixed the first of August for his departure; but on condition that in the meantime His Catholic Majesty, on his part, will make the same arrangements concerning the choice of his Ambassador and the time of his departure. Above all, the King of England insists upon knowing the intentions of His Catholic Majesty before the departure of Cottington, so that he may give the latter better and more precise instructions. He insists also upon the necessity that nothing become known about this, because it might cause the delay of his Ambassador's departure. This is all I have learned so far. For the rest, I refer to that which I have written in my previous letters. I shall only add that a few days ago, when I begged the King of England to allow me to go to Brussels, in order to present his proposals to the Infanta, he told me that this could be done by letter, and that one could send these letters to Spain as well from here as from Brussels. It is necessary above all, he said, in order to remove every shadow of doubt and suspicion from the mind of the King of Spain, that I remain here as witness to all that passes between him and the Ambassador of France. He would keep me informed both to reassure my masters and to deprive the French of the means of ruining our negotiations by spreading false and malicious rumors, according to their custom. Then he confirmed once more everything I have reported to Your Excellency in my previous letters, particularly that he would not form an alliance with France against Spain.

The Ambassador of Holland [1] is asking the King of England for a subsidy to pay 6000 soldiers, but he will not get it. Cottington tells me that in the course of conversation the Ambassador complained that His Majesty was treating with Spain without the States' intervention, whereupon he received the reply that the States and the Prince of Orange had already been informed about this several times by a special envoy [2] of His Majesty, who believed he had thus fulfilled his obligations; but if they wished also to enter into negotiations with Spain, the King of England would gladly act as mediator. To this the Ambassador of Holland replied affirmatively, and said His Majesty would thus do the States a great service; but the peace treaty must be made in such a way as to allow both sides to disarm, in order to relieve their peoples of the many levies, taxes, and imposts which they were forced to continue to pay during all the period of the past truce. On this point a dispatch was sent to Flanders by the Commissioner Kesseler in Holland. [3] But on this subject I dare not open my mouth here, because the Most Serene Infanta has forbidden me to do so. I hope that this negotiation will terminate favorably. To tell the truth, the coincidence of the siege of Bois-le-Duc comes at an opportune time: as long as it lasts, both sides are suspended between hope and fear. The King of England told me only a word on this point, namely that even though the King of Denmark has made peace with the Emperor without consulting his allies, he was very sure that the Hollanders would never do this without his intervention. He said he would give me a message to this effect to present to the Most Serene Infanta. But I passed lightly over this point, not knowing, for the above-mentioned reasons, how to conduct myself.

Today there arrived in this city M. de Châteauneuf, Ambassador of France. He was greeted with little enthusiasm, and the reception was so small that the carriages going to meet him were for the greater part empty, although there were not more than twenty of them in all.

I am writing these minute details to Your Excellency because on my departure from Madrid Your Excellency ordered me to report everything, however insignificant. Today I received your most gracious letter of June 11, to which I do not know how to respond, since I have already, in my previous letters, informed Your Excellency as to what has occurred. Thus you will have received the news concerning M. de Soubise, and will know how his affair stands. When the time comes I shall take care of the matter Your Excellency mentioned to me. Above all it is necessary to fathom the secret which the Ambassador of France will discuss here with the King. I shall keep Your Excellency advised on this point, for I do not

lack the means of gaining information. And since I have nothing further to tell you now, I kiss Your Excellency's feet with all submission and reverence, and humbly commend myself to your good graces.

Your Excellency's most humble servant,
London, July 6, 1629 Peter Paul Rubens

To the Count Duke of Olivares *London, July 22, 1629*

Your Excellency:

I hope Your Excellency has received all my letters written from London on the 15th and the 30th of June and the 1st and the 6th of July. From these letters Your Excellency will be completely informed on all I could say concerning the negotiations which, up to this moment, have remained in the same state. I shall only add that since I see so much instability and diversity of opinion among these ministers, and since I fear some change as a result of the efforts of the French Ambassador, I decided to ask the King to give me in writing all that he had told me orally. This I have finally obtained, though not without difficulty. The statement is written by order of the King and in his name, but it is the Lord Treasurer who drew it up and signed it with his hand. I am sending Your Excellency a copy in cipher, not wishing to risk entrusting the original to a courier who might be robbed en route; it is enough that I have it in my hands. It is true that the King was unwilling to express himself as clearly in writing as he had done orally when he talked with me. But if Your Excellency will pay close attention to the sense of the words which seem to present some ambiguity, you will find that the substance remains the same. I leave this to the sagacity and prudence of Your Excellency. His Majesty desires to have some response before Cottington's departure, so that the latter may go with more precise instructions. His sole purpose in going to Spain is to conclude this peace; it will be based upon His Catholic Majesty's promise that, whether or not he can persuade the Emperor and the Duke of Bavaria to the restitution of the Palatinate, he will in any case return to the King of England those places which he holds in the Palatinate, at the end of the conference to be held in Madrid, in the presence of the Ambassadors of the Emperor and the Duke of Bavaria. Cottington's departure remains fixed for August 1st, old style reckoning; according to new style it will be the 10th. It is possible, however, that he

310

may be delayed by the response expected from Spain, as the King of England has told me. But according to Cottington himself and the Lord Treasurer, this will not prevent his departure. These two gentlemen have promised me to write to Your Excellency. On July 11 the King of England told me to inform Your Excellency that he placed more confidence in Your Excellency's generosity and discretion than in Cardinal de Richelieu's; that he would never have given such a document to the Cardinal, who would at once hand it over to the opposing party for his own profit. The King added that his proposals must in every respect be kept entirely secret, and in this he relied upon the prudence and good judgment of Your Excellency. It will surely be necessary, if His Catholic Majesty should decide to make peace on this footing, that the above-mentioned conditions be discussed secretly, without publicity, so as not to offend the Emperor and the Duke of Bavaria. The King of England told me, besides, that the French Ambassador had not yet broached in detail the principal points of his mission, since the second audience dealt chiefly with affairs in Germany, and a committee had been named to discuss these points. But he said that whatever the result of the negotiation, nothing would alter the points contained in this written declaration. He also assured me that he had had no part in the peace between the King of France and the Huguenots, and that he believed this ought not to have any influence upon our negotiations. I told him that Your Excellency, in a letter of June 11, which I gave to Soubise as soon as I received it, had guaranteed the subsidy for Soubise and that I had this subsidy at my disposal. He replied that he had been told this, and because of his own obligation to that party, he greatly appreciated the promptness and good will of His Catholic Majesty, even though he himself was not in a position to grant this subsidy or any other. Here we place no faith in the article of the above-mentioned peace by which all the Huguenot fortifications, new or old, are to be demolished, and only three — Tresmes, Montauban, and Chartres — will remain fortified as they are now, in the hands of the Huguenots for their security. I shall not dwell upon the details of this peace, for I know that Your Excellency is more fully informed than I am, through the Marquis de Mirabel and others who are close to him. It is strange that M. de Soubise has received no word from his brother, the Duke of Rohan, on this agreement, in which, they say, he is included. For he is to receive in Holland the regiment of M. de Haulterive, brother of the Ambassador Châteauneuf. I have written to nobody but Your Excellency about this document, nor have I mentioned it to anyone. The King of England forbade me to inform even Barozzi,[1] the Agent of Savoy,

and that is why I dare not mention it in my letter to the Abbé Scaglia. But in order not to arouse the mistrust of this man, it will suffice to communicate to him the substance of the propositions without speaking of the document. On this point I rely upon the prudence of Your Excellency, for you have no need of my poor counsel. And humbly kissing Your Excellency's feet, I commend myself to your favor, in which I desire to live and die.

Your Excellency's most devoted and humble servant,
London, July 22, 1629 Peter Paul Rubens

The King, along with the Queen, left Greenwich on July 11 for his annual tour; he will not be far from London, and will return within a few days to Greenwich and go once or twice to London.

[To this letter was attached the following note:] I cannot omit telling Your Excellency that the French Ambassador stated publicly that the King, his master, had no particular dispute with the King of Spain, except in the interests and for the protection of his allies, namely, the Pope, the Signoria of Venice, the Duke of Mantua and the Duke of Savoy.

I hear that this Ambassador is making every possible effort to hinder Cottington's departure for Spain, and that he is negotiating secretly about this with the Lord Treasurer. Both the Treasurer and Sir 81 [Cottington] have promised to send me their letters for Your Excellency today. But since these letters have not yet arrived, it seems to me unnecessary to detain this dispatch. I can send them at the next opportunity, which will be in about a week.

– 191 –

To the Count Duke of Olivares' *London, July 22, 1629*

Your Excellency:

This letter serves only to accompany the two enclosed letters from the Lord Treasurer and Sir Francis Cottington, from which Your Excellency will recognize the good disposition of these gentlemen.[1] Cottington is preparing for his journey, which greatly alarms the French faction. The French Ambassador is making every effort to prevent his departure, and is vigorously urging an offensive and defensive league between France

and England against Spain, or rather, against the House of Austria, as I have already more than once informed Your Excellency. The French Ambassador is carrying on his negotiations with a committee of six, who are as follows: the Earls of Carlisle and Holland,[2] the Lord Chamberlain Pembroke,[3] who has not yet appeared, the Lord Treasurer, the Lord Marshal Earl of Arundel,[4] and Secretary of State Carleton. He has proposed to them that the King of England join forces with those of his King for the restoration of the Palatinate, and the liberation of Germany from the oppression of the House of Austria, which he says has tyrannically usurped the power, to the detriment of all the kings and princes of Europe, both Catholic and Protestant. Everyone knows he is doing this, and discusses it openly in the public squares and streets of London. But most recently, at the instigation of certain Lords of this Court, and particularly the Earl of Holland, as I have learned on good authority, he has begun to insist upon the necessity for the King of England to call Parliament. Otherwise, says the Ambassador, His Majesty will maintain only a poor contact with his subjects, and will have neither the money nor the necessary forces to aid his friends or attack his enemies. This man's intention is not to render a service to the King of England, but rather to gain the good will of the people and in that way, without fail, to put off the peace with Spain. Many people regard it as odious and insolent that the minister of a scarcely reconciled enemy country wishes to intervene immediately in the internal and domestic affairs of this kingdom. The author of this plan is, as I said, the Earl of Holland, a popular person and head of the Puritans who form, so to speak, the body of the Parliament. His real intention is to ruin the Lord Treasurer, with the help of this Parliament. The Lord Treasurer belongs to the other party, and in such a case could not maintain his position, for he is hated by the Parliamentarians simply because they suspect him of being a Catholic. It seems to me certain that the Earl of Holland is hostile to Spain, because the King, although so intimate with him, has not, up to now, communicated to him the propositions contained in the document which I hope Your Excellency has already received, for I sent the copy on July 13 by way of Brussels. It was drawn up after consultation with the Earl of Carlisle, with Weston and Cottington and also with Pembroke, but in such secrecy that the King did not permit me to communicate these propositions, still less the aforesaid document, even to Barozzi, Agent of Savoy. Already the day fixed for Cottington's departure draws near, and in view of the short time, no one urges haste any more. As I believe Your Excellency will see, from the enclosed letters of these two gentlemen, our

reply can be deferred until his arrival in Spain, in order to treat this matter with mature judgment and in a form appropriate to its gravity.

That is all I can tell Your Excellency concerning this affair. Now it will be well to inform Your Excellency as to conditions in this Court, where the first thing to be noted is the fact that all the leading nobles live on a sumptuous scale and spend money lavishly, so that the majority of them are hopelessly in debt. Among these, in the first place, are the Earl of Carlisle and the Earl of Holland, who, by their fine table, maintain their following and their position among the nobility, since splendor and liberality are of primary consideration at this Court. I do not speak of the many other lords and ministers who, for the most part, have inadequate revenues to support their rank, and are forced to provide for their needs as best they can. That is why public and private interests are sold here for ready money. And I know from reliable sources that Cardinal Richelieu is very liberal and most experienced in gaining partisans in this manner, as Your Excellency will see by the report here attached. This was written before the arrival of Your Excellency's dispatch, to accompany the two enclosed letters.

It is considered certain that by these means the peace with France will be concluded, and unless I am mistaken, still other things will occur which will furnish material for a report to Your Excellency. Hereupon I humbly kiss the feet of Your Excellency.

<div align="right">Your Excellency's most humble servant,</div>

London, July 22, 1629 <div align="right">Peter Paul Rubens</div>

<div align="center">– 192 –</div>

To the Count Duke of Olivares [*London, July 22, 1629*]

Your Excellency:

I must explain to Your Excellency exactly how the negotiations have been going. The King had commanded me to inform Your Excellency that he wished to have an answer to his proposals before the departure of Cottington, and that a delay in this answer would also postpone the departure, because he wanted the Ambassador to leave here with definite and clear instructions. I informed Your Excellency about this on July 6.

His Majesty told me at that time that he would give me everything in writing, but this he did not do until July 13. He never asked me whether or not I had sent any report on this matter to Spain before

receiving this document; only when the Lord Treasurer handed it to me did he bid me write to Your Excellency, and Cottington added his own request. Up to the present I have concealed from them the fact that I sent the document; they know nothing more than that my report, and this document, along with their letters, are going by this post. I have not failed to point out to them that by their own delay the time is too short to receive any response from Madrid before the day fixed for Cottington's departure. And they admit this to be true. But they do know that Barozzi and I sent a report to Spain on July 2, announcing the appointment of Cottington as Ambassador to Spain, as well as the time of his departure. Therefore, in case I receive some answer from Your Excellency on this matter which ought to be communicated to these Lords or to the King himself, I could always say that on that occasion I had also sent some new information to Your Excellency. But if Your Excellency puts off any answer until the arrival of the Ambassador, things may very well remain in the state they are now, with the approach of the day set for Cottington's departure.

<div style="text-align:center">– 193 –</div>

To the Count Duke of Olivares *London, July 22, 1629*

Your Excellency:

I cannot refrain from giving Your Excellency information which Cottington told me in great confidence, concerning an Englishman named Furston. He came here recently by the post, sent by Cardinal Richelieu and bringing the Lord Treasurer a document of the following import: considering the friendship which binds the two sovereigns, he wished to give witness of the sincerity and reality of this friendship on the part of his master, the King of France, toward the King of England by pointing out the deception of the Spaniards who are trying, under the pretext of a peace, to betray and ruin him by making him offers which they will never be willing or able to carry out. The restitution of the Palatinate, which the King of Spain promises, does not lie within his hands, but depends upon the consent of the entire Empire, in particular the Duke of Bavaria. Now the King of France has more influence with the Duke, by virtue of their close friendship, than does the King of Spain, for whom he has great aversion. The King of France has decided to attack the King of Spain from all sides and to march in person to the aid of his allies in

<div style="text-align:center">315</div>

Italy, among whom is the Duke of Savoy, against the Imperial troops and all who oppose him. And since he has an agreement with the Hollanders to take the offensive at the same time on their part, and since he would send a second armed force against the Franche-Comté of Burgundy, he would ask of the King of England only the assistance of a naval squadron to join the Hollanders in ravaging the coasts of Spain. And if the King of England was willing to renounce the infamous peace with Spain, the King of France would offer him carte-blanche anything within his power to grant. In addition, the King of France had enjoined his sister, the Queen of England, to love and respect her husband as she ought. It is to be noted that the King of England is extremely devoted to the Queen his wife, and that she has great influence over His Majesty and is strongly opposed to Spain. And finally, he gave assurance that in order to reëstablish His Majesty's sister in the Palatinate, the power and the friendship of the King of France would be more valuable than that of the King of Spain, even supposing it were the latter's intention to do this (but he never had this intention in the past, nor will he have it in the future). He said that the King, his master, had made peace with the [Huguenot] rebels for no other reason than to be able to aid his friends and turn all his forces against Spain. Finally he offered the Lord Treasurer a large sum of money, either in capital or in the form of a pension, as he preferred. The strange thing is that this envoy had orders not to communicate this document to the French Ambassador who is here. Cottington tells me that the Lord Treasurer gave it at once to him, and he presented it to the King. The King simply laughed at it and said he was well acquainted with the wiles and tricks of Cardinal Richelieu, and that he would prefer to make an alliance with Spain against France than the other way around. Cottington revealed this document to me while urging such strict silence that he was hardly willing to allow me to inform Your Excellency. And since I have nothing else to tell you, I kiss Your Excellency's feet with the most humble reverence, and once more I commend myself to your good graces.

<div style="text-align: right">Your Excellency's most humble servant,</div>

London, July 22, 1629 <div style="text-align: right">Peter Paul Rubens</div>

To the Count Duke of Olivares *London, July 22, 1629*

Your Excellency:

I have received Your Excellency's dispatch of July 2 and read the orders it contains. I do not think I have acted contrary to these orders, for I have governed myself strictly according to the instructions Your Excellency gave me on my departure from Madrid. The Lord God knows this, and the nobles here, in particular the Lord Treasurer and Cottington, will bear witness that I have never proposed to the King or his ministers to enter into any negotiation other than a suspension of arms. But, as I have informed Your Excellency, the King had me summoned expressly to Greenwich, and laid before me the conditions which I mentioned in my dispatches of June 30 and July 2. I told him that these things would have to be referred to the Ambassador. But he answered that my instructions, as shown to Weston, would permit me to listen to his communications and make reports where suitable, in order to gain time until the Ambassadors on both sides take up their duties. I have not given the King any indication whether his proposals would be found good or bad, whether they would be accepted or rejected in Spain; I simply promised him to inform Your Excellency, on condition that no league with France against Spain be made as long as negotiations with Spain continue. This I did on the order of the Most Serene Infanta, who dispatched a special messenger to me at Dunkirk; and it was very necessary, seeing the great effort the French Ambassador was making, and in another way, Cardinal Richelieu also, as Your Excellency will see in the document here enclosed. I have always insisted, above all, that an authorized person should be sent to Spain as soon as possible, but the nomination of a minister was, so to speak, pushed into oblivion at my arrival, even though Cottington had written to Your Excellency that the minister would leave at once. He said this simply because they feared here that negotiations would be upset by the peace with France. With the assistance of Barozzi — and Barozzi well knows what efforts I have made and what difficulties I have overcome — I succeeded in obtaining this nomination at the very moment of the arrival of the French Ambassador. I succeeded in the naming of the minister and the day set for his departure, as I informed Your Excellency in my letters of July 2. And when the King of England insisted, as I have told Your Excellency several times, upon receiving a reply to his proposals before Cottington's departure, I prolonged the dis-

cussions under the pretext that I had to have these propositions in writing before I could lay them before Your Excellency. In this way there is no time left in which to expect an answer. I have managed, however, that this fact shall not delay the Ambassador's departure by a single day, as Your Excellency will see from the letters of the Lord Treasurer and Cottington. The day before yesterday Cottington told me that he would go by sea, and that he preferred to land at Lisbon rather than at Coruña, for certain reasons which he explained to me. He believes the route is no longer from one port than the other, and so he has already engaged the ship and settled the bills of exchange. I believe, however, that the endless number of his duties might delay him for several days; since in all political and state affairs he is, if not outwardly, certainly in effect, the first person of this Court. I say, therefore, that nothing will delay his departure except his duties here, which I fear he will not be able to finish as rapidly as Weston told me. All this will be decided within a few days, and I cannot do more than I have done already. But it will seem strange to the King of England if in the interval the person who is to come to England is not designated. I do not feel that I have employed my time badly since I have been here, or that I have overstepped in any way the terms of my commission. I believe that I have served the King, our master, with the zeal and prudence appropriate to the importance of the negotiation which has been entrusted to me. Your Excellency will recall, I pray, that the instructions given me contained the following articles: I was to assure the King of England that His Catholic Majesty had the same good wishes for an agreement as he did, etc., and that "whenever the King of England should send to Spain a person authorized to negotiate the peace, our King, in turn, would send someone to England," etc.; [1] these two points, it seems to me, I have carried out punctiliously.

And "as for the interests of the relatives and friends of the King of England, His Catholic Majesty, with the Emperor and the Duke of Bavaria, will do what he can." I have mentioned this in general terms to the King of England and have faithfully reported his reply to Your Excellency, as I was obliged to do, with all the details which the King added of his own accord. If the King of England has pledged himself by his word and in writing, with full liberty left to us, I do not think this could give rise to any inconvenience. Since the departure of Cottington will not be delayed by a day, and since Your Excellency charges me, in the same instructions, "to prevent as far as possible the accord which

might be concluded with France," I feel that I have fulfilled my duties completely.

I shall not mention the affair of M. de Soubise since it came to an end with the peace between the King of France and the Huguenots.

I have also advised Your Excellency, as I was charged to do, of everything that came to my notice through diligent inquiries; and I do not recall having reported anything false, which I rashly accepted as true, or anything untimely.

Having therefore carried out the orders which the King, our master, and Your Excellency did me the honor to give me, I beg Your Excellency to give me permission to return home. It is not that I place my own interests before the service of His Majesty, but, seeing that for the moment there is nothing else to do here, a longer stay would be a hardship for me. I intend, in any case, to remain here for the short time which the King of England may consider necessary in order that I may report to Your Excellency how far the King carries on negotiations with the French Ambassador. The first proposals he has already told me with his own lips, and he will continue to do so through Cottington. In the meantime I beg Your Excellency to have the goodness to let me know your wishes on allowing me to retire to Flanders as soon as possible. In awaiting your word, I commend myself most humbly to your benevolence, and with a sincere heart and due respect I kiss Your Excellency's feet.

<div style="text-align: right">

Your Excellency's most humble and devoted servant,
Peter Paul Rubens
</div>

London, July 22, 1629

The Agent of Savoy has told me that Don Francisco Zapata is coming as Ambassador to England. I beg Your Excellency to let me know whether this is true, so that I can give information where it is fitting to do so.

I gave Cottington Your Excellency's letter, which he read in my presence. He was surprised that he was expected so soon in Spain, for he does not recall having written in this sense. I believe, however, that he wrote more than he thinks, fearing that the peace with France might cause some alteration in Spain's inclination toward a peace with England, as the King of England admitted to me himself. It is certain that on my arrival it was still undecided whether he or someone else was to go. They were in no hurry to make a decision, and if Barozzi and I had not urged it, perhaps no one would yet be named, Cottington or anyone else. But even now, in spite of the favorable state of affairs, and all the reports

I have made in my previous letters, Your Excellency or the Abbé Scaglia might, without knowing the present situation, write something to these Lords which might alter it. I believe, therefore, that Your Excellency will give me the authority and approval, in regard to the letters you have sent me, from which I can infer the content of the others, if I use my own judgment whether to send these letters on or keep them in my possession for the greater security of the negotiations. When Your Excellency has received this present letter, you will perhaps give me new orders about what I ought to do. The best and safest thing would be to send me these letters under a separate seal.

I should have liked to keep back the letters which the Abbé wrote to the King and to several other Lords in the dispatch of July 3, but after Barozzi had seen them, it was no longer in my power to hold them.

It is certain that if they do the negotiation no harm, neither can they render it any more favorable than it is now.

– 195 –

To Pierre Dupuy *London, August 8, 1629*

Monsieur:

To see so many varied countries and courts, in so short a time, would have been more fitting and useful to me in my youth than at my present age. My body would have been stronger, to endure the hardships of travel, and my mind would have been able to prepare itself, by experience and familiarity with the most diverse peoples, for greater things in the future. Now, however, I am expending my declining strength, and no time remains to enjoy the fruits of so many labors, *nisi ut, cum hoc resciero doctior moriar.**

Nevertheless, I feel consoled and rewarded by the mere pleasure in the fine sights I have seen on my travels. This island, for example, seems to me to be a spectacle worthy of the interest of every gentleman, not only for the beauty of the countryside and the charm of the nation; not only for the splendor of the outward culture, which seems to be extreme, as of a people rich and happy in the lap of peace, but also for the incredible quantity of excellent pictures, statues, and ancient inscriptions which are to be found in this Court. I shall not mention the Arundel marbles,[1] which you first brought to my attention. I confess that I have

* Unless thereby I shall succeed in dying a wiser man.

320

never seen anything in the world more rare, from the point of view of antiquity, *quam foedus ictum inter Smyrnenses et Magnesios cum duobus earundem civitatum decretis et victoriis Publii Citharoedi.*† I am very sorry that Selden, to whom we owe the publication as well as the commentary of these texts,[2] has abandoned his studies *immiscet se turbis politicis.*‡ Politics is a profession so alien to his noble genius and profound learning, that he must not blame Fortune if, in the popular unrest *provocando regis indignantis iram,*§ he has been thrown into prison with other Parliamentarians.

I expect to remain here for a little while, in spite of my desire to breathe once more the air of my own home. It really has need of my presence, for on my return from Spain I stopped only three or four days in Antwerp. I have received a letter here from M. de Peiresc, dated June 2, in which he complains that I changed the plan I had made to revisit Italy on my return from Spain, and to come back by way of his Provence. I wish I could have done this, if only to enjoy for a few days the charm of his conversation. I beg you to be good enough to forward to him the enclosed letter. It is my first after a silence of almost an entire year. And with this I close, kissing your hands and those of your brother with all affection, and sincerely commending myself to your good graces.

<div style="text-align:right">

Your most affectionate servant,
Peter Paul Rubens
</div>

London, August 8, 1629

<div style="text-align:center">

– 196 –
</div>

To Peiresc *London, August 9, 1629*

Monsieur:

If I had been permitted to order my affairs in my own way, *et sponte mea componere curas,*‖ I should already have gone to see you, or I should be with you now. But I do not know what good or evil genius always interrupts the thread of my intentions and draws me in opposite directions. It is true, of course, that I derive some pleasure from my travels, in seeing so many varied countries, *et multorum hominum mores et urbes.*# Cer-

† Than the treaty between the people of Smyrna and those of Magnesia, with the decree of these two cities and the list of the victories of Publius Citharoedus.
‡ To become involved in political turmoil.
§ Provoking the wrath of an indignant monarch.
‖ And carry out my plans as I wished (*Aeneid*, 4.340).
And the customs and cities of many peoples (Horace, *Ars Poetica*, 142).

tainly in this island I find none of the crudeness which one might expect from a place so remote from Italian elegance. And I must admit that when it comes to fine pictures by the hands of first-class masters, I have never seen such a large number in one place as in the royal palace and in the gallery of the late Duke of Buckingham. The Earl of Arundel possesses a countless number of ancient statues and Greek and Latin inscriptions which you have probably seen, since they are published by John Selden with commentaries by the same author, as learned as one might expect from such a distinguished and cultivated talent. You will doubtless have seen that his treatise, *De Diis Syris*,[1] has just been reprinted, *recensitum iterum et auctius*.* But I wish that he had confined himself within the bounds of the contemplative life, without becoming involved in the political disorders which have brought him into prison along with several others accused of opposing the King in the last session of Parliament.

Here also is the Cavalier Cotton,[2] a great antiquarian, versed in various sciences and branches of learning, and the Secretary Boswell.[3] But these gentlemen you must know, and probably you correspond with them as you do with all the distinguished men of the world. Boswell told me a few days ago that he had in his possession and would show me the supplement of certain lacunae in the published *Anecdotes* of Procopius,[4] concerning the debauchery of Theodora. These passages were omitted in the edition by Alemanni, perhaps through modesty or prudishness, and then were discovered and extracted from a manuscript in the Vatican.

Of Spain I have not very much to tell you, although there is no lack of learned men there, *sed plerumq. severioris Minervae et more Theologorum admodum superciliosi.*† I have seen the Library of San Lorenzo, but no more than that. It is true that a certain gentleman named Don Francisco Bravo [5] has recently gone to Flanders, and he has had copies made of a great number of manuscripts. He told me in Madrid that he had found more than sixty books, hitherto unknown, of the ancient Fathers. I believe he is having something printed at the Plantin Press.

The famous philosopher Drebbel [6] I have seen only on the street, where he exchanged a few words with me in passing. He is staying in the country, some distance from London. This man is like those things of which Machiavelli speaks, which, in the popular opinion, appear greater at a distance than at close range. Here they tell me that in all these years he has invented nothing except that optical instrument with

* Revised and augmented.
† But mostly of a more severe doctrine, and very supercilious, in the manner of theologians.

the perpendicular tube which greatly magnifies objects placed under it. As for the perpetual motion apparatus in the glass ring, that is only nonsense. He also constructed several machines and engines for the aid of La Rochelle, but they had no effectiveness whatever. But I do not want to rely upon public gossip, to the detriment of so illustrious a man. I shall visit him at home, and talk with him intimately, if possible. I do not recall ever having seen a physiognomy more extraordinary than his, *et nescio quod admirandum in homine pannoso elucet neque enim crassa lacerne, ut solet in re tenui, deridiculum facit.**

I hope very soon to be able, with the permission of my superiors, to retire to my own home, where I stopped for only four days on my return from Madrid. After so long an absence, my presence is urgently required. But I have not given up hope of fulfilling my wish to go to Italy. In fact, this desire grows from day to day, and I declare that if Fortune does not grant it, I shall neither live nor die content. You may be sure that either going or returning, but more likely on my way down, I shall pay you my respects in your blessed Provence. This will be the greatest happiness which can befall me in this world.

If I knew that my portrait [7] were still in Antwerp, I should have it kept there in order to open the case and see if it had spoiled at all after being packed so long without any light and air, and if, as often happens to fresh colors, it had taken on a yellow tone, very different from what it was. If it arrives in such a bad state, the remedy will be to expose it several times to the sun, whose rays will dry out the surplus oil which caused this change. And if, from time to time, it begins to turn brown, you must expose it once more to the sun, the only antidote for this grave malady.

And since I have nothing else to say now, I kiss your hands with all affection, and sincerely commend myself to your favor and that of M. de Valavez, offering both of you my humblest service and remaining ever

<div align="right">

Your most humble and affectionate servant,
Peter Paul Rubens

</div>

Every time I write to you, I cannot refrain from recommending to you my dear friend M. de Picquery, who highly praises your courtesy toward him.

Your welcome letter of June 2 has given me new life.

London, August 9, 1629

* Something remarkable, I do not know what, emanates from the ragged man, and not even his thick cloak makes him ridiculous, as it would a lesser person.

To the Count Duke of Olivares *London, August 24, 1629*

Your Excellency:

After having received, on August 17, Your Excellency's dispatch dated July 26, I went the following day to find the Lord Treasurer and Sir Francis Cottington, who were at their country houses, and also the King, who was staying in a palace seven leagues from London, called Oatland. When I informed His Majesty of the nomination of Don Carlos Coloma, he replied that he was well satisfied and very glad at this choice of Don Carlos, since he knew him to be a nobleman of excellent reputation, and well-disposed to this negotiation.[1] And then I asked whether Sir Francis Cottington would be ready to leave soon, since on our part we could do nothing before his departure. If so, I said I would immediately inform the Most Serene Infanta, so that she might have Don Carlos come as soon as possible.

The King answered that owing to certain hindrances Cottington could not set out before the end of August, but at the latest he would leave by the 1st of September, old style reckoning. This was confirmed by the Lord Treasurer and by Cottington himself, who entertained me last night at his country house, where he lives the life of a prince, with every imaginable luxury. We had a long private discussion about his journey, and, although I had not told him that I had communicated to *Your Excellency the proposals already made, he asked me whether I thought there would be any response to the declaration. The Lord Treasurer had also questioned me about this in a very pressing manner,*[2] and told me that the contents of this document had remained so secret that neither the Ambassador of France, nor the one from Holland, nor any other person knew anything about it up to the present. I replied to the one, as I had to the other, that I knew nothing certain, but inasmuch as Your Excellency had said in every letter that this affair could not be negotiated at a distance, since each word had to be sent by courier, at great inconvenience and loss of time, I thought that everything would be postponed until the arrival of Cottington in Spain, and that he would best be able to explain the intentions of His Majesty, since the declaration itself was drawn up in terms both obscure and ambiguous. But the Treasurer protested that it was sufficiently intelligible, and that since I had talked with the King himself, and learned from his own lips the

meaning of the document, he did not know why I had delayed until now in interpreting it clearly in my letters to Your Excellency. I said that His Majesty had indeed insisted upon receiving a response (supposing the document would go along with the dispatch announcing the nomination of the Ambassador and the time of his departure), but that he had delayed more than a fortnight in asking me for it; and considering that there remained hardly enough time to receive an answer before the first of August, fixed for Cottington's departure, I did not think it advisable to cast doubt, under any pretext, upon the time of the Ambassador's departure, but preferred to leave it to the discretion of Your Excellency whether to answer or not.

The result was they did not insist further, and whether or not Your Excellency now sends an answer, they will take it in good part. The Lord Treasurer then enlarged upon the content of the document and said that he doubted that they would misunderstand it in Spain, but would think that *if Rubens had obtained such concessions, the Ambassadors would obtain much more.* He swore to me that he was convinced that Cottington would be given no further instructions than to propose the conditions mentioned in the document. Perhaps, he said, there would be one restriction not mentioned in it, regarding the time within which our King would promise to give up the towns of the Palatinate — whether within a year, or another stipulated period. I answered that I could say nothing to this, since I had no orders to embark upon further discussion of the conditions; but that the King of England had not specified any time, either by word of mouth or by writing, although I had requested him to do so. I added that the King of Spain would have to negotiate with the Emperor and the Duke of Bavaria (as the King of England wished) and thus he could not specify a definite time for negotiations which would depend, for the most part, upon others; that he could not answer for their duration or for any delay. This was the reason that no mention of time had been made in the document, and the King of Spain was satisfied without raising the question. In short, the Treasurer repeated that Cottington would bear no other orders; that if the King of Spain would not accept the conditions in the document, he would return immediately to England; if, on the contrary, our King would give his promise, the Peace of 1604 would be renewed at once and made public, and Cottington would bring the text back to England, since affairs of state would not permit his absence. Thereupon the Lord Treasurer asked me whether in this case it would not be necessary to send another Ambassador from

here to Spain, to negotiate the final treaty, and whether likewise the King of Spain would immediately send another Ambassador here; he added that it might be advisable to appoint such a person now. I answered that I knew nothing about this, but there would be time to prepare for it, and that no inconvenience could result while Don Carlos Coloma remained at this Court, and that no other statesman could so surpass him that our King would not wish to retain him even after the return of Cottington. This answer satisfied the Treasurer.

In the meantime Cottington has commissioned me to write to the Most Serene Infanta for a passport which will allow him free entry into any port of Spain or Portugal. Up to now he seems to have decided, for some personal reason or interest which Your Excellency will understand, to debark at Lisbon. *He told me at the end of our discussion that if he did not succeed with this negotiation, this journey would be his final ruin. He said that Your Excellency would have to take pity on him, since he had accepted the mission only because he had been ordered to do so and because of his obligations to you. To the others, and to the King of England, he will be able to excuse himself, but Your Excellency can, if you will, facilitate things. He sets his hope on Your Excellency's help, because he fears that a thousand difficulties will be laid in his way, and no trust placed in his mission. He believes this will mean his ruin.* And when I mentioned that it would be hard to write these things to Your Excellency (suspecting that he spoke in this manner only to exaggerate the difficulties and to place all responsibility upon Your Excellency), he told me again that he called God to witness *that he spoke the truth, and that time would prove it. He protested that a miracle had been wrought in obtaining this document from the King of England and gaining the approval of his Council, at a time when the French were offering carte blanche to the King of England solely to prevent this peace with Spain. The promise alone, he said, not to make any treaty with France to the disadvantage of Spain (contained in the last lines of the document) was of such importance that it would prevent or ruin all intrigues and plots of the opposing party.* The Lord Treasurer told me also that the arrival of Cottington in Spain would settle the peace within one hour, or else it would never be settled. It will, therefore, be absolutely necessary to handle things in an entirely different manner than hitherto, for they cannot remain in their present state.

On all this it seemed to me advisable to inform Your Excellency. I have reported simply what these Lords have said to me; Your Excellency will make use of it according to your discretion. And humbly kissing the

feet of Your Excellency, I commend myself, with all submission, to your favor.

<div align="right">Your Excellency's most humble and devoted servant,</div>

London, August 24, 1629 Peter Paul Rubens

Don Carlos Coloma will be given a furnished and well-appointed house here. It will be advisable to make the same preparations for Sir Francis Cottington in Madrid.

<div align="center">– 198 –</div>

To the Count Duke of Olivares *London, August 24, 1629*

Your Excellency:

In order to satisfy Your Excellency's orders, I shall report everything I have been able to learn concerning the negotiations of the French Ambassador. He continues to try to hinder in every way the departure of Cottington to Spain, or to render it useless; but so far, he has not succeeded, with all his industry, in breaking down the determination of the King of England, who perseveres in his good intentions. In fact, the appointment of Don Carlos Coloma has revived the spirits of our adherents and very much disturbed the opposing party. Your Excellency can accept this for gospel truth. I have learned on good authority that the aforesaid Ambassador is offering the King of England carte blanche to make an offensive and defensive league against Spain and the whole House of Austria, without asking the King of England for any assistance in the war in Germany, either in men or money, or even a fleet for the defense of France or attack on Spain. The King of France pledges himself to recover the Palatinate, and to defend the liberty of Germany with his own forces, at his own expense and that of his other allies, on the single condition that the King of England permit his subjects to form a company with the Hollanders for a joint attack upon the East and West Indies. Discussions are in progress here with the deputies who came for this purpose several months ago, and the conclusion of the agreement has been delayed, according to all I have heard, simply in order that the treaty with Spain might not be brought into question. On this point Your Excellency may be sure, the promise contained in the declaration, not to make any agreements to Spain's disadvantage, has had very great effect. But without fail, Cottington's return from Spain will be hastened,

<div align="center">327</div>

in case his proposals are not accepted, in order that a resolution might be passed immediately to accept the French offer. The French Ambassador is working to this end; seeing that Cottington's journey can no longer be prevented, he now does his best to have him depart as soon as possible, on condition that he return at once if the King of Spain will not pledge himself to the restitution of the entire Palatinate without delay. The Ambassador says His Catholic Majesty is completely independent of the Emperor in this matter. He says also that our King is so much embarrassed by the war in Flanders that the King of England need not be satisfied with a little, and that if he does not obtain all he wants now, it will be his own fault, seeing Spain threatened by the Dutch on all sides, both by sea and land, and expecting worse from the French troops in Italy, in Picardy, Artois, and Hainault. This Ambassador of France is under obligation to maintain these offers until the return of Cottington from Spain, if he returns *re infecta*.*

I firmly believe that the above-mentioned conditions would be accepted without any difficulty. Not that the King of England expects the French King to carry out a single one of these proposals, or keep his promises any more than he has done in the past, but because he could make this treaty with the reputation and appearance of great advantage in the eyes of the world. Several times His Majesty has assured me that if he could safeguard his reputation and honor in any other way than by demanding the conditions which he does in the document, he would not hesitate a minute in concluding peace with Spain, from crown to crown, without any more advantages than the last peace gave him. And I am sure that in his heart he prefers a simple friendship with Spain a thousand times more than all the offers of France, and that he curses the day when the Palatinate came to his attention. That is all I can tell Your Excellency on this subject.

The Ambassador of Holland had an audience with the King recently, and was referred to a commission to which the Lord Treasurer and Sir Cottington belong. He made a speech to them which lasted almost an hour, greatly exaggerating the peril which threatened the United Provinces unless their allies came promptly to their aid with strong reinforcements of money and troops. He said that he himself had never approved of the attack on Bois-le-Duc, but since they had already put so much expense and labor into this siege, they could not abandon it without ruining themselves completely. In fact, the people who have been oppressed by heavy taxes would revolt if some success did not result

* Without accomplishing his mission.

from all the money spent on the enterprise and borrowed at interest, from the first day of the siege, from private individuals. These extraordinary expenses have been even more aggravated by the long duration of the siege. Those who know the character of this Ambassador, and understand the States, suppose that he is exaggerating their needs to the last degree and distorting the truth in order to move the King to sympathy and to give them aid. But one may at least believe the greater part of what he says about the efforts they have to make to resist Count Henry and fortify the region of the Veluwe. The system of trenches and canals is mounting to such a sum that it seems impossible for them to carry it further or ever to pay for it. That is why, as I have said, they demand assistance in money and men, asserting that because of the diversity of the danger, it is necessary to provide for all the frontier of the Veluwe, and every fortress, besides the towns on the Yssel, as far as the borders of Frisia. It is certain that for this purpose, and to continue the siege of Bois-le-Duc, an army of 60,000 men is required. It is estimated that such a force is now under arms in the United Provinces, but this includes the recruits conscripted by Sweden. These the States have kept in their own service, although this is not approved either here or by the King of Sweden. It is thought they will be forced to let these men go, on the promise that an equal number will be sent from England, and the Indies Company will furnish ten to twelve thousand infantry. Therefore the Ambassador should not be refused permission to make some levy of troops in this kingdom, a thing which had not hitherto been granted. At the end of his discourse, the Ambassador turned to Cottington and said he found it strange that instead of assisting his allies, the King was willing to discuss peace with their mutual enemy. He said that Cottington's journey to Spain would in itself arouse such apprehension in the world that those who had some hope of His Majesty's friendship would be discouraged; and it was very apparent that since the King was making so prejudicial a demonstration as to exchange Ambassadors publicly, negotiations must be more advanced than had been thought. This was his conclusion. He was told in reply that His Majesty would at the same time send Sir Henry Vane to Holland, to confer with the States on the subject of the obligations of their alliance.

I have neither the talent nor the position to give advice to Your Excellency. But I consider this peace to be of such consequence that it seems to me the connecting knot in the chain of all the confederations of Europe. The very fear of it alone is already producing great effects. I understand also the changes and the bitterness that would result from a

rupture in negotiations; if these should become completely hopeless, we should in a short time see an overturn in the present state of affairs. I admit that for our King the peace with the Hollanders would be more important, but I doubt that this will ever come about without the intervention of the King of England. But perhaps this peace between Spain and England, made without the Hollanders, would give them something to think about, and make them decide upon peace also. And all this lies in Your Excellency's hands, so that with the promise of relinquishing a few places in the Palatinate, a great step could be made; for it is certain, in every prudent man's opinion, that once this peace is made, all the others will follow. And it might easily happen, in spite of the promise, that in the space of one or two years (a period which I believe will be granted) some incident of such weight might occur, that with good and just reason our King might be exempt from making the stipulated restitution, after having in the meantime enjoyed the advantages and consequences of this peace. Then the King of England, having let slip the opportunity to negotiate to his advantage, would perhaps be content to receive some other sort of compensation from His Catholic Majesty, rather than to risk a new rupture. And even if His Majesty should finally be obliged to give up the places mentioned, following the advice of Cottington, he could, with one part, redeem all the rest.

I hope Your Excellency will pardon me if, through excessive zeal, I have perhaps gone too far. I beg you to believe that the thoughts expressed are not entirely mine, but come, for the most part, from a person whom Your Excellency ought to trust, and whose opinion and counsel ought to be respected.[1]

Herewith I close, and commending myself anew to the good favor of Your Excellency, I kiss your feet.

Your Excellency's most humble servant,
London, August 24, 1629 Peter Paul Rubens

Soranzo, the new Ambassador from Venice, has recently come here from his post in Holland. He has presented his Majesty with a long document opposing the peace with Spain, but it has made very little impression.

To the Count Duke of Olivares *[London, August 24, 1629]*

Your Excellency:

I have learned from a trustworthy person that on August 18 the Earl of Carlisle proposed to the Royal Council, in the presence of the King, that since Don Carlos Coloma had been appointed Ambassador of the King of Spain to this Court, and in consideration of the gravity and complexity of the negotiations which have to be made in Spain, and which will deal principally with affairs in Germany, it might be advisable to give greater prestige to the Embassy by sending to Spain along with Cottington an Earl and a Doctor of Law. He suggested the Earl of Rutland, father-in-law of the late Duke of Buckingham, and Dr. Marten. He realized that the first would be rejected because he was a Catholic, and known as such. But his plan was to try to push the resolution to send an Earl, but if his own candidate should be rejected, then he himself would be named instead; in this way he would attain what he desired most in this world, namely, to take part in this diplomatic mission. The majority of the Council favored the Earl's proposal, especially the idea of sending a jurist well versed in the Imperial laws, the constitutions and privileges of the Electors — in short, familiar with the affairs of Germany. But the Lord Treasurer objected, alleging that this haste and expense would be premature, since Cottington was not being sent to negotiate on German affairs, or to discuss the question of the Palatinate, but simply to present the proposals contained in the document. If, he said, these proposals should be accepted, there would always be time to send competent men to work out the terms. But if they should be rejected, it would be useless to do anything more. The King agreed with this opinion, and it was decided to send Sir Francis Cottington alone this time. I have made some inquiries about this Dr. Marten, and learn that he is a scoundrel, most hostile to Spain; he would be the worst man one could choose in a thousand.

To the Count Duke of Olivares [*London, August 24, 1629*]

Your Excellency:

It is very certain that on August 16 there was presented and discussed at the Council of State, in the presence of the King, a document sent from Turin by the English Ambassador at the Court of the Duke of Savoy, and brought here in great haste by one of his own servants. This document was signed by the Ambassador and by the Prince of Piedmont, after having been approved by Cardinal Richelieu. Its contents were as follows: the King of France would consent to relinquish the town of Susa to the Duke of Savoy, on condition that the King of England would guarantee that the Duke of Savoy would grant free passage to the French armies whenever His Majesty might need to enter Italy to bring aid to his friends and allies.[1] This document caused great discussion and variety of opinions. It was approved by the majority of the Councilors, who said it was a great honor for the King to be chosen by other kings and princes as arbiter and guarantor of their treaties. But one of our partisans declared it would be necessary first to consider whether such an accord would be favorable to the King of England; and second, to determine by what means His Majesty could force the Duke of Savoy to keep his promise in case he broke his word, since he was so far away and beyond the reach of English troops.

Then the King, who really seems to me to be most conscientious in observing his promises, declared clearly that he could not intervene as guarantor in this treaty without breaking his word to Spain. He said that the promise contained in the statement consigned to Rubens bound him to make no new agreement with the French, prejudicial to Spain, while peace negotiations were in progress. Thereupon they postponed the matter for more thorough deliberation. There was much discussion about the bad faith of this Prince who, on the one hand, pretends to ally himself closely with Spain, and, on the other, negotiates separately with France. It was observed how completely mistaken the Abbé Scaglia was in his opinions, particularly regarding the Prince of Piedmont.

This incident seemed to me worth reporting to Your Excellency, and perhaps it would be advisable to inform the Marquis Spinola.[2] Hereupon I commend myself once more, etc.

To the Count Duke of Olivares [*London, August 24, 1629*]

Your Excellency:

I send Your Excellency a thousand thanks for giving me permission to return to Flanders after the arrival of Don Carlos Coloma in this Court. Although I enjoy every comfort and satisfaction here, and although I am universally honored, more than my rank deserves, I cannot remain here any longer than the service of His Majesty requires. Neither do my domestic affairs permit it, although I shall always give the preference not only to the commands of our King, but also to those of Your Excellency for private service. For I profess to be Your Excellency's creature, with the obligation and the will to serve Your Excellency as long as I live. In this spirit I beg Your Excellency to accept me as such, and to keep me in the favor of His Majesty and yourself. And with complete devotion I kiss Your Excellency's feet.

Your Excellency's most humble servant,
Peter Paul Rubens

I hope that the same warship which brings Don Carlos here will serve, a few days later, to take me back to Dunkirk.

To the Count Duke of Olivares London, September 2, 1629

Your Excellency:

Those who share the secret here are beginning to lose hope, seeing that no answer comes from Your Excellency, not even the acknowledgment of receipt of the document. It is useless for me constantly to lay the blame on the lack of time and to cite the reasons which Your Excellency mentioned in previous letters, namely, that one cannot negotiate by letters and dispatches, but, to save time, ambassadors ought to be exchanged; and that since we have now reached this point, a written answer is no longer necessary. Even Cottington is of the opinion that his journey to Spain will serve only to precipitate the rupture, since he will be able to offer no other proposals than those contained in the document. And the King of England wishes the same ships that take Cottington to Lisbon

to wait there for his return. The cause of so much agitation is the fact that the Ambassador of France promises, during the absence of Cottington, to maintain the offers already mentioned in my previous letter — in other words, carte blanche for the terms of an offensive alliance against Spain. And since the Ambassador was unable to prevent Cottington's departure, some believe that he will remain here to await his return. This French Ambassador is now working to have Cottington leave as soon as possible, so that the King of England may be the sooner disappointed. He affirms that this journey of Cottington's is a useless move and nothing but a waste of time, for, according to certain information from Spain, His Catholic Majesty is not willing, for anything in the world, to give up a single one of the places he occupies in the Palatinate. And the King of England, by virtue of his alliances, cannot make peace with Spain without touching upon this point. Already the negotiations are regarded as broken off. The other day Cottington told me that his instructions were now being drawn up, and he added that he knew, from a reliable source, that he was to take with him all the original letters ever written from Spain to King James on this matter, with a number of clear and formal promises to make the restitution demanded. And if perhaps he is told that, with the war, all promises became void, he will reply that it is reasonable to assume that with the peace, such promises regain their force, and things return to their previous state. In case His Catholic Majesty wishes to make peace on the basis of these promises, Cottington will have absolute power to go even further, to break anew with France and to make an offensive and defensive league with Spain against her. From this one may hope for great success, if it is concluded as he will propose it. Cottington told me also, in confidence, that if he should achieve this, he hoped to do more; seeing the King of England already so ill-disposed toward the Hollanders, because of their intolerable insolence, he thought that England and Spain, once reconciled, might together easily check them.

It is certain that the King of England received the news of the capture of Wesel [1] with tears in his eyes, so well-disposed is he toward Spain, although all his Councilors are of the opposite inclination. Your Excellency may believe me that His Majesty alone places great hope in Your Excellency's generosity. He believes that Your Excellency will consider his necessity, and realize how impossible it is for him to make peace unless he receives some semblance of satisfaction, or at least salve to his reputation, by this promise; aside from that, the places in the Palatinate have little or no importance for him. I firmly believe that in case Cottington (to use his own words) brings back the sad news of the breaking off

of the treaty, the King will feel the deepest regret, and will be forced to take a course other than the one he would like. Until now, he alone has resisted every effort of Parliament, and prevented the agreement between the West Indies Company and the Hollanders; he has done this even in spite of the insistence of the Ambassadors of Poland and Holland, who demanded no other condition than this, in order to contract an alliance with His Majesty. But all these resolutions will be settled one way or another, immediately after the return of Cottington from Spain. And having nothing more to say on this matter, I commend myself with all devotion to Your Excellency's favor, and most humbly kiss your feet.

<div align="right">Your Excellency's most humble servant,</div>

London, September 2, 1629 <div align="right">Peter Paul Rubens</div>

I suppose the reason for the change in the Duke of Savoy's attitude [2] is because he has learned from the Abbé Scaglia's letters from Spain that the conditions proposed by the King of England will not be accepted, and that for this reason the treaty will not be concluded.

<div align="center">– 203 –</div>

To the Count Duke of Olivares *[London, September 2, 1629]*

Your Excellency:

It is confirmed that Barozzi, the Agent of Savoy in this Court, is still out of town, following the King in his travels, in order to obtain His Majesty's decision on the document which I mentioned in my letter of August 24,[1] presented to the Royal Council on August 16. Barozzi saw that the matter was making no progress in the hands of Ambassador Wake,[2] through whom the Duke of Savoy wished to discuss it with the King of England as a proposition signed by his own Ambassador. And so he has finally presented a letter, which he was keeping as a last resort, from the Duke of Savoy himself, and addressed to the King of England. In this letter the Duke makes the most urgent request, and uses numerous reasons and arguments to persuade His Britannic Majesty to offer this guarantee for him to the King of France: namely, that if the King restores Susa to him, the Duke will grant free entry to the French armies to pass through Piedmont into Lombardy whenever and as often as this shall be necessary for the aid of their friends and allies. (I have already written this, but I

repeat it so this letter may serve as a duplicate in case my first has not yet reached you.) In short, it appears, from the reasons alleged in this letter, and according to the opinion of the King of England and all those who attended the Council, that the Duke has changed sides and become an out-and-out French partisan. Your Excellency may believe me that, if the Duke should fail to obtain his request here, and should once more change sides upon the arrival of the Marquis Spinola and the Abbé Scaglia in Italy, he will never again enjoy any credit with the King of England. For the King is highly scandalized at such fickleness and told Barozzi this was in direct opposition to what his master the Duke had always advised in the past, and that it contradicted the motives for the journey of Ambassador Scaglia to Spain. The King said he could not understand this new move. It is to be noted that at this same time the Ambassador of France came to make the same proposals and requests to the King, at the order of Cardinal Richelieu. He has been referred to the Lord Treasurer, but he will receive no better reply than before, at least not for the present.

On August 27, about midnight, there arrived by the post a servant of the English Ambassador in Paris, bringing complaints that the French were treating him with great suspicion and showing irritation over things of small importance. They took offense because the King's letters were written in Latin and because he, the Ambassador, had spoken English in his public audience and had referred to his King not as "the King of Great Britain," according to custom, but as "the Most Serene King," without naming the kingdom; to them this seemed too general a title, which could be applied to more than one kingdom. Because of this dispute the ratification of the peace has again been delayed in France for six days. The French still continue to seize English ships, to the great loss and the disgrace of the entire nation, which resents this bitterly. Thus this peace does not yet seem secure in every point, nor will it last very long if the King of England can make any sort of agreement with Spain.

– 204 –

To Jan Caspar Gevaerts *London, September 15, 1629*

Dear Sir:

You make it a practice of always anticipating my desires, and surpassing me in courtesy, without regarding my faults or my negligence in honoring and serving you as I ought. But God knows that I am lacking only in

exterior demonstrations, but not in the deep regard and sincere devotion which I feel for you. This I shall prove by deeds as soon as you offer me an opportunity to serve you, which I await with impatience. I hope that my son [1] will be my successor in this, at least, and will acquit himself of all my obligations to you; for he also has had a large share in your favor, and owes to your good instruction the best part of himself. The higher you esteem him, the more I shall care for him, for your judgment has more weight than mine. But I have always observed in him a very good disposition. I am very glad to learn that he is now feeling better, thank God; I sincerely thank you for this good news, and for the honor and consolation which you gave him by your visits during his illness. He is too young (if Nature runs her course) to go before us. God grant that he live, in order to live honorably! *Neque enim quam diu, sed quam bene agatur fabula refert.* *

I hesitate to remind you of the loss of your dear wife. I should have written to you immediately; now it will seem like nothing more than a painful duty and a needless renewal of your grief, when it would be better to forget, rather than to recall the past. If any consolation is to be hoped for from philosophy, then you will find an abundant source within yourself. I commend you to your Antoninus,[2] whose divine nourishment you still distribute liberally to your friends. I shall add only this, as a poor kind of comfort: that we are living in a time when life itself is possible only if one frees himself of every burden, like a swimmer in a stormy sea.

I do not know what to say about our political affairs, except to blame Fate (*ne Deos et homines accusem*) † for the loss of Wesel and all its consequences. The Hollanders now have reason to imagine themselves the Chosen People who can say to God, *Nos autem populus tuus et oves pascuae tuae.*‡ For it seems to be a stroke of divine Providence which comes to the aid of inexperience, every time misfortune befalls a good cause. I am afraid that Bois-le-Duc also cannot hold out much longer, although we can still place some hope in the rains which are beginning to fall. I suppose, however, that this "water-folk" has already prepared for that.

I am longing to return home, yet with a dread of coming back in such unfavorable circumstances. But I shall not remain here a single day after Don Carlos Coloma arrives. This will be soon, since the Ambassador

* For according to the proverb, it is not how long one lives, but how well.
† In order not to accuse God or man.
‡ We are Thy people and the sheep of Thy pasture (Psalm 100).

who is to go from here to Spain is on the point of departure; he intends to set out within fourteen days at the latest, and on the same day I must send an express dispatch to Don Carlos, who will leave at once for London. I am well aware that you are very much inconvenienced by the long absence of my brother-in-law Brant,[3] and all the more because M. de Pape is also absent, so I hear. This causes all the burden of affairs to fall upon you. I am ashamed to say I had not thought of that. It is true that, according to all appearances, and as far as one could possibly imagine, this business was not expected to last more than two months; and for the short time which still remains, I do not like to send my brother-in-law home. Nevertheless, I should do this in order to relieve you (although his company is pleasant for me and his assistance necessary) were it not that he would run the risk of falling into the hands of the Hollanders. They have strong forces in the Channel, and the royal warship which is assigned to carry us safely across would not set sail for him alone. That is why I beg you to be patient a little longer, and because you have already done so much for my sake, to endure this also.

I owe you thanks, both for myself and for my brother Brant, and I am ready to serve you on a similar occasion, or in any other way, remaining ever

Your affectionate and obliged servant,
Peter Paul Rubens

P.S. My brother Brant commends himself with all his heart to your good graces.

London, September 15, 1629

– 205 –

To the Count Duke of Olivares *London, September 21, 1629*

Your Excellency:

On the 14th of this month I received Your Excellency's dispatch of the 23rd of last month. It gave me great encouragement for the service of His Majesty to see that Your Excellency is satisfied with the way in which I have carried on my negotiations at this Court.[1] This approbation is to be attributed not so much to any ability of mine, as to the goodness and the generous disposition of Your Excellency in appreciating even the slightest talent in others. I shall not fail to do my utmost to serve Your

Excellency, particularly in the matter concerning Sir Walter Aston,[2] but this must be done in the greatest secrecy, in order not to offend the Earl of Carlisle, and cut off his hopes. For he still aspires to this nice "plum," and we have no other means of keeping him in good humor. Otherwise, I see nothing which could interfere with this plan unless the aforesaid Sir Walter is not esteemed highly enough here to be sent on a mission which involves so many diverse interests. I once heard it said by a high minister that Your Excellency was too clever for this man, and had always found it possible to manage him at will. I hope, however, that with the help of the Lord Treasurer this can be negotiated. A few days ago the son of this Aston married the Lord Treasurer's daughter, and it was worthy of note that the marriage ceremony of persons of such high rank was conducted by priests, according to Catholic rites.

When the King came to London recently for a single day, I thought it advisable to go to see him. I wished to inform him that Your Excellency had confirmed receipt of his document, and expected hourly to hear of Sir Francis Cottington's arrival in Lisbon (according to His Majesty's announcement that the Ambassador would leave on the first of August). I thought it would be out of place for me to give His Majesty any reply to his statement, since in a few days the Ambassador of the King of Spain was due to arrive here. I told him that I had not urged a reply, as His Majesty had ordered me to do, because the aforesaid statement had not been delivered to me until fifteen days after the courier had been sent bearing the announcement of the Ambassador's nomination and the day fixed for his departure. I said that it did not seem to me advisable to raise any doubts by announcing new conditions not included in the first report, for this, with good reason, would have aroused strong resentment in Your Excellency, and the suspicion of some change of plan, or some regret. With this explanation the King seemed entirely satisfied, and agreed that it was not reasonable to do otherwise. He promised me to have Cottington leave within a few days, and showed that he was little pleased at such a delay, which he attributed more to the private affairs of Cottington than to his own order. According to all I can discover, the Lord Treasurer will be very much handicapped by this departure of his chief assistant, and would like to put into order a number of complicated matters with him, for their public duties are closely connected. For my part, when I consider what has happened in the meantime, I believe that this delay has been not only very helpful, but necessary for the welfare of our cause, which has been exposed to terrible attacks by the opposing party, as I shall tell Your Excellency in greater detail in a separate letter.

A few days ago something occurred which disturbed me very much. The Lord Treasurer told me openly that it was not fitting for Cottington to leave before an answer to the document arrived; and going on to discuss the contents of this document, he insisted that it was not His Majesty's intention to make peace with Spain based on promises which His Catholic Majesty had made in advance, but only at the end of negotiations in Madrid. He said this notwithstanding the fact that I had seen and examined the document in his presence. Cottington agreed with me that there was no other remedy than for him to go in person to find the King, who was in the country, to learn his intention. The King declared himself clearly in favor of Rubens, and expressed surprise that this doubt could have occurred to one of his ministers who had always shown himself favorably inclined to the treaty. I saw then, before His Majesty declared himself, that Cottington was very uneasy. We suspected that this new reverse might have been instigated by the French Ambassador, but this could not be so, for it is very certain that, up to the present, the Ambassador has not the slightest knowledge of the document. The whole thing is more likely to be traced to the Lord Treasurer's displeasure at being deprived for some time of Cottington's assistance, upon which he has completely relied. But since then it seems that he has agreed to it, and shows himself disposed to work for the success of the negotiations, on condition, however, that Cottington remain only a short time in Spain. As I have already written Your Excellency, he wants Cottington to present his proposals in conformity to the document, immediately upon his arrival, and if they are not accepted at once by Your Excellency, to take leave as soon as possible and return by the same ships which take him to Lisbon, and which are to wait there for this purpose.

The French Ambassador shows himself to be a determined collaborator on this point. Seeing that he could not prevent Cottington's journey, he is trying to cause the ruin of the mission by the manner in which it is organized, and offers, in case Cottington should return soon, to maintain the proposal of the King of France. I opposed this stubbornly, protesting that this method of limiting and restricting negotiations to a precise period was more appropriate for declaring war than for discussing peace, and that we should run the risk of failure by so doing. And finally, thanks to Cottington's ability and prestige, it was settled that his instructions should leave the question of time to his discretion and prudence, with the following clause: that His Majesty trusts him to settle matters with the greatest possible brevity, without prejudice to the negotiations, to fathom the intentions of Spain, in order either to undeceive His

Majesty at once, or to conclude the peace in accordance with the conditions already announced. These conditions it will be difficult to change in any way, as Cottington himself told me.

But from this treaty very favorable consequences would result, especially, as I have already informed Your Excellency, concerning the Anglo-Spanish alliance against France, and the abandonment of the Hollanders. The King of England brought forth the following reasonable argument: he is obliged, by virtue of the terms renewed and set down in final form by the Duke of Buckingham, to give the Hollanders assistance against the oppression of Spain; but if His Catholic Majesty would consent to make some agreement with them in the form of a truce or a peace which would equitably and reasonably safeguard their existence, and they would not accept this, but under pretext of self-preservation, wanted to wage an offensive war against their King, then England would be freed of all obligations toward the United Provinces.

The Prince Palatine has deferred entirely to the arbitration of His Majesty, and his submission to the Emperor has been signed here. It is drawn up in the most satisfactory form, and Cottington will take it with him.

On last Sunday, September 16, at Windsor, the Peace with France [3] was sworn and ratified by the King. It only remains to adjust certain details of no little importance. The banquet lasted a long time. The Ambassador sat at the same table as the King and Queen, though at some distance from Their Majesties. But the service was nothing extraordinary, without gold-plate or any other royal luxury. On the 17th came the news that the French had seized seven English ships, richly laden. Of these seven, one escaped, badly damaged, and brought the news. The capture took place off the island of St. Christopher, near Virginia. Notwithstanding the fact that the peace between the two crowns had already been published there, the French took this island by force. The French commander is named M. de Cussac, and he had six royal warships and six other ships laden with ammunition and provisions. This island had been given by His Majesty to the Earl of Carlisle, who is now so embittered against the French that he has almost lost respect for the Ambassador, seeing himself so poorly repaid for all the friendliness he has shown him during his stay at this Court. It is thought that this was not a chance attack, carried out by individuals, but carefully planned, at the express order of Cardinal Richelieu. It has caused in general the greatest discussion, all the more lively since the news came on the very day following the ratification of the peace.

Six days ago Barozzi, Secretary and Agent of the Duke of Savoy at this Court, left for Turin by way of Brussels. He concealed from me his last negotiations, but asked me for letters to Her Highness testifying to the zeal he has shown in favor of this peace. I did not want to refuse him, but I have already given Her Highness a little information about him in my previous letters.[4]

The Abbé Scaglia urges me, in letters from Barcelona and Nice, to make arrangements for the King of England to recommend to the Duke, his master, that the Abbé go to Spain as soon as possible, to take part in the negotiations with the same authority and powers as Cottington. But Cottington does not want a colleague; and His Majesty, realizing how the Duke has changed sides, cares no more for the one than for the other. And since his own best qualities are constancy and equanimity, he despises and abhors the contrary qualities. Thus, for reasons I have already told Your Excellency, the Duke of Savoy does not enjoy the favor of His Majesty.

There has arrived at this Court an Ambassador of the Duke of Nevers.[5] His name is Count Francisco de Dondolara and he is of the House of Gonzaga. He is to go also to Denmark and Sweden. This Count brings nothing but complaints and grievances against the Emperor and His Catholic Majesty, because by their collusion and violence (as he calls it) his master cannot obtain the investiture of his states.

Soubise has ratified his peace with the King of France through the Ambassador of this country.

Hereupon I close, kissing Your Excellency's feet with the most humble reverence.

London, September 21, 1629

Your Excellency's most humble servant,
Peter Paul Rubens

– 206 –

To the Count Duke of Olivares *London, September 21, 1629*

Your Excellency:

Sir Francis Cottington's delay has turned out to be of great advantage to our negotiations, because it has allowed us not only to resist and counteract the machinations of the French, but also to bring matters to a much more favorable state than they were in the beginning. Cottington has always done me the honor to communicate all his ideas to me in great

detail, as well as to make use of mine. Your Excellency certainly ought to have every confidence in his sincerity and good faith, which could be no greater if he were a Councilor of State of our own King. He is the avowed servant of Your Excellency, and he assures me on his word of honor that if Your Excellency will trust in him, this peace will be concluded to the great advantage of our King and to the honor and satisfaction of Your Excellency. Acting in common accord, we have little by little strengthened our position, pointing out to the King of England that even the Ambassadors of France and Holland say there is no reason to believe that our King will buy peace with England simply by the restitution of the Palatinate. The following arguments can be given for this opinion: since His Britannic Majesty has made peace with France, and, on the other hand, as agreement has been made between the Emperor and the King of Denmark,[1] and since His Majesty wishes to continue his alliance with the Hollanders, an Anglo-Spanish peace can serve only to reëstablish commerce between the two crowns, as important for the one as for the other. With regard to the Palatinate, even though in the beginning Spain had taken it not with the intention of keeping it, and had several times promised to return it, she has been justified since then in retaining it because of the war which the English themselves waged against Spain ostensibly for the sake of the Palatinate. By virtue of this, Spain could justly have taken this territory by conquest if she did not already hold it, and by the same rules of warfare, could keep it. For these reasons, and because in affairs of state it is always necessary to compensate *quid cum quo,* in order to gain one's goal, Cottington and I stated that it might be advisable to offer Spain some notable advantage as a countermeasure; and since in due time justified excuses for annulling the peace with France will not be lacking, His Britannic Majesty ought to decide to give Cottington a secret order offering to form an offensive league with our King against France. We said that he ought to offer to employ his authority to induce the Hollanders to some reasonable accord with Spain, and if they refuse, threaten to abandon them entirely, or even aid our King against them. For their power on sea and land and their insolence are increasing to such a degree that they are becoming formidable, and all the kings and princes of Europe, in the interests of self-preservation, ought to conspire to bring them down. England in particular has reason to beware of their power, being nearest to them and most exposed to their hostility. The Hollanders are far superior to England in maritime strength, so that it practically lies in their hands to gain control of this kingdom one day, with the aid of the Puritans. For the Puritans are all devoted to the

343

Hollanders; on the other hand, they are very discontented and almost in revolt against the King, and they form the greater part of the nation.

By these discussions we have made such progress that Cottington is sure things will turn out well, if Your Excellency will show him confidence. And in case His Catholic Majesty should be disposed not only to make a token peace but also to tie a knot of true friendship with the King of England and unify the interests of the two crowns, Cottington believes he will wield absolute authority to form an offensive and defensive league with Spain against France, under conditions which he will judge favorable to his King. As for Cottington's instructions, His Britannic Majesty will not go into detail, but, in a word, simply commends to him his reputation in concluding this peace. With regard to the Hollanders, Cottington believes there will be no difficulty in taking the measures mentioned above.

Cottington tells me that when he gains Your Excellency's presence, he will speak in two different manners: first, in his capacity as Ambassador of England, and then as if he were State Councilor of our King and the trusted servitor of Your Excellency. On the one hand he will clearly show all the advantages and good consequences that can be derived from the peace and this league, if, as his King desires, it is concluded in a manner to produce the closest possible union, an indissoluble union of the forces and the sentiments of the two sovereigns. On the other hand, he will point out to Your Excellency the great disadvantages that will result if the King of England is forced against his will into an alliance with France and the Hollanders, the King of Sweden and the princes of Germany (including the Duke of Bavaria), and in Italy with the Venetians, the Duke of Nevers and many others who are dissembling now, but will in time, in the event of a break, reveal their bad intentions toward Spain. He says the Duke of Savoy is not to be trusted any more than any of the others, and that, above all, it ought to be realized that the King of England, to the great anxiety and dissatisfaction of his subjects, is holding off the union of the Indies Companies of England with those of Holland. If this union should be formed, it would be very powerful and would cause the greatest harm to the King of Spain.

All this annoys Cardinal Richelieu greatly, as well as the statement which I attach here, and the French Ambassador discusses hardly anything else. This man, having failed to obtain a single one of the things mentioned in my previous letters, now proposes a simple defensive alliance between France and England. But it has been pointed out to His Majesty that this would automatically lead to an offensive league, for if there

should be a break between France and Spain (over affairs in Italy or for any other reason), then England would be forced to go to the defense of France and take up the offensive against Spain. The insolence of this French Ambassador has gone so far that in his rage he forgets the respect due to kings, and speaks in a manner which injures his sovereign's cause. He does everything which he thinks could prevent or retard Cottington's journey, although on the other hand he pretends to wish to hasten his departure. Three days ago, for example, he told the King that he had a reliable report from Brussels that even though Cottington should go to Spain, Don Carlos Coloma would not come to London. And to the Queen, on the other hand, he said that Cottington had an understanding with Spain and was maliciously postponing his own departure in order to gain time and let slip the opportunities that now present themselves.

The unfortunate events of the war in Flanders are causing intolerable insolence on the part of the opposing faction. But, to tell the truth, the King is grievously troubled, and the Lord Treasurer and Cottington are sincerely sorry. The recent news of the loss of Bois-le-Duc has caused general mourning among the Catholics, who are very numerous in this kingdom and extremely pious. They cannot hide their grief, and are as devoted to Spain as if they were subjects of His Catholic Majesty. It will therefore be necessary to encourage them by spreading the rumor that these reverses will arouse the King of Spain to such a point that he will employ all his forces and those of the Emperor to avenge them; and that, since Italian affairs are going to be settled by treaty, the Marquis Spinola will descend upon Flanders with all his provisions and forces next spring, the Duke of Jutland will do the same by order of the Emperor, and perhaps His Catholic Majesty will take the field in person, as he has done on less important occasions in the past; and that, to facilitate this, one must pray the Lord to bless our Queen with a son. These hopes would suffice for the moment to satisfy them.

M. Montagu [2] is going to France to congratulate the King on his happy return, and also to try secretly to have the Duchess of Chevreuse restored to her position at Court. It might be for the same purpose that a gentleman has come here from the Duke of Lorrain; to everyone's surprise, the letters which he brought from the Marquis de Ville [3] were addressed not to the Earl of Holland or to Gerbier, but to the Earl of Carlisle. And since I have nothing more to say, I kiss once more the feet of Your Excellency, and remain

Your Excellency's most humble servant,

London, September 21, 1629 Peter Paul Rubens

To the Count Duke of Olivares London, September 21, 1629

Your Excellency:

The Englishman named Furston [1] has returned to this Court, bringing another communication from Cardinal Richelieu to the Lord Treasurer. It was of almost the same tenor as the previous one, which I reported to Your Excellency at the time. In addition to a thousand invectives against Spain, it seeks to show how easy it would be at this juncture, with the Hollanders so successful in Flanders and the King of Sweden resisting so bravely in Germany, to strike a great blow at Spain by joining the arms and forces of France and England. It makes a particular effort to prevent Cottington's journey to Spain, and with such vehemence that it accuses the Lord Treasurer, as an intimate friend of Cottington, of having arranged this negotiation. This letter goes on to state that the King of France, through the marriage of his sister, has the moral obligation of proving to the King of England his mistake in letting slip this opportunity to reëstablish his own sister [2] and nephews in their estates at the expense of others; that it is unendurable for all his friends and a disgrace to him that while the King of France is arming with all his forces against Spain, and all Europe is trying to shake off the tyrannical yoke of the House of Austria, he alone, the King of England, though more gravely concerned than anyone else, remains inactive. By this unfortunate mission of Cottington he runs the risk of being once more duped and made a fool of by the Spaniards; his own journey to Spain, which exposed him to so much disadvantage and ridicule, should have made him more prudent and cautious. Besides, it is known for certain that these negotiations will have no effect, since the Spaniards are determined not to grant him any satisfaction regarding the Palatinate, either in part or as a whole. This report is said to come from the most reliable sources. There is no doubt, the letter says, that this mission will greatly prejudice their common cause, sowing jealousy and mistrust among the King's friends and allies, for it will show His Majesty's willingness to appease the Spaniards, by sending them a man passionately fond of them and almost a naturalized Spaniard himself, through his long stay in that country; while on the other hand he has done the King of France the injustice of sending him a man ill disposed toward him, who will do all in his power to create difficulties rather than to settle them. But these are the arguments which are brought forward every day by the French Ambassador, not only before

346

the King, but in public, before all the world, in complete agreement with the contents of the above-mentioned letter. Only in one point does the letter differ, regarding the Duke of Bavaria, but this seems to me highly important. It states, in effect, that the King of France offers and pledges to bring this Duke into the league against the House of Austria, and asserts, moreover, that it lies in his hands to prevail upon the Duke to restore to the Prince Palatine (or at least to the sons) all he holds of their estates. The letter pretends to assure the King of England that the Duke of Bavaria will never do such a thing at the demand of the Emperor or the King of Spain, since he is disgusted with the one and hostile to the other, and would even take up arms against them, as a good patriot in favor of a closely united Germany.

This is the principal theme of this long communication, which covered more than two sheets of paper; and the French Ambassador uses the same arguments with such assurance and insistence that one must suppose he has some basis for his words. The conclusion of all this discourse is to beg His Majesty to accept the Palatinate from the hands of the Duke of Bavaria (who holds almost all of it), and to do this by the intercession of the King of France, rather than to ask it in vain of the Emperor and the King of Spain, who have neither the will nor the power to give him more than the smallest part of that territory. When this document was presented to the King, and he had considered it carefully, he said only: "Let Cottington hasten as soon as possible; let Cottington go at once!" And I do not believe they will receive any other reply, for His Majesty told me himself that there would be no change in the treaty with France. That is why he thought it necessary for me to remain here, as witness to his relations with the French Ambassador, so as to be able to convince my patrons of his sincerity. For in spite of the most intense efforts and all kinds of offers, they have been unable to induce him to do the slightest thing to Spain's disadvantage, or contrary to the promises contained in his statement. I thanked him humbly for this, saying that, now this Act was finished, I hoped that as much and more would soon be done on our side. To this he replied: "Please God." With this I close, sincerely kissing Your Excellency's feet and humbly commending myself to your favor.

<div align="right">Your Excellency's most humble servant,</div>

London, September 21, 1629 Peter Paul Rubens

To the Count Duke of Olivares London, September 21, 1629

Your Excellency:

Sir Francis Cottington has had me write to the Most Serene Infanta to obtain two passports of the same tenor for the two ships which are to take him to Lisbon. Thus each will have its own, in case the ships should be separated. He wished particular mention to be made of the valuable merchandise which one of these ships will carry, by permission of the King.[1] Cottington has also asked me to beg Your Excellency, as a special favor, to permit this cargo to be well received, unloaded, and freely sold in that city, without any of the difficulties which Don Fernando de Toledo or other ministers of His Majesty might place in the way of the merchants, other than requiring them to pay the royal customs tax. This they will pay immediately. And in order to be certain that these merchants and their goods which Cottington has taken as cargo, and for which he stands as security, suffer no affront or damage, he begs Your Excellency that on his arrival in Lisbon he may find an order from His Majesty in due form, permitting them to sell the aforesaid merchandise immediately without having to pay any impost other than the royal customs and without meeting any difficulty or embarrassment. On his part, he pledges himself to render Your Excellency a full account and complete satisfaction regarding his purpose in bringing them with him. He asks that as soon as this order is sent to Lisbon, a notice be sent to John Questel, an English merchant who is a resident of that city, and a Catholic. In doing this Your Excellency will infinitely oblige Cottington, who really deserves this and even greater favors, both for himself and those for whom he makes the request. Your Excellency can see, in the letters here attached, that the services he has rendered us and which, by his talent, zeal, and favor with his King, he can still render, are such that they ought to be taken into account, and especially at this time. But it is not fitting for me to say more to Your Excellency, who will know how to arrange everything with customary prudence. Therefore I close, with most humble reverence.

Your Excellency's most humble servant,
London, September 21, 1629 Peter Paul Rubens

To the Count Duke of Olivares [*London, September 21, 1629*]

Your Excellency:

By chance there fell into my hands a note addressed to the Agent of Savoy, from an English gentleman called Commander William Moisson. In it he asks permission of the Duke of Savoy to equip four warships in his name in the port of Villafranca to go out privateering, as he says, against the Turks and the Moors of Algiers, Tunis, and Bougie. But considering how advantageously this port is situated for infesting the Gulf of Leon and preventing passage from Barcelona to Genoa, it seemed advisable to me to inform Sir Francis Cottington, who had heard nothing of this project. I think this matter is of the utmost importance, since these four ships could easily be increased to twenty, and could cause the greatest annoyance to Spain. He has promised me to inform the King and to try in every way to prevent it.

Your Excellency will learn from another source that Philip Burlamachi [1] is sending to Holland a great quantity of artillery. This transaction must be taken simply as a sale for the purpose of redeeming His Majesty's jewels, which, since the time of the Duke of Buckingham, have been pawned to private persons in Amsterdam for 60,000 pounds sterling. Now these munitions will bring such a profit to the King, if they are sold by weight, that he will gain more than two-thirds, receiving thirty pounds sterling for that which cost only nine. And so no better method has been found, for redeeming this pledge, than the sale of this artillery. This report came from Cottington.

To Jan Caspar Gevaerts *London, November 23, 1629*

Dear Sir:

This letter will serve simply to let you know that today, according to your wishes, I strongly recommended to M. Montfort the application of M. Louis de Romere. [1] I should be sorry if my sponsor had someone else in mind, but it could easily happen, for apparently there are many applicants for this office. I recall that even during the lifetime of M. Robiano there were many who sought to become his successor. I have had much experience in affairs of this sort, and will do my utmost to serve you.

We are now awaiting, from day to day, the arrival of Don Carlos Coloma, for he has already sent his baggage ahead to Dunkirk. We are also waiting for the report that the English Ambassador has left for Spain, now that he has received his orders. I hope, therefore, that we can soon present ourselves in person, to serve you and our other friends. My brother-in-law is losing his patience at having to leave all the work to his colleagues for so long, and it also distresses him to be so long deprived of the society of the girls of Antwerp. Probably in the meantime they will all have been snatched away from him.

There is a lot of talk here about the truce, and reports from Holland offer good hopes that it will be concluded. I confess that however much I rejoice at the birth of our Prince of Spain,[2] I should be happier over our peace or truce than over anything else in this world. Best of all, I should like to go home and remain there all my life.

It is very late, and so I beg you to forgive the brevity and the negligence of this letter.

I am very glad to hear of Her Highness' recovery, for her life is most necessary to our public welfare. I deplore the loss of Don Francisco Bravo,[3] who would have done better to continue his studies than to take part in our unfortunate campaigns this year. *Hoc habet et merito (cum indignatione loquor) qui a musis ad ferrea ista rudimenta transfugit.**

God grant that we may find all our friends in good health. And so I commend myself with all my heart to your good graces, I and my brother-in-law, and remain ever

<div style="text-align:right">

Your affectionate servant,

</div>

London, November 23, 1629 Peter Paul Rubens

P.S. I beg you to present my humble and sincere respects to M. Rockox, and also to MM. Halmaele and Clarisse, with all affection.

<div style="text-align:center">

– 211 –

</div>

To the Infanta Isabella *[London, November 23, 1629]*

Your Most Serene Highness:

The island of St. Christopher is located in the Ocean, near another island named La Bermuda; and according to all I hear, there are many islets

* But he who forsook the Muses to take up the sword has only what he deserves (I speak with indignation).

<div style="text-align:center">

350

</div>

in these straits between Florida, Cuba, and Española, but a little more to the north. The island of St. Christopher is small and belongs to the Earl of Carlisle, who received it from the King for colonizing and planting. He has already brought it to the point where a good revenue can be expected from it, although the French are in possession of a part of it. Four months ago the news reached here (and the Earl of Carlisle himself told me) that the French, with great cunning and by the express order of Cardinal Richelieu, came with royal warships under the command of Cussac and seized the English fortress, took their ships, and made themselves masters of the whole island.[1] A few days later the harshness of this report was tempered, without our learning any details of the story. (It would perhaps not be improper for Your Highness to authorize me to present her compliments to the Earl of Carlisle, and to offer her services on behalf of His Catholic Majesty as compensation for this loss. For the Earl has indeed always conducted himself favorably toward us, since I have been at this Court, and he is very much incensed against France). Now there has just arrived at one of the ports of this kingdom a large ship with more than 300 English. And they report that the Spanish flotilla (it must be that of Don Fadrique) which was on the way to join the great fleet, landed on this island of St. Christopher, chased out the French and English alike, demolished the fortress, and destroyed the tobacco plantations (in which many merchants have an interest). The commander, however, treated the English with every courtesy and respect, and offered them a very good ship, with provisions and everything necessary for so long a voyage. This incident is causing some rumors, in the present state of peace negotiations, although the good treatment accorded to the English somewhat mitigates the bad effect. But with regard to the Earl of Carlisle, I am very sorry that he will now feel just as indignant toward Spain, for the considerable loss he has suffered, as he felt toward the French, at the previous report. I make excuses, as best I can, by saying that our men did nothing more than recapture from the French the island which they had seized a short time before, and that, if the English could not defend it, that was no reason for Spain (even though the two nations were reconciled) to leave this nest open to the French, when it lay so close to the possessions of His Catholic Majesty. I understand that neither the King nor the Lord Treasurer attach any importance to this affair. And Sir Francis Cottington must already be approaching Spain, with the good winds that have prevailed these days, although now they have turned unfavorable. God grant, etc. . . .

To the Infanta Isabella *London, November 24, 1629*

Your Most Serene Highness:

Yesterday I wrote to Your Highness at length, by the ordinary courier. Today I dispatch a special messenger to overtake the first in Dover, or, in case they do not meet, to proceed to Brussels. The reason for this message is that the Lord Treasurer has just been talking to me with the greatest agitation and emotion. He showed me a letter from Taylor,[1] written on the 16th of this month, which states that he heard from Don Carlos Coloma's own lips that his instructions from Spain had not yet arrived, and that he could not leave before receiving them! However, the courier who will doubtless bring them is expected within a few days. This news has caused the Treasurer such vexation that he told me clearly that from this hour he considered the negotiations broken off. He said that the French, and especially their Ambassador Châteauneuf, certainly had reason to say that the Spanish were making fun of the King of England, that they had no intention of sending an Ambassador to this Court, but only wished to lure Cottington by vain promises to Spain, where they would listen to his proposals and then decide whether to send an Ambassador to England or not.

The Treasurer told me that he regretted having advanced so far in this affair, and having involved his King, against the advice of the majority of his Council. All the blame will fall upon him and Cottington. But he says there is still time to prevent this deception and remedy it by sending an express courier tomorrow to Cottington in Spain. This will doubtless be done. The courier will probably overtake Cottington somewhere before reaching Madrid. He will present him with an order from the King not to continue further but to return to Lisbon, and there await new orders from His Majesty, with the definite report that Don Carlos has arrived in this Court. The Treasurer wished me to send this information to Your Highness as quickly as possible, and has asked me to show him tomorrow the letters I have received from the Count Duke and Your Highness regarding the nomination of Don Carlos by the King himself. I consider this delay at the present juncture as so unfortunate that I curse the hour when I came to this kingdom. God grant that I come out of it all right! I shall say no more than to beg Your Highness to make every possible effort to avert this embarrassing situation. May the Lord . . . etc. . .

London, November 24, 1629

To the Count Duke of Olivares *London, December 14, 1629*

Your Excellency:

I am making plans to return home, in accordance with the permission granted me by Your Excellency to leave here a few days after the arrival of Don Carlos in this Court.[1] For indeed I cannot postpone my departure any longer without great disadvantage to my domestic affairs, which are going to ruin by my long absence of eighteen months,[2] and can be restored to order only by my own presence. I humbly beg Your Excellency to keep me in your grace and under your protection, and to pardon me that I have not succeeded better in the mission charged to me, considering that I arrived in this Court at the worst possible time. For the peace recently concluded with France had given the upper hand to the faction opposing us, and the presence of the French Ambassador reinforced their power. It was no small task to maintain our position and to open negotiations with the few resources I had at my disposal, after the principal object of my commission had miscarried. Moreover, there have been the greatest difficulties to overcome regarding the journey of Sir Francis Cottington to Spain, and after his departure, the coming here of Don Carlos. Therefore it only remains for me to hope that my loyal intentions and my good will in the service of His Majesty will merit, if not thanks, at least some indulgence. I shall always and everywhere be most ready to receive the commands of His Majesty and Your Excellency, and to sacrifice life and property to your service at any time you may deign to employ me. And with these sentiments I humbly, with all affection and respect, kiss the feet of Your Excellency,

As Your Excellency's most humble and devoted servant,
London, December 14, 1629 Peter Paul Rubens

Fragment, to Peiresc [1630?]

Sostratus

As for the Roman gem inscribed "Sostratus," I am extremely sorry that the head is missing. For I am sure that it must have been of the highest quality, similar to a divine cameo which I found a few years ago

and which, because of its excellence, I kept from the sale of my antiquities to the Duke of Buckingham. That one consisted of nothing but the head of Octavius Augustus. The part preserved was white on a background of sardonyx, with a garland of laurel in sardonyx in high relief, of workmanship so exquisite that I do not recall ever having seen the like. Behind the head, on the ground, is inscribed, very distinctly, "ϹΟϹΤΡΑΤΟΥ." This is my favorite gem, among the many that have come into my hands.

The collections of the Duke of Buckingham are still preserved intact, the pictures as well as the statues, gems, and medals. And his widow has kept the palace in the same state as it was during his lifetime.

PART VII

1630–1640

Return to Flanders

Last Missions

Retirement from Politics

1 6 3 0 – 1 6 4 0

On the day before Rubens left London, March 5, 1630, he did an unusual and surprising thing: in the company of Gerbier he paid a personal call upon one of his most implacable adversaries, Albert Joachimi, Ambassador of the United Provinces. His pretext for the visit, which deceived no one, was to ask for the release of a group of Dunkirk seamen held prisoner in Rotterdam. The real object of the interview was to discuss the problem that was never very far from Rubens' thoughts: peace between the Northern and Southern Netherlands. In going directly to Joachimi Rubens was acting purely on his own initiative. He was not authorized to treat with the Hollanders; in fact he had been instructed not to touch upon this point. The visit was therefore open to misinterpretation, and the Flemish envoy liable to serious criticism for overstepping his orders. But his success in promoting an Anglo-Spanish peace lent him confidence; he was able to tell Joachimi that peace between the two countries was assured, and he hoped thereby to persuade the Dutch Ambassador that the time was ripe for peace in the Netherlands. It was a momentous encounter between the North and the South, between the seventy-year old Joachimi, a seasoned diplomat of twenty years' experience, and the artist-diplomat from Flanders, greatest representative of his country. But it led to nothing. There is no account by Rubens of this meeting. Joachimi sent his report to the States General that very evening, in guarded and noncommittal terms. More illuminating to us is the report Sir Dudley Carleton, Viscount Dorchester, sent to Sir Francis Cottington in Madrid. Carleton quotes Rubens as "telling Joachimi the States might make peace if they would, and therby bring quiett and rest after long warre to all the seventeen Provinces." Rubens was thinking of peace for all the Netherlands, both North and South; but if we are to believe Carleton's statement, in the same letter, "Joachimi answeared, there was but one way . . . by chasing the Spanyards from thence."

Rubens' return to Antwerp was the gratification of his sincerest wish. He had written to Gevaerts from London, "Best of all, I should like to go home and remain there all my life." But his desire to withdraw from politics was not easily attained. The war was going badly for Spain in

357

the Netherlands. During the past year the Hollanders had been increasingly successful both on land and sea, by the capture of Wesel, Bois-le-Duc, and Spain's silver fleet. Don Carlos Coloma had been taken from the command of the armies in the Netherlands in order to become Ambassador to England, but he could ill be spared. Immediately upon the conclusion of peace Olivares summoned the Council of State to appoint a new envoy to London until Coloma could be replaced as Ambassador, thus allowing Coloma to return to Flanders. Of three names suggested, one was that of Rubens. The appointment did not fall to him because one of the Councilors objected that he "practiced an art and lived by the product of his work." It went to Juan de Necolalde, the King's Secretary, who had been for two years in the Netherlands. Nevertheless, Philip IV wished to have Rubens also go to London. He wrote to the Infanta ordering her to send him at once, saying "Rubens is highly regarded at the Court of England and very capable of negotiating all sorts of affairs. . . In such matters one needs ministers of proven intelligence, with whom one is satisfied." The Infanta Isabella, not for the first time, disregarded the orders of her nephew the King of Spain. In writing to Philip announcing the departure of Necolalde she added "I have not sent Rubens because I did not find him willing to accept this mission."

The reluctance Rubens felt at the thought of another long diplomatic journey was understandable. On December 6, 1630, he had taken as his second wife the sixteen-year-old Helena Fourment, daughter of an Antwerp silk merchant. He had also returned with enthusiasm to his interrupted painting. But his respite was to be brief. By midsummer he found himself once more involved in public affairs in the Infanta's service — this time on behalf of the unhappy Queen Mother of France. The mounting discord between Marie de' Medici and Cardinal Richelieu had finally come to an open break. In February, 1631, at the instigation of the Cardinal, Louis XIII had banished his mother to Compiègne, where she was kept a prisoner. Thereupon the King's brother Gaston, Duke of Orléans (called "Monsieur"), who shared his mother's hatred of Richelieu, fled to Lorraine to organize a campaign for her support. After some months in Compiègne Marie contrived to escape on July 18, and crossing the frontier into the Spanish Netherlands, sent a messenger to the Infanta announcing her arrival and asking protection. Isabella sent to meet her the Marquis d'Aytona, Spanish Ambassador to Brussels, and Rubens accompanied him.

The artist and the French Queen thus met again, under circumstances very different from those which attended the decoration of the

Medici Gallery in Paris. The Marquis d'Aytona proposed to the Queen that Rubens act as intermediary in the discussions concerning her asylum in the Netherlands, and she accepted him willingly. He was also put in charge of the secret negotiaions with the Duke of Orléans, who was seeking financial aid for his mother and himself in their struggle against Richelieu. Rubens' task was not an easy one, for the Infanta had been instructed by Philip IV to do nothing to jeopardize relations between France and Spain. But in Rubens' opinion the Queen Mother's cause presented a unique opportunity to strike at Spain's most formidable enemy, Richelieu, and at the same time to check French aggression in Europe. The long and eloquent letter he wrote to Prime Minister Olivares on August 1, 1631, set forth in great detail his reasons for advocating Spanish aid to the royal fugitives. It seemed to Rubens that their cause was not hopeless, and this led him to depart, for the first time, from his well-known policy of peace. Louis XIII was still childless; therefore to support Gaston of Orléans was to support the heir presumptive to the French throne. The risk was great, but the gain might be greater. Personal convictions and hopes also played a part in Rubens' proposal. Cardinal Richelieu was his own enemy, and his devotion to the Queen Mother was genuine. A Medici, daughter of a Hapsburg, and (in Rubens' eyes) a sovereign by divine right, she was also a patron of the arts who had given him his greatest commission. This project was, in fact, unfinished. The artist was still working on the second great cycle of paintings for the Luxembourg Palace — the series glorifying Marie's husband, Henri IV. Only if she were to return to the French court could Rubens hope to bring this work to completion.

Rubens' letter on the Queen's behalf did not meet with approval in Madrid. The King and the ministers were unwilling to antagonize Richelieu and risk a break with France. Philip, in a dispatch to the Infanta, stated that the alleged resources at the disposal of the fugitives were too indefinite; that he himself was ready to negotiate in favor of his mother-in-law, but not to provide funds for armed intervention in France. In spite of this disappointing response, the Infanta and Rubens continued for nearly a year to try to gain assistance for the Queen and her son. In April, 1632, the artist obtained the Infanta's permission to withdraw from this wearisome affair. When, shortly thereafter, in response to repeated urging, Philip IV furnished the Duke of Orléans with the means to raise a small army, it was quickly dispersed by Richelieu. The Duke surrendered to his brother Louis XIII on September 29, 1632.

As the military situation in the Netherlands became more and more critical, the Infanta redoubled her efforts to end the struggle by negotiation. With her able general Spinola gone, she watched the Prince of Orange taking the offensive more boldly, and realized the time had come to seek an agreement with her neighbor at almost any price. Once more she turned to Rubens. We learn from letters written by Gerbier and Hugo Grotius that she took the initiative and sent the artist on a secret mission to the Prince of Orange in December, 1631. Balthasar Gerbier, now the agent of Charles I in Brussels, and thus in a position to observe the actions of his friend Rubens, wrote to his king on December 19: "Sir Peter Rubens is gon on Sunday last, the 14th of this month, with a trumpetter towardes Bergen op Zom, with ful power to give ye fatall stroke to Mars, and life to this State & the Empire." The other letter, sent from Holland by Grotius to Pierre Dupuy, tells us the outcome: "Our good friend M. Rubens, as you will have heard, has accomplished nothing; having been sent back by the Prince of Orange almost as soon as he had arrived." Frederick Henry had rejected his proposals, declaring that only the States General had the power to decide these questions.

During the course of 1632, while the Prince of Orange continued to gain military advantage, Rubens made further efforts, but with no more success than before, notwithstanding the hopeful words of his friend Balthasar Moretus: "Rubens has already, more than once, gone in the name of the Infanta to the Prince of Orange and the Hollanders to negotiate the truce, and he has almost succeeded. He who knew how to make peace with England would be capable of concluding the truce with the Hollanders, seeing that he is well known and liked by the Prince of Orange." The artist went to the camp of the Prince at Maastricht four days after the town had surrendered, but he soon returned to Brussels empty-handed. The Hollanders, emboldened by their success, were no longer willing to treat with Spain or her allies. Rubens' comings and goings did little more than excite the jealousy of the Flemish nobles because of the Infanta's confidence in him.

The year 1632 saw a marked increase in internal unrest, aggravated by the continued military reverses. A feeling of resentment against Spanish domination had been rising in certain quarters ever since the death of the Archduke Albert in 1621 had ended the virtual autonomy of the Spanish Netherlands. The appointment of Spaniards to the highest state offices aroused the jealousy of the Flemish aristocracy. The Hollanders scattered manifestos inciting the Southern Netherlands to throw off the

Spanish yoke. Even Count Henry de Bergh, Spinola's ablest lieutenant, went over to the side of the enemy, putting all troops under his command at the service of the United Provinces. At the same time a group of Flemish nobles conspired to overthrow Spanish rule. They plotted with the Hollanders and even with Richelieu, and received a promise of English aid from the faithless Gerbier. This plot, however, came to naught because the leader, the Duke of Aerschot, repented before it could be carried out, and renewed his allegiance to the Infanta. On his advice and to satisfy the malcontents she convoked the States General of Brussels (which had not met for thirty-two years) in order to debate the perilous situation of the country. One of the first demands of the States General was to be authorized to treat directly with the United Provinces for the conclusion of peace. This the Infanta could not refuse, and ten deputies were accordingly appointed to go to The Hague for negotiations which opened on December 13, 1632.

Madrid was very suspicious of the calling of the States General, and refused to grant to the delegates the authority for negotiating with the Hollanders. The Infanta, doubtful of their success without the King's authorization, and fearing also that the Flemish nobles might abuse the privilege she had granted them, wished to send Rubens once more to The Hague, in order to follow their negotiations, safeguard Spanish interests, and at the same time resume his own efforts in the cause of peace. Rubens' request for a passport to the United Provinces (which was issued on January 19, 1633) only heightened the mistrust and jealousy the Flemish deputies felt for the artist-diplomat. The Duke of Aerschot, who had a personal hatred for him, expressed his outrage at this "intervention" in a letter notorious for its vindictive arrogance, with the result that Rubens did not go to The Hague, and took no further part in the affair.

Small wonder, in the face of such discouragement and opposition, that Rubens wished to give up politics and go home to his young wife and children — and to his "beloved profession." We have his own word for it: "I threw myself at the feet of Her Highness and begged, as the sole reward for so many efforts, exemption from further assignments"; and "this favor I obtained with more difficulty than any other she ever granted me." The Infanta Isabella who had put such faith in Rubens, in her vain attempts to bring peace to the Netherlands, died before the end of the year, revered throughout Europe for her piety and goodness. With her death the artist's diplomatic activity came to an end. He returned to his art, the domain in which he remained the undisputed master, and from that time on devoted himself to painting with an ardor

and intensity unsurpassed in his earlier work. Freed from the restraints of court life and the burden of politics, his natural optimism and enthusiasm found triumphant expression in his art. The portraits, landscapes, mythological subjects and religious paintings that flowed from his brush in such colorful profusion during these years would fill another man's lifetime, and to these were added a wealth of design for tapestries, engravings, book-illustrations. Great commissions were not lacking. Marie de' Medici's exile put an end to Rubens' work on the Henri IV Gallery, but he turned with equal inventiveness and ready brush to the glorification of another sovereign, James I of England. During James' lifetime the project for the ceiling decoration of Inigo Jones' new Banqueting Hall at Whitehall had first been suggested to Rubens, but it was only during the artist's months in London in 1629 that the final arrangements were made with Charles I for the ceiling to be painted in honor of his father. Three large central canvases representing the good government and apotheosis of James I, as well as six smaller ones with allegorical figures, were ready by August 1634, although not shipped until a year later. Today this magnificent ceiling, recently cleaned and restored, is revealed as one of Rubens' grandest compositions.

The triumphal entry into Antwerp of the new Governor of the Spanish Netherlands, the Cardinal-Infante Ferdinand, gave Rubens a splendid opportunity to display his gifts for decoration on a city-wide scale. The young man, brother of Philip IV, who came to take the place of the Infanta Isabella, was publicly welcomed on April 17, 1635, and the city of Antwerp commissioned her greatest artist to design the triumphal arches and stages that lined his route. Once more Rubens demonstrated that whatever he touched received the stamp of his genius. Temporary as this decoration was, it became a landmark of Baroque festival architecture. We may still enjoy the pictorial brilliance and charm of the small oil sketches Rubens painted to serve as models. And the sumptuous effect of the whole may be gained from Theodor van Thulden's great publication, *Pompa Introitus Ferdinandi* (Antwerp, 1641), which reproduces all the principal architectural designs and paintings. The main theme which Rubens carried out with such exuberance and originality was homage to the reigning House of Hapsburg and to the Cardinal-Infante Ferdinand. But in decking Antwerp so lavishly for the formal welcome, the artist made no attempt to hide the city's impoverishment through the blockading of the port by the Hollanders. One of the most impressive of the stages represented "Commerce Deserting Antwerp." Here in allegorical guise was an appeal to the new Governor to provide

a remedy by bringing about the reopening of the Scheldt, thus restoring trade and prosperity.

The Cardinal-Infante Ferdinand honored Rubens by appointing him court painter. And Philip IV remained an admiring and almost insatiable patron. The artist was able to meet the King's demands by providing small oil sketches of amazing fluidity and inventiveness, to be carried out by a host of assistants. He was content to divide his time between his Antwerp home and his country estate, Castle Steen. With his wife and his children as models ready at hand, and the beauty of the Flemish countryside before his eyes, he had no wish to look further. The warmth and harmony of his own existence lent an added radiance to the art of Rubens' last years.

To Viscount Dorchester (Sir Dudley Carleton) *Brussels, June 18, 1630*

My Lord:

Before receiving your last letter of May 27 according to your calendar [*in margin*: which was delivered to me on June 14 according to our calendar], I had no knowledge of the passport which was desired for M. Rustorf. It may be that Your Excellency mentioned it only in the letters addressed to the Audiencier of the Court. In any case, I cannot explain the delay of this dispatch, for I found the Most Serene Infanta most willing, and the Audiencier inclined to grant it promptly. I delivered it at once to your courier, with the letter of Don Carlos to M. Bruneau. The term of the passport is six months, but it can always be renewed, as often as you please. As for his stay in Germany during the Diet,[1] however, Her Highness makes no mention of it, since it does not depend upon her. This will be negotiated at the place itself, by means of Don Carlos Coloma's letter, and the communication of M. Bruneau with the Duke of Tursis.[2] Meanwhile his passage, both going and coming, will be secured, by virtue of Her Highness' passport.

The news that your courier brought us by word of mouth, of the Queen's happy delivery of a Prince of Wales,[3] was received by the Most Serene Infanta with all the satisfaction and joy that she could show on similar occasions in the families of kings, her nearest relatives and allies. And as for me, I confess that my extreme desire to be and to appear the very zealous servant of His Majesty of Great Britain, would have carried me to some excess, had the outward disposition of the state at present in any way permitted me. I hope that the return of Cottington's secretary,[4] who is said to have arrived in London on May 28 or 29 [*in margin*: old style], will have brought the affair a great step forward. We are expecting here at any moment a dispatch from Spain. It is not coming as quickly as usual, because it is being brought by a cavalier of quality, whom the ordinary courier (who arrived the day before yesterday) accuses of having left before him.

As soon as I reach my home in Antwerp I shall not fail to turn my attention to your picture,[5] in conformity to the measurements, making it my responsibility to have Your Excellency served exactly. And wishing for many opportunities to show my zeal and devotion in your service, I remain ever

Your Excellency's very humble and obedient servant,
Brussels, June 18, 1630 Peter Paul Rubens

Monsieur:

I have finally received your much desired packet containing the very accurate drawings of your tripod and many other curiosities, for which I send you the customary payment of a thousand thanks. I have given to M. Gevaerts the drawing of Jupiter Pluvius and showed him all the rest. I showed them also to the learned M. Wendelinus, who happened to be in Antwerp and came to see me yesterday with M. Gevaerts. But I have had no time these days, either yesterday or today, to read your discourse on the tripod,[1] which doubtless touches on all that falls under human intellect, in this matter. Nevertheless, according to my accustomed temerity, I shall not fail to state my own views on this subject, which I am sure that you, with your usual candor, will take in good part.

In the first place, all utensils which rest on three feet were called "tripods" by the Ancients, even though they served the most varied purposes, such as tables, stools, candelabra, pots, etc. And among other things they had a utensil to set on the fire under the *lebes* (*chaudron* in French) for cooking meat, and this is still used today in many parts of Europe. Then they made a combination of the *lebes* and tripod, much like our iron and bronze pots with three feet. But the Ancients gave it the most beautiful proportions and, in my opinion, this was the true tripod mentioned by Homer and other Greek poets and historians, which was adopted *in re culinaria* for cooking meats. And with regard to the use of entrails in their sacrifices, they began to have *inter sacram supellectilem ad eundem usum.** I do not believe, however, that the Delphic Tripod was of this type, but rather a kind of seat on three legs, as is still commonly used throughout Europe. [*In margin*: In ancient monuments we find seats with four feet, like the "Sella Jovis," but also some stools, or seats with three feet, like our own stools.] This seat did not have a concave basin, or if it were concave to hold the skin of the Python, it was covered on top, and the Pythoness could sit on this cover, which had a hole underneath. It does not seem to me likely that she could sit with her thighs in the concavity, because of the discomfort of the depth of the basin and its cutting rim.

It could also be that the skin of the Python was stretched over this hollow as over a drum, and that because of this it was called the "cortina,"

* A sacred utensil for the same purpose.

and that it was pierced, as well as the basin. It is true that in Rome one finds various tripods of marble, which have no concavity. And it was also often the custom, as you will see in several of the quotations below, to place on the same tripods statues dedicated to various gods; and this could not have been done except on a solid and level base. One must believe that the Delphic Tripod was copied and used for other gods, and that the word "tripod" denoted every kind of oracle and sacred mystery, as we see it still used in the pantomimes of Marcus Lepidus.

But the point which has more bearing on our subject I shall state with more care, and that is, that the Ancients used a certain kind of chafingdish or *réchaud* (as they say in French) made of bronze, with a double coating in every part, to resist the fire. [*In margin*: In Paris there are two *réchauds* of this kind, made of silver.] This was in the form of a tripod, and was used in their sacrifices and perhaps also in their banquets. There is no doubt that this was the tripod of bronze so often mentioned in the Ecclesiastical History of Eusebius, and by other authors — the tripod which served for burning incense to their idols — as you will see in the references below. And if I am not greatly mistaken, this bronze tripod of yours, considering its material, its small size, and the simplicity of workmanship, is one of those which was used to burn incense in the sacrifices. The hole in the middle served as an air-hole to make the coals burn better; just as all modern *réchauds* must still have one or many apertures for this purpose. And as far as one can see from the drawing, the bottom of the basin, or crater, is broken and consumed by the fire. [*In margin*: The capacity of your basin does not exceed that of the ordinary *réchaud* which we use today, and the shape is so appropriate to this purpose that if I should need such a utensil, I should want to have it made in this way.] That is all I can say at present on this subject, leaving to you freedom and authority to criticize. In any event, neither MM. Wendelinus nor Gevaerts advance sufficient arguments to the contrary. And so I rather think that, little by little, they will incline to this opinion.

That chimney piece of lead is most remarkable; it ought to be reserved *Saturnalibus optimo dierum.** The fragment with those Egyptian gods and the wind is also curious. In my opinion this must have been some rustic calendar, to indicate the principal feasts and other mysteries of the seasons of the year. The circles around the heads of the gods in the Egyptian manner, as one sees in the Tabula Isiaca, are worthy of notice. But above all, I find those nuptial rings the nicest — so beauti-

* For red-letter days.

fully inscribed that Venus herself, with all her Graces, could do no better. These are worth a treasure, indeed they are inestimable, in my opinion.

Everyone marvels that, in so great a public calamity, you remain with mind so composed that you can, with customary pleasure, continue your noble research in the observation *rerum antiquarum. Specimen animi bene compositi et vera philosophia imbuti.** I hope, however, that with the arrival of this letter the evil will have passed, and that you will at length return to your sacred museum. Please God that it be with all happiness and contentment, and for many years; this your most devoted servant desires with all his heart, as he kisses your hands.

<div align="right">

Your affectionate servant,

</div>

Antwerp, August, 1630 Peter Paul Rubens

We have received very bad news from Italy, that on July 22 the city of Mantua was taken by assault by the Imperial troops, with the death of the greater part of the population. This grieves me very deeply, for I served the House of Gonzaga for many years, and enjoyed a delightful residence in that country in my youth. *Sic erat in fatis.*†

These drawings are exquisitely well done, and I am sure that of this type they could not be better. You will do well to keep that gifted young man near you, to execute your most beautiful conceptions.

Your portrait has brought the greatest pleasure to me, and also to those who have seen it. They are entirely satisfied with the likeness, but I confess that I do not see reflected in this face a certain intellectual power, and that emphasis in the glance, which seem to me to belong to your genius, but which is not easy for anyone to render in a picture.

I send you again a thousand thanks for so many gifts, and pray that you will, on my behalf, sincerely kiss the hands of the most courteous M. de Valavez, your brother. He wrote to me from Lyon on July 4, giving me news of the arrival of my portrait, which I am afraid will have suffered from the long voyage; in any case it is unworthy of your museum, but only worthy of your humble servant.[2]

The passages from Ancient authors have been added by my son Albert, who is seriously engaged in the study of Antiquities, and is making progress in Greek letters. He honors your name above all, and reveres your noble genius. Pray accept his work done in this spirit, and admit him to the number of your servants.

* Specimen of a well-ordered mind, imbued with true philosophy.
† Thus it was fated (Ovid, *Fasti,* 1.481).

To Pierre Dupuy *Antwerp, October (?), 1630*

Monsieur:

I was very happy to hear from you, and I beg you to believe that it was only hesitation to bother you that kept me from writing to you first, in order to renew our former correspondence. I often regretted having lost this correspondence (as I thought) by my journeys to Spain and England. For not only was it pleasant because of your good counsel, but your worth and reputation used to inspire me with ambition. Another reason was the fact that this good fortune came to me through M. de Peiresc, whom I honor as much as any person in the world. I sometimes have news from him, through a merchant [1] who came recently from Marseilles to reside in this city. He has never, throughout your country's calamities,[2] lost his taste for Antiquity, and he has continued to send me his customary favors. He has been telling me his observations and sending me designs drawn from certain ancient pieces, in particular, a bronze tripod found in a ruined temple of Neptune. I am very glad that he has returned home after so long and wearisome an absence. M. de Valavez, his true brother by nature and temperament, has also honored me several times with his letters.

It seems that the plague is making its rounds through all Italy. They write from Venice that it is making great headway there. As for the death of the Marquis Spinola,[3] I can give no further details, except that it was brought on by work and worry, *vires ultra sortemque senectae.* It seems that he was tired of living. I have seen one of his letters, written while he was still well, in which he said, "I hope that God will have the mercy to call me to Him at the end of this month of September, or even before." He was disgusted by the hostile feeling shown him in Spain — especially by the Abbé Scaglia, who had gone to Spain for the sole purpose of making war on him. Even before that, he did not stand in favor with the Count of Olivares. Nevertheless, it is not true that before his death he was deprived of his post against his will. It is more likely, since His Excellency himself said that he felt his end was near, that the government was transferred to the Marquis de Santa Cruz. His illness was a lethargy from which, after having been thought dead on September 12, he awoke. And when his recovery was considered certain, he suffered a

* Forces beyond the lot of old age (*Aeneid*, 6.114).

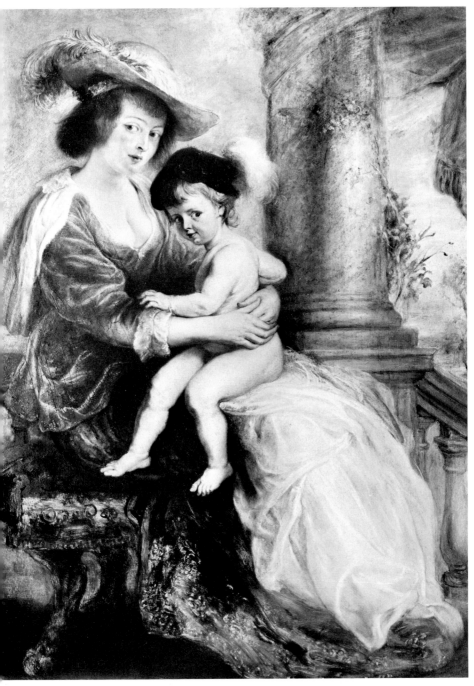

Rubens' second wife, Helena Fourment, and her son Frans. Ca. 1634.

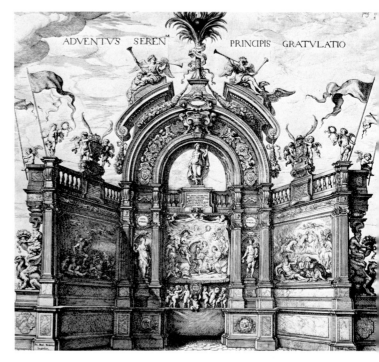

The Stage of Welcome, *Pompa Introitus Ferdinandi.* 1641.

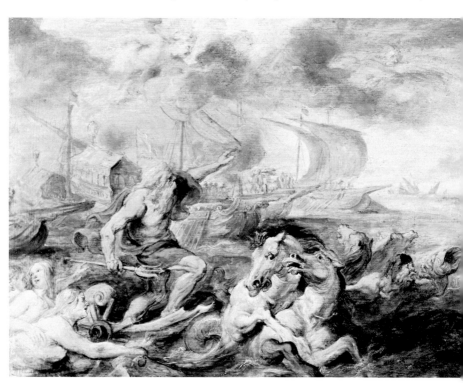

The Wrath of Neptune ("Quos Ego"). 1634-35. Oil sketch for the triumphal entry of Cardinal-Infante Ferdinand.

relapse on the 25th of the same month. According to what they write from all sides, he has brought this war to an end with his life. That is a sign of the greatness of his destiny and the power of his genius. In him I have lost one of the greatest friends and patrons I had in the world, as I can prove by a hundred letters from him. [*In margin*: They write me from Brussels that the Duke of Alba, at present Viceroy of Naples, has been named Governor of Milan.]

As for M. de St. Ambroise, I assure you that I am his humble servant. I esteem his friendship and favor so much that, if his grace should fail me, I should feel that I had lost my fortune in France, not to mention the work for the Queen Mother, or anything else from that quarter. Also I admit that I owe all past success to him, etc. And for the present, I was not aware there was any difference between us, other than some slight misunderstanding regarding the measurements and proportions of the Gallery of Henry the Great. I beg you to consider whether there is any justification on my side; I shall submit entirely to your judgment. They have sent me from the beginning the measurements of all the pictures, and according to his custom, M. l'Abbé has accompanied them most punctually with his letters. And I, acting under his orders, have made considerable progress on some of the largest and most important pieces, like the "Triumph of the King" for the rear of the gallery. Now the Abbé de St. Ambroise himself takes two feet from the height of the pictures, and at the same time he heightens the frames of the doors and portals, so they will in some places cut through the pictures. Thus, without remedy, I am forced to mutilate, spoil, and change almost everything I have done. I confess that I felt this keenly, and that I complained to M. l'Abbé (but to no one else) begging him to grant me half a foot, so that I need not cut off the head of the King seated on his triumphal chariot, and also point- ing out the inconvenience of an increase in the height of the doors. I said frankly that so many obstacles at the beginning of this work seemed to me a bad omen for its success,[4] that I found my courage cast down, and to tell the truth, felt considerable displeasure by these innovations and changes which hurt not only me but the work itself, and will greatly diminish its splendor and distinction. If they had been ordered at the be- ginning, one could have made a virtue out of necessity; nevertheless, I am prepared to do everything possible to please M. l'Abbé and to serve him, and I beg you to favor me with your support. *Quid enim mali feci?** With my humble service I shall be in your debt all my life, quite

* For what have I done wrong? (cf. Matthew 27:23).

369

apart from the earlier obligations, which place me in the ranks of those who profess to be what I am, namely,

<div style="text-align: right;">Your very humble and affectionate servant,</div>

Antwerp, 1630
<div style="text-align: right;">Peter Paul Rubens</div>

P.S. Pray forgive me for having taken the liberty to write this in French without having any mastery of the language. I have done it this time only in case it should be necessary to show the letter to M. de St. Ambroise.

Monsieur, I pray that on my behalf you will humbly kiss the hands of your brother.

<div style="text-align: center;">– 218 –</div>

To Jan Woverius 		*Antwerp, January 13, 1631*

Monsieur:

I have received your most kind and gracious letter of the 28th of last month from the hands of your son. It reflects your customary sincerity and affection toward me, congratulating me on my marriage,[1] with the emphasis of a true friend, and also on the happy success and consummation of the peace with England, on which I really worked very hard, and can say without vanity, *cujus pars magna fui.** I give you a thousand thanks for the first as well as the second, and pledge myself, with my wife and sons, to your perpetual service.

For the rest, even though, by divine grace, I find myself most contented in the conjugal state, as well as in the general happiness over the peace with England, I have occasion to lament my misfortune in ever having become involved in that affair. For I cannot obtain any reimbursement for what I spent in the service of His Majesty on the journeys to Spain and England. You must know and recall that last year, with great difficulty, I obtained a decree or ordinance for 7500 florins drawn on the Receiver of Luxembourg, who, five months ago, sent the said sum, or the greater part of it, to Caverson to be paid to me. But now that I expect to receive it, this portion, as the Treasurer General says, having at length passed into the account of the said Receiver, he declares that the order has been countermanded: that he is not to pay me, but is to give it to the Councilors. This seems to me such an insufferable affront and insult that I could almost abjure the form of this government. What

* In which I played a great part.

more can I do, after having presented to Her Highness duplicate orders, signed by our King's own hand, and to the Marquis d'Aytona [2] and the other Lords letters from the Count Duke written in good ink? I do not write these complaints to you in order to seek your assistance, for I would not like to bother you, *sed pars solatii est deponere justas has querelas in sinum amici.**

M. Asuman has spoken to me about the trade of woolens from England, and I have seen what Don Carlos wrote about establishing it in this city. I told him my opinion about it, saying that the best and most compendious way would be to take up this matter with the Lord Treasurer Weston, whom it concerns directly, and who can do everything he wishes with his King. And knowing what close contact M. Gerbier has with this personage, I have already written to him on the subject, to see whether he would be willing to take it under his charge. But I cannot assure him any compensation, and do not want to burden a friend without offering a cake. Let us see what Don Carlos Coloma will do, for I have no doubt of his good will, provided he has enough zeal.

I am so disgusted with the Court that I do not intend to go for some time to Brussels. Believe me, when I say that I have discharged and in part transferred to others the vast correspondence I had, and from which the greatest results have been realized, as Her Highness knows. My personal ill-treatment annoys me, and the public evils frighten me.[3] It appears that Spain is willing to give this country as booty to the first occupant, leaving it without money and without any order. I sometimes think I ought to retire with my family to Paris, in the service of my Queen Mother, although they say that Cardinal Richelieu is suppressing her, little by little. But this would have nothing to do with me, for I have no other pretension than to do her Gallery, which is in my hands and which is strongly urged. In the meantime, perhaps the storm will pass, but up to now I have not made any decision, and I shall pray the Lord to inspire me to do the best thing.[4] With this I conclude, and with a true heart I commend myself to your good graces, and with all affection pray heaven to grant to you, to Madame your wife, and all your family, a very happy New Year, conforming to all your wishes and desires, *publice, privatim, domi et foris, et omnia bona fortunae corporis et animi.†*

Antwerp, the 13th of the year 1631

* But it is the part of solace to lodge one's just complaints in the bosom of a friend.
† Publicly, privately, at home and abroad, and every good fortune of body and spirit.

To Pierre Dupuy *Antwerp, March 27, 1631*

Monsieur:

I owe you a reply to two of your letters, to that of January 17 and to the one of February 10. The latter I received from the hands of your brother, who did me the honor to visit me, and showed, by his amiability and courtesy, that he was a true brother of yours. I am afraid that the Duke, his patron, has left here ill pleased, for he told me with his own lips that he had not received any too much satisfaction from the Marquises d'Aytona and de Léganès; and they on their part were annoyed, even scandalized at his conduct. The reason for it was this: the Duke of Vendôme [1] had himself called "Highness"; he received the visits of the Grandees of Spain by awaiting them without stirring from his apartment, and scarcely accompanying them out at their departure. This appeared all the more strange since the Prince of Condé was satisfied with the title of "Excellency," and otherwise adapted himself to the customs of our Court.

These incidents in Brussels led to further consequences, for upon his arrival in Antwerp, as well as on his departure, only a single cannon shot was fired, and he was refused entrance to the citadel. He showed great resentment at this, and I was extremely sorry to see him leave with so much ill-will. Nevertheless, it is true that he received complete satisfaction from the Most Serene Infanta. In Brussels one presumptuous action was particularly noticed: the young Prince of Chimay had come to pay him a visit, and when the Duke of Mercoeur wished to accompany the Prince upon leaving, he was prevented by his father, Vendôme. This was not taken at all well. And finally, the Duke of Vendôme departed without returning the visits of the two marquises mentioned above; he sent excuses by a page, feigning to be indisposed on the evening before his departure.

But let us leave this prince to go about the world, where he will not fail to meet the courtesy which his merit and rank deserve, and look a little at the news from the Court of France, which is certainly momentous.[2] Please God, the catastrophe may not be fatal! I am very glad that a dispute with the Abbé de St. Ambroise concerning the measurements of the pictures kept me in suspense for more than four months, during which I could not lay hands to the work. It seems that some good genius has prevented me from embarking upon it any further. I certainly consider all I have done as labor entirely wasted, for it is to be feared that so

eminent a person is not confined only to be released again, and the example of her previous escape will cause such precautions *in posterum* that one may not hope it will happen again. To be sure, all courts are subject to a great variety of hazards, but the Court of France more than all the others. It is difficult to judge rightly on things one observes from a distance, and so it is better for me to be silent than to criticize unjustly.

Here we are making preparations for war with more ardor than ever, since Spain has provided money more generously than usual, and the loyal provinces are making the greatest effort to support many troops at their own expense. Therefore we can hope that the enemy will make no advance this year. And since I have nothing else to tell you, I commend myself humbly to the good graces of you and your brother, and sincerely kiss your hands, remaining always

<div align="right">Your most affectionate servant,</div>

Antwerp, March 27, 1631 <div align="right">Peter Paul Rubens</div>

The Marquis de Santa Cruz is coming from Milan to become General of the Royal Army in Flanders. He is thought to be already on the way.[3]

The books you mention in your letter, by the Emperor Julian and the Greek astrologers, are available here, and so it is unnecessary for you to take the trouble to send them to me. Nevertheless, I am very much obliged to you for your courteous offer.[4]

<div align="center">– 220 –</div>

To Don Fabrizio Valguarnera <div align="right">*Antwerp, June 20, 1631*</div>

Monsieur:

I am surprised that you have not given me an answer regarding the subject and measurements of the picture which I am to paint for you with my own hand. I have an "Adoration of the Magi," seven to eight feet in height and almost square, which is not entirely finished.[1] It could serve as altarpiece of some private chapel or to adorn the chimney piece of a large salon. I should therefore like to know whether such a subject would suit you; I beg you to let me know your inclination freely and with assurance. I am ready to serve you according to your taste and because of the obligation I have contracted toward you, to whom I commend myself.

<div align="right">Your most devoted servant,</div>

Antwerp, June 20, 1631 <div align="right">Peter Paul Rubens</div>

<div align="center">373</div>

I am writing this at a hazard, for I do not know whether you are in Naples, Palermo, or elsewhere. I hope, however, that my letter will reach you; I know that gentlemen of your rank are recognized everywhere.

To the Count Duke of Olivares *Mons, August 1, 1631*

Your Excellency:

Your Excellency need not be surprised that I am still here, for you know that up to now there has been no reply, on your part, to the objections made by the Most Serene Infanta and by me regarding the nature of my mission.[1] In the meantime, such remarkable opportunities have been offered me here, to employ myself in the service of His Majesty, that I dare leave it to the judgment of the Abbé Scaglia himself, whether it is advisable for me to give them up to go to England, now that Señor Necolalde has just gone there; however, we have not yet received news of the arrival of M. l'Abbé at that Court.[2] In any case, Your Excellency may expect of me nothing but pure and simple obedience in all things, and may believe that I do not remain here or interfere in anything except under precise orders from Her Most Serene Highness and the Marquis d'Aytona.

Great is the news from France.[3] The Queen Mother has come to throw herself in the arms of Her Highness, cast out by the violence of Cardinal Richelieu. He has no regard for the fact that he is her creature, and that she not only raised him from the dirt but placed him in the eminent position from which he now hurls against her the thunderbolts of his ingratitude. If this were only a question of the interests of a private person, I should be in doubt what to do; but considering that the great princes have to base their reasons of state upon their reputation and the good opinion of the world, I do not see how, in this regard, one could desire more than this: that the mother and mother-in-law of so many kings should come, with such confidence, to place her person under the arbitration of His Catholic Majesty, offering herself as hostage for her son, who is likewise a fugitive from the kingdom in which he is in direct succession to his brother.

Surely we have in our time a clear example of how much evil can be done by a favorite who is motivated more by personal ambition than regard for the public welfare and the service of his King; to the point where

a good prince, badly advised, can be induced to violate the obligations of nature toward his mother and his own blood. On the other hand, as everything receives greater luster from its opposite, the world sees in the person of Your Excellency how great a support and help for a monarchy like ours is a minister endowed with courage and prudence, who aspires to nothing but the true glory and grandeur of the King, his master. And this will be all the more evident, according to how Your Excellency takes advantage of the opportunity which the Lord God has placed in your hands.

If Your Excellency, with accustomed generosity, will permit me to give my opinion, it seems to me that the more averse Your Excellency appears to be to every intercourse or collusion with Cardinal Richelieu, the more will the hatred and infamy which he has brought upon all favorites of princes decline, and the greater will be the increase and confirmation of the well-justified opinion which is universally held of Your Excellency's sincerity and the success of your administration.

I should not believe the reports of the Cardinal's enemies if I had not proved, in my negotiations with England, that by his perfidy he has rendered himself incapable of ever betraying anyone in the future; this seems to me the worst *raison d'état* in the world, since confidence alone is the foundation of all human commerce. This policy of his has caused the flight of the Queen Mother; it has rendered irreconcilable her cause and that of Monsieur. For that reason the Queen has told me with her own lips that she will never come to an agreement with the King, her son, while the Cardinal remains on earth; she knows for a certainty that if ever they trust him, under pretext of any sort of treaty, they will be irrevocably lost.

I have never worked for war, as Your Excellency can confirm, but have always tried, insofar as I have been able, to procure peace everywhere; and if I saw that the Queen Mother or Monsieur were aiming to cause a break between the two crowns, I should withdraw from this affair. But since they assure me that they have no such intention, I do not feel any scruples, for their reasons are very clear. If they should openly avail themselves of the arms of Spain against the Cardinal, who hides behind the person and the mantle of the King of France, they would render themselves so odious to all the French that it would ruin their party. Also this would make it almost impossible for Monsieur to succeed to the crown of France, to which he is as far from aspiring during the lifetime of his brother, as it is certain that he is simply defending himself against the violence of the Cardinal, and taking up arms by

necessity. For he finds no guarantee for his own life and that of his mother in any kind of peace they offer.

It is probable that his party may be large, being composed of three factions. Since the King of France does not have too strong a constitution, everyone looks toward the rising sun, and wishes to obtain the good-will of Monsieur. I could furnish Your Excellency with a good account of this, since the Marquis d'Aytona has charged me to make every effort to inform myself explicitly. But this is a subject in which it is necessary to trust what one is told, for one cannot demand written proof of secret agreements, and these are indeed very great with regard to Monsieur alone. The Queen, moreover, during a period of thirty years, has won over and bound by obligation to her an endless number of princes and noblemen who form the sinews of the French kingdom. But above all in their favor will be the universal hatred of the Cardinal, which increases every moment, owing to the extreme severity he shows toward all, imprisoning some and exiling others, confiscating their property without a trial. It only remains for Monsieur to raise his banner and open his campaign, so that his adherents can unmask and gather at the arming place; for as long as the party has not yet been formed, no one dares reveal himself.

I am told the party has made arrangements with those in control of the fortresses. The Duke of Bouillon, for example, will receive Monsieur's troops in Sedan, in order to defend it against the King of France. The Count de la Rochefoucauld, Governor of Poitou, will do the same with all that province, as I have been assured by his own brother, the Marquis d'Estissac, who is here in person. They say also that the Governor of Calais, whose brave brother, the Commander de Valençay, has been for some time in Brussels, has offered to deliver Calais to Monsieur, and that the same is true of the city of Reims and other places in Picardy. They also claim there is an understanding with the Dukes of Guise and Epernon and other nobles of high rank, and even with the very colonels and captains of the regiment of His Majesty's guard, who promise to change sides if it comes to a fight. Part of the nobility has already gone over to Monsieur, such as M. de Lignières, the Count de la Feuillade, the Marquis de la Ferté, M. de Caudray-Montpensier, M. du Roy, brother of the Duke of Bouillon, M. de la Ferté. There is no need of naming the Duke d'Elbeuf, or Bellegarde, or the others who have already declared themselves, or are now with Monsieur, such as the Count de Moret, natural brother of the King, the Duke of Rohan, brother-in-law of the Duke d'Elbeuf, the Marquis de Boissy, his son, and many others who

offer to raise their own troops, as is the custom in the civil wars in France. In the first place, the Duke of Bouillon will furnish 4000 infantry and 1500 horses; a foreign prince will furnish the same number of infantry and 500 horses; M. de Vateville, a Swiss, 4000 infantry; an anonymous person, 3000 infantry and 500 horses. In addition, a countless number of French nobles offer to recruit troops for Monsieur — in such numbers that he finds it hard to decline them. But all this will go up in smoke in a short time if Monsieur is not promptly furnished with money to pay the recruits. Moreover, as I was told by the Marquis de la Vieuville,[4] who occupies first place in the Queen's retinue, if we allow this enthusiasm peculiar to the French nation to cool without availing ourselves of its first impetus, we shall allow time for the Cardinal's tricks. Meanwhile the enterprise will be frustrated, for its soul is secrecy and prompt execution, and all will come to naught.[5] And as a reward for their goodwill the friends of Monsieur and the Queen will receive the most cruel punishment. They will pay with their blood, their lives, their property, for the failures of others. And if, for lack of our assistance, Monsieur is unable to make a success at the beginning, he will lose the confidence of his followers, and will never be able to recover it.

The sum which he now asks is so small that it does not seem to us likely that it can produce any great effect. It is true that I have explained at great length to the Queen how unfavorable the circumstances are, with our army facing the enemy in the field, so that we cannot, without incurring great inconvenience, divert any of its pay for use elsewhere. The needs of Monsieur, however, are so urgent, and it would be so unreasonable to let slip an opportunity the like of which has not presented itself for one hundred years, that one ought to make a virtue out of necessity, and give one's blood for the reputation and state-interests of His Catholic Majesty. For surely the Catholic League with the Duke of Guise and his brother, for which King Philip II wasted so many millions, cannot be compared in any way with the present occasion.

It has been a great disadvantage for Monsieur that the Duke of Feria did not pay the 200,000 crowns on the date fixed; after much delay the sum was remitted to the Marquis de Mirabel, who then assigned it to the Marquis d'Aytona. He could probably have paid it if the million destined for Germany and France were really available; but since it is only a million on paper, and the bankers are unwilling to make any advance, poor Monsieur remains without funds, and the Queen Mother is cheated, for she told me the Marquis de Mirabel had offered her this sum in Compiègne, through an intermediary.

377

Your Excellency alone, next to God, can remedy this situation. Your natural generosity loves great enterprises, and you have not only the prudence and the courage, but also the means to carry them out. But it will be necessary to send some assistance promptly, to arrive in time to begin the campaign before provisions fail and the granaries are empty. This is not a thing to be done by halves, because unless Monsieur is supported in such a manner that he can carry out his plan, it means a double ruin for him. And upon this, more or less, depends whether he will be eternally obliged for the success of the enterprise, or whether he will be lost, along with all the advantages that might result. Finally, if he is not able to subsist with our help, he will be forced to throw himself into the arms of the Hollanders; already the Prince of Orange has offered his dominion as a refuge. What a disadvantage and disgrace this would be to His Catholic Majesty I leave to the prudence of Your Excellency to consider.

The Queen and Monsieur have resolved not to make use of the Huguenots in any way, or to restore that party either wholly or partially, or to seek the ruin of anyone in the kingdom of France except the Cardinal, who, in truth, has never done other than devote all his industry and power to undermine, insult and abase the monarchy of Spain. This monarchy, therefore, ought to be willing to pay, even at a cost of millions, for the ruin of so pernicious an enemy, and it will never obtain this at so low a price as by the hands and the blood of the French themselves. Perhaps, after having availed themselves of our aid, they will not recognize it with due gratitude. But one may expect that a great number of French will perish by internal discord, and that that proud nation will be weakened by its own hands. And so whichever party triumphs or loses, we shall have one less enemy.

It is not to be feared that the Hollanders will undertake anything this year. We have a powerful army mobilized, and could, it seems, reorganize some regiments, in order to let them pass over to Monsieur. This has been practiced at all times, and particularly during the truce, without dismembering the companies, but only changing the orders. Thus we should not run the least risk of a rupture. This sort of help, even if one were to grant passage to some of Monsieur's troops for the Calais or Sedan enterprise, would not equal the smallest part of the assistance given to the Hollanders by the King of France. He permits them to beat their drums even in the middle of Paris, and not only provides but expedites and signs with his own hand the commissions of rank and office for the regiments which he maintains at his expense in their service,

commanded by marshals, dukes, and peers of France. Surely it would seem, to me, the greatest indignity and sign of weakness to allow such a thing without daring to do the same, for a cause as pious and honorable as the assistance of the mother-in-law and the brother-in-law of His Catholic Majesty. For my part, I am glad to be able to congratulate Your Excellency that there has fallen into your hands, as from heaven, an opportunity so suited to lend luster and glory to your administration. I hope that Your Excellency will be willing and able to carry it out in a manner that will bring eternal glory to the King, our Lord, and to Your Excellency immortal fame and great honor among all those who are well disposed toward this monarchy.

The sum which is asked to mount Monsieur on horseback is 300,000 gold crowns (at twelve reals to the crown), and this includes the 200,000 from the Marquis de Mirabel. It would hardly provide for two months in Flanders, and with this he will make his expedition. If the enterprise succeeds, it will gain nourishment from the vitals of the kingdom of France itself. But if perhaps Monsieur does not have the following he anticipates, we, on our part, shall have given him satisfaction, and for this small sum. And even if it should be necessary to continue this subsidy, I believe the royal finances could be employed in no better way, for our security, than in supporting a civil war in that kingdom; then at least it could not in the meantime give assistance to our enemies in Flanders and Germany.

The Marquis de la Vieuville has told me that the Duke of Friedland [6] has offered his services to the Queen. He believes that the Duke will come in person, with other princes of Germany, if His Catholic Majesty permits them to make levies in his states for the service of Monsieur. And this seems to me to be a thing of no small importance.

M. Gerbier [7] is making great offers to Monsieur on the part of his King. The Abbé Scaglia will therefore arrive in London at a favorable time. He has certainly given his good friend the Marquis de Santa Cruz very poor information on this matter. But I believe that if they were together for one hour (as far as I understand the temperament of the two), he would easily bring the Marquis to his opinion. If, therefore, Your Excellency takes the present affair to heart, as I hope and as your honor requires, it will be necessary to provide at once for the urgent needs of which I have spoken, and to allow the Most Serene Infanta and the Marquis d'Aytona to act according to the circumstances which present themselves from hour to hour. On the other side, the Marquis de Santa Cruz will serve as a shield against the Hollanders, who, in my opinion,

will undertake very little. The Prince of Orange also secretly favors Monsieur's party, since he is annoyed by the Cardinal's betrayal of the fortress of Orange.[8] It would be desirable, if the affair succeeds, that there should finally be a good general peace, at the the expense of the Cardinal who keeps the world in a turmoil — a peace with the intervention of France and England, and not only in Flanders, but also in Germany and throughout all Christendom. I hope that the Lord God has reserved this task for Your Excellency, who, for piety and holy devotion to the service of His Divine Majesty and of our King, deserves this greater glory of being the sole instrument of such a great good work.

I cannot refrain from telling Your Excellency that the Marquis de la Vieuville, exiled as he is, and with the greater part of his property confiscated, is contributing 50,000 pistoles for the support of the common cause. When I conferred with him on the matter, by order of the Queen and the Marquis d'Aytona, and with the intervention of M. Monsigot, the first Secretary of State of Monsieur, he told me that if he had his customary funds, he would have no hesitation in aiding a friend with such a sum as Monsieur requires. This seems to me a very generous offer, which ought to encourage the greatest monarch in the world to do even more, for his own brother-in-law and mother-in-law, in order not to be surpassed in magnanimity by a private individual. And therefore I beg Your Excellency to redeem the generous Spanish nation from that opprobrium in which it is wrongly held, by a deep-rooted general opinion that it can never decide to seize opportunities promptly when they present themselves, but, after endless deliberation, usually sends *post bellum auxilium*. But this does not correspond to the decisiveness which is the peculiar virtue of Your Excellency.

I do not think that the Marquis de Mirabel will urge Your Excellency to do much for Monsieur (for what jealous reason I do not know).[9] To tell the truth, these French Lords dare not communicate to him their secret enterprises, in spite of his efforts to know them; it is not because they distrust him personally, but because of the lack of discretion of one of his secretaries. I do not know who it is, and do not wish to accuse anyone; I only report what has been told to me on good authority. It is true that the Marquis de Mirabel has ordered that Monsieur be paid 50,000 crowns. But this is so little that it will vanish without any result. In my opinion, assistance ought to be given in proportion to the need, or else not at all, lest one lose both the friend and the money at the same time. In this matter I expect great decisions from the generosity of Your Excellency, although it has been hard for me to convince these Lords, who

have not observed the heroic nature of Your Excellency as closely as I have.

And so I commend myself most humbly to the favor of Your Excellency, and with the sincerest heart I kiss your feet.

Mons in Hainault, August 1, 1631 Peter Paul Rubens

The Queen told me, in expressing thanks to Her Highness for the gifts she had sent her (which were indeed very nice and most pleasing to Her Majesty), that the greatest and dearest gift would be prompt aid to her son, and on this all her happiness depends. She said that, for the rest, there need be little concern for her person, but asked that all favor and grace serve this particular cause, according to the need. She is willing to send someone to Spain for the express purpose of throwing himself at the feet of His Majesty, although the need is so pressing that, if one must await a response before receiving aid, it will be too late. For the King of France is already mobilizing many troops to crush Monsieur, who is still unprepared.[10]

– 222 –

Fragment, to the Abbé Scaglia [*November 16, 1631*]

I do not understand, however, what Your Excellency professes to have written me, but which I do not find in any of your previous letters: namely, that if this matter is to be treated, it ought to be done with great secrecy; that it ought not to pass through the hands of 100 [*deciphered in margin*: Gerbier], who has aroused the deep suspicion of 221 [*deciphered in margin*: Chanteloupe] for having vigorously supported the Marquis [de la Vieuville]. But it would not matter very much if the true secret should be concealed from him. The Infanta tells me that she has had some wind of it.

I had warned Your Excellency that, if you found it good, you ought not to confide in 100, who is of the contrary opinion. Nevertheless, for his own sake, I have advised him that he should not directly oppose a thing which might perhaps take effect, lest he remain napping among persons so competent and of such eminent quality. But neither I nor anyone dependent upon the King of Spain or the Infanta ought to interfere in this; we ought rather to try to keep others from it, if only to save appearances on our side. [*Sentence added in English*: The rest was a relation of the ill-governmt of the Queene Mother.]

To the Infanta Isabella *Antwerp, February 6, 1632*

Most Serene Madame:

That gentleman from the Duke of Bouillon [1] has come expressly to see me in Antwerp, in order to know Your Highness' reply on the points mentioned in my previous letter. But I have not received it through the Marquis d'Aytona, as Montfort had said I would, notwithstanding the fact that I wrote him a letter to this effect. This man tells me that Monsieur [2] is urging the Duke of Bouillon, more than ever, to offer his fortress, and wants him to be the first to declare himself for Monsieur's party. But the gentleman says that the Duke of Bouillon persists in his unwillingness to give his fortress to Monsieur, or declare himself for him, unless on the word and promise of Your Highness that you will maintain and sustain him by force, against the King of France, in case he is attacked by His Majesty. And if Your Highness does not find it convenient now to do this, he begs that you permit him to make the oath of protection to the King of France. This will be without prejudice to his inner intention to serve Your Highness, with his support, as he will declare with effect at whatever hour you may judge the time to be opportune.

I beg Your Highness to condescend to give me a prompt reply to this proposal, or else to relieve me of this responsibility. For this gentleman has no access to any of Your Highness' ministers, nor does he wish it, for greater security; and he has express orders from his master to address no one else but me. And during the time that I cannot give him a decision, he is urged beyond measure, and ill-treated by Monsieur and his ministers.

The oath of protection will oblige the Duke of Bouillon to promise to serve the King with his person and with his fortress, but without receiving any garrison for it, except that the King is to maintain one hundred men-of-arms and two hundred infantry, and pay him 10,000 florins pension per year; and his vassals have the privilege of exemption from duty and excise tax, as well as free commerce with France, like natives of France.[3] Furthermore, the King is obliged to support the Duke against all other pretenders who instigate quarrels with him over the possession of his state.

All this has been promised him in the past; but nothing has been maintained, nor any pension paid, nor men provided, either foot-soldiers

or cavalry, for the last ten years. And for the future, even though the oath may be renewed, things will be the same. Therefore, the Duke says he is sure to be relieved of his obligation by the failures on the part of the French.

This is as much as I can tell Your Highness on the subject of the Duke of Bouillon. And as for the Prince of Orange, I believe that Your Highness will find it good that he is going to take up the conversations. With this I conclude, humbly kissing the feet of Your Highness, and remaining ever

<div style="text-align: right">

Your Most Serene Highness' most
humble and devoted servant,
Peter Paul Rubens

</div>

If Your Highness gives me a reply it will be well if it can be done by a shorter means than through the Marquis d'Aytona, who has a thousand distractions.

Antwerp, February 6, 1632

<div style="text-align: center">

– 224 –

</div>

To the Infanta Isabella *Antwerp, April 12, 1632*

Most Serene Madame:

Seeing that the Prince of Orange did not reply to my letters, I wrote to his Secretary Huygens on the 31st of March, 1632, as follows:

> Monsieur: I wrote you on the 4th of February, and sent a letter to His Excellency on the 12th of the same month. I have no orders to solicit a reply, which depends upon the convenience and pleasure of His Excellency, but one would like to be informed as to whether they safely reached your hands, for there is some doubt of it. I beg you to advise me as soon as possible and give me the honor of your commands, etc.

To this note the Secretary Huygens replied to me in this manner, *ad verbum*:

> Monsieur: I can relieve you of the doubt which I see you feel, in the letter which it has pleased you to write me on March 31, concerning the receipt of yours of the 4th and 12th of February, by assuring you,

as I have orders to do, that all have been well received. The reason for the delay in replying is that those with whom I must communicate the affair of which you speak are not here. And this communication having still to be made, you will in due time be advised, after which there will be the deliberations here on the subject of the said affair. And in the meantime be assured, if you please, that I will always be, Monsieur, your very humble and affectionate servant,

The Hague, April 8, 1632 Huygens

This letter agrees with what I told Your Highness orally, and I do not see that it is possible to make any further effort on our side for now. With this I humbly kiss the feet of Your Most Serene Highness and remain eternally

Your Most Serene Highness' most
humble and devoted servant,
Antwerp, April 12, 1632 Peter Paul Rubens

It will be well for Your Highness to let the Marquises d'Aytona and Santa Cruz see this, for they will ultimately speak to me about the delay of this reply.

– 225 –

To Balthasar Gerbier *Antwerp, April 12, 1632*

Dear Sir:

I found, upon returning home, the Patent of the Privileges of France, along with your letter and those of the Chevalier du Jar and M. Juan Maria. It is unimportant that the seal was broken, for the Patent will have no less effect. I am very much obliged for it, and thank you heartily. I shall also not fail to render the Chevalier du Jar the acknowledgement he expects from me. He is a remarkable man, who knows how to make himself valuable everywhere, among the greatest persons. God grant that all this will end well, as I hope.

You will receive this letter from the hands of the Abbé Scaglia, with whom I have talked a little on the affair of Biscarat. I believe he will give you satisfaction on this point, for whatever blame Biscarat charges to the Abbé, he was none the less fully informed about it beforehand by others, and came only to give him a tongue-lashing. [*In margin*: I am surprised

384

that M. Juan Maria is now beginning to write to me, and request a note from me, when I thought that we had almost forgotten one another, after so long a time.]

I am sorry to hear that the French are also rendering you such ill service with regard to Her Highness and our great ministers. To be sure, you need not be disturbed about it, since you depend upon your King alone. However, this will make more difficult the matters which must be treated with them. I have retired at the right time, and I have never had less regret for any decision I ever made. Since I have nothing else to tell you, I heartily commend myself and my wife to your favor and that of Madame, your wife, remaining ever

<div style="text-align:right">Your humble servant,</div>

Antwerp, April 12, 1632 P. P. Rubens

<div style="text-align:center">– 226 –</div>

To the Infanta Isabella *Antwerp, May 11, 1632*

Most Serene Madame:

A gentleman has come to me secretly from the Duke of Bouillon, by order of his master. He says that he is going to Brussels in order to point out to Monsieur the Duke of Orléans [1] the necessity, before he can go in person to Sedan, of raising a force of 1200 men to forestall any reaction which the Duke of Bouillon's declaration in favor of Monsieur might cause among his vassals. This gentleman is going to make the aforesaid levy of troops in the environs of Sedan. He assures me that the Duke, his master, is a passionate supporter of Monsieur's cause, and that he will not fail in a single point to do all that he has agreed upon with the Marquis d'Estissac. But the Duke desires to be assured by Your Highness of two things. First, he asks that the statement of his protection [*in margin*: which Your Highness promised to sign with her own hand] be drawn up in such a way that Your Highness not only promises, in her name and that of the King of Spain, to defend and support him against the King of France and anyone else who might threaten him, insofar as his cause is linked with that of Monsieur, but also that assurance be given him in case, by some misfortune (God forbid), some incident, or any other reason, this union between him and Monsieur should come to an end, that neither Your Highness nor our King will desert him, but will support him as mentioned above. The other point is this: the Duke of

<div style="text-align:center">385</div>

Bouillon, knowing that all the Marquis d'Estissac has promised him in the name of Monsieur must come from Your Highness [*in margin*: as Your Highness will have seen in the list which d'Estissac has brought from Holland], likewise desires to be reassured that all this will take effect, and that Monsieur will be in a position to keep his promises. [*In margin*: This does not extend to the things which depend on Monsieur alone.] And above all, even though the Duke is pledged to serve Monsieur in person at Sedan, or in his army, at the moment the campaign is begun, he does not consider it in keeping with his own interests or those of the party to come and show himself before the proper time. That is why he wishes to be informed with certainty whether Monsieur is prepared or soon will be, whether our reinforcements are ready to march, or whether some little time will pass before one can mount horseback. He wishes to know precisely when this day will be, so as not to come too early or too late. [*In margin*: The Duke would also like to have a little more time before declaring himself, in order to recall his brother, the Viscount de Turenne, who is at the French Court, and would run the risk of being put into the Bastille if he did not save himself first.]

These are the requests of the Duke of Bouillon, and he desires to receive an answer through me, as soon as possible. And notwithstanding the fact that this gentleman will in the meantime go to Brussels to treat with the French Lords who are there, the Duke's decision will depend upon the information I send him from Your Highness. But this must be done with secrecy, and his demands must not come to the knowledge of the French, for this could cause great inconvenience. [*In margin*: If Your Highness charges the Marquis d'Aytona to send me the answer, I urgently beg him to make haste, for this gentleman will come to see me again within three or four days.]

With this I conclude, humbly commending myself to the good graces of Your Highness, and with all devotion I kiss your feet.

Your Serene Highness' most humble and devoted servant,
Antwerp, May 11, 1632 Peter Paul Rubens

– 227 –

To Balthasar Gerbier (Summary) [*August 4, 1632*]

I am sorry to understand, by yours of the 3rd of August, that still ill offices are don you to your prejudice, & that you are vexed therewith.

386

Though it's not strange that you desire to prevent what might be of prejudice unto your reputation, & would enter into a course of excuses with Her Highnesse, whereunto tend the five articles in your letter; Yett, thereupon, I will tell you freely my opinion, touching the letter from England, which, on my soule, marckt not your name, on which you may rest assured.

The letter was written in forme of advertisements unto Her Highness:

Touching the Articles; You must name noe body, and by noe meanes me, which would only ruine me with my Maisters & disable me to serve you:

I find noe difficulty in the first & second article, for as much as concernes the French & Biscarat: But, on the third, I doe not thinke fitt you should dive soe deepe into Her Highnesses breast, for I never heard that any thing was written against her owne person.

Likewise I doe not find fitt the 4th for the said reasons, neither the fifth:

It may be her Highnes will open her selfe, as it's common that one word brings on the other, etc.

– 228 –

To Balthasar Gerbier (Summary) [*October 15, 1632*]

The subject of our dispute is a case incident to any man, that certaine thinges are written, though I will not sustayne that what is written is grounded on thinges to your charge, but, on the contrary, I doe believe that you doe your utmost endeavors to serve the King of Great Brittany your Maister, faithfully & punctually advertise him of what passeth, &c.

– 229 –

To Frederick Henry, Prince of Orange [*Brussels, December 13, 1632*]

My Lord:

The Most Serene Infanta commands me to inform Your Excellency that she finds it necessary that I go as soon as possible to The Hague, in order to serve and assist the Deputies of our States in clarifying and maintaining certain points on which I have particular knowledge. To this end, I beg you, on your part, to provide me with a passport to the States of the

United Provinces for my person and two or three servants. It is not necessary to insert any title other than "Secretary to the King of Spain in his Privy Council."

I hope that Your Excellency will do this favor for Her Highness, and grant me the honor of believing that I am truly

<div align="right">
Your Excellency's very humble and obedient servant,

Peter Paul Rubens
</div>

I hope, on this occasion, to give Your Excellency so convincing a reason for our silence that you yourself will judge that one could not have done otherwise, for the security of the affair.

<div align="center">

– 230 –

</div>

To the Duke of Aerschot [*Antwerp, January 29, 1633*]

My Lord:

I am very sorry to hear of the resentment Your Excellency has shown upon my request for a passport, for I am proceeding in good faith, and beg you to believe that I shall always render a good account of my actions. Also I protest before God that I have never had any other charge from my superiors than to serve Your Excellency in every way, in the conduct of this affair. This is so necessary for the service of the King and for the preservation of the country that I should consider that man unworthy to live who, for his own private interests, would cause the least delay to it. However, I do not see what inconvenience would have resulted if I had carried my papers to The Hague and delivered them into Your Excellency's hands, without any other commission or capacity than to render my humble service, since I desire nothing in the world so much as an opportunity to show in effect that I am, with all my heart, etc.

<div align="center">

– 231 –

</div>

To Balthasar Gerbier (Summary) [*June 29, 1633*]

I wonder att the brutall proceedings of Sr. Nicolaldy & Taylor [1] in your regard; I take to my charge, the first time I shall come to Bruxelles, to try the Infanta her pulse on the calomnies laid on you &c.

<div align="center">

388

</div>

To Giovanni de' Medici (?) *Antwerp, September 29, 1633*

Your Excellency:

The bearer of this letter will inform Your Excellency of the business he has transacted in Brussels, and will tell you with what difficulty the cutting of the trees progresses. He will also tell you that he has not been able to draw a farthing from the Department of Finance to pay the wages of the poor men who are doing the work, so that it will be necessary to provide some means here for their maintenance. Her Highness pledges to make the reimbursement by drawing from another source. Up to now a thousand trees have already been cut down, and it is planned to have them brought to Antwerp, although I do not see any great likelihood of providing the necessary workmen for this undertaking, and the good weather can last only a little longer. I am beginning to doubt its success. The Most Serene Infanta told M. Montfort it would have been done very quickly if she had not been forced, because of certain reports, to send workers to Dunkirk. It seems to me that this man will have to finish the pile-work and the iron riveting and then suspend operations until further orders. The Auditor, Paredis, has informed me that the 500 florins are on hand. With this money I will aid the man and we will have him give me an account to submit to Your Excellency. M. Montfort wants to give me encouragement and assure me that all will go well, that Her Highness persists in the resolution she has taken, etc. I do not know what to say, and so I rely completely upon the good judgment of Your Excellency, to whose grace I commend myself humbly. And kissing your hands with all my heart, I remain ever

<div align="right">Your Excellency's most humble servant,</div>

Antwerp, September 29, 1633 Peter Paul Rubens

P.S. The foreman who is treating the inhabitants of this country so badly is doing wrong to alienate them in the present circumstances, and renders His Majesty a worse service than he thinks. At least, according to what I hear, the Most Serene Infanta feels it very keenly.

To ——— [*May 4, 1634*]

Monsieur:

M. Arnold Lunden was formerly, for personal reasons, enrolled in the company of Captain Reid, under the conditions stated in the document of which a copy is here enclosed. And it was at my recommendation, following the verbal order of His Excellency, the late Marquis Spinola, the authenticity of which I can vouch for, that this M. Lunden has since been advanced to the position of Councilor and Head of His Majesty's Mint. He does not doubt that the said order is sufficient to defend him against all the tricks and falsehoods one could lay in his way in virtue of the recently published libel on the soldiery — even if, for his greater security, he should desire to be provided with a statement of absolute acquittal of any blame. Since all this happened as a result of my request, I feel obliged to employ every means to protect him — all the more because of our relationship, since he and I married two sisters. And so I turn to you, whose intercession can fulfill my purpose. And herewith, kissing your hands, I remain, Monsieur,

<div style="text-align:right">Your humble and obedient servant,
Peter Paul Rubens</div>

[*Written by another hand*:] May 4, 1634

To Giovanni de' Medici (?) *Antwerp, July 2, 1634*

Your Excellency:

Your Excellency has done me great honor with your letter of June 30, but I cannot rid myself of the suspicion that the men destined for our enterprise will perhaps be employed for other purposes, and I see no remedy but to conform to necessity and to the will of the superiors. Here, however, they talk otherwise, and MM. Edelheer [1] and Chiarles advise postponing the matter until next year, since the season is now past, and dealing this autumn only with repairing the dyke. This has caused the bearer of this letter such alarm as Your Excellency can imagine of a man who has so great an interest in the work, by his past labors and his hopes

for some recompense in the future. That is why I beg Your Excellency with customary kindness to have pity on him and (if this is really the case) to undeceive him and not to engage him any longer, as would be necessary if the work were to be pushed forward. He will be able to give Your Excellency a detailed verbal report on it. It seems to me that I heard from the Marquis d'Aytona,[2] when I saw him recently, that in case the dyke could not be finished this year (although the contractors maintain the contrary), it would be sufficient to lay the foundation piles and fortify the main posts. This can be done, without any doubt, and will give some security until they wish to do the rest. And since the safety of the city of Antwerp (which depends upon this dyke) is more important to the King's service than the interests of private individuals, I shall always prefer the first to the second. I do not want to pose as an arbiter in war, which I do not understand, but I cannot help mentioning that, unless the Marquis has great and perhaps more important plans elsewhere, he could not choose a spot more favorable for diverting the enemy forces than this remote site. It is certain, as Your Excellency will have heard before leaving here, that Morgan and Hoymacker, the governors of Bergen and Lillo, visited the dyke and the environs of Melckhuys (God knows for what purpose). I confess that I should be very much vexed if our delay should allow the enemy to surprise us by occupying these posts and thus advance considerably closer to this city.

May Your Excellency pardon me if I insist upon explaining something which is wholly your own affair. Your Excellency understands it better than all the rest of us together, and you have put so much care and interest into it that, if it is ever carried out, the credit will be entirely Your Excellency's. And humbly kissing your hands, I remain ever, with all my heart,

<div style="text-align:center">Your Excellency's most humble and devoted servant,</div>

Antwerp, July 2, 1634 Peter Paul Rubens

<div style="text-align:center">– 235 –</div>

To Peiresc *Antwerp, December 18, 1634*

Monsieur:

Your most welcome letter of the 24th of last month, delivered to me by my brother-in-law, M. Picquery, was a favor so unexpected that I first felt astonishment mingled with incredible joy, and then an extreme desire to

read it. I see that you continue with more ardor than ever your investigation into the mysteries of Roman Antiquity. Your excuses for your silence are superfluous; I had already imagined that the essential reason for it was the unfortunate haven given to certain foreigners who had retired to this country.[1] To tell the truth, when I consider the dangers to which the suspicions and the malice of this century expose us, and the important part which I had in this affair, I do not feel that you could have done otherwise. Now, for three years, by divine grace, I have found peace of mind, having renounced every sort of employment outside of my beloved profession. *Experti sumus invicem fortuna et ego.** To Fortune I owe great obligation, for I can say without conceit that my missions and journeys in Spain and England succeeded most favorably. I carried out negotiations of the gravest importance, to the complete satisfaction of those who sent me and also of the other parties. And in order that you may know all, they then entrusted to me, and to me alone, all the secret affairs of France regarding the flight of the Queen Mother and the Duke of Orléans from the kingdom of France, as well as the permission granted them to seek asylum with us. Thus I could provide an historian with much material, and the pure truth of the case, very different from that which is generally believed.

When I found myself in that labyrinth, beset night and day by a succession of urgent duties; away from my home for nine months, and obliged to be present continually at Court; having reached the height of favor with the Most Serene Infanta (may she rest in glory) and with the first ministers of the King; and having given every satisfaction to the parties abroad, I made the decision to force myself to cut this golden knot of ambition, in order to recover my liberty. Realizing that a retirement of this sort must be made while one is rising and not falling; that one must leave Fortune while she is still favorable, and not wait until she has turned her back, I seized the occasion of a short, secret journey to throw myself at Her Highness' feet and beg, as the sole reward for so many efforts, exemption from such assignments and permission to serve her in my own home. This favor I obtained with more difficulty than any other she ever granted me. In fact, there were still a few secret negotiations and state matters reserved for me, but these I was able to carry out with little inconvenience. Since that time I have no longer taken any part in the affairs of France, and I have never regretted this decision. Now, by God's grace, as you have learned from M. Picquery, I am lead-

* Fortune and I have come to know each other (Tacitus, *Historiae* 2.47).

ing a quiet life with my wife and children, and have no pretension in the world other than to live in peace.

I made up my mind to marry again, since I was not yet inclined to live the abstinent life of the celibate, thinking that, if we must give the first place to continence, *fruimur licita voluptate cum gratiarum actione.*†
I have taken a young wife of honest but middle-class family,[2] although everyone tried to persuade me to make a Court marriage. But I feared *commune illud nobilitatis malum superbiam praesertim in illo sexu,*‡ and that is why I chose one who would not blush to see me take my brushes in hand. And to tell the truth, it would have been hard for me to exchange the priceless treasure of liberty for the embraces of an old woman.

That is the story of my life since the interruption of our correspondence. I see that you have been informed by M. Picquery about the children of my present marriage, and therefore I shall only tell you that my Albert is now in Venice. He will devote all this year to a tour of Italy, and on his return, please God, will go to pay his respects to you.[3] But we shall discuss this more in detail when the time comes. Today I am so overburdened with the preparations for the triumphal entry of the Cardinal Infante (which takes place at the end of this month), that I have time neither to live nor to write. I am therefore cheating my art by stealing a few evening hours to write this most inadequate and negligent reply to the courteous and elegant letter of yours. The magistrates of this city have laid upon my shoulders the entire burden of this festival, and I believe you would not be displeased at the invention and variety of subjects, the novelty of the designs and the fitness of their application. Perhaps some day you will see them published, adorned with the beautiful inscriptions and verses of our friend Gevaerts (who sends you affectionate greetings).[4] All these occupations force me to ask you for a truce, for it is really impossible for me, in these circumstances, to make the necessary effort to satisfy my obligation to you and to answer the questions in your letter.

I will say only that I still possess my ancient spoon or porringer.[5] It is so light and easy to hold that my wife was able to use it during her confinements, without doing it any harm. The bowl of the spoon is just like the one in your drawing, but it contains no gold, except for the rivet, which seems to be solid rather than plated. I confess that in my ignorance

† We may enjoy licit pleasures with thankfulness.

‡ Pride, that inherent vice of the nobility, particularly in that sex (cf. Sallust, *Jugurtha*, 68).

I mistook what you call Mercury's cap for the fire and the pouch for an apple to be thrown into it as a sacrifice. But what the round, reticulated object is meant to be I cannot imagine, although a certain person here, who is rather ingenious, wants to call it the money this shepherd has received from the sale of his goats and hens, and which he has piled on top of the caduceus of Mercury to indicate the transaction. He says also that the purses of the Ancients had a reticulated aspect, as one still sees sometimes on modern ones, that the cords on both sides must have served to bind or close it, and that from its roundness one might assume the purse to be full, etc. As for the base, I am not very much disturbed, because this seems to me to indicate only the grass or bit of turf on which the shepherd sits. If this is hard to recognize, it must be attributed to poor workmanship. On the contrary, the chasing on the handle of the porringer is much more delicate; therefore I consider that this dates from another century. On it is represented only the mask of a bacchante, a leafy staff to which are bound thyrses and fruits, an altar laden with fruits, a reed pipe and a goat nibbling the vine. On each side is a cartouche which terminates in the head of a fish with a long, toothed jaw like a sword- or sawfish. As for the impressions you sent me, I cannot say anything about the group reclining beside the woman except that I cannot imagine it to be any kind of human body, but rather that of a sphinx or panther. That is what it seems to be, although I am not at all certain. The other points you mention I am forced to postpone until I have more leisure. However, I enclose here a folio from the Reverend Father Sylvester de Pietra Sancta's *De Symbolis Heroicis,* on the mysterious clock (or glass globe) in a decanter filled with water. You will see it reproduced in the engraving and described in the text.[6] I think you will find this machine worthy of an Archimedes or an Architas, and that you will laugh at the "perpetual motion" of Drebbel, which he was never able to set into regular movement. You need not doubt the authenticity of the thing (the mystery consists in a certain attraction and magnetic power); I have talked with men of ingenuity who have seen and operated it with ease, and have the greatest admiration for it.

I have never failed, in my travels, to observe and study antiquities, both in public and private collections, or missed a chance to acquire certain objects of curiosity by purchase. Moreover, I have kept for myself some of the rarest gems and most exquisite medals from the sale which I made to the Duke of Buckingham. Thus I still have a collection of beautiful and curious things in my possession; but these things I must discuss with a tranquil mind.

394

I cannot, however, help refreshing your memory on the subject of certain special and very ingenious methods of weighing which, as I think I once told you, I observed in Spain on my first journey to that Court, thirty years ago. It was at the house of Don Hieronimo de Ayanza, Chief Assayer of Mines of the West Indies, in the Royal Council. The first method was derived from Archimedes, as I have seen in a fragment of his *De Subsidentibus Aquae,* and consisted of the same test which he made to determine the different metals in the crown of Hiero. This Don Hieronimo had a little silver scale which, to my eye, appeared to be of the proportion and depth of a one-third section of a perfect sphere; on the outside were inscribed an infinite number of concentric circles, each bearing a numeral in the minutest characters, although there was hardly space for them between the lines. After suspending this scale by three or four threads from a movable iron rod, to form a balance which could be lowered and raised, when placed across another rod standing upright like a fork, he loaded the scale with whatever he wished to weigh, and let it descend as far as it would go into a basin full of water. Then at the instant he observed it was no longer sinking, he noted the circle which touched the surface of the water. And from that he knew how to calculate the weight very precisely, even to the most imperceptible difference. The other method of weighing was also very ingenious, in my opinion. It was done by means of a straight brass rod which stood upright on a flat surface, likewise of brass. At the top of the rod there was an extremely fine steel needle which by its sharpness formed an indivisible point. Then he took a very small silver scale,* made with such accuracy that he assured me he had worked more than six months in order to have it of an equal thickness throughout. For therein lies the whole secret. The center was marked by an indivisible point on the convex side of the scale. Now when this was placed on the point of the needle, it was held in equilibrium, and was so sensitive that, as I myself have seen, the slightest particle of human hair placed on one side would set it in motion and cause it to incline perceptibly to that side. This man also possessed a series of weights so minute that the smallest of them were practically invisible, and the differences between them imperceptible; but each was designated by a number. These weights he placed on one side of the scale and the object to be weighed on the other. He said that this type of balance was the most precise and exact in the world. But with regard to ancient weights, I do not know whether they ever attained such subtlety. With this I shall put an end to bothering you and fatiguing myself in

* In the margin Rubens sketched a little scale, with the words "of this size."

this limited time at my disposal. And kissing your hands a million times I remain ever, with all my heart

Your most humble and affectionate servant,
Peter Paul Rubens

Just as I thought I had finished, it came to my mind that I have a suit in the Parliamentary Court of Paris against a certain engraver of prints, German by nationality but a citizen of Paris. This man, in spite of the fact that my privilege from the Most Christian King was renewed three years ago, has been copying my prints, to my great detriment and damage. And even though my son Albert had him indicted by the civil lieutenant, and the verdict was published in my favor, this engraver appealed to the Parliament. Therefore I beg you to come to my aid in this affair and to recommend my just cause to the President or to your friends among the Councilors. Perhaps you are acquainted with the official named the Sieur Saulnier, Councilor in Parliament of the Second Chamber of Inquiries. I hope that you will render me this service all the more willingly since it was by your favor that I obtained my first privilege from His Most Christian Majesty. I confess that I feel extremely annoyed and angered over this affair, and that your assistance would oblige me more than any other favor in more important matters. But it will have to come very soon, lest it be *post bellum auxilium*. Forgive me for the trouble I give you.

Antwerp, December 18, 1635 [*sic*]

M. Rockox is alive and well, and sends you sincere greetings. I still have the drawing and also the cast of that agate vase you have seen (which I bought for 2000 gold crowns) but I do not possess the mold for it. It was no larger than an ordinary decanter of somewhat coarse glass; I remember having measured it, and it contained exactly the quantity which in our language is ineptly called a *pot*. This jewel was sent to the East Indies in a vessel which fell into the hands of the Hollanders, *sed periit inter manus rapientium ni fallor.** Although every inquiry was made of the East India Company in Amsterdam, it has not been possible to learn any news about it.[7] *Iterum vale.*

I should like very much to know whether your worthy brother, M. de Valavez, is in good health. I beg you to kiss his hands for me, and assure

* But unless I am mistaken, it perished at the hands of the plunderers.

him that in all the world he has no servant who recalls more often the favors received, or who desires more ardently to serve him than I do.

In addressing your letters to me, instead of saying "Gentleman-in-Ordinary of the Household," etc., will you please write "Secretary to His Catholic Majesty in his Privy Council." I ask this not from vanity, but in order that your letters may be safely delivered to me, on the occasions when they do not pass through the hands of my brother-in-law, M. Picquery.

– 236 –

To Peiresc *Antwerp, May 31, 1635*

Monsieur:

You will have already seen, from my previous letter, that I have received through M. Le Gris the news of the favorable outcome of my lawsuit in Parliament, thanks to the favors and good offices of your friends, as I have written you at some length. My thanks are far below your deserts, which bind me to perpetual gratitude, as long as I live and breathe, to honor and serve you with all my power. M. Aubéry [1] informs me that my opponents have not yet yielded, but have made a civil appeal which has been placed in the hands of the Councilor Saulnier, for him to look over and make a report upon. I understand nothing of chicanery, and am so simple as to have thought that a decree of the Parliamentary Court was the final decision in a lawsuit, without appeal or subsequent rejoinder, like the sentences passed by the Sovereign Councils in this country. I cannot, therefore, imagine what can be the object of this appeal. I did not fail to send at once to Mme. Saulnier the examples of my prints which were ordered by M. Le Gris when he passed through here. When I urgently requested him to tell me what I owed those who had coöperated in this affair, for expenses, gifts, and acknowledgments, he begged me to defer this until his return (Mme. Saulnier excepted; he wished her to be acknowledged at once). He said he did not happen to have the account and wanted to make the distribution himself; that in the meantime he had left everything in good order, so that during his absence nothing might be wanting. He assured me that M. d'Aubéry had undertaken to procure everything necessary for the entire settlement of the affair, but he did not tell me that he would disburse any money, as I see he has done, by the copy of d'Aubéry's letter to you, stating that he has paid twenty *écus quarts* for the fees. He made no mention of this in the letter he wrote to

397

me on May 22. Now I do not know what to do, whether I ought to repay this sum only to M. d'Aubéry immediately, or await the return of M. Le Gris and make the whole payment at once. Or is it better to write to M. d'Aubéry, saying that I assume that in the absence of M. Le Gris he has paid the expenses of my lawsuit, to whatever amount was necessary in order to bring about a settlement, and begging him to inform me how much I owe him, so as to reimburse him as soon as possible — which I will do promptly, and add some trifle as a mark of gratitude, etc. As to the doubt about the three-year interval between the first and the last privilege, this was based upon the date inscribed under the smaller "Crucifixion" [*in margin*: 1632]; but the numbers are engraved so ambiguously that one can hardly discern whether the last figure is a 1 or a 2. It must necessarily be a 2, though its horns and projections are not sufficiently indicated. Everyone knows that in 1631 I was in England, and this engraving could not have been done in my absence, since it has been retouched several times by my hand (as is always my custom).[2] But since this point was not contested by my adversary, there is no need of bringing it up. We shall see what the outcome of the appeal will be.

We are very much disturbed here by the passage of the French army which, on its way to aid the Hollanders, put Prince Thomas [3] to rout [*in margin*: near Marche en Famenne]. This was more important for the discredit and alarm it caused than for the damage; very few were killed, but the greater part of the caissons of the infantry were captured, as well as artillery and baggage. This loss is attributed to the temerity and unpreparedness of the general who, without spies and without information as to the numbers, strength, and movements of his enemy, was willing to fight at such a disadvantage that he was defeated in less than half an hour. Many men escaped in a nearby wood, aided by the ruggedness of the terrain.

It is certain that the rupture between the two crowns is coming to a climax.[4] This causes me great uneasiness, for I am by nature and inclination a peaceful man, the sworn enemy to disputes, lawsuits, and quarrels, both public and private. Besides, I do not know whether in time of war the privilege of His Majesty would be valid; if not, all our efforts and expenses to obtain the decision in Parliament for the purpose of maintaining it will have been fruitless. (The States of the United Provinces have regarded their privileges to me as inviolable even in time of open war.) Above all, I dread the thought that our correspondence will perhaps run the risk of a new interruption for some years — not on my part, but because you, being a person of eminence, in high office, may not be

able to carry it on without incurring some suspicion. I shall always conform, although with infinite regret, to whatever shall be required, for your tranquillity and security. And herewith I humbly kiss your hands with a true heart, remaining ever

<div align="right">Your most humble and obliged servant,</div>

Antwerp, May 31, 1635 <div align="right">Peter Paul Rubens</div>

Of the little box we have no news as yet; and I am recovering, by divine grace, from my gout. I have given orders for the trifles you asked me for, but as for the medals mentioned in the notes, M. Rockox has been unable, so far, to find a single one.

It remains for me to speak of the marvels you tell me about the movement of stones toward the center of gravity (which I well understand). But I ingenuously confess that I have hitherto never found any mention of the movement away from the center of the place where they are formed, toward the circumference; I do not understand how this happens, unless you explain it more clearly. Also incomprehensible to me is the cause of the sympathetic movement, according to the motions of the moon, of the stones in the bladder of that relative of yours who is ill. But my time is up, owing to certain obligations, and I am forced to leave these discussions, so interesting and agreeable to my taste, until a better opportunity. And once more I kiss your hands.

<div align="center">– 237 –</div>

To Peiresc <div align="right">*Antwerp, August 16, 1635*</div>

Monsieur:

I should not have dared to write to you in these turbulent times had not correspondence been reëstablished between the two kingdoms, so that the Paris post goes and comes as usual. Besides, you have induced me to reply to your last letter of June 19, which I received two days ago. I have also received letters from the courteous M. d'Aubéry. He tells me that, since the presentation of the civil appeal, the suit still remains in the same state, in spite of all his diligent efforts to obtain a settlement. He confesses that the times are very unfavorable for me, and that the strongest argument of my opponent is the state of war between our two countries. This man alleges that with my prints I draw immense sums

out of France, and that I wish to continue my monopoly at the expense of the public. All this is so false that I dare to affirm under oath that I never, either directly or through an agent, have sent examples of my prints into France except to the Royal Library, as gifts to certain friends, and those few which I sent at your request to M. Tavernier,[1] who has never asked any more of me. If this, therefore, constitutes the difficulty, I am willing to have my prints banished from all the kingdom of France; there is enough opportunity in the rest of Europe for me to gain some honor, which I esteem more than any other profit. I have begged M. d'Aubéry to find out from the Councilor Saulnier (who is without a doubt disposed in our favor) whether the case is running into any danger, and if so, to make some arrangement with our opponent, who has indicated a similar inclination. I am a peace-loving man, and I abhor chicanery like the plague, as well as every sort of dissension. I believe that it ought to be the first wish of every honest man to live in tranquillity of mind, *publice et privatim, et prodesse multis, nocere nemini.**

I am sorry that all the kings and princes are not of this humor; *nam quidquid illi delirant plectuntur Achivi.†* Here public affairs have changed their aspect; from a defensive war we have passed with great advantage to the offensive, so that instead of having 60,000 of the enemy in the heart of Brabant, as we did a few weeks ago, we are now, with an equal number of men, in control of the country.[2] By the capture of Schenkenschans we have the keys to the Betuwe and Veluwe in our hands, imparting terror and dread to our adversaries, yet at the same time leaving Artois and Hainault well prepared against any outside assault. It is incredible that two such powerful armies, led by renowned captains, have not accomplished anything worth while, but quite the contrary. It is as if fate had upset their judgment, so that through tardiness, poor management, lack of resolution, and without order, prudence, or counsel, they have let slip from their hands all the many opportunities which presented themselves to make great progress. As a result, they were finally forced to retreat in disgrace and with great losses, reduced to small numbers through desertion, and by the butchery which the peasants have inflicted everywhere upon isolated detachments, and also by the dysentery and plague which have taken the majority of them, as one hears from Holland. Please believe that I speak without the slightest passion and say only the truth. I hope that His Holiness and the King of England,

* Both publicly and privately, to render service to the many, and to injure no one.
† Whatever errors the kings commit, the people must suffer for (Horace, *Epistles* 1.2.14).

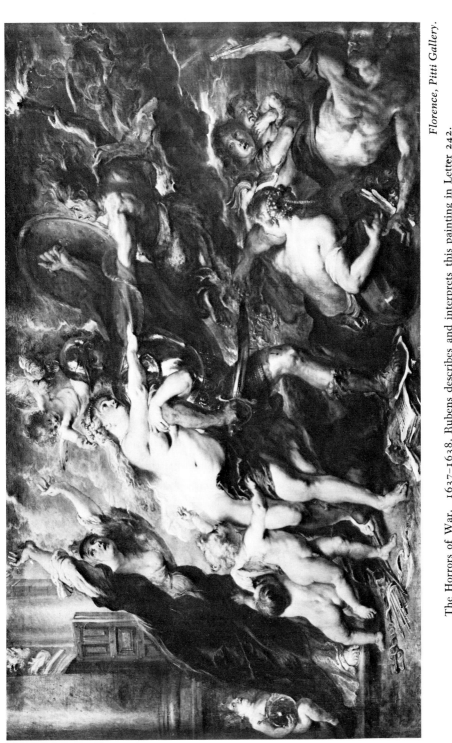

The Horrors of War. 1637–1638. Rubens describes and interprets this painting in Letter 242.

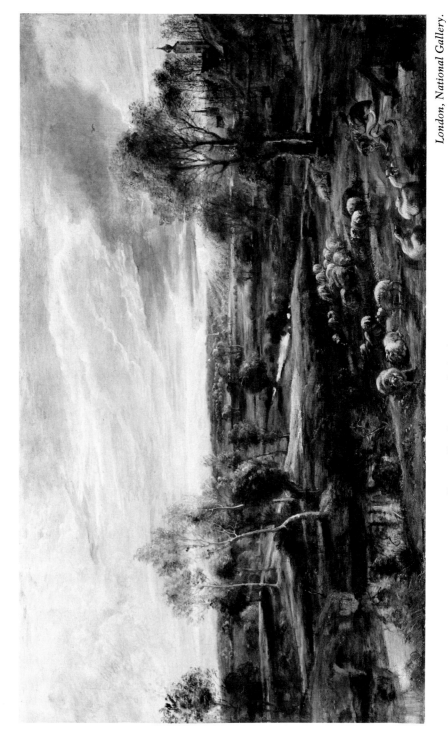

Sunset: Landscape with Castle Steen. 1635–1640.

London, National Gallery.

but above all the Lord God, will intervene to quench a blaze which (not put out in the beginning) is now capable of spreading throughout Europe and devastating it. But let us leave the care of public affairs to those whose concern it is, and in the meantime console ourselves with speculating upon our own trifles.

A few days ago I received, in very good condition, the small case with the impressions which you had the kindness to send me. It has given me the utmost pleasure, for it is full of rare things worthy of the closest examination and whose true mysteries can only be fathomed by a mind keener than mine. The large glass vase is indeed a superb monument of antiquity, but I have not yet been able to guess its subject. This vase has been well cast in lead, with the concave parts of the design clearly indicated. I would not find anyone here who could do it as well. The Trojan who stands in the background and wears a mitered cap with cheekpieces and ribbons could perhaps be Paris. He stands thoughtful, as though in love, with his finger on his lips, like Harpocrates, pondering in his mind some secret enterprise. But in the rest of it I do not see anything which corresponds to this subject, for all the figures are nude, like gods or heroes. However, I do see a youth carrying off a woman.

And now, having let off a little steam for this time, I shall wait until later, for further orders from you, to continue. In the meantime I'll gather together some trifles to fill a box, similar in size, but not in the quality of its contents, to the one you had the kindness to send to me. Already I have the impression of the bowl and the spoon in tin; but as for the agate vase,[3] I have only a plaster cast. Since the vine leaves which encircle it are deeply undercut, it is extremely difficult to make a mold of it. At the worst, I shall send you my own plaster cast, which has not been hollowed out, and give you the measure of its capacity. And for the rest, I shall find something which I hope will not displease you. But that is enough on the subject of antiquity.

I have nothing more to tell you about the marvelous discoveries of Father Linus,[4] since you have had a first-hand report from M. Dormal. (All the Fathers of the Society in our country believe there is some magnetic force in this operation, and some of them are trying to imitate it.) The strong impressions which visible objects make upon your eyes seem to me more curious with regard to the lines and contours of forms than to the colors, and less so for colors resembling a rainbow than if they are the proper colors of the objects. But I am not as versed in this subject as you think, and do not consider my observations worthy of being put into writing.[5] I shall always be willing, however, to tell you what comes to

my mind, to entertain you with my ignorance. But since the hour is now later than I should like, we shall have to content ourselves for this time with the hope that, since great catastrophes are rarely perennial, but usually of short duration, the Lord God will find some relief for our miseries and will grant me the happiness of enjoying these delightful conversations with you by way of letters for many years more. And so, humbly kissing your hands, I commend myself to your good graces, and remain eternally

Antwerp, August 16, 1635

Your most devoted and humble servant,
Peter Paul Rubens

– 238 –

To Peiresc *Antwerp, March 16, 1636*

Monsieur:

It was only a few days ago that I received your most welcome letter, already old, of December 23, along with the engraving of the antique landscape. My reply has also been delayed by an absence of several days, against my liking, in Brussels. This was for some private business, and not for such employment as you suppose (I tell you this in good faith, and beg you to have complete trust in my words). I confess, however, that in the beginning I was asked to exert my efforts in that affair.[1] But I was not given sufficient latitude for my taste, there was some difficulty about my passport, and to this was added a certain voluntary reluctance, not to say evasiveness on my own part. And since there was no dearth of those most eager for such employment, I have preserved my domestic leisure, and by the grace of God, find myself still at home, very contented and most ready to serve you.

Inasmuch as I have a horror of courts, I sent my work to England in the hands of someone else. It has now been put in place, and my friends write that His Majesty is completely satisfied with it.[2] I have not yet received payment, however, and this would surprise me if I were a novice in the ways of the world. But having learned through long experience how slowly princes act in others' interests, and how much easier it is for them to do ill than good, I have not, up to now, had any thought or suspicion of unwillingness to grant me satisfaction. For my friends in that Court sustain me with good hopes, always assuring me that the King will treat me in a manner worthy of himself and me. Nevertheless, I confess

402

that, according to the familiar proverb, "He who wants something, goes himself; he who does not, sends another," I should have gone there in person, to settle things well. But I tell you this only the better to assure you of my desire for peace of mind and my determination to avoid, as far as it depends upon me, every disturbance and intrigue. Thus also I am very little troubled over my lawsuit in Paris, which has been swept aside by the torrent of public affairs. But M. Le Gris writes me that my privileges remain safe and valid. For the rest, I do not see what favor the Procurator of the King has granted me, as against my adversaries, who demanded the confiscation of the *Planches et Images etc. de Rubens.* For I haven't a crown to lose in that whole kingdom. Perhaps M. d'Aubéry meant to say *Les planches des copies condamnées à être rompues,* or that my prints would be confiscated if found in others' hands — a loss which does not bother me — or that my designs are to be banned from the Kingdom of France — which also doesn't disturb me (although such a thing has never been done in the world). So that, strictly speaking, my side could not demand anything but the confiscation of the expenses, and these are owed me by sentence of the judges; but I cannot understand how my adversaries should be excused from paying costs which they have been condemned to pay, and which rightly should concern the Royal Exchequer.

But let us leave these trifles, which do not merit so long and tedious a discourse. I have looked with pleasure at the engraving of the antique landscape,[3] which seems to me purely an artist's caprice, without representing any place *in rerum natura.* Those arches, one above another, are neither natural nor constructed, and could hardly subsist in that fashion. And those little temples scattered on the top of the cliff haven't enough space for such buildings, nor is there any path for the priests and worshippers to go up and down. That round reservoir is of no use, since it does not hold the waters it receives from above, but discharges them again into the common basin through many very wide outlets, so that it pours out incomparably more water than it receives. The whole thing may be called, in my opinion, a *nymphaeum,* being like a confluence *multorum fontium undique scaturientium.** That little temple with three female statues could be dedicated to the nymphs of the place, and those on the summit of the hill to certain deities of the fields or mountains. The square building is perhaps the tomb of some hero, *nam habet arma suspensa prae foribus,*† the cornice is adorned with foliage and the columns with

* Of many fountains flowing from all sides.
† For it has arms hung at the entrance.

festoons and torches. At the corners are baskets in which to place the fruits and other gifts *quibus inferias et justa solvebant defunctis et tanquam oblatis fruituris Heroibus parentabant.*‡ The goats are sacred to some deity, for they are grazing without a shepherd. The picture appears to have been painted by a good hand, but as far as optics are concerned, certain rules are not too accurately observed, for the lines of the buildings do not intersect at a point on a level with the horizon — or, to put it in a word, the entire perspective is faulty. Similar errors are to be seen in certain buildings represented on the reverse of medals which are otherwise well done, and particularly in hippodromes drawn in poor perspective. Some bas-reliefs, even by a good hand, have the same defect, but such ignorance is more tolerable in sculpture than in painting. From this I conjecture that, notwithstanding the precise rules of optics laid down by Euclid and others, this science was not as commonly known then, or as widespread, as it is today. That is all I can tell you on this subject.

I enclose here the drawings of the ancient helmet, in the same size as the original, and also the bas-relief of the Trojan War, drawn by one of my pupils from the Arundel marble itself. But, as this is really very ancient, and the figures have no more than two feet, being somewhat damaged by time, little of the perfection can be seen in the faces. I hope you will already have received my essay on the subject of colors. And having nothing else to say this time, I commend myself with all my heart to your good graces, and humbly kissing your hands, I remain ever

<div align="right">Your most humble and devoted servant,</div>

Antwerp, March 16, 1636 <div align="right">Peter Paul Rubens</div>

– 239 –

To Peiresc <div align="right">*Steen, September 4, 1636*</div>

Monsieur:

You will have been surprised at my long silence, which really makes me blush when I think of it. The reason for it is not entirely laziness, nor is it any cooling of affection toward you. To tell the truth, I have been living somewhat in retirement for several months, in my country house which is rather far from the city of Antwerp and off the main roads.[1] This makes it very difficult for me to receive letters and also to send them.

‡ Which they offered to their dead as sacrifices and obsequies, and gave to their heroes, so to speak, for their enjoyment.

I received your last one, with the drawings of the ancient helmet, the lance, and two swords, a few days before my departure, but forgot to bring it with me, in order to be able to reply in leisure to the points which you discuss so interestingly, according to your custom. I shall answer it as well as I can, at my first return to Antwerp, which will be soon, please God. I shall also carry out your request and verify the capacity of my ancient porringer, and do all the other things in my power for your pleasure. For I am charged with endless obligations toward you, which bind me for life to your service.

As a climax to this superabundance of favors, you have added the colored drawing I wanted so much, which I received through my brother-in-law, M. Picquery, with the copy of that ancient painting [2] which was discovered in Rome in my youth, and being unique, was admired and adored by all lovers of painting and antiquity. It came to me without a letter, but the superscription and the quality of the gift made me recognize the author, and to tell the truth, you could not have made me a present more acceptable, or one that conformed more to my taste and my desire. For even though the hand of the copyist is not excellent, he has been obedient in imitating the original, and has represented the color and the style fairly well, if my memory does not deceive me. But it may have become somewhat vague, after so many years. Once more I offer you eternal thanks, and beg you to think of whatever lies within my power; as for the little I possess in the way of rarities, it is absolutely at your disposal.

I cannot pass over in silence the fact that in this place are found many ancient medals, mostly of the Antonines, in bronze and silver. And although I am not very superstitious, I confess that it did not seem to me a bad omen to find on the reverse of the first two that came into my possession: SPES and VICTORIA. They are medals of Commodus and his father, Marcus Aurelius.

I omitted to tell you that I saw in Antwerp, before my last departure, a very large volume entitled *Roma Sotterranea*, which really seems to me a great and deeply devout work.[3] For it represents the simplicity of the primitive church which, though it surpassed all the world in piety and true religion, remained far behind ancient paganism in grace and elegance. I have also seen letters from Rome which announce the publication of the *Galeria Giustiniana*, at the expense of the Marquis Giustiniani.[4] This is to be a most noble work, and I hope that within a few months some examples of it will come to Flanders. But I suppose that each new fruit comes in all its freshness into your museum. And since I cannot

think of any other subject to entertain you, I humbly kiss your hands, and pray heaven to grant you long life and health, with prosperity and contentment. And I remain, with all my heart, ever

Your most humble and obliged servant,
From my Castle Steen, September 4, 1636 Peter Paul Rubens

– 240 –

To George Geldorp *Antwerp, July 25, 1637*

Dear Sir:

Your honored letter of the last of July [June ?] is in my hands and I am now enlightened, for I could not imagine what occasion there might be for an altarpiece in London. As regards time, I must have a year and a half, in order to be able to serve your friend with care and convenience. As for the subject, it would be best to choose it according to the size of the picture; for there are subjects which are better treated in a large space, and others which call for medium or small proportions. But if I might choose or wish for a subject according to my taste, relating to St. Peter, it would be his crucifixion, with his feet uppermost. It seems to me that that would enable me to do something extraordinary, yet according to my means. Nevertheless, I leave the choice to the one who will pay the expenses, as soon as we know how large the picture is to be. I have great affection for the city of Cologne, because it was there that I was brought up until the tenth year of my life. And I have often had the wish to see it again, after so long. However, I am afraid that the perils of the times, and my occupations, will deprive me of this, and many other pleasures. And so I commend myself, with all my heart, to your good graces, and remain ever

Your affectionate servant,
Antwerp, July 25, 1637 Peter Paul Rubens

– 241 –

To Francis Junius *Antwerp, August 1, 1637*

Dear Sir:

You will be very much surprised not to have heard, long before this, any news of the receipt of the book which, according to your letter of May 24,

406

was sent to me before that date. Yet I beg you to believe that the afore-said book was brought to me only fourteen days ago, by a man from this city named Leon Hemselroy, with many excuses for so late a delivery. That is the reason your letter has not yet been answered, for I wanted first to see the book and to read it, which I have now done, with close attention. To tell the truth, I feel that you have greatly honored our art by this immense thesaurus of the whole of antiquity, recovered with so much diligence, and arranged for publication in the most beautiful order. For this book of yours, to put it in a word, is truly a rich storehouse of all the examples, opinions, and precepts which, relating to the dignity and honor of the art of painting, scattered everywhere in ancient writings, have been preserved to our day and to our great advantage. I believe, therefore, that the title and argument of your book, *De Pictura Veterum*, are fully justified, and that you have attained your end by inserting here and there axioms, laws, judgments, and examples which shed the greatest light for us. Expressed with admirable erudition, a most elegant style, and in correct order, this entire work is carried out with the greatest per-fection and care, even to the slightest details. But since those examples of the ancient painters can now be followed only in the imagination, and comprehended by each one of us, more or less, for himself, I wish that some such treatise on the paintings of the Italian masters might be carried out with similar care. For examples or models of their work are publicly exhibited even today; one may point to them with the finger and say, "There they are." Those things which are perceived by the senses pro-duce a sharper and more durable impression, require a closer examina-tion, and afford a richer material for study than those which present themselves to us only in the imagination, like dreams, or so obscured by words that we try in vain to grasp them (as Orpheus the shade of Eu-rydice), but which often elude us and thwart our hopes. We can say this from experience; for how few among us, in attempting to present in visual terms some famous work of Apelles or Timanthes which is graphi-cally described by Pliny or by other authors, will not produce something that is insulting or alien to the dignity of the ancients? But each one in-dulging his own talent, will offer an inferior wine as a substitute for that bittersweet vintage, and do injury to those great spirits whom I follow with the profoundest veneration. It is rather that I adore their footsteps, than that I ingenuously profess to be able to follow them, if only in thought.

I beg you, my dear sir, to receive well the things I have taken the friendly liberty of saying, in the hope that, after such a good appetizer,

you will not deny us that crowning of the feast which all of us desire so much. Hitherto no one has satisfied our appetite, among all those who have treated the material. For it is necessary, as I have said, to speak of individual personalities. Whereupon I commend myself, with all my heart, to your good favor, and sincerely thanking you for the honor you have done me by the presentation of your book and your friendship, I remain ever

<div align="right">

Your humble and affectionate servant,
Peter Paul Rubens
</div>

Antwerp, in haste, and standing on one foot,
the first of August, 1637

<div align="center">

– 242 –
</div>

To Justus Sustermans *Antwerp, March 12, 1638*

Dear Sir:

I hope that you will have received my letter in response to your last of February 10, in which I acknowledged receipt of the Tragedy and gave you due thanks for such a favor.

Now I must inform you that M. Schutter came to call on me today at home, and paid me 142 florins, 14 sous, in fulfillment of the entire payment for that picture which I did at your order and for your service. I gave M. Schutter the receipt for this sum. I asked information of M. Annoni, in order to be able to speak with certainty, and he tells me that he sent the case, with the picture, three weeks ago to Lille, whence it will go on to Italy. Please God that you receive it soon and in good condition. I hope that the roads in Germany, since the capture of Hannau and the defeat of the Duke of Weimar, will be cleared of all dangerous obstacles.

As for the subject of the picture, it is very clear, so that with the little I wrote to you about it at the beginning, the remainder will perhaps make itself better understood to your experienced eye, than through my explanation. Nevertheless, in order to obey you, I will describe it in a few words.

The principal figure is Mars, who has left the open temple of Janus (which in time of peace, according to Roman custom, remained closed) and rushes forth with shield and blood-stained sword, threatening the people with great disaster. He pays little heed to Venus, his mistress, who, accompanied by her Amors and Cupids, strives with caresses and

embraces to hold him. From the other side, Mars is dragged forward by the Fury Alekto, with a torch in her hand. Nearby are monsters personifying Pestilence and Famine, those inseparable partners of War. On the ground, turning her back, lies a woman with a broken lute, representing Harmony, which is incompatible with the discord of War. There is also a mother with her child in her arms, indicating that fecundity, procreation, and charity are thwarted by War, which corrupts and destroys everything. In addition, one sees an architect thrown on his back with his instruments in his hand, to show that that which in time of peace is constructed for the use and ornamentation of the City, is hurled to the ground by the force of arms and falls to ruin. I believe, if I remember rightly, that you will find on the ground under the feet of Mars a book as well as a drawing on paper, to imply that he treads underfoot all the arts and letters. There ought also to be a bundle of darts or arrows, with the band which held them together undone; these when bound form the symbol of Concord. Beside them is the caduceus and an olive-branch, attribute of Peace; these also are cast aside. That grief-stricken woman clothed in black, with torn veil, robbed of all her jewels and other ornaments, is the unfortunate Europe who, for so many years now, has suffered plunder, outrage, and misery, which are so injurious to everyone that it is unnecessary to go into detail. Europe's attribute is the globe, borne by a small angel or genius, and surmounted by the cross, to symbolize the Christian world.

That is as much as I can tell you, and it seems to me too much, because with your sagacity, you will have understood it easily. And so, having nothing else with which to entertain or bore you, I commend myself, with all my heart, to your good graces, and remain ever, etc.

Antwerp, March 12, 1638

I am afraid that a fresh painting, after remaining so long packed in a case, might suffer a little in the colors, particularly in the flesh tones, and the whites might become somewhat yellowish. But since you are such a great man in our profession, you will easily remedy this by exposing it to the sun, and leaving it there at intervals. And if need be, you may, with my permission, put your hand to it and retouch it wherever damage or my carelessness may render it necessary. And once more I kiss your hands.

To George Geldorp *Antwerp, April 2, 1638*

Dear Sir:

Having learned through M. van Lemens that you would like to know in what state is the work that I have undertaken, at your order, for one of your friends in Cologne, I hasten to inform you that it is already well advanced, and I hope that it will be one of the best pieces that has ever left my hands. You may freely tell this to your friend. However, I should not like to be pressed to finish it, but ask that this be left to my discretion and convenience, in order to be able to do it with pleasure. For even though I am overburdened with other works, the subject of this picture attracts me more than all the others I have on hand. I have not written to your friend in Cologne, because I do not know him, and I thought it better to have you as intermediary. And so, commending myself heartily to your good graces, I remain ever

<div style="text-align:right">

Your affectionate servant,
</div>

Antwerp, April 2, 1638 Peter Paul Rubens

To Lucas Fayd'herbe *Steen, August 17, 1638*

My dear and beloved Lucas:

I hope that this will find you still in Antwerp, for I have urgent need of a panel on which there are three heads in life-size, painted by my own hand, namely: one of a furious soldier with a black cap on his head, one of a man crying, and one laughing. You will do me a great favor by sending this panel to me at once, or, if you are ready to come yourself, by bringing it with you. It would be a good plan to cover it with one or two new panels, so it may not suffer on the way, or be seen. We think it strange that we hear nothing about the bottles of Ay wine; that we brought with us is all gone.

 And so, with best wishes for your health, and for little Caroline and Susanna also, I remain, with all my heart, dear Lucas,

<div style="text-align:right">

Your devoted friend,
</div>

Steen, August 17, 1638 Peter Paul Rubens

Take good care, when you leave, that everything is well locked up, and that no originals remain upstairs in the studio, or any sketches. Also, remind William the gardner that he is to send us some Rosile pears as soon as they are ripe, and figs when there are some, or any other delicacy from the garden. Come here as soon as you can, so the house may be closed; for as long as you are there, you cannot close it to the others. I hope that you have taken good care of the gold chain, following my orders, so that, God willing, we shall find it again.[1]

<center>– 245 –</center>

To Philippe Chifflet *Antwerp, February 15, 1639*

Monsieur:

I confess my ignorance, that I do not understand what His Eminence Cardinal Bagno [1] means by the words "to give him in a sheet of paper, as in an oblong picture the size of the façade of a large hall," etc. For you speak to me of a tapestry which presupposes an entire story distributed in seven or eight pieces, while Monsignor the Cardinal makes mention of only a single piece. Also this is a matter which requires inspection of the place and detailed information about measurements, proportions, and number of pieces. But above all, I beg you to mention to His Eminence my personal indisposition, since the gout very often prevents my wielding either pen or brush — and taking up its usual residence, so to speak, in my right hand, hinders me especially from making drawings on a small scale. I am sorry not to be the able man that His Eminence once knew, and I beg him to accept my good will for the deed. I humbly thank you for the present of this pretty little book you sent me, and wish I had something for your diversion, of similar material, which I hope I shall not fail to find. In the meantime, I kiss your hands, Monsieur, as

<div align="right">Your very humble and affectionate servant,</div>

Antwerp, February 15, 1639 Peter Paul Rubens

I beg you, on my behalf, to kiss the hands of Monsieur your brother, the doctor, to whom my son confesses to owe great obligations.

<center>411</center>

To Balthasar Gerbier *Antwerp, March 15, 1640*

Monsieur:

It is true that Mr. Norgate,[1] when he was at my house, looked at that picture of St. Lawrence in Escorial without noticing the rest, except very slightly. It did not then seem to me necessary to undeceive him, for I did not wish to displease him. But finding myself pressed to speak the truth, in order not to deceive His Majesty of Great Britain, to whom I have so many obligations, I confess that the said picture is not by my hand. It is painted entirely by a very mediocre painter of this city (called Verhulst) [2] after a drawing of mine done upon the spot. Thus it is in no way worthy of appearing among the marvels of the cabinet of His Majesty, who will always be able to dispose absolutely of all that I have in the world, as well as my person, his very humble servant. I beg you to keep me in his good favor and yours, and to honor me with your commands on every occasion when I may serve you, being, with all my heart,

<div align="center">Monsieur,</div>

<div align="right">Your very humble servant,</div>

Antwerp, March 15, 1640 <div align="right">Peter Paul Rubens</div>

To Lucas Fayd'herbe *Antwerp, April 5, 1640 (?)*

Monsieur:

Here attached you will find the certificate you asked of me, which I believe will speak sufficiently in your favor, and will also suffice to assist you, insofar as depends upon my credit. I greatly desire that it will be able to help you, and that the fine work that you have on hand will make a favorable effect from the outset. I pray also that God will grant you, as well as your beloved, every sort of blessing. I beg you to kiss the hands of your dear one on my behalf and on that of my wife; we shall always be ready at her service and for your advancement. Wherewith we com-

mend ourselves to your good graces, and to your father and mother, and I remain, with all my heart, Monsieur,

<div align="center">Your very affectionate friend and servant,</div>

Antwerp, April 5, 1638 [1640?] Peter Paul Rubens

Certificate for Lucas Fayd'herbe *Antwerp, April 5, 1640*

I the undersigned declare and attest by this document that it is true that M. Lucas Fayd'herbe has lived with me for more than three years and has been my pupil, and that, through the relationship that exists between our arts of painting and sculpture, he has been able, by my instruction and his own diligence and good disposition, to make great progress in his art. I declare that he has done for me various works in ivory, very praise-worthy and well executed, as the pieces prove; above all is the figure of Our Lady, for the church of the Béguinage of Malines, which he made alone in my house (without the help of any other hand) and carried out so remarkably well that I do not think there is a single sculptor in all the land who could do better. Therefore I believe that it behooves all the lords and town magistrates to favor him and encourage him with honors, franchise, and privileges, that he may take up residence among them, and embellish their dwellings with his works. In testament whereof, I have written and signed this with my own hand.

Antwerp, April 5, 1640 Peter Paul Rubens

<div align="center">– 248 –</div>

To François Duquesnoy *Antwerp, April 17, 1640*

I do not know how to express to you my obligation for the models you have sent me, and for the plaster casts of the two *putti* for the epitaph of Van den Eynde in the Chiesa dell' Anima. Still less can I praise their beauty properly. It is nature, rather than art, that has formed them; the marble is softened into living flesh. I hear the praises for the statue of St. Andrew, just unveiled, and I, along with all our nation, rejoice and participate in your fame. If I were not detained here by age, and by gout which renders me useless, I should go there to enjoy with my own eyes, and admire the perfection of works so worthy. Nevertheless, I hope to see you here among us, and that Flanders, our beloved country, will one day be resplendent with your illustrious works. May this be fulfilled

before I close my eyes forever, so that I may look upon all the marvels of your hand, which I kiss most affectionately, praying that God may give you long life and happiness.

Your most affectionate and obliged servant,
Antwerp, April 17, 1640 Peter Paul Rubens

– 249 –

To Balthasar Gerbier [*Antwerp, April 1640*]

Monsieur:

Here is the picture of St. Lawrence in Escorial, finished according to the capacity of the master, but with my supervision. Please God, the extravagance of the subject may give some pleasure to His Majesty. The mountain, which is called La Sierra de S. Juan en Malagon, is very high and steep, and very difficult to climb and descend, so that we had the clouds far below us, while the sky above remained very clear and serene. There is, at the summit, a great wooden cross, which is easily seen from Madrid, and nearby a little church dedicated to St. John, which could not be represented in the picture, for it was behind our backs; in it lives a hermit who is seen here with his mule. I need scarcely say that below is the superb building of St. Lawrence in Escorial, with the village and its avenues of trees, the Fresneda and its two ponds, and the road to Madrid appearing above, near the horizon. The mountain covered with clouds is called La Sierra Tocada, because it almost always has a kind of veil around its top. There is a tower and a house on one side; I do not remember their names particularly, but I know the King used to go hunting there occasionally. The mountain at the extreme left is La Sierra y Puerto de Buitrago. That is all I can tell you on this subject, remaining ever, Monsieur

Your very humble servant,
Peter Paul Rubens

I forgot to say that at the summit we found *forze venayson*, as you see in the picture. [*Note in another hand, in English*: He means deare, wich is called venson when putt in crust.]

414

To Lucas Fayd'herbe *Antwerp, May 9, 1640*

Monsieur:

I have heard with great pleasure that on May Day you planted the may in your beloved's garden; I hope that it will flourish and bring forth fruit in due season. My wife and I, with both my sons, sincerely wish you and your beloved every happiness and complete, long-lasting contentment in marriage. There is no hurry about the little ivory child; [1] you now have other child-work of greater importance on hand. But your visit will always be very welcome to us. I believe that my wife will, in a few days, go to Malines on her way to Steen, and so she will have the pleasure of wishing you good fortune by word of mouth. In the meantime please give my hearty greetings to your father-in-law and your mother-in-law, who will, I hope, rejoice more and more every day in this alliance, through your good conduct. I send the same greetings to your father and also to your mother, who must be laughing in her sleeve, now that your Italian journey has fallen through, and instead of losing her dear son, she has gained a new daughter who will soon, with God's help, make her a grand-mother. And so I remain ever, with all my heart, etc.

Antwerp, May 9, 1640 Peter Paul Rubens

APPENDIX

SELECTED ORIGINAL TEXTS

APPENDIX

Letter 42, to Hans Oberholtzer, from Antwerp, April 3, 1620

a Monsieur Monsieur Hans Oberholtzer
agent de son Altesse de Neoburgh in Brusselles
 cito cito cito

Monsieur:

J ay consigne les peintures au mesme marchand [*in margin*: Il sappelle
Jeremias Cocq] auquel jay livre la peinture du jugement car il me monstra
ordre dun sieur correspondent de Francfort lequel estait du charge de role de
part de son Altesse. Il me dit d'estre bien assouré de bon addres. Ayant eu
devant quinze jours advis de Coulogne quils estoyent arrivees en bon estat et
incontinent depesches outre. Voila tout ce que jay de certain et sil vous plait
je vous envoydray par escrit tous les noms des marchans auquels ils sont
addresses de lieu en lieu. Mais je pense que ce peu suffira pour assurer son
Altesse quelles sont tres bien adressees. Esperant que nous aurons bien tost des
nouvelles de leur bon arrivement ce pendant je vous baise les mains et
demeure
 Monsieur

d'Anvers le 3 d'Aprile Vostre tres affectione serviteur
1620 Pietro Pauolo Rubens

Letter 56, to Chancellor Pecquius, from Antwerp, January 22, 1624

A Monseur Monseigr le Chiancellier de Brabant
A Brusselles cito cito

Illustrismo Sigre

Haverà visto V S Illusma la Risposta portata dal Cattolico, il quale non hà
voluto passar per la via ordinaria, come si è usato sino adesso, d'indriccarsi a
V S Illusma et al Sigr Marchese, ma sen è andato à drittura verso la Serema
Infanta et gli l'ha consigniato in propria mano, con molte querelle è lamenti,
che si tratta per altra via e che sono state mandate persone espresse al Principe
d'alcuni ministri di questa Corte, etcetera. In somma costui non se fida
d'alcuno et ha sospetto della sua umbra, et in primis di V S Illusma et di me
si dubita molto che piglio Il Sigr Idio per testimonio d'haverlo trattato da
fratello et ancora le Sigrie vostre mi faranno fede della mia sincerità. Ma
questo fra noi. Ho però voluto avertirne V S Illusma perche nulla ignori. Fra

tanto sapendo ch il negocio non patirà per questo, io sarei di parer che lui fosse alquanto mortificato et havendo noi bisogno di guadagnar tempo che stentasse da verò, per ottenerla risposta et che senza preiudicio del negocio lui imparasse a stimar et riverire gli amici è Padroni et diventasse per l'avenire piu cauto y meno presumtuoso à sprezzar gli ministri del Principe. Et per fine baccio a V S Illustr^ma con tutto le cuore le mani et gli raccommando il secreto de quante gli scrivo in tal confidenza come se io tratasse col proprio mio Padre.

D'Anversa a gli 22 di Gennaro 1624

Di V S Illus^ma
Humilissimo Servitore
Pietro Pauolo Rubens

Letter 57, to J. J. Chifflet (?), from Antwerp, April 23, 1624

Monsieur

Je nay pas respondù à vostre premiere cuidant vous envoyer quant et quand le dessein par icelle requis, aussi je ne pensoye pas estre necessaire vous advertir ce pendant de ma bonne volunte de vous servir en cecy vous ayant offert de bouche mon treshumble service non seulement en ce particularitè mais selon toute la possibiltè de mes forçes en toutes occasions que jamais suffriroyent de pouvoir faire chose que vous seroit agreable. Voici le dessein bien rude mais en conformitè de son original duquel l'artifice sent son siecle, Aussy je crains qu il sera reusci trop grand mais il est bien facile de le faire en moindre estendue de papier per craticulam sans alterer la proportion. En quoy je vous eusse servy tresvoluntiers si neust este que vous m'escrives de vouloir seulement faire tailler l'enfant enveloppè, le quel je vous envoye à part exprimè assez exactement comme me sembla. S il y at aultre chose en mon pouvoir qui vous aggree elle sara toujours preste a vostre commandement et moy en personne a jamais manqueray d estre

Monsieur

Vostre tres humble serviteur
Pietro Pauolo Rubens

Anvers ce 23 d'Avril 1624

Letter 83, to the Marquis Spinola, from Antwerp, June 29, 1626

Ex^mo Señor

Tengo miedo de cansar a V.E. con mis cartas, aunque se deve ymputar mi ymportunidad, a las ocasiones que se offrezen y no a mi. Por agora me ocurre de dar parte a V.E. de lo poco que me escrive aquel Amigo de Zelanda, con el qual V.E. me ha mandado que tenga correspondenzia. Es verdad que por la dificultad del pasage, las cartas son casi siempre algunos dias mas viejas que

no debrian. Escrivenme, que las cartas venidas ultimamente, de la flota de la Compañia Oçidental, que se entretiene, en el Cabo de Lope Gonzalez devajo el segundo grado de alla de la linea, equinoçial traen que havia, tomado algunos Vageles pequeños de poco valor que servian de botin, ligero, para solo mantener en buen humor aquella flota, pero no para dar algun emolumento a la Compañia Oçidental, lo qual entendido de aquellos super intendentes, an puesto a la orden promptisimamente quinze naves poco proveidas, de soldadesca, pero con treinta marineros por cada una, que partieron a los 20 de Mayo açia el dicho Cabo de Lope Gonzalez con esperanza, de allar alli la sobre dicha flota. La comission del Almirante, destas quinze naves fue de hazer extremada diligençia, para juntarse con aquella flota, y repartir buena parte de sus matalotes, sobre ella que tiene grandissima nezesidad, y correr juntamente açia la costa, de la Brasilia, con disignio de recuperar la Baya de todos Santos, al improviso. Esto es çierto, (como escrive este,) [*in margin*: son las palabras del correspondiente] y sirva por aviso ynfalible a S. Md la causa desta festinaçion, es no obstante que la Compañia Oçidental esta resoluta de embiar a aquella buelta una flota de 30, naves, que algunos Portugueses, tomados de Cosarios, y examinados rigurosamente han depuesto que la dicha costa del Brasil esta mal proveida, de defensores y particularmente la Baya de todos los Santos, con la çiudad de San Salvador y ser guardada con tal negligençia que aun no estan reparadas las ruinas que hizo nuestra Artilleria quando se recobro la dicha plaza. [*In margin*: Yo hablo en persona de aquel Zelandes.] Yo he avisado dos meses ha que la dicha Compañia Armava 30, naves, para este efecto, pero la relaçion, destos Portugueses, ha hecho preçipitar el negoçio, por la esperanza, grande, que tienen estos super yntendentes, de poderse valer de su flota que esta en el Cabo de Lope Gonzalez, y de hazerse dueños de la Baya, de sobresalto. Mereçeria, el gasto de avisar a Su Md con un expreso de este evidente peligro, y quiza seria tiempo de avisar al Governador de la Baya, con alguna caravela de aviso, para que estuviese advertido, y sobre la guardia, asi me escrive adverbum, aquel amigo de que me remito al juizio de V.E. y humilmente le beso las manos.

<div style="text-align: right">

De V.E. humilisimo servidor,
Pedro Paulo Rubens
</div>

De Amberes a 29, de Junio 1626

Letter 90, to Pierre Dupuy, from Antwerp, October 8, 1626

Molto Illusre Sige mio Ossermo

Benche non mi sento troppo ben disposto per scrivere non posso tralasciar di dar aviso a V S della nova arrivata hoggi in questa citta y creduta universalte da tutti. Che Il Sigr Conte Enricho de Berghes essendo avisato come gli Ollandesi marçiavano in troppa di mille Cavalli di gente sçielta per disturbar quel opera del divertimento del Reno con un canal artificiale verso la mosa la quale io scrissi a V S colla mia antecedente che al giudicio mio sarebbe il soggietto della nostra guerra per questo anno e forse dalcuni seguenti. Pose

donq il sudetto Conte tre mille moschettari in emboschata viçino à Calcar. Che foçero l'effetto cosi à proposito che la maggior parte degli adversari resto presa y morta. Il giorno non posso dire cosi precisamente ma si crede il secondo o terzo di questo mese y sono arrivati alcuni hoggi di Brusselles ch'affermono d'haver veduto quattro stendardi presi mandati dal Conte Enrico alla Sereniss^ma Infanta per contrasegno della sua vittoria. Non pare che il moderno Sig^r Principe d'Oranges habbia il genio di Marte tanto propiçio come il fratello alla cui gloria arrivara difficilmente se questi infelici primitie del suo governo non verranno oscurate delle prosperita conseguenti. Spero che col ordinario seguente potro dar a V S qualq maggior particularita di questo successo. Ne havendo altro per adesso bacio a V S con tutto il cuore le mani.

<div align="center">
Di V S molto Illus^re

servitor affettuos^mo

Pietro Pauolo Rubens
</div>

d'Anversa il 8 d'Ottobre 1626

Letter 91, to Jacques Dupuy, from Antwerp, October 15, 1626

Molto Illus^re Sig^r mio osser^mo

Ho inteso con gran sentimento l'indispositione del Sig^r suo fratello et mi dispiace in estremo trovando mi simil^te al letto con una terziana molto gagliarda di non poter sustituire per sostento della nostra corrispondenza un mio fratello che gia di molti anni Il Sig^r Idio mi ha tolto, mi rimetto donque ala discretione y cortesia delle Sig^re vos^re di ricevere queste poche righe in recompensa molto inuguale della compytiss^ma y copiosiss^ma sua lettera del 4 d'Ottobre che mi ha dato una singolar consolatione per la varieta d'avisi ch'ella contiene con alcuni punti brevi et efficaci che gli accompagnano. Io mi trovo languido di corpo et animo perche non ostante la remission de la febre V S sa che gli giorni intermittenti vengono occupati da medici con purge e sangrie e simil rimedij più gravi tal volta che il male istesso. I percio V S m'excusara se la lettera sara di poco vigore y conforme a chi la scrive. Et per maggior compendio (sendo la cosa più importante ch'abbiamo per adesso per di qua la zuffa et invasione del Conte Enrico de Berghes nel quartiero de la cavallaria Ollandese che stava accampata insieme colla loro infantaria (alquanto appartata pero) vicino al Reno per impedir il taglio e divertimento di quel fiume dal suo corso ordinario nella Mosa) mando a V S una imagine in stampa colla relatione similmente in stampa di quella fattione alla quale V S potera prestar fede ancor che sia scritta con alquanto di passione perche si confronta colle lettere scritti da tutti le parti delle quali si deve presupponere questo esser un estratto, eccetto pero quel ultimo aviso de Wesel del 6 d'Ottobre Il quale io tengo per falso et adiectivo del Autore. Ancora nella imagine non e osservata alcuna proportione del sito o cosmographica [*in margin*: geographica] symmetria solamente V S potra considerar le citta e fiumi ivi nominati e ricorrere a qualq altra carta più

accurata e contentarsi di cognoscere in questa imagine il luoco dove si fa questo taglio et gli posti de gli duoi esserciti. [*In margin*: nel numero di presi e morti non çie exesso nessuno in questa relatione perche veramente sono presi circa mille cavalli ma non tanti huomini che non arrivano à quattrocento et altretanti morti in circa.] Io non ho potuto per la mia indispositione tradur questa relatione della lingua fiamminga en lingua francese ma spero che non manchara a V S Il Sig\(^r\) Grotio di far questo officio al quale io supplico V S sia servita di bacciar le mani a mio nome. Pare che gli Ollandesi vorrebbono divertire le nostre forze et ancora questa notte passata hanno tentato di tagliar alcuni argini quivi vicini pur in vano. Par che Il Marchese Spinola ha l'occio per tutto e perçio non ostante che la sua presenza fosse molto necessaria a Dunquerque non ha voluto partirsi del centro ne abbandonnar la Ser\(^{ma}\) Infanta per poter prender et esseguire tutti le resolutioni opportuni secondo l'occorrenze che nascono de repente d'un hora a l'altra. Ne avendo altro per deça che meriti d'occupar l'oçio suo e mio mi resta solo di ringraciar V S per l'accuratezza de gli suoi avisi tra quale il primo circa il felice arrivo del Gentilis\(^{mo}\) Sig\(^r\) de Valavez à Lyon mi e stato gratissimo augurando la medesima felicita del restante del suo viaggio, ma la morte del Contestabile rendera mendace il suo strologo chi gli haveva assicurato più di un seculo intiero di vita e una morte vittoriosa al pari di Epaminonda sopra il letto d'honore. Certo Mon\(^s\) de Crecqui ha fatto un colpo di stato sposando la cognata con poche cerimonie per giuocar sicuro y tener tanti richezze uniti che bastarebbono quasi per un Principe assoluto y potrebbono dar gelosia al soverano. Io supplico V S sia servita di voler obbligarmi con dirmi çiaramente il parer suo circa questa congiura se gli pare il caso concevuto esser stato tanto atroce come molti giudichanno dalla commissione Reggia data a gli giudici del Chalais y la sentenza de quel reo cioè chegli volesse attentar sopra la persona y vita di sua maesta che non par verisimile ad altri perche sarebbe troppa gran temerita del Gran Priore di lasciar si indurre presupponendo una tal conscienza a condurre il Ducca de Vendosme suo fratello y se stesso sopra une simplice y dolosa promessa d'impunita ne gli lacci di una inextricabil perditione oltra che si vede che si sono adesso rilassati gli fratelli del Maresal d'Ornano la sua vedova et alcuni altri. Io confesso di non penetrar questo negocio par che tanto fra tanto il Sig\(^r\) Cardinale fa bene di prevalersi della cagione et assicurarsi colle guardie che pur gli accresceranno l'invidia grand\(^{te}\), perche questo non e stato veduto sin adesso in alcun favorito che fosse al mondo eccetto Seiano. Il nostro Marchese benche Generale di tutta la militia non ha alcuno armato appresso de se eccetto nel campo ne il Sig\(^r\) Conte d'Olivares vive con tal sospetto che debba desiderar tal cosa sinon per grandezza e ornamento ma ne anco il Ducca de Boucquingam in tutti gli travagli passati e un mal talento universale d'un Regno intiero si e prevaluto di questo ultimo rimedio che solo discerne la maiesta sovrana dalla potenza privata benche grandissima. Ebbi ventura di veder Mon\(^s\) Ferrier in Pariggi et se no minganno una volta in casa di V S et ho letto alcune cose sue Anonime fatte in favore del governo presente y della pura raggion di stato del Regno di Francia senza alcun altra

consideratione o rispetto del Cattolichismo che mi piacquero in estremo in quanto alla eleganza del stilo e nervosita d'argumenti. Del Theophilo ho visto poco eccetto qualq cosa in onore del gia Princ^{pe} d'Oranges et alcuni lamenti durante la sua priggonia ma quel famoso suo Satirico che fu causa mali tanti non e gia mai pervenuto alle mie mani. ben mi ricordo che in Pariggi alcuni lo tenevono per un Atheo et Corottore della nobilta giovenetta, i quelli della Croce rosea [*in margin*: et ancora molti altri] ne facevano grandiss^m conto. E penoso che nella morte [*in margin*: che leva la maschara alle simulatione] non gli sia stato concesso per quel empirico di disingannar gli uni o gli altri. Ma non potendo più faro fine con baciar a V S con tutto il cuore le mani pregandola di voler far il simile al Sig^r suo fratello da mia parte la cui convalescenza y salute desidero quanto la mia propria et ad ambidue mi racomando humil^{te} in gracia restando

<div align="right">

delle Sig^{re} Vostre
Humiliss^{mo} et Affet^{mo} Servitore
Pietro Paulo Rubens

</div>

d'Anversa il 15 d'Ottobre 1626

Letter 116, to Pierre Dupuy, from Brussels, July 7, 1627

A Monsieur Monsieur du Puy a Paris

Molto Illus^{re} Sig^r mio osser^{mo}

Sarò breve perche mi trovo in viaggio y con poco soggietto di poter scrivere cose digne della sua noticià. La Serenis^{ma} Infanta e tornata per la gracia divina sana e salva della visita del canal novo, della cui riuscita nessuno dubita, ma alcuni sono di parer che l'opera potria andar in longo no travagliandosi à maggior furia, ne con maggior numero d'operaij. Ma S A propria che ne restava contentissima mi disse che non çi trovava difficulta alcuna et che continuandosi il lavoro nel modo che si era cominçiato. In breve tempo si ridurrebbe a buon fine. Mi disse di più haver ordinato che si facessero alcuni forti nella ripa opposta et si mettessero ivi alcuni regimenti di fantaria (oltre la cavallaria) a frente de Banderas per diffesa e sicurezza di lavoranti ma nominò ancora S A una somma delle spese fatte sin adesso tanto poca chio non ardisco di proferirla et mi dubito che ella sia ingannata da gli suoi ministri. Non so se con questo mio viaggetto mi sarà scapato il primo carro alla volta di Pariggi ma tornando io a casa che sara col aiuto divino fra un giorno ò due al più non mancara d'inviar le cose promesse a V S colla prima commodità. Qui non intendiamo che la flotta Inglese si sia mossa sin adesso et poi che tarda tanto potria esser che non uscisse con gran effetto. Il Ambasciator Carlethon e arrivato alla Haya il 19 del passato e posta l'ordine della Giarrettiera al Sig^r Principe d'Oranges. Questo e almeno il pretesto che si per sorte serve di coperta a quelq negocio secreto io non posso divinarlo. Le cose de gli Ollandesi vagno assai prospero in ambidue le Indie y particolar^{te} verso il Brasil onde rapportano piu di venti navi presi

caricate di succaro et altre merçi di valore di quel Corsaro famoso da V S avisato. [*In margin*: Queste navi erano d'Amberes ma locate e caricate da Portughesi.] Le lettere d'Ollanda non fanno cosi gran rumore ne fanno mentione d'una somma tanto eccessiva come mi scrive Il Sig^r Ambasciatore nostro di Pariggi. Ho letto con gusto e compassione le lettere del S^r Comte de la Chappelle che mi paiono esser una canzone d'un Cigno moribundo et mostrandole al Sig^r Marchese S Ex le volse leggere tutte nel medesimo instante et in fine mi disse non esser possibile che fossero scritte colla ansieta e batticuore di un condannato a morte pur determinato quanto esser si possa ne gli pareva esser il stilo di un Gentilhuomo armigero ma di qualq valenthuomo versatissimo nelle buone lettere. Qui non crediamo che l'armata Inglese si sia mossa ancora a danni d'alcuno e per conto nostro nonne abbiamo gran apprensione. Con tutto cio stiamo a la mira si come ancora fa Il vostro Re preparandosi con molta prudenza e valore al peggio che potria occorrere. Ne havendo altro per adesso mi racomando humil^{te} nella buona gracia di V S et il Sig^r suo fratello et ad ambiduoi bacio humil^{te} le mani.

<div style="text-align:right">

Di V S Molto Illus^{re}
Servitor Aff^{mo}
Pietro Pauolo Rubens

</div>

Di Brusselles il 7 di Giulio 1627
ho scritto questa lettera anticipata^{le} perchè
non potrei farlo al tempo competente per
causa del mio viaggare.

P.S. Noi stiamo soppesi per la venuta del Sig^r Don Diegho Messia presupponendo probabil^{te} che gli non abbandona ne anco per pochi mesi quel posto eminento che tiene in Spagna ne differisce le sue nozze colla figliuola del nostro S^r Marchese senza qualq necessita urgente la quale non penetriamo ancora benche si sa che porta negocij di grand^{ma} consideratione.

[*Marginal postscript*:] Pochi giorni inansi l'arrivo di S A al canale gli ollandesi havevano presi e ruinati cinque o sei ridutti et condotti priggioni qualq centinaro di quei lavoranti e guasti buona parte de gli instromenti sendo restati morti ancora qualq pochi d'ambi le parti benche del canto nostro si fece poca resistenza sendo quel luoco mal provisto de soldadesca.

Letter 139, to Pierre Dupuy, from Antwerp, December 25, 1627

Molto Illust^{re} S^r mio Osser^{mo}
La sterilita di questa staggione per di qua concorre colla fretta ch io mi sento adesso per la brevita del tempo. Il Sig^r Marchese Spinola insieme con quello de Leganès et Don Filippo Ducca di Sesto primogenito del Spinola partira Lunedy prossimo e si riscontraranno per strada col S^r Don Carlos Colonna che sara hormai viçino al suo governo de Cambray. Si dubita che Il Conte Henrico de Berghes non sia troppo contento partito de Corte ove si e firmato

pochissimo. Il Re di Francia mostra d'esser generoso e fermo nel suo proposito di non voler lasciarsi scappar delle mani la Rochella havendo l'occasion cosi bella la qual sola al parer mio potrebbe impedire l'accordo con Inglesi li quali essendo la ruina apparente di Rochellesi et causata da questa lor impresa non possono sotto alcun colore abbandonnarli. Habbiamo nova d' Ollanda che la flotta occidentale sia arrivata in Spagna o ivi viçino ma non habbiamo qui alcun aviso straordinario di una cosa tan importante che si fa dubitar della verita di questa nova. La supplico un perdono se finisco troppo secchamente sendo stracorsa l'hora che non mi permette altro che baciar a V S et al S^r suo fratello humil^te le mani.

<div align="right">

Di V S molto Illus^re
Servitor Aff^mo
Pietro Pauolo Rubens

</div>

d'Anversa il 25 di Xembri 1627

Letter 169 (fragment), to Pierre Dupuy (?), May–August 1628

Del ritorno del S^r Marchese non çi e nova alcuna che causa a S A et a tutti gli ben intentionati un grandissimo dispiacere.

Qui si tiene per certo che gli Inglesi habbiano avuto qualq attentato sopra Calais con intelligenza d'alcuni di quel presidio e particolar^te con uno chiamato du Parcq che si dice esser preso del resto non habbiamo particolarità alcuna. Alcuni vogliono che Boulogna habbia corso il medesimo rischio che mi par troppo nisi qui duos sectatus Lepores neutrum capit.

Letter 173, to Pierre Dupuy, from Antwerp, June 29, 1628

Molto Illust^re Sig^r mio osser^mo

Per questa volta mi trovo si mal provisto di novità che non mi resta quasi altro da fare con V S che un nudo complimento colle debite graçie per le sue curiosissime e verissime relacioni, chella mi va dando continuamente del stato di quel Regno poi chio trovo per esperienza ch il successo sempre corresponde alle conjetture e giudicio di V S, ch'ella fonda parte sopra la certa notitia ch'ella ha di negocij corrente e parte sopra la sua prudenza che gli fa antivedere il futuro. In quanto a la Rochella io la stimo perduta senza rimedio, faççiano pur gli Inglesi ogni sforzo io sono di parere che quante volte tentaranno quel soccorso toties in eundem scopulum impingent, colla lor infamia e danno. Mi maraviglio che il marchese de Mirabel non si vergogni di far le sue solite offerte sendo stato per il passato di si poco effetto che si potrebbe dir con raggione quello che si usa per proverbio in Italia quando uno accetta quello che gli viene offerto leggiermente per complimento Voi guastate la cortesia. L'Ingliterra e fra tanto serrata che si tiene per indicio infallibile che debba sortire qualq armata tanto più che Il Re col Ducca di Buckingam furono in persona à Posmuyen a sollecitar l'essecutione. Qui

<div align="center">426</div>

stiamo con tedio aspettando la venuta del Sr Marchese che s'inganna come gli altri nelle sue speranze trapassando la longezza di Spagna ogni sua e nostra aspettatione e pacienza. La colera di gli Inglesi contra Spagnioli si e molto raffreddata forse per vedersi colla guerra di Francia in maggior bisbiglio che non pensavano, et pur l'utile che tirarebbono del commerçio. Ho trovato Il Conte Carlil secondo il suo solito più Francese che Spagniolo ma picchato sopra modo contra illos aut illum potius qui nunc penes vos rerum potitur. Qui si tratta di far un novo canale di questa citta verso Lira et Herentaels col quale si assicurarebbe gran spacio di paese dalle incursioni di nimici et le levaria a loro buona parte delle contributioni che gli rendono assai buona intrata. E cosa incredibile con quanto emolumento le due Compagnie di Levante e Ponente vadano ogni anno ingrossando le lor flotte e rendendosi poco a poco Padroni del altro Hemisphero. Ho inteso di buona parte pur in secreto et in gran confidenza per un aviso certo che hanno scoperto ultra Tropicum versus Austrum un gran paese per non dire novum orbem che sera una cosa memorabile a gli nostri tempi ma sin adesso non abbiamo particolarità dal modo come fu scoperto nè delle qualità del paese. E non avendo altro bacio a V S et al Sigr suo fratello humilte le mani et mi raccommando di vero cuore nella lor buona gracia

<div style="text-align:center">

Di V. Sigr molto Illustre
Servitor affmo
Pietro Pauolo Rubens
</div>

D'Anversa il 29 di
Giugno 1628

Al Sigr de Peiresc respondero per la via
di Marsiglia (che mi par la più breve
e senza incommodar V S) per gli nostri
mercanti qui.

Letter 247, to Lucas Fayd'herbe, from Antwerp, April 5, 1640 (?)

Monsieur:

Cy jointe vous avez l'attestation que vous avez desiré de moi, laquelle, je crois parle suffissament en votre faveur, et suffira aussi pour vous assister pour autant que dependra de mon credit. Je desire fort qu'elle pu vous assister & que le bon ouvrage que vous avez en mains sortira un bon effect au premier jour — ainsi que je l'espère avec l'assistance de Dieu que je prie vouloir vous donner ainsi qu'à votre très bien aimée toutes sortes de bénédictions. Je vous prie aussi de vouloir baisser les mains de votre tres chère de ma part & de celle de mon epouse, & que nous serons toujours prets a son service & pour votre avancement; avec que nous nous recommandons dans vos bonnes graces de vos Pere & Mere, & suis toujours de tout mon coeur

<div style="text-align:center">

Monsieur
Votre très affectionné
ami & serviteur
Pietro Pauolo Rubens
</div>

Anvers, le 5 avril
1638 [1640?]

BIBLIOGRAPHICAL NOTE

NOTES

BIBLIOGRAPHICAL NOTE

Any bibliographical discussion of Rubens' letters must necessarily place at the head of the list the *Correspondance de Rubens et documents epistolaires concernant sa vie et ses oeuvres* by Charles Ruelens and Max Rooses (6 vols.; Antwerp 1887–1909); this is the *Codex Diplomaticus Rubenianus*, further described in my Preface and referred to in these pages as *CDR*. The other publications dealing with the correspondence also are mentioned in the Preface and therefore are not listed here. The subject of the Rubens bibliography as a whole has been repeatedly and thoroughly treated by Prosper Arents. Particularly useful is his *Rubens-Bibliographie, Geschriften van en aan Rubens* (Brussels, 1943).

The Rubens letters not included in the *CDR* but which have appeared in published form elsewhere, and which I have incorporated in this book, may be found in their original texts in the following: P. Torelli, "Notizie e documenti Rubeniani in un archivio privato," in *Miscellanea di studi storici ad A. Luzio* (Florence, 1933), pp. 173–194; A. Paz y Melia, *Serie de los mas importantes documentos del Archivo y Biblioteca del Exmo. Señor Duque de Medinaceli*, Ia Serie (Madrid, 1915), pp. 395–398; *Kunstchronik und Kunstmarkt*, new series, vol. XXX (1919), p. 512; R. Lebègue, *Les Correspondants de Peiresc* (Brussels, 1943), p. 55; *Vasari Society*, vol. IX (1913–14), no. 16. I refer the reader also to Giovanni Crivelli, *Giovanni Brueghel o sue lettere* (Milan, 1868), since many of these Brueghel letters were composed and written by Rubens.

For further references I shall mention only a few of the books which have provided me with source material. For an early account of Rubens as diplomat, see Louis-Prosper Gachard, *Histoire politique et diplomatique de Pierre-Paul Rubens* (Brussels, 1877). Miscellaneous items of interest may be found in the *Bulletin-Rubens* (5 vols.; Antwerp, 1882–1910). A brief but often helpful treatment of the subject in English is Emile Cammaerts' *Rubens, Painter and Diplomat* (London, 1932). Hans Gerhard Evers' *Peter Paul Rubens* (Munich, 1942) has added to our information on the artist's manifold activities, and *Rubens und sein Werk, Neue Forschungen* (Brussels, 1944), by the same author, provides a most useful chronological table which, month by month, relates the biographical data of Rubens' career to the political events of the time. See also the catalogue of the exhibition held at Rubens' country estate, Castle Steen, in 1962: "Rubens Diplomate — Exposition au Chateau Rubens, Elewijt, organisée par le Service de Recherches Historiques et Folkloriques de la Province de Brabant, avec la collaboration de la Ville d' Anvers."

A history of the political and military activity in the Netherlands in the first half of the seventeenth century is treated in some detail by a contemporary work:

BIBLIOGRAPHICAL NOTE

Lieuwe van Aitzema's *Saken van staet en oorlogh*, vols. I and II (The Hague, 1669). I have relied heavily upon the *Correspondance de la Cour d'Espagne sur les affaires des Pays-Bas au XVIIe siècle* by Henri Lonchay and Joseph Cuvelier (Brussels, vol. I, 1923; vol. II, 1927), which provides a concise summary of state documents preserved in the archives of Brussels and Simancas. A more comprehensive history of the Thirty Years' War is to be found in the *Cambridge Modern History*, vol. IV (New York, 1934). For a social and cultural history, see G. N. Clark, *The Seventeenth Century* (Oxford, 1931). And for a survey of the period in its political as well as economic and cultural aspects, see David Ogg, *Europe in the Seventeenth Century* (6th ed.; London, 1952), and Carl J. Friedrich, *The Age of the Baroque, 1610–1660* (New York, 1952).

NOTES

Letter 1

Original in the Archivio Gonzaga, Mantua. — Italian. — No address.

1. Rubens writes in the margin "the 5th of March," but this is an error. He received his passport and left Mantua on March 5, according to a letter from Vincenzo I to his representative in Madrid; he arrived in Florence on the fifteenth.
2. Rubens sometimes misspells Italian names, as in this letter, where the same gentleman is referred to later by the name "Martinello."
3. Clement VIII's Cardinal-Governor.

Letter 2

Original in the Archivio Gonzaga, Mantua. — Italian. — Address: To My Most Illustrious Sir and Most Esteemed Patron, Secretary Chieppio, in Mantua.

1. The Grand Duke of Tuscany, Ferdinand I de' Medici, uncle of Vincenzo Gonzaga of Mantua. The Grand Duke was one of the most capable and influential princes of Italy, an enthusiastic patron of the arts, and his court was one of the most sumptuous in Europe.
2. Virginio Orsini, nephew of the Grand Duke Ferdinand.

Letter 3

Original in the Archivio Gonzaga, Mantua. — Italian. — Address: To My Most Illustrious Sir and Most Esteemed Patron, Secretary Chieppio, in Mantua.

1. The Grand Duke of Tuscany had a well-organized and widespread system of espionage, with agents stationed in all parts of Italy.

Letter 4

Original in the Archivio Gonzaga, Mantua. — Italian. — Address: To My Most Illustrious Sir and Most Esteemed Patron, Secretary Chieppio, in Mantua.

Rubens' complaints about insufficient funds will be heard frequently during the period of his service at the court of Mantua. Vincenzo Gonzaga, like many princes, was as parsimonious as he was ostentatious.

Letter 5

Original in the Archivio di Stato, Florence. — Italian. — Address: To My Most Illustrious Sir and Most Respected Patron, Sig. Jan van der Neesen. In the house of Sig. Dario Thamagno or of Sig. Cavagliere Picciolini. In Livorno. In Pisa.

Jan van der Neesen is the "Flemish gentleman in the service of the Grand Duke" referred to in Letter 2. He belonged to a patrician family of Antwerp, and was the son of the Secretary of that city. He was a particular friend of Rubens' brother Philip.

Letter 6

Original in the Archivio Gonzaga, Mantua. — Italian. — Address: To My Most Serene Lord, the Duke of Mantua.

1. Annibale Iberti was the representative of the Duke of Mantua at the Spanish court. Upon his arrival in Alicante, Rubens had learned that the King was at Valladolid. This meant another long and arduous journey through mountainous country, with travel made even more difficult by the spring rains. Not until May 13 did the party reach Valladolid, only to learn that Philip III had gone to Burgos, and they must await his return.

Letter 7

Original in the Archivio Gonzaga, Mantua. — Italian. — Address: To My Most Illustrious Sir and Most Esteemed Patron, Secretary Chieppio, at the Court of His Most Serene Highness of Mantua.

1. In spite of Rubens' tactful phrases, it is evident that Vincenzo's representative in Spain looked upon him with disfavor, and grudgingly advanced the necessary funds.

Letter 8

Original in the Archivio Gonzaga, Mantua. — Italian. — Address: To My Most Illustrious Sir and Most Esteemed Patron, Secretary Chieppio, at the Court of His Most Serene Highness of Mantua.

1. A letter written at the same time by Iberti to the Duke of Mantua informs us that two of the paintings arrived undamaged: a St. Jerome by Quentin Matsys and a portrait of the Duke of Mantua by Frans Pourbus. Later he wrote that the damage to the others was not as great as had at first been supposed, and that the "Fleming" was making progress in restoring them. Only two of the paintings were damaged beyond repair; these Rubens replaced by a composition of his own, a "Democritus and Heraclitus" pronounced by Iberti to be "very good." The two canvases of "Democritus" and "Heraclitus" in the Prado were long thought to be the ones substituted for the ruined pictures, but Michael Jaffé (*Burlington Magazine*, vol. 110, 1968, pp. 183 ff.) has identified a panel in an English private collection, representing the two philosophers, as the replacement presented to Lerma.

 This letter clearly shows the young Rubens' pride in his own reputation, and at the same time reveals his frankness and honesty. While he does not hesitate to criticize the incompetence of the Spanish painters, he shows no sign of spiteful pleasure in the damage suffered by the inferior copies of his rival Facchetti. Instead, like the loyal servant of the Duke of Mantua that he is, he undertakes the task of restoring them.

2. Rubens' journey from Alicante to Valladolid apparently took him through Madrid, where he stopped long enough to see the King's pictures.

Letter 9

Original in the Archivio Gonzaga, Mantua. — Italian. — Address: To My Most Serene Prince and Most Esteemed Patron, the Duke of Mantua, in Mantua.

Philip III reached Valladodid on July 1, but Iberti was not granted an audience until the 11th, when the presentation of Vincenzo's gifts was made.

1. Without actually saying so, Rubens implies that Iberti had not presented him to the King. He gives fuller expression to his disappointment in the following letter to Chieppio.

Letter 10

Original in the Archivio Gonzaga, Mantua. — Italian. — Address: To My Most Illustrious Sir and Most Esteemed Patron, Secretary Chieppio, at the Court of His Most Serene Highness in Mantua.

1. Iberti's letter to the Duke of Mantua makes the same surprising statement, saying that except for the "Creation" and the "Planets" (copies after Raphael), the paintings, including copies after Titian, were taken for originals. He adds "and after having been retouched by the hand of the Fleming, they appeared quite different from before." Apparently no effort was made to correct this misconception.

2. The Duke of Lerma was so favorably impressed by Rubens that he had asked Iberti if the young painter might remain in His Majesty's service. While declining this proposal, Iberti had placed Rubens at the Duke's service during his stay in Spain. His departure was, in fact, postponed while he carried out various commissions for the Duke of Lerma.

3. See Letter 12.

Letter 11

Original in the Archivio Gonzaga, Mantua. — Italian. — Address: To My Most Illustrious Sir and Esteemed Patron, Secretary Chieppio at the Court of His Most Serene Highness in Mantua.

1. This letter reflects the continued tension between Rubens and Annibale Iberti. The "suspicion of carelessness or fraud" to which Rubens refers is insinuated in a letter which Iberti wrote to Chieppio on this same day, and his mention of Iberti's "fairness" and "prudence" may be tinged with irony.

2. This is the life-sized equestrian portrait of the Duke of Lerma ordered by himself. Rubens began work on it early in October, and on November 23 Iberti wrote the Duke of Mantua that the portrait was finished and that Lerma was extremely pleased. This painting, long thought to be lost, was rediscovered in the collection of the Lerma family. It is now in Madrid, in the Convento de los Frailes Capuchinas.

 Among other commissions which Rubens received from the Duke of Lerma was a series of half-length figures of Christ and the Twelve Apostles. All of these except the Christ, which is lost, are now in the Prado.

Letter 12

Original in the Archivio Gonzaga, Mantua. — Italian. — Address: To My Most Illustrious Sir and Most Esteemed Patron, Annibale Chieppio, First Secretary of His Most Serene Highness, in Mantua.

1. M. de la Brosse was the Duke's agent in France. Signor Carlo Rossi was a courtier from Mantua, at that time in Paris.

2. One of Rubens' assignments in Spain was to paint a series of portraits of the court ladies for the Duke of Mantua's "Gallery of Beauties." This was also the reason for the proposed visit to the court of France. In Letters 10 and 11, Rubens' brief references to this French journey imply that he was very willing to undertake the mission. But this letter shows a change of attitude, and clearly

reflects the young artist's consciousness of his own merit. Whether or not the letter played any part in relieving him of this obligation, Rubens returned from Spain to Mantua, early in 1604, by way of Genoa, without making the detour to France.

Letter 13

Original in the Archivio Gonzaga, Mantua. — Italian. — Address: To My Most Illustrious Sir and Esteemed Patron, Annibale Chieppio, Secretary Councilor of His Most Serene Highness in Mantua. — This letter is written not by Peter Paul Rubens, but by his brother Philip. The painter had been ill and was perhaps still unable to write.

Letter 14

Original in the Archivio Gonzaga, Mantua. — Italian. — Address: To My Most Illustrious Sir and Esteemed Patron, Annibale Chieppio, Councilor and First Secretary of His Most Serene Highness in Mantua. — This letter also was written by Philip Rubens.

1. Sta. Maria in Vallicella was built for Philip de Neri, founder of the Order of the Oratory, on the site of an old chapel dedicated to St. Gregory. It is still known by the name "Chiesa Nuova," as it was in Rubens' day. Begun in 1575, after the plans of Giovanni Matteo da Città di Castello, its construction was so rapid that by 1599 the church was complete, except for the façade. This was finished in 1605 by Martino Lunghi. It was not until after 1650 that the nave paintings were carried out by Pietro da Cortona.

2. Scipione Cardinal Borghese was an ardent patron of the arts. Among his titles was that of "Protector of Germany and the Low Countries," which may explain why Rubens refers to him.

3. The Duke of Mantua granted Rubens' request. On December 13 he wrote to Chieppio: "We are satisfied to grant to Peter Paul the term of three months which he desires, to remain in Rome in order to complete the work he has at hand. You may inform him that he may do as he likes for these three months, but that by Easter he is to come, without fail, to Mantua . . . that we are willing to grant him more, rather than less, than he desires."

Letter 15

Original in the Rubenshuis, Antwerp. — Italian. — Address: To My Most Illustrious Sir and Esteemed Patron, Annibale Chieppio, First Secretary and Councilor of His Most Serene Highness in Mantua.

Rubens' brother Philip had just returned to Antwerp and the painter was alone in Rome and in need of funds. His good friend Chieppio seems to have advanced a sum from his own coffers. The "difficulties" besetting the treasurer in Mantua are the exorbitant expenditures incurred by the forthcoming marriage of the Duke's eldest son Francesco and the nomination of the second son to the Cardinalate.

Letter 16

Original in the Archivio Gonzaga, Mantua. — Italian. — No address.

As the date indicates, Rubens had already stretched his three-month extension in Rome to six. One reason for this was the active part he played in proposing and purchasing for Mantua Caravaggio's "Death of the Virgin." This painting, now in the Louvre, had just been rejected by S. Maria della Scala as unfit for an altarpiece (CDR, I, 362–368).

1. The Duke's plan was to go to Spa for his health, but he soon changed his mind. He went to Genoa instead, and Rubens probably went with him, although there is no documentary evidence.

2. A dispute on civil versus church rights was at that time raging between the Republic of Venice and Pope Paul V, and had brought Italy to the brink of war. Jacobo Cardinal Serra had left Rome at the head of the Papal army, but peace was reëstablished through the intervention of Henri IV of France.

3. This image of the Madonna had formerly occupied a niche in a public place, and according to popular belief, possessed a miraculous power. It was now to be the crowning feature of the high altar of the Chiesa Nuova. It is a mediocre painting in an oval frame. Since it was considered too sacred to be shown except on certain days, Rubens was commissioned to paint another Madonna and Child on an oval panel to fit into this frame and cover the miraculous picture.

Letter 17

Original in the Archivio Gonzaga, Mantua. — Italian. — Address: To My Most Illustrious Sir and Esteemed Patron, Annibale Chieppio, Secretary and Councilor of His Most Serene Highness, in Mantua.

1. Rubens' second picture on slate still decorates the high altar of the Chiesa Nuova. Whereas the first had been a single canvas representing Saints Gregory, Maurus, and Domitilla adoring the Virgin, this second version was in three parts, the central section over the altar, with three saints in each of the side sections occupying the side walls of the choir. The reasons for such a complete change of scheme are not clear. Rubens here speaks of painting a "copy" of the first composition, requiring no new studies, and which he expects to finish in two months at the most. In the following letter, however, he says that the Fathers have given him the liberty of making whatever variations he wishes. See Michael Jaffé, "Peter Paul Rubens and the Oratorian Fathers" (*Proporzioni* IV, 1959).

2. It is strange that after eight years as court painter Rubens was still not represented by a major work in the Ducal Gallery at Mantua. Even this persuasive suggestion of his was not accepted. Chieppio wrote to the Duke's agent in Rome, Giovanni Magno, who had also warmly recommended the purchase: "I do not find His Highness disposed to acquire the painting of Sig. Peter Paul. We are now proceeding with great reserve in the matter of expenses. . ."

Letter 18

Original in the Archivio Gonzaga, Mantua. — Italian. — No address.

1. Rubens did not find a purchaser for this painting in Rome. He therefore had it sent after him to Antwerp, where he later set it up in the Abbey of St. Michael, over his mother's tomb. Today it is in the Museum of Grenoble.

2. The marriage of the Duke of Mantua's eldest son, Francesco, to Princess Margaret of Savoy.

3. Il Pomarancio, whose real name was Cristoforo Roncalli (1552–1626), was at that time one of the most fashionable painters in Rome. According to the biographer Baglione, Caravaggio was so jealous of Il Pomarancio's success that in 1605 he attempted to have him murdered by a hired assassin. Rubens in this letter swallows with good grace his disappointment at the rejection of his own painting by the Duke of Mantua, as he negotiates the acquisition of a work by his popular rival. It was just a few months before that Rubens had

purchased Caravaggio's "Death of the Virgin" for Mantua at a price of 350 gold crowns. The Ducal Treasury, in objecting to Il Pomarancio's high price of 500 crowns, argued that his picture was not even as large as the Caravaggio. The 400 crowns estimated as a fair price by Rubens was finally paid by the Duchess of Mantua in July 1608.

Letter 19

Original in the Archivio Gonzaga, Mantua. — Italian. — No address. — Written in a more rapid hand than usual.

1. The Duke of Mantua, with a suite of thirty-three persons, was making an extended tour which included a visit to Brussels, where he saw the Archduke Albert, and to Antwerp.
2. There is no direct evidence that Rubens himself had any desire to leave Italy before he received the news of his mother's serious illness. His brother Philip had returned to Antwerp in the summer of 1607, and he was probably responsible for the letter the Archduke Albert wrote to the Duke of Mantua in August 1607, saying that Rubens' family needed him, and requesting that he be granted permission, as a Flemish subject, to return to his own country. Vincenzo's reply, stressing Rubens' love of Italy and desire to remain there was in fact a refusal to grant the Archduke's request, although disguised by the most flowery compliments (CDR, I, 387–393). On March 1, 1608, Philip wrote to a friend in Rome, saying that his brother was thinking of returning home soon. But this also may have been more Philip's wish than Peter Paul's.
3. When Rubens left Italy, his mother had already died; her death occurred on October 19, 1608.

Letter 20

Original in the Archivio degli Orfani di Sta. Maria in Aquiro, Rome. — Italian. — Address: To the Most Illustrious and Excellent Signor Giovanni Fabro, Botanist to His Holiness, Lecturer at La Sapienza, Doctor of Medicine. In Rome. Postpaid to Venice. — The transcription of the Italian text in CDR, VI, 323–324, contains several inaccuracies. For facsimile see Bollettino d'Arte, VII (1928), 602–604.

Johann Faber was the German doctor in Rome who had cured Rubens of an attack of pleurisy in 1606. The artist in gratitude had painted the doctor's portrait, now lost, and had presented him also with a painting of a cock, as an ex-voto to his "Aesculapius." Although only slightly older than the Rubens brothers, Johann Faber was already prominent in intellectual circles during their stay in Rome. His home was the recognized meeting place for painters and students from the north.

1. Soon after Philip Rubens' appointment as one of the four Secretaries of Antwerp he married Maria de Moy, daughter of another of the Secretaries.
2. In spite of this remark, Peter Paul married into the same family just a few months later, on October 3, 1609. His wife, Isabella Brant, was a niece of his brother's wife.
3. The Twelve Years' Truce was signed on April 9, 1609, ratified on April 14.
4. Caspar Scioppius, classical scholar and controversialist, was born in the Palatinate in 1576. He went to Rome, where he was patronized by the Pope, and renounced Protestantism to become the most intolerant of Catholics. He was the author of a number of attacks upon Protestantism and its leaders.

5. Joseph Justus Scaliger, famous philologist, was born in Agen, France, in 1540, and became professor at the University of Leyden in 1593. Noted for his erudition, his greatest contribution to learning was in providing ancient history with a scientific chronology. As a Protestant convert, Scaliger was one of the chief targets of the diatribes of Scioppius. His claim to be a descendant of the illustrious Scaligers of Verona was challenged by Scioppius, who contended that he was of the Bordone family.

6. Adam Elsheimer, German painter who lived in Rome, is referred to more fully in the following letter. For further details on Rubens' relation to Elsheimer see Heinrich Weizsacker: *Adam Elsheimer, der Maler von Frankfurt* (Berlin, 1936), I, 82ff.

7. Rubens probably refers here to Count Hendrik Goudt, pupil of Elsheimer, who engraved several of his compositions.

Letter 21

Original in the Archivio degli Orfani di Sta. Maria in Aquiro, Rome. — Italian. — Address: To My Most Illustrious and Honored Signor Giovanni Fabro, Doctor of Medicine and Botanist to His Holiness. In Rome. Postpaid to Mantua. — The transcription of the Italian text in *CDR*, VI, 327–328, contains several inaccuracies. For facsimile see *Bollettino d'Arte*, VII (1928), 605–607.

1. Adam Elsheimer, born in Frankfort in 1578, had gone to Rome in 1600. This letter, with Rubens' very personal tribute to Elsheimer, provides one of the few contemporary records of this artist. Sandrart, in his *Teutsche Academie* of 1675 also mentions Elsheimer's slow method of working, his melancholy, his poverty and imprisonment for debt. In spite of his small production and early death, his influence upon Northern Baroque painting, especially of landscape, was very great.

Letter 22

Original in the Archives du Royaume, Brussels. — Flemish. — Address: Monsieur Monsieur Jaques de Bije, in Brussels.

1. Jacob de Bie, an engraver, antiquarian, and editor, was in the service of the Duke of Aerschot and had been acting as agent between Rubens and the Duke for the purchase of this painting. It is now in the Wallraf-Richartz Museum in Cologne.

Letter 23

Original in the Archives of Sta. Maria in Vallicella, Rome. — Italian. — Address: To My Most Illustrious Lord, the Most Eminent Cardinal Serra, in Rome.

1. When Rubens left Rome so suddenly in 1608, he had received only partial payment for his three great paintings for the Chiesa Nuova of Santa Maria in Vallicella. Now, four years later, he asks for the remainder due.

2. Jacomo de Haze was Father Prior of the Dominicans at Antwerp, and was sent to Rome in 1612. Upon receiving the money due Rubens, he wrote the following receipt across the foot of Rubens' letter: "I the undersigned, Jacomo de Haze, have received from the Fathers of the Chiesa Nuova, by the hand of Father Julio Cesaro, eighty crowns as the remaining and final payment due Peter Paul Rubens for the three paintings done for the said church; and in testimony I have written this receipt in Rome, this last day of March, 1612. Jacomo de Haze, by his hand."

Letter 24

Original in the Archives du Royaume, Brussels. — Italian. — No address. — The omission of any salutation or form of address, as well as the general wording of this document, suggests that it was not a letter addressed directly to the Archduke Albert, but rather a memorandum to be brought to his attention. Across the foot of the page, in the hand of a secretary, appears a note in French, beginning: "A letter to be written to His Reverence of Ghent, on the part of His Highness. . ."

1. The oil-sketch of the "Conversion of St. Bavo" in the National Gallery, London, may be the *dissegno colorito* mentioned here.

2. Charles Maes (1559–1612) had become Bishop of Ghent in 1610.

3. Bishop Maes's successor in 1612 was Francois-Henri van der Burch. In 1616 he left Ghent to become Archbishop of Cambrai, where he remained until his death in 1644.

4. In compliance with Rubens' request, the Archduke Albert intervened on the painter's behalf, but without success. In 1615 the Bishop van der Burch commissioned Robert de Nole of Antwerp to construct a marble altar with a statue of St. Bavo. This was unfinished when van der Burch left Ghent for Cambrai, and the next bishop, Jacques Boonen, made several changes, introducing a number of additional figures. The work was still incomplete in 1622, when Bishop Boonen was succeeded by Antoine Triest. This bishop gave Rubens the long-deferred satisfaction of placing his painting of the "Conversion of St. Bavo" in the center of the altar, with the statue of the saint above it. Instead of the triptych originally planned, however, there was a single picture. This remained in place only until the early years of the eighteenth century. In 1702–1719, when a new high altar was built, Rubens' painting was relegated to a side chapel.

Letter 25

Original in the Library of Christ Church, Oxford. — Flemish. — No address. — This letter is on the reverse of a drawing, a study for the "Feeding of the Five Thousand." See *Vasari Society*, IX (1913–14), no. 16. The drawing is probably not by Rubens himself, but by one of his pupils, for his studio was very active at this period. No finished painting of this subject is known, nor is M. Felix otherwise known to us.

Letter 26

Original in the British Museum, London. — Latin. — No address.

François Swert (1567–1629) was a celebrated Flemish historian and antiquarian. Rubens had evidently been asked his opinion about the subject-matter of an ancient statue or small relief. This letter bears witness to Rubens' erudition and his interest in classical antiquity.

1. William Camden (1551–1623), Master of the Westminster School in London, was an eminent English author and antiquarian. In addition to many archaeological and philological works, Camden's most famous books are the "Description of Great Britain" and the "Annals of the Reign of Elizabeth," both written in Latin.

2. To "drink like Saufeia" is a reference to Juvenal, *Satire* IX. 115. The dictum "Sacrifice a heifer," etc., is a reference to Virgil's *Eclogue* III. 77.

Letter 27

Original in the Public Record Office, London. — Italian. — Address: To the Most Excellent Sir and My Most Honored Patron Sir Dudley Carleton, Ambassador of the Most Serene King of Great Britain at The Hague. — On the back, in Carleton's hand: "Paulo Rubens the 17 of March, 1618."

Sir Dudley Carleton was born in 1573, and was educated at Westminster School and Christ College, Oxford. In 1598 he went to Ostend in the suite of Sir Edward Norris, governor of that city. He was in The Hague in 1600, in Paris in 1601. In 1610 he was knighted and appointed Ambassador to Venice, where he remained for five years. From 1615–1625 he was Ambassador to The Hague, and then Ambassador Extraordinary to France. Charles I created him Viscount Dorchester in 1628, and soon after that made him Secretary of State. He died in 1632 and was buried in Westminster Abbey. This letter is the first of the series dealing with the exchange of Carleton's marbles and Rubens' paintings.

1. George Gage, a diplomatic agent of James I, acted as agent for Sir Dudley Carleton in the purchase of works of art.
2. Frans Pieterssen de Grebbel, or de Grebber, was a Haarlem painter who specialized in historical subjects.

Letter 28

Original in the Public Record Office, London. — Italian. — Address: To the Most Excellent, Most Esteemed Sir Dudley Carleton, Ambassador of the Most Serene King of Great Britain to the Confederate States at The Hague. — In Carleton's hand: "Fro Mr. Rubens the 28 of Ap. 1618 rd the 6 th of May, and the 8 th."

1. This painting of "Prometheus" is in the Philadelphia Museum of Art; Snyders' study for the eagle, in pen and wash, is in the British Museum. (See *Burlington Magazine*, March 1952, pp. 67ff; August 1952, p. 237.)
2. This painting is now in the National Gallery of Art, Washington. The Pierpont Morgan Library possesses a chalk drawing of the figure of Daniel, and several studies of the lions have also survived.
3. Now lost. This may be the painting formerly in the collection of the Duc d'Orléans, known only by the engraving of C. N. Varin. See H. G. Evers, *Rubens und sein Werk* (Brussels, 1944), p. 226, and *Art Quarterly*, IX (1946), 29.
4. Wolfgang Wilhelm, Duke of Neuburg, Count Palatine (1578–1653). See note to Letter 39. The "much larger" "Last Judgment" is now in the Alte Pinakothek, Munich.
5. The hunting scene painted for the Elector Maximilian of Bavaria (1581–1651) was formerly mistakenly thought to be the famous "Lion Hunt" now in Munich. Ludwig Burchard has identified it as one of the set of hunting scenes mentioned by Sandrart in 1675 as decorating the castle at Schleissheim. Taken by the French in 1800, it later went to the Bordeaux Museum, where it was destroyed by fire in 1870.
6. This series of replicas of "Christ and the Apostles" is now in the Rospigliosi-Pallavicini Collection, Rome. The originals, except for the Christ, are now in the Prado.

7. In spite of the artist's praise, Carleton did not accept this picture. In 1628 Rubens took it to Spain and sold it to Philip IV; it is now in the Prado. By "the best of my pupils" Rubens means Van Dyck, who was then nineteen years of age.
8. Now in the Berlin Museum.

Letter 29

Original in the Public Record Office, London. — Italian. — No address.

From Rubens' list, Carleton's first choice was limited to the paintings by the master's own hand. The "Crucifixion" he declined because he found it "too large for these low buildings, and also those of England." The six pictures he chose amounted in the list to a value of only 3000 florins; for the remaining 3000 florins he wanted Brussels tapestries, which Rubens was to purchase for him. Rubens persuaded Carleton to accept an additional 1000 florins' worth of pictures. After trying unsuccessfully to find tapestries for the remaining 2000 florins, the artist paid this amount in cash.

1. Rubens is referring to the palatial new house on the Wapper.
2. The "Decius Mus" cycle. See Letter 31, note 3.

Letter 30

Original in the Public Record Office, London. — Italian. — Address: To the Most Excellent Sir, and my Esteemed Patron, Sir Dudley Carleton, Ambassador of His Majesty of Great Britain at The Hague.

On May 23 Carleton wrote to a friend: "I am now saying to my Antiquities 'Veteres migrate coloni,' having past a contract w^th Rubens the famous painter of Antwerp for a sute of tapistrie and a certaine number of his pictures, w^ch is a goode bargaine for us both, onely I am blamed by the painters of this country who made ydoles of these heads and statuas, but all others commend the change."

1. Lionel Wake, an English merchant established in Antwerp, was agent for Sir Dudley Carleton and was frequently employed by Rubens to pack and transport pictures.
2. In the inventory drawn up at the death of Rubens' father-in-law, Daniel Fourment, there is mention of a tapestry of the "History of Camillus," in six pieces, made at Oudenarde.

Letter 31

Original in the Public Record Office, London. — Italian. — No address. — On the back, in Carleton's hand: "Fro Rubens ye 26 of may re^d by John Frith 1618."

1. The painting is now in the collection of the Duke of Westminster, London.
2. Jan Wildens.
3. These are the cartoons for the set of tapestries which Rubens mentioned in his letter of May 12 as having been commissioned by some Genoese merchants. The cartoons have disappeared, but the paintings which served as models are now in the Liechtenstein Gallery, Vienna. They consist of six scenes from the story of Decius Mus, and Van Dyck collaborated with Rubens in their execution.

Letter 32

Original in the Public Record Office, London. — Italian. — Address: To My

Most Excellent and Esteemed Sir Dudley Carleton, Ambassador of His Majesty of Great Britain, at The Hague. Cito Cito Cito Cito. — On the back, in Carleton's hand: "Fro Mr. Rubens ye 26 May red the 28th."

Letter 33

Original in the Public Record Office, London. — Italian. — Address: To the Most Excellent Sir, Sir Dudley Carleton, Ambassador of His Majesty of Great Britain, at The Hague. — This is the note of authorization mentioned in the previous letter.

Letter 34

Original in the Public Record Office, London. — Italian. — Address: To the Most Excellent and Most Esteemed Sir Dudley Carleton, Ambassador of His Majesty of Great Britain in The Hague. — On the back, in Carleton's hand: "Fro Rubens ye first of June, red by Peterssen ye 3d 1618."

1. There is no record that Rubens really sent his portrait to Sir Dudley Carleton, or that Carleton ever sent Rubens a "memento" of himself.

Letter 35

Original in the Bibliothèque Royale, Brussels. — Italian. — Address: To Mijnheere Mijnheere Pieter van Veen, Advocate in The Hague. — Pieter van Veen, brother of Rubens' former teacher, Otto van Veen, was an eminent lawyer, Pensionary of The Hague, and in his spare time he also did some painting. This letter is the first of five addressed to Van Veen regarding a copyright, or privilege, which Rubens wished to obtain for publishing his engravings in Holland. Van Veen obligingly offered to help, but in spite of his intervention, Rubens' request was rejected by the States General of the United Provinces. Even before this adverse decision, however, the artist had sought the aid of his friend Sir Dudley Carleton, who declared himself very willing to intervene. This application was favorably received and the privilege granted.

Letter 36

Original in the Bibliothèque Royale, Brussels. — Italian. — Address: To the Honorable, Prudent and Discreet M. Pieter van Veen, Advocate in The Hague.

1. Cornelis van Aerssen, Registrar of the States General.

2. The young man here referred to was Lucas Vorsterman (1595–1675), who for two or three years enjoyed a successful and productive collaboration with Rubens as engraver of his compositions. The prints listed in this letter, for the most part by Vorsterman, initiated the "Rubens School of Engraving." See Frank van den Wijngaert, *Inventaris der Rubeniaansche Prentkunst*, Antwerp, 1940. The prints are:

The Battle of the Amazons (Wijngaert 729). Engraved in six plates, representing, with variations, the composition of the painting in Munich, Pinakothek.

Lot and his family leaving Sodom (W. 708), after the composition of the painting in Sarasota, Ringling Museum.

St. Francis receiving the Stigmata (W. 723), after the composition of the painting in Cologne, Wallraf Richartz Museum.

Nativity (Adoration of the Shepherds) (W. 711), after the composition of the painting in Marseilles, Museum.

Holy Family with young St. John (W. 722).

Holy Family returning from Egypt (W. 715), after the composition of the painting in Hartford, Wadsworth Atheneum.

Portraits of eminent men (W. 743–746), part of a series of busts of ancient philosophers, planned by Rubens.

Adoration of the Magi (W. 713), after the composition of the painting in Malines, St. Jean.

Nativity (Adoration of the Shepherds) (W. 712), after the composition of the painting in Rouen, Museum.

Descent from the Cross (W. 718), after the central panel of the triptych in Antwerp, Cathedral.

Elevation of the Cross. This composition was engraved not by Vorsterman, but by Witdoeck, in three plates (W. 760), after the painting in Antwerp, Cathedral.

Martyrdom of St. Lawrence (W. 725), representing, with variations, the composition of the painting in Munich, Pinakothek.

Fall of Lucifer (W. 707), representing, with variations, the composition of the painting in Munich, Pinakothek.

Miracles of St. Ignatius Loyola. This composition was engraved not by Vorsterman, but by Marinus van der Goes (W. 300), after the painting in Vienna, Kunsthistorisches Museum.

Miracles of St. Francis Xavier. This composition was also engraved by Marinus van der Goes (W. 299), after the painting in Vienna, Kunsthistorisches Museum.

Susanna and the Elders (W. 710).

St. Peter extracting the coin from the fish (W. 717), representing, with variations, the composition of the left wing of the triptych of the Fishermen's Guild, Malines, Notre Dame.

Hero and Leander. This composition was apparently not engraved. The Louvre, however, possesses a fine "engraver's" drawing, which may be by Vorsterman, after the painting which later found its way into Rembrandt's collection. Three versions are known today — one in the Yale University Art Gallery, one in the Dresden Gallery, and a third in Groningen. See *Burlington Magazine*, 100 (Dec., 1958), pp. 415 ff.

3. Jacques de Gheyn (1565–1629), renowned engraver, pupil of Hendrik Goltzius.

Letter 37

Original in the Statthalterei-Archiv, Innsbrück. — French. —Address: To Monsieur Monsieur P. de Vischere, Knight and Councilor of His Highness. Brussels. Cito Cito Cito. — Peter de Vischere was the Brussels agent of the Archduke Leopold of Tyrol (1586–1632). We do not know the painting referred to in this letter.

Letter 38

Original in the Public Record Office, London. — Italian. — Address: To the Most Excellent Sir and My Esteemed Patron, Sir Dudley Carleton, Ambassador of the Most Serene King of Great Britain in The Hague. — This letter gives more details on Rubens' application to the States General of the United Provinces for a copyright for his engravings. Carleton had suggested that Rubens submit one of the "Hunts" etched by Soutman, and also his "Miraculous Draught of Fishes." In gratitude to Carleton for his great service in helping to procure the privilege, Rubens dedicated to him one of the finest prints of the series engraved by Vorsterman: the "Descent from the Cross."

Letter 39

Original in the Staatsarchiv, Düsseldorf. — Italian. — No address.

Wolfgang-Wilhelm von Zweibrücken, Count Palatine, Duke of Neuburg (1578–1653), had recently embraced Catholicism and showed all the zeal of the convert. In Neuburg, his ancestral seat, he restored all the churches to the Catholic faith and founded a Jesuit college which was consecrated on October 21, 1618. It was for this church or for the parish church of Neuburg that the altar of St. Michael was intended. This was not Rubens' first commission from the Duke of Neuburg. He speaks of working upon two pictures for side altars, and in the following letter declares them finished — a "Nativity" and a "Descent of the Holy Spirit." And in the list of paintings which Rubens offered to Sir Dudley Carleton we find reference to a large "Last Judgment" done for the Duke of Neuburg. All these paintings are now in the Alte Pinakothek, Munich.

1. This man was probably the Jesuit Andreas Schott, who had written a description and catalogue of the collection of medals formed by Charles de Croy, Duke of Aerschot. Schott's book was published by Jacob de Bie in 1617 under the title *Nomismata imperatorum romanorum aurea, argentea, aerea a C. Julio Caesare usque ad Valentinianum Aug.*

Letter 40

Original in the Staatsarchiv, Düsseldorf. — Italian. — No address.

1. The collection of medals of the late Duke of Aerschot was entrusted to Nicolas Rockox to be sold as a whole. It did not find a purchaser, and in 1623, when Rubens went to Paris to deliver the first of his paintings for the Palais du Luxembourg, he was asked to take a part of this precious collection with him, to be sold in lots. It was thus dispersed among various Parisian amateurs, and Rubens himself was one of the purchasers.

Letter 41

Original in the Bibliothèque Royale, Brussels. — Italian. — Address: To the Very Honorable, Wise and Prudent M. Pieter van Veen, Pensionary, at The Hague.

1. This reference must be to Junius, Secretary to the Prince of Orange, whom Rubens mentions in Letter 55, September 30, 1623, as one "who takes bribes with both hands."

Letter 42

Original in the Staatsarchiv, Neuburg. — French. See Appendix for French text. — Address: To Monsieur Monsieur Hans Oberholtzer, Agent of His Highness of Neuburg, in Brussels. Cito cito cito. — Published in *Kollektaneenblatt für die Geschichte Bayerns insbesondere des ehemaligen Herzogtums Neuburg,* LXXXV (1920), 58–60. — This letter seems to be in reply to a complaint on the part of the Duke of Neuburg that the two paintings promised in Letters 39 and 40 had not been received. We learn from the following letter that they finally arrived safely.

Letter 43

Original in the Staatsarchiv, Düsseldorf. — Italian. — Address: To the Most Serene Wolfgang Wilhelm, by the Grace of God, Count Palatine, Duke of Bavaria, Bergh, Cleves, etc. In Neuburg.

445

Letter 44

Original in the Staatsarchiv, Düsseldorf. — Italian. — Address: To His Most Serene Highness Wolfgang Wilhelm, Count Palatine of the Rhine, Duke of Bavaria, Juliers, Cleves, Bergh, etc. In Neuburg.

Letter 45

Original lost. Copy in the Public Record Office, London. — French. — An extract, transcribed from the original by William Trumbull and enclosed in a letter from Trumbull to Sir Dudley Carleton, January 28, 1621. Trumbull was a political agent of James I, resident in Brussels.

The painting which Rubens is ready to send to Sir Dudley Carleton is described in the following letter as a "Lion Hunt." This picture was not for Carleton himself, but for his friend, Lord Danvers, who wanted to present it to the Prince of Wales, the future Charles I. Rubens received in exchange a painting of the "Creation" by Jacopo Bassano (1510–1592), but because of its ruinous condition, asked in addition 100 "philips," that is, 250 florins. Carleton's agents considered this price excessive, and thought that 80 ducats, or 208 florins, would be quite sufficient. One of them wrote to Carleton: "I did, wth all ye discretion I had, deale wth him about ye price, but his demands ar like ye Lawes of Medes and Persians, wch may not be altered." In this letter, however, Rubens seems more willing to reconsider the price. He had stated that the picture was not entirely by his own hand, although he had retouched it completely. But the painting, when sent to London, pleased no one, and was returned to the artist. Rubens, on his part, returned to Lord Danvers his "Creation" by Bassano, after having thoroughly restored it.

Letter 46

Original lost. Copy in the Public Record Office, London. — French. — Enclosed in a letter from William Trumbull to Sir Dudley Carleton. — On the back, in English: "Copie of M. Rubens his letter to Willm Trumbull."

1. The "Hunt," done on Carleton's order for Lord Danvers, met with much criticism. Lord Danvers, in a letter to Carleton, May 27, 1621, says: "But now for Ruben in every paynter's opinion he hath sent hether a peece scarce touched by his own hand, and the postures so forced, as the Prince will not admitt the picture into his gallerye. I could wishe, thearefore, that the famous man would doe soum on thing to register or redeem his reputation in this howse and to stand amongst the many excelent wourkes wch are hear of all the best masters in Christendoum, for from him we have yet only Judeth and Holifernes, of littell credite to his great skill . . . and theas Lions shall be safely sent him back for tamer beastes better made."

2. Now lost. The composition was engraved by Cornelis Galle, the Elder, about 1610. Known as the "Great Judith," this was the first engraving after a Rubens painting.

3. Sir John Digby (1580–1653) was at that time English Ambassador in Brussels. This "Lion Hunt" which he ordered from Rubens is, according to Ludwig Burchard, the famous canvas now in Munich. See also David Rosand, "Rubens' Munich Lion Hunt — its Sources and Significance" (*Art Bulletin,* vol. LI, 1, March, 1969, pp. 29 ff.).

4. The New Banqueting Hall, Whitehall. The old building had burned in 1619; the new one by Inigo Jones was finished in 1622. This letter shows that even before completion of the new hall, overtures had been made to Rubens regard-

ing the decoration of the ceiling. It was not until his journey to London in 1629–30, however, that he received the definite commission. The paintings, in nine compartments, representing the "Glorification of James I," were not finished until 1634. See Letter 238, note 2.

Letter 47

Original in the Bibliothèque Royale, Brussels. — Italian. — Address: To the Honorable, Wise and Prudent M. Pieter van Veen, Councilor and Pensionary at The Hague.

This letter indicates that Rubens had in mind a trip to Holland. From his remarks, the mission may have been a diplomatic one, for the artist was already deep in politics. There is no record, however, that he went to Holland at this time.

1. The engraver was Lucas Vorsterman, mentioned in Letter 36. The profitable collaboration between painter and engraver was interrupted by Vorsterman's mental breakdown, which caused him to make threats against Rubens' life. Rubens' friends judged it necessary to send a request to the King's Privy Council, asking that Rubens be granted special protection by the public authorities. This request was granted by the Infanta Isabella in a decree of April 29, 1622. Vorsterman later went to England, but returned to Antwerp in 1630. From then until 1632 he did a great deal of work for Van Dyck. See J. S. Held, "Rubens and Vorsterman" (*Art Quarterly*, 32, no. 2, Summer, 1969, pp. 111 ff.).

Letter 48

Original in the Rubenshuis, Antwerp. — Italian. — Address: To the Honorable, Wise and Prudent M. Pieter van Veen, Pensionary in The Hague.

1. *Palazzi di Genova con le loro piante ed alzati,* Antwerp, 1622. The complete work comprised two parts, with 139 plates. In this letter Rubens refers to the first part, *Palazzi Antichi,* with 72 plates, engraved by Nicolaes Ryckemans. The second, *Palazzi Moderni,* with 67 plates, appeared shortly after. Later editions combine the two parts in one volume.

2. See Letter 21.

3. It is strange that in order to obtain a book by his former teacher, Otto van Veen, Rubens writes to the author's brother in Holland, instead of directly to the author, who is still in the Southern Netherlands, perhaps even in Antwerp. Ruelens' explanation is that Rubens and Van Veen had become estranged, when the pupil so eclipsed the master. Since the book is described as anonymous, Rubens may have been reluctant to approach the author. The book may have been *Conclusiones physicae et theologicae, notis et figuris dispositae ac demonstratae de primariis fidei capitibus, atque in primis de Praedestinatione, quomodo effectus illius operetur a libero arbitrio* (Authore Otthone Vaenio, Orsellio, 1621).

Letter 49

Original in the Biblioteca Ambrosiana, Milan. — Italian. — Address: To the Most Illustrious and Most Reverend Lord, My Most Honored Patron Lord Cardinal Borromeo, in Milan.

Jan Brueghel, the Antwerp painter known as "Velvet" Brueghel (1567–1625), had received from his patron Federigo Cardinal Borromeo, in Milan, two gold medallions of the recently canonized San Carlo Borromeo. One of these medallions Brueghel gave to Rubens, who sends this letter of thanks to the Cardinal.

The two artists were close friends. In Brueghel's long correspondence with

Cardinal Borromeo, Rubens for many years acted as his secretary, writing the letters and often signing Brueghel's name. The Biblioteca Ambrosiana preserves a number of these letters (see above, pp. 5–6, for discussion of the Brueghel correspondence). This is Rubens' only known letter written to the Cardinal on his own behalf. Brueghel and Rubens sometimes collaborated also in their painting; one such example was done for the Cardinal: the "Madonna and Child Surrounded by a Garland of Flowers," now in the Louvre.

Letter 50

Original, fragment, in the Bibliothèque Royale, Brussels. — Flemish. — No address.

Frederik de Marselaer was Treasurer of Brussels in 1622, and became Burgomaster in 1623. The letter concerns a painting of "Cambyses and the Judge," commissioned by the city of Brussels, and which ornamented the Town Hall until 1695, when it was destroyed by fire during the bombardment of the city. Rubens, in this letter, offers excuses for hesitating to accept further commissions before finishing the series of paintings for Marie de' Medici's new Luxembourg Palace in Paris. Instead of leaving Antwerp by Easter, as he had hoped, Rubens was delayed for several weeks. It was not until May 24 that he arrived in Paris with nine of the paintings for the Queen Mother. He returned to Antwerp on June 29.

The reverse of the sheet deals with politics, a subject which interested de Marselaer as much as it did Rubens. The reference is probably to a book which de Marselaer had written on the civic position and qualities of a good ambassador, and for which Rubens was to design a frontispiece. The book had first appeared in Antwerp in 1618, under the title Κηρύκειον *sive Legationum insigne*. A second edition, published by Moretus in 1629, was entitled *Legatus*, with a frontispiece by Theodore van Loon. In 1635, when Rubens became a close neighbor of de Marselaer's at Castle Steen, he promised a title page, but not until March 6, 1638, does de Marselaer mention in a letter that he has received the drawing for it. This was apparently not engraved until 1656, and the third edition of the book, with the Rubens title page, appeared in 1666. See CDR, VI, 199ff; Evers, *Rubens und sein Werk,* pp. 191–193, fig. 124.

Letter 51

Original lost. Copy, fragment. — French. — Address: To M. Sauveur Ferrary, money-changer near the chevet St. Méderic, Paris. — Published in *Archives de l'Art Français,* III (September 15, 1852), 208, by Baron de Vêze. — These lines, written in French, formed the conclusion of a long letter in Italian, dealing with financial matters and mentioning a large case of paintings and drawings which Rubens was expecting from Livorno and Marseilles. The Baron de Vêze copied this fragment from the original letter which at that time was in the possession of the Marquise de Grollier.

The person addressed may be the Louis Frarin who was to become the intermediary in the exchange of letters and gifts between Rubens and Peiresc. The date of the letter, unfortunately, is nowhere mentioned. It is generally assumed that the "studies of Sirens" were to be used in the series of paintings for Marie de' Medici. The suggested date of January 1625 is based upon Rubens' letter to Valavez of January 10, 1625, in which the artist states that he has received orders to be in Paris, with all his pictures, by February 4. But even though, as he says, Rubens expected to retouch the entire work after its installation in Paris, it seems unlikely that he would have waited until so near the completion of the series, to

do "three life-sized studies." It may be more plausible to place the letter in the spring of 1623, when Rubens was planning to go to Paris to deliver the first group of completed pictures.

Frédéric Villot, at the time he was Curator of Paintings of the Louvre, published this fragment in his catalogue, *Notice des Tableaux,* II (1853), 235, connecting it with the "Landing of Marie de' Medici at Marseilles," and considering the three "sirens" to be the three Nereids in the foreground of the painting. Ludwig Burchard suggests the three Fates who spin Marie's destiny in the first of the Medici canvases. None of the figures in the finished paintings, however, corresponds to Rubens' description of the Capaio ladies, with their "superb black hair." This brief fragment of a lost letter must remain an enigma.

Letter 52

Original in the Bibliothèque Nationale, Paris. — Italian. — Address: To Monsieur Monsieur Louys Frarin, to be delivered to Monsieur de Peiresc, Councilor of the King at the Court of the Parliament of Provence, in Paris. — Sealed in red wax, with the arms of Rubens. — In Peiresc's hand: "Rubens, August 3, 1623, Antwerp. Receipt of the ithyphallic gems; perpetual motion promised."

This is the earliest of Rubens' letters to Peiresc that has been preserved, although an active exchange of letters had been maintained from 1621. Soon after it was written, the French scholar left Paris for Provence.

1. There was an epidemic of the plague at that time in Paris.

2. This is Rubens' first mention of a subject to which he frequently returns — that of perpetual motion. The search for perpetual motion was one of the manias of this period, but most authorities on Rubens do not think that the great artist seriously believed in the solution of so hopeless a problem. In the following letter of August 10 he mocks those "alchemists who pretend to possess the Philosopher's Stone," and in Letter 196, August 9, 1629, he speaks very disparagingly of Drebbel, the inventor who claimed to have discovered perpetual motion. However, this was after Rubens had had an opportunity to see Drebbel's instrument in London. In 1623 he had only Drebbel's published description, enigmatic as it was, and there is no doubt that it interested him greatly. The instrument which, according to his promise, Rubens had constructed to send to Peiresc seems to have been somewhat similar to Drebbel's, although on a smaller scale. The artist describes it a little more fully in Letter 58, December 12, 1624, as consisting of glass tubes with a certain quantity of green water. This, along with his later reference to Drebbel's *moto perpetuo nel anello di vetro,* leads one to realize that the instrument in question was not, properly speaking, a machine kept in constant motion by its own power. It was simply an apparatus for recording atmospheric changes — in other words, a kind of barometer.

3. Jean de Montfort, medallist and bronze-caster active at the court of the Infanta Isabella in Brussels. Rubens' reference to Montfort as "compadre" may mean that he was sponsor or godfather to one of Rubens' children; this was an honor eagerly solicited by Antwerp artists.

4. The "little mirror" which magnifies things is presumably a microscope, also said to have been invented by Drebbel.

5. Antoine de Loménie was the Secretary of State of Louis XIII.

6. Claude Maugis, Abbé de St. Ambroise, was Marie de' Medici's chaplain and

acted as intermediary between Rubens and the Queen Mother while the artist was working on the paintings for the Luxembourg Palace. Peiresc, in turn, was the mediator between Rubens and the Abbé de St. Ambroise, smoothing over numerous difficulties between them.

7. Louis Chaduc was an antiquarian who possessed a large collection of pornographic medals and engraved gems. He had refused to allow Peiresc to take an impression of one of the items in his collection, and Peiresc had retaliated by refusing to sell him the gems mentioned in this letter.

8. Rubens had just received from Peiresc four erotic gems. The first Peiresc referred to as the "Victoria Nicomediana," the second as "Paris," and the third as the "Diva Vulva." The fourth is not described. Rubens devotes this letter to an interpretation of the third gem, and adds a small sketch of the design. He agrees with the explanation of Peiresc, seeing in the design a glorification of female fertility.

9. Louis Frarin was the mutual friend to whom Rubens had addressed this letter, to be forwarded to Peiresc.

10. The brother of Peiresc, Palamède de Fabri, Sieur de Valavez.

11. A gem of which Peiresc had sent a drawing to Rubens.

Letter 53

Original lost. Copy in the Bibliothèque Méjanes, Aix. — Italian. — No address. — This letter was a reply to Peiresc's letter of August 3, 1623, taking up point by point the subjects discussed by the French scholar.

1. The Basilidians in Seville were members of a mystic sect calling themselves "Alumbrados," the Enlightened. The Inquisition, alarmed at their increasing numbers, arrested 10,000 of them in 1623 and burned a number of their leaders.

2. The Rosicrucians were members of a secret society founded in Germany by Johann Valentin Andreae (1586–1654). Under the pseudonym of Christian Rosenkreuz he issued a great number of publications expounding his religious and political ideas, by which he hoped to regenerate Christianity. The book which Rubens mentions having read is probably the *Chymische Hochzeit Christian Rosenkreuz,* which appeared in 1616. The author pretends to have discovered, in the tomb of a certain Christian Rosenkreuz, the doctrines of this fourteenth-century knight who had learned the mysteries of the Philosopher's Stone and the Elixir of Life.

3. In his letter of August 3 Peiresc wrote that a certain M. Gioly (Rubens called him Goly) had sold his collection of antiquities to François-Olivier de Fontenay, who was Abbé of St. Quentin de Beauvais and a well-known amateur of books and antiquities.

4. Girolamo Aleandro (1574–1629) was one of the leading humanists of the early seventeenth century. He gained a reputation when very young for his poetry and for his studies both in law and classical antiquity. For twenty years he was Secretary to Cardinal Bandini. Pope Urban VIII chose Aleandro to accompany his nephew, Francesco Cardinal Barberini, to France (see Letter 62). Peiresc and Aleandro had much in common, in their taste for antiquities, and there was an active correspondence between them.

5. Wenceslas Coberger (*ca.* 1561–1635), painter, architect, and engineer at the

court of the Infanta Isabella, was at this time engaged in draining the marshes in the region of Wynokberga.

6. Paul Parent was a dealer with whom Peiresc and Rubens were negotiating, and whose practices they criticized.

7. Jan Caspar Gevaerts (1593–1666) was one of Rubens' most intimate friends. He had studied at the Jesuit College in Antwerp and the University of Louvain, and earned a reputation in philology. In Paris in 1617 he published his first poem, on Henri IV; this was followed by other poems and critical works. The University of Paris offered Gevaerts a professorship in history, but he preferred to return to Flanders. In 1620 he went to Louvain to study jurisprudence, and in 1621 received an honorary degree of Doctor of Laws at Douai. That year he was named Clerk of the City of Antwerp, a post which he held until 1662. Gevaerts devoted much of his leisure time to writing a commentary on the works of Marcus Aurelius, and he was the author of many Latin inscriptions which ornamented the triumphal arches and statues erected by the city of Antwerp on state occasions. His most celebrated publication of this sort was his description of the entry of the Cardinal-Infante Ferdinand into Antwerp when Ferdinand became Governor in 1635. Gevaerts had known Peiresc in Paris in 1617 and was responsible for bringing Peiresc and Rubens together. Finally, he was the author of Rubens' epitaph.

8. Alonso Cardinal de la Cueva, Marquis de Bedmar (1572–1655), had been Philip III's Ambassador to Venice and then to Brussels. After the death of Albert, he stayed on as Ambassador of Philip IV at the court of Isabella. His reason for going to Rome in 1623 was to cast his vote for Pope, but he arrived too late; the choice had already fallen upon Maffeo Barberini, who became Urban VIII.

9. Ambrogio Spinola, Marquis de los Balbases (1569–1630), was a member of the rich and powerful Genoese family who entered the military service of Spain. As commander-in-chief of the Spanish army in the Netherlands, he captured Ostend in 1604, after a three-year siege. With the renewal of hostilities at the expiration of the Twelve Years' Truce, Spinola was recalled to the Spanish Netherlands to lead the troops opposing Maurice of Nassau. His capture of Breda in 1625 has been immortalized by Velásquez's famous painting in the Prado. Spinola was the faithful councilor of the Infanta Isabella, sharing her devotion to the welfare of the provinces she governed. Rubens admired him greatly, referring to him repeatedly in the letters as "our Marquis." Spinola later lost favor with Philip IV and incurred the animosity of Olivares for opposing Spanish centralization in Flanders. He had been obliged to pledge his entire fortune as security for the support of the army, before the bankers would advance funds to the government of Spain; and since he was never repaid, he was in the end financially ruined. Spinola was recalled to Madrid in 1628 (see Letter 135, note 1) and he never went back to the Netherlands. In June 1629 he was sent to North Italy to combat the French. He died the following year while directing the siege of Casale (see Letter 217).

Letter 54

Original lost. Copy in the Bibliothèque Inguimbert, Carpentras. — Italian. — No address. — Published by R. Lebègue: *Les Correspondants de Peiresc* (Brussels,

1943), p. 55. — This letter refers to a collection of Latin epigrams belonging to Nicolas Rigault (1577–1654), scholar, writer, and Keeper of the King's Library. Rigault had shown and perhaps lent the collection to Peiresc, and was now seeking to locate it. Peiresc, in turn, had asked Rubens to make inquiries of their friend Gevaerts.

Letter 55

Original in the Archives du Royaume, Brussels. — Italian. — No address.

Pierre Pecquius (1562–1625), son of the celebrated jurist of that name, was Chancellor of Brabant. He had served Albert and Isabella in several diplomatic missions. This is our first of Rubens' diplomatic letters, but it is clear from the contents that his political career had begun at an earlier date.

1. The "Catholic" was Jan Brant, a cousin of Rubens' wife Isabella. Brant's uncle, mentioned in this letter, may be Rubens' father-in-law, also named Jan Brant.
2. Maurice of Nassau, Prince of Orange.
3. The Infanta Isabella.
4. See Letter 53, note 8. Cardinal de la Cueva was opposed to any negotiations with the Hollanders. There was little sympathy between him and Rubens.
5. The report was true. On September 9, 1623, the Prince of Wales (future Charles I) left Madrid, thus marking the conclusion of the ill-fated "Spanish Match," the long-drawn-out negotiations for his marriage with the Infanta Maria, sister of Philip IV. James I had seen numerous advantages in such an alliance, and Spain encouraged his hopes in order to prevent his effective help to the Protestant cause in Germany during the critical years of 1619–1623. In February 1623 Prince Charles with the Duke of Buckingham, impatient at Spain's delay, had set out incognito to win the Infanta's hand in Madrid. But Spain had already gained all she wanted from the marriage negotiations and now sought to break them off without provoking a war. Six months of royal entertainment and evasive discussion followed. To the increased demands by the Spanish court on behalf of the Catholics in England, Charles replied with lavish promises which he had little intention of keeping. On September 7 the matrimonial contract was settled, and the Infanta took the title of Princess of England, awaiting only the Papal Dispensation to become the wife of the Prince of Wales. The Prince and the Duke of Buckingham, however, had hardly returned to England than they broke off the engagement (no more popular in England than in Spain), and hostilities against Spain were at once begun. A marriage with the French princess was regarded as more advantageous, and in 1625, on his accession to the throne, Charles I married Henrietta Maria, sister of Louis XIII.

Letter 56

Original in the Archives du Royaume, Brussels. — Italian. — Address: To Monsieur Monseigneur the Chancellor of Brabant, in Brussels. Cito cito. — Rubens' seal in red wax very well preserved. — This letter is here published, with the permission of the Archives du Royaume, for the first time. For the Italian text, see Appendix.

Nearly four months have elapsed since the preceding letter. Messages are still passing between the Prince of Orange and the Infanta Isabella, without effecting any settlement between the Northern and the Southern Netherlands.

Letter 57

Original in the Historical Society of Pennsylvania, Philadelphia. — French. — No address. — Here published, with the Society's permission, for the first time. For French text, see Appendix. — This may be the letter mentioned in CDR, III, 292, as having figured in a sale of 1846, but which later disappeared. — Although the recipient of the letter is not named, Jean Jacques Chifflet may be considered a possibility. In Letter 59, December 26, 1624, Rubens mentions "a Latin book just published, by M. Chifflet: *De Sacra Lindone Vesuntina aut Sepultura Christi.*" This book, whose correct title is *De Linteis Sepulchralibus Christi Servatoris Crisis Historica* (Antwerp, 1624), deals with the history of the winding-sheet of Christ and attempts to prove that the one preserved in Besançon is the authentic one. In chapter xxviii of Chifflet's book there is an engraving of a child in swaddling clothes, described in the accompanying text as representing a marble figure brought from Rome by Peter Paul Rubens, and ornamenting his house in Antwerp. Could not this engraving be derived from the drawing of the "child in swaddling clothes" which Rubens refers to in this letter?

Jean Jacques Chifflet was a brother of the Philippe Chifflet who was also a friend of Rubens (see Letter 245). Born in Besançon in 1588, he spent years traveling throughout Europe studying museums, libraries, and collections of antiquities. Later becoming magistrate in Besançon, he was sent to the Infanta Isabella, who appointed him her physician and sent him in that capacity to Philip IV. In Spain, Chifflet wrote at the King's request a history of the Order of the Golden Fleece. He died in 1660, after having published numerous works, including several on ecclesiastical archaeology.

Letter 58

Original lost. Copies in the Royal Library, The Hague, and in the Bibliothèque Royale, Brussels. — French. — No address. — First published, in the original French by Philip Thicknesse in *A Year's Journey through the Pais-Bas, or Austrian Netherlands* (London, 1784), pp. 60–64. — Although it bears no address, this letter can only have been written to Valavez, brother of Peiresc. It is our first to Valavez, who became Rubens' Paris correspondent after Peiresc's return to Aix.

1. See Letter 52, note 2. As an example of the general interest which the seventeenth century showed in this problem of perpetual motion, see the entry in the diary of John Evelyn for January 25, 1645, where the writer, in describing the Palazzo Farnese in Rome, mentions seeing "German clocks, perpetual motions, watches and curiosities of Indian works."

2. This same merchant-carrier is more often referred to by Rubens as Antoine Souris, the French form of his name.

3. The letters of Cardinal d'Ossat to Henri IV and to M. de Villeroy had just been published in Paris. This was the Cardinal who negotiated the absolution of Henri IV and later the King's divorce from Marguerite de Valois. His letters form a classic book of diplomacy, and must have been of particular interest to Rubens.

4. Théophile Viaud (1590–1625) was one of the French satiric poets. With the publication of his first verses he aroused the displeasure of official circles, and in 1619 he was banished from France. Upon turning Catholic, he was pardoned. Soon after his return he published a new book, *Parnasse satyrique*

(referred to here by Rubens as *Satyricon*), which brought upon him the sentence of death at the stake. He escaped from Paris, however, and the sentence was carried out in effigy. Viaud's collected works appeared in 1624.

5. Charles Scribanius, Rector of the Jesuit Cloister in Antwerp, was highly regarded in intellectual circles, and was numbered among Rubens' friends. The work Rubens mentions here, for which he designed the title page, bears the title: *Caroli Scribani e Societate Jesu Politico Christianus, Philippo IV, Hisp. regi. D. D. Antverpiae, apud Martinum Nutium, anno MDCXXIV.* The *Ordonnances des Armoiries* has not been identified.

6. Spinola, the "Marquis" referred to here, had laid siege to Breda in August 1624. The city fell on June 5, 1625.

7. This Duke of Croy was Charles-Alexandre de Croy d'Havré, author of the *Mémoires guerriers* dealing with the military events of 1600–1606 in the Netherlands. He was shot at the window of his home by a page whom he had boxed on the ear. The murderer, named Pasturel, escaped to Italy; on his death-bed, thirty-two years later, he confessed his crime.

8. The work which Rubens hoped to finish within six weeks was the series of paintings for Marie de' Medici's Luxembourg Palace. The royal marriage was that of Henrietta Maria, sister of Louis XIII, and Charles I of England. It was celebrated by proxy on May 11, 1625.

Letter 59

Original lost. Copies in the Royal Library, The Hague, and in the Bibliothèque Royale, Brussels. — French. — No address. — First published, in the original French, by Thicknesse in *A Year's Journey* (1784), pp. 65–69.

1. The painting which Rubens did for Cardinal Richelieu may be the panel of "The Flight of Lot from Sodom" now in the Louvre. The painting is, in fact, fairly small in size: 29½ by 46⅞ inches, and the artist, contrary to his custom, signed and dated it: PE. PA. RUBENS FE. AO. 1625. See also the following letter.

2. These letters bear the title: *Mémoires de messire de Philippes de Mornay, seigneur du Plessis Marli . . . contenans divers discours, institutions, lettres et dépêches par lui dressées, depuis l'an 1572 jusques à l'an 1589. . .* Volume I appeared in 1624. It is pleasing to see Rubens' interest in this diplomat and friend of Henri IV whose political views made him the enemy of Spain and therefore of the Spanish Netherlands. Duplessis-Mornay was a zealous Protestant, and his dispute with Cardinal du Perron (while Bishop of Evreux) was occasioned by the book he published in 1598, *De l'Institution, usage et doctrine du saint Sacrement de l'Eucharistie en l'Eglise ancienne,* which was bitterly attacked by du Perron. On May 4, 1600, a theological discussion between the two adversaries took place at Fontainebleau. Duplessis was completely defeated, and the Protestant party suffered a severe blow.

3. See note to Letter 57.

4. The existence of this mummy could be traced until the middle of the nineteenth century. About 1850, in the sale of the collection of M. van Parys in Brussels, one of the items was a fine Egyptian mummy which, according to tradition, had been in the possession of Rubens. This was not impossible,

for van Parys was a direct descendant of Alexander Joseph Rubens, a grandson of the artist. Since that time the mummy has disappeared.

Letter 60

Original lost. Copies in the Royal Library, The Hague, and in the Bibliothèque Royale, Brussels. — French. — No address. — First published, in the original French, by Thicknesse, in *A Year's Journey* (1784), pp. 70–74.

1. See Letter 52, note 2.
2. "Madame" was the sister of the King of France, the Princess Henrietta Maria, about to be married to Charles I of England.
3. The "projected alliance" of which Rubens speaks was that of Charles and the Infanta Maria of Spain (see Letter 55, note 5). Rubens' self-portrait was not sent to Charles until 1628. It is now in Windsor Castle.
4. The question of the Valtelline was a very complicated one, and a dominating feature of the early part of the Thirty Years' War. This small region northeast of Lake Como formed one of the natural gateways through the Alps to Italy, and therefore control of the valley was of vital importance to the great powers of France, Spain, and Austria, no less than to the neighboring states of Savoy, Milan, and Venice. For Spain the Valtelline provided a passage for its troops between North Italy and the Netherlands. Aside from its strategic location, the region offered a rich recruiting ground for the levy of troops. Religion also played a part in the struggle for possession, the native Valtelliners being strongly Catholic, yet dominated by the Protestant Grisons. At the time of this letter, the French were in control of the valley. The Pope had finally been named as arbiter, but his decisions satisfied no one. In France he was said to favor Spain; in Spain he was thought to have an understanding with France. It is this to which Rubens refers.

Letter 61

Original lost. Copy in the Bibloteca Minerva, Rome. — Italian. — No address.

This letter finds Rubens in Paris, according to his instructions. He has finished the series of paintings for Marie de' Medici, and is now supervising their installation in the Luxembourg Palace. But he continues his diplomatic activity, and here he again takes up the project of a truce between the Spanish Netherlands and the rebel Provinces of Holland. The letter furnishes an interesting proof of the Infanta Isabella's confidence in the painter, that he was able to write to her so freely. All negotiations came to another standstill with the death of Maurice of Nassau on April 23, 1625.

1. For Jean de Montfort, see Letter 52, note 3; for the Duke of Neuburg, see note to Letter 39. After a long stay at the court of Brussels, the Duke had gone to Madrid in July 1624 to gain the support of Philip IV regarding his claims to the duchies of Jülich and Cleves. The King granted this support, and appointed him to the Council of State. Whether Philip also gave him the commission for negotiating a truce with the Hollanders, whether the Duke took it on his own responsibility, or whether Rubens' assumption was unfounded, cannot be determined. In the Brussels Archives are ten letters from Philip IV to the Infanta Isabella, all dated March 8, 1625, and all concerning the Duke of Neuburg, but without any mention of a commission for this negotiation at the French court. On the other hand, Philip informs Isabella in a letter of

November 7, 1625, that he has received a report from the Duke of Neuburg regarding his talks with a representative of the Prince of Orange. The Infanta, in a letter to Philip dated February 16, 1626, recalls, with regard to the Duke's negotiations with the Hollanders, that her late husband, the Archduke Albert, had always opposed the intervention of this Duke in the affairs of the Netherlands.

2. Guillaume de Bie was Secretary of the Financial Administration in Brussels. He, like Mme. T'Serclaes, had attempted, as early as 1621, to broach negotiations with the Hollanders.

3. Jean de Saint-Bonnet de Toiras was Captain of the Guard, and from 1625 Governor of Fort St. Louis at La Rochelle. In 1630 he became Marshal of France.

4. Henri de Vicq, Seigneur de Meulevelt, was Ambassador of the Infanta Isabella at the court of France.

5. See Letters 55, 56.

6. The Dominican Father, Michel Ophovius, was the victim of a trap at Heusden. He had been sent there to offer a bribe to Governor van Kessel, but was taken prisoner. See Letter 88, note 2.

7. Benjamin de Rohan, Seigneur de Soubise, born in 1583, served first in Holland under Maurice of Nassau, and subsequently shared the leadership of the Reform Party in France with his brother Henri, Duke of Rohan. In 1621 Soubise held general command of the provinces of Poitou, Bretagne, and Anjou. He defended the Huguenot fortress of St. Jean d'Angely against the troops of Louis XIII until forced to surrender. In 1625 he seized one of the royal fleets and with these ships continued the war against the King. Defeated by the Admiral de Montmorency (see Letter 68), Soubise was obliged to seek refuge in England. Although pardoned in 1626, he continued to remain in England and helped to persuade Buckingham, the following year, to send aid to the besieged La Rochelle — an expedition that ended in failure. Three times he tried to relieve La Rochelle, but without success, and the town was finally forced to capitulate. Soubise was pardoned once more in 1629, but he preferred to remain in England and there to carry on hostilities against the French King. He died in 1642.

8. François de Barradas remained at the height of royal favor until 1626. Richelieu had him dismissed, however, when he opposed the Cardinal's plan for the marriage of the Duke of Orléans, brother of the King, and Mlle. de Montpensier.

9. The Papal Legate was Francesco Cardinal Barberini, nephew of Urban VIII. He arrived in Paris on May 21, 1625.

10. This was Don Diego Messia, afterward Marquis de Léganès. He became Spanish military organizer in Brussels. (See Letter 71.)

Letter 62

Original in the Royal Library, The Hague. — Italian. — No address. First published, in English translation only, by Thicknesse in *A Year's Journey* (1784), pp. 316–323.

1. The marriage of the Princess Henrietta Maria and Charles I of England was described in a number of current journals, with the most detailed account to

be found in vol. XI of the *Mercure françois ou l'histoire de notre temps* (Paris, 1626).

2. The arrival in Paris of the Papal Legate, Cardinal Barberini, was celebrated with great pomp, and the fêtes are described in minute detail. He came as the Pope's representative to negotiate with the King of France on the complicated question of the Valtelline (see Letter 60, note 4), hoping to arrange the transfer of the Valtelline to the Pope and the expulsion of the Protestant Grisons from that region. Rubens mentions the inauspicious omens that attended the legate's arrival. His uncle, Signor Magalotti, who was taken ill in Paris, died within a few days. The mission was, in fact, unsuccessful.

3. The Cavaliere Cassiano del Pozzo was a lover of antiquities and a patron of artists. Domenichino and Poussin enjoyed his particular favor. As Secretary to Cardinal Barberini he accompanied the legate on this mission to Paris.

4. Giovanni Doni was one of the most cultivated men of his time. His particular interest, among many others, was the study of music of all periods.

5. The mounting tension between Rubens and Richelieu is evident in this letter. The artist, in referring here to the opening of the Medici Gallery, speaks of a "murmur" caused by some of the subjects (obviously of the Cardinal's choosing), which might have been avoided, had they been entrusted entirely to him.

 Rubens was already making plans for the second cycle of paintings commissioned by Marie de' Medici — the series to deal with the glorification of Henri IV.

Letter 63

Original lost. Copy in the Bibliothèque Méjanes, Aix. — Italian. — No address.— Rubens must have left Paris on June 8 or 9, since he reached Brussels on the night of June 11. — On June 5, 1625, the town of Breda surrendered to the Marquis Spinola, after a long siege. In honor of this event, Cardinal de la Cueva celebrated mass there in the presence of the Infanta Isabella.

Letter 64

Original in the Rubenshuis, Antwerp. — Italian. — No address. — On the reverse, in Peiresc's hand:

Rubens	Antwerp
July 3	to my brother de Valavez
1625	

 With the engravings of the cameos
 That of the triumphal quadriga of Aurelian or Theodosius
 d'Argouge Breda Sevemberg
 M. Rockox enters into the agreement with Cav. del Pozzo

— First published, in English translation only, by Thicknesse in *A Year's Journey* (1784), pp. 324-328.

1. In 1620 Peiresc had discovered, in the treasury of the Ste. Chapelle, Paris, a large sardonyx cameo which he interpreted as a representation of the "Apotheosis of the Emperor Augustus." This cameo, now in the Bibliothèque Nationale, and called the "Gemma Tiberiana," is identified as representing the "Glorification of Germanicus" (see Letter 81). The second of the "two larger cameos" to which Rubens refers here is the famous "Gemma Augustea"

457

now in Vienna. These two cameos, according to Peiresc, were the "finest pieces he had ever seen, of all that remained of antiquity." Peiresc had written to Rubens in October 1621 asking to borrow a drawing Rubens had of the Vienna cameo, in order to compare it with the cameo of Ste. Chapelle. Since that time he and Rubens had been working together on the preparation of an ambitious publication of the more famous engraved gems of antiquity, to be illustrated by engravings after Rubens' designs. This is the "enterprise" which Rubens mentions in his postscript. Girolamo Aleandro and Cassiano del Pozzo were also interested, as well as Nicolas Rockox. But, for reasons we do not know, the project was never completed. Only the title page, *Varie figueri de Agati antique desiniati de Peetro Paulo Rubbenie,* and a few of the engravings survive. In this letter Rubens announces the completion of some of the engravings. The cameo with the "triumphal quadriga," which he praises, is now in the Bibliothèque Nationale, where it is called the "Triumph of Licinius."

2. Two of these books are by Philip Rubens. The first bears the title: *Philippi Rubenii Electorum libri II. In quibus antiqui Ritus, Emendationes, Censurae. Ejusdem ad Justum Lipsium Poematia* (Antwerp, 1608). It contains six engravings by Cornelis Galle, probably done after Rubens' designs. The second book appeared after Philip Rubens' death: *S. Asterii Episcopi Amaseae Homiliae, Graece e latine nunc primum editae Philippo Rubenio interprete. Ejusdem Rubenii Carmina, Orationes et Epistolae selectiores: itemque Amicarum in vita functum Pietas* (Antwerp, 1615). The Homilies of the fourth-century St. Asterius, Bishop of Amasus, Philip Rubens had found in the library of Ascanio Cardinal Colonna, while he was the Cardinal's secretary. By "parentalibus" Rubens means the poems of his brother Philip and those written by his friends at his death. The last book, *S. Isidori Pelusiotae epistolae hactenus ineditae etc. a R. P. Andrea Schotto* (Antwerp, 1623), is a collection of 569 letters of St. Isidore, written in Greek, which Father Schott had found in a manuscript in the Vatican.

3. This Justo seems to have been Justus van Egmondt, a pupil of Rubens and his assistant in installing the paintings in Paris.

4. M. d'Argouges was Marie de' Medici's Treasurer, entrusted with payment for the Luxembourg pictures.

Letter 65

Original in the Ducal Library, Wolfenbüttel. — Italian. — No address. — This letter and the following were written to a person Rubens addresses as "cousin," and who must certainly be Jan Brant, the "Catholic" referred to in Letters 55 and 56. The present letter once more brings up the question of a renewal of the truce between the Northern and Southern Netherlands. Owing to the recent death of Maurice, Prince of Orange, and to the surrender of Breda, the advantage now lies with Spain and the Spanish provinces. Rubens has discreetly substituted numerals for all the proper names, leaving it to us to provide the key. The first editor of these two letters (C. von Heinemann, in *Kunstchronik,* May 8, 1890) convincingly identified 11 as Maurice of Nassau; further plausible suggestions were made by Max Rooses (CDR, III, 383). Number 3 is quite certainly the Infanta Isabella, 26 the Marquis Spinola. Number 12 could be Mme. T'Serclaes, 14 Balthasar Gerbier, 13 Chancellor Pecquius and 16 perhaps the father of Jan

Brant. Number 28 indicates the town where an interview had taken place the previous year, and 24 may possibly be the Duke of Neuburg.

1. The word "principal" has been crossed out. It referred to the Prince of Orange.
2. This document, in French (see C.D. III, 382), is also preserved in the Ducal Library, Wolfenbüttel, along with a note by Rubens, in Italian, as follows: "I am sending you this copy in order to avoid any error, if by chance you should not have the document with you. It ought to be easy for you to bring back a reply, because circumstances ought to make this desirable. Nor will it receive any more credit or consideration for you to bring this reply in another form than the rejected one. But above all it is important that it be sound, and that it state as much as it can effectively maintain."

Letter 66

Original in the Ducal Library, Wolfenbüttel. — Italian. — No address. — See notes on the preceding letter.

1. Negotiations for a renewal of the truce had up to this time been carried on directly with Maurice, Prince of Orange (see Letters 55, 56). Now that the Prince was dead, Rubens suggests that it might be necessary to deal with "a group of persons" — in other words, the States General.

Letter 67

Original lost. Copy in the Bibliothèque Méjanes, Aix. — Italian. — Address: To M. de Valavez, Paris.

1. From this letter and the following, we learn that the Infanta was in Dunkirk on September 19, 1625, and that on October 18 she was still there. Dunkirk was the most important Spanish port in the Netherlands, and the reason for Isabella's long stay there was to encourage construction of new forts and warships. England and Holland were at this time making extensive preparations for a combined naval offensive against Flanders and Spain. (See Letter 70.)
2. The Prince at the German border can be none other than Wolfgang Wilhelm, Duke of Neuburg (see Letters 39 and 61). The Duke, now back in Germany upon his return from Spain, seems to be involved in truce negotiations with the Hollanders, in spite of Rubens' efforts to exclude him. The artist's hasty trip to the German border was probably concerned with the truce talks.
3. When Rubens bade farewell to Peiresc in Paris in June 1623 he had promised, "of his own accord," to do a colored drawing of the large cameo which Peiresc had discovered in Ste. Chapelle (see Letter 64, note 1). Now, two years later, Peiresc and his brother Valavez have been reminding Rubens of his promise. The artist, deeply involved in politics, appears somewhat annoyed, saying he will do it when he can. It is a painting, rather than a drawing, that he sends to Peiresc the following April (see Letter 81).
4. Claude Maugis, Abbé de St. Ambroise.

Letter 68

Original lost. Copy in the Bibliothèque Méjanes, Aix. — Italian. — Address: To M. de Valavez, Paris.

According to this letter, Rubens' diplomatic mission to the German border lasted about four weeks. The Papal Legate, as already mentioned, was Cardinal

Barberini, and the Cavaliere del Pozzo was his Secretary. Rubens gives in this letter a concise summary of the current military situation.

1. For Soubise see Letter 61, note 7. In a series of naval engagements off La Rochelle, the fleet of the King of France, under Admiral de Montmorency, assisted by a number of English vessels and the Dutch ships of Admiral Haultain, completely defeated the Reform party led by Soubise.

2. The Duke of Feria was commander of the Spanish troops in Upper Italy and Governor of Milan.

3. Early in 1624 Christian IV of Denmark opened an offensive in western Germany against Count Tilly, general of the Catholic League. Albrecht von Wallenstein, greatest of the military adventurers of the period, came to Tilly's aid, laying waste the land as he advanced. He joined Tilly in November 1625 near Brunswick.

4. Balthasar Gerbier (1592–1667) was Master of the Horse to the Duke of Buckingham, as well as diplomatic agent. Rubens had met him, with the Duke, in Paris at the time of the marriage of Henrietta Maria and Charles I. Gerbier's name will appear frequently in Rubens' letters from 1627 on.

5. Pierre Bérulle was the founder of the Congregation of the Oratory in France, an order whose freedom from vows provoked the hostility of the Jesuits. Bérulle, after successfully negotiating the Papal dispensation for the royal marriage, had followed the young queen to England as her confessor, taking with him twelve priests of the Order of the Oratory. The queen was soon suspected by the English of trying to influence Charles I toward Catholicism, and finally the King was obliged to remove the French priests from his court. This was the beginning of a long controversy. Bérulle became Cardinal in 1627, and remained a zealous defender of Catholic interests in England until his death in 1629.

Letter 69

Original lost. — Referred to in *Autographs of Illustrious Personnages . . . Now Selling by Thomas Thorpe*, No. 38, Bedford St., Covent Garden, London, 1833, item 1339: "Sir P. P. Rubens, autograph letter to the Prince of Orange." — Although the present location of this letter is unknown, the date is not given, and even the person addressed is uncertain, we include here the summary of the letter as it appeared in the Thorpe catalogue, because of the unusual interest of the topics discussed. The letter can, with some certainty, be dated late in 1625, and the recipient must be, not the Prince of Orange, but Balthasar Gerbier, whom Rubens had recently met, along with the Duke of Buckingham, in Paris.

The plague, to which Rubens also refers in the following letter, November 28, 1625, was then ravaging Antwerp. The "journey of business" was Rubens' mission to the Duke of Neuburg at the German border, and "his Highness's portrait on horseback" was the equestrian portrait now lost, commissioned by the Duke of Buckingham.

Letter 70

Original lost. Copy in the Bibliothèque Inguimbert, Carpentras. — Italian. — No address. — Valavez was in the habit of sending his brother Peiresc copies of the letters Rubens wrote to him. A number of these copies, preserved in Carpentras, furnish a valuable record of this important correspondence.

1. On October 3, 1625, an English fleet of eighty-seven vessels left Plymouth

to raid the coast of Spain. Eight days later they landed in the vicinity of Cadiz, but encountered such resistance that they had to retreat promptly. There is no report of an alliance with the Moors. This was the first hostile act of Charles I against Spain.

2. Peiresc's father, Regnauld de Fabri, Sieur de Calas, had died on October 25, 1625.

3. The *Admonition,* which first appeared in Latin in 1625, bore the title: *G. G. R. Theologi, ad Ludovicum decimum tertium Galliae et Navarrae Regem Christianiss. Admonitio, fidelissime, humillime, verissime facta et ex Gallico in Latinum translata: qua breviter et nervose demonstratur Galliam foede et turpiter impium foedus iniisse, et unjustum bellum hoc tempore contra Catholicos movisse, salvaque religione prosequi non posse.* In the same year appeared a second part entitled: *Mysteria Politica hoc est: Epistolae arcanae virorum illustrium sibi mutuo confidentium.* The author, or authors, was unknown, although several persons were suspected. On October 30, 1625, both of these books libeling Louis XIII were publicly burned in Paris, and it became an offense punishable by death to read, possess, print, or sell them. Several pamphlets were published in answer to the *Admonition,* of which Rubens mentions here two, the *Miroir du temps passé* and the *Réponse.* Another was the *Apologeticus* of Rigault, which Rubens refers to in Letter 79. Valavez must have run considerable risk in receiving from Rubens, or sending to him, books so severely condemned.

Letter 71

Original lost. Copy in the Bibliothèque Inguimbert, Carpentras. — Italian. — No address.

1. After the failure of his fleet at Cadiz and his troops in Germany, Charles I sent the Duke of Buckingham to Holland to conclude an alliance with the United Provinces and Denmark against the King of Spain and the Hapsburg Emperor. The treaty was signed on December 14, 1625.

2. Christian, Duke of Brunswick-Wolfenbüttel, called "Christian the Mad," was Bishop of Halberstadt, though far more active on the field of battle as a Protestant champion of the Palatine cause. Rubens' report of his death was premature; though stricken with fever he did not die until the following June.

3. The "caprice" of M. de Vaudemont, François II, Duke of Lorraine, was his abdication in November 1625 in favor of his son, who became Charles IV, Duke of Lorraine.

4. Gonzalo Fernández de Cordova, commander of the Spanish armies in the Palatinate, was aiding the Duke of Feria in the war against Savoy and France. They had laid siege to Verrue, Piedmont, in August 1625, but in November the Spanish army was defeated by the French under the Marshal de Créqui, and forced to withdraw with heavy losses.

Letter 72

Original lost. Copy in the Bibliothèque Méjanes, Aix. — Italian. — Address: To M. de Valavez, Paris.

1. Hubert Goltzius (1526–1583) was a Dutch antiquarian, artist, and numismatist, appointed royal historiographer by Philip II of Spain. For a list of this author's works, see *CDR,* III, 187. By the *"Auctarium* of Goltzius" Peiresc

means the *Graeciae Universae et Insularum nomismata veterum,* a manuscript discovered after the author's death by Jacob de Bie, and perhaps the one referred to by Rubens in this letter. It first appeared as a supplementary volume in the edition of Goltzius' works published by de Bie in 1617–20. Peiresc wished to obtain a separate copy of this volume to complete his set, and his brother had asked Rubens about chances of finding one in Antwerp.

2. *Thesaurus rei antiquariae.*
3. For Jacob de Bie, see Letter 22.
4. A short time later, on March 24, 1626, Richelieu issued a severe edict against dueling (see Letter 81, note 3). In spite of rigid enforcement, however, dueling in France was not really stamped out.

Letter 73

Original lost. Copy in Bibliothèque Inguimbert, Carpentras. — Italian. — No address.

1. See Letter 71, note 1.
2. Frans van Aerssens, Sieur de Sommelsdyk (1572–1641), had been envoy of the States General to the court of Henri IV. In 1625 and again in 1628 he returned to Paris on important missions. Richelieu included him among the three greatest statesmen he had ever met. In this letter the name of Aerssens, which the copyist probably could not read, has been inserted by another hand.
3. Johan van Oldenbarneveldt, executed in 1619.
4. Philip Burlamachi was a rich merchant of London and Charles I's banker.
5. Francesco Cardinal Barberini. See Letter 62, note 2.

Letter 74

Original lost. Copy in the Bibliothèque Méjanes, Aix. — Italian. — Address: To M. de Valavez, Paris.

Letter 75

Original in the Archivio di Bagno, Mantua. — Italian. — No address. — Published by P. Torelli, "Notizie e documenti Rubeniani," in *Miscellanea di studi storici, ad A. Luzio* (Florence, 1933), pp. 173ff. — The date of the letter is incomplete, but the last figure is determined by the letter of February 16, 1626, written also to Gian Francesco di Bagno, a few days after this one, and on the same subject.

Gian Francesco Guidi di Bagno (1578–1641), a member of one of the oldest and most important families of Italy, became in 1600 the Secretary to Cardinal Aldobrandini, accompanying him to Florence to bless the marriage of Henri IV and Marie de' Medici. From 1614 to 1621 he was Vice-Legate in Avignon, where he became acquainted with Richelieu, then Bishop of Luçon. Guidi di Bagno was consecrated Bishop of Patras in 1621, and from that year until 1627 was Apostolic Nuncio in Brussels. In 1627 he accompanied Cardinal Barberini to Paris, became Cardinal himself, and remained in Paris as Nuncio until 1631. He died in Rome ten years later, and his tomb, in Sant'Alessio, was ornamented by Bernini.

Guidi di Bagno was a collector of books, paintings, and antiquities, and had many friends among men of letters. He was a close friend of Peiresc, and it was Peiresc who introduced him to Rubens, in a letter of February 26, 1622, in which

he says of the painter: "In matters of antiquity especially, he possesses the most universal and remarkable knowledge I have ever seen." Such high praise appears to be somewhat justified by this letter in which Rubens, although "deprived of books and notes," discusses the history of the Temple of Diana at Ephesus. For Rubens' high opinion of Guidi di Bagno see Letter 106.

1. Herostratus was an incendiary who set fire to the Temple of Diana at Ephesus in order to make his name famous. According to tradition, this happened in 356 B.C., on the night when Alexander the Great was born.

Letter 76

Original lost. Copy in the Bibliothèque Méjanes, Aix. — Italian. — Address: To M. de Valavez, Paris.

1. There was some truth in the Ambassador's report. This is indicated in a letter from Richelieu to the Queen Mother in which he recommends a certain "Josépin" as painter of the Gallery of Henri IV in the Luxembourg. A letter from the Queen to Cardinal Spada shows that Guido Reni was also being considered for the commission. But since Guido Reni could not leave Bologna, and "Josépin," i.e., Giuseppe Cesari, Cavaliere d'Arpino, was thought too old, the contract remained with Rubens, to whom it had been given in 1622.

2. Followers of the Dutch theologian Jacobus Arminius (1560–1609), the Arminians distinguished themselves from Dutch Protestantism in that they did not accept Predestination in its full scope. In 1610 they presented to the States General a justification of their teachings, called the *Remonstrance,* which gave them thenceforth the name of "Remonstrants." The Arminians had supported Oldenbarneveldt, and after his death continued the struggle with the rigid Calvinists, or Gomarists, by means of the press. Which of their publications Rubens refers to cannot be determined.

Letter 77

Original lost. Copy of a fragment in the Bibliothèque Inguimbert, Carpentras. — Italian. — No address.

1. In a letter of December 5, 1625, the Infanta informs Philip IV that the Hollanders tried to capture Gravelines by bribing the Governor of Isendyck; that she, learning of this maneuver, had the Governor imprisoned.

Letter 78

Original in the Archivio di Bagno, Mantua. — Italian. — Address: To my Most Illustrious, Reverend and Esteemed Lord, Monsignor Nuncio of Flanders, Archbishop of Patras, in Brussels. — Published by P. Torelli, "Notizie e Documenti Rubeniani," in *Miscellanea di studi storici, ad A. Luzio* (Florence, 1933), pp. 173ff. — See notes on Letter 75.

Letter 79

Original lost. Copy in the Bibliothèque Méjanes, Aix. — Italian. — Address: To M. de Valavez, Paris.

1. The Gallery of Henri IV. Rubens did not begin the painting of these pictures until early in 1628.

2. *Apologeticus pro rege Ludovico XIII adversus factiosae Admonitionis calumnias in causa principum foederatorum* (Paris, 1626), by Nicolas Rigault. See Letter 70, note 3.

3. On February 5, 1626, the King of France made peace with the Huguenots of La Rochelle. Richelieu shrewdly asked the English to negotiate this treaty. In France there was some fear that this action might lead to a break with Spain. But Richelieu knew very well that, on the contrary, it would hold Spain in check, for Spain feared the power of a French-English alliance. The peace with the Huguenots provided that La Rochelle was to be restored, that numerous rights, return of property, etc., were to be granted, and that the Huguenots, on their part, were to exercise tolerance toward the Catholics. This treaty of La Rochelle, however, proved to be of short duration.

Letter 80

Original lost. Copy in the Bibliothèque Méjanes, Aix. — Italian. — Address: To M. de Valavez, Paris.

1. A contemporary description of this tournament runs as follows: "Dimenche passé, le marquis de Campo Lataro a convié et provoqué les cavaliers de ces pays aux courses de la bague et 'stafermo,' voulant maintenir que la belle Florinde, sa maitresse, estoit l'unique en beauté et mérite. Le prince de Barbanson a soustenu le contraire et parut le premier avec une belle entrée dont il a eu le prix" (E. Gachet, *Lettres inédites de Pierre Paul Rubens* [Brussels, 1840], p. 42). This means simply that the Marquis de Campo Lataro wished to exalt the merits of the Spanish ladies as surpassing those of the Flemish beauties. According to Rubens, this attempt to revive the games of medieval chivalry met with little success. A "Saracen" was a wooden head on a post, used as a target for tilting at.

2. These cartoons were for the "Constantine" series. M. de la Planche was the "tapissier," one of the directors of the Saint-Marcel tapestry shop in Paris. See David Dubon, *Tapestries from the Samuel H. Kress Collection at the Philadelphia Museum of Art; the history of Constantine the Great designed by Peter Paul Rubens and Pietro da Cortona* (London, 1964).

Letter 81

Original lost. — Copy in the Bibliothèque Méjanes, Aix. — Italian. — Address: To M. de Valavez, Paris.

1. The first of these books is entitled *Graeciae universae Asiaeq. minoris et insularum numismata veterum*. This is the *Auctarium* which caused Rubens so much worry (see Letter 72). The name of Nonnius is not mentioned in the edition of 1618, but in the edition of 1644 it appears in the title: *Ludovici Nonnii Commentarius in Huberti Goltzii Graeciam Insulas et Asiam Minorem*. The second book mentioned by Rubens is entitled *Ludovici Nonnii Commentarius in Nomismata imp. Julii, Augusti et Tiberii, Huberto Goltzio scalptore* (Antwerp, 1620).

2. The Decree of the Privy Council of the King dated March 27, 1626, limiting the powers of the Jesuits with regard to the universities.

3. By his severe edict against dueling, issued on March 24, 1626, Richelieu struck at one of the most cherished privileges of the aristocracy. Duelists were to be degraded from the nobility, banished for three years and deprived of half their property. A second offense was punishable by death. (See Letter 72.)

4. This book, by the Spanish Jesuit Juan de Mariana (1536–1624), was entitled *Sur les Défauts de la S. J.: Discursus de erroribus qui in forma gubernationis Societatis Jesu occurrunt* (Bordeaux, 1625).

5. This is the painting of the "Gemma Tiberiana" which Rubens had promised to do for Peiresc three years before (see Letters 64, note 1, and 67, note 3). Peiresc received it in June 1626 and expressed his delight and enthusiasm in letters to Aleandro and Abraham de Vries. The painting, a grisaille on canvas, and about three times the size of the original cameo, is now in the collection of Christopher Norris, London. See C. Norris, "Rubens and the Great Cameo," *Phoenix,* August–September 1948, pp. 179–188.

Letter 82

Original in the Bibliothèque Nationale, Paris. — Italian. — No address. — With the departure of Valavez to join his brother Peiresc in Provence, Rubens' Paris correspondent became the French humanist, Pierre Dupuy (1582–1651). This is the first of the long series of weekly letters which Rubens wrote to Dupuy, who was Royal Librarian, a position he shared with his younger brother Jacques, mentioned in this letter. Both were close friends of Peiresc. Pierre Dupuy's numerous letters to Rubens have not survived. Of his published works the most famous is the *Traité des droits et des libertés de l'église Gallicane* (Paris, 1639).

Letter 83

Original lost. Spanish translation in the Archivo General, Simancas. — No address. — For Spanish text, see Appendix. — This letter, hitherto unpublished, is summarized by Henri Lonchay and Joseph Cuvelier, *Correspondance de la Cour d'Espagne sur les affaires des Pays-Bas au XVII siècle,* vol. II (Brussels, 1927), p. 268, no. 864, as follows: "The painter advises his correspondent of the preparations of the Hollanders for a surprise attack on Brazil." I am grateful to the Director of the Archivo General of Simancas for sending me the text of this letter. The recipient of the letter, whom Rubens addresses as "Excelentísimo Señor," was undoubtedly the Marquis Spinola in Brussels. Rubens' warning was apparently taken seriously, for the Infanta Isabella sent his letter on to Philip IV enclosed in one of her own, dated July 12.

The Portuguese colony of Brazil was at this time in Spanish hands. Its capital was San Salvador, on the fine land-locked harbor called the Bahia de Todos os Santos, often referred to simply as "Bahia." The Dutch West India Company, founded in 1621, had directed its first grand-scale operation against San Salvador, capturing the city in May 1624. This had aroused Spain and Portugal to unaccustomed coöperation; a joint expedition under Don Fadrique de Toledo recaptured San Salvador in April 1625. The Hollanders, however, as Rubens says, were persistent in their efforts to seize the place once more, and Piet Hein in particular — that "sea-terror of Delfshaven," as the poet Vondel called him — ravaged the Bahia de Todos os Santos, sinking Spanish ships and seizing rich booty. See Letter 116.

Letter 84

Original in the Museo Civico, Turin. — Italian. — No address.

This letter was written in reply to Pierre Dupuy's letter of condolence on the death of Rubens' wife, Isabella Brant, who died on June 20, 1626. There is no mention of her illness, indicating perhaps that her death was sudden. Peiresc, writing to Aleandro on June 19, quotes Rubens as saying that the plague was spreading in Antwerp, and Isabella Brant may have been a victim of this epidemic.

Another letter of sympathy, written on August 8, was sent to Rubens by the Count Duke of Olivares. In this letter, an interesting proof that Rubens was

already in personal communication with the Prime Minister, Olivares tries to console the artist by describing his own bereavement by the death of his only daughter.

Letter 85

Original lost. — Copy in the Bibliothèque Inguimbert, Carpentras. — Italian. — No address.

1. Wallenstein, whose vast wealth had built up a large army which he placed at the service of the Emperor, had joined the army of the Catholic League commanded by Count Tilly (see Letter 68). The Protestant armies were headed by Christian IV of Denmark and Count von Mansfeld. In April 1626 Wallenstein repulsed an attack by Mansfeld and inflicted a bloody defeat upon him at Dessau. Tilly, on his part, met the King of Denmark in Thuringia and on August 27 defeated him at Lutter (see Letter 87). These two engagements constituted a severe set-back to the Protestant cause.

2. The peasant uprising of 1626 was one of the phases in the struggle of the Protestant masses against the Catholic Emperor.

3. See Letter 68, note 4. The Gregorian or Reformed Calendar was not adopted in England until 1752. There was a discrepancy of ten days between the old and the new style of reckoning.

Letter 86

Original lost. Copy in the Bibliothèque Inguimbert, Carpentras. — Italian. — No address. — On the reverse, in Peiresc's hand:

Brussels, July 24
Antwerp, July 30
The Meuse Canal
Diverting of the Rhine

This memorandum evidently refers also to the previous letter, providing a date for it and indicating that it was written from Brussels.

1. Count Henry de Bergh, a nephew of William the Silent, became one of Spinola's most successful generals, distinguishing himself for his campaigns against the Hollanders. In 1628, when Spinola was recalled to Madrid, Count Henry took his place as commander of the troops in the Spanish Netherlands. The following year his loyalty to Spain began to fall under suspicion, at first unjustly. In 1632, however, he went over to the Dutch side, joining the Prince of Orange at Maastricht.

Letter 87

Original lost. — Copy in the Bibliothèque Inguimbert, Carpentras. — Italian. — No address. — In margin, in Peiresc's hand: "1626 XI Sept. Kieldrecht attacked by the Hollanders. Rout of the King of Denmark by Tilly."

1. A contemporary report of the expedition against Kieldrecht and Hulst is given by the journalist Abraham Verhoeven, in the *Nieuwe Tydinghe* of September 2, 1626. His account agrees closely with the detailed report of Rubens, but it is clear that the artist, even if he had read Verhoeven, drew also upon other sources of information.

2. Rubens' account of the battle of Lutter is taken, as he himself says, from the dispatch which arrived on September 5. This was addressed to the Infanta

Isabella by the victor, Count Tilly. It was published in full in the *Mercure Français* of 1626 (p. 678). The proper names which Rubens mentions have suffered strange distortions, but it must be remembered that his letter is preserved only in a copy, transcribed by Valavez.

Letter 88

Original in the Rubenshuis, Antwerp. — Italian. — Address: To Monsieur Monsieur de Puy, at the house of M. the Councilor de Thou, Paris.

1. This is Rubens' letter of September 11. It did not reach Valavez before his departure from Paris, but was forwarded to him.
2. Michel Ophovius (1571–1637) was Provincial of the Dominican Order from 1611 to 1615, and soon after that was placed at the head of the Catholic mission in the United Provinces. In 1623 he was entrusted by the Infanta Isabella with a diplomatic mission involving the bribing of the Governor of Heusden, but was captured and imprisoned for eight months. Shortly after his release, he was named Bishop of Bois-le-Duc, but upon the capture of this town by Frederick Henry in 1629, he had to flee to Antwerp. Ophovius was a friend of Rubens and was said to be his confessor.

Letter 89

Original in the Royal Library, The Hague. — Italian. — No address.

1. See Letter 85. On September 21, 1626, Spinola began his gigantic undertaking. He wished to connect the Rhine with the Meuse by a canal running from Rynberg to Venlo, and the Meuse with the Scheldt by another canal and the river Demer. His aim was, on the one hand, to cut off commerce between Holland and Germany, and, on the other, to provide his troops with an unobstructed entry into Holland. Only a part of this vast enterprise was carried out: the canal between the Rhine and the Meuse. This was called the "Fossa Eugeniana," or the "Fossa Mariana." The Prince of Orange constructed a fort at Isselbourg, in order to hinder this work, and encamped on the left bank of the Rhine. Count Henry de Bergh advanced with his troops as far as Issum, for the purpose of protecting the workers on the canal.
2. On September 1, 1626, the Theological Faculty of Paris condemned *La Somme Théologique des Veritez capitales de la Religion Chrestienne,* by the Jesuit François Garasse, because it contained "heretical, erroneous, and scandalous propositions."
3. Melchior Tavernier (1544–1641) was a Flemish engraver who settled in Paris and obtained the title of Engraver and Etcher to the King.

Letter 90

Original in the Pierpont Morgan Library, New York. — Italian. — No address. — For Italian text, see Appendix. — This letter, doubtless the one mentioned by Rooses (*CDR,* III, 477) as having appeared in a sale of 1841 but thought lost, is here published for the first time. I am indebted to Miss Felice Stampfle of the Pierpont Morgan Library for calling it to my attention and to the Library for permission to publish it.

1. Upon the death of Maurice of Nassau in April 1625, his half-brother Frederick Henry became Prince of Orange.

Letter 91

Original in the Bibliothèque Nationale, Paris. — Italian. — No address. — For Italian text, see Appendix. This letter is here published, with the permission of the Bibliothèque Nationale, for the first time. The opening sentences suggest that it is written to Jacques Dupuy, who had been acting as substitute correspondent for his brother Pierre, during the latter's illness.

1. Rubens' brother Philip had died in 1611.

2. Hugo Grotius (1583–1645), great Dutch jurist and humanist, was at this time living in exile in Paris.

3. François de Bonne, Duc de Lesdiguières (1543–1626), although he had fought on the Huguenot side in the religious wars, remained faithful to Marie de' Medici and Louis XIII. Upon abjuring Protestantism in 1622, he became Constable of France. His death occurred a few weeks before Rubens wrote this letter.

4. Epaminondas was the Greek general who won a complete victory at Mantinea in 362 B.C., but died on the field.

5. Charles I de Créqui had married the daughter of the Constable de Lesdiguières in 1611. He became Marshal of France in 1622. Already heir to the name and property of Créqui, he now became Duc de Lesdiguières, upon the death of the Constable. He died in 1638, while fighting the Spaniards in North Italy.

6. This was the famous Chalais conspiracy, in which Rubens took a keen interest. It originated with the plan of Richelieu and Marie de' Medici to arrange a marriage between the King's younger brother Gaston, Duke of Orléans, and the wealthy Mlle. de Montpensier. Gaston (or "Monsieur," as he was officially called) was heir to the Crown, and for dynastic reasons Richelieu considered this alliance desirable. But Gaston objected, and in this he had many supporters. Among them were the Princes of Condé, who did not want to see an increase in number of aspirants to the throne; the Count de Soissons, who loved Mlle. de Montpensier; also the Queen and her confidante, the scheming Duchess of Chevreuse. Both parties sought to win over Gaston's tutor, the Marshal d'Ornano, and the plot that began as an effort to prevent this royal marriage grew into a fantastic conspiracy to overthrow, perhaps to assassinate Richelieu himself. The Duke of Vendôme and the Grand Prior of France, half-brothers of the King, were implicated, and through the Duchess of Chevreuse there was dragged into the plot a young and foolish nobleman, the Count of Chalais, who turned informer. The conspirators were imprisoned, and their trial was one of the sensations of the period. The only victim, in the end, was the unfortunate Chalais, who met his death on the scaffold on August 19, 1626. Gaston, meanwhile, found it expedient to abandon his supporters to the vengeance of Richelieu, and to consent to the marriage with Mlle. de Montpensier, which took place on August 5.

7. Lucius Aelius Seianus was the favorite of the Emperor Tiberius. He was Prefect of the Praetorian Guard, and exercised great influence over the Emperor.

8. Rubens probably refers to Jacques de la Ferrière, a doctor of medicine attached to the household of Alfonse Cardinal de Richelieu, brother of the great Cardinal. De la Ferrière was a friend and correspondent of Peiresc.

9. Théophile Viaud. See Letter 58, note 4.

10. See Letter 53, note 2.

Letter 92

Original in the Bibliothèque Nationale, Paris. — Italian. — No address.

1. François Auguste de Thou, son of the celebrated historian of that name, succeeded his father as Librarian to the King. Since he was still too young at the time of his father's death to fill this position, it was entrusted to Pierre Dupuy, his teacher. De Thou was condemned to death in 1642 for implication in the conspiracy of Cinq-Mars against Richelieu.

2. Regarding maritime codes of behavior at this time, see G. N. Clark, *The Seventeenth Century* (Oxford, 1931), p. 59: "Armed aggression was the heart of commerce. Nowhere was there less of humanitarian or tolerant feeling. . . Even in navies there were only the roughest beginnings of the chivalry of the sea, and it must be remembered that, in the literal sense of the word, at sea there had never been any chivalry, there had never been knights or a knightly code. It was an age of pirates and wreckers, press-gangs and mutineers. The tougher the seafaring man, the longer he lasted, and so with the seafaring nation."

3. Bethlen Gabor (1580–1629) was the perfidious ruler of Hungary, and one of the Protestant leaders who opposed the Emperor in the Thirty Years' War.

4. This is the title of one of the numerous libels against the policy of Richelieu, printed during that year in Flanders and Germany.

5. This refers to the poem by Morisot, described more fully in the following letter, October 29, 1626.

Letter 93

Original in the Bibliothèque Nationale, Paris. — Italian. — No address. This letter, acquired by the Belgian government in 1961, was offered to President de Gaulle by King Baudouin on the occasion of a state visit to Paris in that year.

1. Rubens corrects the spelling of the poet's name to Morisot in his letter of November 12. The only contemporary description of Rubens' Medici Gallery was the Latin poem of Claude-Barthélemy Morisot, *Porticus Medicaea* (Paris, 1626). A second edition appeared in 1628, this one revised by Rubens himself, with the correction of errors such as the artist mentions in this letter. The poet also made amends for the omission of Rubens' name, and added some verses praising the genius of the painter.

2. The treaty between the Emperor and Gabor was not concluded until December 20, 1626.

3. Rubens was right in saying that Turkey was marching toward ruin. In 1617 Mustapha the Idiot had become Sultan, but after three months was deposed. The fourteen-year-old Osman II succeeded him, but he was soon murdered by the Janissaries, whereupon Mustapha the Idiot regained the throne. In 1623 he was replaced by the twelve-year-old Murad IV, who did not take over the government until 1632. During Murad's minority, when this letter was written, the Janissaries gained great power, the war with Persia was going badly, and it was a very dark period for Turkey.

4. See the following letter, November 5, 1626.

Letter 94

Original in the possession of Miss Ruth S. Magurn, Cambridge, Mass. — Italian. — No address.

1. This was the trial of the Marshal d'Ornano, implicated in the Chalais conspiracy (see Letter 91, note 6); d'Ornano died in prison in September 1626.

2. The Prince of Piedmont later became Victor Amadeus I, Duke of Savoy. He was the husband of Christine, sister of Louis XIII.

3. Anne of Austria, daughter of Philip III, had married Louis XIII in 1615. It was not until 1638 that her son, the future Louis XIV, was born.

4. François de Bassompierre (1579–1646), Marshal of France, played an important role under Henri IV and Louis XIII. From 1622 on he was successively Ambassador to Spain, Switzerland, and England. For his part in the intrigues against Richelieu he was imprisoned in 1631 and released only on Richelieu's death.

5. Don Diego Sarmiento de Acuña, Count de Gondomar, was a Spanish diplomat who had been influential at the court of James I.

6. The *Politica Quaestio* and the *Secretissima instructio Gallo-Britano-Batava Frederico V data* were two libelous publications written by a Bavarian author. They dealt with the peace which Richelieu had just made with the Huguenots, and the carrying of the war against the Spaniards into the Palatinate.

Letter 95

Original formerly in the Bibliothèque Nationale, Paris. Present location unknown. — Italian. — No address.

1. This was the Dutch portrait painter Michiel Jansze Mierevelt (1567–1641). Engravings were made after many of his portraits by W. J. Delff and others.

2. See Letter 89, note 3.

Letter 96

Original formerly in the Collection of Samuel Davey, London. Present location unknown. — Italian. — No address.

1. This information concerning Mansfeld was false; at the time this letter was written, he had just died in Bosnia.

2. For the Chalais conspiracy see Letter 91, note 6.

3. A communication from Philip IV to Infanta Isabella announces that the fleet from the Indies arrived safely in Cadiz on November 20, the day after Rubens' letter was written. The King promises the payments long overdue.

4. This was Rubens' journey to Calais and thence to Paris, where he met Balthasar Gerbier. The ostensible purpose of the meeting was to discuss the sale of Rubens' collection to the Duke of Buckingham, but political matters were evidently mentioned as well.

Letter 97

Original in the Bibliothèque Nationale, Paris. — Italian. — Address: To Monsieur Monsieur Dupuy. At the house of Monsieur Councilor de Thou, Paris.

1. This was Rubens' first attack of the gout which, from that time on, never entirely left him, and finally caused his death thirteen years later.

Letter 98

Original formerly in the Bibliothèque Nationale, Paris. Present location unknown. — Italian. — No address.

1. A work by the Cistercian Christophe Butkens entitled *Annales généalogiques*

de la maison de Lynden (Antwerp, 1626), this book was very difficult to obtain as it had been withdrawn from circulation by the author. It is still a rare item.

Letter 99

Original formerly in the Bibliothèque Nationale, Paris. Present location unknown. — Italian. — No address.

1. In January 1627 two Portuguese ships coming from the East Indies with a precious cargo for Spain were wrecked off the French coast, with their convoy of four warships. Of the fourteen hundred men aboard, only about two hundred were saved. The value of the cargo was estimated at more than eight million ducats.
2. The Assembly of Notables was a council convoked by the King of France in times of national danger. The Assembly in question was called by Richelieu on December 2, 1626. Many of the decisions of the Assembly of Notables were afterwards embodied in the articles of the so-called "Code Michaud," a comprehensive series of judicial and financial measures.

Letter 100

Original in the Public Record Office, London. — French. — No address. — Among the papers of Balthasar Gerbier preserved in London, the numerous letters or copies of letters exchanged between him and Rubens form a large and important part. Relations between the two lasted, almost without interruption, from 1625 until Rubens' death in 1640. Political affairs formed the chief subject of their correspondence, although not the only one, for Gerbier was also a painter as well as a diplomatic agent. The present letter is the earliest of Rubens' preserved communications to the agent of the Duke of Buckingham, and the first of a long series dealing with the peace negotiations between England and Spain. It is the reply Rubens was authorized to send to Gerbier on behalf of the Infanta Isabella, hinting that negotiations would be more likely to succeed if they involved only England and Spain, but not the United Provinces and Denmark.

Letter 101

Original in the Bibliothèque Nationale, Paris. — Italian. — No address.

1. This was the rumor of another conversion of the Spanish national debt — clear evidence of that country's deteriorating economy. Another expedient to stave off ruin was the compulsory reduction of the interest on loans to a rate as low as 4 per cent. See letters 102, 106.
2. See Letter 98, note 1.
3. This was the canal which was to connect the Rhine and the Meuse. It was later called the Fossa Mariana. See Letters 89, 99.

Letter 102

Original in the Bibliothèque Nationale, Paris. — Italian. — Address: To M. du Puy, living at the apartment of M. de Thou, Councilor in the Parliament of the King, Rue des Poictevins, behind St. André des Arts, Paris.

1. This was the financial decree mentioned in the previous letter. Although it is here stated that the decree has been annulled, harsh measures were taken during the course of 1627 to avert financial collapse.

Letter 103

Original in the Bibliothèque Nationale, Paris. — Italian. — Address: To Mon-

sieur Monsieur Dupuy, Paris. — On exterior: "To be sent to Monsieur Monsieur Du Puy, living at the apartment of Monsieur de Thou, Councilor in the Parliament of the King, Rue des Poictevins, behind St. André des Arts, Paris."

1. Breda had been taken by Spinola in June 1625. According to the rumors reported by Rubens, the Hollanders were making an effort to recapture it. The town finally fell into the hands of Frederick Henry of Orange in 1636.
2. See Letter 73, note 2.

Letter 104

Original lost. — Copy in the Public Record Office, London. — French. — No address. — The Duke of Buckingham's letter of March 9 to Rubens stated that the King of England agreed to have the question of an accord between the Emperor and the King of Denmark treated separately, that he was in favor of negotiations in Brussels between England and Spain, but insisted that the United Provinces, as England's old ally, be included also. He demanded that the Infanta obtain authorization from the King of Spain for presiding at these negotiations.

Letter 105

Original lost. — Copy in the Public Record Office, London. — French. — No address. — A memorandum by Gerbier provides a date for this and the preceding letter: "Copy of the letter of the Sr. Rubens to Gerbier on the same subject, dated April 21, 1627."

Letter 106

Original formerly in the collection of Alfred Morrison, London. Present location unknown. — Italian. — No address.

1. The correct title of this work by André Duchesne is *Bibliothèque des autheurs qui ont escrit l'histoire et la topographie de France* (2nd ed.; Paris, 1627).
2. Two illegible words here. The book is *Déclaration du roi contre le sieur de Soubise et autres adhérans au parti des Anglois* (Paris, 1627).
3. This merchant-carrier has been mentioned earlier by Rubens under the Flemish form of his name, Antoine Muys.
4. M. de la Mothe is apparently François de la Mothe-le-Vayer (1588–1672), intimate friend of Peiresc and tutor of Gaston, brother of Louis XIII. He was the author of numerous works on philosophy and history.
5. There were rumors at this time concerning the Marquis Spinola and Geneviève d'Urfé, Duchess of Croy, whose husband had been murdered in 1624 (see Letter 58, note 7). It was even hinted that Spinola had had a hand in the murder, in order to be able to marry the widow.
6. See Letter 92, note 1.
7. Gian Francesco Guidi di Bagno (1578–1641). See Lettèrs 75, 78.
8. Denys Petau was a noted Jesuit scholar (1583–1652) who had perhaps harshly criticized one of Rubens' friends. Rubens, on his part, is surprisingly outspoken in his criticism of the Jesuit Order.

Letter 107

Original in the Bibliothèque Nationale, Paris. — Italian. — No address.

1. Rubens probably refers to the book by Julius Caesar Bulenger, *De pictura plastice et statuaria veterum* (Leyden, 1627).

2. This book was reëdited in Antwerp in 1626.

3. By this is meant the debasing of the coinage to one-fourth of its value, mentioned by Rubens in the preceding letter.

Letter 108

Original in the Bibliothèque Nationale, Paris. — Italian. — Address: Monsieur du Puy, in Paris.

1. The ambassador was the Abbé Scaglia, representing Charles Emmanuel, Duke of Savoy, at the French court. See the following letter.

2. For the long title of the royal edict on the *quartos*, published in 1627, see E. Gachet, *Lettres inédites de P. P. Rubens* (Brussels, 1840), p. xxx.

Letter 109

Original lost. Copy in the Public Record Office, London. — French. — On the back, in English: "Copie of a lr from Bruxelles to Mr. Gerbier the 19th of May 1627." — All the names of persons and places in this letter are in code, designated by numbers. These have, for the most part, been deciphered by Carleton's hand, and for purposes of clarity all names have been written in full in this translation. The only number remaining undeciphered is 70, and this probably refers to the King of Spain.

It is hard to say whether Rubens was assuming a little too much initiative in this letter, by suggesting a meeting in Holland without definite instructions from the Spanish King. But in any case, a short time later the Duke of Buckingham ordered Gerbier to go to Holland. Rubens also succeeded in being sent there, as his letter of July 10 indicates (see Letter 117).

1. The Ambassador of Savoy, the Abbé Scaglia, was something of a busybody, but nevertheless played an increasingly important part in these negotiations. He had gone to England in 1626 ostensibly to offer condolences to Charles I on the death of his father, but really to gain that country's support in the Duke of Savoy's conquest of Corsica. He was now in Brussels to ask the Infanta Isabella to intercede with Philip IV for the reconciliation of Spain and Savoy. In passing through Antwerp, Scaglia met Rubens. He told the painter that, while in London, he had heard of the Anglo-Spanish negotiations in which Rubens was engaged, but that England and France were negotiating an alliance which might wreck the whole scheme. At this news the Infanta sent an urgent message to Philip IV, again asking authority for treating with England, not knowing that Philip had just ratified a treaty with France. It will thus be seen that all three of the great western Powers were trying to carry on a seesaw policy, making any genuine attempt at peace extremely difficult. Philip IV, in granting to the Infanta the necessary powers for treating with England (antedated by fifteen months), expressed his royal displeasure at the intervention of the Abbé Scaglia and the Duke of Savoy in Spain's affairs.

2. For Rubens' previous relations with Sir Dudley Carleton, English Ambassador at The Hague, see Letters 27–34.

3. Rubens is referring to the sale of his personal collection of antiquities and paintings to the Duke of Buckingham. The antiquities were apparently sent to London first. The group of paintings, including a number by Renaissance masters and thirteen by Rubens himself, was not sent until September 1627.

Letter 110

Original in the Bibliothèque Nationale, Paris. — Italian. — Address: To Monsieur Monsieur du Puy, Paris.

1. The celebrated duel between François de Montmorency, Count de Bouteville, and the Marquis de Beuvron excited the interest of all Europe, and it is not surprising that Rubens refers to it repeatedly. The Count de Bouteville was a confirmed duelist with a reputation of great skill, who refused to be deterred by the King's edict against this practice which Rubens called the "curse of France" (see Letters 72 and 81, note 3). This "duel of six champions" took place on May 12, 1627, at two o'clock in the afternoon, under the very windows of Cardinal Richelieu, in the Place Royale (now called the Place des Vosges), Paris. Bouteville and his second, the Count des Chapelles, after killing one of their adversaries, escaped. They were later brought to trial and condemned to death. In spite of many petitions on their behalf by members of the nobility, they were executed in accordance with the royal edict.

2. Bernardino Cardinal Spada (1593–1661) was Papal Nuncio in Paris. His "impudence" concerned the question of precedence at the French court.

Letter 111

Original lost. Copy in the Bibliothèque Inguimbert, Carpentras. — Italian. — No address.

1. Rubens has graphically described the decadent condition of Antwerp in a few lines. The closing of the mouth of the Scheldt by the Hollanders had crippled the city's commerce and brought an end to her prosperity. One of Rubens' sincerest aims in his diplomatic career was to bring back the benefits of peace to his own city. His concern for the lot of the common people was an exceptional trait among courtiers and diplomats of that time.

Letter 112

Original in the Bibliothèque Nationale, Paris. — Italian. — Address: To Monsieur Monsieur du Puy, Paris.

1. This was another consequence of the royal edict against dueling. Following a dispute at Versailles in November 1626 the Sieur de Liancourt challenged the Duke of Halluin. No duel took place, but the affair was regarded as very serious, since the provocation occurred in one of the royal palaces while the King was in residence. Halluin and Liancourt, fearing punishment, left the court. The intercession of their relatives and friends, however, resulted in their reinstatement.

2. The Abbé Scaglia's opinion of Rubens is given in a letter he wrote to the Duke of Savoy on July 26, 1627, from The Hague: "Rubens, very celebrated painter of Antwerp, a person capable of things much greater than the composition of a design colored by the brush, has finally arrived in these provinces. . ."

3. Whatever these pictures were, they were never executed. Dupuy seems to have asked for a series dealing with the themes of royal favorites or conjugal love, to be drawn from ancient history. For further discussion of these subjects see the following letters of June 10 and 25.

Letter 113

Original in the Historical Society of Pennsylvania, Philadelphia. — Italian. — Address: To Monsieur Monsieur de Puy, in Paris. — This letter, long thought to be lost, was known for many years only in the copy preserved in the Bibliothèque Inguimbert, Carpentras. The original, which figured in the Donnadieu sale in 1851 and which differs in a few details from that of the Carpentras copy as published in CDR, IV, 272, is here published for the first time.

1. The Duchess of Orléans was the Mlle. de Montpensier whose marriage to "Monsieur," brother of Louis XIII, had been arranged by Richelieu in spite of all the plots to prevent it (see Letter 91, note 6). The Duchess died on June 4, 1627, at the birth of her first child. Instead of the "king to be born," mentioned in Rubens' previous letter, this child was a daughter, who, however, was later to play a very active part in French politics. She was the famous Anne-Marie-Louise d'Orléans, Duchess of Montpensier (1627–1693), more popularly known as La Grande Mademoiselle.

Letter 114

Original in the collection of Mrs. Raphael Salem, Paris and Cambridge, Mass. — Italian. — No address.

1. The princess, La Grande Mademoiselle, became, in fact, famous for the number of marriage projects that were made for her, none of which materialized. After having been destined for a succession of kings, emperors, and princes, she fell in love with the Count of Lauzun and obtained permission of Louis XIV to marry him.

2. See Letter 60, note 4.

3. The "Revisidor" was Don Diego Messia, Marquis de Léganès, already mentioned in Letters 61, 71. His name will appear more frequently from now on.

4. This is the Mercure Français, which appeared annually from 1605–1643. It summarized the political events of each year, especially in France, but also in other European countries, thus providing one of the richest sources of historical information for this epoch.

Letter 115

Original in the Musée de Mariemont, Belgium. — Italian. — No address.

1. This is probably the Loxias by Wendelinus, mentioned in Letter 107.

2. This was the Cardinal-Infante Ferdinand, brother of Philip IV. As early as 1623 this plan had been formulated to send him to Brussels to receive training from his aunt, the Infanta Isabella. Owing to the jealousy of Olivares, however, it was never carried out. Ferdinand did not go to the Spanish Netherlands as Governor until 1635, after Isabella's death.

Letter 116

Original in the Wisbech Museum, Wisbech, Cambridgeshire, England. — Italian. — Address: To Monsieur Monsieur du Puy, in Paris. — For the Italian text, see Appendix. — This letter, doubtless the one mentioned by Rooses (CDR, IV, 286) as having figured in a sale of 1827, is here published for the first time. I am grateful to Mr. A. N. L. Munby, Fellow and Librarian of King's College, Cam-

bridge, for drawing my attention to the letter, and to Mr. G. R. Stanton, Curator of the Wisbech Museum, for permission to publish it.

1. Rumors had been current that operations on the Fossa Mariana were not progressing well. See Letter 106.

2. In response to his request in Letter 109, Rubens was granted a passport to Holland, for the purpose of meeting Gerbier there.

3. An eye-witness account of this ceremony is given by Sir William Segar, Knight, Garter Principal King of Arms, and appears in *The Institution . . . of the Most Noble Order of the Garter*, by Elias Ashmole (London, 1672), p. 419. The writer, after describing the journey to The Hague, continues: "It was about nine or ten days before we could be resolved whether the Order should be accepted or not; for the French Ambassador there resident opposed it by all means possible that he could, alledging it stood not with the French King his Master's honor, considering the League between him, the Prince and States, that his Enemy the King of Great Britain should be so much favored and honored by the Prince as to have the Order of the Garter by him received, the King of Great Britain having entred his Dominions to relieve Rochell, which he held Rebels to him; all which by the wisdom of the Lord Ambassador Carleton was so discreetly answered, and so far prevailed, that a day was appointed for the reception of the Order, which was to be done on the Sunday following, in the afternoon. . .

"The oration ended, the Ambassador presented his Majesty's commission, under the Great Seal of England, during the reading whereof, the whole table of the States stood up, their heads uncovered, only the French Ambassador excepted, who sate covered."

Rubens' suspicion that the conferring of the Order of the Garter upon the Prince of Orange might serve to cover some secret negotiation is but another proof of the general atmosphere of mistrust that permeated all international relations.

4. "That famous pirate" can only be the Dutch Vice-Admiral Piet Hein. See Letter 83.

5. See Letter 110, note 1.

6. Don Diego Messia was a cousin of Olivares, and enjoyed the Count Duke's favor. He had just been created Marquis de Léganès. Owing to a long delay at the French court, he did not reach Brussels until September. His marriage to Donna Polyxena Spinola did not take place until his return to Madrid in February 1628. See Letter 155.

Letter 117

Original lost. Copy in the Public Record Office, London. — French. — No address. — Rubens' request that Gerbier meet him in Zevenbergen, a few miles from Breda and just across the frontier, was not acceptable to Sir Dudley Carleton and Gerbier. The two artist-diplomats later met in Delft.

Letter 118

Original in the Bibliothèque Nationale, Paris. — Italian. — No address.

1. Rubens discreetly says nothing about the purpose of this journey, but we know that he is referring to his diplomatic mission to Holland. This letter was written during the interval when he returned to Brussels for further instructions.

Letter 119

Original in the Bibliothèque Nationale, Paris. — Italian. — No address.

1. See Letter 98, note 1.
2. The book by Louis Nonnius entitled *Diaeteticon sive de re cibaria lib. IV* (Antwerp, 1627) may be the one to which Rubens refers.
3. The Duke of Buckingham had sailed from Portsmouth late in June with more than one hundred ships and a large force, with the avowed intention of relieving the besieged Huguenots of La Rochelle. On July 21 he landed upon the Ile de Ré, commanding the approach to La Rochelle, and laid siege to Fort St. Martin. The gallant commander Toiras succeeded in holding him off until relief arrived, and Buckingham was obliged to retreat on November 17, 1627, with heavy losses.

Letter 120

Original in the Bibliothèque Nationale, Paris. — Italian. — No address.

1. Groll was captured by the Hollanders on the very day after Rubens wrote this letter. The siege of the town is described by Hugo Grotius in his *De obsidione Grollae*.

Letter 121

Original in the Public Record Office, London. — French. — No address. — On the back, in Gerbier's hand: "Letter from Rubens, of August 27, received the first of September, 1627, The Hague."

1. Arnold Lunden of Antwerp, whose wife was a member of the Fourment family, was not only an intimate friend of Rubens but later became his brother-in-law, upon the painter's marriage to Helena Fourment in 1630.

Letter 122

Original in the Bibliothèque Nationale, Paris. — Italian. — No address.

1. Charles de Longueval, Count de Bucquoy, had been Commander of Artillery in the Spanish Netherlands until his death in 1621. The portrait of Bucquoy which Rubens promises to Dupuy is the engraving by Lucas Vorsterman, done in 1621 or 1622.
2. This was the second edition of the work by Jacob de Bie, *Imperatorum romanorum numismata aurea a Julio Caesare ad Heraclium,* the first edition of which had appeared in 1615.
3. Rubens painted the portrait of his friend Spinola several times. The engraving of which he speaks was never executed.

Letter 123

Original in the Bibliothèque Nationale, Paris. — Italian. — No address.

1. Fort St. Martin was the citadel of Ile de Ré, off La Rochelle, which was resisting the attack of the English under Buckingham.
2. This is the famous Cameo Gonzaga, now in the Hermitage, Leningrad. It is remarkable for its size (160 x 120 mm.) and its quality of execution. The design represents the heads of Ptolemy and Arsinoë.
3. The book to which Rubens refers is perhaps one by Rodolphus: *Limites humani partus* (Paris, 1613).
4. The name of this author is incorrectly written. He is Giuliano Bossi, and the

book is entitled *Breve trattato d'alcune invenzioni per rinforzare e raddopiare li tiri degli Archibugi et Moschetti* (Antwerp, 1625).

Letter 124

Original in the Public Record Office, London. — French. — No address. — On the back, in Gerbier's hand: "Letter from Rubens of September 18, received at The Hague on the 24th."

Gerbier, impatient and discouraged, had written to Rubens on September 6, bluntly asking for a written confirmation that the Infanta Isabella and Spinola wished to continue negotiations for a peace between Spain and England. Rubens was also discouraged; for, with the final arrival of Don Diego Messia, he had learned that Spain, while sanctioning his efforts toward peace with England, was negotiating with France to invade that country. This letter is Rubens' official and rather guarded reply to Gerbier. It was no doubt dictated by his superiors. On the same day, however, he wrote the two more personal letters that follow, one in French and one in Flemish, where he gave freer expression to his disappointment.

1. This and the two following letters Gerbier turned over to Sir Dudley Carleton, who underlined the passages which appear here in italics.

Letter 125

Original lost. Copy, in Gerbier's hand, in the Public Record Office, London. — French. — No address. — Note added by Gerbier: "Another letter on the same subject, but written in confidence."

Letter 126

Original lost. Copy in the Public Record Office, London. — Flemish. — No address. — On the back: "Copie of a lre from Mr. Rubens to Mr. Gerbier." — On the French translation of this letter which he sent to Sir Dudley Carleton Gerbier wrote: "Third letter which he wrote to me in Flemish."

1. See Letter 109, note 3.
2. Indications are that Rubens made another brief journey to Holland early in October 1627, perhaps to take leave of Gerbier before the latter's departure for London. On October 12 Jacques Dupuy wrote to Peiresc: "M. Rubens has gone for a short journey in Holland, but he tells us nothing about it." On October 14 (Letter 130) Rubens himself wrote to Pierre Dupuy: "I did not write by the last post because I was in the country."

Letter 127

Original lost. Copy in the Public Record Office, London. — French. — No address. — On the back: "Copie of a lre from Mr. Rubens to ye Duke of Buckingham of ye 18th of 7 ber 1627." — This letter and the three preceding letters to Gerbier brought the peace negotiations to a standstill. Charles I ordered Gerbier to be recalled from The Hague to London on October 4.

Letter 128

Original formerly in the Bibliothèque Nationale, Paris. Present location unknown. — Italian. — No address.

1. This was the village of Doel, in the neighborhood of Santvliet.
2. The correct title is *La Congiura de' Baroni del Regno di Napoli contra il Re Ferdinando Primo, Raccolta del S. Camillo Portio* (Rome, 1565).

3. The Duke of Buckingham had sent a note to Toiras, Governor of the Ile de Ré, demanding the surrender of Fort St. Martin. Toiras, in a letter dated September 1, 1627, flatly refused.

Letter 129

Original in the Bibliothèque Nationale, Paris. — Italian. — Address: To Monsieur Monsieur de Puy, Paris.

1. This projected union of the Spanish states for common defense had been described to the Infanta by Philip IV in a letter dated August 9, 1626. It was a plan to prevent Castile from continuing, as the King said, to bear the financial burden of Spain's military expenditures. Now, a year later, Don Diego Messia was in Brussels to persuade the provinces of the Spanish Netherlands to join this union. According to the proposal he brought from the King of Spain, the object was to form a single permanent army of 140,000 men. The quota of troops to be furnished and maintained by each of the Spanish states was as follows: Castile and the Indies, 44,000 men; the Spanish Netherlands, 12,000; Aragon, 10,000; Valencia, 6,000; Catalonia, 16,000; Portugal, 16,000; Naples, 16,000; Sicily, 6,000; Milan, 8,000; the Islands of the Mediterranean and the Ocean, 6,000.

Those states that had to serve as battlegrounds were granted a reduction in the levy of troops and funds, and this, it was thought, would appeal to the Spanish Netherlands. But the proposal was not acceptable to all the provinces without certain modifications and was finally abandoned. The idea of a standing army maintained in peacetime as well as in war was very new in Europe in the seventeenth century. Although Don Diego's elaborate plan was not realized, Spain was probably the first European country to create a true standing army.

Letter 130

Original in the Bibliothèque Nationale, Paris. — Italian. — No address.

Letter 131

Original formerly in the possession of J. J. Merlo, who published it in *Nachrichten von dem Leben und den Werken Kölnischer Künstler* (Cologne, 1850), pp. 390–391. Present location unknown. — Italian. — No address.

1. Early in October there was a rumor that the States General of the United Provinces was permitting Spanish vessels, which the Dutch fleet had been blockading in the ports of Dunkirk and Ostend, to go out into the open sea. Rubens was surprised at this tolerance, and expressed the wish that such permission be granted to the ships in the port of Antwerp — the only means, he said, of restoring that city's commercial prosperity.

2. In spite of the efforts of his friends to dissuade him, François-Auguste de Thou set out for Constantinople, arriving there in May 1628.

Letter 132

Original formerly in the possession of J. J. Merlo, who published it in *Nachrichten von dem Leben und den Werken Kölnischer Künstler* (1850), pp. 391–92. Present location unknown. — Italian. — Address: To Monsieur Monsieur du Puy, in Paris.

1. Henri, Duke of Rohan (1579–1638), one of the greatest Huguenot leaders,

began his military career as a favorite of Henri IV. In 1603 he married Sully's daughter, Marguerite de Béthune, and became a peer of France. At the King's death Rohan fell into disgrace, but reconciled himself with Louis XIII in 1616. His opposition to the decrees against the Protestants made him undertake the leadership of the Huguenot party in 1621. Raising troops in Languedoc, he delivered Montauban from siege, but was forced to see the surrender of Montpellier. Rohan's brother, the Seigneur de Soubise, with a royal fleet captured in 1625, took up the defense of La Rochelle and ranged the western coast, intercepting commerce (see Letter 61, note 7).

At the time of this letter, in 1627, Richelieu and the King were beginning in earnest the task of subjugating the Huguenots by laying siege to their stronghold of La Rochelle. The Prince of Condé, in the meantime, was sent with an army to check the Duke of Rohan, whose vigor and ability made him a formidable adversary of the royalists. The surrender of La Rochelle in 1628, however, coupled with dissension in his own party, forced Rohan to submit to the King. He went into exile in Venice, and there he remained until 1635, when France began to play a more conspicuous part in the Thirty Years' War, and Richelieu chose Rohan to direct the war in the Valtelline. He died in 1638.

The Duke of Rohan is also remembered for his literary achievements. While in Venice he wrote his *Mémoires sur les choses qui se sont passées en France,* as well as his famous book on the history and art of war: *Le Parfait Capitaine.*

Letter 133
Original in the Bibliothèque Nationale, Paris. — Italian. — No address.

Letter 134
Original in the Bibliothèque Nationale, Paris. — Italian. — No address.

1. The final retreat of Buckingham and the English fleet from the Ile de Ré took place on November 17, 1627.

2. This book, whose correct title is *Lettres de Phyllarque à Ariste,* was written in 1627 by Père Goulu as a bitter attack upon Jean Louis de Balzac, celebrated littérateur and favorite of Richelieu. Balzac had in 1624 published his *Lettres,* which were to be so influential in reforming French prose style. A few amusingly derogatory references to the clergy infuriated Père Goulu to the point of directing a relentless press-campaign against Balzac. In the *Lettres de Phyllarque* Balzac is referred to throughout as "Narcissus." The book, in two large volumes, enjoyed extraordinary popularity for its vitriolic wit, but did Balzac no permanent harm; the controversy died with Goulu in 1629. Rubens' enthusiasm for Goulu's book may be due partly to the fact that he had not yet read the *Lettres* of Balzac.

3. Rubens confuses Roger Bacon with the philosopher and statesman Francis Bacon (1561–1626), author of the *Life of Henry VII.*

Letter 135
Original lost. Copy of this fragment in the Bibliothèque Inguimbert, Carpentras. — Italian. — No address.

1. The Marquis Spinola had been summoned to Madrid at the request of the

Infanta Isabella, in order to explain to the King the critical situation in the Spanish Netherlands.

Letter 136

Original in the Biblioteca Nazionale, Florence. — Italian. — No address.

1. Guillaume Bautru was French Ambassador in Madrid. The "meager compliment" was in return for Spain's tardy aid to France in sending a fleet to resist the English at La Rochelle (see the following letter).
2. Don Carlos Coloma (1573–1637) was a Spanish statesman then residing in the Netherlands as Governor of Cambrai. As Rubens says, he replaced Spinola as supreme commander upon the latter's departure for Madrid. We shall find frequent mention of Don Carlos Coloma in Rubens' letters from London; it was he who, in 1629, was named the King of Spain's Ambassador to England, and who concluded the Anglo-Spanish peace for which Rubens laid the groundwork.

Letter 137

Original in the British Museum, London. — Italian. — No address.

1. Don Fadrique de Toledo was Grand Admiral of Spain. After long delay his fleet reached Morbihan when the French no longer needed help in resisting the English. He therefore returned soon to Spain.

Letter 138

Original lost. Copy in the Archivo General, Simancas. — Italian. — No address. — The copy was written by a Spaniard who introduced many errors into Rubens' text.

1. The failure of the Duke of Buckingham at Ile de Ré paved the way for a renewal of Anglo-Spanish negotiations. Moreover, Madrid had by this time lost much confidence in the French alliance, and so did not discourage Rubens from taking up again the matter of a truce with England.

Letter 139

Original in the Houghton Library, Harvard University. — Italian. — No address. — For the Italian text, see Appendix. — This letter, hitherto unpublished, was found in the Locker-Lampson-Warburg-Grimson Album acquired by the Harvard College Library in 1953. I am grateful for permission to publish and to reproduce the manuscript.

1. Count Henry de Bergh's loyalty to the King of Spain was at this time beginning to be questioned. See Letter 86, note 1.

Letter 140

Original in the British Museum, London. — Italian. — No address.

1. See Letter 134, note 2.
2. Jerome Cardan was a sixteenth-century Italian doctor, mathematician, and astronomer who published many works. In a later letter Rubens mentions this particular book as *Proxeneta seu de Prudentia civili* (Leyden, 1627). The book by Grotius is identified as his *De veritate religionis Christianae,* which had just appeared in a second edition.

Letter 141

Original in the Rubenshuis, Antwerp. — Italian. — Address: To Monsieur Monsieur du Puy, in Paris.

1. This was the dyke across the harbor mouth which was intended to close the port to all assistance by sea.
2. Rubens was right in predicting a struggle over the Mantuan succession. Duke Vincenzo II, before his death, had acknowledged as his successor Charles, Duke of Nevers, and had arranged the marriage of his niece to Charles' son, the Duke of Rethel. This niece was also the granddaughter of the Duke of Savoy, and through her Savoy laid claim to Montferrat.

Letter 142

Original in the Bibliothèque Nationale, Paris. — Italian. — No address.

1. See Letter 136, note 2.

Letter 143

Original in the Bibliothèque Nationale, Paris. — Italian. — No address.

1. See Letter 134, note 2. Balzac exposed himself to criticism by his vanity, his *philautia,* and Rubens was quick to detect it.
2. This was a new edition of the *Imperatorum romanorum numismata aurea a Julio Caesare ad Heraclium,* containing a description of the collection of the Duke of Aerschot, with engravings by Jacob de Bie and text by Jan de Hemelaer.
3. See Letter 93.
4. The Flemish Ambassador at Paris was Henri de Vicq, Seigneur de Meulevelt.

Letter 144

Original lost. Spanish translation in the Archivo General, Simancas. — No address.

1. The Minister of the King of Denmark to the States General was Josias Vosberghen.
2. The Infanta does not seem to have granted Rubens the desired authority, but to have required that he come to Brussels with the Danish minister for verbal negotiations. She ordered Rubens to report to Spinola on the proposals of this new agent, which Rubens did in his letter of February 11.

Letter 145

Original in the Bibliothèque Nationale, Paris. — Italian. — Address: To Monsieur Monsieur Du Puy, at the house of Councilor de Thou, Rue des Poictevins, behind St. André des Ars, Paris.

1. The Marquis Spinola arrived in Paris on January 11. He made his entry into the city in the Queen's carriage and was lodged with the Spanish Ambassador, the Marquis de Mirabel. He left on the fourteenth.
2. This was the Gallery of Henri IV, which was to be a pendant to that of Marie de' Medici, in the Luxembourg. It was never completed.
3. This was probably an inscription celebrating the arrival in Paris of the standards captured from the English at Ile de Ré.

4. The title of this work is *Stemmata principum Belgii, ex Diplomatibus ac Tabulis publicis potissimum concinnata* (Brussels, 1626).

Letter 146

Original lost. Spanish translation in the Archivo General, Simancas. — No address.

1. In answer to this letter Spinola wrote to Rubens on March 3, saying that he attached little importance to the proposals of the Danish minister, Josias Vosberghen, and considered that he was acting without sufficient authority. In the same letter Spinola gave Rubens to understand that the King of Spain was disposed toward peace.

 Vosberghen, with the passport received from the Infanta, went on to Calais, where he embarked for England. He was accompanied on this voyage by Jan Brant, the cousin of Rubens mentioned in this correspondence as "the Catholic."

Letter 147

Original in the Bibliothèque Nationale, Paris. — Italian. — Address: To Monsieur Monsieur du Puy, Paris.

1. See Letter 137, note 1.
2. Wallenstein had become Duke of Friedland in 1624. Count Octavio Sforza Visconti was a diplomatic agent sent to Wallenstein by Philip IV.

Letter 148

Original in the collection of Frits Lugt, The Hague and Paris. — Italian. — No address.

1. Gilbert Gaulmin, French poet (1585–1665).
2. Louis XIII, after at first directing the siege of La Rochelle in person, grew tired and returned to Paris on February 10, 1628, leaving the command to Cardinal Richelieu. He returned to the siege on April 17.
3. Henri, Duke of Rohan, one of the leaders of the Huguenots, had been sentenced by the Parliament of Toulouse, on January 22, 1628, to be burned alive. On February 5 he was burned in effigy. See Letter 132, note 1.
4. On December 30, 1627, Giorgio Cornaro, son of the Doge Giovanni Cornaro, attempted to assassinate Raniero Zeno, one of the Council of Ten. Zeno recovered, but Cornaro was degraded from the nobility, his property confiscated by the republic, and a price set on his head.
5. A newly discovered document in the Bibliothèque Nationale, Paris (ms. Baluze 323, folios 54–57) may have been the memorandum Rubens was looking for. See *Revue de l' Art*, no. 4 (1969).

Letter 149

Original in the Bibliothèque Nationale, Paris. — Italian. — No address.

Letter 150

Original in the Bibliothèque Nationale, Paris. — Italian. — Address: To Monsieur Monsieur du Puy, Paris.

1. The second volume of *Lettres de Phyllarque à Ariste,* by Père Goulu, which had just appeared. See Letter 134, note 2.
2. Davus is the name of a Roman slave, often met with in the plays of Plautus and Terence, and in the satires of Horace. It signifies an ignorant man.

Letter 151

Original in the Bibliothèque Nationale, Paris. — Italian. — No address.

1. The States General of Holland, wishing to avoid hostilities with the Imperial troops, who were demanding that the town of Emdem be turned over to them, ordered the evacuation of the villages surrounding the place.

2. Lucas Holstenius, German scholar, was born in Hamburg in 1596 and died in Rome in 1661. He went to Paris in 1624, where he came into contact with the brothers Dupuy and with Peiresc. He became a favorite of Cardinal Barberini, and later the favorite of several popes. In 1627, shortly after his arrival in Rome, he published a poem on the marriage of Taddeo Barberini, Prefect of Rome, and Anna Colonna.

3. This friend is probably Nicolas Respaigne, an Antwerp merchant, who returned from the Levant in 1624, and whose portrait, in Oriental costume, Rubens painted soon after. It is now in Cassel.

Letter 152

Original in the Bibliothèque Nationale, Paris. — Italian. — No address.

1. In his next letter to Pierre Dupuy, Rubens corrects these two dates. Instead of February 26, he says 24, and instead of February 8, he says 28.

2. Rubens is referring here to the *Lettres de Phyllarque*. See Letter 134, note 2.

Letter 153

Original lost. Copy by Gerbier in the Public Record Office, London. — Flemish. — No address.

1. Soon after this letter was written, Charles I granted a commission to Josias Vosberghen authorizing him, as a neutral person, to negotiate with Spain for a truce or peace.

2. Jan van den Wouwere (Woverius), (1574–1635) was one of Rubens' close friends. A scholar and writer, he was Commissioner of Finances in Brussels, and one of the Infanta Isabella's trusted diplomatic agents. See Letter 218.

Letter 154

Original lost. Copy in the Public Record Office, London. — French. — No address.

Letter 155

Original lost. Copy in the Bibliothèque Inguimbert, Carpentras. — Italian. — Address: To Mr. Mr. du Puy, Paris.

Letter 156

Original lost. Spanish translation in the Archivo General, Simancas. — No address.

Letter 157

Original lost. Spanish translation in the Archivo General, Simancas. No address. — Gerbier's complaints were not unfounded. The manner in which Rubens presents them indicates that he shares Gerbier's dissatisfaction in this case, and lays the blame upon Spain.

1. This passage is in French in the text. The two kings referred to are those of Spain and France.

Letter 158

Original lost. Spanish translation in the Archivo General, Simancas. — No address.

Letter 159

Original lost. Spanish translation in the Archivo General, Simancas. — No address. — On the back: "Letter of Peter Paul Rubens without date, in which he says he is sending all the documents which he has received concerning the negotiations with England." This letter is placed with the series written to the Marquis Spinola on March 30, 1628, since it is closely related to them and must have followed soon after that date.

1. Rubens had for some time been thinking of going to Italy. He had also promised to visit Peiresc in Aix in the fall of 1628. Neither plan, however, was carried out.

2. The Dutch ambassadors to Paris were Sommelsdyk and Gaspar van Vosberghen. Their mission was to interest the King of France in an alliance with their country and peace with England. After ten months at the French court, however, and long negotiations, they departed without having achieved any results.

Letter 160

Original lost. Spanish translation in the Archivo General, Simancas. — No address. — If the copyist was accurate, Rubens wrote this letter from Antwerp on the same day as the preceding letters written from Brussels. But this was not impossible. The following letter, written to Pierre Dupuy on the evening of that same day, March 30, begins: "Just at this moment, upon my return from Brussels . . ."

Letter 161

Original lost. Copy in the Bibliothèque Inguimbert, Carpentras. — Italian. — Address: To Mons.^r Mons.^r du Puy, Paris.

1. It was a fleet of thirty English vessels, under Lord Denbigh, that reached La Rochelle in May. But it sailed off again without attempting to force an entrance into the harbor.

2. Prince Maurice and his brother were sons of Charles Emmanuel, Duke of Savoy.

Letter 162

Original formerly in the Bibliothèque Nationale, Paris. Present location unknown. — Italian. — No address.

1. See Letter 134, note 2.

2. The Duke of Rohan, in attempting to take the citadel of Montpellier, had fallen into a trap and lost a large part of his troops. See Letter 132, note 1.

3. The Earl of Carlisle arrived at The Hague on May 11. On May 28 he was in Antwerp and tried to see Rubens, who was that day in Brussels. On the following day Carlisle went to visit Anthony van Dyck, and there met Rubens, just returned.

4. This is the phenomenon already mentioned in Letter 155. A fruit tree growing near Haarlem, when sawn into sections, was thought to show symbolical figures foretelling the return of the Northern Netherlands to Catholicism.

Letter 163

Original in the Bibliothèque Nationale, Paris. — Italian. — No address.

1. Rubens' memory has failed him here. He was actually in the service of the Duke of Mantua from the middle of 1600 until October 1608.

Letter 164

Original formerly in the Bibliothèque Nationale, Paris. Present location unknown. — Italian. — No address.

1. Rubens is perhaps referring to a poem by Abraham Remius, which Peiresc sent to many of his correspondents.

2. Walter Montagu had been employed as a political agent of Charles I in Savoy and in France. He was imprisoned in the Bastille as an English spy. He later became converted to Catholicism and entered the service of Louis XIV.

3. Marie de Rohan, Duchess of Chevreuse, had followed the young Queen Henrietta Maria to the English court in 1625, where, through her numerous intrigues, she attained a certain notoriety. She was banished from the French court in 1626 for her part in the Chalais conspiracy (see Letter 91, note 6). She was later exiled to Brussels and allowed to return only after the death of Richelieu.

4. Lorenzo Ramírez de Prado, member of the King's Council in Madrid, was the author of a number of books on jurisprudence.

Letter 165

Original formerly in the collection of Gustav Oberlaender, Reading, Pennsylvania. Present location unknown. — Italian. — No address.

1. The claims of Charles Emmanuel, Duke of Savoy, to the duchy of Montferrat were founded upon the marriage, in 1608, of his daughter to Francesco IV, then Duke of Mantua and Montferrat. Francesco had died in 1613, leaving a daughter, and the Duke of Savoy was now advancing the claims of this granddaughter, who was married to the son of the Duke of Nevers. See Letter 141, note 2.

Letter 166

Original in the Bibliothèque Royale, Brussels. — Italian. — No address.

Letter 167

Original lost. Copy in the Bibliothèque Méjanès, Aix. — Italian. — No address.

1. This painting is the famous "Aldobrandini Marriage," now in the Vatican. It had been discovered in Rome in 1606, while Rubens was there. Its owner was at that time Cinthio Cardinal Aldobrandini. Although Rubens has not seen this painting for twenty years, his memory of its details is remarkably accurate. See Letter 239.

Letter 168

Original formerly in the collection of John Gribbel, Philadelphia. Present location unknown. — Italian. — No address.

1. In 1628 the Duke of Savoy fomented a revolution in Genoa, with the aid of a rich Genoese named Vacchero. The purpose of the plot was to procure for the commoners a part in the government. It was discovered, however, and Vacchero and his accomplices were put to death.

Letter 169

Original in the Bibliothèque Nationale, Paris. — Italian. — No address. — For the Italian text, see the Appendix. — This fragment in Rubens' handwriting, bearing neither date nor signature, is here published, with the permission of the Bibliothèque Nationale, for the first time. It probably formed the postscript to a letter. The reference to the prolonged absence of the Marquis Spinola makes it possible to date the fragment between May and August of 1628.

Letter 170

Original formerly in the Barker Collection, London. Present location unknown. — Italian. — No address.

1. See Letter 71, note 4.
2. Rubens was in Brussels with Don Carlos Coloma on May 23 and 24. During the following week he had to go there again.

Letter 171

Original in the Bibliothèque Nationale, Paris. — Italian. — No address.

1. Charles I of England and Victor Amadeus, Prince of Piedmont and son of the Duke of Savoy, were brothers-in-law; both had married sisters of Louis XIII.
2. Lord Denbigh, brother-in-law of Buckingham, was commander of the fleet which had failed to aid La Rochelle in May. See Letter 161, note 1.
3. This was the sale of the greater part of the ducal collection of Mantua to Charles I of England, arranged by Vincenzo II, Duke of Mantua, before his death. The "English gentlemen" who negotiated the sale was Nicolas Lanier. Among the paintings thus acquired for the English royal collection were Correggio's "Jupiter and Antiope" and "Mercury Instructing Cupid," Raphael's "Madonna of the Pearl," also works by Titian, Caravaggio, Guido Reni, Andrea del Sarto, and Tintoretto. In 1629 Mantegna's "Triumph of Caesar" was added. The total sum paid by Charles I for these treasures was 18,280 pounds sterling. The sale aroused such a stir in Italy, and in fact throughout Europe, that the new French Duke of Mantua would have liked to break the contract. Rubens felt a very personal regret at the dispersal of this precious collection. What remained in Mantua, however, was looted or destroyed during the sack of the city by the Imperial troops in 1630.
4. Sir William Boswell, English poet and humanist, was secretary to Sir Dudley Carleton and later succeeded him as Ambassador to The Hague.
5. The Vosberghen here referred to is Gaspar van Vosberghen, Dutch Ambassador to France (see Letter 159, note 2). The relative was possibly Jan Brant, "the Catholic," who lived in Holland.

Letter 172

Original in the Bibliothèque Nationale, Paris. — Italian. —No address.

1. Rivius' book was published in Frankfort in 1628 as a refutation of the ninth book of Procopius' *Anecdotes,* published by Niccolo Alemanni in 1623 and dealing with the vices of the Byzantine court under Justinian and Theodora. The authenticity of this ninth volume has been doubted.

Letter 173

Original in the British Museum, London. — Italian. — No address. — For the Italian text, see Appendix. — This letter is here published, with the permission of the Trustees of the British Museum, for the first time. It is, without a doubt, the letter to which Rooses refers (CDR, IV, 437) as having figured in sales of 1851, 1874, and 1879, but whose location was unknown to him.

1. The unfortunate town that found itself in the path of an invading army was forced to pay a contribution in order to escape depredation.

2. Spain watched with increasing anxiety the growth of the Dutch East and West India Companies and their successes in the New World. By *ultra Tropicum versus Austrum* Rubens refers, of course, to Australia. The idea of a vast uncharted southern continent had long attracted geographers and navigators. During the sixteenth century Portuguese and Spanish explorers made important discoveries in that region, but as the Dutch sea power increased, the Hollanders took over exploration of the unknown territory. Perhaps the earliest printed account of the Australian mainland appears in the *Descriptionis Ptolemaicae Augmentum* of Cornelius Wytfliet, published in Louvain in 1598: "The *Terra Australis* is the most southern of all lands, and is separated from New Guinea by a narrow strait. Its shores are hitherto but little known, since, after one voyage and another, that route has been deserted, and seldom is the country visited, unless when sailors are driven there by storms. The *Terra Australis* begins at one or two degrees from the Equator, and is ascertained by some to be of so great an extent that if it were thoroughly explored it would be regarded as a fifth part of the world." This book may have been known to Rubens. By 1628, the date of this letter, much of the north and south coasts of Australia had been explored, and the territory given the name of "New Holland." Further discovery was made by Tasman in 1642–1644, but a correct determination of the continent's shape was not reached until the end of the eighteenth century.

Letter 174

Original sold by the Parke-Bernet Galleries, New York, in 1938; present location unknown. — Italian. — Address: To Monsieur Monsieur du Puy, Paris. — Rubens' seal in red wax very well preserved. — A revision of the original text necessitates the following corrections in Rooses' transcription as it appears in CDR, IV, 437–438: for *vituperatore* read *tricciatore;* for *inacerbiscono qui* read *inacerbiscono più;* for *uometto* read *stromento.*

1. The "trickster" was the Duke of Savoy, who was contesting the claims of the Duke of Nevers to Montferrat. See Letter 141, note 2.

2. D'Esplang, or Desplans, Sieur des Plans, was a favorite of Louis XIII and one of Dupuy's correspondents.

3. The *Gazette* of Holland, the earliest newspaper of that country, appeared from 1619 on.

4. Henri II de Bourbon, Prince of Condé (1588–1646), was the son and grandson of Huguenot generals. When placed at the head of the King's troops to reduce the Huguenots of Languedoc to submission, he distinguished himself by the cruelty with which he carried out his task.

5. "Your Marquis" was perhaps a portrait of Spinola which Rubens had promised Dupuy. See Letters 122, 179.

6. M. Gault was an antiquarian in Paris from whom Rubens had purchased various things, including the ancient spoon mentioned in Letter 235, note 5.

Letter 175

Original in the Bibliothèque Nationale, Paris. — Italian. — No address.

1. François Savary de Brèves was one of France's ablest diplomats under Henri IV and Louis XIII. In 1591 he was appointed Ambassador to Constantinople, returning to France in 1606. Two years later he went as Ambassador to Rome. He died in Paris in 1628. The story of de Brèves' travels was written from his memoirs by Jacques du Castel, one of his secretaries. It was entitled: *Relation des voyages de M. de Brèves, tant en Grèce, Terre Sainte et Egypte, qu'aux Royaumes de Tunis et Alger; ensemble un Traicté faict l'an 1604, entre le roi Henry le grand et l'empereur des Turcs etc., le tout recueillé par J.D.C.* (Paris, 1628).

Letter 176

Original in the Biblioteca Trivulziana, Milan. — Italian. — No address. — In very damaged condition; certain words and parts of phrases have had to be reconstructed.

Letter 177

Original in the Bibliothèque Municipale, Nantes. — Italian. — No address.

1. Fabio de Lagonissa, who succeeded Guidi di Bagno as Papal Nuncio at Brussels, almost at once made himself unpopular by his disregard for the laws and customs of the provinces and his demand for radical changes. The episode here described caused such a scandal that the Infanta wrote to Philip IV urging the recall of the new nuncio.

Letter 178

Original in the Bibliothèque Nationale, Paris. — Italian. — No address.

1. Rubens had first written "and the people in general one-quarter." He crossed out these words and replaced them by "the possessor one-quarter."

2. The Duke de la Trémouille was converted to Catholicism on July 18, 1628.

Letter 179

Original in the Autographensammlung, Veste Coburg. — Italian. — No address. — Published by L. Burchard, *Kunstchronik und Kunstmarkt*, new series XXX (1919), 512.

1. Now that Rubens has been in Madrid for several months, there is no longer any reason for secrecy. Moreover, news of the final surrender of La Rochelle has inspired him to write letters of congratulation to his two closest friends in France — Pierre Dupuy and Peiresc.

2. The equestrian portrait of Philip IV mentioned here was destroyed in the fire of 1734 in the Escorial.

3. The Queen of Hungary was the Infanta Maria, the sister of Philip IV who had been betrothed for a short time to Charles, Prince of Wales, in 1623 (see Letter 55, note 5, for an account of the ill-fated "Spanish match"). In April 1628 she was married by proxy to Ferdinand of Hungary, who later became

Emperor Ferdinand III. She did not make the voyage to Genoa to which Rubens refers here.

Letter 180

Original in the Royal Library, The Hague. — Italian. —No address. — First published, in English translation only, by Thicknesse in *A Year's Journey* (1784), pp. 329–333. Thicknesse gives the date erroneously as December 2, 1625.

1. This was the self-portrait which Rubens had promised to send to Peiresc. Nicolas Picquery was the husband of Elizabeth Fourment, whose sister Helena was to marry Rubens in 1630. Picquery was established in Marseilles, and the brother-in-law referred to here was probably Daniel Fourment. The portrait was a long time in reaching Peiresc in Aix. On July 4, 1630, Valavez writes to Rubens that Peiresc has just received it. (See Letter 216, note 2.)

Letter 181

Original in the Bibliothèque Royale, Brussels. — Flemish and Latin. — No address. — Although Rubens begins by writing in Flemish, with apologies for his Latin, more than half the letter is in the ancient language. He sometimes changes from one to the other in the middle of a sentence.

1. Gevaerts was writing a commentary on the works of Marcus Aurelius, and had asked Rubens to look up some manuscripts in the Escorial.
2. Don Francisco Bravo de Acuña was a Spanish scholar distinguished for his knowledge of languages.
3. In September 1628 the Dutch Admiral Piet Hein had captured an entire Spanish fleet off the coast of Cuba. It comprised sixteen ships and the cargo was valued at twelve million florins.
4. Albert Rubens, born in 1614, was the eldest son of Rubens and Isabella Brant.
5. The murder of Buckingham.

Letter 182

Original in the Public Record Office, London. — French. — No address. — The Earl of Carlisle was British Ambassador to Savoy (see Letter 162, note 3, and Letter 171). The Abbé Scaglia had just come from Turin to Madrid as Ambassador of the Duke of Savoy. His primary aim was to tighten the alliance between Savoy and Spain, in order to resist French influence in Montferrat, but he was no less interested in promoting peace between Spain and England.

Letter 183

Original in the Public Record Office, London. — French. — No address. — Not signed, but written in Rubens' hand. — The Earl of Carlisle was engaged in trade as well as diplomacy, as is indicated here.

Letter 184

Original formerly in the collection of Alfred Huth, London. Present location unknown. — Italian. — No address.

1. See Letter 180, note 1; Letter 216, note 2.
2. Rubens perhaps knew by this time that he was to be sent to London, and would have to give up his plans for Italy and Provence.
3. The treaty "so infamous to the Crown of Spain" was concluded between the

King of France and Spain's ally, the Duke of Savoy. Early in March 1629 French troops had penetrated into Savoy to support the claims of the Duke of Nevers to the duchies of Mantua and Montferrat. The Duke of Savoy, whose policy was always dictated by his own interests, was easily overcome and made peace with France. By this treaty Gonzalo de Cordova, commander of the Spanish troops in that region, was obliged to lift the siege of Casale (see Letter 170) and to agree not to contest the Duke of Nevers' possession of Mantua. The articles of this treaty, all in favor of France, were ratified by Spain on May 3, 1629.

Letter 185

Original lost. Copy in the Archivo General, Simancas. — Italian. — No address. — This letter finds Rubens in London as official representative of Philip IV at the court of Charles I, and describes his second interview with Charles.

1. Sir Richard Weston (1577–1635) was Lord Treasurer, and since the death of Buckingham had become the most powerful minister of the English court. Sir Francis Cottington (1578–1652) was Chancellor of the Exchequer. Both Weston and Cottington believed that Charles I had gone too far in conceding possible partition of the Palatinate.

2. The French Ambassador was the Marquis de Châteauneuf (see Letter 187).

3. The Venetian Ambassador was Alvise Contarini. He was on the side of France and antagonistic toward Rubens.

4. After the recall of Spinola from the Spanish Netherlands, the Prince of Orange had taken the offensive and laid siege to Bois-le-Duc (Hertogenbosch) in May 1629. The town capitulated in September.

Letter 186

Original lost. Copy in the Archivo General, Simancas. — Italian. — No address.

Letter 187

Original lost. Copy in the Archivo General, Simancas. — Italian. — No address.

1. Sir Thomas Edmondes was the newly appointed Ambassador to France.

2. Sir Walter Aston had been Ambassador to Spain from 1620 – 1625, and was to serve again in that capacity from 1635 – 1638.

3. Benjamin de Rohan, Seigneur de Soubise, was still the champion of the Huguenots (see Letter 61, note 7), in spite of the capitulation of La Rochelle. He was at this time in London, seeking support in his campaign against the King of France.

4. Sir Henry Vane (1589–1654). He had been in Holland as Ambassador Extraordinary and returned to London at the same time as Rubens arrived there.

Letter 188

Original lost. Copy in the Archivo General, Simancas. — Italian. — No address.

Letter 189

Original in the Archivo General, Simancas. — Italian. — No address.

1. The Ambassador from Holland was Albert Joachimi.

2. Sir Henry Vane.

3. Jan de Kesseler, Councillor of Finances in Brussels, was the mediator in the

truce negotiations which the Infanta had been carrying on directly with the United Provinces for several years. Rubens' mission in London was limited to a truce between England and Spain.

Letter 190

Original lost. Copy in the Archivo General, Simancas. — Italian. — No address.

1. Lorenzo Barozzi, Agent of the Duke of Savoy, was Ruben's best friend among the foreign diplomats in London. The two were in frequent contact, for Rubens went to mass daily in Barozzi's private chapel.

Letter 191

Original in the Archivo General, Simancas. — Italian. — No address.

1. These two letters, in addition to confirming Rubens' reports, speak of the painter in very complimentary terms. Weston, the Lord Treasurer, says: "Rubens, in his dispatches, will have informed you as to what has been done here since his arrival, and I refer to his report, by which Your Excellency will see that what has been written from here conforms to the truth, and will see what pains Rubens has taken, and how he has gained esteem, not only by his fine talent, but also by his great aptitude . . ." Cottington writes: ". . . I shall only say that his having been sent here has been highly approved, because he is not only very clever and adroit in negotiating matters, but also knows how to win the esteem of everyone and especially of the King, my master."

2. Henry Rich, Earl of Holland (1590–1649), had been Ambassador Extraordinary to Paris and also to The Hague. He enjoyed the favor of Charles I until 1640 and was beheaded by the Parliamentarians in 1649.

3. William Herbert, Earl of Pembroke and Montgomery, had been a favorite of James I. He died in 1630.

4. Thomas Howard, Earl of Arundel (1585–1646). See Letter 195, note 1.

Letter 192

Original lost. Copy in the Archivo General, Simancas. — Italian. — No address. — Not signed or dated; probably July 22, 1629.

Letter 193

Original lost. Copy in the Archivo General, Simancas. — Italian. — No address.

Letter 194

Original in the Archivo General, Simancas. — Italian. — No address.

This letter indicates that Rubens had received a letter of criticism from the Count Duke of Olivares. He was admonished for dealing with a peace treaty when his instructions authorized him to deal only with a truce, and for expressing his opinion too freely. The truth was that Madrid had become somewhat alarmed at Rubens' straightforward activity, which ran counter to the usual Spanish policy of evasiveness and procrastination. He was fulfilling his task too well, whereas Spain still wanted to gain time while weighing the relative advantages of a treaty with England or a treaty with France. In Rubens' reply to Olivares, the artist, in the most courteous terms, does not hesitate to acquit himself of blame, and to point out the progress he has made during his stay in London.

1. This passage and the others which Rubens quotes appear in Spanish in his Italian letter.

Letter 195

Original in the Bibliothèque Nationale, Paris. — Italian. — Address: Monsieur du Puy.

1. The Arundel Marbles, named for their owner, the Earl of Arundel, formed the most famous collection of ancient sculptures in England. Statesman and traveler, as well as patron of the arts, Thomas Howard, Earl of Arundel, had many competent agents who constantly enriched his collection with treasures sent from Italy, Greece, and Asia Minor. He was particularly interested in ancient inscriptions, and these, of course, interested Rubens also. This group of marbles was given to Oxford University in 1667.

2. John Selden (1584–1654), famous English historian, jurist, and philologian, published the Arundel inscriptions in 1629 under the title *Marmora Arundeliana, sive saxa graece incisa, ex venerandis priscae Orientis gloriae ruderibus, auspiciis et impensis Thomae, Comitis Arundelliae, etc. Accedunt Inscriptiones aliquot veteres.* Selden, as Rubens says in this letter, occupied himself much with politics, and at this time, 1629, was again in prison. But in spite of Rubens' fears, Selden never let politics interrupt his scholarly work.

Letter 196

Original lost. Copy in the Bibliothèque Nationale, Paris. — Italian. — On the back of the fourth page: "Letter of M. Rubens to M. de Peiresc, of August 9 from London, 1629."

1. The treatise *De Diis Syris syntagmata* was published by Selden in 1617. It had just been reprinted in Holland in 1627.

2. Sir Robert Bruce Cotton (1570–1631) possessed a rich library of old manuscripts, relating especially to the history of England.

3. See Letter 171, note 4. Peiresc knew Boswell very well, and corresponded with him.

4. The edition of the *Anecdotes* mentioned here was published in Lyon in 1623 by Niccolo Alemanni (see Letter 172, note 1). A subsequent edition, more complete, appeared in Paris in 1662.

5. See Letter 181, note 2.

6. Cornelis Drebbel (1572–1634) was a Dutch physicist and philosopher who settled in England and won great repute in the service of James I. He was called to Prague by the Emperor Rudolph II, and after remaining there for several years, returned to England. Drebbel was an eccentric and something of a charlatan, but among the inventions attributed to him were the microscope, the first navigable submarine, and a "perpetual motion" machine, patented in Holland in 1589. For Rubens' interest in perpetual motion, see Letters 52, 58, 60.

7. This is the portrait of himself which Rubens had promised to Peiresc as far back as 1627, and which he mentioned again in Letters 180, 184, 216.

Letter 197

Original lost. Copy in the Archivo General, Simancas. — Italian. — No address.

1. See Letter 136, note 2. Don Carlos Coloma was at this time Commander of

the Spanish armies in the Netherlands. He was a historian and humanist as well as a general and statesman, the author of a history of the wars in the Netherlands from 1588 to 1599 (*Las guerras de los Estados Baxos*, 1625) and of a translation of Tacitus.

2. Passages in italics appear in Spanish in the Italian text. They were probably in code, and were deciphered into Spanish. These passages are sometimes lacking in clarity.

Letter 198

Original lost. Copy in the Archivo General, Simancas. — Italian. — No address.

1. Rubens probably refers to the Infanta Isabella.

Letter 199

Original lost. Copy in the Archivo General, Simancas. — Italian. — No address. — Not signed or dated; probably August 24, 1629.

Letter 200

Original in the Archivo General, Simancas. — Italian. — No address. — Not signed or dated; probably August 24, 1629.

1. By the terms of the recent treaty between France and the Duke of Savoy (see Letter 184, note 3) France had kept the town of Susa as security. After a few months the French occupation became oppressive, and Victor Amadeus, Prince of Piedmont and son of the Duke of Savoy, attempted, through the English Ambassador at Turin and with the consent of Richelieu, to gain the mediation of the King of England in this affair. However great an "honor" this offer was, the King nevertheless declined it.

2. The Marquis Spinola was at this time on his way to Milan as Governor and Commander of the Spanish forces in North Italy.

Letter 201

Original in the Archivo General, Simancas. — Italian. — No address. — Not dated; probably August 24, 1629.

Letter 202

Original lost. Copy in the Archivo General, Simancas. — Italian. — No address.

1. On August 19 the town of Wesel fell to the Hollanders. Twelve hundred prisoners were taken, and much booty.

2. For some time the Duke of Savoy had been favorably disposed toward Spain. Since the French invasion of Savoy, however, he had found it more advantageous to ally himself with France.

Letter 203

Original lost. Copy in the Archivo General, Simancas. — Italian. — No address. — Not signed or dated; probably about September 2, 1629.

1. See Letter 200.

2. Sir Isaac Wake had been Secretary to Sir Dudley Carleton before becoming British Ambassador to Savoy. He later served as Ambassador to Switzerland, to the Republic of Venice, and to France.

Letter 204

Original in the Bibliothèque Royale, Brussels. — Flemish. — No address.

1. This was Rubens' eldest son Albert, whom the artist had entrusted to his friend Gevaerts during his diplomatic travels. See Letter 181.
2. Marcus Aurelius. Gevaerts was making a particular study of the works of this emperor.
3. Hendrik Brant, brother of Rubens' wife Isabella, had accompanied the artist to England. He had succeeded his father, Jan Brant, as Clerk of Antwerp, in 1622. He was thus a colleague of Gevaerts.

Letter 205

Original lost. Copy in the Archivo General, Simancas. — Italian. — No address.

1. The report to the King of Spain on the meeting of the Junta on August 20, 1629, contained the following passage: "The Junta took cognizance of the letters of Peter Paul Rubens dated the 6th and the 22nd of last July, in which he reports the state of negotiations with England on the subject of peace, and the forthcoming arrival in Madrid of Sir Francis Cottington. . . . As for Rubens, the Junta gave him approbation and thanks for what he had done and written, and for the tact with which he had acted in this affair. It charged him to remain in England until the arrival of Don Carlos Coloma."
2. Sir Walter Aston was Spain's preference for English Ambassador to Madrid. He had already served in this capacity, and was regarded in Spain as a less dangerous adversary than Cottington. Rubens had been charged by Olivares to negotiate secretly for the appointment of Aston as Ambassador. The maneuvers of the Earl of Carlisle to gain the appointment for himself were revealed by Rubens in Letter 199.
3. This peace between England and France was ratified on the same day by Louis XIII at Fontainebleau. It had been signed on April 24.
4. Barozzi and Rubens had been close friends and confederates (see Letter 190, note 1). This intimacy cooled after the change in policy of the Duke of Savoy.
5. See Letter 141, note 2.

Letter 206

Original in the Archivo General, Simancas. — Italian. — No address.

1. The Treaty of Lübeck, May 22, 1629.
2. See Letter 164, notes 2 and 3.
3. Charles, Marquis de Ville, or de la Vieuville (1582–1653), had been Superintendent of Finance in France until he fell into disgrace and was imprisoned in 1626. He escaped, however, and after remaining for some months outside of France, was permitted to return. At the time of this letter he was Ambassador of the Duke of Lorraine. He later became involved in the intrigues against Richelieu, and fled to Brussels with Marie de' Medici (see Letters 221, 222). He was condemned to death in 1632, but remained in exile until after the death of Richelieu, when he returned to France and again became the Superintendent of Finance.

Letter 207

Original lost. Copy in the Archivo General, Simancas. — Italian. — No address.

1. See Letter 193.
2. Elizabeth, Countess Palatine, sister of Charles I.

Letter 208

Original lost. Copy in the Archivo General, Simancas. — Italian. — No address.

1. Sir Francis Cottington, like the Earl of Carlisle, was engaged in trade.

Letter 209

Original lost. Copy in the Archivo General, Simancas. — Italian. — No address. — Not signed or dated; probably September 21, 1629.

1. Philip Burlamachi was a rich merchant of London, banker of Charles I.

Letter 210

Original in the Bibliothèque Royale, Brussels. — Flemish. — No address.

1. Rubens had evidently been asked to recommend Louis de Romere for the office of Warden of the Hotel des Monnaies at Antwerp, left vacant by the death of Gaspar de Robiano. Jean de Montfort was Master General of the Mint at the court of Isabella in Brussels.

2. Balthasar Carlos, born October 17, 1629.

3. See Letter 181.

Letter 211

Original lost. Spanish translation in the Archivo General, Simancas. — Not signed or dated; according to the following letter, it may be dated November 23, 1629.

1. See Letter 205.

Letter 212

Original lost. Spanish translation in the Archivo General, Simancas. — Not signed.

This letter reached the Infanta at the same time as Philip's orders to Coloma to leave for London. Isabella sent a courier to Rubens to have him inform the King of England that the Spanish Ambassador would be at Dunkirk on December 20. Coloma also wrote to Rubens, announcing his forthcoming arrival in London, and saying that he had the best of intentions. Rubens reported this good news, and King Charles sent a second order to Cottington countermanding the order of November 19. Cottington had left London on November 2. After receiving the King's second order in Lisbon, he left that city on December 24 and reached Madrid early in January 1630.

1. Henry Taylor was an Englishman living in Brussels, who sometimes acted as diplomatic agent for the Infanta Isabella, in dealings with England.

Letter 213

Original in the Archivo General, Simancas. — Italian. — No address.

1. In spite of the Infanta's promise that Don Carlos Coloma would soon leave Brussels for London, there was a further delay of several days. Not until January 11 did he reach London, where he was received with much ceremony. Even then, however, Rubens was not able to leave as promptly as he had hoped. Don Carlos Coloma detained him for six weeks longer, claiming that he needed Rubens' assistance.

On March 6 Rubens left London to embark at Dover. But still another obstacle was to delay his departure. A group of young English Catholics of both sexes sought to profit by the sailing of an envoy of the King of Spain and asked passage on Rubens' ship in crossing the Channel. The boys were going to study at the Jesuit College at Douai, the young girls wished to enter convents.

But English law prevented anyone but merchants from leaving the country without special permission of the King. At Dover the young Catholics were refused permission to embark with Rubens, and his departure was delayed by negotiations between Don Carlos Coloma and the King's Secretary. Whether or not the negotiations were successful, allowing Rubens to take these young people with him, is not known. But he himself did not sail until March 23, 1630.

2. With this statement Rubens included his stay in Madrid, but he exaggerated somewhat, for he had been away from home only fifteen months when he wrote this letter. By the time he left London, however, his absence had stretched to eighteen months.

Letter 214

Original in the Bibliothèque Nationale, Paris. — Italian. — No address. — This note in Rubens' handwriting, preserved among the Peiresc manuscripts, is unsigned and undated, but it was evidently sent to Peiresc soon after the artist's return from England. Although not a letter, we include it here because of its subject matter.

Letter 215

Original in the Public Record Office, London. — French. — On the back: "Brussels, June 18, 1630. M. Rubens to M. the Viscount Dorchester." (Sir Dudley Carleton became Viscount Dorchester in 1628).

1. The Diet in Germany for which Rustorf requested a passport was that of Regensburg. It was the first convoked by the Emperor Ferdinand.
2. Carlos Doria, Duke of Tursis, was the Spanish Ambassador to Genoa.
3. Later Charles II of England, born May 29, 1630.
4. Cottington's Secretary in Spain was Sir Arthur Hopton, who himself became Spanish Ambassador in 1638, serving until 1644.
5. Rubens was not expected to paint this picture, but was to serve as intermediary. Gerbier writes to Viscount Dorchester on July 22, 1631, that Rubens has given him the names of those who are worthy to paint the pictures His Excellency desires.

Letter 216

Original formerly in the collection of the father of Noel Sainsbury. Present location unknown. — Italian. — No address. — In the margins were a number of drawings of tripods, chafing-dishes, etc. These were first reproduced by Noel Sainsbury in his publication of the letter in *Original Unpublished Papers Illustrative of the Life of Rubens* (London 1859), p. 260. See also CDR, V, 310–311. Rubens added to his letter a page of quotations from Isidorus, Julius Pollux, Pausanias, and Surius on the subject of tripods. This material, as the artist said, had been collected and transcribed by his son Albert.

1. Peiresc had sent to Rubens in December 1629 a long discourse on the subject of the tripod which had recently been discovered not far from Aix. Another copy of this discourse, preserved in the Archives Nationales, Paris, is published in CDR, V, 317ff.
2. This is the long-promised portrait of Rubens referred to in Letters 180, 184, and 196. It was not, in fact, by the master's own hand, but that of a pupil (see *Bulletin Rubens*, III, 238). Peiresc and his friends believed it to be by Rubens himself. César Nostradamus, writing to Peiresc on August 23, 1630,

497

says: "I have learned that you have received the portrait of M. Rubens by his own hand, whereupon, admiring this personnage and his reputation, I have made the sonnet which I send you." Rubens knew that Peiresc cared little for artistic quality, but it is nevertheless strange that he sent him a portrait by a pupil's hand, while criticizing the "lack of emphasis" in the portrait Peiresc sent to him.

Letter 217

Original in the Bibliothèque Nationale, Paris. — French. — No address. — The month is not given, but is probably October, 1630.

1. This merchant was Nicolas Picquery, whom Rubens has mentioned before.
2. Plague and warfare had been ravaging Provence.
3. The Marquis Spinola (see Letter 53, note 9) was directing the siege of Casale when he was taken ill. The city fell to his troops on September 4; he died on September 25, 1630.
4. Early in 1628 Rubens had begun the designs for his second great commission for Marie de' Medici, the Gallery of Henri IV in the Luxembourg. But only after his return from England was he able to apply himself seriously to this enormous task. The presentiments expressed in this letter were fulfilled, for the banishment of the Queen Mother in 1631 brought Rubens' work to an end. The painting here mentioned, the "Triumphal Entry of Henri IV into Paris," is now in the Uffizi, Florence. See Ingrid Jost, "Bemerkungen zur Heinrichs-galerie des P. P. Rubens" (*Het Nederlands Kunsthistorisch Jaarboek*, 1964, pp. 175 ff.).

Letter 218

Original lost. Copy in the Archivo de la Casa de Medinaceli, Madrid. — Italian. — No address. — Published by A. Paz y Melia, *Serie de los mas importantes documentos del Archivo y Biblioteca del Exmo. Señor Duque de Medinaceli,* Ia Serie (Madrid, 1915), pp. 395-396.

Jan van den Wouwere (or Woverius), (1576-1639) had been a devoted Antwerp friend of Rubens since boyhood. He had been a fellow-pupil of the artist's brother under Lipsius at Louvain, and like Philip Rubens, had turned from humanistic studies to public service, becoming Alderman of Antwerp in 1614, and later Commissioner of Finances under Albert and Isabella. He also played a part in the negotiations for renewing the truce between Spain and the Northern Netherlands (see Letter 153).

1. Rubens had married Helena Fourment a few weeks before, on December 6, 1630.
2. Francisco de Moncada, Marquis d'Aytona, had just replaced the Cardinal de la Cueva as Ambassador of Philip IV to Brussels.
3. In this letter to a close friend and compatriot, one who, like Rubens himself, had devoted many years to public service, the artist is unusually outspoken in his expression of personal grievances, as well as criticism of the courts of Madrid and Brussels. Within a few months after writing this letter, Rubens was reimbursed for his traveling expenses to Spain and England, to the amount of 12,374 Flemish pounds, delivered in two installments. The second installment, of 6374 pounds, was paid by order of the Infanta on March 24, 1631 (see *Bulletin Rubens,* III, 128).
4. Rubens' notion of retiring to Paris, to work on the Gallery of Henri IV, was

soon abandoned when Marie de' Medici was banished from the French court. In spite of the artist's desire for private life, he had proved too valuable as a diplomat for his resignation to be accepted easily. Within a few months he found himself again drawn into politics, this time in the "service of the Queen Mother," but under conditions very different from those he anticipates in this letter. See Letter 221.

Letter 219

Original in the Bibliothèque Royale, Brussels. — Italian. — No address.

1. César, Duke of Vendôme, was the eldest son of Henri IV and Gabrielle d'Estrées. He and his younger brother Alexander, the Grand Prior of France, had been imprisoned by Richelieu in 1626 for their part in the Chalais conspiracy. Alexander had died in prison, but César was later granted liberty on condition that he leave France for one year. He arrived in Brussels in February 1631, accompanied by his nineteen-year-old son, the Duke of Mercoeur, and had an audience with the Infanta Isabella. There were many conflicting conjectures concerning the reasons for his visit, but he was, on the whole, regarded with suspicion. We see from this letter that he was not satisfied with his reception, either in Brussels or in Antwerp. From Flanders he went to The Hague, where he offered his services to the Prince of Orange. After a short period of military assistance to the Hollanders, he received permission to return to France.

2. Rubens is referring to Richelieu's banishment of Marie de' Medici, the Queen Mother, to Compiègne. This, Rubens realizes, means the end of his project to decorate the Henri IV Gallery in the Luxembourg. He recalls the Queen Mother's escape from a previous exile in Blois in 1619. Contrary to Rubens' prediction, she succeeded in escaping a second time, on July 18, 1631, and sought asylum in the Spanish Netherlands.

3. The Marquis de Santa Cruz arrived in Brussels on April 2.

4. The works mentioned here are a new edition of the writings of the Emperor Julian, published by Father Petau in 1630, and a collection of writings by Greek astronomers, also published by Petau and bearing the title: *Uranologion seu systema variorum auctorum qui de sphaera ac sideribus eorumque motibus graece commentati sunt* (Paris, 1630).

Letter 220

Original lost. Copy in the Archivo di Stato, Rome. — Italian. — No address.

The recipient of this letter, Don Fabrizio Valguarnera, was a Sicilian nobleman whom Rubens had met in Madrid in 1629. A man of many accomplishments — mathematician, doctor of law, chemist, possessing secrets to cure certain illnesses — he had treated Rubens for gout in Madrid, and this is probably the reason for the artist's "obligation" to him. He was also an amateur of the arts, a collector and an experienced judge of paintings.

At the very time this letter was written, when Rubens was wondering about Valguarnera's whereabouts, the police of Rome were seeking him also, for complicity in a huge theft of uncut diamonds. He was arrested in Rome shortly after, on July 12, 1631, and the trial, which lasted until September, was sensational. This letter of Rubens' was used as evidence, and, although the original is lost, the copy is preserved in the court records. Valguarnera's death in prison, a few months later, cancelled Rubens' "obligation." See Jane Costello, "The Twelve Pictures

'Ordered by Velasquez' and the Trial of Valguarnera," *Journal of the Warburg and Courtauld Institutes*, XIII (July–December 1950), 237–284.

1. The painting here referred to cannot be identified with certainty.

Letter 221

Original lost. Copy in the Archivo General, Simancas. — Italian. — No address.

1. This letter finds Rubens engaged in another diplomatic mission for the Infanta Isabella. He is seeking Spanish support, both financial and military, for Marie de' Medici, now a fugitive in the Spanish Netherlands. He had successfully eluded an order of the King of Spain to return to London, but it was less easy to refuse to serve the Infanta.

2. The Abbé Scaglia had just been named Ambassador to London by the new Duke of Savoy, Victor Amadeus. Since Savoy and Spain were once more reconciled, Philp IV had asked Scaglia to act as his representative also at the English court. The Abbé did not reach London until September; his first audience with Charles I was on September 21.

3. In the struggle between Marie de' Medici and Cardinal Richelieu, Gaston, Duke of Orléans and brother of the King, took his mother's side and fled to Lorraine to organize a campaign on her behalf. In June 1631 Gaston sent Achille d'Etampes, Commander of Valençay, to Brussels to seek the aid of the Infanta. She commissioned the Marquis d'Aytona, Spanish Ambassador at Brussels, to consider the proposals of the Duke of Orléans, but d'Aytona, who was obliged to take over command of the army, turned the task over to Rubens.

 On July 18 the Queen Mother escaped from Compiègne. She made her way across the border to the town of Avesnes, sending a messenger to Brussels to inform the Infanta of her arrival. Isabella sent to meet her the Marquis d'Aytona and the Marquise de Mirabel, wife of the Spanish Ambassador in Paris, who happened to be in Brussels at the time. The Queen Mother was asked to choose one of her retinue as her spokesman, and she accordingly named the Marquis de la Vieuville. Rubens was named as intermediary for the Infanta. The party then proceeded to Mons, where Rubens wrote this letter to the Count Duke of Olivares.

4. See Letter 206, note 3.

5. Rubens is probably quoting Machiavelli here. See *Discorsi* III, chap. 6, on conspiracies.

6. This was the great Wallenstein, Duke of Friedland. In 1630 he had been dismissed as Commander-in-Chief of the Imperial armies.

7. Gerbier had been appointed Agent of the King of England at the Court of Brussels.

8. The little principality of Orange lay about eighty miles within French territory. Its governor had plotted with Richelieu in 1630 to deliver the fortress to France. He was killed by partisans of the Prince of Orange before being able to carry out this plan.

9. Rubens was mistaken about this; the Marquis de Mirabel was in favor of supporting the Duke of Orléans.

10. This long and eloquent defense of Marie de' Medici and her cause, which some writers have called Rubens' diplomatic masterpiece, was nevertheless completely unsuccessful. To this letter of Rubens were added letters by the

Marquis d'Aytona and the Marquis de Mirabel, exhorting the King of Spain to seize this opportunity to strike a blow at the power of France. The Council of State was summoned on August 19, and the session was an unusually long one. The Count Duke of Olivares, while acknowledging the good intentions of Rubens, found his letter full of "absurdities and Italian verbiage." He and the other ministers unanimously opposed any intervention in French affairs.

Marie de' Medici left Mons on August 12 in the company of the Infanta, who had visited her there, and went to Brussels. From there, in spite of the disappointing response from Madrid, Isabella and Rubens continued for a time their efforts to gain assistance for the Duke of Orléans.

Letter 222

Original lost. Copy in the Public Record Office, London. — Italian. — No address, but bearing the following note in English: "Extrait of a letter of Sr. Peter Rubens to the Abbé d'Escaglia sent by Mr. Hurst Sr. Robert answered and secret, the 6 november 1631 stilo angliae." — This rather unclear fragment apparently concerns further intrigues by Marie de' Medici to gain support for her son, the Duke of Orléans. Père Chanteloupe, though one of Marie's partisans, was suspected of being influenced by Richelieu. He was responsible for turning the Queen Mother against the faithful Marquis de la Vieuville.

Letter 223

Original in the Archivo de la Casa de Medinaceli, Madrid. — Italian. — No address. — Published by Paz y Melia, *Serie de los mas importantes documentos del . . . Duque de Medinaceli* (1915), pp. 397-398.

1. Frédéric-Maurice de la Tour d'Auvergne, Duke of Bouillon (1605-1652), was one of the most powerful nobles of France. Son of the Huguenot leader, Henri de la Tour d'Auvergne, and grandson of William the Silent, this Duke of Bouillon was actively hostile to Richelieu. His willingness to take an "oath of protection" to Louis XIII, solely to be given an excuse to break it, furnishes a commentary on the variable loyalties of the times. The brother of the Duke of Bouillon was to become the brilliant general and Marshal of France, the Viscount de Turenne.
2. "Monsieur" was Gaston, Duke of Orléans.
3. Sedan, seat of the Duchy of Bouillon, had been virtually independent of French sovereignty since the middle of the sixteenth century.

Letter 224

Original in the Archivo de la Casa de Medinaceli, Madrid. — Italian and French. — No address. — Published by Paz y Melia, *Serie de los mas importantes documentos del . . . Duque de Medinaceli* (1915), pp. 396-397.

This letter comes back to the subject which had never ceased to be the chief concern of the Infanta Isabella: peace between the Spanish Netherlands and the United Provinces. And in her continued efforts to attain this goal, she still placed her greatest confidence in Rubens.

Letter 225

Original in the Public Record Office, London. — Flemish. — No address. — On the back, in Gerbier's hand, in French: "Antwerp, 12 April, 1632. Pedro Paulo Rubens, concerning the bad services which the French render Gerbier."

The "privilege" mentioned is a renewal of the copyright which Rubens first received from the King of France in 1619 for publishing his engravings in that country. The Chevalier du Jar and M. Juan Maria, who helped him to obtain it, are otherwise unknown to us. Likewise unknown is Biscarat, and the affair which concerned Rubens, the Abbé Scaglia, and Gerbier.

Letter 226

Original formerly in the Archives du Royaume, Brussels. Present location unknown. — Italian. — No address.

In April 1632 Rubens had obtained the Infanta's consent to withdraw from the negotiations on behalf of Marie de' Medici and her son. But this letter finds the artist still involved in the fortunes of the Duke of Orléans. Whether the Duke of Bouillon succeeded in gaining the Infanta's promise of protection against the King of France is not known (see Letter 223). It seems, however, that the Infanta did not wish to have anything to do with the Duke, for soon after this he entered the Dutch army and joined his uncle, the Prince of Orange, at the siege of Maastricht.

1. The Duke of Orléans had come to Brussels on January 28 to join his mother and conduct his campaign. In the meantime the urgent and persistent requests of the Queen Mother produced some result: Philip IV furnished the means to raise a small army for the Duke of Orléans at Trèves. The Duke took command of these troops on May 18, 1632, and penetrated into France, where the Duke of Montmorency joined him. But he was defeated on September 1 at Castelnaudary, and on September 29, 1632, he surrendered to Louis XIII. The Queen Mother spent her remaining years in exile, going finally to Cologne, where she died in 1642, a few months before the death of her enemy, Cardinal Richelieu.

Letter 227

Original lost. Summary in English in the Public Record Office, London. — Note, in Gerbier's hand: "Translation and extract of lres of Sr. Peter Reubens unto me B. Gerbier, who had written unto him to draw the said Sr. Peter Reubens unto answeares, in writing, to confirme the particulars he had tould me att his being here. Sommary of his lre of August 4, 1632."

The luckless Gerbier, who, because of his questionable behavior, so frequently found cause to complain of his treatment by his superiors, had again fallen under suspicion while British minister in Brussels. This time he had become involved in a plot of certain Flemish nobles against Spanish rule. Rubens evidently did not at this time know of his unworthy friend's part in this conspiracy, or the good reasons why Gerbier feared for his reputation.

Letter 228

Original lost. Summary in English in the Public Record Office, London. — Note, in Gerbier's hand: "Sommary of the lre of October 15, 1632."

Letter 229

Original in the Royal Archives, The Hague. — French. — No address. — This request of Rubens' was granted, and a passport was issued on January 19, 1633, for a period of four months.

Letter 230

Original lost. — Published by E. Gachet, *Lettres inédites de P. P. Rubens* (1840), p. lviii. — French. — No address.

When the Flemish deputies learned that Rubens had asked for a passport to The Hague, their jealousy and suspicion increased. The States General, meeting at Brussels on January 4, 1633, remonstrated with the Infanta Isabella on this irregular intervention of Rubens. Her explanation that if Rubens went to The Hague, it would be to furnish necessary information and not to interfere, failed to satisfy the deputies, who demanded Rubens' papers. The Duke of Aerschot, their leader, had a personal hatred for Rubens, "for several reasons, too long to relate," as Gerbier says in a letter of January 28. On the Duke's return to The Hague, for further negotiations, he stopped for twenty-four hours in Antwerp, expecting Rubens to come to him. Rubens, in accordance with the Infanta's orders, did not go to see him at his hotel, or show the Duke the documents in his possession. But he wrote this letter, protesting against the Duke's suspicions.

The Duke of Aerschot answered Rubens on January 30 in a letter concluding with the words: "It is of very little importance to me how you proceed, and what account you render of your actions. All I have to say is, I should be very glad that you should learn for the future how persons in your position should write to those of my rank." He gave his reply great publicity, sending copies to the States General in Brussels, who informed the Infanta that "this form of procedure of Rubens was disagreeable" to them. As a result of this opposition, Rubens did not go to The Hague. He waited in Brussels for news of the negotiations, and receiving none by February 5, he returned to Antwerp.

Discussions between the Catholic Netherlands and the United Provinces continued for several months, but without reaching any conclusion. And when the Infanta Isabella died on December 1, 1633, efforts to make peace received another setback.

Letter 231

Original lost. Summary in English in the State Paper Office, London. — Note, in Gerbier's hand: "Summary of the letter of June 29, 1633." — See notes to Letter 227.

1. Henry Taylor, English diplomatic agent in Brussels. See Letter 212.

Letter 232

Original in the Rubenshuis, Antwerp. — Italian. — No address.

The recipient of this letter is not known. He must be a person of high rank, since Rubens addresses him as "Excellency," and he is probably the one to whom Letter 234 is also addressed. I suggest Don Giovanni de' Medici, Marquis de San Angelo, whom Rubens mentions in Letter 99 as the Infanta's Superintendent of Public Works.

Letter 233

Original lost. Text given to Rooses by Henri Hymans. — French. — No address. — We do not know to whom this letter was written. Arnold Lunden, here mentioned, had married Susanna Fourment, sister of Rubens' wife Helena.

Letter 234

Original formerly in the collection of the Count of Valencia, Madrid. Present location unknown. — Italian. — No address.

Henri Hymans, who first published this letter (*Gazette des Beaux Arts,* August 1, 1894, p. 163) assumed that it was written to the Count Duke of Olivares, but there is nothing to confirm this. The recipient is probably the same person to whom Letter 232 is addressed, and the subject in both letters deals with engineering projects for the defense of Antwerp. Giovanni de' Medici, Marquis de San Angelo, the court engineer who directed the cutting of the "Fossa Mariana," may be the one addressed.

1. Jacques Edelheer was a Councilor of Antwerp.

2. Upon the death of the Infanta Isabella in December 1633 the Marquis d'Aytona became interim Governor of the Spanish Netherlands, until the arrival of the Cardinal Infante Ferdinand.

Letter 235

Original in the Bibliothèque Nationale, Paris. — Italian. — No address. — Rubens dates this letter 1635, but this is incorrect. On the back, in Peiresc's hand: "18 dec. 1634. Ancient spoon or porringer. Most exact method of weighing." — Correspondence between Rubens and Peiresc had fallen off during the period of the artist's greatest political activity, and now for four years had been completely suspended. Rubens' intervention in the discord between Louis XIII and the Queen Mother had placed him under suspicion in France, and Peiresc was reluctant to compromise himself by writing. This letter, in reply to a lost one of Peiresc's dated November 24, 1634, reëstablishes the correspondence, giving a full account of the intervening years, and taking up, one by one, the various questions Peiresc had asked.

1. Rubens refers to Marie de' Medici and Gaston, Duke of Orléans.

2. Rubens' second wife, whom he married on December 6, 1630, was the sixteen-year-old Helena Fourment, youngest daughter of Daniel Fourment, a silk merchant of Antwerp.

3. This is Rubens' only reference to his son's visit to Italy. Albert did not visit Peiresc, and Peiresc's letter of February 26, 1635, to Jacques Dupuy expresses a certain resentment at this lack of courtesy, but excuses it because of Albert's youth.

4. The entry into Antwerp of the new governor, Cardinal-Infante Ferdinand, was originally set for January 1635, but was delayed by the excessive cold of that winter. It finally took place on April 17. The verses and inscriptions composed for the occasion by Gevaerts were published in a small volume in 1635. The large de luxe edition, with etchings of all the designs by Theodor van Thulden, appeared in 1641, under the title *Pompa Introitus Honori Serenissimi Principis Ferdinandi Austriaci Hispaniarum Infantis.*

5. This ancient spoon, discovered in Autun, Rubens had bought in Paris in 1625. Peiresc has now asked Rubens about it because he has seen another similar spoon, owned by M. de Montaigu of Autun, and suspects that one is a cast of the other (see *CDR,* VI, 45–50). He confirms his suspicion in a letter of April 15, 1636, to a M. Guyon in Paris: "M. Rubens has finally communicated to me his figured silver spoon; it is undoubtedly a counterfeit of M. de Montaigu's. But please do not tell him, so as not to make anything disagreeable for him . . . " (R. Lebègue, *Les Correspondants de Peiresc* [Brussels, 1943], pp. 48, 49). The drawing of his spoon, sent to Peiresc by Rubens, is now in the Bibliothèque Nationale, with a long inscription in Peiresc's hand. See Michael Jaffé, *Van Dyck's Antwerp Sketchbook* (London, 1966) pp. 78–80 and fig. xxxi.

6. The plate to which Rubens refers is found on page 146 of Sylvester de Pietra Sancta's *De Symbolis Heroicis,* published by Balthasar Moretus in 1634. The "mysterious clock" described in this book was the invention of Father François Linus, of the English College of the Jesuits in Liége.

7. This agate vase is now in the Walters Gallery, Baltimore. See Marvin C. Ross, "The Rubens Vase — Its History and Date," *Journal of the Walters Art Gallery,* VI (1943), 9-39.

Letter 236
Original in the British Museum, London. — Italian. — No address.

1. M. Aubéry, or d'Aubéry, Sieur du Mesnil, was an advocate in Paris, and a friend whom Peiresc had asked to take up Rubens' case (Lebègue, pp. 51-54).

2. Rubens himself makes two mistakes here which are hard to explain. The "Crucifixion" he refers to is dated 1631, not 1632. It is the engraving done by Pontius and commonly called "Le Christ au coup de poing." Secondly, Rubens was not in England in 1631, as he states, but in Antwerp.

3. Prince Thomas of Savoy was the general of the Spanish armies in the Netherlands.

4. A very few days before the date of this letter, on May 19, 1635, Louis XIII had sent a herald to the Cardinal-Infante in Brussels to declare war on the King of Spain. For some years France had been accumulating grievances against Spain, and Richelieu had been making perparations for war. With France now casting her weight into the scale, the Thirty Years' War entered its last phase.

Letter 237
Original lost. Copy in the Bibliothèque Méjanes, Aix. — Italian. — No address.

1. Melchior Tavernier, a Flemish print-seller established in Paris, is referred to in Letters 89 and 95, of 1626.

2. France, as we have seen, had concluded an alliance with the United Provinces and declared war upon Spain. The combined French and Dutch armies then set out to subjugate the Spanish Netherlands. After an initial success they met the stiff resistance of the Cardinal-Infante Ferdinand and were driven back across the Dutch border. The loss of the fort of Schenkenschans, at the junction of the Rhine and the Waal rivers, was such a blow to the Hollanders that negotiations for peace were renewed.

3. See Letter 235, note 7.

4. Father François Linus (1595-1675) was the inventor of the "mysterious clock" already mentioned. A professor of Hebrew and mathematics at the English College of the Jesuits in Liége, he published a number of works on astronomy and horology.

5. Peiresc was much interested in colors and their optical effects, and keenly desired to have Rubens write a treatise on this subject. In a letter of May 29, 1635, to Jacques Dupuy, he describes the remarkable effects upon his eyes of colored images which "transform themselves successively from one color to another in a certain admirable order," and goes on to say that Rubens had begun a "discourse on colors" which Peiresc had hoped to have him finish before the rupture between the two countries (CDR, VI, 105). On June 1 Peiresc's friend Luillier, hearing about this project, writes in happy anticipation that "a discourse on colors by Rubens would be like hearing Brutus discourse

on virtue" (*CDR*, VI, 112). Since such a treatise has never been found among Rubens' papers, Rooses believed it had never been written, apart from the few phrases in this letter of August 16, 1635. R. Lebègue, however, found a hitherto unpublished letter of Peiresc dated February 5, 1636, in which he speaks of a discourse on colors which Rubens has all ready to send to Peiresc (R. Lebègue, *Les Correspondants de Peiresc* [Brussels, 1943], p. 51). This would explain Rubens' statement in his letter of March 16, 1636, to Peiresc: "I hope you have received my essay on the subject of colors." Whether Peiresc ever did receive it or not, there is no trace of it now.

Letter 238

Original lost. Copy in the Bibliothèque Méjanes, Aix. — Italian. — No address.

1. Rubens here alludes to a projected diplomatic mission to Holland. An effort was made to draw the artist once more into the peace negotiations mentioned in the previous letter (note 2), and Rubens agreed to sound out the Prince of Orange. He applied for a passport to Holland for the ostensible purpose of seeing some Italian paintings newly arrived in Amsterdam. The French Ambassador in Holland was so suspicious of this move that he made an effort to persuade the States General to refuse Rubens a passport, and it seems that he succeeded. Rubens did not go to Holland, and negotiations for peace between the Spanish Netherlands and the United Provinces again came to a standstill. This was the last act in Rubens' diplomatic career.

2. The work sent to England was the series of ceiling paintings on canvas for the New Banqueting Hall, Whitehall, commissioned by Charles I in 1629 to glorify James I (see Letter 46, note 4). Although finished by August, 1634, the paintings were still in Rubens' studio, uncalled for, a year later. They were finally sent, after the necessary retouches, on October 8, 1635, and reached London in November or December. As for the promised sum of 3000 pounds sterling, the first payment of 800 pounds was not made until November 28, 1637, and the last on June 4, 1638, along with a gift of a gold chain from the King of England to the painter. See Oliver Millar, *Rubens: the Whitehall Ceiling* (Charleton Lectures on Art, 40), London, 1958. Also Julius S. Held, "Rubens' Glynde Sketch and the Installation of the Whitehall Ceiling" (*Burlington Magazine*, vol. 112, 1970, pp. 274 ff.).

3. The "antique landscape" here discussed was a painting in the possession of Cardinal Barberini. Rubens bases his detailed description and appreciation upon an engraving of it which Peiresc had sent to him.

Letter 239

Original lost. Copy in the Bibliothèque Méjanes, Aix. — Italian. — No address. — This is the last of Rubens' letters to Peiresc which has been preserved. Peiresc died within a year, on June 24, 1637.

1. Castle Steen, which Rubens had purchased in 1635, and where he spent much of his time after his retirement from public life.

2. This is the famous "Aldobrandini Marriage." In his letter to Peiresc dated May 19, 1628, Rubens described this painting in detail, from memory, and asked for a colored drawing of it. See Letter 167.

3. *Roma Sotterranea*, by Antonio Bosio (Rome, 1632).

4. The *Galleria Giustiniana* of Vincenzo Giustiniani appeared in 1640, in two volumes.

Letter 240

Original formerly in the Mitchell Collection, London. Present location unknown. — Flemish. — No address. — George Geldorp was a painter, born in Cologne, member of the St. Luke Guild of Antwerp, who had settled in London. Rubens' surprise at receiving from London a commission for an altarpiece was satisfied by the explanation that the picture was intended for the well-known Cologne banker and amateur, Eberhard Jabach, who wished to present it to his native city. The painting in question, the "Crucifixion of St. Peter," was not finished until after Jabach's death, and was still in Rubens' studio when the painter died. In 1642, however, it was sent to Cologne and set up in the church of St. Peter, for which it had been commissioned, and where it remains.

Letter 241

Original in the British Museum, London. — Flemish and Latin. — Address: To Mr. Francis Junius, at the Court of Earl Marshal Arundel, in London. — Francis Junius (1591-1677) was born in Heidelberg, educated in Holland, then went to France and finally to England, where he became librarian to Thomas Howard, Earl of Arundel. Rubens had probably met him in London. The book which the artist praises so highly is *De Pictura Veterum* (Amsterdam, 1637). In 1638 an English translation appeared, and a Dutch one in 1641. A second Latin edition came out in 1694.

Letter 242

Original lost. Published by G. G. Bottari, *Raccolta di Lettere sulla Pittura, Scultura ed Architectura* (Rome, 1759), III, 356. — Italian. — No address. — French translation in François Mols, Rubeniana, 14 vols. of manuscript, 1771, Bibliothèque Royale, Brussels. — Justus Sustermans was a well-known Antwerp painter who had settled in Florence and become court painter to the Duke of Tuscany. The painting here described, the "Horrors of War," was probably commissioned for the Medici Gallery; it is now in the Pitti Gallery, Florence. This letter provides us with one of the few detailed descriptions by Rubens of one of his own works.

Letter 243

Original in the Wallraf-Richartz Museum, Cologne. — Flemish. — Address: To Mr. George Geldorp, artist-painter, London. — The painting here referred to is the "Crucifixion of St. Peter" mentioned in Letter 240, of July 25, 1637.

Letter 244

Original lost. Published by F. J. van den Branden, *Geschiedenis der Antwerpsche Schilderschool* (Antwerp, 1883). — Flemish. — French version in Mols's Rubeniana, Bibliothèque Royale, Brussels. — Address: To Monsieur Lucas Fayd'herbe, at the house of Monsieur Peter Paul Rubens, on the Wapper. Cito cito cito, in Antwerp. Post.

Lucas Fayd'herbe (1617-1697), a Malines sculptor, was at this time a pupil and young friend of Rubens. As the letter indicates, he was left in charge of Rubens' Antwerp studio, while the painter was at Castle Steen. Fayd'herbe was a skilled carver in ivory, and executed several works in this material after drawings by Rubens. The marble madonna decorating the altar in Rubens' funerary chapel is also by his hand.

1. This gold chain is probably the one which Charles I sent to Rubens in April 1638 as a token of his satisfaction with the ceiling paintings for Whitehall.

Letter 245

Original in the Archivio di Bagno, Mantua. — French. — Address: To Monsieur Monsieur Philippe Chifflet, Chaplain-in-ordinary to Her Most Serene Highness, Behind the stables of the Hoochstralte House, in Brussels. — Published by P. Torelli, "Notizie e Documenti Rubeniani, *Miscellanea di studi storici, ad A. Luzio* (Florence, 1933), pp. 173ff.

Philippe Chifflet, brother of Jean Jacques Chifflet (see Letter 57), after completing his studies in Louvain, was admitted to the priesthood and later became Abbé of Balerne and chaplain to the Infanta Isabella. He was a close friend of Balthasar Moretus. The frontispiece of Chifflet's book on the Council of Trent (*Sacrosancti et OEcumenici Concilii Tridentini Canones et Decreta*, Antwerp, 1640) came from Rubens' workshop. The design was executed by Erasmus Quellinus, since Rubens, as he admits in this letter, was prevented by the gout from carrying out drawings on a small scale. Chifflet, however, in writing to Moretus a few days after Rubens' death, says: "The frontispiece will be considered beautiful in Rome. I think it is the last design of Rubens, whom God has taken to glory. We can say, for his memory, that he was the most learned painter in the world."

1. This Cardinal was Gian Francesco Guidi di Bagno (see Letter 75), an enthusiastic collector of tapestries. He had requested Chifflet to ask Rubens to design for him a tapestry representing the story of Sts. Aglae and Boniface. Owing to Rubens' illness, this commission was never carried out.

Letter 246

Original lost. Copy in the Public Record Office, London. — French. — No address.

1. Edward Norgate was an English miniature painter patronized by Charles I and the Earl of Arundel. This letter is in reply to Gerbier's letter to Rubens in which he says, "The Sieur Ed. Norgate, having told His Majesty that he had seen, at your house, a Landscape representing the environs of Madrid in Spain . . . the King my master wishes to have the said picture." (*CDR*, VI, 255).

2. Verhulst, whom Rubens calls a mediocre painter, seems to have been one of his pupils. He is probably Pieter Verhulst, or van der Hulst, of Antwerp.

Letter 247

Original lost. French translation in the Bibliothèque Royale, Brussels. — No address. — This letter, hitherto unpublished, appears in Mols's Rubeniana (vol. II, part I, p. 54) under the date of April 5, 1638. We join it here, however, to the certificate dated April 5, 1640, to which it seems to belong. The copyist may have made a mistake in the date. — For Mols's French text, see Appendix. — This letter is published with the permission of the Bibliothèque Royale.

The "beloved" referred to in the letter is probably Maria Smeyers, whom Fayd'herbe was soon to marry, on May 1, 1640.

The certificate, written in Flemish, is preserved in a copy in the Bibliothèque Royale, Brussels. It clearly states Rubens' high regard for the sculptor.

Letter 248

Original lost. Copy in the Hermitage, Leningrad. — Italian. — French transla-

tion in Mols, Rubeniana, Bibliothèque Royale, Brussels. — Address: To M. François Duquesnoy. — François Duquesnoy (1594-1642) was a celebrated Flemish sculptor who went to Rome in 1618 and remained there for the rest of his life. He gained wide recognition for his numerous figures of putti in marble, bronze, and ivory, as well as for his statues of St. Susanna in Sta. Maria di Loreto and the colossal St. Andrew in St. Peter's. This latter work is the statue referred to by Rubens in this letter.

Giovanni Pietro Bellori in his *Vite dei Pittori* (Rome, 1672), I, 284 (Life of Duquesnoy) quoted this letter in full, saying that it was a translation from the French. Rooses (*CDR*, VI, 271) considered the Leningrad letter, which is in Italian, to be the original, although he noted that the text, when compared with Bellori, lacked a phrase of fourteen words. Jacob Hess (*Revue de l'Art Ancien et Moderne*, LXIX [February-June 1936], 21-36) states that the Leningrad document is copied from Bellori, and that the copyist omitted an entire line. Hess's argument is that the Bellori letter itself was a forgery, written perhaps by a clever merchant in order to raise the price of the putti of Duquesnoy. Ludwig Burchard, to whom I am indebted for these references, agrees that the Leningrad letter is an inaccurate copy of the Bellori text, but believes that it was an original letter which Bellori printed, under the mistaken assumption that it was a translation from the French. Rubens rarely wrote in French, and to Duquesnoy, who had lived in Italy for more than twenty years, he would surely have written in Italian.

Letter 249

Original in the collection of Christopher Norris, London. — French. — No address. — Undated; probably written late in April 1640.

In spite of Rubens' statement in Letter 246 that the Spanish landscape was painted not by his own hand, but by that of a mediocre pupil, it seems that he was asked to send the picture to Gerbier. Rubens therefore sent it, along with this letter, the last we possess in his own handwriting. Gerbier, in turn, sent the picture and, almost certainly, the letter also, to Henry Murrey, Keeper of the King's Pictures, as a present to Charles I on June 1, 1640. I am grateful to Christopher Norris for the information concerning this letter. This painting by Verhulst is now in the collection of the Earl of Radnor, Longford Castle. Reproduced by Christopher White, *Rubens and his World* (New York, 1968), p. 86.

Letter 250

Original lost. Copy in the Bibliothèque Royale, Brussels. — Flemish. — No address. — This, the last of Rubens' letters that has come down to us, although only in a copy, was written three weeks before his death. Lucas Fayd'herbe (see Letters 244, 247) had married Maria Smeyers on May 1, and this letter, congratulating him, is one of the most personal and affectionate of Rubens' entire preserved correspondence. Reading it, one regrets all the more that none of his family letters have survived.

Balthasar Gerbier, writing from Brussels on May 31, says: "Sr. Peter Rubens is deadly sick. The Physicians of this Towne being sent unto him for to trye their best skill on him." And on the same day, in a letter to King Charles I, Gerbier adds a postscript: "Since I finisht this letter, neewes is come of Sr. Pieter Rubens death, many fine things wilbe sould in his Almoneda [auction]."

1. I am grateful to Ludwig Burchard for the information that the "little ivory child" probably referred to in this letter has survived. It is the figure of a boy,

after Rubens' design, and so close to his style that, according to Burchard, it was apparently modeled and cut at Antwerp under Rubens' supervision, with only the finishing touches done by Fayd'herbe independently, after he moved from Antwerp to Malines. Bronze casts of this little figure, of a later date, indicate that it was one of a pair, the companion piece being a little girl. Rubens, in this letter, appears to be replying to one from Fayd'herbe which announced that the little ivory child was now finished, and that Fayd'herbe would soon bring it to Antwerp. But whether the figure of the little boy is meant, or that of the girl, is not certain.

LIST OF CORRESPONDENTS

INDEX

Absolutism, 14–15

Aerschot, Charles de Croy, Duke of, 72, 73, 199, 439, 445, 482

Aerschot, Philip Charles d'Arenberg, Duke of, 361, 388, 503

Aerssen, Cornelis van, 69, 443

Aerssens, Frans van, Sieur de Sommelsdyk, 124, 174, 462, 485

Aix-en-Provence: Peiresc in, 82, 97, 155, 226

 Bibliothèque Méjanes, Rubens letters in, 6, 450, 457, 459, 461, 462, 463, 464, 486, 505, 506

Albert, Archduke, sovereign of the Spanish Netherlands: as Rubens' patron, 4, 49, 52, 56–57, 440; death of, 7, 360; and truce negotiations, 84–85, 456

Aldobrandini, Cinthio, Cardinal, 486

"Aldobrandini Marriage," painting, 14, 405, 486, 506; described, 263–264

Aleandro, Girolamo, 2, 93, 108, 111, 113, 116, 132, 148, 226, 450, 458

Alemanni, Niccolo, 270, 322, 487

Alexander, Grand Prior of France, 146, 468, 499

Alexander the Great, 126, 188, 463

Algiers, 119, 349

Alicante, 24, 28, 29, 30, 32

Amiens, 109

Amsterdam, 93, 209, 349

Andreae, Johann Valentin. See Rosenkreuz, Christian

Angola, 297

Anne of Austria, Queen of France, wife of Louis XIII, 109, 131, 152, 470

Annoni, M., 70, 408

Apelles, 407

Antiquities: Rubens' interest in, 3, 5, 6, 50, 58–68 passim, 93, 353–354, 401, 442, 450, 504. See also Cameos and engraved gems; Medals

Antiquity, classical, 13, 82, 83, 365–367, 368, 392–394, 405, 407, 440

Antwerp: and Twelve Years' Truce, 4, 49, 51; described, 13, 185, 209, 279, 474; defense of, 139, 389, 390–391, 504; compared to Casale, 257; entry of Cardinal-Infante Ferdinand, 362–363, 393, 451, 504; mentioned, 45, 52, 54, 119–120

 Rubens' House, 14, 50, 62, 411, 436, 442, 447, 457, 467, 482, 503

Aragon, 207

Archimedes, 394, 395

Architecture, 14, 88, 126, 129, 362, 447

Archytas, 394

Argouges, M. d', 112, 458

Arminians, 13, 127, 130, 463

Arnhem, 194

Arpino, Cavaliere d'. See Cesari, Giuseppe

Artois, 102, 328, 400

Arundel, Thomas Howard, Earl of, 313, 322, 507

Arundel marbles, 320, 404, 493

Aston, Sir Walter, 304, 339, 491, 495

Aubéry, M. d', Sieur du Mesnil, 397–400, 403, 505

Augustus Caesar, 126, 129, 354

Aurelian, Roman emperor, 111

Australia: discovery of, 272, 488

Austria: peasant uprising in, 137; mentioned, 288

Austria, House of, 243, 313, 327, 346–347. See also Hapsburg, House of

Autun, 504

Ayanza, Hieronimo de, 395

Aytona, Francisco de Moncada, Marquis d': and Marie de' Medici, 358–359, 374–380, 500; as ambassador in Brussels, 371, 372, 382–384, 386, 391, 498; as interim governor, 504

Bacon, Francis, 212, 480

Bacon, Roger, 480

Baglione, Giovanni, 437

Baglioni, Paolo, Captain, 139

Goulu, Father, 480, 483
Gravelines, 129, 463
Great Britain. *See* England
Grebber, Frans Pieterssen de. *See* Pieterssen
Greenwich, 286, 299, 312, 317
Grenoble, 437
Gribbel, John, 486
Groll: siege of, 138, 194, 196, 197, 477; capture by Dutch, 166, 198–199, 200, 262
Grotius, Hugo, in Paris, 146, 468; works of, 218, 230, 239, 242, 256, 477, 481; mentioned, 360
Guise, Charles de Lorraine, Duke of, 225, 230, 376
Gustavus Adolphus, King of Sweden, 245, 329, 344, 346
Guzman y Idiaquez, Juan Carlos de, 139
Gyron, Don Fernando, 120

Haarlem, 59, 247, 257, 485
Hague, The: Carleton in, 50, 64, 192, 250, 251, 441, 476; Pecquius sent to, 85; Rubens kept from, 361, 387–388 Rubens letters in: Royal Library, 453, 454, 455, 456, 467, 490; Royal Archives, 502
Hainault, 102, 213, 328, 400
Halberstadt, Christian of Brunswick-Wolfenbüttel, Bishop of, 120, 461
Halluin, Duke of, 185, 474
Hamburg, 26, 27, 200
Hamilton, James, Marquis of, 77
Hanau, 408
Hapsburg, House of, 3, 8, 15, 161, 288, 359, 362, 461. *See also* Austria, House of
Harvard University, Houghton Library, 481
Haultain, Admiral, 117, 460
Haulterive, M. de (French agent in Holland), 311
Haze, Jacomo de, 56, 439
Hein, Piet, Vice-Admiral, 465, 476, 490
Heinemann, C. von, 458
Hemelaer, Jan de, 22, 231, 482
Hemselroy, Leon, 407
Henri IV, King of France, 81, 104, 124, 185, 437, 453, 454, 462
Henri IV Gallery. *See* Luxembourg Palace
Henrietta Maria, Queen of England: marriage by proxy, 82, 107, 161, 452, 454, 456–457; as "Madame," 101, 455; and Charles I, 112, 316; religious

difficulties, 123, 125; release of French prisoners, 241; and French Ambassador, 345; mentioned, 290, 312, 341, 486
Henry VII, King of England, 212, 229, 480
Hephaestion, 188
Herenthals, 98, 169, 171, 183, 272
Herostratus, 126, 463
Hertogenbosch. *See* Bois-le-Duc
Hess, Jacob, 509
Hesse, 137
Heusden, 138, 142, 456
Hiero II, King of Syracuse, 395
Holland, Henry Rich, Earl of, 304, 313–314, 492
Holland. *See* United Provinces
Holland Gazette, 7, 273, 488
Holstenius, Lucas, 243, 484
Homer, 365
Honthorst, Gerard, 164
Hopton, Sir Arthur, 497
Horace, 5, 483; quoted, 33, 53, 238, 262, 269, 279, 321, 400
Hornes, Count de, 153, 155
Huguenots: aided by Dutch, 86; peace with Louis XIII, 130, 289, 311, 316, 464; and Buckingham, 167, 477; and Richelieu, 225; and Soubise, 288, 305, 319, 456; and Marie de' Medici, 378; and Rohan, 479–480; and Condé, 488; mentioned, 280. *See also* La Rochelle
Hulst, 139, 466
Huth, Alfred H., 490
Huygens, Constantine, 383–384
Hymans, Henri, 503, 504

Iberti, Annibale, 21, 30–37, 45, 434, 435
Indies, the, 84, 192–193, 209, 327, 470; West, 341, 350–351; East, 396, 471. *See also* St. Christopher
Innsbruck, Statthalterei-Archiv, 444
Inojosa, Juan de Mendoza, Marquis d', 244
Isabella of Bourbon, Queen of Spain, 345
Isabella Clara Eugenia, Infanta, Governor of the Spanish Netherlands: and Archduke Albert, 7, 49, 52, 84–85; efforts to renew truce, 8, 10, 85–86, 95–96, 103–107, 360–361, 501, 503; death of, 10, 361, 504; described, 16, 142, 276–277; and Rubens, 17, 286, 291, 292, 392; and Marie de' Medici, 81, 359, 374, 379–386 *passim*, 500–501; at Breda, 111, 112; at Dunkirk, 118, 459;